HELSINKI

THE INNOVATIVE CITY

MARJATTA BELL & MARJATTA HIETALA

HELSINKI

THE INNOVATIVE CITY

HISTORICAL PERSPECTIVES

Finnish Literature Society & City of Helsinki Urban Facts

2002

Finnish Literature Society Editions 857
City of Helsinki Urban Facts

Language adviser: Robert Bell
Picture editor: Martti Helminen
Maps: Ari Jaakkola (1, 2), Arttu Paarlahti (5)
Figures: Pirjo Lindfors

ISSN 0355-1768
ISBN 951-746-359-6

Gummerus Kirjapaino Oy
Jyväskylä 2002

Contents

List of tables, figures, maps and appendixies

Tables:

Figures:

Maps:

Appendixes:

Foreword

The idea of this book arose from discussions at the end of the 1990s between Eero Holstila, the Director of the City of Helsinki Urban Facts and Professor Marjatta Hietala. Every now and then the ability of the Finns to adopt quickly new innovations had emerged and the idea became increasingly topical in view of their advance in high technology, most evident in Helsinki. A research team led by Hietala had studied the dissemination and adoption of new ideas and had published in the early 1990s three volumes entitled *Tietoa, taitoa, asiantuntemusta. Helsinki eurooppalaisessa kehityksessä* (Know-How and Professionalism. Helsinki as Part of European Development), which provided interesting evidence on the dissemination of innovations.

This present book, written with non-Finnish readers in mind, explores elements of innovativeness in a much wider sense and in the much wider time span of the last two hundred years. It discusses not only innovations related to the development of the city of Helsinki itself but also, in many cases, to the development of Finland as a whole because of the influence exerted by Helsinki as the capital city.

The book is a joint effort by Marjatta Hietala and Marjatta Bell. Marjatta Hietala is the author of Chapters III, IV, VI and IX and the note on Nature and the City Milieu. Marjatta Bell is the author of Chapters I, II, V and X as well as of the notes on International Immigrants, Finnish Design and Music. The remainig chapters are the result of joint labour.

We wish to thank the Directors of the City of Helsinki Urban Facts, Eero Holstila and Asta Manninen, as well as Juhani Lomu, the Director of the Helsinki City Archives. The staff of the City of Helsinki Urban Facts helped in collecting material and in designing graphical presentations and we especially want to thank Pirjo Lindfors and project researcher Ari Jaakola. The staff of the Library of Historical Photographs and Illustrations at the Helsinki City Museum, especially Director Riitta Pakarinen and her team, helped to select the illustrations. Our special thanks must go to Martti Helminen, Special Researcher in the Archives and Picture Editor of this book.

We received much assistance in collecting research information and source material from the History Department of Tampere University, where we wish to single out for particular thanks the Library Amanuensis, Teijo Räty, Amanuensis Sari Pasto, Office Secretary Risto Kunnari and Student Sampsa Kataja, who all did invaluable work in the final stages. Furthermore we wish to thank all those who agreed to be interviewed as well as Per-Ole Forsström, Martti Häikiö and Susanne Lindgren in Helsinki, Ossi Laurila in London and Anna Ingold in Aberdeen for their generous help in providing further material. Dr. Mervi Kaarninen and Pol.Lic. Kari Hietala are also thanked for their valuable comments. Naturally we also owe out heartfelt thanks to our families and to a countless number of friends and colleagues for their understanding and support during the past three years.

We also wish to thank the Finnish Literary Society and the City of Helsinki Urban Facts for including this book in their publication series. Our very special thanks go to Rauno Endén, Managing Editor, for his co-operation in the many stages of this project.

Finally, we thank Dr Robert Bell for advise on language and MA Jari Koski for the graphic design of the book.

London and Helsinki
May 2002

Marjatta Bell *Marjatta Hietala*

Introduction

On the eve of the new millennium, in March 1999, Mr Alan Osborn observed in the well-known British newspaper *The Daily Telegraph*, that

> **"If such a thing could be measured, you might well find that Helsinki is the most intelligent city in Europe. No other European capital approaches Helsinki today in its enthusiasm for, and expertise in, information technology. Visit any school or university in Helsinki and you see that the mobile has passed from being a novelty into something as unremarkable as a book."**

These views were confirmed a year later, when Bill Gates announced that he had donated one million dollars to the Library of the City of Helsinki in recognition of their promoting the use of the Internet in Helsinki municipal libraries. Yet on his way to St Petersburg in 1799 the English traveller Edward Daniel Clarke, coming from the most advanced industrial country of his time, had rather condescendingly noted that

> **"Helsinki itself is a small but a very pretty town. It has many stone buildings and appears to be quite a significant merchant town".**

Thus it appears that two centuries later Helsinki, the capital of remote Finland in the far north, has not only caught up with the older European capitals but even surpassed them in the everyday application of most modern forms of technology as it is reported that in Finland the E-mail and the Internet networks are now one of the densest in the world per capita.

How can such technological advance have been possible in a society so far away from the mainstream of European development, a society with agriculture as its main industry until as late as the 1960s? In the 1880s 73 % of the economically active population in Finland worked in agriculture, in the 1920s it was still 70 % and in the 1960s 35.5 % but in 2000 the figure has shrunk to a mere 6 % and the service sector now employs most people in

Finland (see appendix I). How then was this essentially urban leap forward achieved and what was the role of Helsinki and its decision-makers? How innovative were they themselves and what innovations were sought from abroad to help to develop the country and the capital? And how did the city itself benefit from these developments?

The purpose of this book is to explore these questions by tracing the origins and the routes of innovations, of new ideas, products and processes to Finland and to Helsinki, one of Europe's cities of culture in the year 2000. The aim is to look at how the fortunes of the city and the country were formed by native inventiveness, by employing foreign experts, by arranging study tours abroad and subsequent personal contacts, by studying professional literature, journals and statistics and by attending international congresses and exhibitions. The aim is also to investigate how far Helsinki itself could offer anything to foreigners, or be an inspiration to foreign experts. In brief, we examine Helsinki as an innovation centre within a developing Europe.

Compared with most European countries Finland is a latecomer to history as represented in written documents. It was gradually freed from the receding ice of the latest Ice Age some ten thousand years ago leaving it a country with an inclement climate and thin, relatively barren soil. Nevertheless it was being gradually populated by 8500 B.C. and there is evidence that even Lapland was inhabited by 7500 B.C.

Covered by spruce, pine and birch and sparsely occupied, it attracted few strangers except for raiders en route for areas offering more lucrative prospects, as Snorri Sturluson's sagas describe.

Finland was located on the easterly route of the Vikings during the 10th century and they had, along with some Finns, their special winter quarters in Novgorod. Archaeological findings in the Åland islands prove that there had even been a Christian influence in Finland as early as the 11th century. However, the problem in tracing early Finnish history is that wood was the major building material and it, of course, decays.

Finland only entered Europe's general history as a result of a campaign in 1155 by the Swedish king Erik who added the country to his realm. During the late Middle Ages the Catholic Church certainly did connect Finns with Southern Europe and its influence is manifest in the Finnish stone churches that date from the 14th century. The sea also acted as a link with Europe.

From the end of the 14th century until the middle of the 16th century fish from the Gulf of Finland and the Gulf of Bothnia, corn and honey from the Baltic area, Skåne herring and Finnish fur skins were sought after by the Hanseatic merchants who had their bases in Stockholm and Tallinn. Moreover, it was during this period that the connections with trading centres, such as Flanders, Lübeck and Danzig were made and the Hanseatic merchants also travelled from Viipuri up-country by water routes to inland Finland.

For six hundred years Finland remained a part of the Swedish realm during which period the citizens of Finland had the same rights as the inhabitants of Sweden and its importance to the king was indicated in the maps of the 17th and 18th centuries where it was designated a grand duchy (Magnus Ducatus Finlandiae). In 1809 Finland was ceded to Russia after the 1808–09 War and the Grand Duchy was recognised to be autonomous, allowing it a large measure of self-government based on the Swedish law and administrative system. The Lutheran Church also kept its position and Swedish remained the official language. Russian rule was eventually to end when Finland used the opportunity provided by the First World War, the abdication of the Tsar and the Bolshevik Revolution to declare its independence on 6th December 1917.

During the period of foreign rule ultimate political power inevitably lay outside the country itself, first in Stockholm and then in St Petersburg. However, it was necessary also to establish native administrative centres and from the Middle Ages onwards the capital of Finland was Turku (in Swedish Åbo) situated close to Sweden in the south western corner of the country. The other major medieval Finnish town, Viipuri (Viborg in Swedish and Vyborg in Russian), was a defensive post against Novgorod and Muscovy as well as an administrative centre for eastern Finland and it remained the provincial centre after the Russians, in the 18th century, conquered those south eastern parts of Finland. In 1812 tsar Alexander made Helsinki the capital in place of Turku.

Helsinki, or Helsingfors as it was known internationally until the Second World War, had been established in 1550 in the middle of a Swedish-speaking area. Swedish-speakers partly originated from settlers from Sweden who in the Middle Ages had colonised the Åland islands and the coastal areas of Finland. But as the country was also a fully incorporated part of Sweden the language of administration was also increasingly Swedish and by

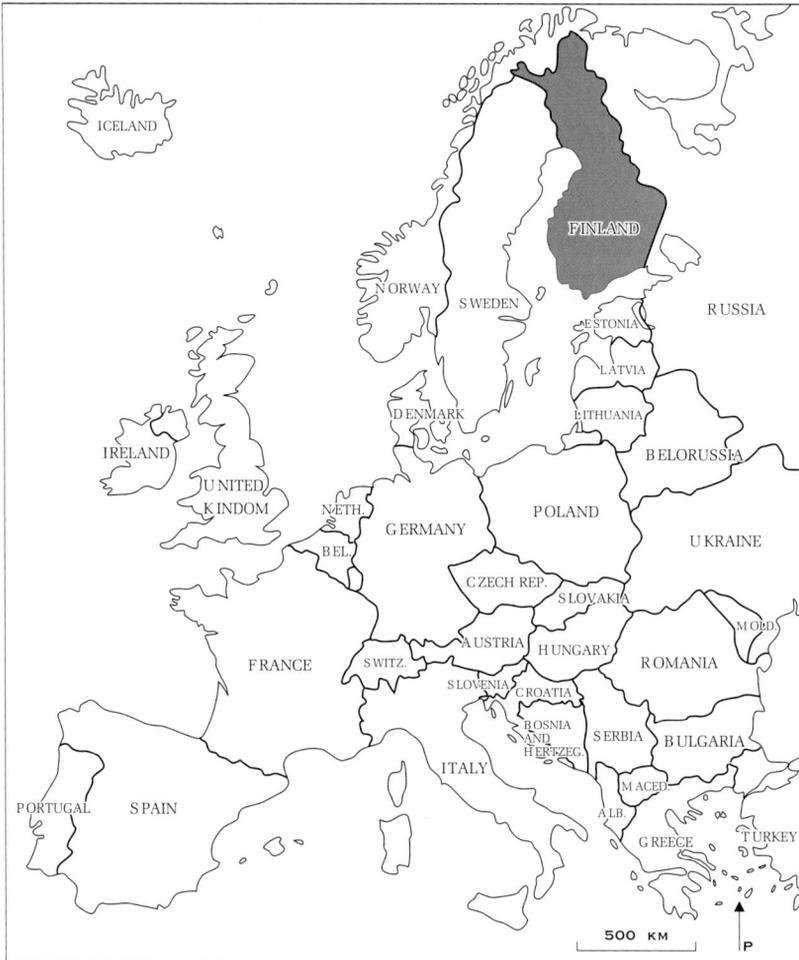

Map 1. Finland in Europe.

the end of the 18th century the entire social elite was using that language although the majority of the Swedish-speaking people in Finland, which by 1815 totalled some 160,000 or 15 % of the population, were farmers, fishermen and artisans.[1] The arrival in Helsinki of the administration and University from Turku strengthened the speaking of Swedish in the new capital and the Finnish-speaking workers who had arrived to construct the many new buildings remained a small linguistic minority. However, in 1863 Finnish was given the status of an official language and the increase from the 1870s onwards of Finnish-speaking people engaged in industry, construc-

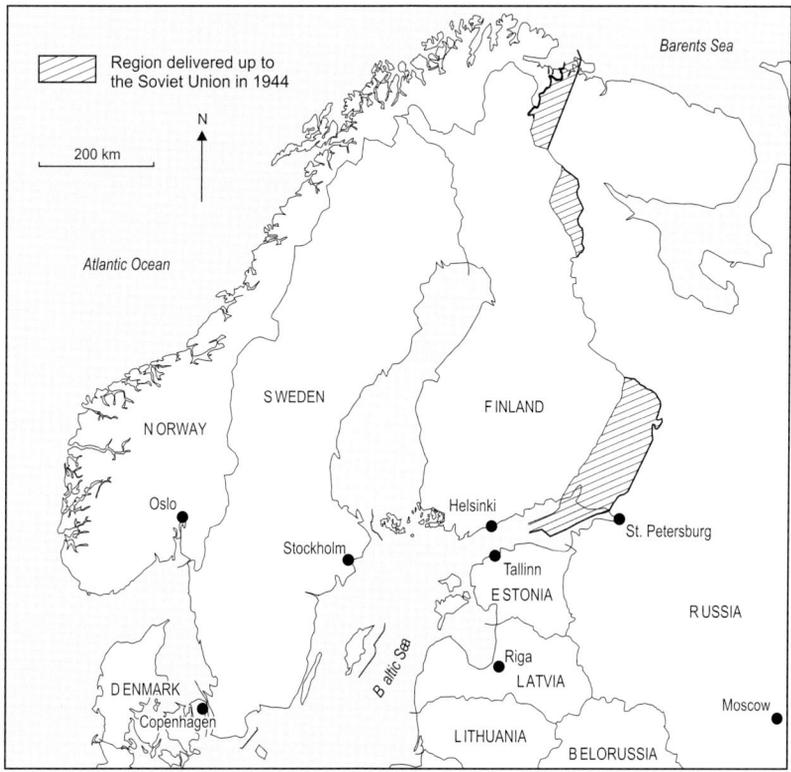

Map 2. Finland as part of the Baltic Region

Suomi Finland

– Independent republic since 6 Dec. 1917
– Population 31.12.2001 5,194,901

Helsinki

– Population 31.12.2001 559.718

– Finnish-speaking 87.6 %
– Swedish-speaking 6.4 %
– Other languages 6.0 %

tion and domestic service as well as the emergence of a Finnish-speaking educated class swelled the numbers of those speaking Finnish as their first language. Helsinki thus became a bi-lingual city[2] with a distinctive local slang in the working class areas,[3] the result of mixing Swedish and Finnish at home, in the yards and in the work place. Until the Second World War Swedish was still the most commonly used language among leading circles in the city. Yet in 2000 a mere 7 % of Helsinki people still had Swedish as their mother tongue.

Helsinki having become the capital and being a major port and the main centre of communications was soon to be a natural channel for the spread of innovations, a channel for the wider modernization process in Finland, and for the eventual move from a resource-based economy towards one based on knowledge. This virtuous development circle, if continued, will bring Finland to a completely new position in the international division of labour providing the country with a much-improved opportunity to face the challenges of the future. In this regard Finland's development is perhaps unique in Europe[4] and in the late 1990s much international attention was focussed on Helsinki. Such scholars as Charles Landry and Manuel Castells have used it as an important example of innovativeness and a creative urban milieu. Thus in his latest book *The Creative City* Landry emphasises the hidden resources of the city as well as its successful management of opposites:

> "Helsinki is a city which seems to have achieved a successful balance of priorities between men and women, between the wish for safety and the need for cultural stimulation, in part by providing the unexpected within a secure framework. It has balanced its awareness of its own history with the desire for modernity and innovation. There are also more basic polarities which form an integral part of Helsinki's culture: it embraces both heat and cold – snow and sauna; solitude and Finnish tango; light and dark, land and sea. It is a modern urban culture, yet it has its roots in rural society – it is a culture rooted in the natural world. Helsinki's ability to master these seeming contradictions is an asset to be harnessed. The images entertained by foreigners are still stereotypical. Helsinki is thought of as 'cold', 'distant', 'unknown', 'gloomy' and 'mysterious'. But when visitors come to the city their perceptions change radically for the better. Helsinki is less cold than they thought, there are unexpected things to do even in the cold, there is a passion and a 'wilderness'. Helsinki has flourished despite an administrative practice, which depends overmuch on historical precedent, an excessively compartmentalized approach to development and a fear of organizational change. The unpredicted and the unexpected have nonetheless found their place"[5]

In this book we explore how this happened by studying the process of innovation and the channels for the diffusion of innovations in and through the city during the 19th and 20th centuries. We have applied an historical perspective when aiming to analyse some of the factors that promote innovation. We discuss the accumulation of know how and the factors that encourage progress as well as those that hinder it paying attention also to the formation of networks,[6] co-operation between organisations and learning from the experience of others, making occasional references also to the spreading of new ideas from Helsinki to other Finnish cities and vice versa.

What were the reference groups for the city of Helsinki itself? How quickly were its decision makers willing to adopt new innovations? What kind of factors and elements made Helsinki a centre of innovation? And what are those innovations, which could provide people with precedents and examples, a creative mythology, to be referred to whenever they encounter the challenges of the emerging global society of the 21st century.

I Helsinki – The Innovation of a King, a Queen and Two Emperors

A general view of old Helsinki at the beginning of the 19th century.
(Helsinki City Museum)

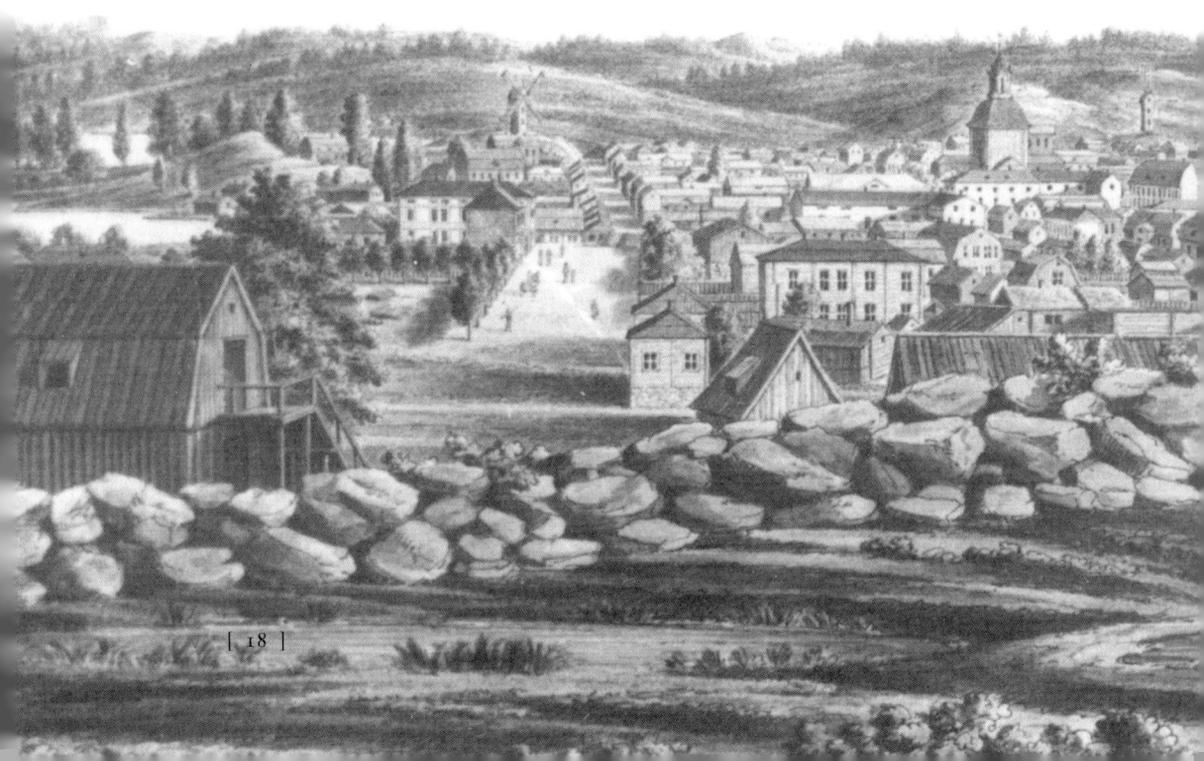

Helsinki, often called by Finns themselves the Daughter of the Baltic, can also be described as the offspring of not only the king that founded it but also of a queen and two emperors. For unlike most other capitals it was not an ancient trading place, which had developed in the course of history into a town and a city; it was rather the result of the innovative actions of four sovereigns of Finland, King Gustavus I and Queen Christina of Sweden and the Tsars Alexander I and Nicholas I of Russia.[1]

It was King Gustavus I who ordered the foundation of Helsinki (Helsingfors in Swedish) in 1550 as a trading centre for the whole of Southern Finland to compete with Tallinn on the southern shore of the Gulf of Finland. The king was keen to benefit financially from the increasingly competitive Baltic trade between carried on by the Germans of Lübeck, the ancient Hanseatic town with traditional supremacy over these waters, and the Dutch, a trading nation then in its ascendancy. However, the king's military experts decided that the site he first favoured was too exposed and consequently the new town was eventually located at the mouth of the River Vantaa, which was well protected by an archipelago.[2]

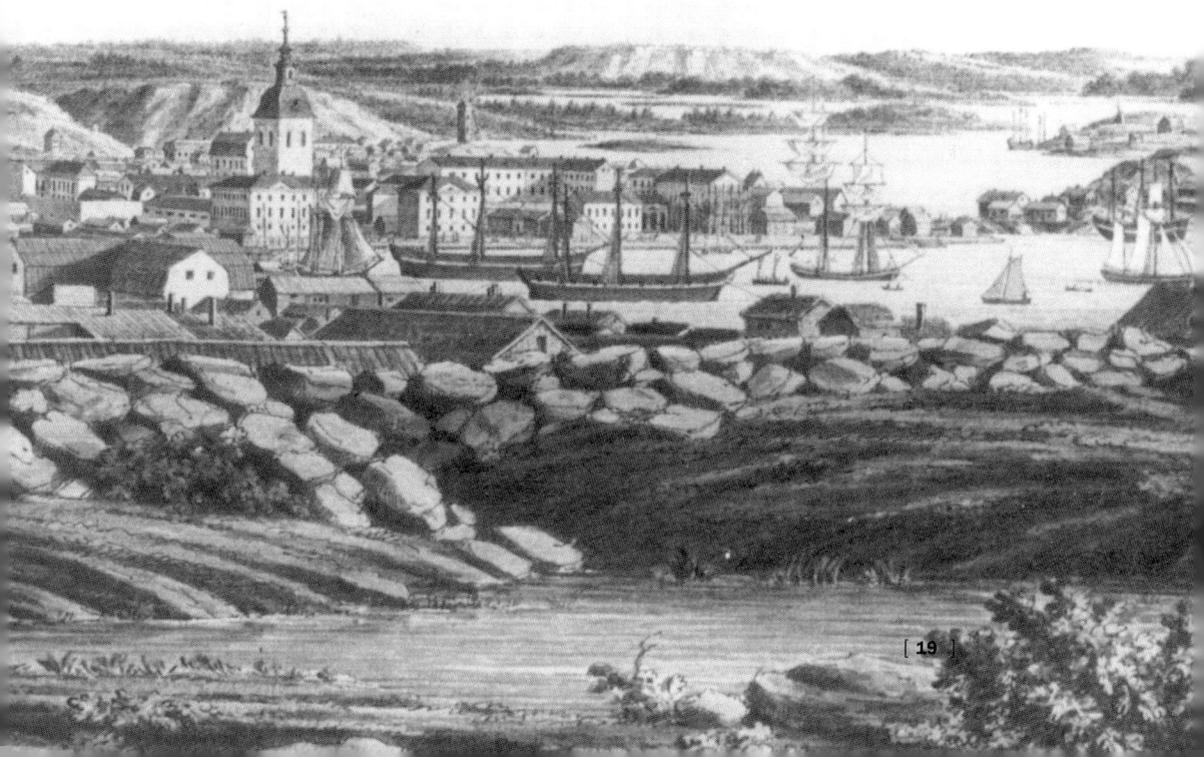

In spite of the forced transfer to Helsinki of burghers from the nearby coastal towns of Porvoo and Tammisaari as well as from the western Finnish towns of Rauma and Ulvila, the new development did not prosper, and about some ninety years later Queen Christina, the king's great-granddaughter, ordered it to be moved five kilometres to the south to its current position where it could be even more easily protected and provide an excellent base for the Swedish navy. At the same time she confirmed Helsinki's status as a staple town, giving it the right to carry on trade with foreign countries, and the town's coat of arms, a boat with a golden crown above it, symbolising Helsinki's role as a trading and seafaring town under the special protection of the Swedish crown.[3] But by this time Sweden already held the southern coast of the Gulf of Finland including the town of Tallinn. Therefore there was no longer any need to pay further attention to the fortunes of Helsinki or its immediate fortification, and like other Finnish towns, apart from the capital, Turku, Helsinki continued its existence as a small provincial port.

The Russian Tsar, Alexander I, became involved in the history of Helsinki as a result of the war of 1808-09[4] waged by Russia against Sweden in order to force that country to join in Napoleon's trading blockade of Britain. But once they had occupied Finland the Russians decided to keep the country and adopted a conscious policy of pacifying a population[5] disillusioned with a Sweden that during the war had neglected the defence of Finland.[6] Indeed, in June 1809 at a meeting of the four Finnish estates, that is the nobility, clergy, burghers and peasants, held in Porvoo, Alexander I confirmed Finland's status as an autonomous Grand Duchy directly under the personal rule of the Tsar.[7] By annexing Finland Alexander I had achieved a strategic aim of Peter the Great and his successors, the safeguarding of the routes to St Petersburg, the capital of the Russian empire.[8] During the following months he was also won over to the idea of reconstructing Helsinki, where during the war one third of all the buildings had been destroyed by a fire in November 1808.[9] In spite of this calamity the town had had to continue to quarter some 2,000 Russian soldiers amongst its native population of somewhat over 3,000 people,[10] and in February 1811 Alexander I approved a reconstruction plan along with compensation for those who had lost their homes in the fire and 20 year loans for those who would consent to having new homes built from stone.[11]

From Seaport to New Capital

By the time of the Russian conquest Helsinki had never achieved the dominance of the Gulf of Finland hoped for by Gustavus I but it nevertheless was an important seafaring town, which had exported the timber needed in Europe for ships during the late 18th century conflicts and especially during the French Revolutionary and Napoleonic Wars.[12] The English traveller, E.D. Clarke had, indeed, noted in 1799 that Helsinki was obviously quite a significant merchant town, which shipped planks to Spain in exchange for salt.[13] These business ventures had financed the construction of a number of merchant houses built in stone and even made it possible for a leading Helsinki merchant, Johan Sederholm, to lend money to the French state.[14] Most importantly, its successful shipping trade had elevated Helsinki in 1805 to the position of fourth port in the whole of the Swedish realm after Stockholm, Gothenburg and Gävle.[15]

A turning point in the history of Helsinki had been the fortification from 1748 onwards of the islands of Susisaaret at the entrance to the harbour. This new fortress of Suomenlinna (originally Sveaborg in Swedish or Viapori in Finnish) had brought new life to the town. Not only did the 2,500-6,000 men working at any given time on its construction[16] bring more business opportunities for local merchants but in the completed garrison were many officers and their families from the Swedish upper classes who brought with them the cultural ideas of the Enlightenment and the refined tastes of the court of the Francophile King Gustavus III. Consequently assemblies were held, amateur plays in French were performed and in winter sleighing parties were organised in the town[17], which by 1805 had itself a total of 3,227 inhabitants while the population of the Suomenlinna garrison comprised some 5,616 people.[18] In order to provide for this clientele Helsinki shops stocked not only wines from France and Spain, herring from Holland and a variety of cloths from England but also such luxury goods as East-Indian taffeta and other silk garments including black silk stockings, along with tea, coffee, spices and chocolate. Toys and musical instruments were imported from Germany.[19] Travelling theatre groups from Sweden and Germany also visited Helsinki in the 1780s as did dance and elocution teachers, drawing masters and musicians. According to a witness of the time,

"Due to mixing with persons of rank Helsinki burghers (had) become more polished in their manners and their children (had) married with them."[20]

After the arrival of the Russians some leading Finns therefore started to promote the idea that Helsinki could become the capital of the new Grand Duchy.[21] Gustaf Mauritz Armfelt and J.A. Ehrenström also suggested turning Helsinki and its port into the centre of all Finnish trade and "a source of great prosperity not just for Finland but also for Russia" while the burghers of the town entertained the idea of making Helsinki into a free port. This latter proposal was not too popular among the other Finnish trading towns, however, and due to their strong objections the status of a free port continued to elude the merchant princes of Helsinki.[22]

However, from the strategic point of view the idea of establishing Helsinki as an impressive new capital appealed to the Russians and those Finns who were close to the Tsar. The city – along with its fortress, which at that time was generally considered equal to Gibraltar[23] – was nearer to St Petersburg and less under the influence of Sweden than the older capital Turku, still the biggest and wealthiest city in Finland[24] with strong economic, cultural and family links with Sweden. Viipuri, traditionally the second merchant town of Finland, had too many monuments and memories of its history as a main defence post against the Russians. Helsinki, on the other hand, had played no particular role in the history of Swedish-Russian conflicts and much of what had remained from the Swedish period had now been destroyed by fire. It thus provided the Tsar with a perfect opportunity for the launching of a new era.

This elevation of Helsinki cast a new light on the Tsar's plans for the reconstruction of the town. Clarke had noticed that a number of well-to-do merchants already lived in private stone houses,[25] not too common a feature in those days in a Finland where timber was the natural construction material. Some of these, such as the Bock family house to the south of the present Senate Square and the Heidenstrauch mansion near the South Harbour had survived the fire, but the majority of the dwellings that had escaped the flames were Gustavian style single storey wooden houses painted in red ochre with similar outhouses in spacious plots. The remaining public buildings of the town consisted merely of a town hall, a church and a *trivium* (secondary school) as well as a small hospital. Thus Helsinki's overall appearance remained very rural amidst its ashes.

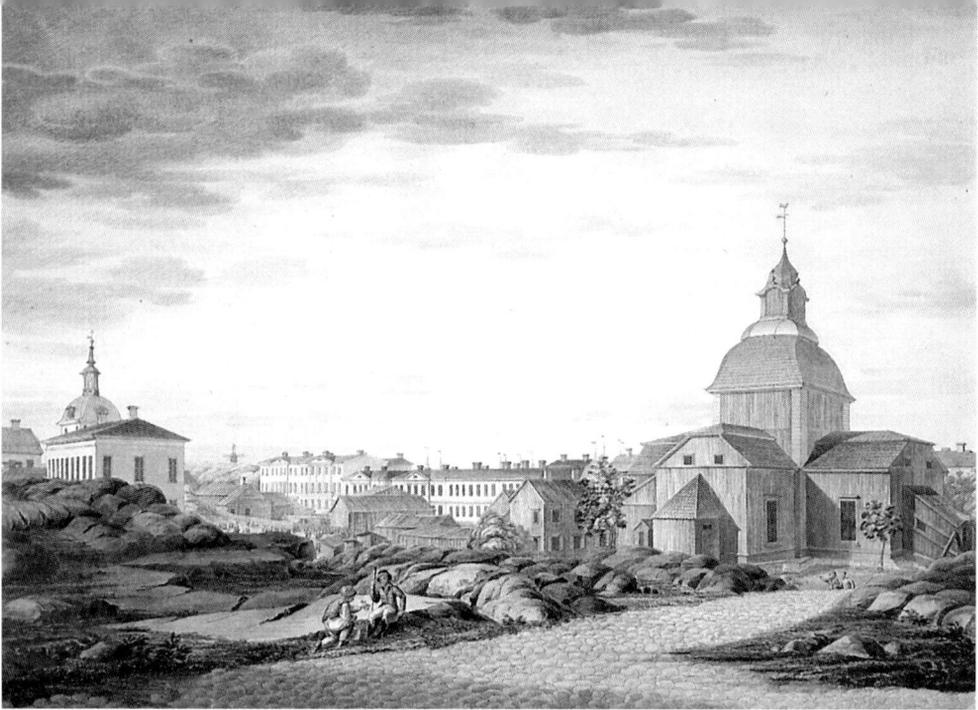

The idea of redeveloping this potentially important Finnish town took the fancy of Alexander I, who had initiated in his own capital, St. Petersburg, many building projects with a new architectural manner, the "empire", or "classical" style as it was called by the Russians.[26] While the Tsar was pondering his options, some of the prosperous merchants had already started to build new townhouses from stone for themselves taking advantage of the reconstruction grants, and a few of them reflected new St Petersburg trends including the building now used as the Helsinki City Information Office on the North Esplanade. It was designed by Pehr Granstedt, the former Swedish conductor of fortifications, who had in the summer of 1808 been a prisoner of war in St Petersburg and had made copious notes in his diary on architectural features of the city.[27] However, although there is no direct evidence, another likely source of St Petersburg influence was a *Collection of*

The old Helsinki was built in Gustavian style, mainly of wooden houses painted in red ochre, and was almost destroyed by fire in November 1808. In this watercolour of 1820 C. L. Engel shows the wooden Ulrika Eleonora Church (right), the old Town Hall, built of stone in 1804 (left), and behind it the Bell Tower, which all escaped the fire. Note the rocky terrain of the site, which is now the Senate Square. (Helsinki City Museum)

elevations for private buildings in towns in the Russian empire as confirmed by His Imperial Majesty.[28] This was published in three volumes in 1809, 1811 and 1812 and included some 250 proposals for private building elevations with 62 pages of fences and gates.[29] The Helsinki burghers were bound to have noted the application in Viipuri of a similar collection by Catherine the Great on their way to St Petersburg on business, and it is highly unlikely that they were not made aware of the existence of the Alexander I collection by the Tsar's advisors. Moreover, like in Viipuri, Helsinki's rebuilding committee was ordered to appoint a resident architect for assisting private people in their building activities,[30] as well as for designing public buildings. It is therefore not too much to assume that the system tried earlier in the rebuilding of Viipuri had also been applied in the reconstruction of the private houses of Helsinki and that the use of the Alexander collection would explain why a number of plans for private dwellings in Helsinki dating from the early 19th century do not carry the name of any architect.[31]

In the light of Helsinki's new status as the capital a town plan approved earlier, based on the Gustavian grid plan, was now considered too modest in style, and the Tsar used the opportunity to appoint J. A. Ehrenström, a Finnish fortification engineer and surveyor by training and a friend of his Finnish favourite Count Gustaf Mauritz Armfelt, to the chair of the reconstruction committee with the duty of revising the whole plan. Like Armfelt he had been influenced by the refined style of the Swedish court and had also visited Vienna with its magnificent Habsburg buildings. Through Armfelt he had access to the Tsar and because of his training he was able to overcome the obstacles presented by the rocky and swampy terrain of the town and its surroundings. Fortunately the only task he did not need to tackle was the demolition of city walls – for unlike most European towns Helsinki had never been surrounded by any such defence system.

The present Senate Square and its environs including Aleksanterinkatu and the Market Square, Kruununhaka, the Esplanades, Bulevardi and the Kaisaniemi park were all included in Ehrenström's farsighted plan, which formed the basis of construction until the mid-19th century. It reflected the two artistic categories, "regularity" and "grandeur" which had been supreme in St Petersburg architecture from the mid-18th century onwards, achieving their apex during the reign of Alexander I. The St Petersburg style was dominated by the straight line and the right angle, and there the combination

of vast squares, expansive boulevards, precisely outlined rectangular plots, standardised dimensions, and geometrically regular gardens made the plan of the city one of beauty and wealth still influencing Russian city planners and architects in the late 20th century. The scale of the centre point of Ehrenström's plan, the Senate Square, must also have reflected this St Petersburg influence,[32] because it was made spacious enough for an audience twenty times larger than the 4,000 people then inhabiting Helsinki, as was evident in June 1993 at the joint concert of the Finnish rock band Leningrad Cowboys and the Red Army Choir which attracted a capacity crowd of 80,000 people to the square.[33] Even if Ehrenström and the Tsar had quietly been preparing for a proportionally similar expansion of population in Helsinki as was taking place in St Petersburg,[34] it was still excessive and even in the 1870s and early 1880s foreign visitors felt that a plan laid out on such a scale was far too ambitious for the city's population of some 30,000 inhabitants.[35]

C.L. Engel (1778-1840), the German architect whose main life's work was to transform Helsinki, a small port, into a handsome capital. (Helsinki City Museum)

As his architect Ehrenström invited to Helsinki the young German Carl Ludvig Engel who had already demonstrated his abilities in Turku. Engel had trained in the Berlin Bauakademie about the same time as Karl Friedrich Schinkel, the famous architect of Prussian hellenism, and had also become familiar with James Stuart and Nicholas Revett's *The Antiquities of Athens* (1762), which had been a seminal architectural work in London since the 1760s.[36] During periods in Tallinn and St Petersburg Engel had also become familiar with the buildings of the Italian Giacomo Quarenghi and the Scottish Charles Cameron.[37] Engel was therefore not only well prepared for his task but also fully aware that he had been given a rare opportunity to turn a backwater town into a

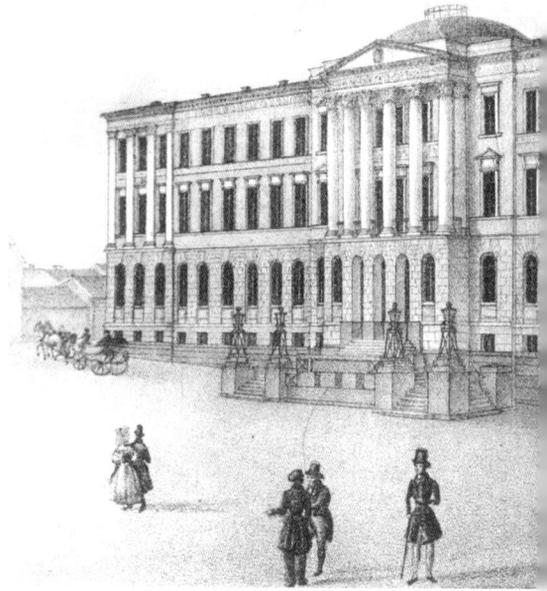

The Senate (1822) was the first major building to reveal to Helsinki people the monumental scale on which their new town was planned. Compared with the simple style of old stone buildings (see picture 1) the architecture is now more majestic. This lithograph by F. Tengström (1838) also shows a few citizens who had come to see the handsome town centre with some horse cabs (right) waiting for customers. (Helsinki City Museum)

capital.[38] Once the Tsar in 1817 had personally approved Ehrenström's revised town plan, Engel's task in the new Helsinki was to form handsome "architectural landscapes" reminiscent of St Petersburg and his success in this respect became interestingly evident a hundred and fifty years later, when a number of film directors chose to film in Helsinki in order to capture the atmosphere of a Russian townscape.[39]

In his memoirs the history professor Topelius recalls how to many of the burghers the plans of Ehrenström and Engel appeared far too grand and seemed likely to destroy many of the comfortable features of their familiar town.[40] Yet Alexander I, whose own grandmother Catherine the Great had built nearly 150 new towns in Russia,[41] obviously wanted to make Helsinki not only the new administrative and military centre of Finland but also a symbol of a new imperial era. He also named the planned major north-south street Unionin-katu (Union Street) to emphasise the new link between the two countries and he personally checked all the plans down to minute details and paid a visit in 1819 to inspect progress.[42] At a time when the daily wages of a manual labourer in Helsinki were less than one rouble,[43] by 1819 he was providing for the construction works a total of some 1.6 million roubles,[44] a total that was to rise to 4,229,743 roubles and 91 kopecks by the time all the public building

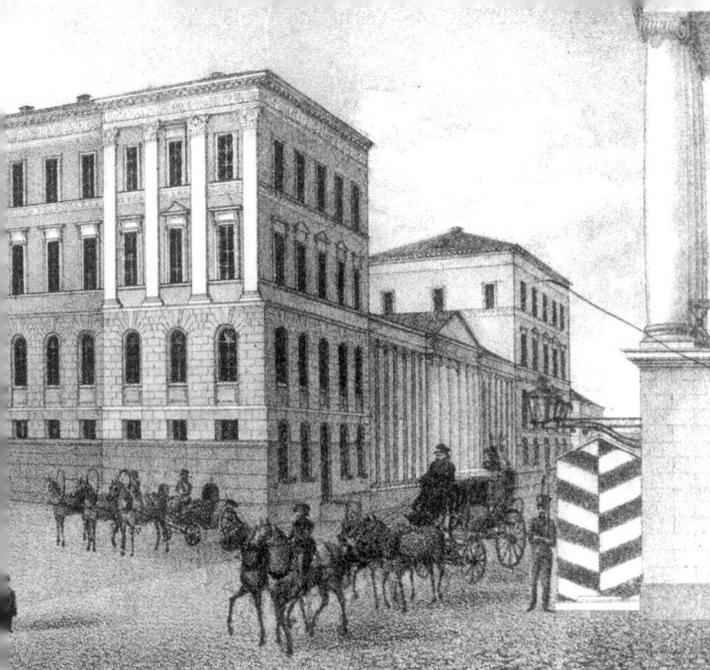

projects had been completed.[45] All this was partly financed by various taxes generated in Finland, such as an excise duty on salt and an export duty on tar, as well as partly by loans from the State Loan Bank at St.Petersburg. [46]

Architecture being in the early 19th century the art favoured by princes[47] Alexander's brother and successor, Nicholas I, was also familiar with such issues and shared his predecessor's personal interest in the development of Helsinki. Especially keenly he followed the planning of the University buildings and of St Nicholas Church (now the Cathedral) demanding that the proposed altarpiece in the latter should be changed for a more handsome one.[48] Many of the present Helsinki streets such as Aleksanterinkatu (Alexander St.), Mariankatu (Maria St.) and Liisankatu (Elizabeth St.)

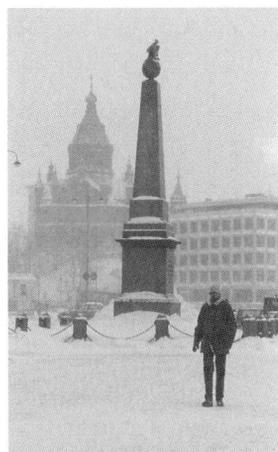

The Russian era is still evident in this Helsinki cityscape. The Empress´s Stone, in the front, was erected to commemorate the visit of Tsar Nicholas I and his Empress Alexandra in 1833. The obelisk is adorned with a two-headed eagle, the symbol of the Romanov Imperial Family. In the background is Uspensky Cathedral (1868), the largest orthodox church in Western Europe. Today Orthodoxy accounts for less than one per cent of the population. (Photo Jussi Kautto)

were named in honour of members of the imperial family, and to mark their family visit to Helsinki in1833 the town also got its first public monument, Keisarinnan kivi (the Empress's Stone), which is still to be seen in the Market Square.

From 1817 onwards and especially during the 1820s and 1830s the burghers of Helsinki thus witnessed continuous building activity, with the blasting of rocks and the filling of swamps for new streets and buildings. Each year, on average, construction work was being carried out simultaneously on three major public buildings designed by Engel.[49] These included all the major state and civic administrative buildings and four military barracks, three hospitals, three churches (including the present Cathedral), the university buildings, the official residences of the Governor General and the Russian military commander as well as a theatre, and a hotel, the Seurahuone Assembly Rooms, which the town council decided to erect in 1827.[50] During this construction work a watery meadow was fenced in to become the Esplanade Park with its lawns being established and trees planted in 1824,[51] while the University Botanical Gardens were laid out in the Kaisaniemi Park. The conversion of the Heidenstrauch mansion on the South Harbour into the imperial residence was one of Engel's last works[52]. Of his total of some 30 neo-classical style public buildings in Helsinki some twenty or so major works are still in use and with them Engel transformed Helsinki from a Gustavian small town into a handsome administrative, military and cultural centre in neo-classical style to demonstrate the new glorious rule of the Russian Tsars as Grand Dukes of Finland.

One of the major sets of Engel's new buildings consisted of the University, the University Library and the Observatory, which together with the new Botanical Gardens, provided Helsinki with some of the most handsome and spacious higher education premises in the Europe of that time. The universities of the old mother country Sweden, Uppsala and Lund, had to wait for over a further half century before getting main buildings of the same size.[53] Indeed, the new buildings symbolised in very concrete terms the changed position of what had been the old Academy. This had originally been established in Turku by Queen Christina in 1640 to educate clergymen and civil servants for Finland and although it had been one of only three Swedish seats of higher learning it was far away from the political centre of Stockholm with its major

cultural and scientific organisations, such as the Swedish Academy. When the Tsar decided to move it to Helsinki after the great fire of Turku in 1827, it was given a prime site in the new capital, facing the Senate, the main government building.

Helsinki's present centre consisting of the Senate Square, the South Harbour and the Esplanade still reveals Russian, Italian, German and British influences and is one of the few neo-classical townscapes in Europe that survived the later 19th century construction boom. Like buildings in Russia but unlike those of the same period elsewhere, as in Bath, Edinburgh, London, Paris or Washington, the neo-classical buildings in Helsinki were painted, in Italian style, in shades of yellow or in pastel colours while their Corinthian or Ionic columns and other architectural details symbolising the purpose of the building were picked out in white. Their solid foundations were made of massive blocks of granite and the plate roofs were painted black or red. The low horizontal lines of the buildings emphasised the width of the streets, a feature, according to the British architectural expert J.M. Richards, that is peculiarly Russian in Helsinki and in other Finnish towns[54] for from the 1820s onwards they all had to observe the Russian regulations which required the main streets to be 28 metres wide and other streets 18 metres wide to prevent the spread of fire. In practice this meant doubling and almost trebling the width of many Helsinki streets. As a further precaution different parts of the town had also to be separated with streets lined with deciduous trees, such as lime trees[55] and following the style of the continental capitals they were given names such as Esplanade and Boulevard.

In principle it was only in suburbs located beyond these leafy streets that the burghers were still allowed to construct their wooden houses in the regulation one storey cum basement form with spacious plots for outhouses. Even here, however, all sauna bathing in Helsinki was restricted to a number of public establishments constructed in stone in different parts of the town, the most famous of all being the Marienbad in Kruununhaka. Moreover, it was also laid down that nothing should be built at distances of less than 10 metres on either side of plot boundaries. This left space for gardens with fruit and other deciduous trees, vegetable plots and even for small summer-houses which, taken together, gave major parts of empire Helsinki the appearance of a garden city.[56] – These town planning ideas were later incorporated into the 1856 Town Building Acts and were adopted as a model

in Sweden, with a number of Finnish town plans being copied and sent there as examples. The Swedes commented on "their unusual functionality and beauty" and they were included in eight of the thirteen booklets of such plans published in Sweden as late as 1875.[57]

While engaged in his major Helsinki building projects Engel did not cut himself off completely from his hometown of Berlin. In the 1830s he published a series of articles in a Berlin trade journal describing his Helsinki and St Petersburg experiences.[58] It was in Finland, however, that his major wider influence was felt. In 1824, in the middle of the reconstruction period, he was also made Director of the Intendent's Office and became responsible for all planning and public construction throughout the country:

> **"My area of work now spreads throughout Finland and I really do wish to be able to leave permanent marks in this country … as my intention is to disseminate better architecture and good taste as well as more know how among the artisans."[59]**

This rare opportunity continued to keep Engel in Helsinki. It is possible that this was not entirely to his taste. Some people were still suspicious of him and he never quite learned to enjoy living in "this land of bears" where "the summers are so damned short", though for his relaxation he had established a garden with a glass house in his home in Bulevardi, then a popular suburb, the home of academics and civil servants.[60] However, until his death in 1840 Engel and his students spread Helsinki's innovative architecture around the country designing scores of churches, town halls, hospitals, gaols and manor houses. Their style, using horizontal weatherboarding painted with pale colours, was also employed in the following decades in the design of the private wooden houses still in evidence in Finnish country towns, many of which also depended on an actual town plan prepared by Engel.[61] It was also due to him that Finnish houses became better equipped against the harsh winter climate as he promoted the use of double glazing and of tiled stoves for the storage heating of rooms. While both inventions had already been known in Sweden by the end of the 18th century and were to be found in the most exclusive private buildings of western Finland, it was due to Engel that they were adopted (in a Russian version) for Helsinki's public buildings and thus were subsequently to spread from the capital to all parts of the country.[62]

Helsinki burghers also joined the effort to embellish their town. To provide properly for high ranking visiting officials and its own luminaries Helsinki town council decided in 1827 to establish a magnificent building housing a restaurant, assembly rooms and hotel in the Market Place. Once opened in 1833 this building, Seurahuone, became a principal venue for Helsinki´s social life for generations until the early 20th century. It is now the City Hall of Helsinki. (Helsinki City Archives)

Helsinki Becomes a Cosmopolitan Middle-Class Town

In the early years of Russian rule the majority of the inhabitants of Helsinki remained relatively untouched by all the potentially enriching contacts and new influences. It was only with the arrival from Turku in 1819 of the Senate and its attendant administrative offices and the transfer of the University in 1828[63] that the city's social life really began to change. Government officials and their families accounted for about one thousand extra bodies in addition to the shopkeepers and craftsmen who followed their important customers to the new capital,[64] while the arrival of the University brought more than three hundred students[65] along with some forty university teachers plus their families and staff. By 1830 not only had the number of aristocrats living in

Helsinki trebled but that of all persons of rank had grown eight fold so that they now equalled the number of the burghers, who still in 1810 had been the dominant group,[66] and this naturally lead to social readjustments that were not always easy.

Nevertheless, to make their city's facilities more suited to the needs of these luminaries as well as of visiting officials and tourists, the town council decided in 1827 to establish a proper hotel, restaurant and assembly rooms in Helsinki. The imperial blessing for the project was received when Nicholas I acquired shares in the company, which commissioned Engel to build on such a grand scale that the ball room alone could accommodate 1,200 people, a number equal to ten per cent of the population in 1830. Once the Seurahuone Hotel and Assembly Rooms were completed on the North Esplanade near the harbour in 1833, it was the biggest and most handsome hotel in Finland and became the major venue for Helsinki's social life and cultural events for decades, staging for example a great ball in 1840 for the full complement of 1,200 people paid for by the association of Helsinki merchants to mark the 200th Anniversary celebrations of the university. At the same time, once the hotel company started to make a profit, it also benefited Helsinki's poor, because the Tsar had registered his investment in this venture, one quarter of the shares costing some 20,000 roubles, in the name of the municipal poor relief institution.[67]

It was significant also that along with the University the new capital began to acquire a number of other intellectual stimuli. For example, it got new bookshops, one of which, Wasenius's, was appointed the supplier of the university in 1831 with a duty to order, as instructed by the university staff, books, maps, lithographs, sheet music and other printed material from Russia, Sweden, Norway, Denmark, the Netherlands, Germany and Switzerland at least three times a year, from France at least twice a year and from other countries at least once a year.[68] No wonder therefore that the Wasenius shop (the core of the present *Akateeminen Kirjakauppa*) accumulated a considerable stock of foreign language books[69] becoming the largest and the most important in the whole country while the city itself became the centre of book imports for the whole of Finland. For the merchants, shopkeepers, artisans and fishermen all of this was new; earlier they appear not to have been all that keen on books: in 1813 the value of book imports had merely

equalled that of playing cards. However, with the arrival of the University the value of book imports increased over sixty-fold at a time when imports in general were significantly reduced, and by the Crimean War the value of book imports had increased to nearly two thousand times the 1813 figure, while imports in general had increased a mere seven times.[70] At the same time Helsinki became a significant printing town. By 1828 three local printing companies had started to operate and by 1850 their number had increased to seven. These included two lithographic printing plants,[71] which in the early 19th century were very fashionable all round Europe as providers of sheet music, reproductions of old masters for wall decoration and picture books of townscapes and landscapes for middle class households.

Moreover, with the arrival of the University two new newspapers were also launched to suplement the official government newspaper *Finlands Almänna Tidning*. These new publications, *Tidningar ifrån Helsingfors* (later *Helsingfors Morgonblad*) and *Helsingfors Tidningar,* became the country's first real newspapers. From the 1840s onwards news from Europe reached Finland in less than half the time required in the 1810s[72] and articles translated from the foreign press were given a prominent place in *Helsingfors Tidningar.* This paper was written in a varied and light-hearted style and it developed, during the 1840s and 50s, into Finland's most widely read newspaper. It not only discussed foreign political matters but also social, pedagogical, and economic issues within the limits allowed by the Russian censorship of the day, which was eager to prevent western revolutionary ideas from entering the empire.[73]

The arrival of the University in Helsinki also stimulated a new, innovative solution to the schooling problems of the town. For some two hundred years the only school had been the old Trivium School. To mark the visit of Tsar Nicholas I in the summer of 1830 the burghers of Helsinki decided to establish a Bell-Lancaster school to give elementary education to boys from the lower classes. Such schools, which were based on the idea of the more advanced children teaching newcomers, were cheap to run and had become very popular both in Sweden and in Russia and one had been operating in Turku for ten years.[74] However, such a school could not adequately satisfy the needs of the new affluent families arriving in Helsinki. They preferred to employ private tutors to coach their sons for university studies or to send them to the famous gymnasium in Porvoo. A permanent solution to this problem was provided, however, by members of *Lauantaiseura,* an informal

group of young academics who, in 1831, established a private lyceum, based on the model of schools in Denmark.[75] In accordance with neo-humanistic ideals this Helsingfors Lyceum no longer provided merely a training ground for the priesthood nor did it operate as a purely utilitarian institution; instead it aimed to give an all-round humanistic education for the future leaders of the church, the civil service and academic life. Class teachers were replaced with subject teachers, who gave instruction not only in classical but also in modern languages and mathematics, and maintained order by appealing to the pupils' sense of duty and honour. The use of corporal punishment, a common feature in all Finnish schools at the time, was replaced by detention. In Finland the Helsingfors Lyceum thus represented the first concrete attempt to apply neo-humanistic pedagogical ideals at the secondary school level and was to serve as a national model in the 1860s when major school reform took place in Finland.[76]

However, it was not only the life of the middle class in Helsinki that began to change. Construction workers and their families were increasingly drawn to the town not only from the neighbouring communes but also from inner Finland and Ostrobothnia. For them Helsinki provided wider horizons; they began to learn stone masonry skills from the Russian construction workers brought from St Petersburg by Engel and building contractors to help construct the Senate and other major buildings with their complicated vault structures.[77] People in Helsinki also learnt to benefit from the examples of market gardening introduced by the Russian soldiers and their families on sites near the current Lasipalatsi and the western shores of Töölö Bay.[78]

Yet in other respects the Russian and other foreign incomers did not always make as great an impact as might have been expected. The potentially most significant group, the Russian administrative personnel, was limited to the small staff of the Governor General. Most of the country's administration was in the hands of the Finns themselves and was still executed according to laws, rights and privileges inherited from the era under the Swedish crown.[79] This accorded with the usual Russian practice dating from the time of Peter the Great of maintaining the legislative structure of conquered areas.[80] The strong body of Russian troops, stationed in the Helsinki barracks and in Suomenlinna admittedly were highly visible in the town when marching to their daily exercises and carrying out parades on the numerous days of

imperial celebrations but most of those below officer rank kept themselves and their families distant from the general population in line with a general Russian policy in annexed areas.[81] Most incoming Russian civilians worked as victuallers, forming as early as 1820 about one third of all the merchants and shopkeepers in Helsinki, a position that they held until the 1850s.[82] The majority of Russians, were they traders, soldiers, market gardeners or construction workers, preferred to socialise within their own closed circles separated by the Russian language and the Russian-Orthodox religion from a Helsinki dominated by the Lutheran faith and the Swedish language.[83]

There were, however, exceptions. Some Russian entrepreneurs had followed the troops and had established themselves in Helsinki between 1810 and 1830. The Sinebrychoff family for example accumulated considerable wealth by establishing the first major brewery. The Kiseleffs expanded the sugar factory and along with the Uschakoffs manufactured materials for the reconstruction of the city while the Korastieffs operated as actual building contractors. This influential group soon got its representatives on to the town council[84] and in spite of their modest origins were increasingly at home in Helsinki's social life along with the Russian officers, who formed an important part of Helsinki's society from the beginning of the town's career as the capital. However, the officers normally mixed only within the most aristocratic circles of the new Grand Duchy, the Armfelts, Aminoffs, Rehbinders, von Haartmans, Mannerheims and Walleens. Such upper-class families, living in Kruununhaka and especially in the vicinity of the present Liisanpuistikko, sometimes called "the little Faubourg St. Germain" of Helsinki,[85] did not neglect the opportunity resented by the officers' presence to advance their sons' careers in the service of the new rulers. Using the French language as a convenient tool of communication they showed hospitality to young Russian officers with good connections.[86] The houses of such notables were increasingly filled with empire style mahogany furniture imported from St Petersburg[87] and equipped with samovars and porcelain tea sets.[88] Moreover, they may also have adopted from St Petersburg the custom of leaving the city to spend a long summer in the country.[89]

Even so social life in the new capital remained at first as boring as in most provincial towns round Europe centring as it did on "dancing, ribald stories and promotions in the official ranks."[90] Apart from social visiting there was

some revival of the concerts and theatre performances that had been known in Swedish times giving colour to everyday life in winter, but in summer Helsinki usually went to sleep. However, everything began to change in 1833 when Helsinki people had their first sighting of the latest innovative means of travel, the steamboat. In the early summer the Tsar Nicholas I and his Empress Alexandra steamed in on board the *Ischora*. Their brief stay culminated in a great ball in the evening when the Senate Square was illuminated by 2,000 lamps and all of this one-day event was considered a great success. Its major long term consequence, however, was the encouragement it gave to the use of the steamboat in the Baltic and it was soon realised that one possible attraction for people using the new form of transport might be the establishment in Helsinki of that most fashionable of European enterprises – a spa.

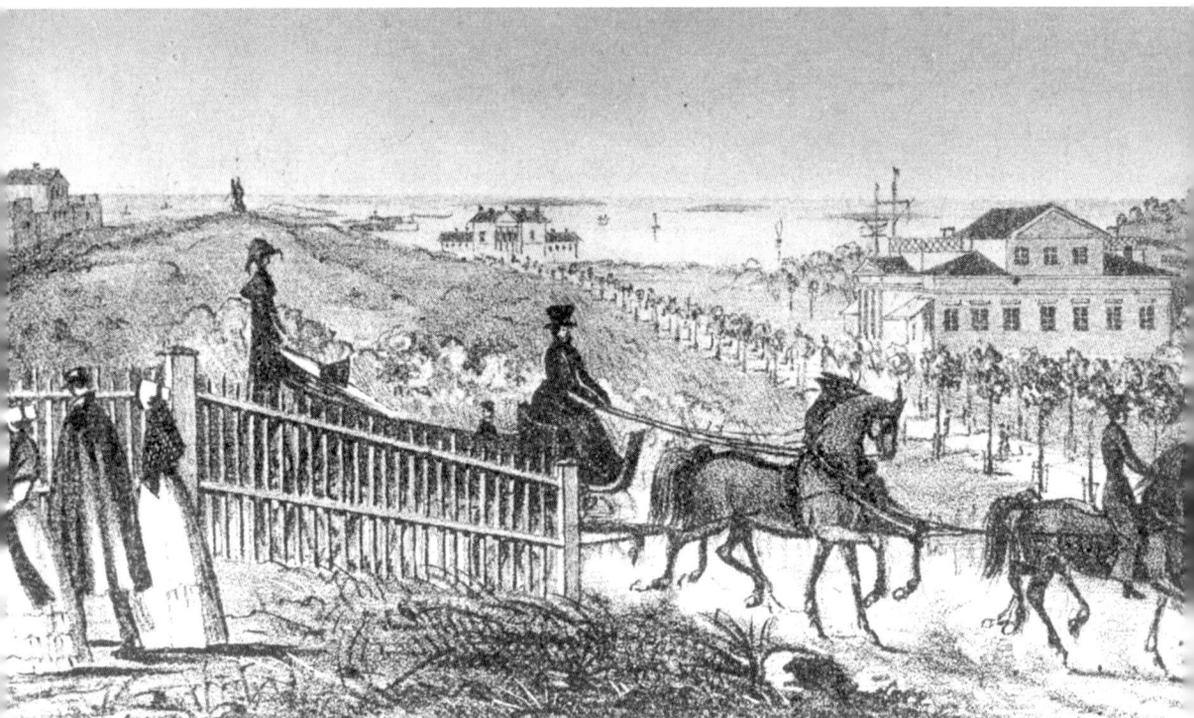

Helsinki as an Early Tourist Centre

The idea of the spa was of course not a new one. In 18th century Europe "taking the waters" had certainly already become a fashionable activity and by the early 1840s in Central Europe alone there were operating over a thousand spas. This enthusiasm had also spread to Finland and spas had flourished in Turku and Rauma at the beginning of the 19th century while some score or so mineral springs all round the country catered for local needs including one as near to Helsinki as Töölö. By the 1830s, however, the latter had long since ceased to operate.[91]

The new spa to be developed in the Helsinki of the 1830s, however, was innovative in three major ways. First it was on an exceptionally large scale as it involved the construction of a dedicated resort and the simultaneous creation of the large Kaivopuisto Park in what was then a very unpromising rocky and swampy terrain, an enterprise that was perhaps the most challenging

When foreign travel was restricted in Russia the Kaivopuisto Spa (established in 1838) became popular among the Russian and Baltic nobility, some of whom journeyed over 400 kilometres in luxury coaches to Helsinki. Johan Knutson´s lithograph (1840s) shows the Spa in the background and the Kaivohuone for "taking the waters" in the middle of the newly established park. (Helsinki City Museum)

beautifying project ever undertaken in the city. Second, and quite unusually, the spa establishment combined both forms of water cure fashionable at that time: that is the taking of seawater baths and the drinking of mineral waters, and the third, a quite astonishing innovation, was that these mineral waters were to be entirely artificial. In the Kaivopuisto there were no natural springs providing medicinally beneficial liquids. Thus the enterprise had to rely on the chemical and medicinal knowledge available at the University of Helsinki.

At its launch the new spa in Helsinki benefited from current political developments in Europe. In order to avert the possibility of the political turmoil of the July 1830 revolutions spreading from the Continent to Russia the Tsar Nicholas I imposed on his subjects very rigorous travel restrictions at a time when the Russian nobility in particular had become accustomed to regular trips abroad. Thus semi-foreign Helsinki, safely a part of the Tsar's empire, began to look attractive to them. This fact, coupled with the introduction of the steamboat, provided new business opportunities both for a young Helsinki entrepreneur, Henrik Borgström, and for the two university men who manufactured the mineral waters, P. A. von Bonsdorff and Viktor Hartwall, who had already experimented with their production during the 1831 cholera epidemic.[92]

Henrik Borgström was one of a number of influential businessmen in the Helsinki of that time. Although young he had worked hard to build up a wholesale and international agency business and had himself taken the waters first in his former hometown of Loviisa and later at a Swedish spa. From three years spent in Liverpool, he had learned to love English town parks and had since then entertained the dream of establishing one in Helsinki.[93]

Borgström's scheme for creating a spa with a large leafy parkland on the barren and stony southern tip of the Helsinki peninsula was officially launched in the autumn of 1834 and once it became publicly known that the Tsar had himself taken out thirty 100 rouble shares in the spa company, there was no difficulty in raising the remaining capital. In 1835 Borgström also became a shareholder in a steamboat company along with other major shareholders from Turku, Tallinn and St Petersburg, which were to be the other destinations of the future steamboat's regular route, and it opened to traffic in May 1837.[94] Hartwall and Bonsdorff for their part applied for a

licence to manufacture their mineral waters on a large scale. This was approved by the Senate on 2 February 1836, a date which is today considered the official birthday of Hartwall,[95] now the oldest soft drink company in the Nordic countries.

The Kaivopuisto Spa opened in June 1838. The building was designed by Engel in neo-classical style and the ladies' and gentlemen's departments each consisted of twelve suites of bath cum dressing rooms while the twenty-fifth suite of three rooms, a bathroom and a balcony was reserved for Her Majesty the Empress – though, truth to say, she never came.[96] The customer could choose between a great variety of different types of baths and showers, and the nearby beach also formed part of the spa as the electric and magnetic currents in the seawater were considered almost a miracle cure and the iodine and bromide in the water very beneficial. Bathing in the sea was also said to be good for the nerves and it clearly improved the appetite. If anyone remained in doubt about all this Wasenius's bookshop had on sale eleven titles which explained the benefits of taking the waters.

The most important element in the water cures was nevertheless the Kaivohuone (the Pump House), also designed by Engel, where customers could take the mineral waters and socialize in the great salon where all fifteen types of Hartwall productions were on offer. Between drinking their daily portions, normally 8–16 glasses of warm and 6–8 glasses of cold waters, the customers were required to move briskly and were consequently milling around the salon or dancing to the tune of a band. After the morning sessions and before the table d'hôte dinner at one o'clock the regulatory constitutional could be taken in the park,[97] created by the German-born gardener Holm from the rocks and swamps. It became an added attraction to the Kaivopuisto Spa, which was considered by at least one foreign visitor to be the best in Europe[98] and inspired the founding of many similar watering places in other parts of Finland.

From the beginning the Kaivohuone also became the hub of the summer social life of Helsinki. Not only did its German restaurateurs provide high standard catering but the salon provided a venue for concerts and especially for dance-soirées twice a week. While the Sunday event, according to one observer, provided an opportunity "for country cousins to charm second lieutenants and for shopkeepers to make triumphs" the Wednesday evening dance-soirées were decidedly aristocratic events.

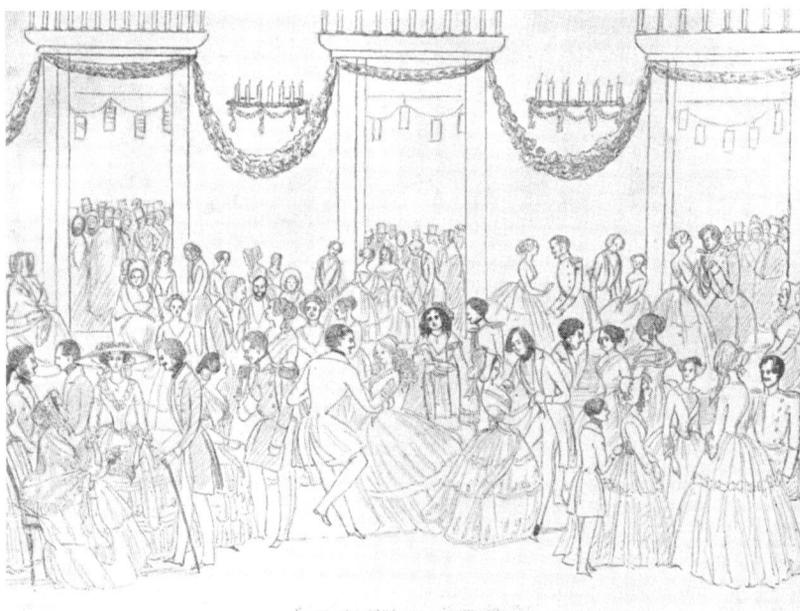

A fashionable ball - *a bal des eaux* - at the Kaivohuone in the 1840s. (Finnish National Museum)

According to Xavier Marmier (1808–1892) a traveller and a member of the Académie Française, who visited Finland on the eve of the Grand Duke Alexander's visit to Helsinki in 1842,

> "The salons of the Helsingfors aristocracy are as elegant as the finest Paris Salons, and the society that frequents them, Finnish at heart, Russian through circumstance, French in wit and manners, present the foreigner with a curious assemblage of ideas, sympathies, ancient traditions, new hopes and various languages... All this mixture of facts, analyses, cosmopolitan narratives, truly has great charm."[99]

Indeed, for people in Helsinki the early summers of the 1840s were very glamorous. The guests from Russia and the Baltic provinces included princes, generals, counts and officials of the highest rank, the names and arrival dates of whom the good burghers could learn from *Helsingfors Tidningar*.[100]

Most of the guests rented houses or rooms but others were wealthy enough to build their own houses, like the Princess Youssupoff, whose highly ornate villa in the oriental style on the highest tip of Kaivopuisto raised considerable local curiosity.[101] Many arrived by steamboat while some of the aristocratic guests preferred to travel by land via Viipuri, and on this journey of over 400 kilometres luxury coaches drawn by nine horses were no rarity. Many of those who used the steamboat also sent their furniture and other equipment by land to ensure the standard of living to which they were accustomed.

However, the truth is that once the romantic attraction of peaceful rural Helsinki started to wear thin the entertainments then available started to seem somewhat provincial and old fashioned. "The subscribed dance as-semblies," also known as "indoor picknicks," for example, which were organi-sed in the 1830s and 1840s in the Seurahuone Assembly Rooms,[102] had already become out of fashion in the London of the 1830s.[103] True, there continued to be theatre performances given by Swedish groups, visits from German opera companies and Italian and German popular entertainers; there was a circus in Töölö gardens and concerts by such luminaries of the time as the great Swedish singer Jenny Lind and the equally famous Norwegian violinist Ole Bull. Yet the Russian aristocrats, the Tolstoys, the Obolenskys and other high-ranking Russians, started to miss more lively amusements. Consequently some organised very expensive pranks at the cost of the local restaurateurs and the general public, others patronised masquerades and events where the champagne flowed. Such lively activities in turn attracted high-class prostitutes from Sweden, and no doubt many a Finnish girl also showed initiative, for cases of venereal disease rapidly increased in the Helsinki of the early 1840s.[104]

As the highest-ranking spa guests started to turn their attention to newly fashionable places elsewhere middle class visitors on the other hand were still tempted to take advantage of another important attraction that Helsinki could now offer. Due to the favourable customs regulations in autonomous Finland shopping in the town had become very cheap, and many a Russian or Baltic housewife could cover the costs of her entire family holiday by combi-ning it with a shopping trip for her winter supplies. Even so, by the early 1850s, two cholera epidemics in Helsinki and the abolition of Russian travelling restrictions made even middle class Russians turn in a more southerly direction and the Kaivopuisto spa was never fully to recover from

the blow of these developments. Even so, it is estimated that during the sixteen years of its heyday the number of foreign spa guests reached almost four thousand, a very respectable total when compared with the number of foreign guests visiting the spas of Riga and Tallinn, though it remained hopelessly small when compared with the famous Central European establishments which attracted thousands of guests every summer.[105]

Despite the reduced attraction of the spa, however, Helsinki itself continued to attract an increasing number of visitors. From as early as the 1830s it was possible to meet tourists speaking German and French as well as American and British tourists admiring the sights not only of Helsinki but of inland Finland also[106] though the impact of the capital as well as their idea of its significance could vary. One American visitor, for example, observed in the 1840s:

> **"This, the modern capital, contains one of the largest naval arsenals in the world, and is the principal recruiting station of the imperial fleet. So important is Finland to the naval marine of Russia, both in regard of men and materials, and the sailors and timber she affords, that the whole province is under the immediate control of Prince Menshikoff, Minister of Marine. The town of Helsingfors is not worthy of particular mentioning. It is regularly laid out and the most youthful looking town we saw in Europe"[107]**

For many others, on the other hand, it was the very modern townscape that attracted them. Already in the mid-1830s leisure trippers from Tallinn were arriving to admire Helsinki with its empire centre and, from the early 1840s onwards, they came also to dance the polka, the rage of the time, in the Kaivohuone. Once the steam ships had established their regular routes the passenger numbers exploded reaching 2,268 in 1839 and a massive 7,000 in 1850[108] at a time when the total population of the town was still less than 21,000. Obviously the boat line, the stories of spa guests and the provision of the first guidebooks and information leaflets on Helsinki and Finland in Swedish, German and French[109] attracted further foreign tourists. According to a letter published in *Helsingfors Tidningar* in the autumn of 1850 "there were six steam ships sailing every weekday between Helsinki and St Petersburg, never empty and often filled to capacity."[110] For Finns similar trips to Tallinn provided their first actual tourist outings as well as the first Finnish package tours.[111] In this enthusiasm they were well in tune at least with the English, for whom Thomas Cook had organised his first advertised package

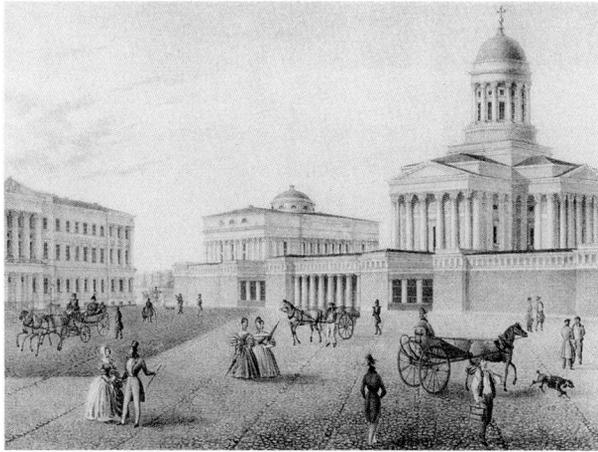

Senate Square as it was seen by the early tourists of the 1830s. In 1840 the Guard House in front of St Nicholas Church was replaced by the present steps flanked with corner pavilions. The four smaller cupolas, which are customary in Russian churches, were also added later. In the background the Helsinki University Library, which is considered Engel´s most beautiful building. Today its Slavica Collection provides scholars with an invaluable source on Russian developments in the 19th century. F. Tengström´s lithograph 1838. (Helsinki City Museum)

tour in 1841, and from the 1860s onwards affluent Finns keenly followed the Russians' example by travelling to all the famous Central European destinations.

There is no doubt that the spa had a decisive impact in securing regular steamboat services to Helsinki and the development of general passenger traffic between the Baltic ports. Other innovations adopted to facilitate the use of the spa included the *Lentäjä*, a small steamboat sailing between Helsinki south harbour and Kaivopuisto, as well as the first macadamised road in Finland[112] and a rank of a hundred horse cabs in Senate Square. Nevertheless, the most profound effect of all this was the widening of the townspeople's horizons. According to Päiviö Tommila, historian of the Finnish press, there was a clear change in the city's newspapers during the spa years. From being leaflets all too often filled with local announcements and gossip they changed into more informative publications and their size and page numbers grew thus moving their readers from parochialism towards metropolitanism, a change which prepared them for a further widening of horizons following the Crimean War.[113]

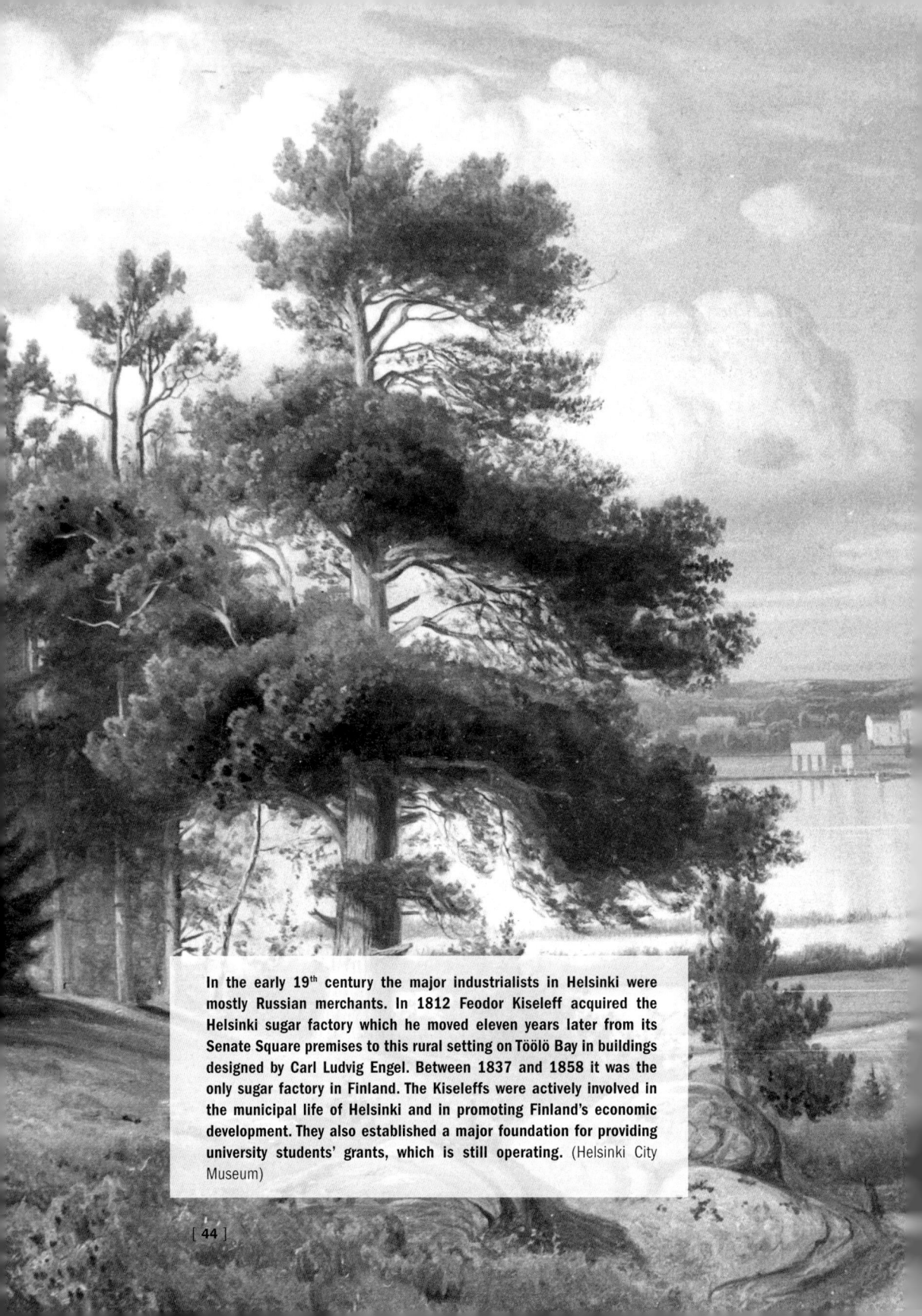

In the early 19th century the major industrialists in Helsinki were mostly Russian merchants. In 1812 Feodor Kiseleff acquired the Helsinki sugar factory which he moved eleven years later from its Senate Square premises to this rural setting on Töölö Bay in buildings designed by Carl Ludvig Engel. Between 1837 and 1858 it was the only sugar factory in Finland. The Kiseleffs were actively involved in the municipal life of Helsinki and in promoting Finland's economic development. They also established a major foundation for providing university students' grants, which is still operating. (Helsinki City Museum)

II "Handsome Appearance with Nothing Inside"?

A visitor of the period, quoted by Topelius, remarked of the new Helsinki "Schöne Aussenseite und nichts dahinten" – handsome in appearance with nothing behind it[1] and some historians have suggested that, notwithstanding evident progress in many areas, the development of Helsinki in the early 19th century was largely based on external administrative actions that had created an artificial economic climate. Thus what in Finnish terms were huge

investments ploughed into the construction of the new capital only produced a temporary increase in wealth and the shaky nature of the town's economy became evident in the slump in its building trade during the 1840s.[2]

But this is to underestimate the profound, constructive effect that the events of this period had on the future development of enterprise. Although the establishment of the spa remained for a long time the most important innovation, its success not only carried Helsinki people beyond merely parochial concerns but also provided the city with a major boost to its general trade and industry. The sudden increase in the potential clientele meant that the number of craftsmen grew between 1810 and 1850 by almost five fold from 272 to 1,253 including journeymen and apprentices.[3] The increasing wealth and sophistication, already evident in 1805 from the creation of new guilds concerned with such luxury trades as those in gold, silver and brass-casting, continued to grow in the Russian period with the establishment not only of guilds for master builders and decorators but also for bookbinders, glaziers, bakers and furriers.[4] By 1850 the first master jeweller was operating a workshop in Helsinki[5] and in the same year the Russian Professor Grot observed that life in Helsinki had become immensely more luxurious during the ten years he had been residing in the town.[6]

Increasing Wealth and Declining Shipping

From the 1830s onwards the improvement in the general prospects of Helsinki attracted, for example, an increasing number of foreign restaurateurs, confectioners and journeymen, especially from Sweden but also from Germany, Switzerland and the Baltic countries. In 1825 there were only four cafés and six restaurants;[7] by 1847 their number had increased to a total of 32 along with other inns thought suitable for spa guests[8] and following the opening of the Seurahuone Assembly Rooms with its hotel in 1827, the number of Helsinki hotels also increased so that by 1850 there were eight with the Hôtel de Bellevue and the Seurahuone being first class establishments.[9]

Foreigners brought many new specialist skills and innovations,[10] some of them with names that are still recognizable in the Helsinki of today. One of the newcomers was the Swiss journeyman tailor Eduard Fatzer (as he still

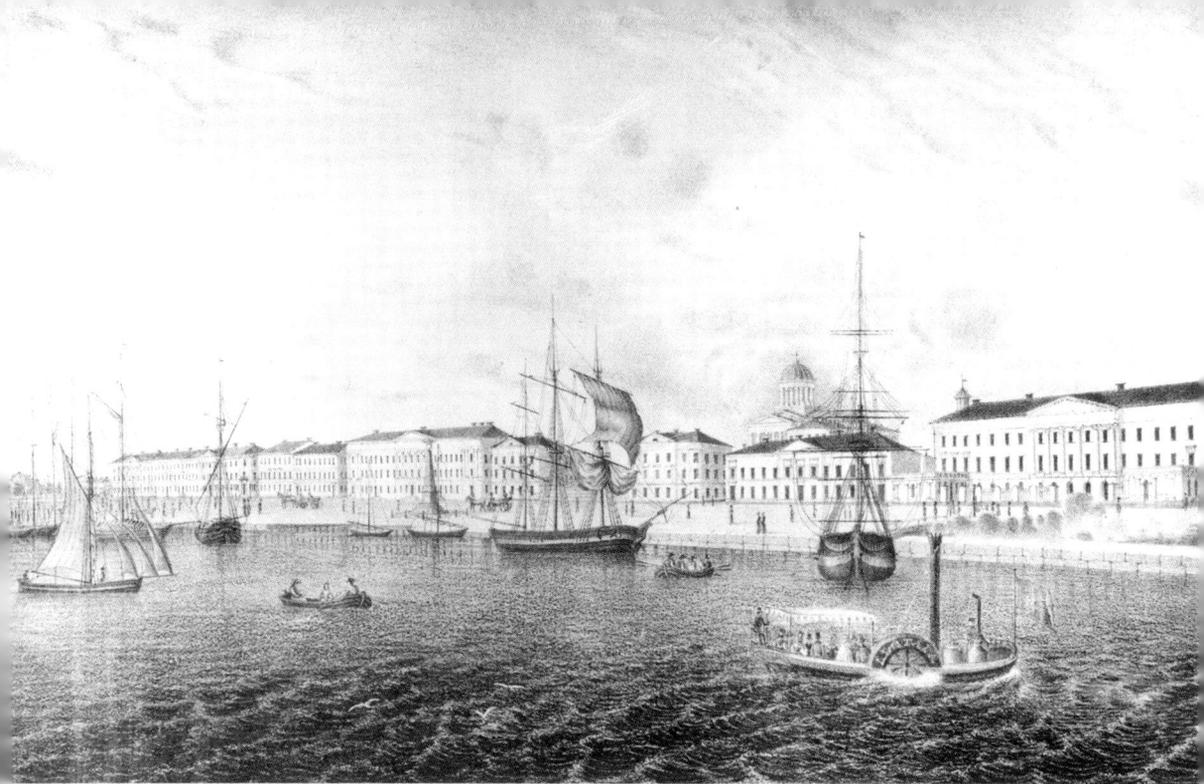

The South Harbour and the Market Square as they were seen by foreigners coming to Helsinki to work or play from the late 1830s onwards. The small paddle steamer on the right sailed to Suomenlinna fortress and also served the spa guests by stopping at Ullanlinna quay. (Helsinki City Museum)

spelt his name) who came via Lübeck to Helsinki in 1844 becoming a Finnish national five years later and thus acquiring the right to establish his own furrier's business. Seven years after that this founding father of what eventually became the Fazer dynasty (embracing enterprises from chocolate manufacturing to music publishing) purchased property at Kluuvikatu 3, still the site of the main Fazer café and restaurant, and within seventeen years of his arrival he owned a two storey stone building in Aleksanterinkatu.[11]

With his arrival and that of others from the continent Helsinki was just one scene of a wider European mobility of people seeking better working and learning opportunities. It has been calculated that in the late 1830s there were some 20,000 German journeymen working in Paris while London had attracted 10,000.[12] Similarly many journeymen from the Helsinki area, who would earlier have gone to Sweden, now customarily travelled to St Petersburg

to hone their craft skills in the workshops of local – often German or Finnish – master craftsmen.[13] Already by 1840 there were some 11,300 Finnish craftsmen, journeymen, labourers and domestic servants in St Petersburg making the city the third largest "Finnish" town after Helsinki and Turku (with their 13,300 and 13,200 inhabitants respectively) and by 1869 the 16,000 strong Finnish community in the Russian capital was the second largest ethnic minority after the Germans outnumbering even the Poles.[14] Interestingly among these Finns there were not only a goldsmith who first instructed Carl Fabergé in his craft but also the Helsinki-born August Holmström, the chief jeweller at Fabergé between 1857 and 1903, whose family, the Holmströms and the Pihls, were employed during three generations as leading designers and foremen by the Fabergé jewellery workshops in St Petersburg and Moscow. They included Holmström's niece, Alma Pihl, who in 1913–14 designed two Easter Eggs for Tsar Nicholas II and a number of necklaces, armbands and other jewellery as corporate gifts for the Nobel concern, one of the most important customers of Fabergé.[15] Other master craftsmen included a former crofter's son from the Helsinki rural commune, Alexander Tillander, who became a prosperous proprietor of his own goldsmith business, which was transferred after the Russian revolution to Helsinki[16] where it employed a number of former Finnish Fabergé jewellers, and is still trading on a prime site in Aleksanterinkatu.

An example of the Fabergé Snow Flake jewelry. It was made by the Finnish designer Alma Pihl in gold, platinum and small diamonds exclusively for the Nobel corporation in Russia. Alma Pihl was a third generation Fabergé designer and the famous jeweler Albert Holmström was her uncle.

She had never had any formal training but showed an early talent and, apart from the Snow Flake range, her designs included those for three famous easter eggs, one for Nobel and two for Tsar Nicholas II. Her design books were later acquired by Wartski in London. After the Russian revolution Alma Pihl worked, unrecognised, as an art teacher in a Finnish country school.

German immigrants to Helsinki, some of whom came via the Baltic provinces, were normally natives of the North German towns. During the economic hardship and political repression in Germany of the 1830s and 1840s[17] the Finnish capital became an increasingly attractive destination.[18] On the other hand, unlike in Manchester, where the German community mainly consisted of merchants (running 75 out of the total of 101 foreign export firms there in 1837),[19] in Helsinki by 1842 there were only three German merchants[20] and the growing German community there consisted mainly of craftsmen, shop assistants and bookkeepers.

The Helsinki economy was for the moment still dominated by the craft guilds, which were expanding in numbers even as late as 1842. Ironically, this expansion took place at a time when elsewhere in Europe the guilds were beginning to lose their grip on the urban economy. Nevertheless modern industrial enterprises were also steadily gaining a foothold in Helsinki. Between 1810 and 1850 the number of industrial workplaces increased almost five fold with the launch, on average, of four new manufacturing businesses a year in the 1840s and the 1850s whereas in the 1810s and 1820s the figure had rarely risen above one.[21] Moreover, compared with manufacturing establishments in Germany, these new workplaces in Helsinki were of good size, as each had on average a workforce of ten people, i.e. twice the average number employed by German firms.[22] One of the very few larger establishments was Henrik Borgström's tobacco factory which from its beginnings in 1834 employed over fifty people and kept on expanding in the following decades.[23] But the generally small scale of Helsinki firms reflected the fact that apart from the town itself Helsinki's inland market area in the neighbouring Uusimaa and eastern Háme provinces was small compared with those of Turku or Porvoo, which together catered for the major part of Southern Finland. Helsinki's trading hinterland was not be easily expanded until the emergence of the railway as a means of mass transportation. Moreover, the still self-sufficient lifestyle of a predominantly agricultural Finland meant that in the countryside there was little demand for manufactured goods with tobacco being the only major exception.

Like the new 19th century guilds the manufacturing enterprises in Helsinki mainly catered therefore for the growing middle class population of the town itself. Whereas at the beginning of the century the main industries had served the town's seafaring interests and had included a sawmill, two ship yards and a sailcloth factory with 12 handlooms, the new industrial businesses naturally concentrated on such matters as providing bricks for the reconstruction of the city. There were five furniture factories and four mirror manufacturers to equip the new houses (a big mirror was an essential ingredient of middle class Biedermeier style homes), and other aspects of modern urban life were catered for not only by Borgström's tobacco factory but by a perfume manufacturer and three makers of playing cards. The number of printing plants also increased while Helsinki's cultural aspirations were further served by a musical instrument workshop and Erik Granholm's piano factory, which produced between 1835 and 1852 over 200 upright and grand pianos "always maintaining good workmanship and applying the latest foreign innovations," according to *Helsingfors Tidningar*. [24]

It is therefore something of a surprise that the steamships in the harbour for long remained merely visiting vessels rather than Helsinki-owned boats for it was Turku merchants who took the initiative in the launching of the steam boat line plying between Stockholm, Turku, Helsinki, Tallinn and St Petersburg which so much benefited the Kaivopuisto Spa and Helsinki itself.[25]

That all this was not due to any lack of public interest in steamships is very evident from the attention to them shown by people in Helsinki during and after the Tsar's visit in 1833 and the Helsinki papers regularly reported on progress in the construction of the vessels ordered by the Turku consortium. When *Storfursten,* a steamboat made by Fletcher & Faernell, arrived from London the whole of Helsinki was in the harbour to welcome it, dazzled not only by the magnificent 223 ft vessel itself but also by its British engineers' white leather overalls. According to Topelius, Editor of *Helsingfors Tidningar,* who the next day made a tour of the vessel,

> "Few are those – and those I think of as pompous asses – who are not overwhelmed, during their first sailing on board a steamboat, by the power of intelligence and who do not therefore, in their heart of hearts, praise the man who first magically discovered the power of steam".[26]

Nor had there been signs of any slackening in Helsinki's seafaring enterprise at the beginning of Russian rule. On the contrary, Helsinki people had been keen on getting their town declared a free port and earning their living from the sea. In 1813 over 40 % of Helsinki merchants were also ship owners or had shipping interests. Consequently the Tsar had granted the town its own navigation school and it still had a good stock of able seafarers, who were commonly called the "Finnish Americans" because of their enterprise, fearlessness and sailing skills[27] and Eino Jutikkala has pointed out how Helsinki's merchant ship owners had been capable of taking great financial risks.[28] However, during the following decades the interest in seafaring appears to have faded and Helsinki businessmen seemed to see their future as lying elsewhere.

One natural explanation for this change of direction may lie in the fact that during the 1830s the wealthiest merchant-seafaring dynasties, the Sederholms and the Heidenstrauchs, who had sent their ships as far afield as the West Indies and Canada, lost their position either through death or through lack of business acumen.[29] Another, equally natural reason must have lain in the building of the new Helsinki itself. It had tied leading merchants into construction committees or the supervision of public spending[30] while providing others, such as Carl Etholén, still a merchant and ship owner in 1813, with new business opportunities as a contractor for the construction of the new civic buildings and the supplying of the Russian troops in Helsinki.[31] An important role may also have been played by the example of the newly arrived Russian merchants. Many of these had their origins in the inland provinces[32] and were, like their colleagues in St Petersburg,[33] more interested in land-based trading and industries with the only significant Russian-born ship owner in Helsinki being the sugar manufacturer Kiseleff.[34] Symptomatically Etholén's son Justus, though still a ship owner in 1829, had also become a shareholder in a broadcloth factory in Turku,[35] and even Henrik Borgström, although an agent for Lloyds of London and Hamburger Assuradörerne as well as, since 1823, a wholesale and retail trader, did not become seriously involved in shipping until 1850[36] when he bought the first steamship owned in Helsinki and opened a new regular shipping line between Helsinki and Lübeck.[37] In the meantime he had, of course, established his tobacco factory and founded the Spa, an enterprise which also tied up some of the capital of other very wealthy Helsinki burghers.[38]

Above all an increasing number of Helsinki people from all social classes[39] preferred to invest their money in property following the boom of the 1830s,[40] produced by the need to accommodate the newly arrived administrative and university personnel as well as the new merchant families. As the spa guests normally stayed in Helsinki for at least a month, accommodating them also provided a considerable income for private town dwellers, with well over half the spa guests renting accommodation in private houses.[41] No doubt the rents helped with the construction of a number of the stone buildings along the Esplanade and Aleksanterinkatu, and it seems obvious that property ownership had now become a more convenient and safer, if less lucrative option than investment in ships whether powered by sail or by steam.

There were also many new career opportunities away from the sea. The central government of Finland provided new roles for Finnish persons of rank and the number of administrative and judicial posts had increased from 610 in 1810 to 940 ten years later, something that was bound to have consequences for the capital. A career in the Russian army also provided the scions of the Finnish social elite with another prestigious opportunity for earning their livelihood, and it has been estimated that by the mid 1850s one in five adult noblemen in Finland had served in the Russian army.[42]

The Tsars' Testing Laboratory?

However, some Finnish historians have suggested that from the very beginning the Russian rulers had also been envisaging a much more important role for Finland. It was a country with a population of free peasant farmers who had regularly taken part not only in local administration but also in the work of the Swedish *Riksdagen* and had thus been directly involved in decisions on matters of national importance. In Russia, where serfdom was acknowledged by the Tsars to be the biggest social problem, many saw Finland as a model for modernising Russia.[43] Alexander I's reform policies aimed at improving and making the administration more effective in the spirit of the French Enlightenment. To this end his State Secretary, M.M.Speransky, had been planning the establishment in Russia of a Diet as well as governmental structures based on the example of a Swedish-style Finland.[44] There was nothing new in this. As early as the second half of the 18th century

the Tsars had been entertaining the idea of using the Baltic states as models and in 1815 Alexander I granted the Poles wide autonomy appearing to regard Poland as a more advanced and sophisticated region in which to try out reforms before applying them in Russia itself.[45]

However it was the Finnish university that was particularly seen as having an important role to play.[46] Alexander I had reopened Tartu University in Estonia in 1802[47] and had also founded universities in Kazan (1804), Kharkov (1805) and later in St Petersburg itself (1819) while also decreeing in 1809 that holders of a university degree would be given priority in all administrative appointments throughout the Empire.[48] For this reason alone the generosity shown to the University of Helsinki by Alexander I and Nicholas I, who both personally made a number of practical changes facilitating its operations, does suggest that the Tsars had serious plans to use Finland and its university as a base for nurturing future administrative reforms.

In the early years of autonomy, while the university was still in Turku the number of its academic staff had almost doubled. The revision of the 17th century statutes in 1811 provided a solid financial basis for its operations and the improvement of its teachers' salaries, and in 1812 Alexander I appointed as its Chancellor his favourite, Gustaf Mauritz Armfelt, who also saw the university as a major training ground for the future leaders of the country. He energetically promoted it as a national power base and certainly it was to become an increasing source of leadership especially in the closing years of Russian rule.[49] During the final years in Turku it had taught an annual average of 455 students[50] making it a considerable academic establishment when viewed in the context of the whole Empire for the other six universities had between them an aggregate total of only 1,700 students.[51] This was perhaps because in Russia far more emphasis had been traditionally placed on technological or professional training institutions under the appropriate ministries and interestingly Matti Klinge, a Finnish expert in university history, has suggested that the Finnish university was seen much more as a training place for civil servants unlike the Russian universities which were more clearly centres of general learning and scholarly research.[52]

Engel created in the very centre of Helsinki a set of new university buildings deemed to be among the best in Europe in terms of space and

style[53] and, significantly, a system of bursaries gave opportunities for foreign travel. The change of the institution's name to the Imperial Alexander University and the appointment of the heir to the throne as its Chancellor underlined the public protection that was being afforded it by the Imperial family. Moreover, the University was also made politically independent of both the Russian and the Finnish governments[54] in terms of freedom of research and teaching and this was true of all four faculties of arts, law, theology and medicine. Moreover, while Alexander I later in his reign was to close down some of the new universities he had established in Russia,[55] he never altered the basic privileges of the university in Finland nor did his successors curtail its autonomy when reforming its statutes in 1828 and in 1852. Thus the University occupied a fundamentally different position from the Empire's other universities, which were subject to far greater state control[56] and in many respects it can best be compared with the University of Berlin, which was a similarly independent university, located in the capital and favoured by the sovereign.[57]

All this encouraged Russian intellectual and learned circles to assist the Finnish academics. In 1826 for example the Russian Chancellor, Count N. Rumjantsev, financed the publication of Gustaf Renvall's extensive Finnish-Latin-German dictionary[58] and following the establishment of Helsinki University's Botanical Garden on the model of the Imperial Botanical Gardens in St. Petersburg the administrators of the latter donated a great number of plants as did the Botanical Gardens of Tartu in Estonia.[59] Co-operation was also established with the Imperial Science Academy in St Petersburg on projects studying the origins of the other Finno-Ugric languages spoken by peoples living deep in Russian territory. The University thus continued without interruption its tradition of studying the history and language of Finland, the origins of its people and its folklore. Importantly also, following the almost total destruction of the university library of 40,000 volumes in the Turku fire, major book donations were received from university and upper class circles in

Helsinki University has played an important role in the development of Finland throughout the centuries. Founded in 1640 by Queen Christina of Sweden as the Academy of Turku it was moved to Helsinki in 1828. It was then renamed the Imperial Alexander University in honour of Tsar Alexander I, its major benefactor. The picture also shows the Guard House and the presence of Russia's military might in the very centre of the town. F. Tengström's lithograph of 1838. (Helsinki City Museum)

Russia and the Baltic provinces. Smaller donations were also received from Denmark, Sweden, Germany and Britain so that within twenty years of the fire the volumes available in the University Library had doubled in number.[60] Furthermore, in 1820 it was made a copyright library entitled to receive free copies of all Russian publications[61] so that the Finnish intelligentsia were able to benefit from the intellectual resources of the whole empire. Indeed, the Slavica Collection in Helsinki University Library still provides today an invaluable source for international scholars concerned with 19th century Russian developments. In all these ways the University was thus given a real opportunity to develop into a major intellectual centre and high-class training establishment.

But at first there were setbacks. In the early 1830s after the growth of the previous decade there was an actual drop in the number of students, and although this was not unusual at the time (it was also happening elsewhere in

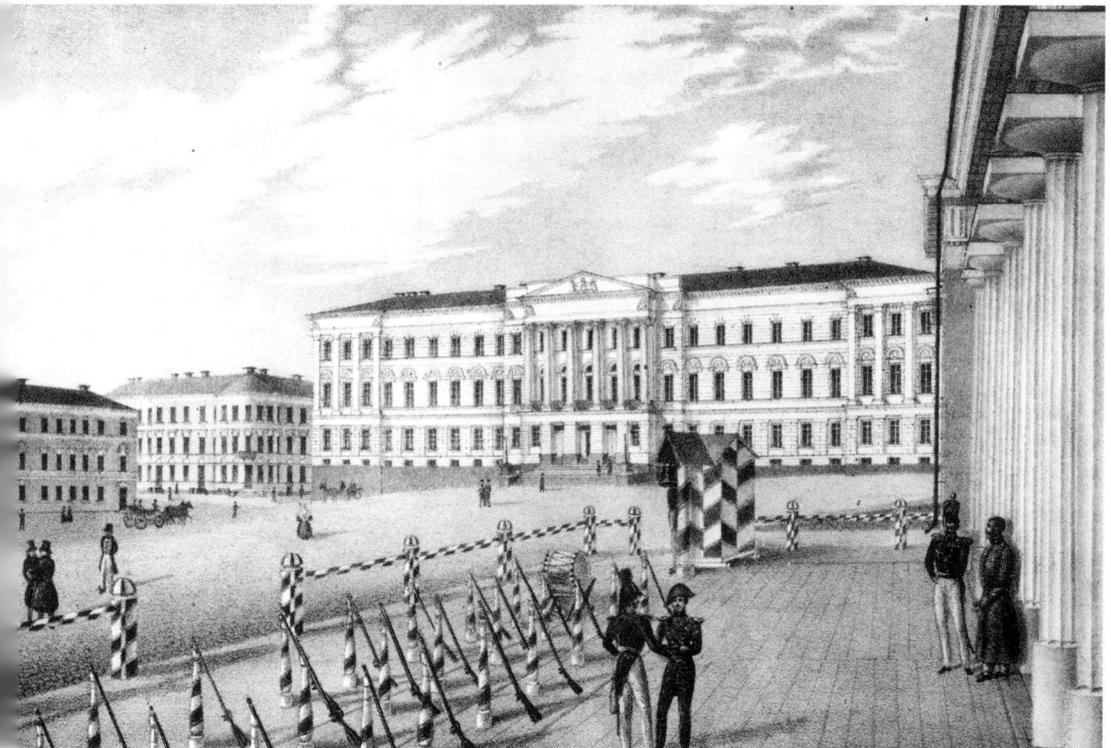

the Russian empire[62] as well as in England[63]) it was disheartening. Moreover, in the 1830s and 1840s the number of burghers' sons attending the university remained low.[64] Like the Prussian government, the Russian government increasingly made it clear that it was positively opposed to promoting social mobility through education.[65] That some Finish leaders felt similarly is evident from a letter written in 1849 by Count C. G. Mannerheim. He was noted as an enlightened promoter of the use the Finnish language in the legal and administrative systems but as the chairman of the committee revising the university statutes, he suggested that ways should be found to restrict the access of the lower classes to the university and thus into public service, an area traditionally the domain of the upper classes in Finland.[66] Such attitudes were, however, to disappear as the century proceeded.

In addition, although Helsinki professors were able to follow international scholarly developments[67] the University did not in these early years produce too many distinguished academic figures. The few who gained international fame included Friedrich Wilhelm August Argelander, the well-known astronomer and Georg August Wallin, the internationally celebrated explorer of Arab countries. Even so, such people were rare and if most of the work of the University remained unremarkable, the reason may have lain not so much in any lack of academic quality among its teachers as in political nervousness. Alexander I himself had already resorted to closing down some of the universities he had established in Russia[68] and the first generation of professors in Helsinki were perhaps convinced that caution was a prime civic virtue, and their fears were probably strengthened by the expansion into Helsinki of a system of secret policing from 1829 onwards, run by the Governor General on behalf of the Russian Minister of the Interior.[69] Although the facilities existed for the encouragement of academic initiative, there were for the moment hidden inhibitions and only politically harmless experiments, such as those concerning mineral waters or entomology seemed safe to pursue[70].

Also, although the still basically Swedish system of public administration remained intact, there was growing evidence of Russian influences within it. A nomenclatura of social ranking was, for example, confirmed officially in 1826. This established in Finland a system of 14 classes of administrative offices and 168 posts, each of which required the wearing of a uniform the colour of which was now Russian green instead of Swedish blue.[71] According

to this system every civilian post was deemed to be equivalent to a particular military rank. Thus the Rector of the University and the Director of the Chancery of the Governor-General were equal in rank to a Colonel while the translators of Russian equalled a Captain. However, a translator of the Finnish language ranked merely as a Second Lieutenant.[72] All this increased the temptation to show an often excessive deference to the Russian bureaucratic authorities and apparently in Helsinki toadying became a rule of life.[73] Such factors were hardly likely to encourage academic innovation and enterprise, despite the Tsar still being seen as the benevolent father of his Finnish subjects. Other people also were becoming conscious of the deep differences of mentality between the Russians and the Finns, some of whom increasingly emphasised the need to establish a clearer Finnish national identity in order to maintain their self-respect and to build up their personal confidence.

It is a commonly held opinion nowadays that if Finland had remained part of Sweden Finns would gradually have become more and more swedified and certainly during the 18th century Swedish influences had strengthened their grip. Many a Finnish-speaking burgher's or peasant's son who had studied to become a clergyman or had otherwise entered the ranks of the learned classes, adopted the Swedish language as a matter of course as well as changing his name into a more socially acceptable Latin, Greek or Swedish form. Once the political link with Sweden was severed however and the links with Russia were fully established, opinion leaders among the young Finnish intelligentsia started to seek their roots once more in Finland. As early as the 1820s in Turku the editor of *Åbo Morgonblad*, A. I. Arvidson, had coined the famous phrase "We no longer are Swedish, we cannot be Russians, let us therefore be Finns!"

This nationalism, which was very much in line with the romantic school of nationalist thought then alive around Europe, was to find fertile ground in Helsinki, which as early as 1826 was described by a secret police informant as "Finnish Helsinki" in contrast to "Swedish Turku" and "Russian Viipuri".[74] The concept of Finland as a state in its own right and not merely a province within the Russian Empire was increasingly developed and promoted in Helsinki by a group of young university graduates who had formed in the 1830s an informal discussion group *"Lauantaiseura"* (the Saturday Society),[75]

Kalevala, the Finnish national epic, has provided material for a great many Finnish artists, writers and musicians including some cartoonists and rock musicians of the 1990s. *Kalevala* has been translated into 45 foreign languages. It was a model for the Estonian national epic, *Kalevipoeg*, and its verse form was used by Longfellow in *Hiawatha*.

which, as we noted earlier, had launched the new advanced secondary school, the Helsingfors Lyceum. Its members included J. L. Runeberg, the future national poet of Finland; J. W. Snellman, the philosopher of Finnish nationalism and a major social critic; Elias Lönnrot, a doctor who compiled the Finnish national epic, *Kalevala*, from the material he had collected; J. J. Nervander, an eminent physicist and an early explorer of electricity and Z. Topelius, the journalist and historian. Most of these men were also connected with Henrik Borgström, who has sometimes been described as the Lorenzo de Medici of Helsinki being not only a successful businessman and founder of the Spa but also a major benefactor of the city's two main cultural associations, the Musical Society and the Finnish Arts Society.

The quiet work and enterprise of this group resulted not only in the establishment of the Finnish Literature Society in 1831, but also in the publication in the early 1830s of Runeberg's epic poem *Hirvenhiihtäjät* which was intended to draw the attention of the Finnish middle and upper classes for the first time to the Finnish peasant and the nobility of his simple way of life. The publication in 1835 of Lönnrot's first version of *Kalevala* and the

expanded version of the national epic in 1849 created a sensation in Finland as well as internationally awakening the active interest of famous figures as diverse as the brothers Grimm and Henry Longfellow, who was inspired to use its verse form for his *Hiawatha*. Moreover, it later became a model for the compilation of the Estonian national epic, *Kalevipoeg,* which was published in 1862 and was to have a profound cultural influence on the Estonian people.[76]

For members of the *Lauantaiseura* Finnish nationalism did not necessarily involve anti-Russian feelings nor did the Russians object to their activities. True, Arvidsson was expelled from Finland by the Russian authorities as a political agitator. But members of *Lauantaiseura* did not usually meddle in political or military matters. Runeberg and Topelius, for example, were even encouraged in their activities by the government who awarded them honours and academic posts for developing the concept of Finland as something separate from Sweden and for taking the country in new directions. The Tsar and his family considered Finland part of a multinational dynastic union and therefore saw nothing threatening on those numerous occasions they heard "Our Land", the new Finnish national anthem written by Runeberg, being sung alongside the Imperial Anthem.[77] It can be argued that by producing this national reawakening, making Finland's own cultural heritage not only respectable but also admirable in the eyes of the upper classes, the members of *Lauantaiseura* in fact quietly achieved the most fundamental innovation in the whole of Finnish history. Certainly this feeling of national pride was to provide a continuing stimulus to the creativity of both the country and its capital city.

If Alexander I had already established favourable conditions when recognising Finland's autonomy, it was during the reign of Nicholas I that the foundations for really fundamental reforms were quietly laid by the Finnish Senate. Nicholas I decided to maintain Alexander's policies in Finland[78] and himself suggested measures to improve Finnish agriculture and industry. Measures to improve general education were also on the agenda and the University's chair of education and pedagogy, established in 1852, was to be the first in the Nordic countries.[79] The extent to which Nicholas I really did wish to use Finland as an administrative model for Russia can perhaps never be accurately assessed for many of his proposed reforms were still at the

The Crimean War touched Helsinki in the summer of 1855, when French and British naval squadrons bombarded the Suomenlinna fortress. In Finland the war is, above all, remembered as an event which put pressure on the Tsars to introduce major political and economic reforms. (National Board of Antiquities))

planning stage when he died. Yet there are indications that administrative innovations made in Helsinki were adopted elsewhere in the empire. Finland, for example, was the first country after Britain to employ prepaid envelopes (1845), which were launched in Moscow a year later (1846) and in the rest of the Empire in 1848. Finland also pioneered the issue of postage stamps (1856), and it was only after these were deemed successful that they were adopted in Russia.[80]

Alexander II

A number of reforms, prepared by the Senate of Finland, and undoubtedly with the full knowledge of Nicholas I, only came to fruition during the reign of his son, Alexander II, and when recalling the early years of the new reign Zacharias Topelius, by then an emeritus professor of history, claimed that the new Tsar

> "... loved Finland with the love of his youth and wanted to make this country the testing ground for the future of Russia and the rebirth of its people."[81]

Although this statement may be seen simply as the opinion of an ardent loyalist, there is no doubt that Alexander II had learned within his family a positive attitude towards the Grand Duchy. His father had invited Speransky, the early architect of Finnish autonomy, to tutor his son during his most formative years,[82] and towards the end of his reign Nicholas, who had had to face a series of uprisings and revolts not only in his own empire but elsewhere in Europe, is reported to have said to those urging the restriction of Finnish autonomy,

> "Leave the Finns in peace. Theirs is the only province in my great realm which during my whole reign has not caused me even a minute of concern or dissatisfaction".[83]

thus suggesting that the fears and caution of the Helsinki professors had been unjustified.

Alexander II succeeded his father in the middle of the Crimean War, which directly touched Finland and especially Helsinki. Indeed, the citizens were actual eyewitnesses of a bombardment of the Suomenlinna fortress by British and French naval squadrons in the summer of 1855.[84] Following the war Russian public opinion demanded reforms both in industrial life and in the administration and similar reform demands were heard in liberal circles in Finland, which in spite of its handsome new capital and its ambitious businessmen remained, in modern terms, a developing rather than a developed country. Although it had a well-structured administration and a highly efficient legal system, a relatively progressive Lutheran church and wide general literacy, the economic life of Finland as a whole still remained

Tsar Alexander II visited Finland five times and inspired such trust and affection among the Finnish people, that his statue is still standing in the middle of Helsinki's Senate Square. During his time the Finnish language was given equal status with Swedish in public life, the parliamentary system was re-adopted and the foundations of the modern economy were laid by decreeing freedom of occupation as well as by the launching of banking and monetary reforms. (Helsinki City Art Museum)

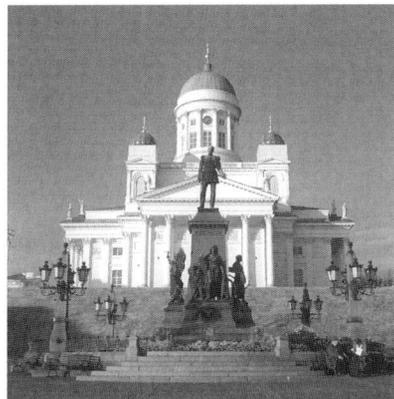

seriously underdeveloped; the vast majority of its people were still involved in self-sufficient agriculture and the differentiation of labour was low as was productivity.[85] Moreover, the shortage of native capital continually hampered the establishment of industrial enterprises and the construction of the railways, vital to the improvement of communications not only within Finland but also with St Petersburg which offered the vast market of a major European city with a population of over a million.

Alexander II, on his visit to Helsinki in March 1856, promulgated in the Senate a general programme for developing Finland's trade, shipping, industries, education and communications, and instructed the Senate to appoint a number of committees to prepare proposals for relevant reforms thus launching his Grand Duchy into nearly a quarter of a century of liberal economic and cultural reforms. Furthermore, the 1860s saw the expansion of democracy with the re-convening in 1863, after fifty-four years, of the Finnish parliament, the quadricameral Diet. There followed reforms in local self-government both for the rural areas (in 1865) and then for the towns (in 1873).

As similar reforms were also being carried out in the same decades in Russia, one is again justified in asking whether Finland really was now being used as a testing ground for empire-wide administrative reforms or whether the stream of various political and economic innovations might not actually have been flowing in the opposite direction – from St Petersburg to Helsinki. However, Osmo Jussila, a Finnish expert on 19th century Russo-Finnish history, suggests that except in one case, that of the conscription law, the Finnish reform programme and the Russian reforms were not exact replicas even in the case of local government.[86] It is however important to notice that at least one crucial non-governmental initiative did take place in Helsinki in 1862, some years earlier than in Russia, and we must now examine this in more detail.

The Reform of Banking

The programme of Alexander II for the development of Finland's economic life through developing its trade, shipping, industries, education and communications had one common basic requirement, money. Yet, it was generally agreed that Finland was short of capital and that its banking system was underdeveloped. However, within less than a decade Finland was to carry out

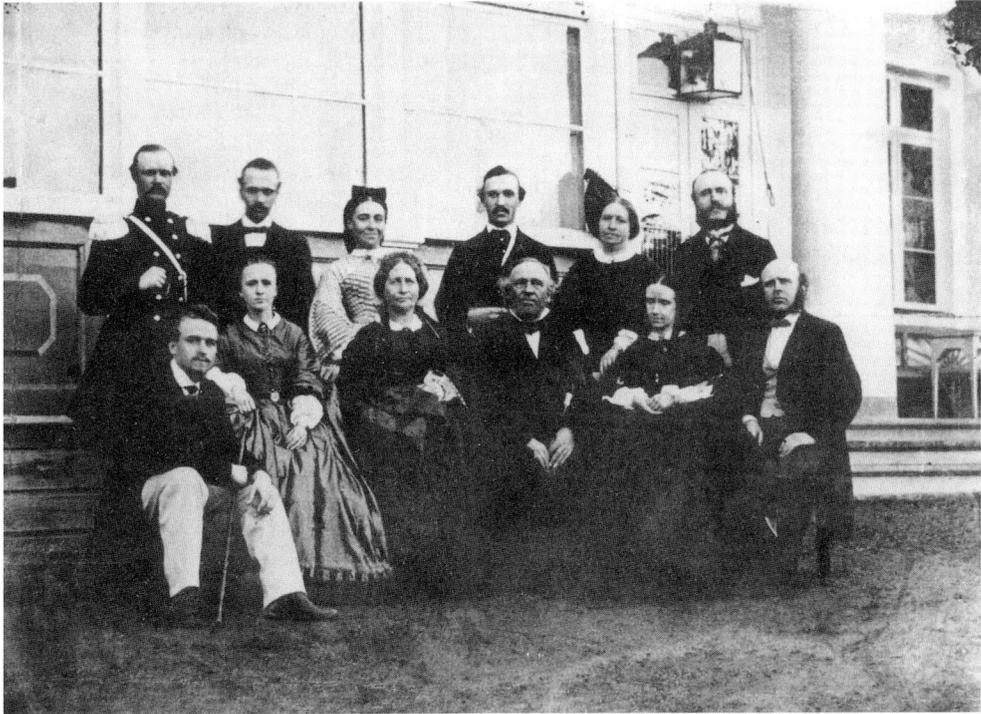

a reorganisation of her whole banking system and to establish what was the first joint-stock bank with limited liability in the whole empire. All this was done in such a manner that N. C. Frederiksen, professor of economics at Copenhagen University and himself a banker, in his major 1902 survey of Finland's economy, considered it one of the finest and most important reforms there during Alexander II's reign.[87] The funds deposited in the new commercial bank, the Union Bank of Finland, in its first year, 1862, already exceeded 1.8 million marks, rising in less than three years to over 11 million marks, which was more than the aggregate capital of all the industrial joint-stock companies established in Finland between 1856 and 1864. In 1874 deposits in the bank had further increased

The Borgström family in Turholm in the summer of 1860. Henrik Borgström Snr and his wife Caroline are in the centre of the front row. Their son Leonard Borgström (front row, right) was then the vice-consul for Prussia and Spain and a future director of the Forssa textile factory as well as a member of the burghers estate in six Diets and the chairman of the Helsinki Music Society. The eldest son Henrik Borgström Jnr (back row, right) had by then published his landmark proposals on financial reform in Finland. Major General Julius af Lindfors (left in back row), a son-in-law, was to launch the Finnish Red Cross, become a member of the City Council and be involved in organizing Finnish industrial exhibitions. Son Georg (back, third from right) was to become an agronomist and owner of Östersundom Manor. (Borgström Family Archives)

to nearly 25 million marks, which was more than 22 times the annual budget of the city of Helsinki for that year[88] and the driving force behind all this were again members of the innovative Borgström family of Helsinki and especially Henrik Borgström Jnr.[89]

It was the financial crises of 1847–8, 1857 and 1859 that had clearly demonstrated that the Finnish financial system as it stood was not satisfactory to meet the emerging need for credit.[90] Since 1809 Finland had had its own central bank providing loans for landed estate holders.[91] Savings banks had also been established quite early, first in 1823 in Turku and then in 1826 in Helsinki, following English models but organised in the Swedish manner.[92] These were intended to provide the poorer classes with a secure and profitable way of saving their earnings for a rainy day. However, they and the 13 savings banks subsequently established round the country in the 1840s maintained a maximum limit of savings per customer and could not serve the capital needs of major industrial or infrastructure projects. Thus trading houses, such as Hackman & Co in Viipuri and Borgström & Co in Helsinki, had to rely upon their Swedish, German and British business contacts as a source of finance while new entrepreneurs could only approach relatives or acquaintances.[93] Furthermore, a public debate in the 1840s in e.g. *Vasa Tidningen, Åbo Underrättelser, Wiborg* and *Helsingfors Tidningar* concentrated on discussing how savings could be used as insurance for pensions rather than as a means of generating new wealth by rational investment of the accumulated funds.[94] Obviously banks were still seen in Finland as institutions to serve the common good rather than as commercial enterprises established to service trade and industry.

However, when the Senate in the autumn of 1857 convened a committee of businessmen to discuss banking issues, they were able to base their work on discussions started as early as 1836 by John Julin from Turku and Henrik Borgström from Helsinki,[95] who both had close contacts with Britain where private joint-stock banking was then rapidly expanding. The issue of private banks was brought again into public debate in 1855 in articles by J. V. Snellman, who had often pondered banking issues with Henrik Borgström and his son when working in their office as a clerk in 1851–53.[96] These writings were followed by two groundbreaking publications by Henrik Borgström Jnr. The first one, in 1858, called for the establishment of a mortgage

association to provide long-term loans for agriculture and based its argu-ments on the author's extensive survey of similar institutions round Europe.[97] The next publication, in 1859, discussed private banking as a facilitator of capital for trade and industry, and was based on an equally wide theoretical and practical knowledge of commercial banking.[98] Since Henrik Borgström Jnr had been interested in finance and banking since his student years and had studied banking issues in France, England and Scotland as well as in Stockholm's Enskilda Banken, the first private bank in that city established in 1856.[99] Discussing the recommendations of the 1857 banking committee Borgström argued in his book that instead of establishing independent private banks in Viipuri, Helsinki, Turku, Vaasa and Oulu the Finns should aim at following the Scottish model, i.e. setting up a single major private bank with branches round the country, as this could in the most easy way channel surplus funds to productive ventures everywhere and thus help to increase the total national wealth.[100] He also suggested that all financial decisions should be based on efficiently collected official statistics for which purpose a special office should be established in Finland[101] and that in order to stabilise the economy Finland should have its own currency based on silver.[102]

Both publications created much interest and led to the establishment of two financial institutions for the provision of capital, *Hypoteksföreningen / Suomen hypoteekkiyhdistys* (the Mortgage Association) in 1860 for facilitating long-term loans to agriculture, and the first private commercial bank, *Förenings-Banken i Finland / Suomen Yhdys-Pankki* (the Union Bank of Finland), which began its operations in 1862. In Finnish terms both of these institutions were certainly important innovations even if they used foreign models. In the case of the Mortgage Association the Governor General, Count Berg, keenly followed its planning and provided access to know-how in the Baltic provinces, where a system of agricultural loans had been operating since 1802.[103] The success of the Mortgage Association can be measured by the fact that it was, until the First World War, the major provider of agricultural mortgages in Finland.[104]

The Union Bank's Scottish style organisation based on a Helsinki head office and several local branch offices[105] was innovative so far as mainland Europe was concerned as was its legal status as a joint-stock company. While banks in Europe were still normally local financial institutions, the Union Bank began as a nation-wide organisation with a less costly overall

management while still being able efficiently to collect deposits from customers round the country. Moreover, although the first French and German joint-stock banks had been established in 1848 more than a decade earlier, the actual boom in establishing such banks did not take place until the 1850s and early 1860s. It was not until 1864 that the first joint-stock banks were established in Sweden and only in 1870 that the Prussian government ceased to oppose joint-stock companies and allowed the establishment of the Deutsche Bank in Berlin. In France the big joint-stock banks started to open branches approximately at the same time as the Union Bank while in Germany this development did not take place until the 1870s and in England, in the main, not until the 1890s.[106]

The constitution of the Union Bank also marked an important new departure by clearly stating that its shareholders had only limited liability. The issue of liability in joint-stock companies had been much debated in Europe since the early decades of the century when they were launched for constructing railways and other enterprises carrying major financial risks.[107] In the Finland of the 1850s the existing law did not recognise limited liability.[108] Thus the companies established in Helsinki before the Crimean War, such as those of the Seurahuone Assembly Rooms, the Helsinki theatre and the Kaivopuisto Spa, had all involved the personal liability of their shareholders, and it was not until 1856 (the same year that a Joint-Stock Act was passed in Britain) that the constitution of the first newly established industrial company in Finland pointedly included a limited liability clause.[109] Moreover, it was only in 1864, i.e. two years after the establishment of the Union Bank, that Finland's new law on joint-stock companies actually allowed limited liability.[110]

The establishment of the Union Bank also required innovation at an everyday level. It involved developing the practical details of running a bank and its branches, providing operational guidelines, creating book-keeping systems, training the staff, designing and printing all stationery and administrative forms and purchasing office furniture. As the bank was a pioneer of its kind in Finland Henrik Borgström Jnr, the new managing director, used appropriate foreign examples but much had to be developed from scratch by him personally.[111] It was therefore a remarkable achievement that once the Senate had finally confirmed the statutes of the bank on 21 May 1862, not only the Helsinki head office but seven branch offices round

The Union Bank of Finland, established in 1862, was the pioneer of modern joint-stock commercial banking in the Russian empire. Its old building (1896-98) displays the opulence of the neo-renaissance style that was fashionable in all the major cities of Europe at that time. (Helsinki City Museum)

This advertisement for the bank, in English, dates from 1910. (Helsinki City Archives)

Förenings-Banken i Finland.

Oldest Private Bank in Finland. Founded 1862.

Share Capital and Reserve Funds
(on March 31 1910)

Finn. Marks 35,000,000.

Head Office in Helsingfors.
36. ALEXANDERSGATAN.
Branch Offices in 26 different places.

Complete Banking operations.

Letting Safes in the Bank's Strong Room in Helsingfors. Valuables in sealed covers taken charge of for any period under the Bank's guarantee. ◻◻◻◻◻◻◻◻◻◻◻◻◻◻◻◻◻◻◻◻◻◻◻◻◻◻◻◻◻◻◻◻

the country were, surprisiongly, already able to start trading as early as 1 July, that is within a mere six weeks, while three further branches were opened in September of the same year.[112]

Matters developed so systematically and with such accelerating speed[113] that it may well be assumed that Alexander II himself had already become familiar with the planned financial reforms at an early stage and had not only approved of them but given them his active support. Certain of his actions, including his approval of limited liability for the Union Bank's shareholders in 1862 two years before the Finnish company law was revised to include it, as well as the confidence with which Borgström and his colleagues moved forward, all suggest this.[114] Osmo Jussila has commented, that Alexander II never lost sight of the common good of the whole empire and, quoting Snellman, suggests that the Tsar always discussed financial matters with his ministers,[115] and while there is no direct evidence that Alexander II had personally read Henrik Borgström Jnr's writings, nevertheless, one can imagine the appeal to the ruler of an empire then facing a major financial crisis[116] of the section where Borgström reports how the Scottish private banks with their local branches had helped to increase the productivity of trade, industry and especially agriculture in Scotland to such extent that by the mid-19th century no other European country had experienced as rapid an increase in its general standard of living – and all without any support from the government.[117] That some in authority had noted this last point is evident from a covering letter sent by the Senate with the Union Bank's constitution seeking the Tsar's approval. Clause 20 in the commentary makes it clear that the Union Bank itself should not expect to receive any subsidies or other assistance from the government.[118]

It is evident therefore that Helsinki was the first city in the empire to establish a modern commercial private bank with limited liability and offered an innovative model that could be followed elsewhere. When Borgström launched his campaign for a commercial joint-stock bank in 1859 there was no equivalent elsewhere in the empire even if Russia and Poland each had a national bank[119] and Russia had also had provincial Noble Land Banks since 1785[120] while Land Credit Associations had been operating since 1802 in Estonia[121] and 1825 in Poland.[122] Moreover, the Russian joint-stock law of 1836 had become outdated[123] and following the grave financial crisis of 1859

officials including the Finance Minister Reutern pressed for reforms to make it easier for businessmen to establish joint-stock companies.[124] However, the first modern commercial bank with limited liability was not to be established in Russia until 1865, in Estonia until 1868 and in Poland until 1870.[125]

In Finland before 1862 government loans had been an important source of capital for emerging industries. However, as the role of the Union Bank in channelling capital rapidly grew, this meant that the government was then able to concentrate on the financing of the infrastructure and the reform and maintenance of the school system.[126] The 1864 joint-stock company opened capital markets to a much wider public[127] and its provision of limited liability, which reduced risks, also encouraged individual enterprise. Thus it was not only major industrialists and businessmen that purchased shares in the Union Bank; the early investors also included "married and unmarried ladies as well as artisans" in Turku, several farmers in the Hämeenlinna region and two farmhands and one bathhouse attendant in the Mikkeli area.[128] In Helsinki the new law facilitated in the 1870s the establishment of the "Helsinki Joint Stock Dwellings" followed by workers' joint-stock dwelling companies in the 1880s.[129] Moreover, 1865 finally saw the establishment of the public statistical office in Helsinki that Borgström had advocated. Thus it is fair to say that the results of his innovative writings and his practical actions in the launching of the Mortgage Association and the Union Bank were major factors in permanently improving the operational conditions of Finnish agriculture, trade and industry.

Compared with Western European countries, where early industrialisation was financed by private capital as in England or by private banks as in France and Germany, Finland clearly had been an exception with its dependence on government support. Even so, compared with Eastern Europe, and especially Russia, where industrialisation was late and where the state still had a very active role in financing industrialisation as well as in banking throughout the 19th century,[130] state involvement in financing Finnish industry was minimal apart from a brief period in the mid-19th century.[131] Thus it could be said that Henrik Borgström Jnr of Helsinki had found an essentially Finnish solution to the problem of acquiring the capital that was crucial for the future development of the country.

Helsinki in a Maelstrom of Change

So far as Helsinki itself was concerned the reforms of Alexander II changed life in the capital completely. By 1856 many of the restrictions on foreign travel had been removed enabling men like Borgström to travel abroad to study new ideas and institutions in a Europe experiencing massive industrialisation and urbanisation. This meant that the ideas of European liberalism were from 1857 onwards being openly debated on the basis of personal observation and experience and students in particular had no longer to rely on reading about them in German, French and Scandinavian journals and the newspapers to which the Helsinki University's Student Reading Society subscribed.

The establishment of new secondary schools[133] and the abolition of limits on recruitment[132] naturally increased the total number of students in Helsinki and while the number of students from the city itself had grown[134] the capital could not yet provide adequate living facilities for all those coming from the countryside.[135] To improve the situation a national appeal was launched in the late 1850s for the building of a meeting and eating-house. This was to take the form of the present Old Student House at the corner of Aleksanterinkatu and Mannerheimintie, fittingly the city's first major building to adopt the modern neo-renaissance style. The circumstances of its construction reflect the gradual emergence of the new civil society as a result of the liberalisation of the daily life of the capital and the country. The project was launched at a general meeting of University students, which was also attended by eminent professors, and fund raising was carried out round the country not only by students themselves but by volunteers who organised raffles, lectures and soirees, while some well-to-do Helsinki burghers also made major donations.[136] A significant part were also played by women, who since 1864 had been officially given control over their own property and were no longer happy merely to run ladies' societies in Helsinki and other towns, but started increasingly to take part in the work of the charitable organisations of the 1860s such as the Helsinki-based Association for Correctional Treatment and the Helsinki Deaconess Institute. The latter was a pioneering establishment bringing modern nursing to Finland, and was established in 1867 by Aurora Karamzin, who had been inspired by the German Evangelical Home Mission movement.[137]

Above the main entrance of the Student House, completed in 1870, were inscribed the words *"Spei suae patria dedit"* in recognition of the vital importance of those Helsinki University students who had so nurtured Finnish nationalism that in 1856 Finnish was finally accepted as a language of instruction and, in 1863 was given equal status with Swedish in the administrative system. Indeed, since the early 1860s a small but increasingly numerous and ever more vociferous group of educated Helsinki people had started to use the Finnish language in their daily life, and these "Fennomen", promoters of the Finnish national culture, soon gained importance in national politics as opponents of the European orientated and often Swedish-speaking liberals, later known as "Swecomen". Coupled with the re-established Diet, which started to meet in Helsinki at regular intervals, these movements naturally made Helsinki the national political centre, where newspapers such as the liberal *Helsingfors Dagblad* and the Fennomen's *Suometar* soon gained importance as channels of the latest political and cultural trends and reached even the remotest parts of the country.

The abolition of the guild system in 1868 and the establishment in 1879 of freedom of trade, which were essential parts of the modernisation of Finland's economic life, changed Helsinki irrevocably from a mere administrative capital into a major industrial town. Already the early 1860s saw a surge in the number of newly established industrial enterprises from an average of four in pre-Crimean War years to eleven per annum[138] while the manufacturing work force in Helsinki more than doubled during the same decade representing nearly 60 % of the total skilled work force in 1870 while craftsmen who had constituted nearly 45 % in 1860 now represented a mere 31 % ten years later.[139]

Interestingly the enterprises launched in the 1860s and the early 1870s included such traditional Helsinki companies as Osberg & Bade's engineering workshop, Tampella's dry dock in Hietalahti, Tilgmann's printing plant and the Arabia pottery – all still operating in Helsinki today. It is also significant that apart from Adolf Törngren, the founder of the dry dock company, the other entrepreneurs were of foreign origin: Osberg's family had arrived from Sweden and Bade's from Germany via Tallinn while Tilgmann also was a German. The Arabia pottery was a branch of the well-known Swedish Rörstrand ceramics manufacturer, now seeking entry to the Russian markets.

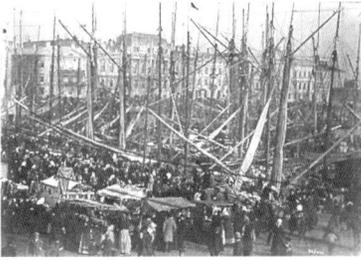

The first Baltic herring market was arranged in 1743. The tradition continues and even nowadays the October Baltic herring markets are a yearly attraction. (Helsinki City Museum)

Again it appears therefore that it was foreign entrepreneurs who were among the earliest to take advantage of the opportunities emerging in Helsinki and the access it provided to the seemingly unlimited markets of Russia, whose population increased from 73 million in 1861 to 126 million in 1897.[140] Foreign entrepreneurs were also alert to the emerging trading markets in Finland once industrial timber plants, powered by steam, had started the large scale buying of logs from farmers, providing them with cash thus beginning the break-up of the self-sustenance economy, while railways had eased the transport of goods deep into inland Finland. Consequently out of a total of 156 Helsinki merchants and shopkeepers in 1874 only 80 were Finnish while 55 were Russian, 12 German, 8 from Scandinavian countries and a single one from Britain.[141]

Alongside the expansion of trade and industry Helsinki also started to attract an increasing number of people seeking work opportunities in a city where labourers and carpenters were known to be much better paid than in other Finnish towns.[142] The new metal works especially but also other factories were employing a much larger work force than before the war. Whereas Borgström's tobacco factory with its 50–70 employees had been one of the largest employers in the 1840s, by 1874 Osberg & Bade's engineering workshop employed over 600 people and in seven others the number of employees exceeded one hundred.[143] Migration, both national and international was therefore clearly an important spur to 19th century development and initiatives. Consequently the total population of Helsinki increased from some 18,800 in 1860 to 30,800 in 1875.[144] Such a growth inevitably meant that the amenities available in the city could not meet all the emerging needs and unplanned housing areas began to grow up beyond the

outskirts of the established city. Increasing foreign travel also created in Helsinki demands for the adoption of the innovations and procedures that Finns had observed in other European cities. The inward-looking city of the early Russian period had certainly started to look outwards.

Innovative Immigrants

As discussed in chapter 1 some of the early Russian arrivals accumulated a considerable fortune in the city's sugar, brewery and construction industries. Among them was Nikolai Sinebrychoff. Once he was granted exclusive rights to brew beer by the city and later to distil spirits he and his family became the richest inhabitants of Helsinki and also owned a shipyard and large areas of land outside the city. A brother of Nikolai Sinebrychoff, Paul, was actively involved in the municipal administration [1] and the family spent considerable sums on charities establishing a hospital and patronising the arts in the city. In 1921 Paul Sinebrychoff Jnr and his wife eventually bequeathed their large collection of art and valuables to the Finnish state and this formed the nucleus of and provided the premises for what is now the National Gallery of Foreign Art.[2] Being members of the Orthodox Church a large number of them had also subscribed considerable sums for the construction of Uspensky Cathedral consecrated in 1868 in Katajanokka near the South Harbour.

In 1868 a Russian theatre was established in Helsinki forging working links with the Finnish language theatrical world and sharing the premises of the Arkadia Finnish Theatre though it was later to acquire its own building, the Alexander Theatre, in Bulevardi.[3] A Russian secondary school, the Alexander Gymnasium, was also established in 1870, on the specific initiative of the Tsar.[4] By the 1880s a great number of Russians were living in Töölö near the Turku barracks (the site of the present Lasipalatsi) while from the 1910s onwards a conspicuous number of Russian officer families moved into the newly built Katajanokka.[5] With the Russian forces arrived also soldiers from Poland and the Baltic states and they were numerous enough to establish their own churches as early as the middle of the century, a Lutheran parish for the Estonians and Latvians and a Roman Catholic one for the Poles and Lithuanians.[6]

With the Russian army came also Jews and Muslims to Helsinki. Many Jews specialised in the second hand clothes business situated in the *Narinkka* flea markets and, with the support of the liberal intelligentsia and press, they were able to establish a synagogue and a school on a site donated by the City Council.[7] Among them was the Stiller family, who had arrived in Helsinki in the 1870s. One of their Helsinki-born sons, Mauritz Stiller, was to make a distinctive film career in Sweden and to launch Greta Garbo in Hollywod while the Rung brothers were actively involved in the cinema business in the Helsinki of the 1910s[8] Fashion retailing, however, remained their strongest field and, especially from the 1950s onwards, Jewish families were to own a number of

the largest clothing shops in the city. Similarly the Muslim community, which originated mostly from the Tartar villages of the Nizhny-Novgorod district, was extensively involved in the luxury trade selling furs and carpets and even today in the Fredrikinkatu area there are many furriers' shops run by their descendants.[9]

The Germans had arrived in Helsinki much earlier than the Russians, and families with names such as Baumgarten, Dobbin, Wetter, Siliacks and Heidenstrauch appear in official records from the early 18th century onwards. New German immigrants (from Lübeck in particular) had continued to arrive in the country from the 1840s onwards[10] and the number of essentially German families remained high. A separate German Lutheran parish had been established in 1858 and the German girls' school, opened in 1862, became so popular with non-Germans that 70 % of its students in 1875–76 were from Swedish-speaking families of Helsinki.[11] The community also established its own library, and like the girls' school, which later became co-educational, the library has been operating in Helsinki ever since.

The German-speakers who arrived in Helsinki in the 19th century proved particularly innovative in business practices and marketing. Eduard Fazer, who had been one of the immigrants arriving in Helsinki in the 1840s, soon reported home that he had had to instruct his employers on how to run their business[12] and it was his sons who introduced to Finland a whole new range of business fields. Although Max, his eldest son, rather conventionally became a wholesale merchant and sugar manufacturer, Georg, an amateur violinist, founded the Fazer music firm. Edward was a concert pianist and an impresario who arranged in 1909 the Western European tour of the *Ballet Russe* and who became later the first director of the Finnish Opera.[13] In 1891 the youngest son, Karl, launched a confectionery and patisserie business after thoroughly learning the trade in St Petersburg, Paris and Berlin. Six years later, when the customs regulations between Russia and Finland changed, he grasped the opportunity to launch the industrial production of sweets. He advertised on the Helsinki trams and his careful following of foreign trends and subsequent product development combined with his innovative marketing secured increasing sales in Finland and abroad giving it the pre-eminence that it still enjoys in Finland today.[14]

Other German immigrants arriving in Helsinki from the 1850s onwards showed similar acumen and ability establishing equally successful enterprises, which are still thriving today. They included Kleineh of the Hotel Kämp and Karl König, the equally well-known restaurateur. Many had arrived as simple bookkeepers, such as Frank Stockmann[15] and Eduard Paulig[16] both of them from Lübeck, but were later to develop businesses that dominated their field. Innovation was the essential key to their success. Stockmann's early business career included being an agent for the shipping of cotton directly from New Orleans and the transporting of Christmas turkeys and plum puddings to British engineers stationed in Tampere.[17] Thus by 1880 Stockmann's shop was exceptionally modern. It had internal telephones and gave receipts and its big windows allowed for window displays to attract passers-by. In 1886 Stockmann's launched a novelty, the bicycle, and, according to an 1900 advertisement, the company was already selling everything but books and food stuffs, ironically the two lines that are among its best-known today. It had, in fact, become a department store in the most fashionable European style.

Gustav Paulig's success in the coffee business was based on the innovative idea of selling roasted coffee beans in neat standardised consumer packages each weighing 250 grams, thus replacing the old system of selling raw coffee

Female lift operators at Stockmann's department store in the 1930s waiting to whisk customers to different floors, something quite unique in Finland at the time. The firm is still located in its modern building completed in 1930. Today, it is a major listed company and there are still family members on its board. (Stockmann Archives).

Kruunajaismarmeladi fruit jellies, originally made to commemorate the coronation of the British king Edward VII. Since 1948 the product has been known as *Finlandia marmeladi*. For over a century, Fazer has been one of Finland's leading confectionery and chocolate manufacturers with a big export trade. Their *Wiener Nougat* chocolates and "Blue" chocolate bars are as popular today as in the early 20th century. Their mint chocolates have been a more modern success. (Fazer)

beans direct from jute sacks to be roasted by the consumers themselves. From the beginning he also put much effort into marketing. Later the firm's business expanded so as to include tea and spices, and with typical enterprise Henrik Paulig, the grandson of Gustav in 1942-43 made a dangerous mid-war journey to the USA to study methods of deep freezing. This resulted in the establishment of a plant for the freezing of berries and vegetables, the first of its kind in the Nordic countries, though the use of freezing was not a novelty for the Pauligs who, as early as the 1890s, had used it to preserve flower bulbs.[18]

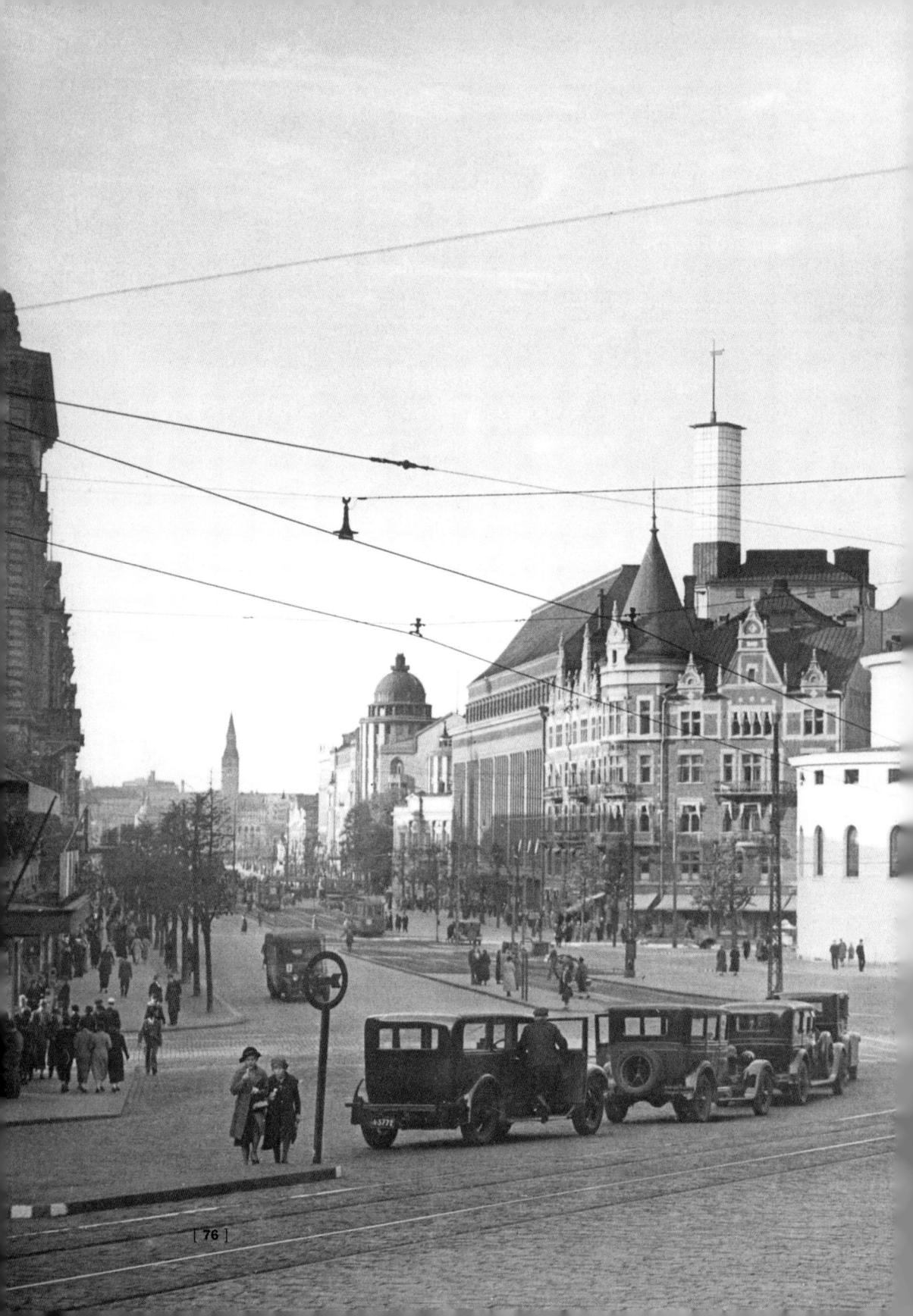

III The City of Helsinki and "the Urban Question"

The Background to the Progress of Finland's Economy

According to many indicators Finland in the mid-1850s, as was mentioned earlier, was in modern terms comparable to a developing rather than a developed country (see Appendix V). Indeed, at the beginning of the 1860s Finland's gross domestic product per capita was about 25 % lower than the average level of the rest of Europe. In the following decades economic development accelerated significantly and just prior to the outbreak of the First World War Finland's GDP per capita had already caught up with the average level of European countries.

This rapid development was made possible by the economic and industrial exploitation of the forestry resources of the northern European hinterland due to the demand generated by the expanding of the world economic system led by western Europe. Already at the end of the 19th century, the relation of foreign trade to GDP was almost 50 %, which is very high even for small countries at that time which integrated previously self sufficient and closed economies into the network of international trade. During the second half of the 19th century the vigorously expanding western oriented timber exports were joined by an export trade in paper and pulp, which in its early stages linked the Grand Duchy of Finland to the rapidly expanding economic area around St. Petersburg.

The view from Erottaja looking up Heikinkatu in 1930s, (later Mannerheimintie). On the right is the Swedish Theatre (Svenska Teatern). Finland had to keep pace with more developed countries. Parks and boulevards were an integral feature of European cities. (Helsinki City Museum)

The Sinebrychoff brewery in the late 1800s. On the left is the family home of the Sinebrychoffs who became one of the richest families in Finland through their brewery and distillery interests. That home is now an art museum, part of the Finnish National Gallery, and a bequest by Paul and Fanny Sinebrychoff in 1921 formed the core of its foreign art collection. (Helsinki City Museum)

When it came to large-scale investments in the infrastructure to open up economic bottlenecks and stimulate activity, the financial resources of private capitalists and entrepreneurs gave way to state capital. The railways and canals also demonstrated that the government of the Grand Duchy had adopted a strategy of modernising the Finnish economy and promoting industry. The strong nationalist movement (Fennomania) helped in this modernising project. Improving transport conditions and the opening of the western markets meant that both imports and exports increased.

During her autonomy Finland enjoyed formal customs autonomy. In Russia Finnish goods had a favoured tariff treatment with no or low tariffs. It has been estimated that this was favourable for Finland's industrialisation, particularly for the paper industry together with the consumer goods and metal industries.[1] Bearing in mind that Helsinki as a capital was also becoming Finland's financial centre the city itself was experiencing an economic boom.

So far as Helsinki was concerned, its first major period of growth began in the 1870s continuing until the 1930s, and during that time the city's economic life became more active and varied. Big banks and insurance companies were located in Helsinki. New hotels and restaurants opened their

doors. This prospering of business life was facilitated by the construction of a railway to Hämeenlinna in 1862, and then in 1870 to St Petersburg, which provided a major market place for Helsinki industries. Thus by the 1910s Helsinki was no longer a mere administrative town and university centre but also a major commercial and financial centre with flourishing industries of its own although it could not be compared with Stockholm, where one quarter of the working population gained their livelihood from commerce.[2] By 1910 industries and services had become the biggest employers in Helsinki.

Helsinki City Administration 1875–1917

In just over two decades Helsinki has grown from a big small town into a small metropolis," commented the city treasury as they pondered accelerating municipal expenditure in the early years of the 20th century.[3]

The period from the 1870s to the First World War was one of brisk development in almost all fields of life, and urbanisation was then as its liveliest in Central Europe so that it was felt that new hierarchical concepts should be developed to handle the phenomenon. To be regarded by experts as a major city at the turn of the century a municipality had to have a population of at least 100,000. Helsinki was thus Finland's only city in this category. Its growth rate had been extremely fast as between 1860 and 1910 its population had increased from 22,228 to 133,150 – an average annual growth of 3.6 %. This was almost on a par with that of leading German cities. In the Nordic countries only the yearly growth figure of Kristiania (Oslo) (4.1 %) was similar between 1850 and 1900 while the equivalent rate for Stockholm was 2.3 % and for Copenhagen a mere 2.1 %.[4]

By 1907 the population of Helsinki exceeded 100,000 but the growth had been not only quantitative but also qualitative; the people's expectations and demands had increased. They expected new, higher standards of services from the "metropolis" that Helsinki now appeared to be. The decision-makers were keen to compare Helsinki with "Europe", and with conditions in the metropolises "of civilized countries".[5] The industrial revolution and urbanisation had by this time effected developments not only in Britain and Central

Hotel Kämp was a glamorous, continental hotel built in 1887. The interior was commissioned from Berlin and St. Petersburg. In 1965 the hotel was demolished; later on, in 1999, it was reopened in the same place with the same name. (Helsinki City Archives)

Europe but also in the Nordic countries. These places therefore offered a natural source of experience for Finns who needed to solve the social problems caused by the rapid growth of Helsinki.

The 1873 Act concerned with Local Government in Towns had somewhat vaguely defined the tasks of the local authorities as the management of the "common affairs of order and economy " of the inhabitants. Thus it allowed the local self-governing bodies freely to adopt new tasks if they so wished to be carried out in the name of the municipality. An increasing number of technical, administrative and moral issues arose with advancing social change well beyond the personal experience of the city's decision-makers and the state legislation did not provide any guidelines. Moreover, like elsewhere in Europe, epidemics, high death rates and high infant mortality were problems well into the 20th century. The local authorities had therefore to seek a lead on certain matters from the solutions adopted in countries

that were in a more advanced stage of industrialisation, urbanisation and hygiene. But it was also important to find innovations, which provided the best long-term solutions in financial terms, as alongside the progress of urbanisation Helsinki city's expenditure was rapidly escalating especially in the fields of law and order, health care and education.[6]

Between 1875 and 1917 the Helsinki City administration was very much based on the work of elected officials. The highest authority was vested in the elected City Council and its members also sat on the City Treasury, the executive body, as well as on various municipal boards, the members of which were all elected. In the same period the number of such boards trebled. As most of the matters on the agenda of the City Council were prepared in sub-committees manned by elected council members the influence of elected representatives was even greater. Between 1875 and 1918 a total of over 800 such sub-committees were instituted.

Compared with the old administrative system based on the leadership of the burghers of the town and the highly bureaucratised city administrative court the new municipal administrative system allowed fresh innovative forces to make an impact. The plutocratic voting system (the number of votes varied between 1–25 according to taxed annual income while companies had also right to vote[7]) had a vital impact on the emergence of this cultural, financial and social elite, which was a professionally modern group of people with extreme versatility in terms of its intellectual capacities and the knowledge its members already possessed.

Of all city councillors perhaps the most typical was Leo Mechelin, the chairman of the City Council in 1875–76, 1878, and 1892–99. A university professor he was also a banker, a member of the Senate and was considered the "most European statesman" in Finland, the torchbearer of liberalism and later of the passive resistance to the russification to be discussed in Chapter Five. It was the initiative taken by him in 1896 in the City Council that led to a breakthrough for modern welfare policy in the Helsinki municipal administration during the next few years, and it was he who in 1905 introduced into the government programme the development of welfare laws in Finland. Subsequently the most influential decision-makers on Helsinki's welfare policies soon took over the key positions in the national administration in order to force through a number of welfare reforms. Apart from Mechelin himself

this "mafia" included K. J. Ståhlberg, the future first president of Finland and Leo Ehrnrooth, the influential chairman of the Finnish Municipal Asociation. They were all lawyers by training.

Indeed, it was the educated classes that dominated Helsinki City Council from the very beginning and of the total of 359 councillors two thirds (246) were university graduates including 74 PhDs. Four fifths of the councillors also belonged to the highest social category. Unlike the schoolmasters and post office officials who were to be found leading the councils of Finnish country towns and rural communes the City Council in Helsinki thus included in its ranks top experts and opinion leaders at national level. They included 37 university professors, 28 members and high officials of the Senate of Finland while the heads of National Boards of Construction, Health Care and Education were joined by the editors-in-chief of the major newspapers, the directors of the most important banks, insurance companies and major industrial and transportation companies.

It was also typical all through the period that a great number of high-ranking civil servants and national politicians were to be found in the self-governing municipal bodies of Helsinki. Thus by 1918 one councillor in two (from a total of 154) had been a member of the Finnish parliament, the Diet or the Eduskunta (the new parliament in 1906) that succeeded it, while one in eight had also been a member of the government of Finland. As a result among the highest level of state authorities there was a continuing knowledge of the municipal planning in Helsinki while these personal links also benefited the city, as its decision-makers were well aware of the ways of thinking and planning of the national bureaucracy and politicians. This interrelationship was particularly important as the capital could act as a source of inspiration and experiment for the innovative policies required to solve the problems and satisfy the reform needs resulting from its having the fastest growth rate in the whole country.

Consequently, between 1875 and 1917 the network of know-how availab-le for the city administration of Helsinki embraced the international links established by the top ranking representatives of learning, business and state administration in the whole of the Grand Duchy. The leading civil servants in the services that were expanding most were physicians, engin-eers and architects representing professions where at that time professional

further education abroad was almost *de rigueur*. In the City Council they also formed a significant group so that there might even be 8–9 physicians among the elected councillors. Of the total of 359 councillors elected between 1875 and 1918 the physicians numbered 30 along with 27 engineers and 15 architects, totalling 20 %.

Before the Helsinki City Council was formed in 1875 the City Administrative Court had played a significant role in municipal decision-making. The picture shows a City Administrative Court meeting in 1912. (Helsinki City Museum)

The professional experience of these men, coupled with their international connections, was available to the City during the decision-making process as well as in the preparatory stage in the sub-committees. They also often debated issues related to the development of the city in meetings of learned bodies, such as legal, economic, medical and technological associations. Moreover, these decision-makers had trained, in their professional capacity, the architects, engineers, lawyers and physicians, who as municipal officials prepared and executed these decisions.

Various opinions have been put forward concerning the input of the educated classes in municipal life. In 1885 one critic lamented that the "bourgeois business-like running of affairs" had been replaced by "eloquence acquired from academic life or the formality of the civil service" and that the lack of practical experience and the municipal committee system were delaying the handling of complicated issues. On the other hand the councillors belonging to the educated classes adopted an unprejudiced attitude towards the solving of new emerging problems and this was helped by their capacity to seek help from abroad, often from countries where they had studied.

The limited nature of the franchise which favoured the wealthier classes helped to facilitate in practice the ideas promoted by the better educated while it did not allow the great masses to take part in decision-making on matters closely related to their own life. Some thirty years later such an administrative model based on the active involvement of elected representatives was no longer adequate for the needs of "the small metropolis" and the municipal bureaucracy grew steadily after the early 1890s with this becoming an escalating growth after 1908. In total the consequent increase of bureaucracy was five fold between 1885 and 1918 while the population had increased only four fold. The areas where the numerical growth of municipal employees exceeded that of population growth were the education and cultural services, poor relief and above all the health care services where the number of employees increased by a staggering thirty fold. One must also bear in mind that the establishment of services such as water, gas and electricity plants clearly marked a development in the municipal administration not anticipated in the framework delineated by the law.

The political parties were also evident in the City Council of Helsinki. The franchise and the election system guaranteed that Swedish-speakers held absolute dominance in the municipal life of the city as in the elected council there were only some 20 % Fennomen, i.e. promoters of the Finnish language and the finnification of public life in Finland. The early Labour movement, which from the beginning had established good foreign contacts, also maintained good relations with the Helsinki city administration though once it adopted a more social radical line with the formation of the Social Democratic Party in 1898 it became increasingly isolated. Socialism as well as the bourgeois welfare policies, devised to counteract them, were in the main foreign imports to Helsinki.

During the second half of the 19th century, improvements to street lighting and expansion of the gas distribution network were recurrent items on the agenda of Helsinki City Council. Gas was first used in Helsinki for lighting, then for cooking. The picture shows gas lamps being cleaned at Konstantininkatu 10 (Meritullinkatu since 1928). Gas lamps had to be regularly cleaned to ensure they functioned. Photo from 1912. (Helsinki City Museum)

The Introduction of Public Utilities: Gas in the 1860s...

A high standard of expertise and contacts were certainly needed if Helsinki was to acquire all the modern utilities that were being launched all round Europe and were considered now the indicators of the progressiveness of a city. The introduction of gas demonstrates well the problems Helsinki had to face before this service was launched there in 1860, that is more than forty years after gas had first been used for street lighting in Europe.[8]

The first experiments in using gas as a source of lighting were made in 1804 in the works of Boulton & Watt near Birmingham and gas for lighting the streets was first used in London in 1814 by a private company; within a few years some 26 miles of pipes had been laid under the London streets for this purpose. The use of gas then spread rapidly so that by 1850 the number of companies in Britain totalled 200. The Americans, too, were quick off the

mark in the adoption of this new technology. The city of Baltimore was lit by gas in 1816 and by 1870 it was being used in 46 cities and towns as the method of lighting.

It was also British companies which first established gas in continental Europe, and they were soon followed by native firms. Thus the first gas plants operating in Germany were established in Hanover and in Berlin in 1826 as concessions of the Imperial Continental Gas Association, though native German firms had already established the gas plants in Dresden in 1828 and Leipzig in 1838. The number of plants expanded rapidly. While in 1850 there were only 35 gas plants in Germany by the 1870s their number had increased to 551 and by 1908 to 1,250.

In Sweden a gas plant started to operate in Gothenburg in 1846, another in Norrköping in 1852 and the first actual gas lighting plant a year later in Stockholm. Compared with Scandinavian countries Finland was not too far behind: the first experiment took place in 1842 in the Finlayson cotton mill in Tampere under the direction of its British technical director John Barker. However, it was not until 1860 that concessional private gas plants were providing street lighting in Helsinki and Viipuri while Turku streets were not lit by gas until two years later.

In Finland, as in the other Nordic countries, gasworks were initially privately owned but in the 1870s they began to be taken over by towns. Gasworks were established in Finland ten years later than in Sweden, first in Helsinki and Viipuri in 1860 and then in Turku in 1862. Helsinki City Gasworks was taken over by the city in 1901. Photo from 1912. (Helsinki City Museum)

Thus in Finland the adoption of gas lighting was delayed for forty years in industrial plants and for nearly fifty years as a source of street lighting. Such a delay was not caused by ignorance. When visiting St Petersburg high-ranking Finnish civil servants and military men must in the early 1830s have seen there some examples of gas street lighting, as had the young Gogol.[9] Certainly during their travels abroad private individuals had become familiar with this innovation and had spread information to their circles. In a letter to his wife J. V. Snellman, for example, writing in August 1847, described the gas lighting of Berlin. Finnish newspapers had also reported foreign applications of this innovation. In early 1860 *Helsingfors Tidningar* noted that about hundred gas companies were being established abroad each year

> "... even in the smallest foreign towns and in recent years even in Sweden... But here in Helsinki there seem to be personages who think it more profitable to acquire Russian oil and Russian candles for their old miserable lighting..."

According to Jaakko Pöyhönen, the resigned tone of this comment reflects two of the major reasons for the delay in applying gas lighting in Finland. An unwillingness to take financial risks, due to the lack of venture capital available, was the major one. The other reason is hinted at in the article's words "the smallest foreign towns". The towns that even the largest Finnish towns, including Helsinki, were following as a model were, indeed, small foreign towns and thus it is clear that the Finnish towns had a very peripheral reference group. A third factor was the lack of interest shown by foreign companies in the business opportunities provided by Finland. As early as 1824 the Imperial Continental Gas Association had offered to construct a gas plant in Stockholm, and the same company had established gas plants in many continental European cities including Copenhagen. However, in the 1820s none of the Finnish towns could provide markets interesting enough for the company.

These three indicators thus reveal that in European terms Finland, and Helsinki, in the first half of the 19th century appeared to major foreign entrepreneurs a hopelessly small market.

It was not until 1856 that the use of gas for street lighting was first proposed at the City Administrative Court and it took four years and a visit by a foreign expert invited from Britain, before the municipal authorities decided

to acquire gas lighting for Helsinki. Following the example of Stockholm, and using that city's contract as a model, the city in 1860 granted a private company a 40 year concession to establish a plant for gas lighting. The actual planning and constructing of the plant was in the hands of German experts and engineers and its first director was also a German engineer formerly employed by the University of Helsinki. The other Finnish gas plants of the early 1860s, in Turku and Viipuri, were also packages from abroad. They were planned by foreign experts using foreign technological systems and installed by foreign technicians. The only Finnish novelty in the Helsinki and Turku plants was the replacing of coal as the fuel with the domestic raw material, timber.

This transplanting of a ready system to Finland soon proved problematic, however, and the early years were spent in rectifying planning mistakes. Due to the limits of private capital and the small population in each town at the time of the establishment of the plants, they were also relatively small and could not cope with the later expansion of the towns with all their new streets that needed lighting.

Thus it was the hapless task of the new Finnish director of the Helsinki gas plant, Edvin Bergroth, to adapt the system to Finnish circumstances and expanding needs. Bergroth was eminently suited to his job as he had studied engineering in the Hanover College of Technology graduating in 1860, and after taking up his post in early 1862 he almost immediately travelled to Augsburg and Zürich to investigate gas production technologies and their financial yields there. During his six month stay he also took part in the construction of a gas plant in Eisenach before returning to Helsinki in the summer.

During his term of office Bergroth subsequently made several study tours abroad especially to investigate the use of coal as a fuel and the equipment required. It was difficult for him, however, to convince the company that coal could prove better and it was not until 1882 that it was introduced as the gas plant fuel in Helsinki after the Finnish Senate had provided a low interest rate loan. The annual report of the plant could then pointedly state that, "only after this reform can the plant be considered to have the development

potential required by a capital city," and indeed, during the first two decades of the existence of the plant the population of Helsinki had doubled from some 22,000 to nearly 42,000 inhabitants.

In spite of such a massive increase in the potential customer base the company appeared to be more interested in providing high profits and in creating reserves than in further developing its services for domestic customers. Some researchers have even pointed out that the company deliberately started to slow down this development as the licence of the company was drawing to an end in 1900. Thus the introduction in 1892 of Auerlamps, known since 1885 and already being successfully used abroad in domestic lighting, did not have any major impact in Helsinki. Similarly, although experiments abroad and in Turku in using such lamps for street lighting had proved successful, the gas company in Helsinki only started slowly to switch to these gas saving lamps after pressure from the city authorities. By the autumn of 1900 only half of over 1100 street lamps had been fitted with the Auerlamp. These delaying tactics meant that, even if the invention of the incandescent mantle in 1895 increased the efficiency of gas lighting, the gas company eventually lost its position as the provider of lighting to electricity, which was introduced in Helsinki in 1880.

... Electricity and the Telephone in the 1880s

In contrast to the late adoption of gas, Finland emerged as one of the pioneering countries in the whole of Europe in the adoption of the electricity and telephone technologies.

In fact a Finnish interest in electricity had already been manifested in academic dissertations published in the 18th century while 19th century publications included not only scholarly treatises on the measuring of electric currents by the internationally renowned physicist J. J. Nervander, but also popular works on the various forms that the applied use of electricity could take.[10] As early as the 1840s the phenomenon had already been given the specifically Finnish name *sähkö* rather than some form of the Greek word *elektron* as had happened in most European countries.[11] The 1870s saw the first electrical experiments in Finland carried out by a Helsinki University physics dozent (later Professor) Karl Lemström and the German mechanic

Poster of the Elektrizitäts-Gesellschaft, Berlin by Louis Schmidt, 1888.

Martin Wetzer[12], who had earlier come to Finland to install gas plants. Both had contacts abroad and especially in Paris, which in the 1870s was one of the leading cities in Europe in the field of electricity. The first demonstrations of its use for lighting took place in 1877 in the mechanical works of the State Railways in Pasila and at the Kaivohuone restaurant. During the summers of 1880 and 1881 the Kaivopuisto Park was also lit by electricity, and the first electrical retail outlet was opened in the capital in 1880.

Similarly the telephone was introduced to Helsinki in 1877, only two years after its invention by Alexander Graham Bell.[13] Four years later Tsar Alexander III gave his consent for the Finnish Senate to grant loans for establishing local telephone lines and within a couple of years similar loans were made available for long distance lines. The Telephone Act of 1886 was in force for the next hundred years[14] giving a major boost to the establishment of local telephone companies. Consequently private telephone companies were established in 1882 in Helsinki, Turku, Tampere and Viipuri, and within the next three years such companies were operating in 19 Finnish cities and towns, and banks and entrepreneurs in particular found the telephone very useful for running their business. The Union Bank of Finland, for example, had telephone links with its branch offices in Hämeenlinna and in Viipuri by 1890.[15]

The arrival of the telephone was just one of the electricity related developments that created a real interest in such matters and in the men behind these new innovations. The best known among the Finnish general public was the American Thomas Alva Edison and he was sometimes erroneously given credit for being "the noted inventor of the telephone" as well as more accurately "of the phonograph and the microphone". Without exaggeration he was the most popular American in Finland in the last quarter of the 19th century and hardly a month passed without at least one news item on Edison appearing in the Finnish press. When he was developing his incandescent

lamp, which was to revolutionise the use of electricity for indoor lighting, the Finnish papers reported almost every step of his progress in experiments with filaments of various materials. What was also significant was that news of these reached the Finnish public only a few days later than newspaper readers in Britain, Germany and Sweden. In effect this meant that unlike in these countries such news reached virtually the whole adult population in Finland given that the literacy rate was already almost 100 %.[16]

Such news items were bound to create enthusiasm among Finnish would-be inventors and one of them was the 17 year old schoolboy Gottfrid Strömberg (1863–1938) from Central Finland, who managed in 1880–81 to construct a DC-dynamo of 65V and 8Amp with the help of his little sister on the basis of assorted snippets of information collected from Helsinki newspapers. This dynamo, the first ever made in Finland, was used to light the porch of his family house to the great astonishment of the villagers. After studying at Institute and gaining a degree in electrical engineering in Berlin

The telephone and post office offered employment opportunities for single women. The photo shows the Helsinki Telephone Exchange, about 1900. (Helsinki City Museum)

Strömberg became the first lecturer in electrical technology at the Helsinki Polytechnic Institute in 1887.[17] Two years later in 1889 he established in Helsinki his own company, Oy Gottfr. Strömberg Ab, for the production of generators for local electricity companies.[18]

According to the 19th century English traveller, Mrs Alec Tweedie, there was no lack of technological interest in Helsinki in the closing years of the 19th century. On the contrary, on her visit in 1896 she was astonished to observe that the city was modern and that electric lighting and telephones were already commonplace.[19] Indeed, by the time Mrs Tweedie visited the city telephone apparatuses had been on sale there for some twenty years and the network with nearly 4,000 subscribers covered the whole city area – a considerable number bearing in mind that in St Petersburg there were less than 5,000 installed telephones in 1901.[20]

Similarly Finland had been among the first countries in Europe to make practical use of electricity. Following the Paris Electrical Exhibition of August 1881 Edison lighting had been installed in London, Paris and Strasbourg in January 1882, but by March it had also reached Tampere in Finland. In Helsinki the small plant of D. J. Waden began to operate in late 1884, the same year that the first electrical plant began to operate in Berlin[21] and by the time of Mrs Tweedie's visit there were more than thirty electricity plants of various sizes[22] providing the power for some 20,000 electric light bulbs[23] in a city with less than 80,000 inhabitants.

The first electrical plants were established in Finland, like elsewhere in the world, by private initiative. Compared with the case of gas, the delay in the arrival of electricity in Finland was reduced from several decades to a few years or even a few months.

Therefore, so far as the establishment of electrical plants was concerned, Finland found itself among the pioneering countries. According to Jaakko Pöyhönen there were five reasons for this the first one being that the readiness to take business risks was much greater than twenty years earlier. Moreover the total of capital available had increased significantly after the banking reforms. The second reason was the strong growth of the towns, which in turn meant the growth of potential markets in Finland. Consequently foreign companies were keener to approach prospective customers, industrialists and the city fathers, through their agents and with their tenders. The

third significant factor was the emergence of native technical expertise. That was increasingly available as more and more people studied at what was first the Helsinki Technical Realschule (established in 1848). This became in 1872 the Helsinki Polytechnic School and in 1879 the Polytechnic Institute, but Finns also studied at foreign technical institutes, and in many cases they also worked abroad for a few years. The Helsinki Polytechnic in particular was highly appreciated in the German-speaking world and its representatives were invited to the centenary celebration of the German-speaking Polytechnic universities by a group representing many European institutes of higher education.[24]

Instruction in electrical studies started as early as 1885 at the Helsinki Polytechnic, which was again upgraded to become the Helsinki University of Technology in 1908. The fourth, and certainly a major reason, was the much lower costs of establishing an electrical plant compared with those of a gas plant. Finally, the Finnish towns based their calculations of the benefit of use of electricity on static consumption thus avoiding time-consuming debates on the potential capacity for satisfying future needs, something that had often arisen as a central issue in many cities before the final decisions were actually made.

The introduction of electricity involved four possible courses of action: the employment of foreign engineers, the employment of Finnish engineers working as agents for foreign companies, the employment of Finnish firms with Finnish engineers and the undertaking of the work by the municipalities' own engineers. In the case of Helsinki German, American, Swedish and Finnish engineering companies were all involved. By the turn of the century more than 30 independent electrical plants were in operation in the city and it was not until such plants had been in operation for more than twenty years that the city established its own electricity company, which gradually took over the whole operation.

Private or Public Services

To begin with the City Council had not taken any part in the operations of electrical companies,[25] but the great number of electrical plants meant that it had to get involved in the debate on whether utilities should be publicly or

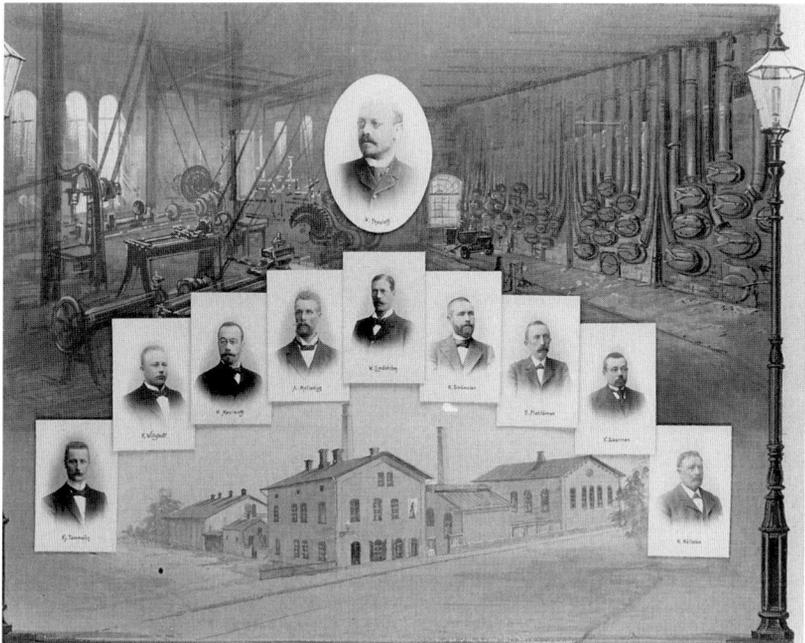

The Director of the Helsinki Gas Lighting Company, Wilhelm Thesleff and some of his colleagues. Included in the painting is an old gasworks. (Helsinki City Museum)

privately run, a question also very topical elsewhere in Europe at the beginning of the 20th century. The arguments presented in different countries were essentially quite similar. The opponents of the municipally owned public utilities used the arguments of the British Lord Avebury who spoke disapprovingly of "municipal socialism" while the supporters pointed out the positive results of municipal enterprise achieved in a number of big German cities.[26]

In Helsinki the matter had become topical in 1896 when the licence for operating the gasworks was running out. After lengthy deliberations the city decided to acquire the plant in 1898, probably encouraged by a Swedish example for in Stockholm the gasworks had been municipalised as early as 1884. In Helsinki the gasworks started to operate as a municipal enterprise from 1900 onwards. Its new managing director, Victor Emanuel Montgomery, immediately introduced a considerable cut in tariffs, and by the end of 1907 the consumption of gas had trebled according to the Annual Municipal Report.

In spite of these apparently promising developments the issue of whether to municipalise electricity production was hard to settle. In memoranda submitted to the City Council by a number of working parties and committees between 1901 and 1907 the main issue, whether or not to establish a municipal electricity company was invariably discussed in terms of foreign experience using as examples Stockholm, Copenhagen and a number of big German cities. The first report noted that Stockholm and Copenhagen both had municipal lighting companies and exclusive rights for the establishment of cable networks. In Berlin, Hamburg and Leipzig electrical companies were given concessions on the basis of sharing the annual profits with the city. On the other hand such German cities as Cologne, Munich, Frankfurt am Main and Dresden had opted for municipal electrical companies, which had proved quite profitable. The same report also pointed out that the city could run the public utilities better than private companies, as it could co-ordinate the construction and maintenance of various cable and piping networks and would also be more successful in securing advantageous contracts. Moreover, it could also regulate the power supply for the benefit of local industries, and the private citizens would benefit from ensuing tax reductions.

The fighting over the question of municipal enterprise in electricity carried on for some years and with such intensity that the 1905 municipal elections in Helsinki were called "the electricity elections" and the issues raised were so complex that the Swedish Party was divided into three separate factions. Nevertheless their official list of candidates which strongly opposed "monopolies and municipal socialism" in the end carried the day.

Before these elections a long battle over the issue of municipal enterprise had been going on since 1901 in the pages of *Teknikern,* the important trade journal of the engineering profession. At odds were V. E. Montgomery, the managing director of the Municipal Gas Plant and Hugo Mäklin, the managing director of a private Electricity Lighting Company in Helsinki. Interestingly, Montgomery, who had been born and educated in Sweden where he had also worked for several local gas boards, was an ardent defender of municipalisation, whereas Mäklin, who after graduation from the Polytechnical Institute had trained in a Massachussets electrical company, was just as fearless a spokesman for private utility companies.

The first electric light in Helsinki was lit only six months later than in Berlin. The picture shows the billhead of the Albion lightning store. (Helsinki City Archives)

The subsequent debate over many years engaged not only Montgomery and Mäklin but also a board member of the Jönköping Gas and Water Company in Sweden. *Teknikern* which appeared to sympathise with Mäklin's case, published in 1903 a series of anti-municipalisation articles taken from *The Times*, published in London. Referring to a number of examples ranging from the size of the municipal workforce in Birmingham and Glasgow to municipal rabbit hutches in Torquay and municipal fireworks in Harrogate, these articles pointed out that once public utilities gained a monopoly status in their localities they killed all entrepreneurship, and this in turn would have a detrimental effect even on the nation as a whole. On the other hand it was quite proper that municipalities were responsible for efficient drainage systems, well-maintained roads and streets and that they organised health care and an adequate supply of good quality fresh water, as all these were services needed by the whole population and therefore indispensible. Naturally the *Teknikern* also published an article on the thoughts of Lord Avebury, who was then perhaps the most prominent opponent of municipalisation in Britain. According to Avebury very few municipal decision-makers were able to run complicated business ventures as their membership changed too often and could not therefore gain adequate competence in what were increasingly technical issues. Moreover, municipal officials running monopolies would be the last ones to undertake major reforms in a municipally owned firm while

[96]

private entrepreneurs, who had to survive in competition, were on the constant look out for improvements in running the business according to the most modern methods.

The debate continued among Helsinki's decision-makers and technical experts with the issues ranging from technical problems to the question of the role of Finnish expertise in planning and development. It also involved the issue of a planning perspective and the decision-makers' vision of the future of their city. In order to clarify both the technical issues and possible future developments the City approached experts in Stockholm and Gothenburg and commissioned detailed plans from the Allgemeine Electrizitäts Gesellschaft and Siemens & Halske.

However, it became quite obvious that any system should be adapted to meet Helsinki's special conditions thus making the native Finnish experts invaluable. As Hugo Lindeberg, an engineer who had studied in the Polytechnic Institute under Gottfrid Strömberg, pointed out in 1905 the reading of

The Helsinki electrical plant, designed by the architect Selim A Lindqvist, was inaugurated in July 1907. (Helsinki City Museum)

Bernhard Wuolle, the chief resident engineer of the Helsinki City Electricity Plant and its first managing director and a supporter of municipal enterprise. After graduating from Helsinki Polytechnic Wuolle studied for some years at the Charlottenburg Technical University in Berlin and simultaneously worked at Siemens Schuckert Werk. Wuolle made several study tours and business trips abroad making personal contacts with foreign electrical engineers and the managing directors of electric plants in other cities. Later Wuolle would use his contacts for the good of Helsinki.
(Helsinki City Museum)

foreign statistics did not require any particular training background nor did the straight imitation of foreign systems. However, in order fully to benefit from the new innovations in electricity technology the city should definitely engage Finnish electricity engineers. They were well qualified not only to take into account the Finnish climate and other special circumstances and to adapt foreign systems accordingly but also to maintain and develop these systems in the future. Indeed, on this particular issue Finnish and Swedish-speaking engineers joined forces by emphasising the value of Finnish expertise and the need to employ more Finnish, not foreign engineers in Finland.

Obviously Helsinki's decision-makers followed this advice as the municipal electricity committee decided to send Bernhard Wuolle on a long study tour in Europe meeting experts in Gothenburg, Munich and Zurich as well as Berlin. Following his report the City Council finally decided in July 1907 to establish a municipal electricity plant in Sörnäinen and to adopt the mixed system of three-step alternating current, which would be transformed to DC power in substations. Thus Helsinki adopted a system which was becoming increasingly popular in large German cities. However, from Wuolle's report it is possible to read between the lines some concern about whether Helsinki could adopt the models of German, Swiss and Scandinavian large cities and

omit some of the earlier development stages or whether it should use Warsaw and other East-European cities as its reference group. Interestingly, once established, the Helsinki Municipal Electricity Works in 1907 joined the *Vereinigung der Elektrizitätswerke*, an organisation of municipal and private electricity companies in German cities. However, a quarter of its members were Austrian, Swiss, Hungarian, Russian, Romanian, Serbian, Spanish, Dutch, Belgian, Norwegian, Danish, Swedish and Finnish electricity companies. Thus in principle the expertise of the whole of Europe was at the Helsinki electricity company's disposal.

What is also interesting is the almost total omission of references to Russian expertise during this discussion on private – public utilities. After all, St Petersburg had municipalised its water-distribution system in 1893 and other municipal enterprises there included municipal gasworks, trams, city markets, cemeteries, wharves, a slaughterhouse and even a municipal bank, and in 1901 the city municipalised the telephone system with a consequent eightfold increase in subscribers. By the turn of the century more than half of the St Petersburg city income was actually derived from these municipal enterprises.[27]

The main reason for this omission may be the fact that the discussion on private versus municipal ownership of public utilities was carried out mainly in connection with a debate on the provision of electricity. Although St Petersburg reservedly enjoyed a high international reputation as a major centre of expertise in electrical sciences, Helsinki Polytechnic Institute was fortunate to have Gottfrid Strömberg as the first teacher of electricity. Being himself an inventor and industrialist he could implant a tradition of practical application alongside theoretical instruction. Moreover, while Helsinki was one of the pioneers in Europe in the use of electricity, it also had access to St Petersburg expertise for example through Hugo Lindeberg, mentioned above, who had worked in St Petersburg for five years, while other Finnish engineers customarily worked at some point in their career for Russian based companies. That the Finns did not let concern over the russification of Finland or potential health hazards prevent them from travelling to Russia in search of major innovations is evident from the trip made by representatives of the Helsinki Telephone Company (which is still a private company!) to Moscow in 1905 to see one of Europe's most modern telephone exchange systems installed there by a Swedish company.[28]

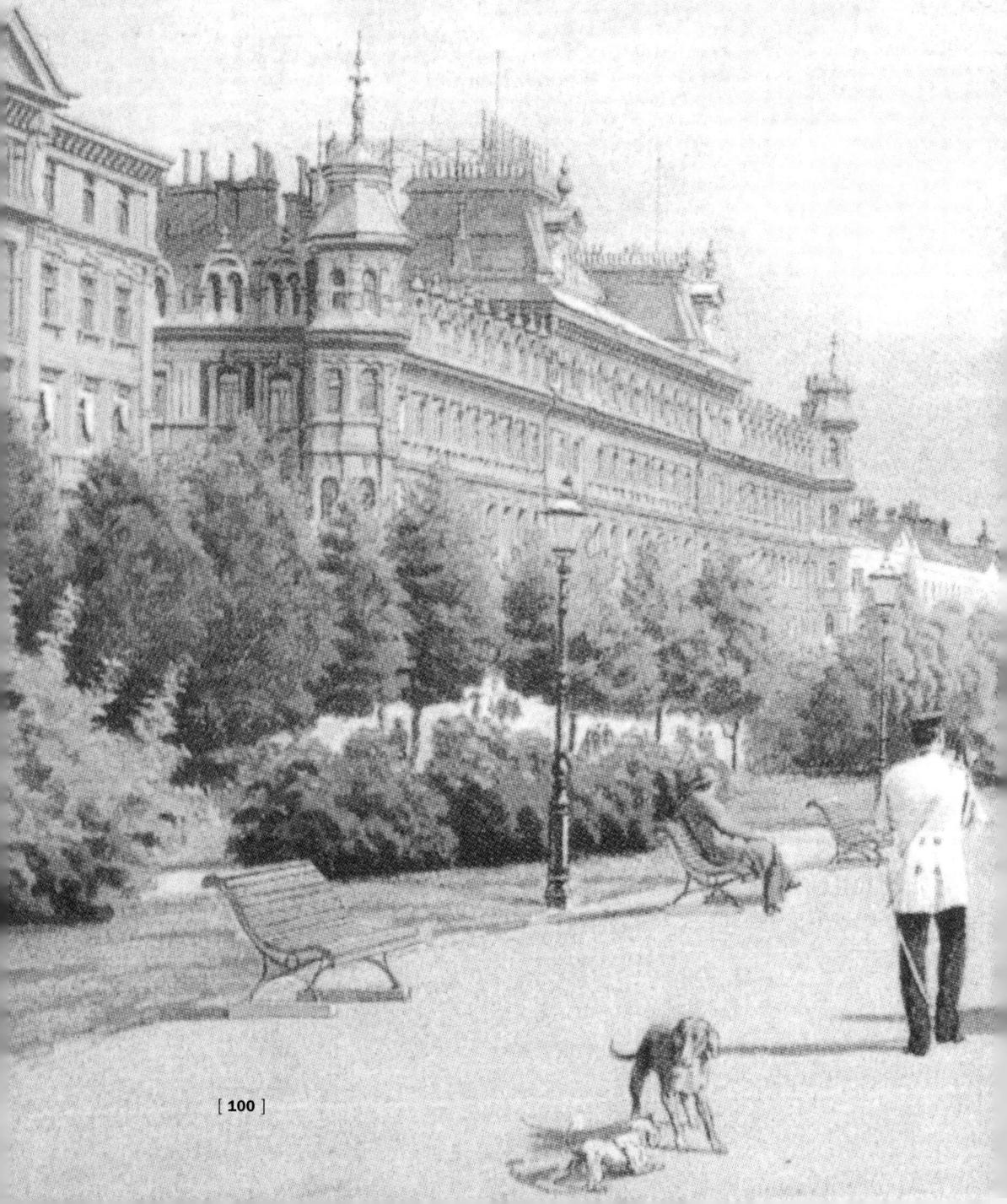

IV The Quest for
International Know-How

When urbanisation was at its liveliest at the end of the 19th century and the beginning of the 20th it became extremely clear that cities and towns had started to form their own ever-expanding network. The municipalities were in the process of establishing mutual co-operation which transcended national frontiers and oceans. It started on a regional and then on a national basis and developed soon into an international phenomenon. Contributing to this process were the emergence of ever more specialized groups of experts and professionals, the pressure of keeping up with developments and the improvement of communications. European and American cities competed in demonstrating how progressive they were and how far they had adopted modern technology.[1]

This process manifested itself at town congresses and meetings where municipal officials discussed common economic, social and cultural questions while city exhibitions provided a forum for demonstrating the progress made in various sectors of municipal life and in the implementing of public utilities. Such events were the products of a growing self-assurance among municipal officials and of their wish for collaboration with their counterparts in other cities. The Municipal Exhibition at Dresden in 1911 was generally accepted as unique and the first in this field.[2] In his studies of urban planning Anthony Sutcliffe has called this increasing internationalism of the cities and towns "creative internationalism."[3] Civic pride and inter-city rivalry provided the motivation, the increasingly efficient development of statistics provided the useful tools and improving communications and travel connec-

Esplanade park. By European standards, Helsinki remained a small town until the 1880s, when it began to grow rapidly. The outward symbols of metropolitan life, i.e. the wide boulevards and the neo-renaissance buildings, are indications of the ambition to make Helsinki a continental city. The Grönqvist house on the left, designed by architect Th. Höijer and completed in 1882–83, was at the time the largest residential building in Scandinavia. A painting by an unknown painter in the 1890s. (Helsinki City Museum)

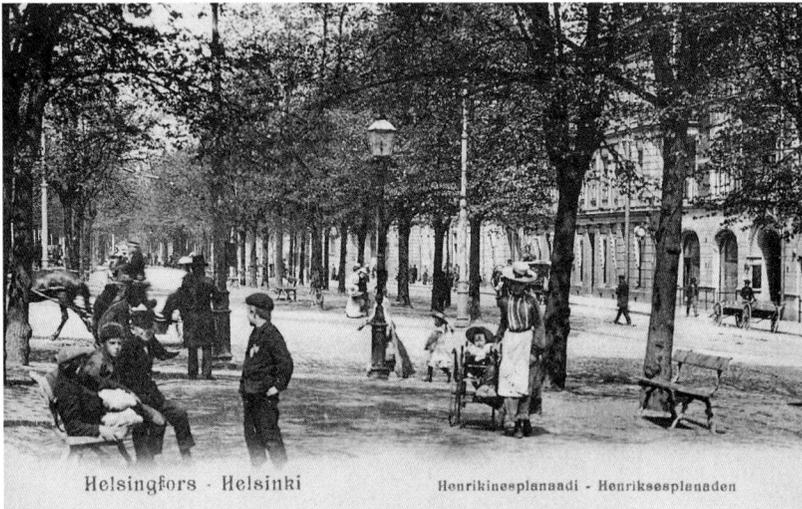

Henrik´s Esplanade, also known as Heikinkatu (later Mannerheimintie) in 1916. All age groups enjoyed the comforts of the area. (Helsinki City Museum)

tions provided the means. Helsinki was among the first cities to take advantage of these developments by sending its first officials to study urbanisation and the urban infrastructure in other European cities as early as the 1870s.

Professionals – the Agents of Urbanisation

Like elsewhere in Europe professionalisation was an essential part of the process of modernisation in Finland, and Helsinki as the capital was the hub when the renewal of state administration and industrial development created a demand for various new professional categories at national level. Moreover, in the 19th century as the need for professionalisation also became increasingly urgent in municipal operations, Helsinki, as the biggest city, was again in the forefront of these developments. Both the political and economic sectors needed efficient experts in specialist fields, who in turn secured the status of highly trained professional groups. In Germany, for example, the number of officials increased from 1.6 % of the actively working population in

1882 to 6.1 % in 1907.[4] Similarly in the city of Helsinki the total of people employed by the state, city and church, 4.5 % in 1870, had become 10.1 % by 1910.[5] In short, both the state and the city became dependent on an elite of officials, and in Finland this professionalisation was, in its early stages, essentially a Helsinki based phenomenon.

In the second half of the 19th century many new professions emerged as society was modernised and new laws, statutes and regulations were enacted requiring supervision by trained professional groups while the expanding paper work inevitably called for an increase in the number of clerical personnel. Consequently a great variety of inspectorates requiring special knowledge was created, such as inspectors of health, kindergartens, buildings, gas and smoke. Similarly many of the new professional groups formed in the 19th century answered the urgent needs resulting from rapid changes in the occupational structure and from the growth of population in urban centres. They included social workers and school doctors as well as district nurses and Municipal Officers of Health. Energy questions, traffic problems, water supply and drainage difficulties were all a challenge to municipal technicians and engineers. The widening technical sector in particular provided work for new, highly trained professional groups.

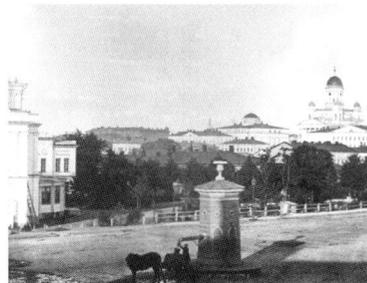

The photograph shows a public well in the centre of Helsinki. The well was dug in 1869 and first provided spring water and later mains water. (Helsinki City Museum)

Efficiency and rationalisation required a special degree of skills in certain medical fields and among teachers in schools for retarded children, as well as among architects responsible for town planning and statistical experts in various branches. However, the drive for efficiency often led to the control of others belonging to the same professional group, and when any professional field became more scientific, those with special training and/or experience in their trade controlled the admission of others to the relevant group. Such supervision was to be found among doctors and lawyers, for example. Along with the emergence of new tasks for the highly trained officials in state or municipal administration, the difference between them and those with less

training in the same profession became more sharply defined.[6] The profes-sionals also had working hours and salaries fixed on a regular basis in contrast to labourers, from whom they aimed to detach themselves not just at work but also in their way of life.

The passing of examinations for professional qualification linked mem-bers of the same professional groups together, and the establishment of professional associations further strengthened professional identity. This process, which took place parallel to the development of industrial capita-lism, urbanisation and improving educational services, was first witnessed in Britain and the USA, where industrialisation had also started early. In Britain 13 professional groups each launched their own specialist organisation between 1825 and 1880 while in the USA 11 such organisations were established between 1840 and 1887. The associations strengthened their members' professional identity as well as the credibility of the group in relation to outsiders and society.[7] Such associations and organisations often developed further into real pressure groups, and their influence was even stronger as many represented professional groups essential for the develop-ment of the welfare society. In Finland it was the medical profession that was the pioneer in organising itself by establishing the *Finska Läkaresällskapet* in 1835. This medical society as well as, from 1881 onwards, *Duodecim* (the association of Finnish-speaking physicians) both provided an excellent forum for discussing the latest innovations. A much discussed topic at the end of the 19th century was, for example, hygiene ranging from housing and disinfec-tion to health conditions in the women's correction institute in Hämeenlinna and the teaching of hygiene in schools. The impact of such professional societies was twofold: they strengthened professional identity and were sources of professional information. For the latter purpose the *Finska Läkare-sällskapet* systematically collected medical literature. Its library, by 1885, had established an exchange of publications with 17 medical societies and as a result regularly received 71 different medical journals, of which 62 were foreign – a telling indicator of the society's extensive foreign contacts. Similarly *Duodecim* also maintained its own library. The language of the abstracts in such journals is another indicator of the nature of the internatio-nal links. So far as the publications of the *Finska Läkaresällskapet* were

concerned, French was the language used between 1879 and 1901 in the abstracts of articles published by the society, while *Duodecim* started to employ the German language from 1902 onwards.[8]

However, on the whole, it was in the 1880s and 1890s that the founding of professional societies began to become commonplace. The society of technologists, the *Tekniska Föreningen för Finland*, was established in 1880 and in Helsinki teachers organised themselves in 1887 into the *Helsingfors folkskolors lärare och lärarinne föreningen* while the pharmacists founded the *Suomen farmaseuttinen yhdistys* two years later. The 1890s saw the establishment of, for example, the *Arkkitehtiklubi* as a sub-division of the *Tekniska Föreningen* in 1892 and the *Teknikkojen seura* for the Finnish language engineers in 1896. In 1910 the Finnish Library Association was established. Without exception all these professional bodies were based in Helsinki.[9]

The level of professionalisation may be roughly measured not only by the number of different associations but also by the number of professional periodicals and bulletins. Often the establishment of both took place concurrently, and between the early years of professionalisation in the 1830s and 1917 when the country became independent, a total of 81 professional journals and periodicals were established in Finland. Their foundation accelerated in pace during the 1890s and reached a high point in the first and second decades of the 20th century. Bearing in mind the major concerns in the 19th century, it is hardly surprising that the most numerous were the journals in technology (30 %), health care (27 %) and schooling (22 %) whereas there appears to have been less need to establish professional journals in matters related to social policy or adult education. Many Finnish professional newspapers and journals also functioned as the mouthpieces of particular organisations with consequent implications for the decision-making process.[10]

Sources of Information

When there was a clear need in Helsinki for some renewal or change, models and systems from various countries and cities were investigated and compared from a range of written sources while a fact-finding tour provided an opportunity for personal observation, often the most important stage in the Finnish system of finding facts about new innovations and their application.

Such tours were normally based on thorough preliminary investigation involving the careful study of the published materials available. One of the essential sources of information was the comparative municipal statistics, which emerged towards the end of the 19th century following the principle of openness, which could not only provide a boost to civic pride but was also an efficient means of spreading information on innovative practices. In Germany most cities had established municipal statistical offices as early as the 1860s, and by the end of the century such bureaux were functioning in almost all cities with more than 100,000 inhabitants, and from 1879 onwards their heads held annual conferences for deciding priorities in the gathering of statistical data at any given time. This provided the basis for the comparative municipal statistics published annually from 1890 onwards for German cities with over 50,000 inhabitants. With this German statistical publication being used as a model comparative municipal statistics were also published in Austria from 1893 onwards and in Italy from 1906. A single volume of *Comparative Municipal Statistics* was published by London County Council for the year 1912–1913 but the outbreak of war in 1914 put an end to any further publication.[11]

In Finland the value of comparative statistics as the basis for decision-making was fully recognised by the early 1860s, and a modern statistical office for compiling information at the national level was established in Helsinki in 1865 following especially Belgian models.[12] By 1910 it had become obvious that the City of Helsinki itself could no longer manage with statistical information generated by a variety of municipal offices, and in September of the same year the City Council decided to establish a centralised Municipal Statistical Office with quite wide terms of reference. Under the supervision of the City Treasury the office had the duty not only of collecting, organising and publishing statistical and other information on the municipal administration but also more extensive surveys of the city's popu-

lation, economy, social conditions and culture. Consequently the city's affairs can now be explored in the extensive annual reports on municipal administration from 1875 onwards[13] as statistical data had been collected from very early on in many sectors. For example Johan Rabbe, a Doctor of Medicine, analysed mortality statistics in Finland in the mid-19th century publishing annual reviews and comparing the figures with foreign statistics.[14] As a result municipal officials could participate in the international exchange of statistical information and the *Statistical Yearbook for Helsinki* first appeared in 1905.

Other sources of information used in preparing study tours were the leading encyclopaedias and handbooks, which were available for Helsinki municipal officials as were reports on municipal congresses attended earlier by colleagues as well as the follow-up publications of such meetings. Yet, by far the most important documents to consult were the professional journals and periodicals as they reflected the latest achievements of different municipalities in relevant specialist fields.

In Central Europe and in Britain special periodicals were published for municipal officials and decision-makers, which provided information on developments in various sectors of municipal life. They included the German *Städte-Zeitung, Kommunales Rundschau,* and *Kommunale Praxis* and in Britain *The Municipal Journal and Local Government Review*, and they especially focussed on making comparisons between different countries and cities. The *Yhteiskuntataloudellinen aikakauskirja*, established in Finland in 1905, followed the same principle.[15]

Regular congresses and civic exhibitions in turn provided a more detailed survey of the pertinent issues. As in the case of municipal statistics, the provision of open information was the standard practice. In the Victorian era progress was a definitive goal, and the aim of the municipal congresses and civic exhibitions was to show others how advanced and skilled the management of civic affairs could be. This in turn strengthened feelings of civic pride creating a motivational environment for the spreading of innovations. Therefore attending some of the most important national and international municipal congresses was essential also for the development of Helsinki. At these meetings Helsinki city officials were not only able to get the latest data for comparing the Finnish capital with other European cities but also to forge the useful personal links needed for later fact finding tours.

Postcards sent home by travellers depicted the multiformity of the European metropolitan culture. The picture shows postcards sent to Finland from Berlin at the turn of the 19th and 20th centuries. (National Board of Antiquities, the Archives for Prints and Photographs)

City renewal exhibitions were specially numerous in the early 1900s. Examples include the Düsseldorf city exhibition of 1909 and the Berlin exhibition of construction held in 1910, which presented the results of the planning of Greater Berlin. The City of Helsinki sent participants to Berlin in 1910 as well as to the Royal Institute of British Architects Town Planning Conference in London in the same year as well as to the Municipal Exhibition held in Dresden in 1911.[16]

In Finland also it was civic pride, the need to keep up-to-date with the developments taking place in your reference group that was one of the major motives of many fact-finding tours. For Helsinki this meant attempting to develop in the same direction as other capitals, bearing in mind that different municipal sectors had their own model cities. Attending municipal conferences and making fact-finding tours were another important part of the development of professional competence. Thus by financing such travel the city

embarked, in modern terms, on investment in human capital and the further training of staff. It was understood that such investments had to be made to secure the availability of trained experts whether generalists or specialists. Therefore the Finnish Senate, central administrative boards and educational establishments, notably Helsinki University and the Polytechnic, together with the cities, gave grants and travel assistance for the acquisition of the latest knowledge.

In the central boards and administration of the city of Helsinki there were many experts who had themselves studied abroad and appreciated the application of the latest knowledge. They understood the importance not only of acquiring other countries' experience but also taking regard of local conditions in the application of innovative ideas as opposed to merely directly imitating solutions used elsewhere. Therefore those planning to travel abroad for study or in order to attend a conference normally had no difficulty in obtaining leave of absence. Individual experts, for their part, naturally had a great interest in acquiring the latest knowledge in their specialist field and had often privately followed foreign developments in order to maintain their professional skills by acquiring, during their travels, professional literature and periodicals.

Improving Communications and Travel Conditions

The undertaking of such tours had become much easier with improvements in international communications. By the end of the 19th century Helsinki was connected with the rest of Europe both by telephone and telegraph. The telegraph, which had been used during the Crimean War for military purposes became more widely used from the 1880s onwards and in the 1890s the telegraph network covered the whole country. We have already seen that Helsinki was well advanced in the field of telephones, and that it was as early as 1877 that a civil servant or a businessman was able to use it in Helsinki for the first time. By 1900 all Finnish cities and towns had a telephone company linked to some 2,000 kilometres of telephone lines, and by 1916 the density of telephone networks in Finland was higher than in Russia.[17]

The Baltic Sea has always been a busy sea route and ships have brought merchants and entrepreneurs from Central Europe and Britain to Finland. The introduction of regular steamboat services in the 19th century was revolutionary facilitating the mobility not just of scholars but also of the general population. This advertisement for the Finland Steamship Company, in both English and German, dates from 1913. (Archives of the FÅA)

Icebreakers were first introduced in Finland in 1890. The picture shows delegates at the first international port congress in Finland (22–23 January 1923) visiting Helsinki's harbours aboard the icebreaker "Herkules" bought by the City of Helsinki. (Helsinki City Museum)

At the same time improved postal links facilitated the speedier availability of background material, newspapers and professional journals.[18] While in 1860 there had been a mere 37 post offices in the whole country normally located in towns, in the following decades their number grew rapidly so that by 1900 there were 700 post offices operating in Finland. In the early 20th century this expansion of the post office network continued at accelerating speed so that by 1920 there were 1,161 post offices and nearly 1,300 sub-post offices round the country.

However, it must have been the improving travel conditions that most helped the undertaking of foreign fact-finding tours. From the mid 19th century onwards people travelling from Helsinki to continental Europe had three alternative routes to select from. The oldest was the southern route by sea across the Baltic to Stettin or Rostock and from there by train to different European cities. The second, the western route led first to Sweden from where the journey could be continued by boat and by train. The third, eastern

route from Helsinki through St Petersburg to Berlin, became an all-year round alternative once the railway link between Helsinki and St. Petersburg via Riihimäki was completed in 1870.

The western route was the cheapest but also the longest. In 1867 a journey from Helsinki via Stockholm and Lübeck to Paris took 4–5 days. In 1871 a trip by train using the eastern route via St Petersburg reached Berlin in 68 hours and 15 minutes including a 13 hour long wait in St Petersburg. Ten years later, in 1885, it was possible to travel from Helsinki to Vienna in 70 hours including a five-hour long wait in St Petersburg and a 90 minute wait in Warsaw. These travel alternatives were all compared in the Finnish press especially before the world fairs, which certainly attracted visitors from Finland. Moreover, steamships also shortened journey times so that one could sail from Helsinki to Travemünde within a few days, and soon it was also possible to travel by boat to English ports, such as Hull[19] even if the ships primarily transported butter and timber to Britain and passengers were of secondary importance[20] According to Mrs Alec Tweedie who arrived in Helsinki in 1897:

> "… The first impressions on entering the Finnish harbour of Helsingfors were very pleasing; there was a certain indefinable charm about the scene as we passed in and out among the thickly-wooded islands… (and) the arrival of the Hull boat once a week (was) one of the great events in Helsingfors life, and everyone who could went down to see her come in."[21]

The introduction of the steamship in the 1850s and the railway in 1870 was followed by the launching, in 1883, of a shipping line, the Finnish Steamship Company, to Stettin, Bremen, Rotterdam, Antwerp and many English sea-ports. The introduction of ice-breakers in the 1890s finalised this development. Finns now had all the year round access by sea not only to the Scandinavian capitals and the capital of the Empire but above all to the European continent and the British Isles. All this improvement in travel possibilities was clearly a major factor in the further widening of horizons evident in all fields of life in late 19th century Helsinki.

The Active Search for Foreign Know-how

Helsinki was quick to take advantage of these improving travel connections, as the first fact-finding tours by city officials were made as early as the 1870s, and between 1870 and 1917 officials and employees of the city of Helsinki (doctors, chemists, elementary school teachers, progressive librarians, architects, engineers and promoters of adult education and social work) carried out a total of 390 journeys in search of foreign expertise and know-how.[22]

The duration of these travels varied from a weeklong journey to a specific congress or exhibition to a year-long study tour. The longest journeys in terms of time and distance were often carried out by senior figures in a particular field, who undertook tours up to a year length round European cities in order to get an overall picture of the latest developments. There was also a great

Oy Nikolajeff Ab's vehicles outside their premises in 1914. At the end of 2000, there were around 2.5 million vehicles registered in Finland. Cars accounted for almost half of this figure. Motoring got off to a slow start in Finland and there were only 170 registered vehicles in Helsinki in 1915. By 1991 this figure had grown a thousand fold. (Helsinki City Museum)

number of visits around Europe, exploring the operations of institutes, hospitals, schools and education systems with the aim of solving specific Finnish problems.[23] This recalls Vogel's account of how the Japanese collected knowledge as they rebuilt their country after 1945. The method used was participant observation and those sent abroad were people with long working experience on whose power of evaluation great reliance was placed.[24]

The reasons for travelling abroad also varied. Of the 390 journeys mentioned 99 involved attending international congresses while the main aim of eleven was to visit important exhibitions. Occasionally the initiative came from foreign sources in the form of invitations to attend international exhibitions or scientific congresses. But the journeys could also be initiated out of private interest and they were in many cases financed by private funds, as a form of professional further education. A great many of the journeys were initiated, financed and even made obligatory by the city itself, which funded 158 of the trips. The state was also a very significant source of funds, and a number of physicians in particular travelled on Senate grants.

The number of journeys was naturally small in the early years of the new municipal administration system established in 1875 but with the increase in the economic prosperity of the country the number escalated.

Thus three quarters of all fact finding tours for the benefit of the city of Helsinki during the period covered took place in the early years of the 20th century, as economic growth provided an increase in the number of travel grants available. In relation to the gross national product one can observe that its volume index and the number of travels both peaked in the same years of 1890, 1897, 1900 and 1913. However the fact that the number of journeys grew two and half times faster than the growth of the economy[25] indicates the feeling of urgency in finding solutions for the escalating problems caused by the urbanisation process.

Table 1. The study tours of Helsinki municipal officials and experts

1870–79	3
1880–89	33
1890–99	73
1900–09	146
1910–17	135

Sources: Printed papers of Helsinki City Council 1875-1917. Annual Reports of the Health Committee 1888-1917, Reports of the Municipal Elementary Schools in Helsinki 1902-1917.

Apart from economic growth the political situation also had an impact on travel. During the second period of oppressive Russian policies in Finland between 1906–1914 it was difficult to make progress by means of legislation as many measures were being delayed for political reasons. Consequently state civil servants and municipal officials prepared many reforms either individually or within committees. The Chairman of the Association of Finnish Towns, Leo Ehrnrooth, even stated in 1912 that when the state did not wish to facilitate any progress the municipalities were to take on the role of supporting economic, cultural and social development.[26] Increasing resources were therefore directed to gaining the latest know-how from abroad and it was the norm for all such committees to include an extensive survey of relevant foreign developments in their report.[27]

Matters concerning elementary education were the concern of almost half of all journeys and they were the topic of over two thirds of the conferences attended by Finns (see Table 2). Travel related to health care amounted to some 30 % while town planning, poor

Leo Ehrnrooth, LL.D. (1877–1951) became a member of the Helsinki City Board of Workers' Affairs in 1905 and, in 1911, of Helsinki City Council. In addition, between 1911 and 1917 he was the chairman of the Helsinki Board of Workers' Affairs, later the Helsinki Board for Social Welfare, and, from 1912 to 1917, the director of the Association of Finnish Towns. (National Board of Antiquities)

Table 2. The Nature of study tours

Service sector	Total	Including	
		Congresses	Exhibitions
Health care	115	16	2
Elementary schools	187	67	3
Town planning	20	3	4
Social services	21	5	1
Adult education and Training	31	–	1
Lighting	16	8	–
Total	390	99	11

Sources: See table 1.

relief/social welfare and workers' education some 5–8 %. Lighting accounted for less than 5 %, perhaps because Finland itself had been a pioneer in the field of electric lighting. The main emphasis was on fields where growth and change were then most rapid.

Although it was very common for the traveller to visit several countries, cities and institutions during one single fact finding tour,[28] bearing in mind Finland's position as a part of the Russian empire, it is somewhat surprising that only eight out of 390 study tours included Russian destinations. The major targets were the Scandinavian countries (a total of 292 journeys) and Germany (148). The popularity of Sweden (154) including Stockholm (124) can partly be explained by the old cultural and linguistic links, partly by the fact that Stockholm was en route to the Continent and partly by the fact that a considerable number of elementary school conferences were held in that city. Denmark (93) and Copenhagen (78) were also a quite normal part of any itinerary. Germany was another major destination lying as it did on the way to the rest of Europe. Even so, its capital, Berlin, was only visited in 71 cases

Table 3. The study tours of Helsinki municipal officials 1870–1917

Total visits		Visits to capital	
Sweden	154	Stockholm	124
Germany	148	Berlin	71
Denmark	93	Copenhagen	78
Norway	45	Kristiania	44
Switzerland	34	Bern	9*
Austria	22	Vienna	19
France	22	Paris	22
Great Britain	21	London	15
Belgium	18	Brussels	8
Holland	17	The Hague	6
Russia	8	St Petersburg	6
Hungary	7	Budapest	7
USA	6		–
Canada	1		

*Tours to Zurich totalled 16; note also that the destinations total more than 390 as one tour could include a number of countries and cities.

Sources: See table 1.

out of a total 148 journeys to Germany (see Table 3). Normally the capital of a country was a major destination but in the German case the comparative neglect of Berlin may reflect the fact that many Finns already had knowledge of other major locations of expertise in that country having spent some or all of their study years in German institutions, so that they had no need to seek guidance in the capital.

It is evident from the travel reports that the Nordic capitals, Stockholm, Copenhagen and Kristiania, as well as other large European cities formed the reference group for the Helsinki municipal officials and experts and that such metropolises as London, Paris and Vienna held special attractions for them. Nevertheless over the years they also visited a number of other cities and locations. The wide range of destinations is illustrated in Table 3.

The main aim of the comparatively few trips to Russia was to attend health care and hygiene exhibitions as experts in order to give talks. Albert Palmberg, for example, who was an internationally famed expert on hygiene and had received an important international award at a hygiene exhibition in Paris, was the head of the Finnish section at the 1893 hygiene exhibition in St Petersburg and chairman of the organising committee of an international medical congress held in Moscow in 1897, where he also gave a talk on school children's physical education. He had become a much sought-after expert in hygiene as far afield as Argentina and was invited to become a member of numerous foreign scientific societies.[29]

It may be that at that time Russia was considered less developed than Finland with no significant innovations of interest to those who wanted to develop their urban infrastructure. In fact St Petersburg, which in the early 19th century had been safer and more orderly than the Paris or London of the day[30] was now facing the near collapse of its municipal administration, which could not cope with the escalation of its population after the emancipation of the serfs, and the city suffered from chronic epidemics, a soaring crime rate, abysmal housing conditions[31] and very high infant mortality.[32] In addition it is worth bearing in mind that the cholera epidemics arriving from Russia[33] and the Tsar's conscious Russification policies in Finland from 1899 onwards with the consequent creation of anti-Russian feeling also coincided with the peak decades of study tours before the First World War.

When relating the destinations of the journeys to the services that interested Helsinki officials one can detect the following broad outlines:

- Sweden was particularly interesting for teachers, physicians, engineers and other town planners as well as developers of social welfare and adult education;
- Germany attracted physicians, teachers, engineers and town planners as well as adult educationalists, teachers, developers of welfare policies and town planners;
- Denmark was an essential model for those interested in hygiene and milk control as well as an important source of information for welfare politicians and town planners;
- Norway was important for primary school teachers and developers of health care;
- Switzerland for developers of the primary school system as well as for adult educators and engineers;
- France was important for those interested in food inspection, hygiene and the education of the labouring classes;
- Belgium was important for the hygienists; and
- The Netherlands for those interested in water supply management.[34]

Several of the experts, as we have already noted, had been abroad in their study years including many of the Helsinki doctors, who until the mid-19th century had often studied in Paris, and later in Germany. Between 1900 and 1914 a total of 102 veterinary surgeons gained their professional qualification in German institutes of higher education in Hanover and Dresden, as at that time it was not possible to study this field in Finland. At the same time there were in Berlin alone a hundred Finnish students, half of whom were studying medicine. Thus international contacts were often the result of these study years spent abroad during periods of specialisation, but they were also the result of attendance at scientific congresses, or of time spent working abroad or making study tours. The co-operation between new professional groups knew no language barriers. Personal contacts facilitated the exchange of information and could make international contacts more readily accessible to colleagues.[35]

A children's ward at the Surgical Hospital. Fresh air and sunlight were regarded as important elements in the care of the sick and convalescents and were taken into account when designing hospitals. (Helsinki City Museum)

This was particularly striking in the case of medicine. The collection of statistical data on infectious diseases and mortality rates in Finland provided an opportunity for instant comparisons and when news about the revolutionary treatment of tuberculosis by Prof. Koch reached Finland by way of foreign medical journals such as *Medicinsk Tidskrift*, the Grand Duchy immediately sent dozent Richard Sievers to Berlin to investigate. Sievers's report was duly published in 1890 in *Finska Läkaresällskapet Handlingar*, the professional journal of the Finnish Medical Association and in the following year Sievers also described the effects of this medicine in *Tidskrift för Hälsovård*, a magazine for members of the general public interested in health care.

The travel by Sievers to Berlin was no exception. In health care matters Germany was clearly a leading country and the attraction of Berlin unquestionable. Between 1875 and 1918 out of 58 German fact-finding tours carried out in medicine as many as 38 included visits to Berlin. Sievers, the head of the Maria Municipal Hospital in Helsinki, was himself a frequent participant in international medical and scientific congresses and had since 1884

regularly travelled to Germany to visit not only consumption institutes but also spas and to investigate the latest developments in medicine, as in 1890 when he had a state grant to do so. In the spring of 1903 he carried out investigations in Berlin, Hamburg, Copenhagen and Stockholm. He was also a regular contributor to the *Berliner Klinische Wochenschrift* and *Hygienisk Tidskrift.*

But the Maria Hospital had also a number of other staff members with international connections in addition to Sievers. The assistant doctor in the infectious diseases' department, Dr Herman Viktor von Willebrandt, travelled in 1910 to Stockholm, Copenhagen, Berlin, Hamburg, Paris, Marseilles, Vienna, Budapest and Odessa to investigate the state of epidemiology in those cities. A year later the head of the same department, Dr Max Björksten, travelled with a grant from the Finnish Senate to the Nordic countries and Germany to investigate the prevention of infectious diseases and the disinfecting of dwellings. During this trip he visited a total of 32 cities and smaller towns. In the same year a delegation of four doctors from the hospital visited a health care exhibition in Dresden, and among them was Dr Jarl Hagelstam, another director of the hospital, and a veteran in the establishing of international connections. Hagelstam had studied in Leipzig in 1881-82 and subsequently had made by 1912 a total of 19 study trips including eight visits to Berlin, four visits to Paris and two to the USA. He reported on his trips and the experiences gained not only in Finnish medical and learned journals but also in a number of foreign publications such as the *New York Medical Journal* and the *Deutsche Zeitschrift für Nervenheilkunde.*[36]

We have already mentioned Albert Palmberg, Helsinki District Medical Officer and his career well illustrates the Finnish search for medical expertise. As a young man he had undertaken his first fact-finding tours, once foreign travel had again been made possible after the Crimean War. He visited Paris, Berlin, Edinburgh, London and Brussels, collecting experiences that were later to be of vital importance in the planning of the Finnish health care system. When embarking, at the age of 55 years, on a half year long tour to Stockholm, Edinburgh, London, Brussels, Paris and Leipzig in 1886–87 he had already published his major scientific works and made several earlier tours to European cities. He published a 95-page report[37] on this tour in which he described the standard of health care in the various countries. He had, for example, heard lectures in Stockholm given by professors

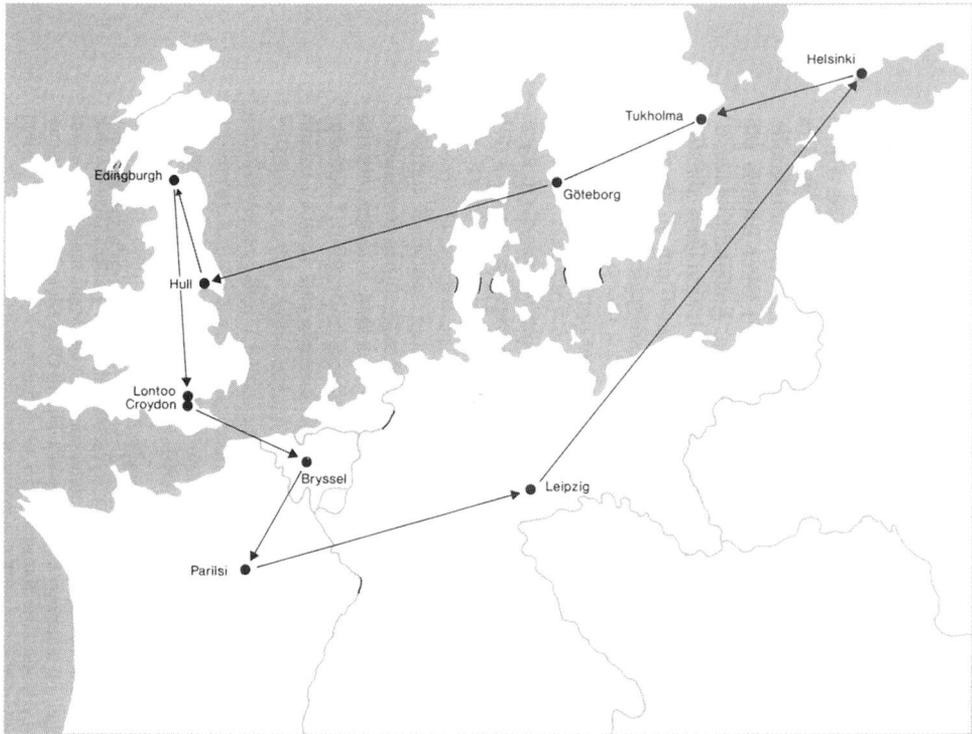

The map shows a study tour of Albert Palmberg, District Health Care Officer, later Professor of hygiene in Helsinki, to Stockholm, Edinburgh, London, Brussels, Paris and Leipzig 1.9.1886–1.3.1887.

Heyman and Wallis. Through Heyman's lectures on public sanitation systems, illustrated with maps, models and statistics, Palmberg first became acquainted with the British health care system and became convinced of the excellence of a wide-spread system of water closets. He was also impressed by Stockholm's health care regulations, its health police and its health care association, which according to Palmberg, placed that city in the first rank in Europe. Yet, it was in Britain that he was able to observe the impact of health care on everyday life believing that there health care principles were second only to religion in their impact on the public mind. He wrote,

> "As soon as I had stepped on the shores of England I could not fail to notice the difference that there was in life style compared with that of continental Europe."

He was especially impressed by the English tiled bathroom, and in his report he gave a detailed description of its fittings and decoration. Similarly he wrote of English housing, eating habits and the composition of meals. He even discussed England's boarding-house system.

Palmberg's extensive study tour to many universities and institutes was made possible by the fact that in different countries the medical teaching staff knew of each other and wrote letters of introduction for their students or colleagues wishing to study at the recipient's university or institute. Thanks to a Swedish letter of introduction Palmberg was able to attend the lectures in Edinburgh of the Chief Medical Officer, Littlejohn, and his assistant, Charles Stewart Hunter, as well as those of Professor Rutherford. With the help of Hunter he was also able to investigate the treatment of consumptives and diabetics, while Littlejohn guided his examination of Edinburgh's public sanitation and water purification systems.

In London Palmberg was particularly interested in the pavilion system as it was operated at St Thomas's Hospital whereby patients suffering from the same illness were isolated in buildings or annexes separated from the rest. On a recommendation by Prof. Heyman from Stockholm he was able to visit the communal health care carried out by Dr Wynter-Blyth in St Marylebone where the latter had started the renovation of working class slums with good results. In London Palmberg also visited cattle markets, disinfectant plants and other working class areas. Air conditioning systems, especially those using Boyle & Son's method were an innovation that Palmberg had already found useful in Stockholm, Edinburgh and London. So far as health care regulations were concerned he considered Belgium a model country very much admiring the tidiness and cleanliness of Brussels,

> **"This city which has applied British models has a well-organised health care administration including a separate laboratory for inspecting foodstuffs."**

In Brussels he also met Dr Janssen, a world famous hygienist, who had developed a medical and demographic register (*Annuaire démographique*), which was later to be a model for Prof. Vilhelm Sucksdorff, the first Medical Officer of the City of Helsinki. Internationally an even more important Belgian publication was the *Bulletin hébdomaire*, which provided information on existing diseases and illnesses for public administrators and physicians. This

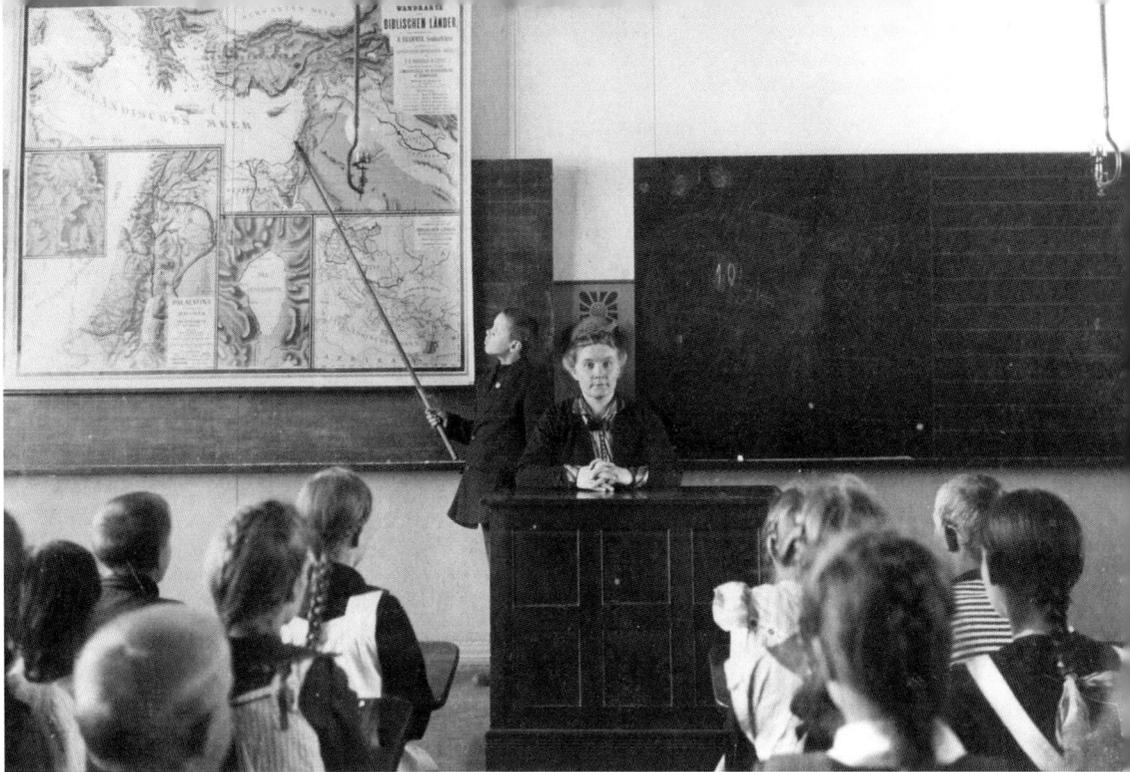

English municipal experts visiting Helsinki were especially interested in the Nordic elementary school system in the municipalities. Education was compulsory and open to all. The photograph shows Töölö Elementary School in Helsinki in the early 1900s. The German map on the wall tells of the close links between German and Finnish teachers. (Helsinki City Museum)

publication later evolved into the *Moniteur internationale de la statistique sanitaire du globe,* which contained information on 81 Belgian cities and towns as well as on 105 other cities including Stockholm, Copenhagen, Kristiania, St Petersburg and Warsaw.

> "Only data on Helsinki is missing. Let us hope it will not be too long before Finland is included among these international statistics. After all there is no better way of defending our status as a nation than to keep abreast of scientific progress."

Therefore Palmberg was delighted to hear that Dr Janssen knew the publications of K. E. F. Ignatius, the head of the Finnish Statistical Office. Moreover, during his tour Palmberg also noticed that Finland was, indeed, now being represented under its own name at international congresses and welcomed the fact that Finland sent participants to such congresses. According to Palmberg it was due to the fact that the Finnish Statistical Office had an

active international presence that Finland was now presented under a separate heading in the general statistics. He hoped that Finnish physicians would have the same visibility, for "each scientific congress may be an epoch making event."[38]

Palmberg's itinerary was partly followed, some ten years later, by Dr Konrad Relander, the District Medical Officer of Oulu and later of Helsinki. Following the common practice his tour was financed by a Senate travel grant, and letters of introduction opened doors for him to Central European hospitals and institutes where he could investigate health care and various aspects of hygiene. Relander produced a 600-page long report on his tour[39] describing the latest innovations. Everybody who received such a grant from the Senate had to submit such a report that could be used later as a source of information by those planning their own study tour.

Such tours had a multiplier effect evident at two different levels. On the one hand they provided information and know-how for the decision-makers and on the other hand the information was disseminated in a popular form for ordinary people to read in such magazines as *Terveydenhoitolehti* and *Tidskrift för Hälsovård.* The former was established by Relander, who, as Editor, followed intently such foreign publications as the *Deutsche Medizinische Wochenschrift* and *Deutsche Vierteljahrschrift für Öffentliche Gesundheitspflege.* It took only a few months for the most interesting articles and findings in these publications to be made available in a popular form in Finland.[40]

It should be emphasised that even if the great majority of Finnish doctors who travelled abroad were men, they also included some women. Thus Dr Alma Josefina Rosquist, a woman specialist in tuberculosis at the above-mentioned Maria Municipal Hospital travelled in 1907 to Berlin, Dresden, Leipzig, Frankfurt am Main, Davos, Paris, Lille, Douai, Antwerp, Brussels and Liège to study methods of treating tuberculosis.[41]

Nor were the study tours just the prerogative of the leading municipal officials and doctors in Helsinki. Elementary-school teachers travelled widely at both their own and the city's expense and imported new ideas from the Nordic countries, Germany, Switzerland and England. Indeed, many reforms that were carried through in the 1880s and 1890s owed their existence to the initiative and inventiveness of the teachers. In the late 19th century, both the elementary school board and the school inspectors were still rather

The teacher, Maikki Friberg (1861–1927) was assiduous in touring Europe looking for new ideas on the teaching of geography and on the reform of girls' countinuing education. In addition, during her longer stays and tours in central Europe, her interests extended from teaching methods to the women's and peace movements. (National Board of Antiquities)

circumspect about foreign influences, and so if the teachers wanted to reform the elementary school system, they themselves had to import and develop new ideas and put them into practice. For example, in 1882 women teachers set up an extension course for girls who had completed elementary school. These teachers taught the course without remuneration until 1885, when the municipality finally took over the running of the course.[42]

At the turn of the century, the elementary school board reconsidered its stance and adopted a more favourable attitude to foreign examples. The change opened up new opportunities for teachers who were interested in importing new ideas from abroad and in developing the elementary school system. Not less than 27 % of the teachers who worked for the Helsinki elementary schools in 1902–1914 made one or more study trips abroad.[43] Their travel reports formed a central part of the 'knowledge' on which

decision-makers in Helsinki built the new curricula in the early 20th century. This curriculum development stood as evidence of the teachers' commitment to follow the lead of the most 'progressive' countries. The reforms also reflected the determination of the teachers to consolidate their own position. Study trips, high-profile conferences and contacts at home and abroad were all important in building up the prestige of the teachers and that of the elementary school.[44]

Women teachers from girls' vocational schools were also keen to make study tours, because in the Helsinki Vocational School, established in 1904, the shortage of suitable textbooks was an acute problem. Such schools had already been operating in Paris and Linz during the last years of the 19th century, and between 1908 and 1916 eight members of the staff of the Helsinki Vocational School for Girls made a total of eleven study tours normally spanning several countries. Thus the teacher of dressmaking, Ms Anna Pulkkinen, spent the autumn term 1912 visiting Parisian vocational schools and also used the opportunity to visit similar schools in London, which had been established on the Paris model. This detour may have proved more useful than anticipated because, as pioneers in the field, the Parisian schools and ateliers themselves had been so overbooked by foreign visitors that it was very difficult to gain adequate information and guidelines from them. Ms Pulkkinen also regularly visited Mme Guerre-Lavagre's atelier, learning there the pattern making, which she used as the basis for her own text-book on the subject which was later published in Finland.[45]

Jonathan Reuter (1859–1947), head of Helsinki Technical School and Chief Editor of *Teknikern*, made several fact-finding tours abroad and his expertise proved remarkably useful when the occupational training system in Helsinki was being planned. (National Board of Antiquities)

Similarly the speedy establishment, in the autumn of 1899, of the Boys' Vocational School in Helsinki was inspired by one specific fact-finding tour of a Municipal Engineer Jonathan Reuter round European vocational schools in the previous year. Importantly his expertise acquired on several similar tours also proved of good use nationally when he became a member of a committee planning an occupational training system for the whole country. [46]

In addition to the establishment of public services the developers of Helsinki also paid attention to the ways such services operated in practice and examining this was often the aim of foreign tours. A good example were tours made by Uno Therman, an early developer of public libraries in Helsinki. His enthusiasm took him to the USA, Germany and the Scandinavian countries, as his aim was to develop a proper municipal library, which could meet the needs of all Helsinki people whatever their social class. Consequently the building of the Branch Library in the working class area of Kallio, inaugurated in 1912, contained not only the customary library facilities of the day but also a newspaper reading room as well as a children's department. The librarians were also authorised to acquire books in foreign languages, and thus books in German, English and French became available to the people in Helsinki.[47]

Finnish municipal officials and experts were certainly not the only ones who travelled in Europe. Significant channels for the spread of innovations were the visits of English and German municipal officials in search of information, and Günther Hollenberg has studied how political development affected public opinion and the tours in England and Germany. Anglo-American co-operation at the municipal level was mainly limited to the period 1905–1914[48] but the British were especially active in studying other countries' municipal activities. The British Committee for the Study of Foreign Municipal Institutions had Henry S. Lunn, a former missionary doctor and journalist, as secretary and Lord Lyveden as chairman. The Committee made visits to Switzerland, Germany, the United States and the Nordic countries visiting, in Finnish fashion, Stockholm, Kristiania and Copenhagen. The English municipal experts were especially interested in the elementary school systems of municipalities in Norway and Sweden, where schooling was obligatory and

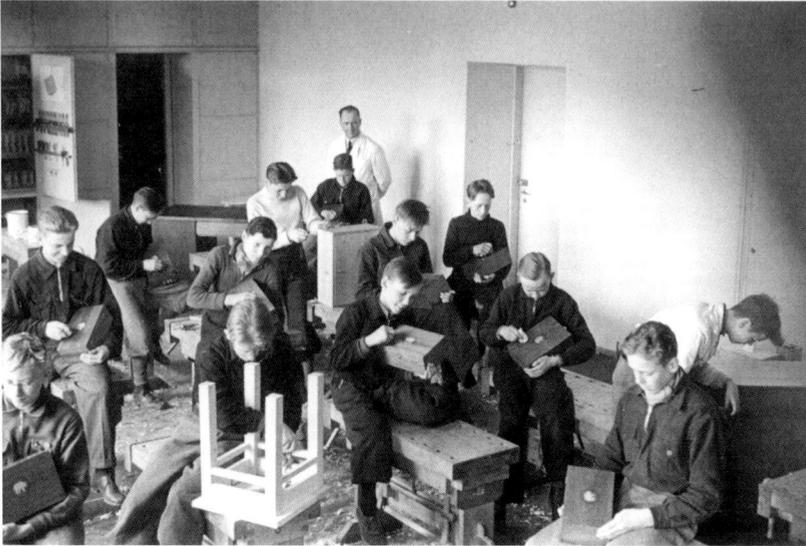

During the 1930s, Aleksis Kivi Public Elementary School was described by international visitors as the most modern school in Helsinki. The picture shows a woodwork class. Woodwork was on the curriculum of elementary and vocational schools in Finland from the late 19th century and was something every man was expected to master. Later, during the 1970s and 1980s woodwork became an optional subject. (Helsinki City Museum)

open to all. In addition to the school system the visitors were interested in Stockholm's telephones and its gas and electricity works. In Copenhagen health care and the homes for the aged were admired.[49]

In France Pierre-Yves Saunier, inspired by the project "Tietoa, taitoa, asiantuntemusta, (Helsinki in international development)" led by Marjatta Hietala, studied how the city of Lyons strove to establish international contacts. In 1906 the newly elected mayor, Edouard Herriot, inaugurated an active policy of seeking international information. One of the early tours in the same year was a weeklong trip by a delegation to Manchester, Glasgow and Edinburgh, which proved to be a milestone in the development of Lyons' international relations. The city's earliest attempt at such fact-finding had been much less successful, however. In 1873 the Chief Engineer of the city's Board of Works had visited London to study cesspool-cleaning machines. However, not only was it badly timed, taking place between Christmas and New Year, but the visitor did not speak English, had a bad interpreter and

found that the English leaflet he was using for guidance was already twenty years out-of-date. In fact London had already abandoned cesspools in favour of modern sewers![50]

That the city of Stockholm was actively seeking foreign knowledge is evident from the great number of travel reports kept in the city archives.[51] However, the great public interest shown by Swedes in improving the city's services is demonstrated by the fact that in 1912 the newspaper *Aftonbladet* felt it worthwhile to send a special correspondent on a tour of European cities to study how problems that were seen as the most relevant for the city of Stockholm could be solved. He investigated tramways (public, private or concession based), traffic between the suburbs and the centre and the distribution of foodstuffs in various European cities for a year and submitted a total of 36 articles, published in the paper between November 1912 and August 1913.[52]

But what was perhaps not so common was the scale of the foreign travel undertaken by Finns, who were arguably among the most eager people in Europe to embark on such foreign fact-finding tours – an assumption easy to accept given that three-quarters of a century later Finns were, apart from Britons themselves, the biggest single national group to visit the British Open University at a time when the Finnish open university system was in the process of development. Secondly, their systematic preliminary preparation for tours enabled them to avoid the disappointment of the Chief Engineer of Lyons. The provision of letters of introduction, the careful reporting at the end of the journey and the public financing of such travel were all characteristics of a well established system of international fact finding which may not have been so common a practice at that time elsewhere in Europe. The third striking feature is that, while the Germans or the English sent committees or deputations to investigate interesting innovations,[53] the Finns, probably at least partly for financial reasons, sent one or two experts to familiarise themselves with specified innovations in their field; for example when building a modern hospital was in question a doctor and an architect would make a fact-finding tour together. Strikingly a remarkable number of private individuals were enthusiastic enough to dip into their own pockets and these included elementary school teachers, who never had too much to spare.

Helsinki Reaches a European Level of Services

Certainly this drive by Helsinki officials and other professional people was rewarded. Through the application of the results of extensive fact-finding, by the early 20th century Helsinki had in most fields reached the level of other European cities, to which it had aspired and, during this process, had developed and institutionalised a solid system of fact-finding that was no longer simply dependent on casual enthusiasm and the personal contacts of private individuals.

Indeed, as we saw earlier, in the first half of the 19th century, before the period of publications, statistics, congresses and exhibitions, the spread of information had been relatively sporadic and taking personal initiatives and using personal contacts were of decisive importance, as in the case of the Borgströms, father and son. Later, however, the growing circulation of periodicals and the developing system of comparative statistics, exhibitions and congresses kept up a continuing flow of information on the rate of progress in relation to various issues and matters. These channels for the spread of information were complementary and formed an interrelated whole, which changed and developed along with technological advance and progress. Thus the spread of innovations became institutionalised. However, during the decades before the First World War these merely supplemented – and did not replace – study tours, which provided an opportunity for personal observation, further investigation and the creating of useful professional networks for the future.

In Helsinki the information gained by such means resulted in development at unprecedented speed, especially in urban technology, hygiene, training and popular education as the application of foreign know-how was normally carried out quite speedily. Examples of the rapid application of foreign know-how can be found in the case of electricity or drainage, where the German model was followed as well as in the fields of public libraries and education, just to mention a few examples. Public services were provided with new premises built to provide the Helsinki cityscape with new landmarks. Schools built at the end of the 19th century and in the early 20th century looked like small castles while libraries and theatres erected then became public monuments. Everyday life had been improved by replacing wells with municipal water mains and sewage pits with a public sewerage system. The municipal

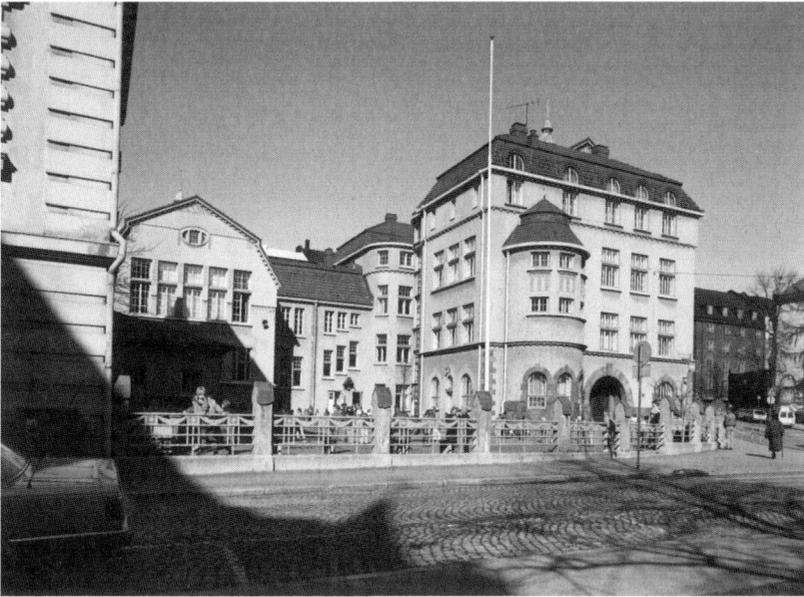

Archiecture reflects the importance given to schools and teaching. In the early 1900s, Finnish teachers and architects visited schools in Sweden and Germany. These schools were fine buildings and soon handsome buildings with special classrooms and collection rooms began to appear in Helsinki. The photo shows Cygnaeus School, which was designed by Karl Hård af Segerstad and built between 1909–1912. (Helsinki City Museum)

inspection of milk and meat and the establishment of covered markets had reduced health risks, and modern hospitals, also often based on German models, provided a better chance of speedy recovery for those who did fall ill. At home the work of the housewife (or the maid!) was made much more convenient by the use of gas for cooking and electricity for lighting while the telephone revolutionised communication not only within the city but also far beyond its boundaries.

Admittedly some time lag might occur if the innovation was initially found to be unsuited to conditions in Helsinki, if the demand for it was still insufficient, if the infrastructure was not ready or there had not been time to train experts. The main cause of delay, however, could often be active political resistance, for example, when defenders of economic liberalism and enterprise opposed municipal monopolies and socialism, delaying social reforms or plans for the use of land.[54]

The Esplanade was a popular place for promenades. In the picture children in the Esplanade Park in Helsinki in the 1910s. (Helsinki City Museum)

In many fields, such as engineering, the aim of replacing foreign expertise with native talents was gradually achieved, so that Finnish engineers directed the construction work while foreign firms acted merely as sub-contractors. This did not mean any diminishing of foreign contacts. On the contrary, in many professional fields there were so few specialists in Helsinki or even in Finland, that links with colleagues in Germany, for example, did provide many Helsinki-based professionals with the peer group that they were seeking for active up-dating of their professional standards. Indeed, on the basis of the number of foreign periodicals, congress reports and other professional publi-

cations with subscribers in Helsinki, it is possible to conclude that the highly trained professional groups and educated classes did still feel a considerable need to strengthen their identity[55] by using international professional networks especially in cases where there were few if any experts working in the same specialized field in Helsinki itself.

For many a Finn an official position provided not only a much sought-after career but also the opportunity for foreign experiences and a valuable entry into an international community of professional colleagues. It is interesting, therefore, that in spite of extensive study tours and periods of working abroad, Helsinki professionals did normally return to Finland. Many believed in the future of Finland and had a clear ideological reason to return in order to contribute to the building of the fatherland. For others the dissemination of useful information to the general public was seen as the major task while some believed strongly in the power of self-development and human capital. Many received strength from religion, some from the working class movement or from the temperance movement. The common aim was to keep Finland in the ranks of civilized countries and to keep Helsinki at the same level as other European capitals.

This often demanded personal sacrifice and unprecedented zeal. But officials accepted that this was so and as a result they succeeded. The knowledge acquired was for the good of both the individual and the community.[56]

V A Metropolis of Modest Proportions

That all this effort in developing Helsinki to meet European standards was a clear success is obvious from the reports of two European travellers, the English Mrs Alec Tweedie, who has been mentioned earlier, and the Spanish consul, Angel Ganivet. Both had arrived in Helsinki in 1896 and after extensive travels Mrs Tweedie wrote of her experiences in *Through Finland in Carts* while Consul Ganivet's *Cartas finlandesas* were first published in the newspaper *El Defensor de Granada*.

Helsinki harbour in 1898, as seen by Daniel Nyblin, one of the capital's most successful photographers. (Helsinki City Museum)

N:o 1.
HELSINGFORS.
HELSINKI.

134

Daniel Nyblin, H:fors, 1898.

To both of them Helsinki was above all a modern city. Approaching by steamboat from Hull on a brilliant sunny morning early in June 1896 Mrs Alec Tweedie discovered

"... a town with its fine Russian church of red brick with rounded dome, the Finnish church of white stone, and several other handsome buildings denoting a place of importance and considerable beauty,"[1]

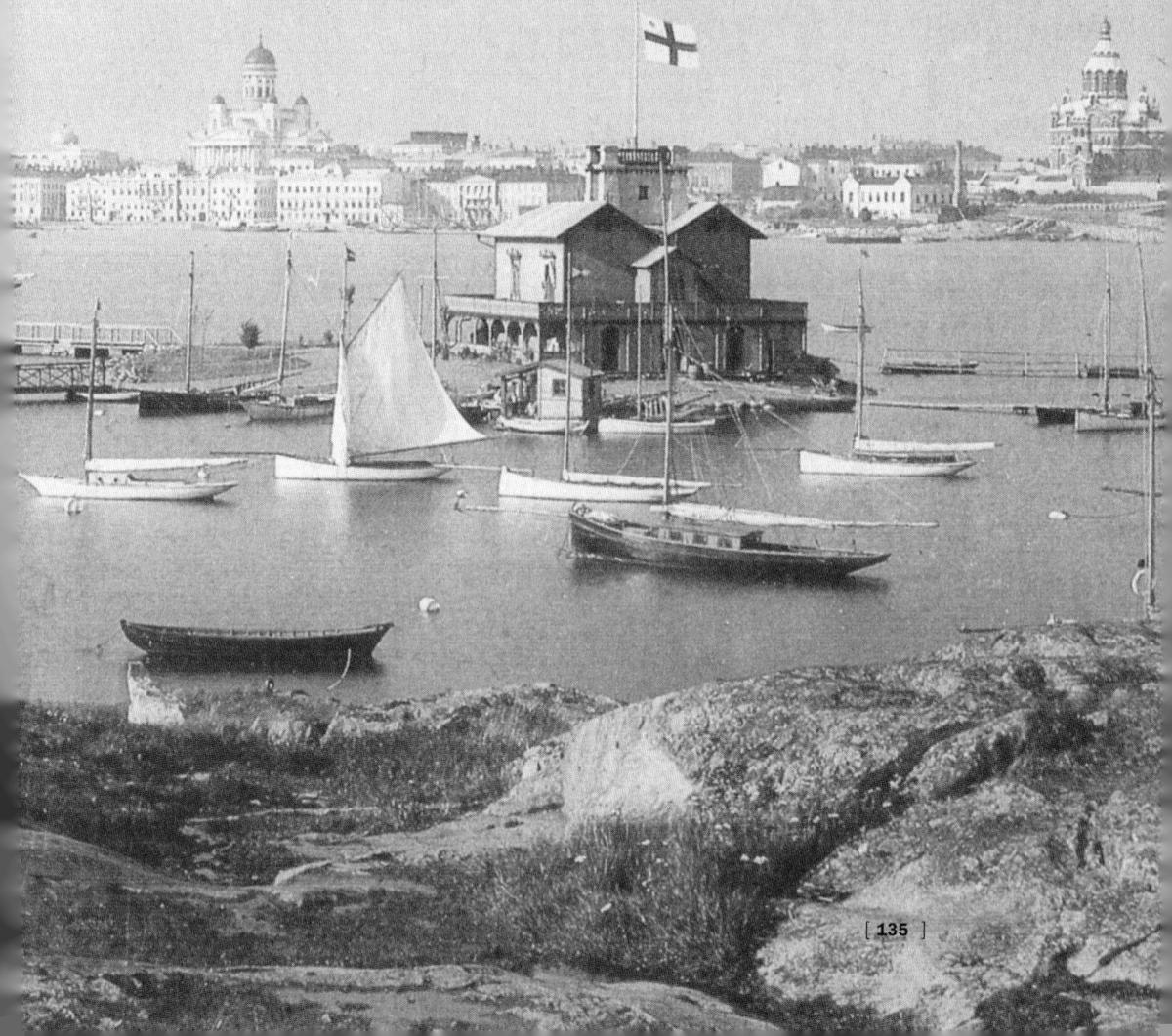

while in his first letter to the Spanish paper Consul Ganivet described the city as a modern capital, which had grown like foam.[2]

Undoubtedly Helsinki had a modern air. In addition to the new hospitals, schools, covered markets and utility plants erected in the city, the central area had begun to change from an idyllic garden city into something much more modern and dynamic. The neo-classical wooden family houses in the centre of the town had been replaced by four and five storey high apartment blocks in the neo-renaissance style that had been so much in evidence in major European cities since the middle of the 19th century. Like the municipal decision-makers, who had taken their models from such cities as Berlin, Paris and Vienna,[3] the general public had begun to demand a new continental image for the city. According to art historian Sixten Ringbom, as early as the beginning of the 1880s people in Helsinki had become increasingly embarrassed by the fact that one of its central public venues, the Esplanade, was still lined with wooden buildings.[4] However, unlike in continental European cities, Helsinki's town plan was conveniently spacious enough to accommodate new buildings and there was no need to demolish Engel's neo-classical centre in the name of modernity. By the 1890s it was already surrounded by such landmarks as the National Archive and the House of Estates in Kruununhaka, and the *Ateneum* in Railway Square. Hotel Kämp and the massive Grönqvist building on the North Esplanade were also already in existence along with many recently built banks and insurance company offices [5] while European style cafés gave the city an extra continental elegance.[6]

Tweedie and Ganivet recognized in Helsinki a number of other features typical of a late 19th century European metropolis. Although the city was still quite small by European standards with no more than 70,000 inhabitants it was already the site of several public museums and galleries. It had many pleasant public parks as well as a multitude of restaurants and there was a full range of lively theatrical and other public entertainments with the city benefiting from a steady stream of visits by international artists and performers en route to St Petersburg. According to Ganivet Finns were passionate about music in general and especially passionate about singing.[7]

Both visitors also noticed the keen interest of Helsinki people in technological novelties including bicycles, which already totalled 3,000.[8] But they seem to have taken for granted the progress in building arrangements[9] and

the development of shops and department stores. Nor were they apparently surprised by the city's conservatoire and art school, its orchestra and annual art exhibitions.[10] These were obviously things they expected to find in any self-respecting modern city. But the really noteworthy discovery that made the feminist Mrs Tweedie describe Helsinki as "very advanced in its ideas,"[11] was the extent of its educational development and, even more important, the position of women, a subject to which both writers dedicated a full chapter.

Advanced Ideas on Women and Education

Unlike Consul Ganivet, who found Finnish women too thin, lacking in passion and a bit masculine,[12] Mrs Tweedie was full of admiration for them and considered their active role to be one of the factors most likely to give Finland a great future and one from which her fellow Britons could learn a great deal. For her

> "... it was remarkable that so remote a country, so little known and so unappreciated, should thus suddenly burst forth and hold the most advanced ideas for both men and women. That endless sex question is never discussed. There is no sex in Finland, *men and women are practically equals*, and on that basis society is formed."[13]

Obviously Mrs Tweedie's comments tell us as much about the situation in Britain as about Finland. Although emancipation of women and the family as an institution had been extensively discussed in the Helsinki press as early as the 1840s the reforms of family law were in many respects behind Sweden not to mention France.[14] However, when stating that Finnish women were treated by their husbands as equals Mrs Tweedie may have had in mind the number of young married couples in Helsinki sharing intellectual, political and artistic interests within the "Nuori Suomi" (Young Finland) group and the academic circles of the 1890s.[15] She probably also based her comments on the increasingly evident drive not only for political and social equality but also for the promotion of greater equality within the family.

One of the champions of such equality in Helsinki from the 1880s onwards had been Valfrid Vasenius, a librarian at the University Library and later a professor of Finnish and Nordic literature. Unlike his father Gustaf Otto

Wasenius, the founder of the Wasenius bookshop, who had organised the life of his family and his business on traditional authoritarian lines, Valfrid Vasenius called for improvements in the status and legal rights of labourers, women and children. To him despotism in a family or in a society was equally indefensible; women and the common people had the right to play a direct role in public life as legally competent citizens and not merely indirectly, through their fathers and husbands or their employers. In Helsinki the women's issue had become a hot topic following the landmark performance of Ibsen's *Doll's House* in 1880 and this had paved the way for the development of women's education and their emancipation in Finland. Vasenius, who had made a doctoral dissertation on Ibsen defended the play; to find happiness in a marriage, he believed, people had first to find their own independence. Subsequently his own daughter Herta got the same opportunities as her brothers. She was sent to a Finnish-language co-educational school, gained a university degree and became a teacher of mathematics.[16]

When reading Mrs Tweedie, it is quite obvious that what impressed her even more than their education were the working opportunities available for women, a topical issue from the 1840s onwards as the number of unmarried women started to increase. While providing detailed statistics of women employed in the civil service, the public utilities, and various trades and industries she points out that

> "… one cannot travel through Finland without being struck by the position of women on every side. It may, of course, arise from the fact that the Finns are poor, and, large families not being uncommon, it is impossible for the parents to keep their daughters in idleness and as no country is more democratic than Finland, where there is no court and little aristocracy, the daughters of senators and generals take up all kinds of work. Whatever the cause, it is amazing to find the vast number of employments open to women, and the excellent way in which they fill these posts. There is no law to prevent women working at anything they choose. … "Instead of work being looked upon as degrading, it is admired on all sides, especially teaching, which is considered one of the finest positions for a man or a woman in Finland. And it is scientific teaching, for they learn how to impart knowledge to others, instead of doing it in a dilatory and dilettante manner, as so often happens elsewhere."[17]

Members of the Amateur Photographers' Club dining at Hotel Kämp in the early 1890s. Mrs Tweedie was amazed that women in Finland could join associations on equal terms with men. The first photographs taken in Finland date from 1842. Some women also became professional photographers and probably the best-known was Signe Brander, who systematically recorded the streetscape of Helsinki in the early 1900s. (Helsinki City Museum)

According to Ganivet this meant that in Helsinki a Don Juan had to turn into a schoolmaster and be prepared to argue like a Sophist as the Finnish Doña Inez usually had a pile of study certificates. These she had often gained at co-educational establishments and might even have taken a university degree, and she was now working in order to earn money, which provided her with an opportunity to enjoy personal freedom with the right to visit theatres and restaurants independently.[18]

Although it is perhaps exaggerated, Ganivet's picture nevertheless demonstrated the wide opportunities for women to study in Helsinki. By the autumn term of 1892 the city had a total of twelve secondary schools, five for boys, three for girls and four co-educational establishments.[19] It had been the site of one of the two girls' schools established in Finland in 1844 as a result of the 1843 School Act; as well as of the first entirely Finnish-language

In the late 19th century Helsinki became an increasingly international city. Russian military men strolling in the Esplanade were a common sight as Helsinki was also a garrison town with several large barracks. In the background is the Wasenius Bookshop, which was noted for its large stock of foreign language books. It was the forerunner of the present Academic Bookshop. (Helsinki City Museum)

girls' school established in 1869; and, in 1883, of the first co-educational school in the country. – Co-educational schools were a cost-efficient way of developing secondary education in a sparsely populated country and between 1883 and 1899, following Helsinki's example, a further 31 co-educational secondary schools were to be established elsewhere in Finland.[20] As secondary schools received state subsidies, they also managed to keep their annual tuition fees low and this same low-fee policy was also to be found in the University, Mrs Tweedie noted.[21] Between 1870 and the time of her visit a total of 251 Finnish women had enrolled to study there[22] while others had entered the Polytechnic Institute.[23] Thus Finnish women were able to study the full range of subjects available at the higher educational institutes to a degree leve including sciences, medicine and architecture.[24] In the early years of the Drawing School in Helsinki of the Finnish Fine Art Association women even formed a majority of the students and by the late 1880s a total of 249 Finnish women had studied at that school while the number of male

students had amounted to only 99. Both sexes were also given the same teaching, and women embarking on the career of professional artist were usually given travel grants to study abroad in the same way as their male colleagues, and this resulted in the emergence of a particularly strong group of Finnish women artists from the 1880s onwards.[25]

It is fair to say, however, that the inspiration for all this came from outside Finland. Catherine the Great of Russia had already promoted women's education and consequently the girls' schools in Russia were famously of a high standard. Significantly it was a Russian, Maria Tschetschulin, the daughter of a well-to-do businessman residing in Helsinki, who was the first girl to take the matriculation examination. Similarly the idea of co-educational education at post elementary level was probably based on American models arriving via Sweden where two such schools had been founded in the 1870s. It is therefore worthwhile to explore the flow of foreign ideas and how they arrived in Helsinki, a city of many languages where Swedish, Russian and Finnish were used not only on street signs but also regularly in everyday communication, as both Tweedie and Ganivet immediately discovered.[26] As late as 1870 among the upper classes Swedish speakers had formed some 75 % and Russian and German speakers were in fact three times as numerous as Finnish speakers in this top group. Of the total population in 1870 people with Finnish as their mother tongue still made up only a quarter. However, the growth in the number of Finnish speakers had accelerated considerably from the 1880s onwards so that by 1890 the two major language groups had become equal.[27]

Cosmopolitan Capital

A telling example of the extent to which the Helsinki of the 1890s was a mixture of linguistic and cultural assumptions was to be found at a rehearsal in 1892 of Sibelius's new *Kullervo* symphony. Here the composer-conductor had to use German to address the professional musicians of the orchestra, Swedish when speaking to the members of the amateur male choir and Finnish to the student organists acting as tune leaders for the choir. On the other hand his Russian proved inadequate in a discussion with an English

enthusiast, who had studied music in St Petersburg, and they had to revert to a mixture of French and German.[28] Such multilingualism was obviously the result of history, but it had also developed both as a result of Helsinki people working and studying abroad and of the interaction with the many foreign incomers increasingly to be found in the city. (See a note on Innovative Immigrants, page 73)

The journey of foreign ideas on their way to Finland could be quite complex. The founder of the Finnish national school system, Uno Cygnaeus, for example, had learned from the German School of St Petersburg of Pestalozzi's methods and had later investigated them further in Switzerland.[29] Many Finnish soldiers, engineers and commercial representatives worked in the Russian Empire[30] and a few had married Russians or members of St Petersburg's own very cosmopolitan community. These people also brought new influences to Helsinki. General Alexander Järnefelt, for example, had married Elisabeth Clodt von Jürgensburg, a member of a Baltic-German titled family in the Russian capital. She had introduced to the cultured circles of Helsinki the artistic ideas of Russian realism and the works of Turgenev, Dostoyevsky and Tolstoy;[31] moreover, she was the mother of some of Finland's leading artistic figures. The Ramsay family of Munkkiniemi Manor had received a daughter-in-law from the well-established English community in St Petersburg,[32] thus strengthening the links with English culture maintained in Helsinki not only by the English-born Baroness Elisabeth Ramsay but also by the Anglophile Borgströms and their two British daughters-in-law.

Similarly, in the 1890s a number of upper-class families still maintained very close contacts with their relatives in Sweden,[33] where many new ideas arrived earlier than in Helsinki. Thus the women's movement and the temperance movement, which both originated in the USA, came to Finland via Sweden in the 1880s,[34] although Alexandra Gripenberg, the leading Finnish feminist, herself made several trips to America and Topelius had direct links with the USA, corresponding with Longfellow and Harriet Beecher-Stowe[35] Obviously foreign literature also was one of the major channels of ideas. Certainly Sweden remained the most important source of such literature throughout the second half of the 19th century[36] and according to some estimates up to one third of the latest fiction published in Sweden was actually sold in Finland.[37] However Anglo-American authors also figured prominently in the field of translated literature.[38]

From the 1860s onwards the Finnish newspapers had been allowed to report foreign news quite freely. Thus they had made their own impact on industrial development, for example by reporting Edison's progress in the matter of electricity. The papers had also increasingly published informative letters from Finns living abroad thus spreading interesting new ideas to a much wider circle than was the case in the 1840s when Snellman was only able to communicate by letter with his family and a close circle of friends.[39] After the Crimean War foreign travel had become more and more common after graduation from the university while artists had continued their studies in Rome, Düsseldorf and, from the 1870s onwards, in Paris where they had become numerous enough to form their own artistic colony by the early 1890s.[40] Through them ideas topical in the "new France" of the Third Republic, such as Darwinism, liberalism and women's rights also found their way to Helsinki.[41] Coupled with the extensive study tours and travelling undertaken by doctors, engineers and city officials one must conclude that by the turn of the century Helsinki people had forged more cosmopolitan links than ever before in the history of the city and that they were also increasingly eager to cultivate them. Yet it was ironic that this internationalism coincided with and actually complemented the growing fervour of Finnish nationalism.

The decorations in Unioninkatu for the coronation of the Tsar Nicholas II and his wife Alexandra in May 1896 show that before the russification period people in Helsinki celebrated major imperial events in the same manner as did loyal subjects of the time in other European countries. (Helsinki City Museum)

Finnish Nationalism as the Source of Innovations

As we noted in Chapter Two this new growth of nationalist sentiment was not peculiar to Finland. Such movements were found in many European countries but in the Finnish case, a further impetus had been provided by a change in Russian attitudes. This change resulted in part from an intensifying Pan-Slavism, which had led many Russians to adopt a far less tolerant attitude towards the other nationalities in the empire but also in part from the changing geopolitics of the Baltic region following German unification in 1870. Consequently acts of deliberate russification had become more and more common in the Baltic countries from the mid-1880s onwards.[42]

The Grand Duchy of Finland had usually been considered a favoured province under the Tsars.[43] However, the developments south of the Gulf of Finland inevitably spurred the Finns into safeguarding their position and looking for ways of further strengthening their own national identity. In Helsinki a number of groups were to carry out significant innovative actions in support of this goal. The most important and oldest of these bodies was the University while the early 1890s also saw increasing activity by *Helsingin Suomalainen Klubi* (the Finnish Club of Helsinki), a society of younger academics and university graduates, and by *Nuori Suomi* (Young Finland) a group of Finnish artists, writers and journalists whose endeavours resulted not only in the music of Sibelius but in what has been termed the Golden Age of Finnish Art.[44]

University Teachers as Innovators

In the life of Finland the position of the university had been of crucial importance for the whole of the 19th century. When Mrs Tweedie enquired about its role in the national life she was astonished by the reply:

> **"You see, we have no court here, no great wealth, but few nobility, and, therefore, every one and everything is centred round our University."[45]**

In this apparently glib answer there was certainly an element of truth. Since J. W. Snellman, professor of ethics and the structure of sciences, had got involved in the government and financial reforms of the 1860s, university professors had become increasingly influential in Finnish public life. Even if

one of Snellman's opponents had suggested that "one should pray God to preserve us from professors in Government,"[46] this had not prevented professors from taking a considerable part in the political and cultural life of the capital as well as in its municipal administration where their professional expertise and contacts proved very valuable as we saw in Chapter Three. Furthermore during the last decades of the 19th century it was the professors, who not only laid the foundations of successful Finnish design, so crucial in the following century, but established also a number of prosperous commercial ventures and even launched a co-operative movement, which was later to grow on such a scale that by 1997 its annual turnover was equal to that of the electronic giant Nokia.[47]

These professorial initiatives had been very much in tune with many general developments in the Helsinki of the 1870s and 1880s as the new ideas of the temperance, labour and women's movements along with a new enthusiasm for sports had sparked off an "association fever," and the number of societies in the capital had increased tenfold from 25 in 1875 to 246 in 1900.[48] Although a great majority of these organisations had been meant to serve the whole country, their headquarters were in Helsinki and they contributed a great deal to the corporate life of the city.

What is surprising, however, is the fact that quite frequently the professors' personal academic expertise bore little or no relation to the innovative public ventures which they undertook. Why, for example, did professors of Sanskrit, surgery, astronomy or history become the founding fathers of insurance companies and why did professors of botany, Nordic literature, pedagogy or Greek become so deeply involved in the establishment of the co-operative movement?[49] Of course friendships within the relatively small university staff at that time[50] and an aptitude for getting involved in organisations[51] played some role. However, a more important explanation is probably to be found in the Finnish academic ethics of the period, which required that professors and students should be active as citizens promoting Finnish nationalism through cultural activities while also working to improve the people's economic condition.[52]

Significantly the first book published in Finnish by the Finnish Literature Society (a body not only of professors but of academics who worked in the civil service, journalism or banking[53]) had been not the national epic the *Kalevala* but *Kultala*, a book on dairy co-operatives by the Swiss J. H.

The Finnish National Theatre in Railway Square. Among the earliest cultural buildings in Helsinki was a theatre erected in 1827, and in the second half of the 19th century when plays were increasingly seen as a major tool for developing the Finnish language there was a demand for a national theatre. Its eventual national-romantic building, designed by Onni Tarjanne, was completed in 1902. (Helsinki City Museum)

Zschokke and it had proved to be an early bestseller with 4,500 copies printed.[54] However, subsequently the *Kalevala* was published along with the *Kanteletar* (a selection of folk poems) and other collections of Finnish folklore. In fact the Society had concentrated on developing a cultural infrastructure in the Finnish language and as early as 1866 it had been able to claim that through its efforts there were now available all the books necessary for studying in Finnish at the secondary school level.[55] At the same time the Society had begun to lay the foundations for theatrical activities in Finnish, which were then considered vital for the further development of the language and they published a number of original Finnish dramas together with translations of plays by Molière, Schiller, Lessing, Sheridan and Shakespeare, and this was followed by a systematic translation into Finnish of other major works of world literature.[56] Dictionaries and books on such

specialist subjects as law, seafaring, history, botany and so forth had helped
to develop specialist vocabularies in Finnish[57] and similar work was later
undertaken by professional organisations and a number of new commercial
publishers.[58] Due to such systematic work Finnish, which had been short of
conceptual terminology, had been elevated within a mere fifty years into a
language of high culture served as early as the last decade of the 19th
century by its own literature and press.

But, as indicated earlier, the professors had also been keen to launch
ventures aiming to strengthen and widen the economic base of Finland,
which within the three years, 1866–68, had lost over a quarter of a million
people, i.e. over 13 % of the total population, due to famine and subsequent
disease,[59] with thousands of beggars roaming the streets of Helsinki.[60] For
both Topelius, professor of history, and C. G. Estlander, professor of aesthet-
ics, nationalism most definitely involved modern industrial life and not just
language and folk poetry. In his pamphlet *Den finska konsten och industrin
utveckling hittills och hädanefter* (The development until now and from this
onwards of Finnish art and industry) the latter had promoted the strengthen-
ing of Finnish industry in order to safeguard the national standard of living
and had declared it a national duty to produce industrial products of a very
high standard:

> "We have unavoidably been drawn into the mighty stream of modern industrialisation,
> and it would appear more dignified and more fitting to our claims for a place among
> nations if we steped forward with determination instead of being dragged along after the
> others... We must, therefore, abandon once and for all that opinion that we are a
> neglected people who can hardly achieve anything else but provide raw materials and
> operate at the elementary level of further processing"[61]

Models had been taken from abroad. As early as the 1840s Sweden had
established, as a part of their industrialisation programme to overcome rural
and urban poverty, a Society of Crafts and Design and a Slöjdskolan (a Craft
School) to assist in the creation of products fit for European markets.[62] The
1851 Great Exhibition in London had also very clearly demonstrated the
importance of the quality of design of industrial products. Therefore Topelius,
Estlander and others had decided in the autumn of 1870 to establish a
training institute in Helsinki to develop the artistic and technical skills of

young people working in the fields of crafts and industry. The *Veistokoulu* (the Craft School), later to evolve into the present Helsinki University of Art and Design, had opened its doors in January 1871[63] while another brainchild of Estlander's, the Finnish Society for Crafts and Design, had been founded in 1875 in Helsinki to support the school. The Friends of Finnish Handicraft had been established in 1879 (also following a Swedish model) "to promote Finnish handicrafts and to further develop these in patriotic patterns and materials,"[64] and the opening of the *Ateneum* in 1887 on a site donated by the city of Helsinki[65] had completed this setting up of an infrastructure for the development of Finnish design.

That the *Ateneum* provided premises for the training of both fine and applied arts under the one roof had been due to the influence of Estlander. In his pamphlet he had also stressed above all the importance of close co-operation between the fine and the applied arts[66] – an idea which was to become increasingly popular also in Germany.[67] To this seminal concept was added in the 1890s the second fundamental ingredient for the early success of Finnish design, the search for an artistic inspiration based not just on Finnish traditional crafts but also on the modern ideas brought by Finnish artists who had studied in Paris and other European centres. Their efforts were aided by two foreigners, the Swedish-Italian Count Louis Sparre and the British-Belgian painter and ceramic artist A. W. Finch, who both came to be recognised as the founders of modern Finnish ceramic design as well as early practitioners of the graphic arts in Finland.[68] The ultimate aim was to develop "a genuine Finnish style" as an antidote to the standardizing influence of international trends,[69] but, as became evident in the preparation of the Finnish pavilion for the 1900 World's Fair in Paris, the Finnish style was only acceptable once it was blended with contemporary international trends.[70]

Apart from the University another forum for the development of economic life and especially for those speaking the Finnish language was the *Helsingin Suomalainen Klubi* (The Finnish Club in Helsinki), a society of professors and university graduates which was probably based on a model adopted from Prague, where one of the young Fennomen had met leaders of the Czech nationalist movement.[71] In its first year it had enrolled 84 members whose average age was only 34[72] and it had soon become involved in the establishment of a number of voluntary organisations such as the *Finnish Women's*

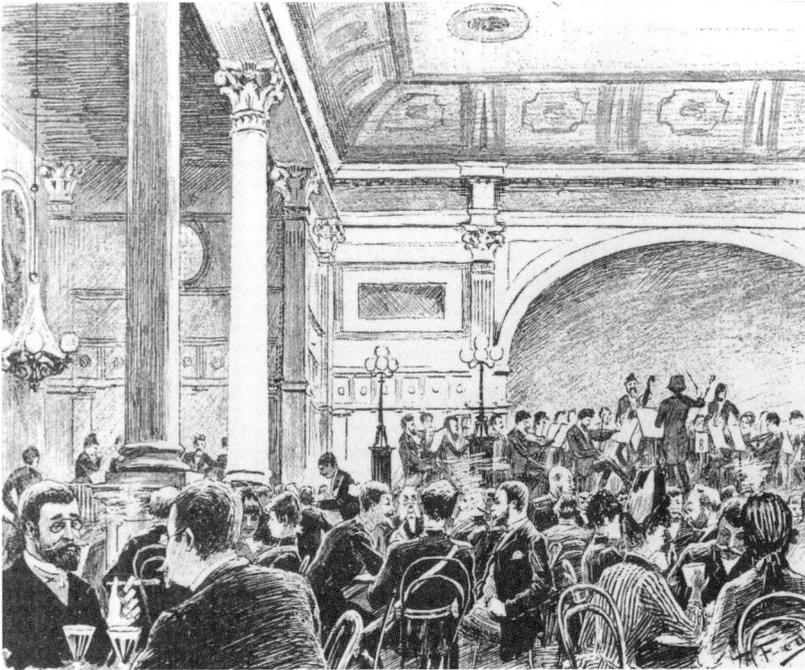

A popular concert at the Seurahuone in the late 1880s. Twice-weekly concerts, conducted by Robert Kajanus, were part of Helsinki people's social calender until the late1910s. Since its opening in 1833 the Seurahuone had been the venue for a wide variety of events ranging from "picnics" and imperial balls to meetings of eminent businessmen and industrialists. The first performances by the Cinématographe Lumière took place there in 1896. The Seurahuone is now Helsinki City Hall. (Drawing by A. Federley, 1888, Helsinki City Museum)

Association. It was two of the club's young members, Otto Stenroth, 27, and Lauri Kivekäs, 36, who had first put forward the idea of launching financial institutions based on the Finnish language[73] and the club was the forum where suggestions for such enterprises were first discussed.[74]

The first of these ventures was a life insurance company *Suomi* launched in 1890 and taking its place alongside the *Kaleva* company. The latter had been established in 1874 and operated in the Swedish language. Both aimed to counteract the dominance of foreign companies, which at the end of the 1880s had still been collecting over 60% of new insurance premiums in Finland.[75] Furthermore, the year 1890 saw also the founding of two further key Finnish-speaking institutions, the commercial joint-stock bank *Kansallis-Osake-Pankki* (KOP) and the publishing house *Otava*.[76] Professors had been

much involved in these four ventures[77]and both KOP and Otava were to become major players in their respective fields. From these developments grew up the peculiarly Finnish system of having two parallel language based business groups centring round on the one hand the Swedish language based *Union Bank* and on the other the Finnish language based KOP, a situation which was to continue until the late 20th century. A similar duplication of institutions based on language emerged also in a number of other fields including professional, educational and cultural organisations.

The Arts Create the Identity of Finland

In the 1890s signs of a threatening change in Russian policies towards Finland became ever more frequent. The growth of Pan-Slavic Russian nationalism was clearly influencing Russian government and the attitude towards Finland of the Tsar. The Post Manifesto of 1890 had linked the previously independent Finnish postal system to that of the rest of the empire, and other signals of systematic unification could have been seen in the appointment of civil servants and in demands for an increase in the use of the Russian language in administration and in schools.[78] That Finland survived this process of russification was, perhaps unexpectedly, due in part to the innovative work of a colony of young Finnish artists and writers who had opted to live and work during the winters of the early 1890s in the building of the Kaivopuisto Spa.

In the first chapter we saw how the Spa had been the fashionable hub of Helsinki's summer season up to the time of the Crimean War but had then suffered a decline. In 1883 the lease had run out and the city had taken over the park and the buildings. Until the turn of the century the premises continued to be used by the city for spa activities in summer while in wintertime the building was rented out to students, writers and artists. In the early years of the 1890s it thus had become a base for a young cultural elite, people who had studied abroad but had not yet established any permanent home in Finland. This new generation of writers, painters and composers were accompanied by their wives and occasionally also by their children, who were each given their own bedroom in the bathing cubicles and slept in the bathtubs while the parents shared a big living cum sleeping cum working

room. The awareness that there were others on the same corridor working with dedication behind closed doors in their chosen creative field was in itself inspiring. Venny Soldan-Brofeldt, a painter and her writer husband Juhani Aho had their quarters on the upper floor, where, she recalled[79]

> "... in the quiet room divided by a huge old wardrobe into sleeping and working quarters we enjoyed undisturbed working peace at a partners' desk, longing at the same time for the wider world, where Paris and Italy were enticing."

In order to secure peace for working, pianos were forbidden but singing was allowed especially during the get-togethers attended by close friends, many of whom were members of the informal cultural group *"Nuori Suomi"* (Young Finland).[80] Apart from the Spa customary meeting places included the offices of the liberal newspaper *Päivälehti*, the predecessor of *Helsingin Sanomat*, as well as the restaurants Kappeli and Kämp. In his memoirs the journalist Santeri Ingman recalled how [81]

> "We frequently got together, sometimes in the small offices, sometimes in the ateliers, sometimes round restaurant tables. We discussed movements and trends – as the art movement was in a transitional stage in the great wide world – and we argued about the main objectives of art, practised atelier criticism, but above all constructed plans, big, ambitious plans based on our home country."

The ever intensifying russification had already been causing concern among the colony of Finnish artists working or studying in Paris during the winter of 1890–91, and in spite of the earlier call for an "opening of the windows to Europe", so frequent in the 1880s, this strong patriotic concern had led almost all members of the Finnish artistic community to return to Finland. Following the example of Akseli Gallén-Kallela, who had travelled to Karelia, the home of the *Kalevala,* for his honeymoon in 1890, artists and writers all made journeys in search of the roots of their Finnishness. What had made these tours so important was that the urgency to counteract the pressure from russification produced a rich and rapid flourishing of Finnish art. The new enthusiasm might also have drawn confidence from the opinion prevalent in Paris in the late 1880s and early 1890s that the next cultural boom was to come from the Nordic countries.[82]

In the visual arts the year 1892 had been the peak year of Karelianism and the autumn exhibition of Finnish Artists had demonstrated the extent to

which all of them were working in a national spirit. In full seriousness artists and writers had sought definitions of Finland, and this process continued throughout the 1890s although many had moved from Helsinki to ateliers in the country to find a more peaceful working environment.[83] The project of defining the identity of Finland involved practically all of the younger generation of journalists, writers and visual artists. Thus in the late 1890s Eliel Saarinen, an up-and-coming architect somewhat younger than the rest, joined in the get-togethers of artists, men of letters and musicians and composers drawn from both sides of the Finnish-Swedish language divide. Sibelius was one of the leaders of the group and according to J. S. Sirén "The time was characterised by a forceful release of creative power, born of daring and unrestrained conviction"[84] and gradually it adopted a tone of passive political resistance.

One of the vehicles for promoting the new image of Finland was the yearly publication *Nuori Suomi,* an album modelled on Estonian cultural calendars and circulated as a Christmas supplement to *Päivälehti.*[85] Its purpose was to present the best and most modern in Finnish culture as evidence of the independent spiritual strength of the nation.[86] Due to the adoption of technical innovations in printing introduced into Finland by Ferdinand Tilgmann in the early 1890s[87] it also reproduced the works of Finnish artists that had been exhibited the same autumn in Helsinki. The general public round the country was now able to follow the development not only of Finnish art and writing but also of Finnish music, as *Nuori Suomi* also published works by Sibelius and Oskar Merikanto, a composer of simple popular melodies.[88] This certainly changed the standing of the arts for the older generation of Fennomen had largely relied on the power of the written word for spreading their message. Now with its supplement *Päivälehti* was the first Finnish-language newspaper to pay serious attention to the use of pictures as a means of communication.[89]

Recalling the excitement of this period Louis Sparre, who had befriended Finnish artists in Paris in the 1880s and lived in Finland from 1891 until 1908, remembered that

"It was magnificent to be allowed to take active part in that tremendous upswing of national culture. Our circle of friends included all the major talents of the time: Sibelius, Järnefelt, Gallén-Kallela, Edelfelt, Pekka Halonen, Juhani Aho..."[90]

and for him moving to Finland had "opened a new world of enthusiasm and patriotic pathos."[91] This national drive of Finnish artists was also to inspire colleagues in the Baltic countries, and both Estonian and Latvian artists were influenced especially by Gallen-Kallela's works.[92]

Diaghilev and Mir Iskusstva Come to Helsinki

One of the major ironies of the situation was that amid the growing menace shown towards Finland by an increasingly Pan-Slavic Russia, a surprising new development took place. In 1898 Sergei Diaghilev and other leaders of the Russian avant-garde art movement *Mir Iskusstva (the World of Art)* came to Finland to seek the help of the Finnish artistic community in modernising Russian art!

Early in the 1890s Diaghilev had already declared "I want to nurture Russian painting, clean it up and, most importantly, present it to the West, elevate it in the West."[93] For that purpose he had not only travelled widely in Western Europe, but had also organised in the autumn of 1897 a highly successful exhibition of Scandinavian art in St Petersburg. A year later in the autumn of 1898, Diaghilev attended the Finnish Artists' Exhibition in Helsinki bringing with him his close friends the writer Dimitry Filosofov, the painter and theatrical designer Leo Bakst and others associated with the *Mir Iskusstva* movement. On the basis of what he had seen, Diaghilev had formed a definite opinion

"Finnish art is not Scandinavian ... neither does it have any Russian touch; it is original, national."[94]

At the dinner that followed their visit to the exhibition Diaghilev stressed that Russian artists had much to learn from their Finnish colleagues and called for closer co-operation. He obviously was impressed by the Finnish art world

with its cultural links to both west and east, while the Finns were flattered by the attention of this cosmopolitan Russian with such a reputation as an art critic.[95]

Diaghilev's suggestion was quite natural. The Russian avant-garde intellectuals and Finnish artists had already started to form links, and one of the very first articles by Diaghilev as an arts critic had been about Albert Edelfelt,[96] the Finnish painter who in 1880 had won a reputation in Paris and been consequently been elected in 1881 to the Academy of Arts in St Petersburg.[97] In 1893–96 Leo Bakst had studied in Edelfelt's studio, [98] and it has been suggested that it was he who brought Diaghilev and Edelfelt together in Paris in 1895 and that this may have played a part in bringing together the Finnish and Russian movements.[99] Up till then Finnish art had still been relatively unknown in Russia, and it was certainly an interesting development when a whole group of leading Finnish artists decided to take part in the 1896 All-Russia Exhibition in Nizhny-Novgorod[100] despite the continuing attacks on Finland by the Russian press.

However, it was the major Russo-Finnish art exhibition organized by Diaghilev in St Petersburg in January 1898 that really created a great stir in the Russian capital. The exhibition was perceived as a manifesto of the latest trends, and it shocked some of the Russian public who saw it as introducing decadent tastes into Russian society. People were particularly dismayed by Gallén-Kallela's symbolist paintings on Kalevala themes, *Lemminkäinen's Mother* and *The Defence of the Sampo,* which along with the Russian Vrubel's *Morning,* were referred to as "decadent affectations" and the whole exhibition described as "an orgy of debauchery and madness." Ironically these works are now ranked as classics of their respective national cultures. Certainly the exhibition established Helsinki as an art centre on an equal footing with St Petersburg and Moscow.[101]

Many of the Finnish artists involved were not just the torchbearers of symbolism but were also members of *Nuori Suomi* with its Finnish nationalist programme. It is therefore ironic, that according to the Russian art historian Vladimir Kruglov the history of the groundbreaking *Mir Iskusstva*, which led to the reforming of Russian art, actually began with this 1898 Russo-Finnish Exhibition.[102] However, this paradox and the attraction of the Finnish artists to Diaghilev becomes understandable if one assumes that his main aim was not to divert Russian art away from nationalist and social issues but to demonstra-

te, by using as examples the works of Finnish artists with a strong nationalist programme,[103] that even the most avant-garde western artistic styles can be successfully applied in works of art loaded with nationalist significance.

Up to this point Russian artists had been so much preoccupied with a deeply rooted need to illuminate the social problems of their country that even when studying in Paris they had not paid adequate attention to new artistic styles,[104] and by the 1890s the increasingly wealthy middle-class Russian intelligentsia found the arts in their country lagging behind western developments.[105] Finnish artists, who had not normally pursued further studies in St Petersburg,[106] had been more inclined to adopt new art trends from Dusseldorf and Paris. Consequently Edelfelt had developed from being simply a competent painter of historical subjects to being a talented painter *en plein air* and an internationally famous portrait painter, and recently one French critic has described him as the bridge between academic naturalism and impressionism in Finnish art.[107] Similarly Gallén-Kallela, considered radical by the Finnish art critics of his time, had also been quick to try his hand at a number of emerging styles before settling down to executing Finnish national themes in a highly stylized symbolist manner influenced by Japanese art.[108] The move to symbolism in Finnish art had begun in 1891 and gained strength in 1893–1894 when Halonen and Blomstedt had studied with Paul Gauguin, perhaps the most important symbolist artist at that time.[109] However, from the mid-1890s onwards, Finnish artists began to travel to Italy and for many the interest in symbolism was therefore short-lived. Even so, according to Sixten Ringbom it was precisely symbolism with a national orientation that had such an epoch-making effect on Finnish art.[110]

Thus, following his visit to Helsinki, in the first issue of the *Mir Iskusstva* magazine, published in the late autumn of 1898, Diaghilev provided a wide overview of the Finnish Artists' autumn exhibition[111] and paid close attention especially to Edelfelt and Gallen-Kallela, whom he called a "champion of the new Renaissance in the North."[112] Soili Sinisalo believes that Finnish artists made a prominent contribution at an important turning point in Russian art and that Diaghilev's ambitious plans were initially conceived as involving an alliance with the Finns.[113] A few months later the four leading Finnish painters, Edelfelt, Enckell, Gallén-Kallela and Järnefelt took part in a further International Exhibition,[114] organised in St Petersburg by Diaghilev at the end of January 1899 as part of an ambitious attempt to display in the Russian

Lemminkäinen's Mother by Akseli Gallen-Kallela (1897) caused a great stir at the Russo-Finnish art exhibition held in St Petersburg the following year. Some Finns, who a few years earlier had labelled Gallen-Kallela a radical, probably felt quietly vindicated. Nowadays this symbolist picture based on a theme from *Kalevala* is regarded as one of the great classics of the Golden Age of Finnish Art.

capital the works of leading painters from Western Europe and America.[115] Later in the same year *Mir Iskusstva* published another major survey of Finnish art including 47 reproductions of important works. Among individual artists Gallén-Kallela continued to attract special interest and a further issue ran an article on his atelier in Ruovesi including a splendid presentation of the interior of the building.[116]

But while this 1899 International Exhibition was still on show in St Petersburg, the Governor General of Finland, Nicholai Bobrikov, published the infamous February Manifesto, which in the eyes of the Finnish people amounted to a breaking of the Finnish constitution. To the Finns it was

manifestly a *coup d'etat* by the Tsar, and this event meant an end to all official links between Finnish and Russian art circles.[117] The attention of Finnish artists had, however, by then already turned in a new direction. They were busy preparing the Finnish pavilion for the 1900 World's Fair in Paris.

The Paris Exhibition of 1900

Given the circumstances the Finns were understandably keen to use the World's Fair as a forum for presenting Finland as a nation in its own right to the widest possible international public. The Tsar had already in 1897 approved Finnish participation in the Fair, but it was only after lengthy negotiations by Edelfelt, who had contacts with the Imperial family, that the Finns finally got permission to have their own pavilion in Paris.[118] Foreign observers, however, were not too optimistic about Finland's future. One of the French organisers of the Fair noted:

> "The 1900 World's Fair is without doubt one of Finland's last occasions to retain a semblance of autonomy. We must congratulate ourselves that it is here, in France, that Finland will have the opportunity to do so, and to erect her delightful pavilion."[119]

Ignoring or unaware of such misgivings the Finns had organised a competition for the design of the pavilion. This was won by *Gesellius, Lindgren & Saarinen, Architects*, a firm of three 23 and 24-year old partners, which had recently started to attract public attention.[120] The pavilion was intended to provide a general overview of Finnish society, its culture and science while actual works of art were supposed to be displayed in the Russian section of the Fair.

However, in the end the pavilion also was itself filled to the brim with Finnish art because the leading artists had been invited to produce fourteen large canvases illustrating the life, landscape and economy of Finland. The Paris based Emil Wickström created ornamental sculptures of Finnish fauna and flora for the outside decoration while Gallén-Kallela painted the frescos on the domed ceilings using themes from *Kalevala.* He also produced a Finnish-style interior design complete with textiles[121] and it is interesting to note that Wassily Kandinsky who had a particular admiration for Gallen-Kallela, regarded him as even more original in relation to the applied arts than fine arts.[122]

The thirty Finnish artists represented in the Paris World's Fair included six leading women artists and fourteen drawn from the Young Finland group.[123] Over twenty of them were awarded either a medal or commendation, [124] and though this might simply be taken as showing political sympathy for the Finns, most of the critics of the time did regard the Finns as artistically stronger and more original than the Russians with particular praise regularly going to Gallén-Kallela, Halonen, Enckell and Järnefelt,[125] i.e. to artists that Diaghilev had already singled out. A further evidence of the high standards achieved by the Young Finland artists emerged a hundred years later in a major exhibition mounted in London and New York to commemorate the 1900 Paris World's Fair. All six Finnish painters selected for this exhibition[126] had been involved in *Nuori Suomi*.

The pavilion itself was an exception among the national pavilions, which were mostly designed as pastiches of their respective national architectural styles. The Finnish pavilion on the other hand was generally considered to be looking to the future and therefore it was for many observers the most fascinating of all. In the important journal *L'Art et decoration* it was accorded an extensively illustrated article occupying the first eleven pages and Gustave Soulier wrote enthusiastically

> **"Character imposes itself so powerfully on the complete architectural and decorative ensemble which is the Finnish Pavilion, this odd union of roughness and tenderness from a people who have retained something primitive with the utmost sincerity thanks to the rigorous climate, the struggles which they must endue and also the persistence of their national legends."[127]**

The pavilion appears also to have succeeded in distinguishing Finland both from Swedish and from Russian culture, which was one of the original aims, and the domestic interior, the "Iris Room" designed by Gallén-Kallela as a total work of art, was particularly praised in the press for its simplicity and beauty.[128] The success of the Finns both as individual artists and as a team in producing such a sensational Finnish pavilion, proves that in 1900 the Finns had managed to intertwine nationalism with internationalism and avoided that conflict between the two, which had been so prevalent for example in Germany and in Russia during the last decades of the 19th century.[129] For the Finns themselves the success in Paris provided a much-needed boost to their confidence amid the dangerous political situation that followed the issuing of the February Manifesto.

The Finnish Pavilion at the Paris World's Fair of 1900 still excites architectural writers. It provided Finnish artists and craftsmen with a unique opportunity to show their skills to the world. The Russian imperial eagle on the tower was, as here, deliberately removed from most of the Finnish photographs taken at the time. (Museum of Finnish Architecture)

The Co-operative Movement as Civil Resistance

While Finnish artistic circles were feverishly preparing the Finnish presence in Paris academic people at home had become much afraid that the Russians might take over not only the national government, but also municipal government in Finland, as had happened in Estonia some ten years earlier.[130] To counteract this possibility, Dr Hannes Gebhard, a university privat-dozent, suggested that a co-operative movement would provide a suitable and effective civil organisation to resist the Russian measures. As any small nation such as Finland had to strengthen its resources, it was most important to develop the national awareness of the great majority by promoting the economic, social and cultural emancipation of not only the farming population but also of the landless people and the industrial and urban working class. According to Gebhard the most efficient method for achieving this was to encourage entrepreneurship based on co-operation.[131]

> "It links people together in localities. In order to succeed, the local co-operative societies must establish joint national firms, which, as powerful economic institutions, would in turn influence the local co-operatives. No state authority could dismember such an economic organisation as a co-operative movement, which is certain to attract the majority of the population and root itself so strongly among them that it can never be uprooted. Moreover, although it is primarily concerned with economic activity, the co-operative movement has proved to be also a vehicle for raising the moral and intellectual standards of the poorest groups of the people. Therefore the co-operative movement is both economically and socially a progressive popular movement even if progress will take place quietly and gradually."[132]

It is difficult to imagine any other form of popular movement that could have provided a more suitable framework for civil resistance in Finland. First, the Russians could hardly oppose it as producers' co-operatives in the form of *artels* had for long been a part of their own tradition with the first producers' co-operatives and credit-co-operatives having been launched in Russia as early as the 1860s.[133] Nor, second, were co-operatives a novelty from a Finnish point of view. Working as a team had, as in many countries, been normal in such communal tasks as the maintenance of roads and in the exchange of neighbourly help in constructing new buildings. Moreover, numerous publications had also disseminated information on co-operation abroad

beginning with *Kultala* as we noted earlier. The first Finnish consumer co-operative shops had been established in 1877–78 in Viipuri and in 1882 in Tampere but these were limited to workers in particular enterprises. However, the *General Nutrition Association in Helsinki*, founded in 1889, had success-fully expanded its business because its membership was open to all people of good repute. It continued to operate as an independent enterprise until 1921 when it joined forces with the Swedish-language co-operative chain *Andelslaget Varuboden.* Information about the Danish co-operative dairies had also been spreading in the countryside in the 1880s, at a time when dairy farming was becoming increasingly common in Finland. Furthermore, leading Fennoman politicians had shown an interest in the movement. Geb-hard himself had learned about it while studying in Germany and Austria in 1893–94 and had later lectured on the subject at university summer courses.[134]

Subsequently a small group of Helsinki University academics[135] held a number of meetings in the spring of 1899 in order to draft a proposal for a law on co-operatives along with model rules and operational guidebooks for local co-operative ventures. Gebhard's talks, using as a particular example the beneficial impact on farming in Ireland of that country's farmers' co-operatives, were published by Otava and during the summer 20,000 copies were circulated round the country by students. The *Pellervo-Seura*, an ideolo-gical and advisory organisation for promoting co-operation among country people, was formally established at a meeting held in October 1899.[136] The founders were drawn from among the elite of Finnish society and taking part in the inaugural meeting were 25 professors, 11 current or former senators, several high-ranking civil servants and many major businessmen.[137] The next year the Senate granted *Pellervo Seura*'s agents free travel on the Finnish Railways and the law on co-operatives was approved by Nicholas II in July 1901.[138]

Once other forms of civil resistance and political actions had also been launched in Finland,[139] the co-operative movement became less obviously an anti-russification device and more an organisation of positive national bene-fit, although it had succeeded in mobilising quickly an astonishingly large number of people as Gebhard had forecast.[140] In 1914 the aggregate mem-bership of consumer co-operative societies was 97,000 and this more than doubled in the war years bringing the total to 201,000 by 1918.[141] Henrik

Stenius, in his study of mass movements in Finland, points out that the Finnish co-operative movement was launched from the beginning on a much larger scale than was the case in other Nordic countries.[142] Later the movement was to encourage progress among the population of towns and countryside alike and by 1970 not only were two of the three major department stores in Helsinki owned by co-operative firms but more than a million Finns, some 25 % of the total population, were members of consumers' co-operative societies while the aggregate membership of both consumers' and producers' co-operative ventures in the country was nearly two million.[143] Clearly businesses run on co-operative lines had become an inalienable part of everyday Finnish life.

Building the Jugendstil Metropolis

While the fight for Finland's survival was being waged in political circles and while an increasing multitude of voluntary organisations were busy turning Finland into a civil society capable of voicing its concerns, people in Helsinki had at the same time to face a serious housing crisis. In 1890 there had been some 61,000 inhabitants but as the First World War loomed the population had nearly trebled to 170,000. This never created such slums in Helsinki as Väinö Tanner, the future head of Elanto Co-operative in Helsinki and Social-Democrat Prime Minister, remembered seeing during his study years in the back streets of Hamburg. Even so the city was facing a serious housing problem during the last years of the century.

Tanner himself was fortunate enough to have been brought up in the Ruoholahti district in a building erected by the oldest of the workers' own joint stock housing companies which had been established in Helsinki from the 1880s onwards.[144] However, although the working class housing issue had also been extensively debated in the meetings of the City authorities actual innovative actions on their part was largely a phenomenon of the years following the First World War.[145] Nevertheless the first experiments in such provision were already being carried out in the Vallila working class district in 1908 when over two hundred wooden houses were built according to a site plan which embraced both the traditional grid pattern and the curving streets typical of Jugendstil. Unfortunately the operation of the plan was marred by

On the left the Lundqvist building in Aleksanterinkatu by Selim A. Lindqvist (1900) has been called Finland's first real business building. The frame of the structure is on cast-iron columns to allow flexibility for any later alterations to the interior. On the right the headquarters of the Pohjola Insurance Company by Gesellius – Lindgren – Saarinen (1901) is a typical national-romantic stone building. (Helsinki City Museum)

speculation over leases[146] and from 1910 onwards further experiments with other forms of municipal working class housing had to be launched in Vallila.[147]

However, urban planning both in the short and the long term had now clearly become an important duty of the City Council. Helsinki may have been fortunate in having such ample reserves of undeveloped land, but the planning of its use had been piecemeal. In 1898 the 26-year old architect Lars Sonck published a pamphlet entitled *Modern vandalism: Helsingfors stadsplan*, which made a passionate plea for a more modern approach to such issues employing the principles of the Austrian architect Camillo Sitte. The City Council reacted by organising the first urban area planning competition in Finland in this case for the district of Töölö. Not surprisingly it developed into a confrontation between the supporters of traditional practices and the younger generation. This led in 1903 to the production of a weak compromise plan. Even so, the contest had aroused a new public interest in the planning of Helsinki. In 1907 Sonck himself drew up a plan for the

Kulosaari villa area, at that time still outside the city boundaries[148] while in the same year the Helsinki City Council appointed a permanent standing-committee for urban planning and also established the new post of city planning architect, with Bertel Jung as the first holder of this office.[149] Actions on these matters were now becoming increasingly urgent because of the rampant land speculation in the Helsinki region and in addition to Kulosaari many new suburbs were about to be established outside the city boundary such as Haaga and Kauniainen, which were built up around 1910.[150]

In revising the Töölö plan, so that it allowed the formation of large common courtyards surrounded by apartment blocks, Jung revolutionised Finnish urban planning according priority to the provision of more light and thus improving the hygienic condition and the well being of the inhabitants. In 1910 he visited the Berlin housing exhibition and a year later produced, for the first time in Finland, an overall plan for the city treated as an organic whole. In the accompanying memoranda he forecast Helsinki's future growth, its options for expansion by land acquisition as well as problems concerning communications, which he suggested could be solved by efficiently running light local railways. He also suggested the establishment in Helsinki of a central park on the lines already outlined in the plans for Greater Berlin and the Vienna green-zone. According to Jung

> "The modern buzz words are: more space, less dense housing, lower buildings, more parks and open spaces! Our aspirations take us in the same direction and each year we hear increasingly loudly the demand that each family should have their own home."[151]

Nevertheless, the need for new housing had in the main to be met by private building enterprise and it was the consequent massive boom in the building industry, which really did speed up the transformation of Helsinki into a moderate sized modern metropolis. In 1912 A. Ramsay described this sudden ferment:

> "An unexpected turn of events took place by the beginning of 1895. Everywhere in the world there appeared to be too much money. ... The building industry in the capital became a strong business, willingly entered into by private individuals, firms and joint stock companies. From this time onwards our architects had more abundant opportunities than ever before to carry out a re-creation of our capital, testing their energies in great and demanding ventures as well as promoting art and applying it in practice."[152]

The boom brought about experiments in new building technology. In the 1890s the construction of houses was still very much based on traditional, non-industrial methods employing gangs of skilled workers and work had to be carried out during the warm season. Therefore the aim was to discover how to shorten the construction period while at the same time developing materials better able to safeguard against fire, a necessity in a city increasingly demanding multi-storey buildings. Among the new ideas explored was the industrial production of wooden houses, the subject of experiments in the 1890s by the Helsinki firms *Hietalahden Osakeyhtiö* and *Sörnäisten Puusepäntehdas Osakeyhtiö*. Another new feature was the use of the "American building method" which employed a lighter wooden structure and used plaster panels as partition walls.[153]

However, the need for more and more multi-storey buildings for both business and accommodation encouraged two further major innovations. One was the development of a new type of façade architecture and the other the use of reinforced concrete in building structures. In the 1890s the quality of Finnish bricks, the main material for both new apartment and business blocks, was still so uneven that durable façade bricks had to be imported. To counteract the extra expense that this involved increasing attention was paid to the use as a façade material, especially on public buildings and banks, of native granite, which was prized as a symbol of the resilience upon which the Finns prided themselves, and links with Swedish architects and geologists now proved useful, although influential also were ideas derived from examples of American, Scottish and German natural stone architecture. In less pretentious apartment blocks the façade was covered with a blanket-like rendered surface without any attempt at rustication. A few years later, in the early years of the 20th century, reinforced concrete also became increasingly popular for the making of foundations and load bearing pillars as well as floors. This greatly reduced the risk of fire, and the first specialist in this field was the engineer Jalmar Castrén, who established his Helsinki business in 1904.[154]

To the 21st century visitor the most obvious reminder of that period is the Finnish national romantic architectural style. So many of the original buildings have remained intact in so many Helsinki neighbourhoods that the city's Jugendstil townscapes are quite an exceptional feature among European cities making the Finnish capital the leading site of this style in the Nordic countries.[155]

The roots of Helsinki's Jugend architecture lay in the deliberate search for a genuine building style and formed part of a general search for a national Finnish style. A parallel process was taking place in many other countries such as Germany, Hungary, Norway, Belgium, France, Austria, Scotland, Russia and the United States, and in each country the national style took on also many of the features of the contemporary international visual style, variously labelled Art Nouveau, Jugendstil, Liberty, and resulted in a unique blend with a highly individual national flavour.[156] In Finland this process produced national romanticism, the style of the 1900 Paris pavilion.

As was evident in this pavilion, an essential part of the Finnish movement was the drive to use native materials, to take motifs from nature as a starting point in decoration and to design all aspects of the building as a total artwork. Like in other countries William Morris's ideal of viewing a new

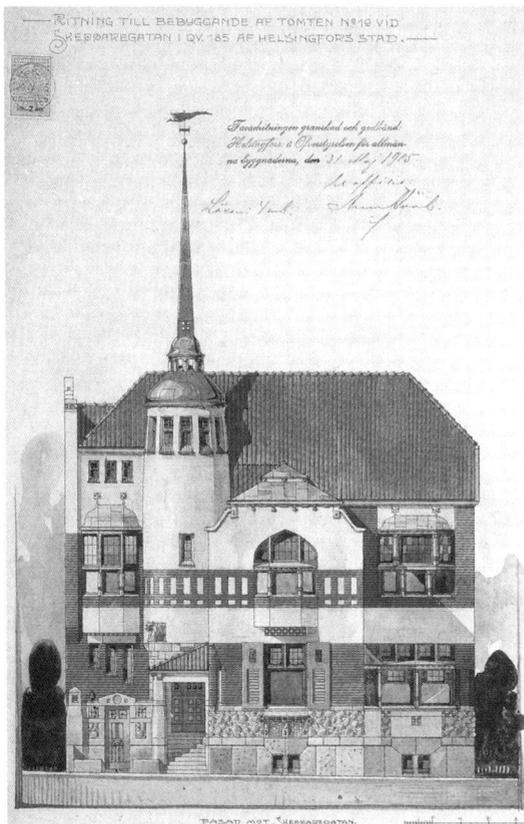

The romantic Villa Johanna is one of the rare detached family houses near the old centre of Helsinki. Located in a garden plot in Laivurinkatu the building was commissioned by businessman Uno Staudinger for his wife Johanna and it was designed by architect Selim A. Lindqvist. The plan is dated 1905. (Museum of Finnish Architecture)

building as a total artwork with its interior and its exterior being planned down to the smallest detail had also influenced many Finnish artists and craftsmen in the 1890s when such magazines as the English *The Studio* were becoming available and being widely read in Finland.[157] Consequently Gallén-Kallela had travelled in 1895 to London to sketch Morris fabrics and other decorative items in the Victoria and Albert Museum,[158] and the designs prepared later by him and Sparre for the Friends of Finnish Handicraft and the Iris factory established them both as pioneers of Finnish industrial design. In 1899 the Iris factory opened a major show room in the Tallberg building opposite Stockmann's present department store. The shop not only displayed the factory's own products assembled to form total interiors including textiles and lamps but also introduced the latest trends of the art nouveau movement to the people of Helsinki by importing international top design products from the London store of Liberty's for which Sparre was an agent.[159] Taking all these factors into account it was quite natural that Saarinen's house Hvitträsk near Helsinki should later become an internationally celebrated example of a Finnish Jugendstil "total milieu". The architecture was based on the use of native timber and granite and the exterior and the interior, which showed the strong influence of the Scot Charles Rennie Mackintosh, formed a perfectly harmonious whole.

Saarinen himself was to become the internationally most famous among a group of ambitious and talented architects who were the chief players in the massive building programme in Helsinki. They had been spurred by ample working opportunities not only to graduate young but also to establish their own businesses, which designed buildings for public and private clients round the country.[160] Saarinen recalled the birth of the new Finnish architectural style during his student years in 1894–97,

> **"It finally became evident that classical form after all is not the form to be used for contemporary purpose, but that our time must develop an architectural form of its own. So was the reasoning in forward-looking circles and, for sure, the view of forward-looking circles are the only criterion"** [161]

Together with his partners Herman Gesellius and Armas Lindgren he had already in 1897 tested their ideas by designing a multi-storey apartment and office block in Katajanokka for Julius Tallberg using the Jugend style, and it was Katajanokka which became the first district of Helsinki to be built in a

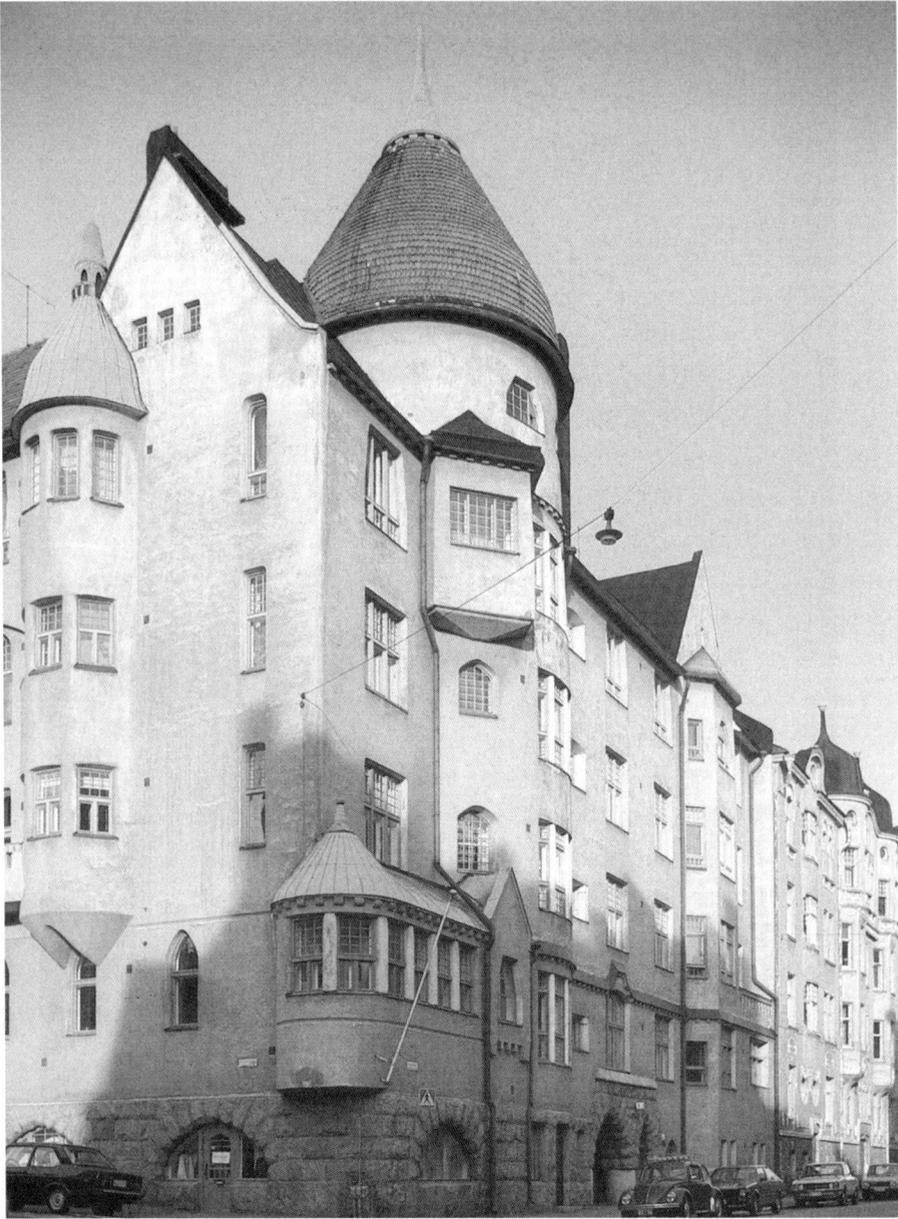

The Finnish national-romantic style is perhaps best in evidence in Katajanokka, which became popular as the base of many of the city's cultural and artistic families. It was the childhood home of Tove Jansson, the creator of the Finn-Family Moomintroll. Her father was a sculptor and her mother a graphic artist. (Photo Michael Carapetian)

uniform style creating new, rich and varied urban landscapes (1903–06). A common feature of these dozens of apartment blocks was their pale rendered facades, their elastic design, with bay windows and tower motifs placed asymmetrically, creating varied silhouettes and a fortress-like general impression. Alongside these gently curving buildings Saarinen and his partners also designed a number of public and commercial buildings including that of the Pohjola Insurance Company, the exterior of which was made of squared granite and soapstone with bears (recalling the company logo) crouching above the entrance amid a frieze of fir tree branches.[162]

Saarinen himself also became the first Finnish architect to set out to design not just buildings but cities as works of art, and his celebrated plan for Munkkiniemi-Haaga and Greater Helsinki in 1915 presented an idealistic vision of the city as well as being a speculative building project aimed at making a high financial profit. In this plan he combined the traditions of both Central-European and British urban planning; the large closed blocks concealed court-yards containing spacious gardens and towards the edges of the area the buildings become lower and consisted of terraced houses and villas with further ample gardens creating a harmonious and sculptural but essentially urban whole. Even if the plan never fully materialised, it turned Saarinen into an internationally sought after urban planner, who made proposals for town plans for Tallinn, Budapest, Cairo and Melbourne, while in Finland his Munkkiniemi-Haaga plan continued to be used as a text book until the Second World War.[163]

Sometimes even the greatest architects and planners, however, have to face the challenge of major cultural change. The enthusiasm for national romanticism in architecture only lasted for some ten years from the mid-1890s to the mid-1900s when both technological and artistic styles had to respond to both social change and new public taste. One of the most celebrated buildings produced by Saarinen's company was the National Museum in Helsinki completed in 1904 and Saarinen's own initial entry in the competition for the design of Helsinki Railway Station in that same year was created on similar lines, very much as a national romantic building taking its exterior form from medieval church architecture. Although Saarinen was awarded the first prize, the architects Sigurd Frosterus[164] and Gustaf Strengell publicly demanded a more rational and modern railway architecture and Saarinen had to make radical changes in his design eliminating practically all

Generations of Helsinki children have loved this bear guarding the entrance to the National Museum (1902–10) designed by Gesellius-Lindgren-Saarinen in Finnish national romantic style. (Helsinki City Museum)

the national romantic elements, drawing on German building style and using reinforced concrete vaults in the elegant interior. Being a great architect he recognized that Frosterus had been right when he had declared,

> **"We in Finland no longer gain our livelihood from hunting and fishing; thus the plant ornamentation and bears – not to speak of other animals – are hardly suitable symbols for the present time based on the use of steam and electricity."**[165]

In other words the elements that had dominated the 1900 Paris pavilion were no longer valid for modern Finnish architecture and design.

By the time the station was completed in 1919 Helsinki had become virtually a new city. It had been the site of many political demonstrations, seen a general strike in 1905 and witnessed the launch in 1907 of a modern unicameral parliament based on universal voting rights for both men and

women. It had also witnessed the collapse of Tsarist Russia, the gaining of Finnish independence and a devastating civil war. But it had also become a city of teeming international business and cultural life, a city of cinemas and a blossoming film industry,[166] of cars and motoring and all kinds of electrical gadgets, and it had got a foretaste of a new visual world in exhibitions of works by such artists as Munch, Kandinsky, and Chagall.[167] The Railway Station, therefore, was Saarinen's necessary answer to Frosterus's legitimate demand for an architecture displaying "internationalism, individualism and rationalism which did not hesitate to call a task by its right name,"[168] and justifiably it became an internationally celebrated classic of a new but still recognizably Finnish national style.

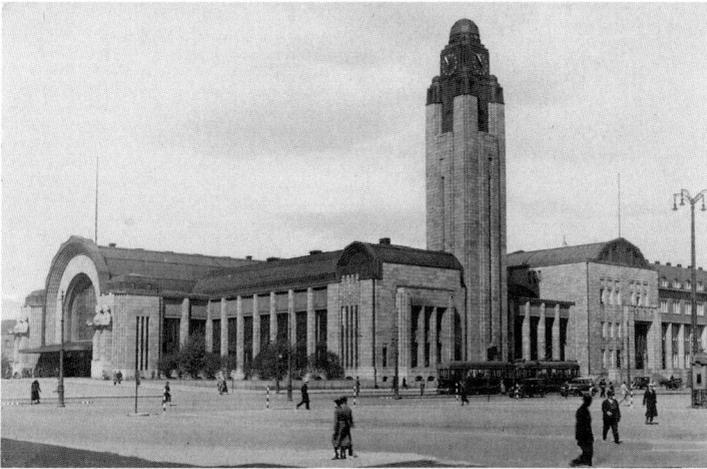

Helsinki's main Railway Station (1904–19), was originally designed by Saarinen in the national-romantic style but he was later persuaded to take account of more modern tastes. (Helsinki City Archives)

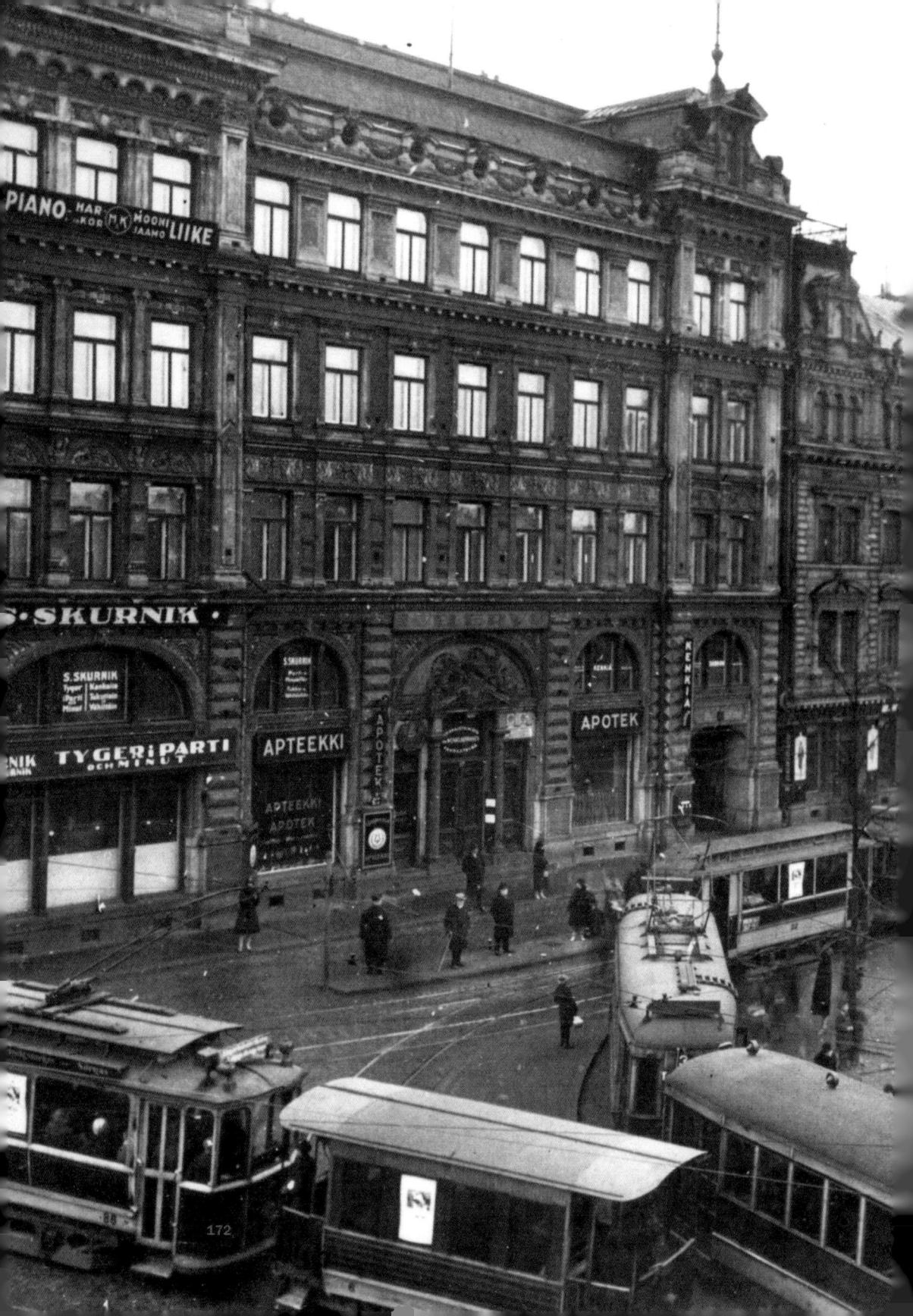

PIANO HAR-KOR MK MOOHI LIIKE PAANO

S.SKURNIK

S.SKURNIK
Tygel | Kanhain
Parti | Sekpinen
Minat | Vehilain

TYGER | PARTI
DEHMINUT

APTEEKKI

APTEEKKI
APOTEK

APTEEKKI
APOTEK

KENKIA

APOTEK

172

VI Helsinki Turns Finland into a Modern Society

The Legacy of the Civil War

A few months after Finland's declaration of independence on 6 December 1917 Helsinki and the whole country were struck by a disaster, the Civil War.[1] This started in late January 1918, when the Socialist revolutionaries (the Reds), supported by Soviet Russia[2], seized power in Helsinki and elsewhere in southern Finland, and ended in mid-May the same year when the government troops (the Whites) led by General Mannerheim marched into Helsinki in a parade of victory.

The war in Helsinki lasted just two and half months to mid-April when German troops, who had come to the aid of the Whites, occupied the city. Bearing in mind the ruthlessness normal in civil wars Helsinki, the base of the revolutionary government, suffered relatively little in spite of a number of murders and hundreds of temporary arrests. For ordinary citizens the main worries were the grave shortage of work and food and the harassment by Red Guard troops searching homes for weapons. The cityscape also remained virtually intact, although the Turku Barracks of the Russian troops on the site of the present Lasipalatsi were destroyed by the advancing German troops and there were huge bomb holes in the wall of the Borgström tobacco factory where a particularly tenacious group of Red women had resisted the might of trained German soldiers.

Helsinki has systematically developed public transport such as trams and buses. At a time when many cities were withdrawing their trams, Helsinki opened new routes and extended existing ones. This is Heikinkatu (since 1942 Mannerheimintie) in the 1930s.
(Helsinki City Museum)

The aftermath in Helsinki was more tragic, however, as Suomenlinna became one of the major concentration camps for imprisoned Reds, and there a great number of them succumbed to diseases caused by malnutrition. An extremely severe shortage of food in Finland had been one of the major underlying causes of the war to which the Finnish state had now to find a solution and it had been well nigh inevitable once the March 1917 revolution in St. Petersburg had stopped the normal import of Russian grain; the second problem had been the unemployment caused by the ending of Russian orders for Finnish industrial goods and the third the issue of the landless who formed some 40 % of the population in a country culturally so much tied to an agricultural way of life.

One of the most urgent issues concerned the children, who had been living in an unstable society from early 1917 onwards. They had experienced the violence of the March and October revolutions followed by a civil war, hunger, destruction and the break up of families. Wild and ill-mannered behaviour among children was much more common than before and in 1918–19 the municipal authorities even encountered fully orphaned children roaming the streets trying to scrape a living.[3] For their part the people of Helsinki concentrated therefore before anything else on the alleviation of the plight of its children.

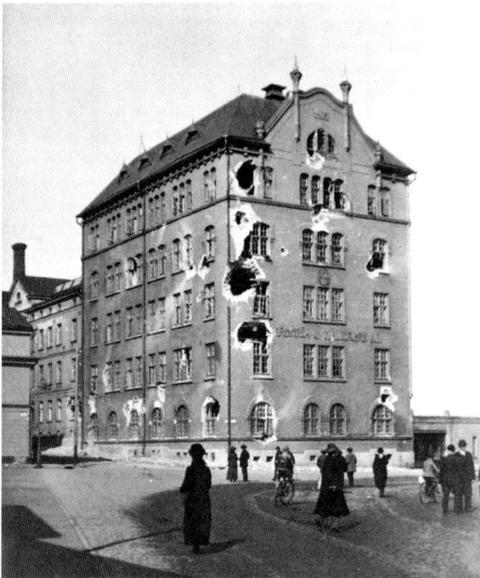

During the Civil War in April 1918 the workers at the Borgström tobacco factory defended their jobs to the last. (Helsinki City Museum)

"Helsinki – a Children's Paradise"

While carrying out emergency relief among Helsinki children the city officials recognised the need for a co-ordinating body and in May 1919 a child welfare committee was established. On its recommendation an independent Child Welfare Board started to operate at the beginning of 1922. It followed a comprehensive child welfare plan that was the first in any of the Nordic countries and also incorporated preventive measures.[4] Needless to say, this plan was kept up-to-date with the latest foreign developments by the sending of representatives to many child and youth welfare congresses.[5]

Two new major children's charities were also launched by two of the country's highest ranking personalities, Mrs Ester Ståhlberg, the wife of the President of Finland, and General Mannerheim. These new bodies were still necessary despite the fact that by 1910 there were already over thirty established charities giving priority to children.[6] *The General Mannerheim League for Child Welfare* was started in 1920 and Mrs Ståhlberg's *Homes for Homeless Children*, which later evolved into the *Save the Children Fund of Finland*, was launched in early 1922.[7]

It is significant that in a city where, after the civil war, Social Democrats held over 40 % of the City Council seats[8] it was nevertheless possible to establish efficient co-operation between city officials and private, mostly "bourgeois" childcare charities, and this non-party co-operation was a vital ingredient in the situation which helped Helsinki to its pre-eminence in this field. It dated from the previous century[9] and what mattered was not ideology but the practicalities in each particular case. The Mannerheim League aimed from the very beginning to improve the general conditions of children and from the early 1920s onwards provided playing fields, summer camps and other similar activities though in some "Red" parts of the city the same things were organised by the Child Welfare Board as any association with the name of the White General would not have been acceptable there.[10]

The most impressive examples of public – private co-operation were the actions taken to improve public education in child health care once it was established that many children's health problems were due to parents being ill informed. The Mannerheim League and another charity *Maitopisara* launched public campaigns and established the first advisory clinics for antenatal and baby care, and once the Helsinki City Child Welfare Board also got

involved and provided support for the expansion of these clinics they totalled eight by the early 1930s.[11] Alongside this the Child Welfare League commenced preventive work and health education by training public-health nurses in Helsinki, a total of 215 such nurses being educated between 1924–1931 in addition to some 50 nurses educated by *Samfundet Folkhälsan i Svenska Finland* in 1927–1930. In 1921 Professor Arvo Ylppö, the founder of Finnish maternity and child welfare clinics, had also launched a scheme for training nursemaids in Lastenlinna, a hospital founded by the Mannerheim League, and eventually several other services that had started the training of public health nurses on a private basis became the government's responsibility so that between 1931 and 1945, a total of 1,081 such nurses were trained in Helsinki. When the 1936 Act on Child Welfare was promulgated, the City of Helsinki could claim that it had already met the requirements of the new law. Similarly when the Maternity Benefit Act was passed in 1937, Helsinki already had all the required maternity and baby clinics in operation and could smoothly move on to implement this law also.[12]

It is worth noting, however, that although the 1920s had seen new developments such as child welfare clinics, the first steps in preventative school health care services had already been taken much earlier, in the late 19th century. Summer camp activities began very early compared with the rest of the Europe. In Helsinki the Schoolmistress Society had established the first school camps in 1895 giving city children the opportunity to "gain strength with wholesome food in the freedom of country life." The child also learned "amusing and useful work" in school gardens,[13] and the initiative of teachers was also behind the establishment of places for play and sports, and it was again on a teacher initiative that in 1914 the city employed its first "play leader ladies" for its playgrounds[14].

From 1905 onwards the city of Helsinki employed physicians in elementary schools who had the task of promoting pupils' health and preventing disease. They were also responsible for sexual hygiene and sex education, another innovation in Europe. Fittingly Helsinki's first school physician, and later professor of hygiene, Max Oker-Blom had already distinguished himself by writing popular sex education books, including *Hos Morbror-Doktorn på landet* [With Uncle Doctor in the Countryside], published in Finnish and Swedish as early as 1903 and later translated into nine languages.[15] Among

A mother and son at Avo Ylppö's surgery in 1921.
The professor of paediatrics, Arvo Ylppö (1887–
1992), became a symbol of the care of small
children. He founded maternity and child welfare
clinics. Arvo Ylppö's greatest achievement was the
founding of Lastenlinna children's hospital (on the
right). The hospital moved to its current premises,
designed by architect Elsi Borg, in 1948. (Helsinki
City Museum)

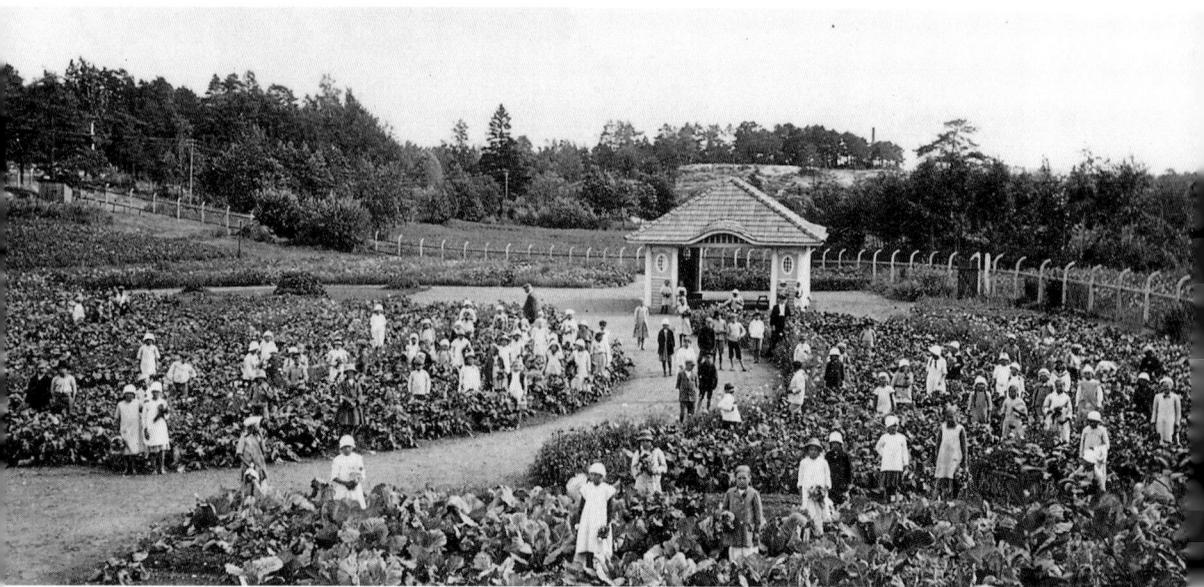

A school garden in Helsinki in the 1910s. Gardening was introduced as a subject of study in Helsinki elementary schools in the summer of 1912 using German models. School children worked their patches of land, growing different varieties of flowers and vegetables and sampling fertilizers. (National Board of Antiquities)

the first findings of the school doctors was the fact that most of the children were undernourished. For this reason *Kansakoululasten ruokintayhdistys* (the Association for Providing Food for Elementary School Children) started to provide school meals for the poorest of the pupils from 1907 onwards[16] and by 1913–1914 all elementary schools in Helsinki provided meals for poor pupils.[17]

Similarly dentists Th.Weber and Axel Aspelund had set up a dental care clinic for school children with their own funds in 1907, the same year that a dental care clinic was established in Stockholm, and they were supported financially by the city of Helsinki. However, it was not until the year 1925 that the first dental care clinic fully dependent on public funding was established in the city.[18] A decision was made to commission a survey concerning the condition of schoolchildren's teeth in 1927.

The advanced state of Finnish childcare was noted in Helsinki at the beginning of the 1930s by the British author, Kay Gilmour. It must have made a

strong impact on her because she uses the term "children's paradise" when describing the kindergarten affiliated to the Finland Ebenezer Training College.

> "In one morning I saw some 500 Finnish children between babyhood and seven years of age, offspring of the poorest inhabitants in Helsinki, and not a single face but was wreathed in smiles, or absorbed in a glow of interested contentment. 'What', I asked, 'is the secret of this Children's Paradise?' 'We believe that the occupied child is the happy child', smiled my guide, Miss Borenius of the Social Ministry".[19]

Ebenezer Training College in Helsinki and its pioneer teachers, Miss Elsa Borenius, Elisabeth Alander and Hanna Rothman impressed Gilmour powerfully. This institution had been established in 1890, and affiliated to it were Finnish and Swedish language kindergartens, day nurseries, and school children's day care centres applying the educational ideas of Fröbel, mainly based on play. The beautifully decorated doll's houses, versatile toys and a great variety of hobby equipment made Gilmour marvel at the endless creativity. She was particularly impressed by the way the children were taught to work at chores such as watering flowers or doing the laundry. According to Gilmour, "the Finnish educationalists have taken the German idea and developed it to the highest point".

Gilmour found that there was a desire to develop the idea of "no must, only may" in the Finnish kindergartens, and that the spirit of mutual help was much encouraged:

> "Downstairs we came to some particularly happy groups. One was carefully washing and watering the plants; another engrossed in polishing brass cooking utensils; a third, in a miniature laundry, was eagerly laundering doll's clothes." ... "More important even than the actual knowledge being acquired is, to my mind, the spirit of service engendered and the real co-operation, which prevails. Each child works for the house, and the school, and for each other, and the greatest privilege is to be allowed to help the teachers or 'Aunts'... One party of Children were enjoying their special privilege of peeling potatoes, others were giving expression in 'potatoes' to their artistic ideas.[20] Truly to realize the potentialities of a potato one must visit a Finnish kindergarten"... "The spirit of helpfulness, of working for the whole, of service before self is surely the quickest road to happiness. It is written all over the faces of the Finnish kindergarten children."[21]

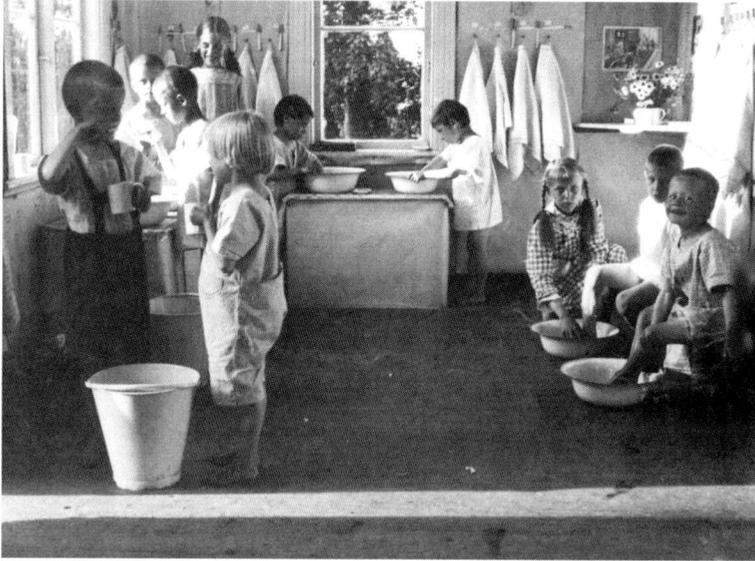

Children at their evening ablutions at a kindergarten summer camp in 1931. Healthy children were considered the strength of the recently independent state. City children who didn't have a place to spend the summer were sent to summer camps. They were taught basic personal hygiene and how to wash. Health education has played a major role in preventing disease. (Helsinki City Museum)

Gilmour's expression "Children's Paradise" lived on in the British *Children's Encyclopaedia*, edited by Arthur Mee, which in its 1941 edition included a section on Finland titled "A country in which everybody reads and likes to read". It notes that

> "Its provisions for the welfare of children, its model kindergartens and nursery schools have won for Finland the title of the Children's Paradise"[22]

The city had always been in the vanguard in terms of establishing kindergartens. The first Swedish language kindergarten had already been established in 1861 by Ida Lindroos, who had studied at the Fröbel Institute in Germany. Later Hanna Rothman became a legendary figure after she founded kindergartens in the 1880s for children from families of means as well as for children whose parents were less affluent.

Initially, however, Helsinki's municipal kindergartens were established mainly for children of indigent families and single mothers and were located in working class districts. In 1926, there were 26 such subsidised establishments in Helsinki, with a total of 2,525 children in the full-time departments. But during the 1930s the attendance of officials' own children increased[23] and a municipalization process that had begun in 1930 meant that the city took over 28 private kindergartens providing 2,575 places. A decision was also made to grant larger subsidies to private day nurseries and during the early 1930s the number of kindergartens in Finland rose to almost a hundred.[24] Further funds for development were provided by the 1936 Social Assistance Act, which directed some of the business profits of the state alcohol monopoly to municipalities including the city of Helsinki.

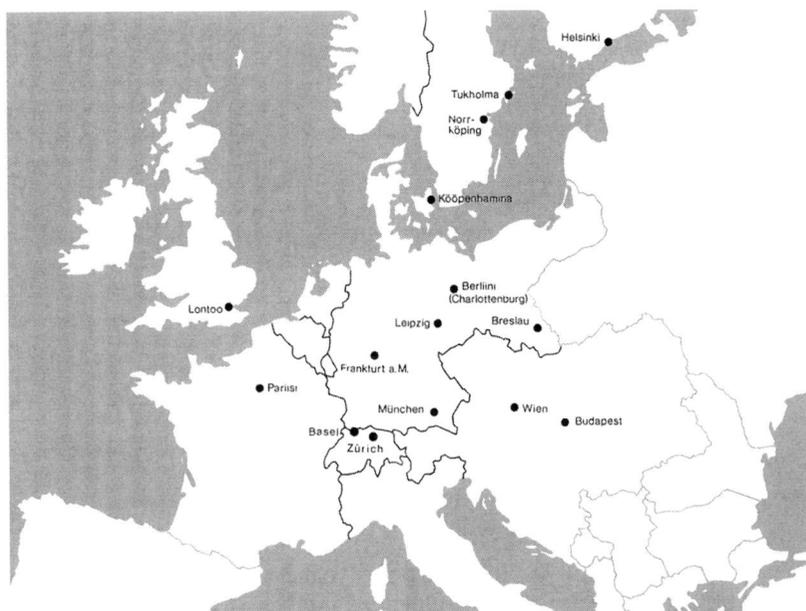

Map 4. Ms. Thyra Gahmberg was obliged to make a study tour before she could take a job as an inspector of kindergartens. For five months in 1912 she toured and familiarised herself with kindergartens in different countries.

When the city decided to establish the post of an inspector of municipal kindergartens the chosen candidate, Thyra Gahmberg, was given a scholarship so that she could make the study tour in Europe that was a requirement for the position. In her report she not only paid attention to teaching methods but also to the teachers' training, salaries, and working conditions. In the Swiss system she particularly admired the female teachers' personal freedom in choosing their working methods and their sense of responsibility. She was also interested in retarded children and their teaching as well as the regulations governing clothing, illness and sanitary conditions. In Budapest she was interested in the teachers' ability to play the violin, to dance, and to act as an accompanist. She supported the Fröbel method without reservation.[25] S. Warhenmaa, an inspector of municipal kindergartens, later received

International congresses provided an opportunity to get information on the latest know how in the field. Almost one thousand people, of whom half came from abroad, attended the International Union of Nurses congress held from 20 to 25 July 1924. The main private and public hospitals opened their doors to congress visitors, who also had an opportunity to visit Ebeneserkoti, the kindergarten teachers' training institute, and to see the work of child welfare clinics and Lastenlinna, the children's hospital. Besides the National Museum and art museums, the Finns also wanted to show visitors the Child Welfare Museum and Labour Welfare Museum. Likewise, visits were also arranged to the Academic Bookstore. The photo shows congress representatives in front of the National Theatre. (Helsinki City Museum)

300 marks in 1923 to familiarise himself with municipal kindergartens in Germany[26] and there was much co-operation at the Scandinavian level. There was great interest in the Scandinavian discussion of the Montessori method, and Elisabeth Alander in particular had close relations with Ellen and Maria Moberg of Norrköping and Bertha and Anna Wulff of Copenhagen. The professionalization and internationalisation of kindergarten work are evidenced by the fact that Helsinki hosted Scandinavian congresses on such topics in 1928, 1950, and 1978. Thus people in Helsinki created in an innovative manner a solid foundation for childcare in an independent Finland.

Fact-Finding Tours to Scandinavia Become the Norm

When we compare the periods before and after independence, it becomes clear that a solid basic infrastructure for Helsinki had already been constructed before the First World War. Education and health care services had reached international standards and specialisation had progressed. By 1917 the capital already had a functioning and satisfactory supply of energy and water, a good tramway system and an adequate road network. However, accelerating technical developments in all of these fields made it imperative for the city to continue its practice of sending officials on foreign fact-finding tours in order to find solutions that would provide the best possible long-term benefits for a city which was experiencing further industrialisation and had an ever growing population.

For this reason the City Council decided, in 1919, to include in the budget a general grant for city officials' study trips abroad[27] and applications were immediately invited. The condition of the travel grant was that the recipient would later produce a travel report and stay in the service of the city for two years after the trip. This decision meant also that the grant system became permanent. Representatives of each of the different branches of the administration received grants in almost equal proportions and the amount of the grants increased throughout the 1920s and 1930s.

International travel was clearly related to economic developments and business trends and naturally ceased almost entirely during the First World War.[28] For example in 1918, the only significant traveller was the building engineer K. V. Hedman who received a grant to attend an exhibition of low-cost construction materials organised in Berlin.[29] However, between 1918 and 1925, 80 officials received grants for trips abroad and between 1926 and 1930 the number of recipients was 144. As Table 4 indicates, the grants increased significantly in the latter half of the 1930s and again after the Second World War. Between 1936 and 1940, Helsinki City granted a total of 201 travel grants, and between 1946 and 1950 a total of 402. The contacts developed to at least the same extent* in the 1950s.

The depression years 1931–1935 and the war years mark distinct breaks. Between 1931 and 1935 there were only 118 trips and in the war years 1941–1945 only 70, mostly trips to Sweden to study civil defence. While before the First World War it had been usual to visit several countries and to make a grand tour of different cities, from the 1920s onwards the trips usually involved only one or two countries while the localities visited in the various countries were still quite numerous. The closer we come to our own era, the clearer this development becomes. This naturally reflects the changing nature of travel and, in particular, the switch from boat and train to plane. Sometimes the municipal reports do not yield information about the destinations, but on the basis of what evidence they do provide it seems clear that the Nordic countries were increasingly Finland's major reference group and trips to those countries increased throughout the 1920s and 1930s. Certainly they seem to have been the only major destination for travel in the period immediately after 1945 and while Germany had retained her position as an important destination in the inter-war years this did not appear to continue in the post-war period.[30]

Table 4. The number of travel grants for Helsinki municipal officials 1918–1960*

Period	
1918–1925	80
1926–1930	144
1931–1935	118
1936–1940	201
1941–1945	70
1946–1950	402
1951–1955	378
1956–1960	455

*These figures do not necessarily indicate the total volume of travel grants as the registration in some years seems to have been somewhat erratic.

Source: Kertomukset Helsingin kunnallishallinnosta (Annual Reports on the Helsinki Municipal Administration) 1918-1960

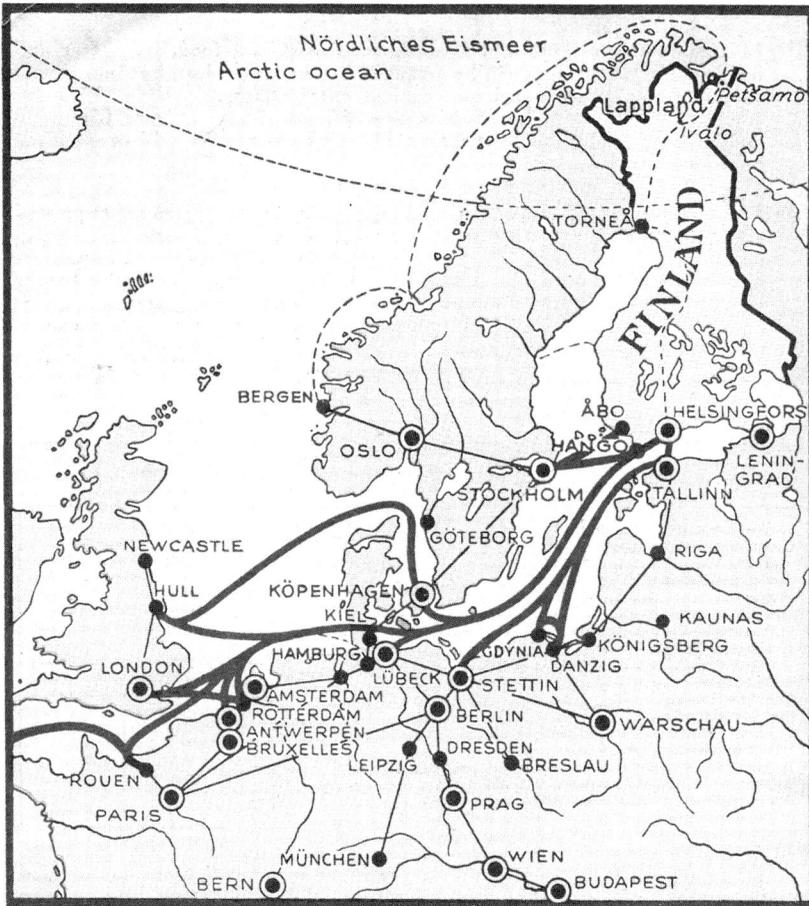

The map shows the boat traffic services from Finland to the Continent and on to the USA in 1936. (Archives of FÅA)

In many cases those travelling were people working in middle management or at a technical level as such people were more likely to discern more easily the innovative operational details of a process than their superiors who were more concerned with the overall picture. This is clear, for example, in the distribution of grants for the year 1931, when 36 municipal employees undertook sponsored travel. Although the recipients included a senior judge of the municipal court and a head of the fire brigade they also included an assistant housing inspector, a tuberculosis hospital assistant physician, an isolation hospital refectory assistant, a children's home headmistress, do-

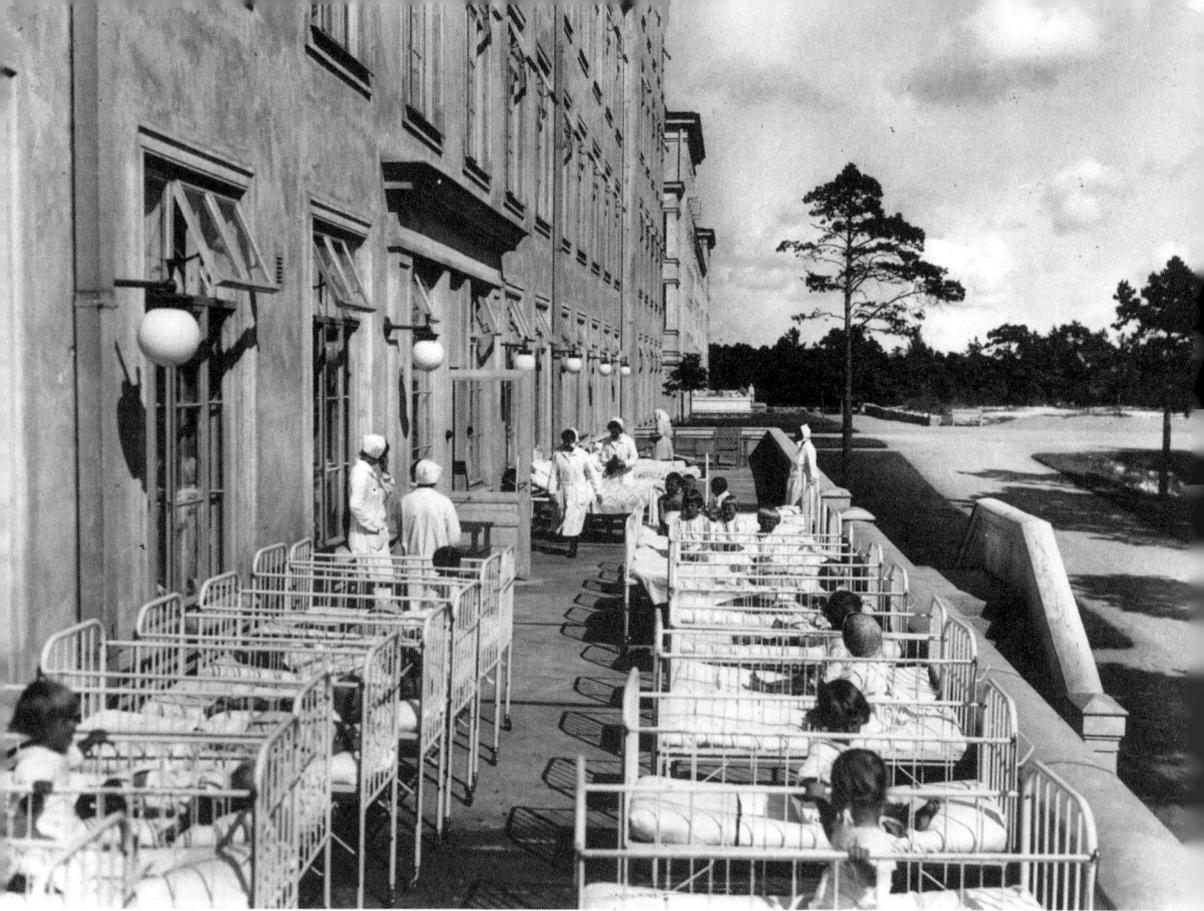

It was thought that fresh air had a beneficial impact on the treatment of tuberculosis. Some patients stayed in sanatoria situated on high ground, others were treated out of doors. Children suffering from tuberculosis slept in open-air wings. This picture is from the 1930s. (Helsinki City Museum)

mestic science teachers from an elementary school, an assistant to a water plant chemist and a foreman in the building department. As democratic and non-hierarchical practices are, according to Manuel Castells, among the characteristics of innovative societies, one can conclude that the City Council was thus supporting the innovativeness of its own employees.

Between the wars the connections with the city administrations of Stockholm and Gothenburg, which had already existed before the First World War, became closer. By now investment in the most important parts of the infrastructure had been completed, and the decision-makers began to pay

attention to rationalising the way in which their activities were conducted and how to encourage the best administrative practices. For example, two representatives were despatched to Stockholm in 1927 to familiarise themselves with the office equipment used there and to study its suitability for similar purposes in Helsinki.[31] When the Moderna Kontoret (Modern Office) exhibition was organised in the Swedish capital in 1935, Helsinki's chief accountant, N. O. Fellman, was sent "to familiarise himself with the latest innovations in office technology as well as machines and systems used in offices"[32] G. Brotherus, the city treasury clerk, also got a grant to study the organisation and work methods of Scandinavian municipal offices during his summer holiday.[33]

Standardisation was the key issue of the day in all fields of life and many of the trips undertaken reflected this. E. Streng, a hospital accounting office inventory assistant, received 2,000 marks in order to familiarise himself with the standardisation of the administration of hospitals' economies in Copenhagen while, in the private sector, the Finnish Association of Architects and the Finnish Association of Master Builders established as early as 1919 a committee for standardisation. They published recommendations for standardised types of windows and doors and the model drawings were then distributed by voluntary civic organisations throughout the country. Such ideas were further developed during the Second World War and during the post-war years the standardisation of all construction elements became the rule except in the case of a few important public buildings, such as Mäntyniemi in Helsinki, the residence of the Finnish President, which was custom built to the smallest detail.[34]

In the 1920s the City also concentrated on extending its already existing communication networks. New tramlines were constructed both in the city centre and to newly developed outlying areas and by the turn of the 1920s and 1930s, most of the city's tram network was finally completed. Close attention was increasingly paid also to traffic conditions.[35] The growth of car traffic necessitated better street surfacing. Asphalting had begun with the pavements, but in the early 1930s asphalt was increasingly used to surface the streets themselves. In 1930 the first hot asphalt station was erected, and while in 1929 51,000 square metres of streets in Helsinki had been

paved with cobblestones by 1931 no more than 9,900 of these remained.[36] However, the remaining cobbled streets provided an unsuitable surface for bus traffic and also raised other problems because the earliest cars lacked air tyres, which only became obligatory in 1937.

The leadership of the harbour department developed close connections with harbour departments in the Baltic countries. Harbour warehouses and customs practices were studied in the 1930s in Stockholm, Malmo, Oslo, Copenhagen, and Stettin[37] while the department also created a connection with Leningrad harbour department as early as 1936.

Cooling technology, the construction of industrial kitchens and the modernisation of refuse disposal by burning were other topical concerns during the interwar period and entire delegations travelled to study the latest machinery, especially in the 1920s and 1930s.[38] Oscar von Hellens, the chairman of the health care board, received a grant in 1927 to familiarise himself with the long-term pasteurisation of shop milk. Two years later the inspection of milk was transferred from private inspection bodies to a municipal organisation. This change to tighter civic control reduced the total amount of inferior milk from 15–20 % to only 2–3 %.[39]

Health care also remained a very urgent concern, as epidemics and high death rates remained acute problems throughout the interwar period. Nevertheless infant mortality had already been decreasing rapidly since the 1900s, reaching 5.7 % in 1934.[40] Tuberculosis and its prevention particularly troubled decision-makers, as there were 20.3 deaths from tuberculosis for every 10,000 people in 1917–20.[41] Thus a model for a new tuberculosis hospital was sought from abroad. In 1938, tuberculosis physician A. V. Virta travelled to Stockholm, Gothenburg, and Copenhagen to study tuberculosis treatment methods.[42] Mental health and deviations were also of considerable interest and work in this and other medical fields often took officials to the United States, the destination also of regional physician R. Lagus who attended an international psychological welfare conference[43], and Y. Seuderling, the chief of Kivelä hospital X-ray department who was sent to an international radiologists' congress in Chicago.[44]

The burden of poor relief was a severe problem especially during the depression years of the 1930s. The City especially subsidised the operation of voluntary general-purpose associations in the 1930s (the YMCA, the Salvation

Army and the City Mission, for example) and accepted a request from Finland's Nurses Association for city funding to enable municipal nurses to participate in the second Scandinavian nurses' congress in Oslo.

But it would be wrong to imagine that early twentieth century Helsinki was simply a borrower of advice and expertise from other countries. It was also a place of enterprise and inventiveness serving the whole country as the many technological developments that took place there in the 1920s and 1930s demonstrate.

Helsinki Helps in the Building of the Nation

The economic and political turmoil surrounding the First World War had in many ways been the turning point for the progress of Helsinki as an industrial centre as within the space of two years, 1916–17, the city became the site of three major research institutes which were not only vital tools for advancing Finnish exports but also for the starting of advance level research among businesses in cooperation with them. These were the Helsinki-based research bodies, *Keskuslaboratorio* (the Central Laboratory, est. 1916), the *Chemical-Bacteriological Laboratory* (est. 1916) and the *Forestry Research Institute* (est. 1917).

Before the war the only proper research institute in technology had been the *Material Testing Institute* established in connection with Helsinki Polytechnic Institute in 1890 following western European models. Up to that time the Polytechnic Institute itself had been largely content merely to help produce a workforce adequately trained to apply foreign technology in a Finnish industrial setting[45] and had only a very limited research capability. However, the new Institute had a far more positive role. Undoubtedly its testing of construction materials such as Portland cement and its observation of the behaviour of natural stone in the Finnish winter proved useful when Jugendstil Helsinki was in the process of being built. Even so the Material Testing Institute was able to serve only a very narrow sector of industry while other sectors had not as yet seen the value of furthering Finnish research and development activities.

The situation changed profoundly however with the closing of the Russian markets in 1917. This forced Finnish businesses to seek customers in the

west where success depended not just on the quantity but even more on the quality of their products. The anticipated changes had already led to the establishment in 1916, on the initiative of the forest industry, of a private research institute called *Keskuslaboratorio* (the Central Laboratory) based on German and especially on American models. Starting with extremely modest facilities the Laboratory developed methods for controlling the quality of paper pulp on site thus helping the Finnish paper industry to expand in the 1920s and 1930s into the highly competitive European and American newsprint markets. However, because of the fierce battle thus provoked the laboratory did not have the resources to develop into the strong, independent research centre needed to lead the R & D of the country that its founders had hoped for. It was, therefore, the two other new Helsinki-based institutes, the Forestry Research Institute and the Chemical-Bacteriological Laboratory, that were to play a vital role in securing the long-term success of Finland's traditional exports, timber and butter.

In the field of forestry management Finland had been a pioneering country since the early 19th century. The foundation for establishing forestry as a scientific discipline was laid in 1909 when A. K. Cajander published his internationally renowned theory of biological-geographical forest types, *Über Waldtypen*.[46] In the early 1920s the Forestry Research Institute launched the first systematic evaluation ever of the country's total stock of timber. This and subsequent evaluations (the ninth to be completed in the early 21st century) have provided comprehensive data about forest growth providing the basis for the rational maintenance of the Finnish forest resources by means of systematic re-plantation. The importance of forest research to the national life is symbolised in the *Metsätalo* (Forest House), which was erected in 1939 in Helsinki close to the University to accommodate both the Research Institute and the highest academic forestry teaching in the country.

 A more immediate impact on the national economy was, however, made by the Chemical-Bacteriological Laboratory, which was established by Valio, the Helsinki-based marketing organisation of the farmers' co-operative dairies. Valio had already in 1912 started actively to seek ways of developing Finnish dairy produce and especially the quality of butter, which in 1907

represented nearly 14 % of the total value of Finland's exports.[47] The founding document of the laboratory from 1916 reflected a profound change in attitude towards the value of scientific research for the industry.

> **"It is nowadays generally acknowledged that it is not possible to raise any industrial sector high enough on the basis of experience gained in practical work but that it is imperative to get the support of science. Recent experiences alone have already proved that only a country which is basing its whole economy on scientific research can gain and maintain the first place in the economic battle between nations."[48]**

In the early 1920s the laboratory became a centre of biochemical research, introduced into Finland by its director, A. I. Virtanen, who had studied in Germany, Switzerland and Sweden and by the end of the 1920s Virtanen's team had produced two major innovations: the AIV butter preservation salt and the AIV-method of preserving silage for cows, which in Finland are kept permanently indoors for the 7–8 most inclement months of the year. These radically improved the productivity of Finnish dairy farming and secured the competitiveness of Finnish butter in world markets in the period up to the 1940s.[49] Valio was later able to sell the AIV patents to the USA, Canada, Switzerland and even Germany and Virtanen himself, who had in the 1930s moved on to study enzymes and vitamins, was awarded a Nobel Prize for chemistry in 1945.[50]

While the agricultural and forestry research institutes still continued in the 1950s to form about half of the national research system[51] Finland had, nevertheless, already started to change into a clearly industrial nation between the world wars. In the spirit of building up the nation whose key industries should not be dependent on any outside power the state established a sulphuric acid factory, the predecessor of the present day Kemira, thus founding the modern Finnish chemical industry. The state also funded the establishment in Imatra of the first hydroelectric power plant to supply electric current over long distances. Furthermore, the development of the Outokumpu copper and Petsamo nickel mines in the 1930s made Finland a significant producer of some of the most coveted non-ferrous metals in Europe.[52]

For the general public the most tangible nation-building project was, however, the complete electrification of the whole country, which became possible

once the technology of transmitting power over long distances had been adequately developed.[53] In 1925 it was already estimated that some 40 % of the Finnish countryside was provided with electricity, but because of the country's huge land area, fragmented by more than a hundred thousand lakes, its sparse population and the interruption of the war years it was not until the mid-1970s that the whole country was finally electrified.[54] – Ironically it was this general electrification, far more than the development of the timber industry, butter production or the metal industry, which created the basic foundation for the modern high tech Finland, which has Helsinki as its hub.

In such promising circumstances, and given the presence of such obviously talented people as Gottfrid Strömberg and Eric Tigerstedt, "the Edison of Finland",[55] it would have been reasonable to expect the emergence of at least some internationally significant electricity companies in Helsinki. The Swiss Brown Boveri & Cie (est. 1891) and the Swedish ASEA (est. 1883), for example, had both managed to extend their business activities beyond their quite limited home markets[56] and Gottfried Strömberg's company, although having started modestly in 1889 in rented old sauna premises in a backyard in Eerikinkatu,[57] did in fact develop in time into a major high tech company employing some 1,300 people by 1939.[58] Other major Helsinki companies with similar potential were Suomen Kaapelitehdas (The Finnish Cable Works) established in 1912, a manufacturer of cables for power transmission and telephone and telegraph networks; and Ab Kone Oy (est.1910), which had begun manufacturing electric lifts and joisting devices in 1918.[59] There were also the two Helsinki-based radio manufacturers, Helvar Oy (est. 1921) and Fenno-Radio (est. 1924) which both began the production of radio sets long before the beginning of regular transmissions by the Finnish Broadcasting Company in 1927.[60]

However the fact that the development of such enterprises still remained so limited at this stage was partly due to the competition of foreign technological companies, which had begun to realise the potentialities of Helsinki. For them Helsinki provided a good bridgehead for expanding into the rest of Finland, which they found a small but interesting market with well-functioning central and local administration, a western legal system, good educational institutions and a quite well developed system of communications.[61] Thus not only AEG, ASEA and Brown Boveri & Cie but also other international high-

Fresh fish has been sold in Helsinki's central market square since the 1880s but the sale of cheese and meat was forbidden for reasons of hygiene. The market hall in this picture was built in the late 19th century from European models to protect foodstuffs from sun and dust. (Unknown painter 1890s, Helsinki City Museum)

Jugendstil houses in Bulevardi. (Helsinki City Tourist Office)

In some winters the coastal waters of Helsinki freeze. People skating in front of the Suomenlinna fortress. (Helsinki City Tourist Office)

The Market Square has retained its attraction for Helsinki's residents despite the emergence of several 'shopping paradises' around the area. Furthermore, the Market Square is a place that all visitors to Helsinki see at some point. (Helsinki City Tourist Office)

Kiasma, the National Museum of Contemporary Art in Helsinki, designed by the American architect Steven Holl, has aroused much international admiration. With this new museum, the provision of art exhibitions in Helsinki has been brought to a high international level. (Photo Jussi Kautto)

Helsinki has become a real summer city. People having a picnic in the Esplanade Park. (Helsinki City Tourist Office)

An open-air terrace in front of the Café Strindberg on the North Esplanade. (Helsinki City Tourist Office)

In the early 1950s Armi Ratia (1913-1979) who had been trained as an applied artist, began to print gaily coloured fabrics on her small printing press in Helsinki. Showing the Marimekko spirit became a way of life in Finland. Ratia´s marketing target was that every Finnish woman should own at least one Marimekko dress. Marimekko´s *Jokapoika* (Every Boy) shirt for men, designed by Vuokko Nurmesniemi in 1956 became the best selling Marimekko product ever. (Marimekko, Jokapoika, Photo Ari Lyijynen)

Since there has been such rapid growth in Helsinki during the last few decades, there has been a constant shortage of housing so that many former harbour, industrial and storage areas have been used for that purpose. The Ruoholahti area, including Jätkäsaari and Munkkisaari, have been designated a new central seaside district intended to attract 22,000 inhabitants and 15,000 jobs. IT firms were among the first to move into this high-tech area. (Photo Vesa Peltonen)

The Viikki Infocentre Korona, designed by architects Hannu Huttunen, Markku Erholtz and Pentti Kareoja was completed in 1999. The information centre was constructed on the basis of the winning entry in a competition held in 1996. The central part of the building consists of a large science library and a branch of the Helsinki City Library. (Photo Studio Voitto Niemelä, Helsinki University)

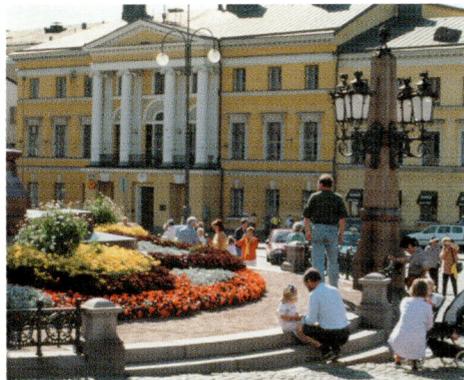

Architect Carl Ludwig Engel (1778-1840) designed the Senate Square in neo-classical style. On the south side of the square, opposite the Cathedral was the Helsinki Magistrates' Court. (Helsinki City Tourist Office)

On the north side of the Senate Square is the Lutheran Cathedral (completed in 1852) that dominates the square. The Cathedral, formerly the Church of St Nicholas, is a reminder that during the Autonomous period Finland was allowed to keep the Lutheran Church. (Helsinki City Tourist Office)

The Market Square and the North Esplanade

The Viikki Ecological Housing project aims to create realistic designs for ecological housing in an urban area. Viikki is a large nature conservation area with tracks for walking, cycling and skiing. Two bird observation towers are located close to the wetland area and it is one of the major sites in Southern Finland for observing migrating birds. (Photo Jussi Tiainen, Helsinki University)

Suomenlinna (Viapori/Sveaborg) was declared a World Heritage Site by Unesco in 1991. The sea-fortress was built during Swedish rule to provide a stronghold close to the Russian border. In 1809 Suomenlinna was surrendered for the use of Russian garrisons. Nowadays it is home to museums as well as to the Finnish Naval Military Academy and numerous inhabitants who live in renovated barracks or have built houses on the island. (Helsinki City Surveying Department)

The monument erected in honour of the longest-serving president of Finland, Urho Kaleva Kekkonen, president from 1956 to 1981. The monument, called Spring, was designed by the sculptor Pekka Jylhä and takes the form of a stainless steel pool illuminated from below. The monument was unveiled by President Tarja Halonen on the centenary of President Kekkonen's birth, September 3, 2000. (Helsinki City Art Museum)

tech companies, such as AGA, Ericsson, Westinghouse and Thomson-Houston all either established subsidiaries in Finland, acquired shares in prominent Finnish companies or appointed influential agents in order firmly to establish themselves in the Finnish market place.[62] In the early 1920s Oy Gottfr. Strömberg Ab, the top high tech company in Finland was actually the target of takeover bids by the German Siemens, the Swedish ASEA and the American Westinghouse and Thomson-Houston companies after a string of loss making years attributable to dumping by its foreign competitors.

The arrival of such foreign companies did not however finish off Strömberg, and in 1930 it became jointly owned by the Swiss Brown Boveri & Cie (who took 29.1 % of the shares) and the Swedish ASEA (29.1 %) with the Finnish shareholders left holding 42 %.[63] This was the result of negotiations in Switzerland instigated by the Finnish Ministry of Defence, which had become concerned about the fate of orders given to the Swiss company with Strömberg acting as an intermediary.[64] By that time the Finnish electrical industry's share of the total sales of generators and electric motors in Finland had dropped from about two-thirds to one-quarter while their exports had shrunk to no more than a modest amount.

However, a further factor inhibiting Finnish development may have been the impact of this foreign influence on the professional standing and credibility of the Finnish electrical engineers themselves. In the early 1900s it was difficult for an electrical engineering graduate trained in Finland to get any significant post in his own country as Finnish industrial leaders preferred to employ either foreigners or Finns trained abroad. Thus many Finnish electrical engineering graduates sought work outside the country to acquire the necessary experience[65] and others were expected merely to apply foreign technologies in Finnish production systems even if they had been able to develop their own R & D skills during their foreign studies.[66] Indeed, in 1913 one engineer had expressed his disillusionment in the engineering journal *Teknillinen Aikakauslehti*

> "By today we have not dared to embark, on our own, on any important task without the help of foreigners. Even less have we achieved anything new, for example in the fields of water works or railway systems, as our contribution to the progress of technology. Everything new that we introduce or construct is merely more or less a successful imitation of foreign models."[67]

Already since the 1900s, a number of Finnish engineers were accepted to train and work in several different foreign countries and companies for lengthy periods and through their experiences abroad, information about Finnish skills in engineering as well as knowledge of languages got about in Europe and the U.S.[68]

Nevertheless, for the native electrical companies a major opportunity emerged with the new electricity law of 1928, which gave every Finnish citizen the right to establish an electricity utility, a measure considered more liberal than its counterparts in many European countries.[69] The "finnification" of the new technology, which had already started in the 1840s, had continued with new vigour in the 1920s when a Finnish language terminology was systematically developed for electro-technology making it more accessible to ordinary people[70] while the number of electricity related publications in Finland more than doubled in the 1920s including many titles dealing with the electrification of rural areas and a total of nine correspondence courses on electricity and its installation.[71] These developments naturally benefited the native electricity companies and some were consequently also able to shake off foreign competition in their own particular field.

Indeed, the 1930s was for the Helsinki electricity related companies a period of growth in spite of the worldwide recession. Hankkija, the Helsinki-based co-operative wholesaler of agricultural machinery, was a major designer of local electricity grids for rural electricity firms.[72] Oy Suomen Kaapelitehdas Ab managed to overcome the domination of the Finnish markets by German firms[73] and by 1938 supplied some 80 % of all cables required in Finland. The same firm also began to export its products to Estonia and the Netherlands.[74] Strömberg almost trebled its production in terms of gross value between 1928 and 1939, especially after the inclusion of electric cookers, cooking plates, hot water and central heating boilers in its production programme in 1936. The consumption of electricity in Helsinki increased annually by 12 % and Strömberg became the market leader supplying nearly 30 % of all new electrical equipment.[75] The former subsidiary of Strömberg, Ab Kone Oy, raised the standards of its lifts to the international level and was thus able to profit from the boom in housing development in the Helsinki of the 1920s and 1930s as well adding cranes and electrical escalators to its list of products.[76] Electric lamps were supplied by Oy Airam Ab, which had begun as a renovator of damaged foreign light bulbs. It began domestic

production once it had been taken over by a Finnish consortium including Suomen Kaapelitehdas and Oy Strömberg Ab,[77] and in the early 1930s it was embroiled in a trade war with a foreign cartel of light bulb manufacturers. However, the Helsinki-based company survived with the help of an increase in import duties[78] and is still the major supplier of light bulbs in Finland.

The early 1930s also saw the development by Professor Vilho Väisälä of the radiosond, an important meteorological innovation, which could be used for measuring the strength and direction of winds and the condition of the atmospheric layers, e.g. pressure, temperature, humidity and radioactivity, even at a height of thirty kilometres. It was the first product of Finnish technological research to gain wide international markets and his company, Vaisala Oy based in Helsinki, was later to supply a variety of sonds not only to UN meteorological projects in the 1970s and later to individual developing countries [79] but also to the US Department of Defence and the Department of Transport in the 1990s.[80] Väisälä, a professor of meteorology at Helsinki University, was thus possibly the first Finn successfully to exploit a niche in the international high technological market in a way that many of his compatriots were later to try and emulate.

The City of Helsinki
Pioneering Service to the Consumer

Given the longstanding interest shown by the people of Helsinki in electricity it was only to be expected that the city would be one of the leaders in the adaptation of that modern source of power for everyday use. The first electrical irons had been seen there as early as 1888 while electric cooking plates had been introduced, equally early, in 1905.[81]

The provision of electric lighting improved considerably due to competition between the electricity companies especially in the early 1910s, when the newly established Municipal Electricity Company battled for customers with the last private supplier using as its weapons not only increasingly efficient services employing the latest technical devices but also, most potently perhaps, a policy of lowering tariffs. The Company also pioneered in Finland the development of a consumer information and advisory service, spreading an understanding of the new technologies by means of lectures, exhibitions

Table 5. The standard of equipment in Helsinki dwellings 1910-1998
(Share of dwellings that were equipped)[1]

	1910	1920	1930	1950	1960	1970	1980	1990	1998
WC	32,4	43,9	68,8	74,1	82,5	93,2	97,1	98,7	99,5
Water pipe	62,2	71,6	85,7	82,0	88,6	95,6	98,4	99,6	99,8
Warm water				40,4	67,2	89,4	96,1	98,1	99,0
Bathroom	19,2	23,5	34,4	44,3	59,1	78,1	88,8	94,2	97,4
Gas	31,5	42,5	67,3	60,9					
Electric light	27,8	91,7	98,6		99,9	100	100	100	100
Central heating				63,1	81,7	93,2	96,3	99,1	99,5
Sink	60,0	65,5							
Sewerage				82,2	89,1	95,8	98,4	99,7	99,9
Private sauna									
(in flat)							7,7	13,3	24,6

[1] Different variables have been used in surveys during the 20th century; for every year information is available only on WCs, water pipes and bathrooms.
Source: Helsinki tilastoina 1800-luvulta nykypäivään, p. 55.

and demonstration. Thus by 1939 the city's homes enjoyed better and more customised lighting arrangements than could ever have been imagined twenty years earlier.[82]

The Company saw the final disappearance of its only remaining private rival in 1912 but another powerful adversary remained, the Municipal Gas Company, which had by 1910 provided gas mains to some 37 % of all dwellings and as early as 1900 had founded its own show room in which to introduce consumers to the use of the latest appliances. Consequently by the end of 1905 Helsinki households had a total of 3,100 appliances using heating gas, of which nearly 1,000 were gas cookers. As one can see in Table 5 gas was still used in 1950 for cooking in 60.9 % of the households in Helsinki.[83] However, the approach of the City Council to the two rivals was not even-handed. They firmly took a stand for electricity and, in their budget for 1912, lowered the domestic tariffs. This completely undermined the competitiveness of gas as a source of indoor lighting and by 1918 it had lost that particular market to electricity.[84] Subsequently private electricity consumption in Helsinki increased fifteen fold between 1910 and 1930 from 1.1 million kWh to some 15.8 kWh. But as 87 % of all installed household electricity

meters in 1930 were used purely for measuring use in lighting,[85] it is quite obvious that gas maintained its position as the primary energy source for cooking.

But the Municipal Electricity Company was not just interested in providing lighting. From their earliest days they were also keen to promote the use of electrical appliances, especially in the home. Bernhard Wuolle, the company's managing director, was convinced of their future after reading accounts of their use in Swiss and German publications[86] and as a beginning the company appears to have joined forces with AEG, which on its own behalf had embarked on the systematic marketing of electrical cooking plates, kettles and other equipment as early as 1908 by publishing as many as 20 catalogues of products they could supply [87]

In 1912 the Municipal Company launched its own series of consumer information booklets on electric stoves and cookers, vacuum cleaners, irons and washing machines, and it also established, in Kasarminkatu, a permanent exhibition where members of the public could get first hand experience of using such equipment. To begin with their campaigning was targeted at wealthier families emphasising not only the convenience of electricity as a source of power but also pointing out that despite the relatively high cost of electrical appliances savings could made be made by reducing the need to employ so many servants. The Company's advertising made great play with the vision of a Self-Operating Kitchen suggesting as early as 1912 that in such a kitchen various electrical devices could be connected to a central motor in the middle of the room, providing power for

> "... a potato peeler, an egg whisk, a coffee grinder, a fruit juice extractor, an ice-cream maker, a butter churn and a mixer of bread dough. It is obvious that by using such equipment one can manage with a smaller number of servants and thus make considerable savings."[88]

The early campaigning appeared to be quite promising and the 13 items of electrical household equipment in use in Helsinki in 1910 had increased to at least 166 by the end of the next year[89] though this was a mere flea-bite given the fact that the city had by then a population of some 140,000 (see Appendix II). Moreover, although the number of middle-class women working outside the home was increasing[90] so also was the number of domestic servants at least until the end of the 1920s.[91] The Company seems therefore

Helsinki families started acquiring domestic appliances in the 1920s and 1930s. The picture shows early advertisements for machines. Today Finns are among the greatest consumers of coffee in the world. (Vuokko Lepistö, Joko teillä on priimuskeitin?, Helsinki 1994, pp. 116–117.)

to have widened its target audience and to have put a special effort into promoting the use of the electric iron, which could benefit the ordinary housewife and the housemaid alike. By November 1930,[92] over 18,000 such irons constituted nearly 44 % of all the electric household equipment then being used in Helsinki. Other items were also suited to general use. There were nearly 9,000 vacuum cleaners, which had first been introduced as "dust-suckers" in 1914 and were also of use to both housewives and maids, while the large number of cooking pans, kettles and hot plates (over 6,000) may have reflected the fact that in the same year some 16,300 people in the city were living as subtenants.[93]

What was striking was the total absence of full-size electric cookers. In fact there were only 278 electric ovens and one of the main reasons was the construction boom in the 1920s, when many new apartment buildings, for example in Töölö, were universally equipped with gas cookers and water heaters.[94] Obviously the promotional efforts of the Municipal Gas Company had paid off, for the first women's housing conference, held in Helsinki in 1921, had recommended that a gas cooker should be a standard fitting in every kitchen even though it should also be equipped with electrical appliances and a wood-burning stove where there was no central heating.[95]

However, electricity was gradually winning the race. By 1930 Helsinki had expanded its electricity works and the contract it had signed with Imatran Voima, the newly established hydroelectric power supplier, made much surplus energy available.[96] Consequently from the late 1920s onwards the

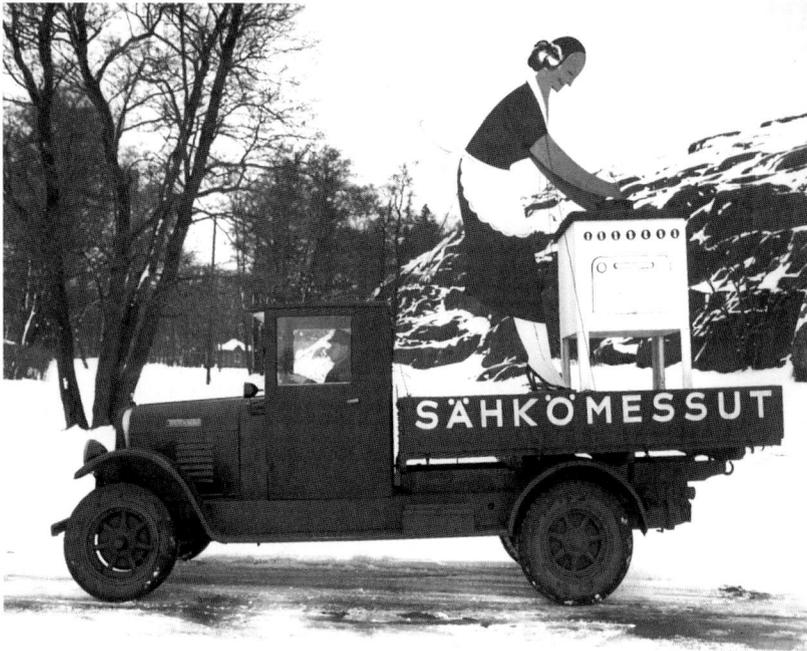

The first electricity fair in Finland was held in the Fair Hall in Helsinki from 24 to 29 March 1936. The first Finnish electric stoves were then introduced by Strömberg Ltd. The slogan was "Cook with the white coal". However, in spite of many such campaigns, gas stoves are still being used over large areas of Helsinki. (Helsinki City Museum)

Municipal Electricity Company embarked on a campaign to increase the use of electricity for cooking. It hired a consumer advisory engineer, installed electric cookers at the Girls' Vocational School (where gas stoves had previously been provided by the Municipal Gas Company in 1912) and again effectively reformed the electricity tariffs. Consequently hotels and restaurants became interested in completely electrified kitchens, the first of these being installed in the Hotel Torni in 1931 while 1932 saw the completion of the first building in Helsinki where electric rather than gas cookers became a standard fitting in the kitchens of all the private flats.[97]

It was, however, the Helsinki fairs of the 1930s that provided the Municipal Electricity Company with the best opportunity to promote electricity nationally on a really major scale. At the 1932 food exhibition, visited by 48,000 people, it displayed a fully electrified kitchen, where the general

public was given a demonstration of the possible uses of what a decoration on the stand described as "a native, clean, healthy and cheap source of energy." The 1936 fair, specially mounted to promote electricity, which was described in a kitchen context as "energy from white coal" was visited by 16,000 people and the Municipal Electricity Company had two stands, one of which was dedicated entirely to practical demonstrations.[98] The whole process was a striking example of how the company continually pursued its policy of educating and developing the understanding of the consumer in the face of modern opportunities.

The fairs saw the launch of a number of Finnish-made appliances, such as the "Mainos" electric iron in 1930, the first Finnish electric cookers in 1932 and full range of appliances from Strömberg in 1936.[99] These events certainly popularised the use of electric cookers in the Finnish kitchen and by early April 1938 the thousandth electrified kitchen was being connected to the power utility's network.[100] Such success obviously posed a challenge to the Municipal Gas Company, and it too was represented at the 1938 food fair, which attracted 50,000 people. According to Harry Röneholm both companies had very successful information sections where they demonstrated the advantages of their respective cookers and the most economical ways of using them. In such a setting it was also certain that the ideas and methods developed in Helsinki would be passed on to the country at large.

Helsinki Fairs as a Stimulus to National Innovations

The city's great enthusiasm for active participation in some of the fairs in the 1930s well demonstrated the growing importance of national exhibitions in Finnish life.

The first general exhibition to be held in an independent Finland opened on 27th June 1920 and was immediately hailed as a major national event. Thousands of flags were flying round the city. The President of the Republic, K. J. Ståhlberg made the opening speech and Jean Sibelius conducted his Jubilee Cantata. Altogether some 120,000 people visited the fair where the products of some 1,000 exhibitors (760 of them Finnish[101]) were displayed in stands and pavilions, nearby schools and neighbouring open spaces.[102]

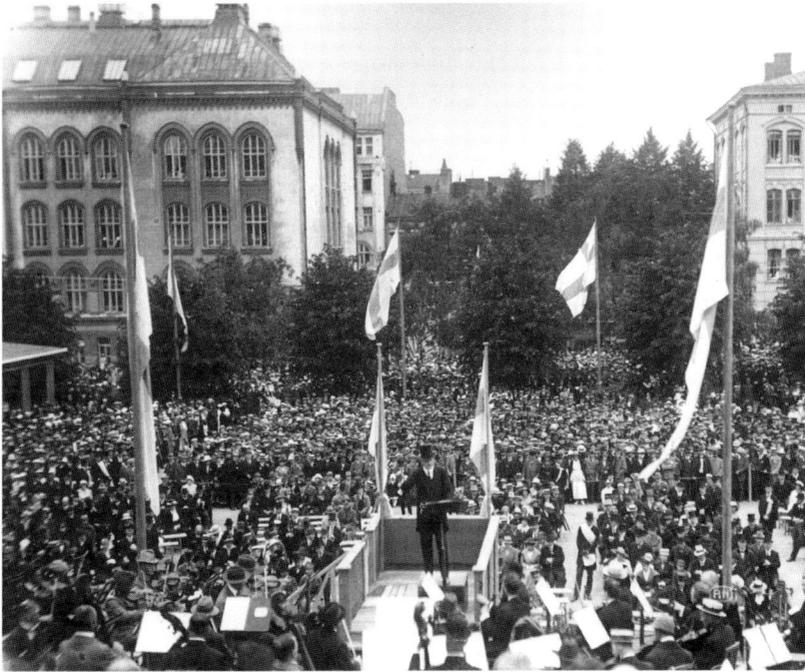

Independent Finland's first Finnish Fair was held in Helsinki in the summer of 1920. The exhibition planners included architects Carolus Lindberg, Armas Lindgren, Alvar Aalto and Eliel Saarinen. There were almost 1,000 exhibitors, one fifth of whom were foreign businesses and associations. At the opening ceremony on 27 June 1920, the Suomen Laulu Choir and the Helsinki Symphony Orchestra were conducted by Jean Sibelius. (Helsinki City Museum)

The engineering, metal and woodworking industries formed the largest group among Finnish exhibitors (146). Other industries included those concerned with paper and printing (111 stands), and the textile and clothing industries (95 stands). There were also numerous stands displaying food and beverages (67 businesses in all) that gained great popularity among the public and the media, in addition to stands of leather and footwear as well as of the chemical industry. Various shops and agencies also had their own displays.[103] Foreign businesses from Sweden, Germany, the United States, Norway, Estonia, England, Denmark and Holland took part, but due to the Finnish aim of promoting domestic trade they were only allowed to bring to

the fair such materials and merchandise as were not to be found in Finland, and such as could be imported. Moreover, luxury goods were not supposed to be exhibited, although this stipulation was not always honoured.[104]

Of course other exhibitions had been held before independence. The first major agricultural show, for example, had been organised in Finland in 1847, just a few years later than the Royal Agricultural Society's first show in London, and similar shows were then organised on average once in every ten years until the beginning of the 20th century.[105] Finnish companies had been attending international exhibitions since the late 1840s but the credit for drawing Finns' attention to the importance of such showcases must go to Topelius who, as we saw in Chapter five, drew attention to the 'invisibility' of Finnish goods at the London exhibition of 1862 and issued a clarion call for more positive participation.[106] But although 270 Finnish exhibitors subsequently accepted the challenge and won 91 awards at the Stockholm exhibition of 1866 it was not until 1876 that the first general exhibition of Finnish industrial, handicraft, agricultural, and cultural achievements was organised in Helsinki. Obviously encouraged by the very positive outcome of this event Finns participated in most of the major European exhibitions in the period up to the First World War gaining a number of awards.[107] Nevertheless it was not until some forty years later in 1918 that the idea of staging another general exhibition in Finland began seriously to be mooted.[108]

This time lag may have been caused by overconfidence on the part of Finnish industrialists in the prospects of their export trade, or perhaps the years of russification had made people cautious about organising mass events. Whatever the reason, by the early 1910s industrialists in Finland had to recognise that the general public, which had been accustomed to foreign products, had little confidence in Finnish manufactured goods. As the Russian export market contracted, it was seen vital not only to create new foreign markets but also to make Finland self-sufficient in most important consumer goods.[109] The key needs were to educate the public to support domestic manufacturing goods and to persuade manufacturers to meet quality demands. In 1913 a new body, *Kotimaisen Työn Liitto* (the League of Finnish Work), launched a "Finnish Week" celebrated all round the country in order to encourage people to choose native products provided they matched foreign products in terms of price and quality[110] and once Finland became indepen-

dent its leaders recognised that to survive the country would also have to become more independent economically. This was spelled out in the public invitation to the 1920 general exhibition, signed by representatives of some thirty major industrial, business and labour market organisations as well as a representative of the City of Helsinki.[111]

The idea of organising exhibitions and fairs was by no means an innovation in post First World War Europe. Most countries faced the same need to revive their economic life as quickly as possible, and this created an exhibition boom everywhere, especially in Germany.[112] But what may not have been so commonplace was the active role played by consumer advisory organisations in disseminating the message of the Finnish exhibitions round the country. We have already seen the emphasis placed on consumer education and advice by Helsinki's Electricity and Gas Companies but the city was also the base of other national consumer organisations, which were to make a powerful contribution in promoting modernisation, rationalisation and consumer ideologies in Finland.

The oldest of these advisory organisations was the *Martha Association*, a voluntary civic body established in Helsinki in 1899 to disseminate information on home economics and child and health care. In 1928 it already employed round the country some 187 consultants and by 1938 its membership had grown to some 60,000 in both town and countryside.[113] The other most important bodies were the bourgeois-agrarian *SOK* and the progressive *KK*, the Helsinki-based central organisations of the Finnish consumer cooperative movement and major producers and retailers of consumer goods. Consumer education was an essential part of their ideology and business strategy, and already in 1922 the combined circulation of their organs, *Yhteishyvä* (SOK) and *Kuluttajain Lehti* (KK) were to rise to some 380,000 in a country with less than four million people.[114] Together the three organisations, the Martha Association, SOK and KK provided an almost unparalleled channel for disseminating efficiently new ideas and innovations among Finns round the country especially as they were among the first to employ radio and film as methods of communication. Indeed, in many localities the KK´s travelling consultants were the first organisers of film events and by the mid-1930s the annual audiences at these and other KK events probably reached up to half a million people.[115]

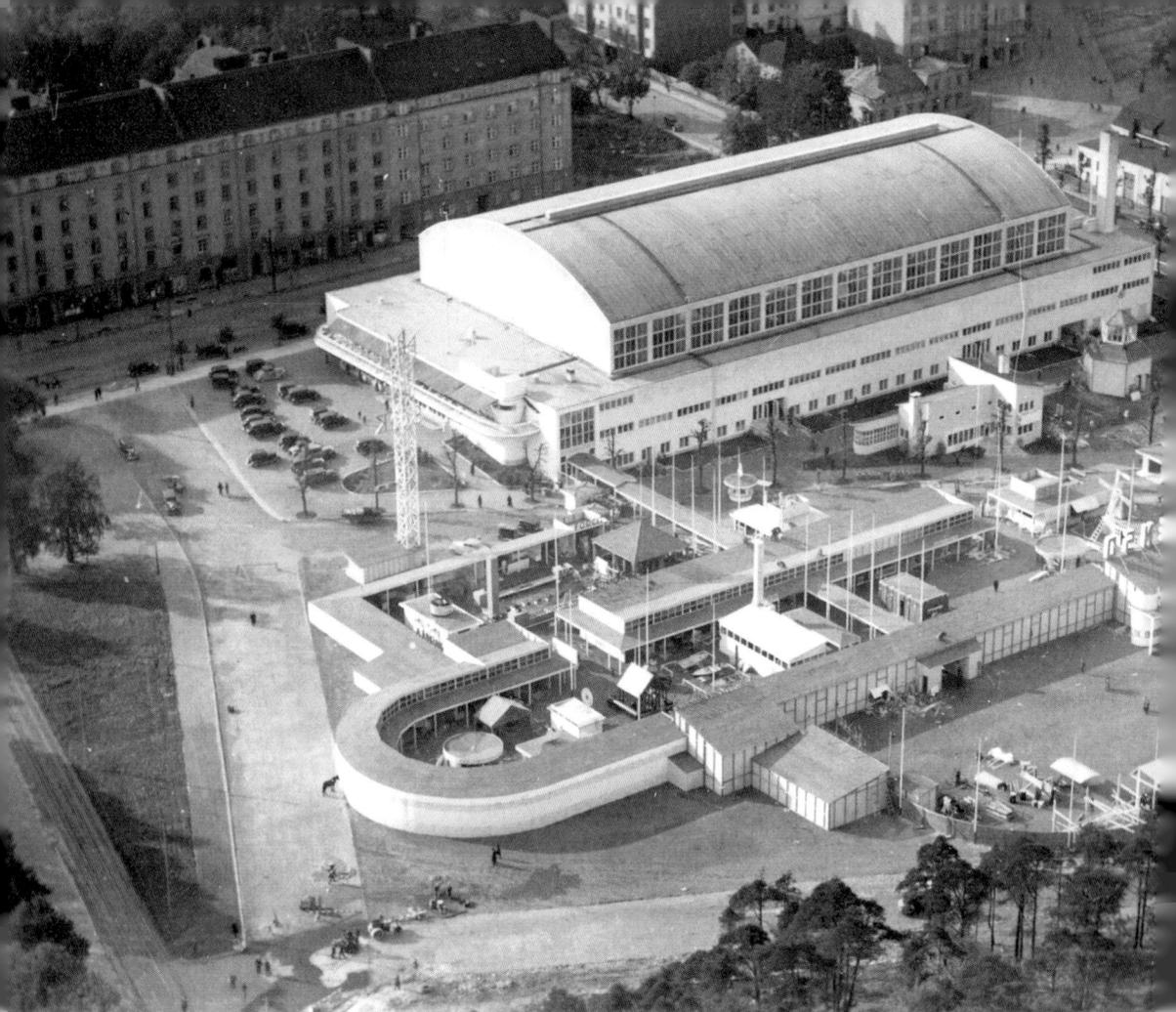

The first Fair Hall (Messuhalli) opened in Helsinki in 1935 and was inaugurated during the celebrations marking the centenary of the publication of *Kalevala*. (Helsinki City Museum)

Following the 1920 exhibition a new organisation, *Suomen Messut Oy* (Finnish Fairs Ltd), was established as a permanent body to organise exhibitions and to advise businessmen on such matters. It was subsequently reorganised into a co-operative society, Suomen Messut Osuuskunta, to allow small entrepreneurs and producers to join on equal terms with big industrial and business companies alongside the labour market organisations, which also remained members.[116] In 1933 the Helsinki City Board decided to let a site for the construction of a permanent Exhibition Hall while

also guaranteeing a loan for that purpose,[117] and this hall was subsequently equipped with the latest exhibition technology. The first event mounted in the building was the Kalevala Jubilee Festival, which opened on February 28, 1935 followed by a three-day exhibition. 30,000 people took part in the celebrations and an additional 60,000 people visited the exhibition.

"A long row of luxury cars and thousands of pedestrians streamed along Turuntie, lined with flags, to the ceremony place decorated with wreaths. The visitors walked to the Kalevalan feast of Pohjola along a marines' guard of honour..."

As many as 25 nations were represented by distinguished guests and high ranking diplomats indicating that Finland was by then making good progress towards becoming an internationally recognised country and the whole event was interpreted as a striking feat of Finnish culture.[118] Later the Exhibition Hall provided Helsinki with a venue for major national celebrations as well as for art and sports events. Nevertheless it remained, above all, a venue for general fairs and specialist exhibitions demonstrating and promoting Finnish progress while its functional architecture marked it out, in the eyes of the general public, as a fitting symbol of modernity.

Between 1920 and the outbreak of the Second World War a total of 29 out of 31 national exhibitions were organised in Helsinki. The Finnish industrial companies could not yet produce enough new products to justify general fairs every year, so from 1925 onwards the general exhibitions took place every five years while annual spring exhibitions promoted new consumer goods: innovative textiles, furniture, food and products related to aspects of modern life such as motoring, aviation, broadcasting and electricity.[119]

Which Innovations Were Introduced
to the Public at the Exhibitions?

It was a product at the luxury end of the consumer goods market, the motorcar, which became the first major success of these exhibitions. Cars were first displayed at the 1924 general exhibition[120] but three specialist motor shows were organised in 1926–27, and their impact was clearly seen in the city with the number of private cars almost trebling from 1,120 in 1925 to 3,229 in 1928.[121] This demonstrated the relative affluence of Helsinki's inhabitants, whose average income was approximately four times that in the rest of Finland.[122] The car was a romantic thing, the product of modern, technological man. The charm of *l'homme Hispano* was now recognised also in Helsinki,[123] where the most well-to-do were already leading a European upper-middle class lifestyle making trips to Paris, wearing the latest fashions, going out almost every night in evening dress to such restaurants as the Börs, Kämp, or Fennia, followed by *Nachspiels* at home listening to the gramophone and dancing the tango or the foxtrot with drinks flowing in spite of Prohibition.[124]

Prohibition lasted in Finland from 1919 to 1932. However, from the mid 1920s onwards with typical Helsinki ingenuity one could get a variety of quality wines on a medical prescription from the city's pharmacies. It is ironic that the State Alcohol Company, the supplier of the pharmacies during Prohibition, took part in the 1923 general exhibition and even received a special diploma awarded to the best exhibitions stands.[125] Whether this encouraged the company or the pharmacies is not entirely clear, but in the next year, 1924, there were available in the pharmacies 129 titles including ten sparkling wines and nine whiskies, and in 1932, the last year of Prohibition the selection on offer included 30 different brandies, 10 whiskies, 41 strong and 33 less strong wines as well as 8 champagnes. By then those in the know could choose between Ch. Haut-Brion 1924 and Ch. d'Yquem 1925 as prescribed by a friendly doctor for purely medicinal purposes![126]

Much more far reaching as a function of the fairs was the introduction of modern materials. Already at the first exhibition in 1920 Enso Gutzeit Oy demonstrated how timber could be processed into a number of modern building materials such as wallboards and papers by displaying a one family

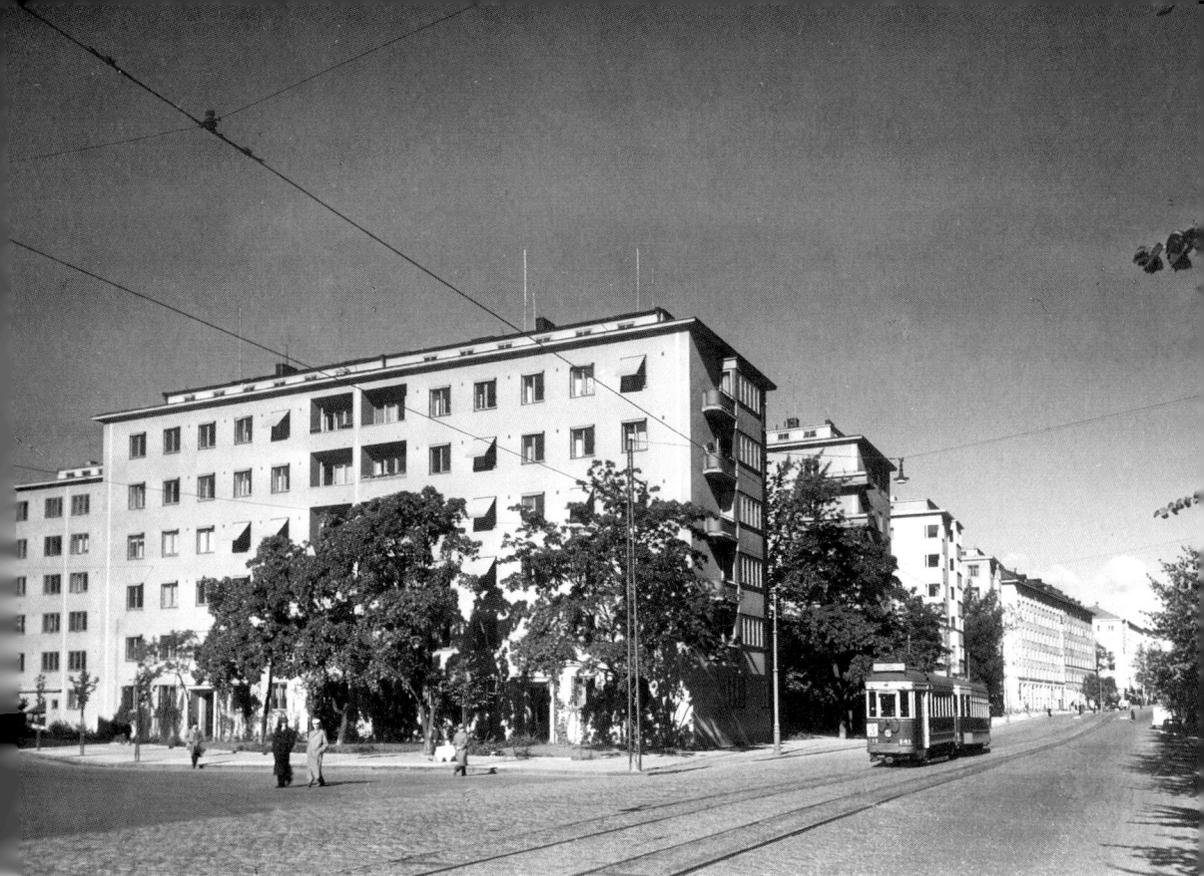

Helsinki expanded to the north. The Taka-Töölö area was built mostly in the Functionalist style of the 1930s. (Helsinki City Museum)

house constructed entirely from their own range of wood-based products. Wilh. Schauman Oy, another timber industry pioneer, gained much acclaim for their veneers, which became a major export article in the next year's exhibition and still attracted experts' attention ten years later in the 1930 Antwerp exhibition.[127] On the other hand consumer goods on show displayed the arrival in Finland of a number of other modern materials. Thus casein, an early form of plastic, was first presented at the 1922 and 1923 exhibitions when Sarvis Oy from Tampere [128] publicised their combs, buttons, cigarette holders and necklaces using the slogan "Ivory from Milk" while Hackmann & Co from Viipuri displayed stainless steel cutlery sets in the 1924 exhibition. Aluminium pots manufactured by Kone & Silta in Helsinki were introduced in 1930 alongside enamel vessels, their traditionally strong line.[129] Curiously,

however, it was not until 1939 that rayon was first exhibited in Helsinki when Kuitu Oy displayed it as "silk made of Finnish trees",[130] although the raw material, cellulose, was indigenous to Finland and the fibre had been patented in the U.S. as early as in 1902 and used in Germany from 1910 onwards.[131] This delay may well have been the result of a desire to protect the interests of the domestic textile industry rather than fear of innovation as such. In fact, the Helsinki exhibitions demonstrated the accelerating progress of the textile and clothing industries in terms both of the variety and sophistication of their ranges and of the materials and style of their ready-made garments.[132] The 1926 and 1938 foodstuff fairs displayed a similar development in the food industries, which were producing by 1938 a greatly increased variety of charcuterie, cheeses and bakery products including patisserie.[133]

A further striking feature was the drive to modernise the Finnish home as demonstrated by the 1930s exhibitions. The first major call for changes was launched by the exhibition of industrial art in the autumn of 1930, which was inspired by the radical exhibition of functionalism in Stockholm earlier in the same year. Given the enthusiasm of young Finnish architects and avant-garde industrial art companies, it was decided that the exhibition should be divided into two sections, one of which should be arranged as an exhibition of "rationalisation in a small home," the main organiser being Alvar Aalto, an enthusiastic supporter of functionalism as well as a champion of rationalisation.[134] The sections included a model flat designed for a family of 4–5 people, a group of model interior designs for lodging rooms, a model hotel room and displays on technological issues related to housing.[135] Aalto and his wife Aino were so involved with the project that they furnished the model family flat with their own furniture in order to demonstrate that a family can lead a full, satisfying life even in a minimum space.[136]

However, Aalto's concept of a minimum space was 60– 70 square metres,[137] i.e. larger than 69 % of all dwellings in Helsinki in that same year,[138] and thus while denouncing 200–250 square metre dwellings merely as a handicap in modern life[139] he in fact promoted an increase in the size of family houses. In an article published in the autumn of 1930 Aalto argued that the fundamental changes in modern family life were caused by the woman's changed status and emancipation, which placed totally new requirements on the planning of houses. As the starting point of all planning of

dwellings one should have regard to the fundamental functions of the house as a sheltered space for eating, sleeping, working and playing and they should replace outmoded principles related to the extent of internal space and the symmetry of the façade. He also thought that the modern person was more mobile than before, and the structural qualities of furniture should meet this challenge. By using pieces of furniture that were more mobile and easier to blend with each other, the small dwelling would in fact expand as needed. His ideal was a dwelling where all changes and movements from one activity to another could take place organically, without much fuss or disturbance, and where light and acoustical arrangements were pre-considered to provide a high-standard, comfortable life.[140]

Unlike most others the 1930 industrial art exhibition had a clear message, that the solving of the housing issue was the most important current socio-economic problem. At the same time it also promoted positive co-operation between creative people, such as the initiators of the exhibition, and industry, the vehicle for reproductive manufacture. Moreover, it promoted a positive attitude towards mass production by machines and made industrial aesthetics more acceptable. In this the organisers shared the ideas that had been expressed as early as 1914 in the Werkbund Köln exhibition, i.e. the need of liberation from outmoded and over-fussy artistic styles, still to be found in the exhibitions of the 1920s,[141] and the need for a determined drive to develop honest industrial art. No wonder that this Finnish exhibition attracted so much public attention and it is fair to say that it heralded a new way of thinking in housing architecture and interior design alike.

Foreign Countries Discover Finland and the British Week

From the beginning the fairs in Helsinki attracted many foreign exhibitors and visitors eager to form business contacts in Finland,[142] and the wares displayed reflected their perception of the increasing sophistication of the Finnish public. Estonia was already participating with its own pavilion displaying linen in 1920 and a Finnish-American group showed a car in 1921. At the agriculture fair of 1922, the Swedes were the only foreign exhibitors, but in the following year Soviet Russia introduced itself, with its furs and porcelain.

In 1924 France and Poland had their own sections and the Swedes displayed their glass, tableware and crafts products. In spite of its specialist nature the 1929 aviation show attracted even wider international interest with foreign exhibitors in the majority including such newcomers as Czechoslovakia, Germany, Britain, and Italy, all with their own displays.

A major event in the course of this internationalisation process was the British Week, September 4–10, 1933, which had the President of the Republic and the Prince of Wales as its patrons. Britain had for long been Finland's most important export market although not the main source of her imports. To balance this situation Finnish business circles had suggested that a promotion of British industries, similar to one held in Copenhagen in 1932, should also be organised in Helsinki.[143]

This British Week was an initiative intended to pay dividends for both countries and was the object of very careful preparation. In the preceding months a succession of British figures ranging from Frank Green, the head of the world's biggest milling company to Chief Scout Lord Baden-Powell had visited Finland while Helsinki businessmen had been invited to industrial centres in Yorkshire at the same time as arrangements were being made for the Helsinki City Orchestra to visit London in the following spring.[144] It is significant, that Helsinki City Council, which so far had been quite tight fisted in showing hospitality to visiting foreign dignitaries (even during state visits), was now fully involved. The city authorities had not only decided to show hospitality to the British guests during the week, but had also lunched the visiting British business delegation in February and the British press in June.

The opening ceremony of the Week took place in Senate Square. The Parliament Building and the Cathedral were floodlit for the first time and enormous crowds attended the one week long programme of exhibitions, cultural and sporting events and pageantry. 80,000 people attended the closing event, which culminated in the most magnificent fireworks display ever seen in the city. Needless to say, the Helsinki newspapers gave all the events of week very wide coverage.[145]

Crowds of people gathered to see the ships in the North Harbour and the displays in Stockmann's twenty-three windows featuring Burberry coats and fabrics, Wedgwood ceramics, sewing and marking threads, stainless steel products, bronze utensils and ornaments. In addition, there was a model of a steamroller used in road construction, a model of a coalmine and a miniature

model of the s/s Mauretania, as well as a diorama displaying British indust-
rial fairs.[146] The Wedgwood ceramic products consisted of traditional items,
such as Jasperware and "the distinguished pale cream-coloured Queensware
vases and ornaments", as well as simple classical vessels imitating the
Etruscan or Greek style.[147]

The introduction to the British car industry was particularly significant with
leading representatives of the industry interested in the Finnish market being
involved in a number of displays. It soon became obvious that the British
thought that there was a market for British products in Finland. However, the
success of the week, which certainly led to an increase in the imports from
Britain,[148] depended as much on the enterprise shown by the hosts as on the
entrepreneurial instincts of the visitors.

Certainly by the mid-1930s very many foreign visitors had discovered Helsin-
ki. There were popular package tours on special ferries bringing people from
Stockholm and Tallinn to participate in the general fair of 1935 and a
specialist expedition of economists led by the Finnish Ambassador in Stock-
holm, R. Erich, also came to this event.[149] When the leaders of Sweden's
industry, commerce and agriculture had acquainted themselves with the
Finnish products on show, they became convinced that Finland could increase
her exports to Sweden and that the Swedish people should be made more
aware of Finnish products. On the initiative of the Export Society, a Finland
Festival was therefore organised in Stockholm in the spring of 1936.[150]

The success of Finnish design in Milan in 1933 as well as the similar
triumph two years later, at the Brussels exhibition in 1935, seems to have
attracted to Finland an astonishingly high-powered group of foreign buyers,
who were invited by Suomen Messut to visit the 1937 spring fair. Then twenty
of Europe's largest department stores and multiple chains sent their purcha-
se managers to the spring fair of 1937 and together they represented some
300 of Europe's largest stores and chains. Their comments revealed that
many had been most pleasantly surprised by the Finnish achievements on
display at the exhibition.[151]

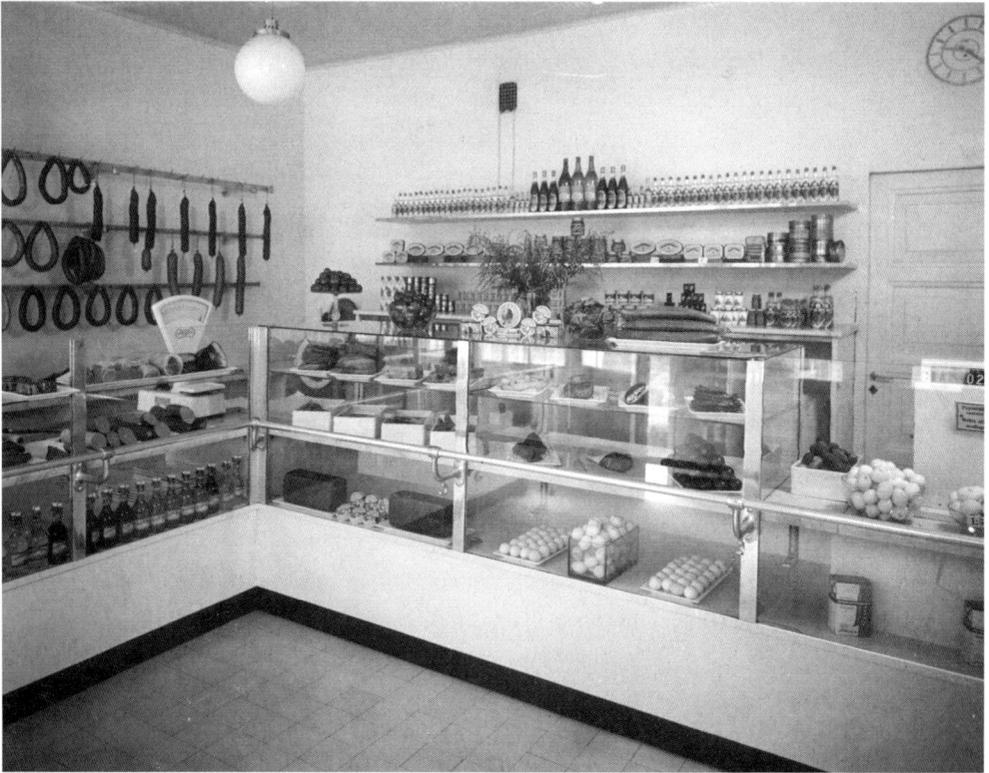

There were three cooperative movements in Helsinki: the progressive Elanto, the Finnish language Helsingin Osuuskauppa and the Swedish language Varuboden. Elanto was founded in 1905 and tried to keep abreast of modernisation and hygiene. The photo from 1930s. (Helsinki City Museum)

On the Importance of the Exhibitions

The 1939 spring fair was by general consent a great success, and by attracting 62,000 paid visitors it broke all records. It also demonstrated the ever increasing multitude of Finnish goods available for the public, e.g. new lifts, central heating plants, glass building bricks, fabrics, fashion, furniture, designer lamps, radios, counting machines, private safes, electrical gardening equipment, the next generation of "Mainos" electric irons, cooking vessels for electric hobs, the world smallest compass, Polaroid spectacles and enamel paints not to mention Oy Gottfr. Strömberg's innovative electrical kitchen technology including an electric oven combination, a mobile cooking

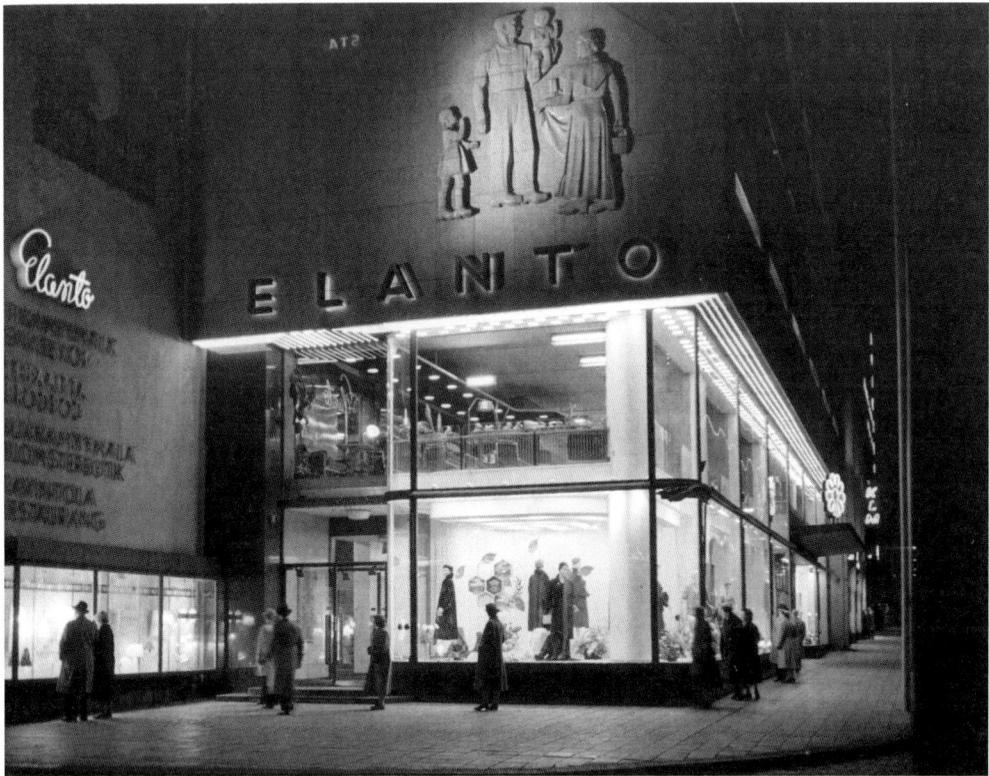

Elanto built a department store in the heart of the central business district on Aleksanterinkatu. The Elanto story came to an end during the recession of the early 1990s. This picture is from the 1950s. The retail structure underwent a dramatic change in the 1980s and 1990s. As offices moved into the city centre, residents moved out into the suburbs and small stores lost custom. The cooperative movement was also involved in building huge supermarkets and hypermarkets on the main thoroughfares into the city. (Helsinki City Museum)

unit and many other electrical household appliances. [152] Burton Benedict has, indeed, emphasised the importance of exhibitions as a means of helping the middle class to embrace the whole current culture as the goods and features on display help to form their taste.[153] But obviously the fairs also provided Finnish retailers round the country with one central and convenient forum where they could become familiar with the most recent technical innovations and the latest fashions and new trends. All this helped the development of both the retail trade and the manufacturers.

The increasing variety of goods available demonstrated not only technological progress but also the development of a modern consumer society in Finland. Moreover, the emergence of significant Finnish manufacturers, many of them freshly established, reflected increasing public confidence in Finnish products, thus fulfilling what had perhaps been the main aim of annual national exhibitions in the first place. This growing confidence manifested itself in the annual statistics. In 1938 the native manufacturers' share of all textile sales in Finland rose to 70 %,[154] while the Helsinki firm of Strömberg almost trebled its production in terms of gross value between 1928 and 1939, a growth especially evident after the inclusion of electric cookers, cooking plates, hot water and central heating boilers in its production programme for 1936.[155] Between 1920 and 1938 the number of workplaces in Helsinki's textile industry expanded 2.4 times while the number of employees grew five times with the gross production value increasing seven fold[156] In the food industries the increase in the workforce exceeded the population growth and the gross production value increased over three fold.[157] Thus Helsinki had clearly become a major centre of the consumer industry.

Importantly, the exhibitions also showed the development of a new visual perception. In the 1925 general fair Hangon Keksi had used a traditional rustic room for their display and at the next year's food fair Elanto's stand was designed using idioms of Nordic classical architecture.[158] In both cases the overall appearance was hardly dissimilar to the 19th century fairs in the fussiness of the canopies, drapes and wreaths made of spruce. However at the advertising fair in 1928 there were already some indications of a changing visual style and a really marked change took place at the 1929 fair held in Turku, where the pioneers of modern, functional architecture, Alvar Aalto and Erik Bryggman, were responsible for the overall architecture of the fair.[159] Consequently from 1930 onwards Finnish exhibition design followed the modern style irrespective of whether it was used for fairs in Finland or in the construction of Finland's own exhibition stands abroad (Antwerp 1930, Poznan 1930 and Helsinki 1930 were all clear statements of functionalism)[160]. From 1933 onwards the textiles and furniture on show in exhibitions increasingly reflected the influence of functionalism and many items of furniture displayed by Stockmann's and Asko in the 1939 housing exhibition[161] still look amazingly modern some sixty years later at the beginning of the 21st

century. Thus the fairs in Helsinki become one of the major means for spreading a new visual culture not just in the city but throughout the whole of Finland.

So far as the foreign exhibitors were concerned the Finnish goods on display not only highlighted the latest technological developments but also created strong images of the producers of these goods and of Finland as a new, independent, forward-looking country. The fact that Germany, Holland, Italy, and Sweden had their own sections and that some 60 foreign companies also displayed their products at the 1939 fair also indicates the increasing importance of the Helsinki exhibitions as an entry to the expanding Finnish markets. A great number of deals were struck, and the General Manager of Suomen Messut, Harry Röneholm recorded with satisfaction, that the great majority of the exhibitors had immediately booked their place for the next fair. That was scheduled to take place in 1941 as the Exhibition Hall had been reserved for the 1940 Olympic Games.[162]

As the 1939 fair closed the attention of the Finns turned to the New York World Fair and from there they heard not only that the Finnish pavilion designed by Alvar Aalto had been highly praised but also that a new Finnish innovation in the producing of wood-pulp, the single-ball-mill, developed by a Finnish engineer, A. Lampén,[163] had caused a sensation among experts in the paper industry. People in Helsinki had every reason to be optimistic about the future.

VII The Interruption of the Second World War

So far as the people of Helsinki were concerned the Second World War started at 9.16 am on 30th November 1939 with an attack by Soviet bombers and officially ended in an armistice with the Soviet Union on 19th September 1944.

The Soviet Union's invasion of Finland was a direct result of the Ribbentrop-Molotov pact of August 1939, a secret clause of which had divided Europe into German and Soviet spheres of influence. Finland had been allocated to the Russians and the Soviet leaders now got an opportunity to act on their long-standing concern for the security of Leningrad, the second city of the USSR, which was located only some thirty kilometres from the Finnish border. In October 1939 Finnish delegates were invited to Moscow where Finland was asked to cede to the Soviet Union parts of the Karelian Isthmus and some islands in the Gulf of Finland in exchange for compensation in Eastern Karelia. Such a request had been presented already in the 1920 peace negotiations between the Bolsheviks and Finland, and then as now the Finnish negotiators responded that they had been given no authority to give away any major part of historic Finnish soil. According to the Soviet Foreign Minister, Molotov, the matter was therefore "left to the soldiers". After creating a puppet government for Finland consisting of Finnish emigrant communists based in Moscow the Russians launched military provocation in

Considering the massive attacks, Helsinki suffered relatively little damage thanks to its modern anti-aircraft defences.

The forces also used simple methods for misleading the enemy bombers such as setting fire to large firewood stocks near the city and using magnesium anti-aircraft shells in its barrage, which confused and deterred the enemy. Approximately 90 per cent of the bombs during the February 1944 attacks never hit their intended target. (Finnish Military Archives)

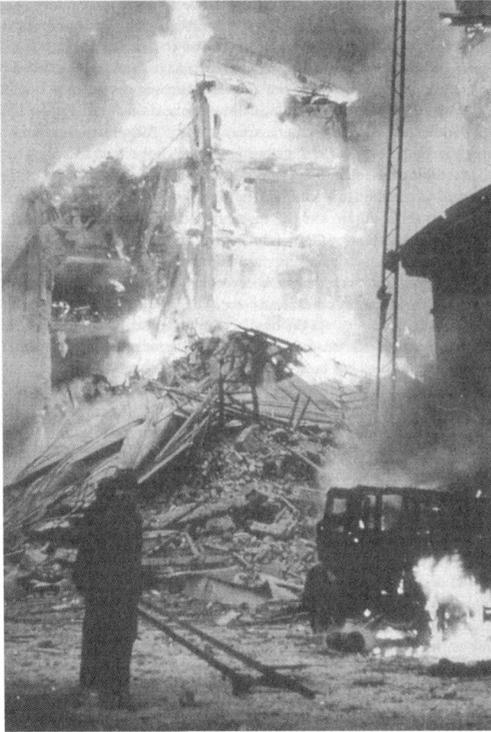

the Karelian Isthmus on 26th November and on the 30th at 6.50 am opened artillery fire. Less than two and half hours later the first Soviet bombers were emptying their loads on Helsinki.

Thus started the Winter War in which Finland defended herself against the might of the Soviet army until, in the armistice of 13th March1940, she was forced to cede not only the Karelian Isthmus which embraced Viipuri, Finland's second city, along with the towns of Käkisalmi and Sortavala and areas of agricultural and industrial importance, but also the city of Hanko which was to be used as a Soviet military base.[2] The bravery of the Finnish troops and people was praised in foreign newspapers, which spoke of the Spirit of the Winter War, but there was very little material help from outside.

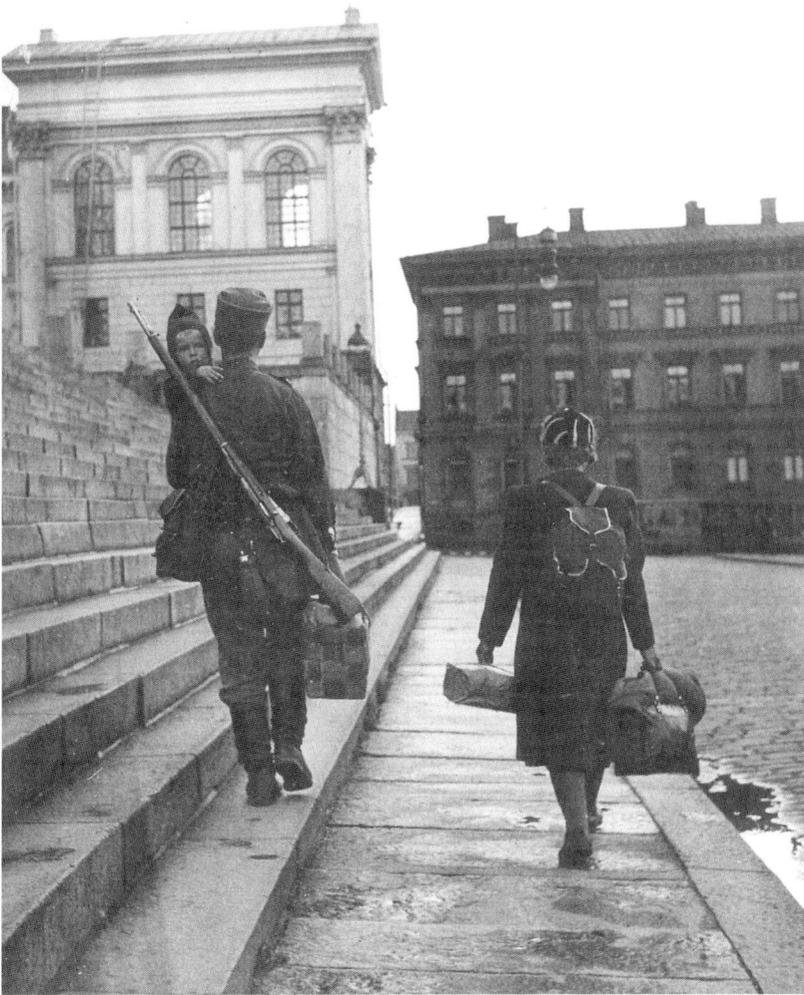

The total number of victims of the Winter War was 24,000 people. A great number of women and children living in Helsinki were evacuated during the first weeks of the war. Three quarters of Helsinki's population left the city following the first bombings. (Finnish Military Archives)

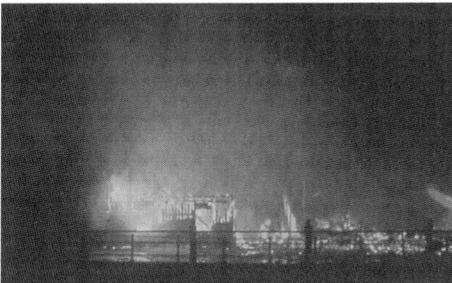

The Soviet Union bombed Finnish cities heavily during the spring of 1944, when many buildings were damaged in Helsinki. Fire bombs had devastating effects due to strong air currents from nearby explosions fanning the flames. (Finnish Military Archives)

After this Winter War the alternative partners available to Finland for strengthening its position were few. A mooted alliance with other Nordic countries became impossible as Moscow considered such an alliance would break the Soviet-Finnish peace agreement. Britain, the other preferred choice, was geographically too far away once Germany had invaded Denmark and attacked Norway in April 1940[3] and, in any case, after the fall of France was in too difficult a situation itself to help such a remote country.

The occupation of the Baltic countries by the Soviet Union in mid-June demonstrated that any attempt to form an alliance with the Russians would inevitably lead to Finland becoming part of the direct communist sphere of influence[4]. Reluctantly even the most Anglophile Finnish leaders, Marshal Mannerheim and Risto Ryti, the then Director General of Bank of Finland, agreed that Germany was therefore the only possible source of help. The Nazi system was not much admired by Finnish political leaders and both Ryti and Mannerheim positively loathed Hitler. Moreover, the Finnish people bitterly resented the fact that despite the many historical links between Germany and Finland the Germans had left Finland at the mercy of the Russians during the Winter War.[5] Nevertheless, in the last days of June 1940 Finland and Germany did sign a trade agreement, under which Finland was able to get much needed foodstuffs[6] to meet the needs of some 420,000 evacuees who had arrived from the Karelian Isthmus and Hanko, as well as fuel and raw materials. Germany later also promised arms. In return Finland provided Germany with copper from Outokumpu and nickel from Petsamo. Thus both countries, suffering from the western trade embargoes imposed in the autumn of 1939, had found in each other a useful trading partner.[7]

In this process Finland inevitably became closely tied to Germany, especially after the Finns learned that on his autumn 1940 visit to Berlin Molotov had requested a free hand to deal with Finland in the same way as the Baltic countries. When informed of the imminent German attack on the Soviet Union in June 1941 Finland nevertheless declared her intention to remain neutral unless attacked. However, once the Soviet Union had bombed several Finnish towns on 25 June Finland's Prime Minister indicated that the country was now at war.[8] Finland had thus drifted into what Finns called the Continuation War against the Russians. At first this second war was popular with the Finnish people as the defence forces were able by the end of the summer to reconquer the lost

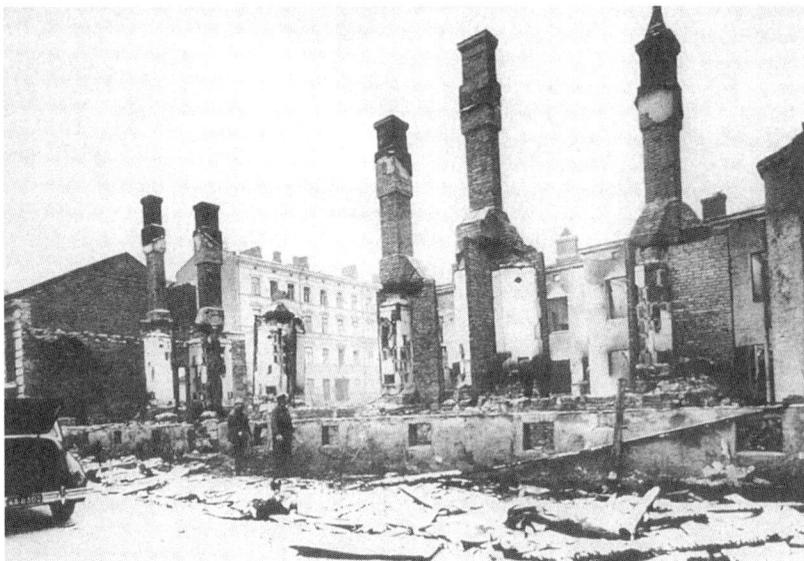

The wooden houses burnt quickly to the ground. (Finnish Military Archives)

Karelian territories. This allowed some of the evacued Karelians to return to their homes during the autumn to prepare the neglected fields for the next summer's cultivation. Much of the farming had to be assigned to women, young boys and elderly men and where all the buildings had been burnt down beginning a new life was extremely difficult. In addition farms that earlier had been highly mechanised now had to operate without tractors or threshing machines. Even so, Karelians built new farms and an infrastructure – only to discover in 1944 that they had to leave the area for the second time.

Later, however, war exhaustion began to take its toll and from February 1943 onwards there began to be a few private Finnish attempts to arrange a separate peace settlement.[9] The eventual armistice signed in September 1944 after the massive Soviet offensive in Karelia in the previous June meant that Karelia was again lost, together with the Petsamo nickel areas and Finnish access to the Arctic Ocean. Moreover, under the same agreement Finland was to lease to the Soviet Union the area of Porkkala, dangerously close to Western Helsinki, to be used as a naval base for fifty years. In addition, she was to pay as war reparations 300 million dollars at the 1938 price level, i.e. some 600 million dollars in current terms,[10] within six years

along with other forms of compensation. Given also the need to re-locate the Karelians and war veterans and to build up the damaged country the armistice terms stretched the Finnish economy to breaking point. The only glimmer of hope lay in the fact that relatively little was needed to restore the capital city itself after Soviet bomb attacks during the war.

The Innovative Defence System Saves Helsinki

Because it was the capital and the main administrative and information centre Helsinki, with some 250,000 inhabitants, had been a natural target for hostile attack, especially as the city was also the largest industrial locality in the country, when measured by the number of workers, the number of jobs and the value of production.[11]

Yet during the five years of the Second World War the number of Helsinki civilian casualties had been less than 1,300 of which only some 400 actually died as a direct result of the bombing and when compared with other Central European cities the wartime damage in Helsinki was relatively moderate. The ratio of casualities to bombs dropped on Helsinki was merely 1/132 compared with Berlin where it was 1/64.[12] The total of damaged or destroyed buildings remained at only a few hundred.[13] These figures must be considered remarkable as during three major air raids in February 1944 alone Soviet bombers, emulating the methods used by the British Air Marshal Arthur "Bomber" Harris against German cities, had attempted to drop nearly 20,000 bombs on Helsinki. But this tactic of launching an initial massive paralyzing air attack followed by a continuous exhausting flow of further bombings[14] did not succeed in the way that it had done in Germany for in February 1944 Soviet bombers actually managed to drop a mere 799 bombs on the city area, that is 5 % of what was intended.[15] Consequently there were only 120 dead and 437 wounded while only 109 houses were totally destroyed with some 300 houses suffering damage.[16] The actual military losses in the February air raids were a mere 5 dead and 6 wounded[17].

This lack of success was due not to any geographical advantages enjoyed by Helsinki or to any massive preparedness for the war. On the contrary, unlike many other cities Helsinki was not protected by open sea islands which could have been used for siting air surveillance systems. Neither could the defenders of Helsinki limit the scope of the attacks to some distinctive industrial or residential zones. The most important industries were be found not only in the northern part of the city but also in the south-western and eastern harbour areas and therefore close to the very compact centre. This city centre, the traditional administrative and residential area, was also the location of important commercial undertakings as well as of the offices of the Finnish Broadcasting Company and the printing plants of the main national newspapers.

Moreover, Helsinki was not too well prepared in civil defence. Although from the Spanish Civil War onwards it had been evident that any new military conflict would involve the bombing of population centres, from 1935 onwards Helsinki had been preoccupied with the planned 1940 Olympic Games and the construction of the Olympic stadium and other sports facilities had been the city's top priority. Finns in general had also been putting their trust in the League of Nations and existing international agreements.[18] A civil defence office for the city was not in fact created until September 1939 and it was only after mid-November, when the Olympic Games were cancelled, that the city started to invest heavily in developing its civil defence systems. This meant that the people of Helsinki entered the Winter War and faced its bombings armed in the main only with the scanty information and training that had been unofficially provided by voluntary organisations since the late 1920s while the first actual bomb shelters in the city were organised in the autumn of 1939 by Stockmann's in the basement of their eight storey high department store.[19]

For people in Helsinki the first Winter War bombings had come as a surprise. In October the world situation had become so alarming that the population had been given some instructions on what to do in case of air raids and a voluntary evacuation was commenced. The schools had been closed, trenches had been dug in parks and air-raid shelters put in better order. But as nothing happened the evacuees returned to the city and their civilian concerns and were mentally unprepared for the first bombings when they actually came. Many were too curious to go to the air shelters and were hit by machine gun fire. During the first two days 91 persons lost their lives

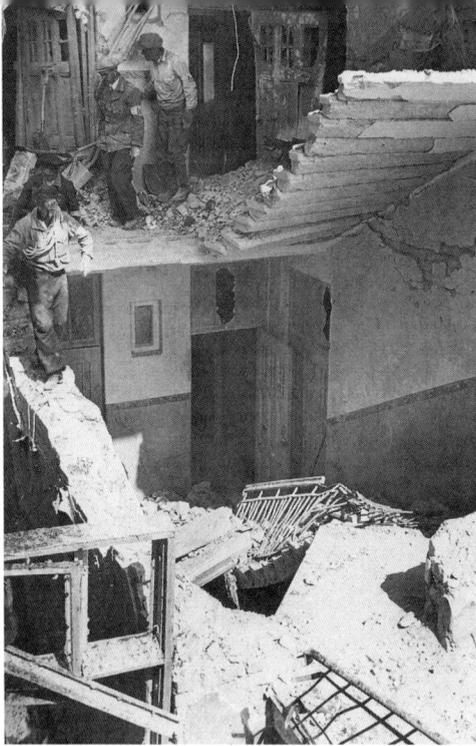

Helsinki experienced its most painful moments in February 1944 when the Soviet Union bombed the city heavily in three large scale attacks. Altogether 120 people died and 437 were injured; a total of 109 buildings were destroyed and 325 damaged. (Finnish Military Archives)

and 236 were injured; and these figures were to represent 76% and 94% respectively of all the civilian casualties during the total of 81 air-raid alarms in Helsinki in the 105 days of the Winter War.

The decreasing casualty numbers in the later stages of the Winter War were partly due to the fact that the city made speedy progress in developing the infrastructure of its civil defence. By February 1940 it could already provide shelter, at least against shrapnel, for 170,000 people[20] at a time when the total population had shrunk to 120,000 as a result of a second evacuation in early December when three quarters of Helsinki's population left the city following the first bombings. Another reason was probably also the rapidity and discipline with which people in Helsinki and elsewhere reacted to the air raids, a fact that amazed John Langdon-Davies, a veteran war correspondent.[21] A major reason for the small casualty level in Helsinki may have been that in spite of the number of air-raid alarms the city was actually bombed only nine times while the south coast port of Hanko, for example, was the target of 72 bombing raids. Yet as Helsinki's air defence during the Winter War was modest it should have been very easy for the Russians to destroy the city using Estonian air fields, only 80 kilometres from

Helsinki, as their base. It has, therefore, been suggested that, anticipating that the campaign against Finland could only last for a couple of weeks, the Russians had actually wanted to preserve Helsinki undamaged for them to enter as its new masters.[22]

After the Winter War Helsinki continued its programme of constructing public shelters while encouraging and supervising also the construction of shelters in the basement of private buildings. Following the example of Turku the city also purchased anti-aircraft equipment[23] and a new air defence organisation was developed by

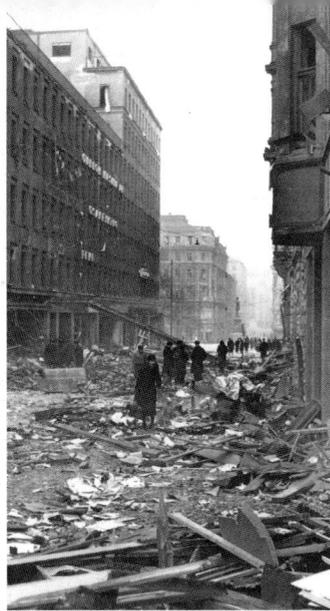

Kasarminkatu after the bombings. Signs of the damage can still be traced in the granite at the base of the walls. (Finnish Military Archives)

Lt.Col. Pekka Jokipaltio and due to careful planning Helsinki had a civil defence centre in full readiness at the beginning of the Continuation War in June 1941. This second war was fought to regain the territory lost under the Peace of Moscow in March 1940 rather than in pursuit of any German war aims. It was therefore a separate war within a war, fought under conventional rules and with the possibility of concluding a separate peace independent of Germany.[24]

To help families a number of Helsinki children were evacuated to Sweden and Denmark and in autumn 1942 Helsinki city sent teachers and all the necessary schoolbooks there so that they could continue their education[25] However, the real salvation of the city and its people was to lie in the development of a quite new air defence system from the autumn of 1941 onwards. As the Finns did not have targeting devices capable of following the path of enemy bombers with sufficient precision they found an alternative method of defence by using a preventative crossfire barrage whereby several anti-aircraft batteries concentrated their fire on a previously decided air space using pre-calculated range configurations. When completed this crossfire barrage system surrounded Helsinki with ten concentric barrage zone circles stretching to 14 kilometres from the city centre.

Once the air-defence command had established the route of an attacking aircraft it only needed to choose the most appropriate barrage location and instruct the relevant batteries to open fire at that point using their pre-calculated tables. The aim was to frighten the Soviet bombers into dropping their load well before arriving in Helsinki air space and to help ensure this the shells used by the defenders also contained added electro metallic chemicals, which increased the startling lighting effect. Once this was achieved the defenders did not waste ammunition on the Russian planes that had already dropped their bombs.[26]

The eventual acquiring of modern German radar improved the early detection of the enemy. This assistance arrived in 1943 together with several further batteries equipped with newest German air-defence guns. Thus Helsinki was much better prepared once the Soviet Union finally launched massive bomb attacks on the city following the agreement by the Allies in Teheran, that Finland should be forced out of the war.[27] Dealing with this onslaught, however, was not too easy for the Finns, as the Soviet planes were now drawn from their elite air force group, the ADD. The strength of their attacks escalated from 350 flights on the first night (6.–7.2.) to some thousand on the third (26.–27.2.), and it was reported that defending soldiers loading the anti-aircraft guns became so hot that they had to strip to the waist in spite of the temperature being several degrees below zero centigrade.[28]

This onslaught led to the development of another unique feature of the Helsinki defence system, the diversion of the enemy by lights. During the second air attack (16.–17.2.) the night sky was cloudy and searchlights proved useless in detecting enemy bombers. The defenders therefore decided to switch on only the easternmost searchlights. This duped many Soviet pilots into locating the blacked out city more to the east than it actually was and led to their unloading their bombs there.[29] The defenders prepared for the next raid accordingly. Immediately following the beginning of the attack personnel from the Vuosaari anti-aircraft battery east of the city proceeded to light twenty huge bonfires that had been prepared beforehand while once more only the easternmost search-lights were brought into use as the battery kept up a fierce barrage. In spite of the moonlight this artificial "relocation of an apparently burning city" towards the east seemed to work once more as Soviet bombs started to rain down on this largely empty area with such violence that they cut off the battery's communications with the central air-defence unit.[30]

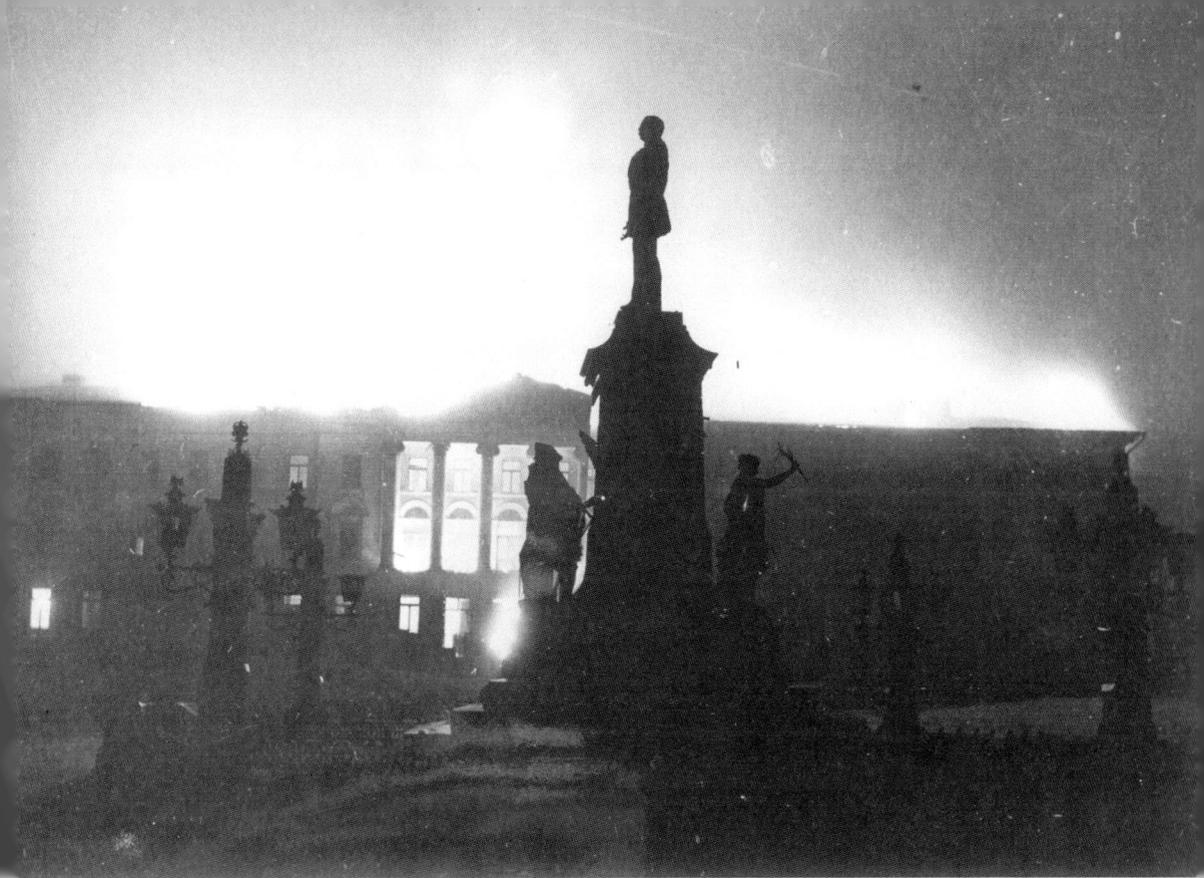

Helsinki University Main Building in flames during the air raids of 26.-27.2. 1944. (Helsinki City Museum)

In fact the bombing of Helsinki was probably a grave mistake. So far from breaking the will of the Finnish people it strengthened it.[31] Compared with other bombing operations in Europe the raids were hardly a success either. Drawing comparisons with the attacks on Hamburg and Dresden Helsinki should have been completely ruined and the number of casualties should have been between eight and ten thousand.

It was unfortunate, bearing in mind the traditional Finnish emphasis on education, that among the few major public buildings that were damaged really badly were the University of Helsinki, the University of Technology and some elementary schools as well as the Guard Barracks[32]. The number of private dwellings destroyed or damaged beyond repair was merely 610, i.e. less than 20 % of the total of new dwellings built in Helsinki in 1939.[33]

However, the Soviet leaders appeared to have remained ignorant of this state of affairs. No doubt some Soviet pilots anxious to boost their reputation gave somewhat misleading information about their "hits" when back at their base and what is certain is that faulty information was also passed on to Moscow by an apprehended Russian spy, whom the Finns persuaded "by methods customary in war" to become a double agent. After each bombing attack he sent radio messages, compiled by the Finns, describing significant destruction in Helsinki.[34] It was no wonder therefore that arriving in Helsinki after the cease fire in September 1944, the Russian Control Commission were astonished not to find a city razed to the ground as they had expected.[35] All they did find were relatively few destroyed buildings, a rather larger number of burnt attics and shrapnel damage to the pedestal of the statue of J.W. Snellman. It is no wonder either that Russian officers wanted to inspect the Helsinki Air Defence Centre and that the Swedes invited the head of Helsinki air defence and his team to help re-plan Stockholm's defence system and train their military in the use of it.[36]

Aftermath of the War

Following the armistice the first representatives of the international press again began to arrive in Helsinki, and were also apparently amazed by the good order and relative well-being evident among the general public. Although Finland as a whole had suffered considerable military losses, with nearly 90,000 dead and 200,000 wounded of whom almost 60,000 remained permanently disabled[37] producing a total loss of population of 2.2 %,[38] foreign observers considered that the home front in Finland had fared better than in most other parts of Europe. The correspondent of the London *Sunday Times* even went so far as to express the view that the Finns "had fared lightly in the war".[39] The damage in the cities had in a few cases reached 10 % but it was often less than that and the standard of clothing and nourishment appeared generally to be better than in those continental European countries that had taken part in the war.[40] When referring to the good order that they had found in Helsinki the foreign correspondents must have been comparing the Finnish situation to that in other European countries, most of which were

in turmoil. Many German cities had been devastated. Countries such as the Netherlands, Norway, Denmark and certain parts of Hungary and Italy were suffering from the aftermath of German occupation. In liberated France and Belgium the people were carrying out private vendettas against the collaborators while in Greece and Yugoslavia open civil war continued.[41] Even London, though more tranquil, had been considerably more devastated by bombing with one third of the City and much of the East End in ruins.

This good state of affairs in Helsinki may also have had something to do with the fact that it was one of only three capitals of the European nations involved in the war that were never occupied by foreign troops (the other two being London and Moscow). Yet Helsinki's comparatively favourable situation was not because its citizens had failed to play a full part in the war effort. During the Winter War the majority of the soldiers drawn from the Helsinki area had served in the infantry regiments JR10 or in JR11, "the Ässä Regiment", which was widely noted for its fighting spirit. Even at the end of 1940, in the interval between the two wars the city was calculated to be providing a reserve of over 33,000 men for the defence forces, mostly for the army but also for the navy, the air force and the coastal artillery.[42] As members of the Lotta Svärd organisation (the Women's Auxiliary Defence Organisation) Helsinki women had served in hospitals and as caterers and nurses at the front as well as in civil defence tasks while others had replaced men in the city's transport system and in the ammunition industry.[43]

Wartime tasks undertaken in Helsinki had also included night-time patrolling of their own neighbourhoods by some 30,000 youths and older men not so much as fire-watchers but in order to help the police prevent crime.[44] Schoolchildren and older girls often spent their summer holidays working in the countryside on farms while those youngsters remaining in Helsinki supported the war effort by collecting not only berries from the nearby countryside but also dandelion roots, wild raspberry leaves and lime tree blossom which were then used by Paulig Ltd to produce substitute coffee and tea. [45] Some specialist groups of adults who normally worked in Helsinki had also taken part in helping to support agricultural production. Thus the staff of all government departments had had the duty of spending half their annual holidays helping with the harvest[46] and in 1943 even the staff of Suomi-Filmi,

the major film company, interrupted their production of 19th century costume dramas and rural comedies so that a 150 or so of their staff members and friends could plant potatoes in the fields of the Invalid Hospital.[47]

The reason why immediate post-war Helsinki seemed so well dressed may have lain in the long Finnish tradition of carefully recycling all textiles, a policy especially promoted by the women's voluntary organisations during the early 1930s recession. In war time women's magazines were again filled with instructions on how to recycle adult garments for children – with plenty of allowance in the seams to provide for growth – as well as on how to refashion two old dresses into a new one. It was not rare either to cut a fashionable lady's suit out of men's cast-offs, as almost all the men were wearing uniform. All women had already been taught basic dressmaking skills at school and a Singer sewing machine was a very common piece of household equipment. The use of sewing skills became even more important when textiles as well as footwear and other leather goods were rationed between 1941 and 1949, the only exceptions being bridal veils, artificial flowers and soldiers' leather belts.[48]

The reasons for the relatively good level of general nourishment, when compared with that in so many other European capitals, were not so obvious. Food rationing had also been in force in Finland since late 1939 and in the winter of 1941–42 there had been a real shortage of food in Helsinki and other towns before the arrival of the German supplies. The food situation in the autumn of 1944 also looked grave even if the crops in the Karelian Isthmus had been hurriedly harvested before the final departure.[49] To alleviate food shortages in Helsinki private individuals in Sweden as early as the autumn of 1941 had organised free food for undernourished children and expectant mothers; this work had been expanded in 1942 and again in 1943 to feed daily some 20,000 children and their mothers in 32 municipalities. In Helsinki alone there were six centres for distributing free food financed by Swedish and Danish people.[50] However, so far as the adult population was concerned the most important factor in Helsinki's favourable situation must have been the close links people in Helsinki still had with the countryside. Since 1920 the population of the city had doubled, mainly due to migration to the capital, and therefore many people still had families or close relatives in rural Finland. Many of them still had the knowledge and skills required to raise pigs and to cultivate vegetables even in an urban setting.[51] More

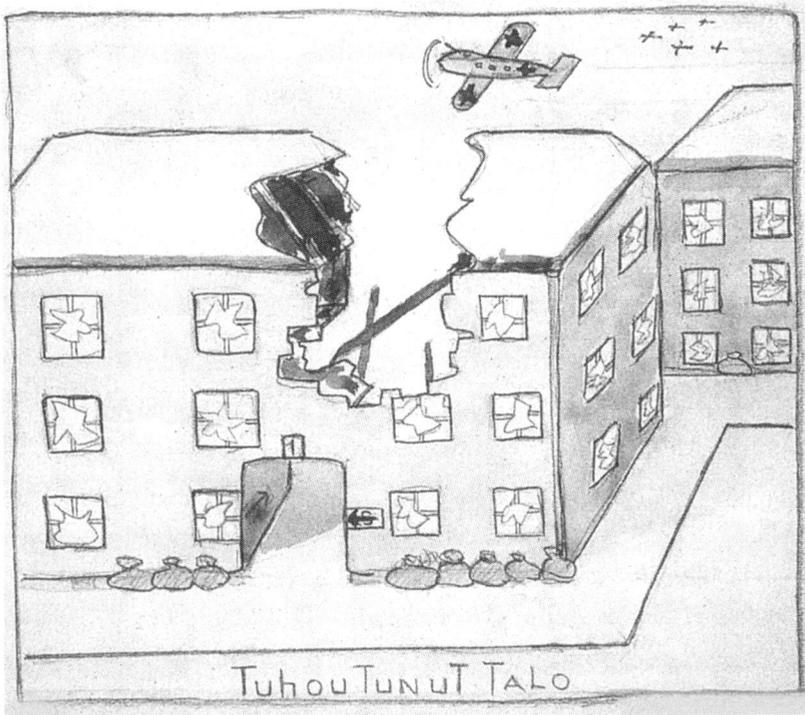

A child's drawing during the war. (Helsinki City Archives)

importantly, the capital's links with the countryside had been strengthened during the several major voluntary evacuations that had moved some half to three quarters of its population to the countryside. Whether Helsinki people came as evacuees or in order to help on the farms they were given food, and parcels were not infrequently sent afterwards not just to family members living in the capital but to the new acquaintances as well.

The mother of Arvo Hautala, a future chief shop steward at the Arabia ceramic factory in Helsinki, for example, had been raising a pig "in hope that her sons would return from the war alive". After demobilisation Arvo visited his mother in the country and was duly given one half of the pig. Moreover on this visit he was able, in spite of food rationing, to purchase butter, eggs, flour and potatoes as well as leather boots and a pair of trousers. He returned to Helsinki and a suspicious station policeman immediately de-tained him as someone who looked like "a professional hoarder" with his

three suitcases of scarce commodities. Showing his papers Hautala argued that he needed food to build up his fitness for work after a long period of deprivation at the front to which the embarrassed policeman could only retort, "Pack up your bags and off you go home".[52]

Although as in many other European countries, food and fuel rationing continued in Finland until the early 1950s, life in Helsinki returned relatively quickly to normal. By November 1944 the streets were already fully lit in the evenings[53] and some fun was gradually allowed to enter everyday life after the war years when public dances had been banned.[54] Unlike in Britain where broadcasting comedy and pop music had provided important support for the war effort, Finnish wartime radio broadcasts had been extremely serious, filled with dignified music and educational talks, news and propaganda items. The lightest music transmitted had been Finnish folk songs, which are notoriously melancholic in tone.[55] It was no wonder that in 1943 each Finn went to the cinema on average 7.5 times a year. Many of the films shown were foreign, mainly American, but as each new Finnish film was released it was seen on average by 400,000 people, i.e. one in ten Finns.[56] No wonder therefore that by 1944 Suomi-Filmi was able to equip two new studios in Helsinki on the site of the former indoor tennis courts in Liisankatu. [57] After the 1944 armistice the cinemas of Helsinki also took note of the changed political situation by starting to screen Russian films such "Volga, Volga" and "Ruslan and Ludmilla". They even showed a documentary on the battle of Stalingrad as German and Hungarian films were quietly withdrawn from the programmes. In November the first new editions of books and magazines in English began to appear in Helsinki bookshops and were invariably sold out in no time.[58]

Indeed, a new political orientation was evident in Helsinki within weeks of the armistice. The Control Commission of the Allies, i.e. the Russians and the British (the Americans had never declared war on Finland), arrived in early October making the Hotel Torni their headquarters until the autumn of 1947 when a peace treaty was signed in Paris. Though at first the Helsinki public was deeply suspicious, it did not cause any incidents and the members of the Commission behaved in a matter-of-fact manner.[59]

Indeed, the situation in Finland was comparatively benign. According to the terms of the armistice the evacuation of the areas ceded to the USSR

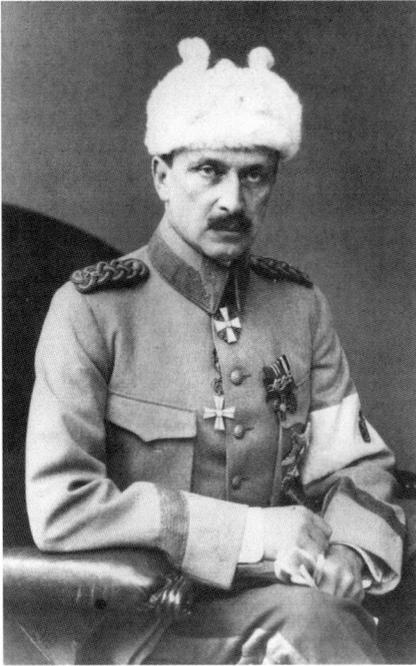

Marshal of Finland, Baron Carl Gustaf Emil Mannerheim (1867–1951) was appointed Commander-in-Chief, when the Soviet Union attacked Finland in 1939. During the Winter War and the Continuation War he earned the Finnish people's trust and adminisration. Toward the end of the Continuation War he was elected President. Mannerheim was born into the Swedish-Finnish nobility and began his career in the Russian imperial Army in the late nineteenth century. Following the Bolshevik revolution he returned to a newly independent Finland and in 1918 the Finnish Senate appointed him Commander-in-Chief of the newly established army. After the civil war he served as Regent of Finland from late 1918 until mid-1919. (Finnish Military Archives)

had been completed by the end of September 1944.[60] The Soviet Union had also demanded that the Finns order all Germans troops to leave the country, and thus the Finnish army found itself mounting an offensive against the 200,000 retreating Germans who had accumulated in Lapland.[61]

In the south the main threat to general order had been the potential political turmoil following the release from prison of Communists and other supporters of the political left who had been detained because of their pro-Soviet sympathies. Another potentially disruptive factor was the extremely swift demobilisation in November of nearly half a million men and women who had been serving in the defence forces and their auxiliary organisations. To ensure the orderliness of travel at this time there had to be a total ban on the sale of all alcohol for a month until the day after Independence Day, 6th December, which was then followed by three weeks of drinking on a massive scale no doubt expressing general relief that the war was over.[62]

The peaceful continuity of the democratic system was also facilitated in November by the inclusion in J. K. Paasikivi's new government of a Communist minister along with Social Democrats and representatives of the bourge-

ois parties. The existence of such a coalition government helped finally to heal the division of the Finnish people caused by the 1918 civil war, a healing process that had already started during the Winter War when the employers' organisations had entered into an agreement with the trade union movement.[63] The good will of the labour movement had also been demonstrated by the prominent role played by their leader Väinö Tanner in the war cabinets. This healing process now continued and as there had been no underground resistance movements which could have stirred up and divided society, as in many other European countries, the Finns were now able to start, "in good order" the major post-war tasks of rebuilding the country and paying off the huge war reparations demanded by the Allies.

Nature and the City Milieu

The strong connection Finns have with nature is manifest in the city milieu. It can be discerned in Finnish design and architecture as well as in the new Euro coins. Both Jugendstil at the end of the 19th century and Finnish post-war Modernism were both successful in part because of their closeness to nature, something regarded as a distinctly Finnish quality well to the fore in the construction of a Finnish identity. According to the architect Kirmo Mikkola

"Forests and trees, rock and natural boulders, wilderness and fire came to the forefront as the immemorial starting points of Finnish architecture"[1]

Erecting monuments related to nature is a particularly significant phenomenon in Helsinki.[2] Roughly estimated there are more statues portraying animals than statesmen. The first Finnish statesman to be portrayed in a statue was J.W. Snellman (1923), the Finnish nationalist philosopher and senator but statues portraying the presidents of the Republic were not erected until after the Second World War.[3]

On the other hand there were already four statues of bears.[4] We know from research that the bear symbolises power; it is also known that Finns used to worship the bear. Out of the nineteen statues erected in the 1930s, five portrayed animals and this trend continued in the 1940s (a crane statue, a lion statue, fishes, A Boy and a Fish, Fish Boys etc). In the 1950s, further statues were erected depicting a roe, bears at play, and pigeons. In the 1970s, eagles, an elk and calves also got their own statues. In addition other kinds of natural elements are a part of Finnish tradition, for example trees are planted in honour of a certain event, such as in 1931 a spruce in honour of Independence.

From national romanticism and Finnish Jugendstil architecture it is clear that animal figures were seen as good ornaments for a building and, particularly at the beginning of the 20th century, forest animals were paraded in the heart of the city by architects and sculptors. Bats, squirrels, bears and wild birds, especially owls and swans, decorated city façades, rooftops and gates. The statues erected in Helsinki also underline the city's closeness to nature as well as its status as the nation's capital, the place where statues of heads of state, builders of the nation, writers and poets were to be located.

At the end of the 19th century architecture's use of natural stone, particularly granite, took on a patriotic significance; it is, after all, quarried from the very bedrock of the country. At the turn of the 20th century Helsinki museums, like the National Museum and the Ateneum[5] had a symbolic meaning in the creation of the national profile. During these years Finnish architectural practitioners blended international ideals with national traditions, drawn mostly from eastern Karelia, the area which was the source of *Kalevala*, the Finnish national epic.

Moreover, Finnish nationalism was strengthened through a symbolism related to nature, which manifests itself most clearly in the national romantic buildings round the city, and through symbolism related to national mythology. In fact the first statues to be erected in Helsinki were those depicting the male

The statue of an elk by Jussi Mäntynen from 1930.
(Helsinki City Museum)

The House of Culture in Sturenkatu, designed by Alvar Aalto and built 1955-1958, is still one of Helsinki's major concert venues. (Photo Heikki Havas 1958, Helsinki City Museum)

heroes of *Kalevala*[6] and it can be assumed that the statues based on Finnish mythology that were unveiled during the war years and afterwards, strengthened the Finnish will to live through the difficult years of crisis.[7]

The fundamental features in the best Finnish architecture from the 1930s onwards were also the lively use of space and the connection with surrounding nature. Even in small buildings each space was differentiated so as to give it its own characteristic form and then the mixture of various building elements were adapted to the contours of landscape on the building site. Architecture was adapted to its surroundings.

Tapiola Garden City in Espoo, in the Helsinki region was the largest, most ambitious and internationally best-known of all the new suburbs in Finland. It was named after Tapio, the forest God of *Kalevala* and ancient Finnish mythology. The objective was to create a unified housing area with plenty of forests and gardens, laid out to a modern town plan, all carefully thought out with the welfare of the future inhabitants in mind, particularly that of the children and the young. The idea of this forest town was first presented in a pamphlet "Do our children need homes or barracks?" written by Heikki von Hertzen, head of the Finnish Population and Family Welfare Federation. He set up Asuntosäätiö, a non-profit housing foundation to build Tapiola and the area was designed according to the theories of Otto-I. Meurman, Finland´s first professor of town planning, adapting the inherited wisdom of rural building to urban development. In Meurman's ideal city nature held sway over human achievements.

The development of suburbs in Helsinki took place in the first half of the 20th century, first of all outside the city boundary, but it was only in the 1950s that blocks of flats began to be built on a major scale in suburban areas. The construction activity of Helsinki broadened out to the eastern and northern parts of the city. The first suburban area in which prefabricated elements were widely used was Pihlajamäki, a suburb on a hill with high cliffs and the biggest suburbs built in the 1960s were Jakomäki and Kontula.[8] The dominant principle in planning suburbs such as in the plans for Maunula was to ensure that the houses were so located that the inhabitants were not isolated from nature. They had all the modern amenities of a city but the buildings were erected in a natural way with large, enclosed courtyards, trees, plants and playgrounds.[9] When the long-standing Helsinki family of the writer Anto Leikola moved to Maunula in the late 1950s they thought that now they would never need a summer cottage of their own.[10]

According to the British architectural historian J.M. Richards the early parts of the Tapiola Garden City are recognised as the finest achievements of Finnish

architecture in the 1950s in which large units were designed by several architects. Many ideas were crystallised there: the clusters of houses blended with the landscape and its hillocks and meadows while the houses themselves were experiments in industrial construction techniques. Tapiola consisted of three residential neighbourhoods of approximately equal size each with a mixture of terrace houses and tall flats built to an overall density of 120 people per hectare (2,5 acres), set among trees and winding roads. The houses and flats had been designed by a number of architects, and the standard both of architecture and of landscaping was, with few exceptions, high. The centre included a tower block containing offices and a top floor restaurant and a shopping square. It was sited alongside a large open space containing a lake, with a secondary school nearby. All the dwellings in Tapiola were supplied with heating, hot water and electricity from one central power station. Later several new suburbs were built in Helsinki and its environs and the main principle behind their design was the desire to hide the architecture in a landscape, usually of forest, in harmony with nature.[11]

In Alvar Aalto's (1898-1976) architecture the strong relationship he had with nature was already visible in the late 1920s. According to Riitta Nikula he was a past master in applying international theories and influences. Even in his most militant functionalist phase he was never hostile to the caprices of the natural world. His library in Viipuri became a monument to functionalism liberated from the historicist reference, with free interior planning and ingenuous lighting arrangements at its artistic core. The purely cubic composition also meant a first step on the road from rectangularity to free form and a new respect for the intrinsic value of natural materials. In his designs in downtown Helsinki, such as the House of Culture and the main office of the Social Insurance Institution of Finland red bricks were used as the building material.

The House of Culture, built in 1955-58, is still one of the best concert halls in Finland and consists of two parts. The curving, sculpturesque red-brick walls of the concert hall proclaim the public nature of this section. The more pedestrian five-storey office wing, with its darkening copper façade, withdraws shyly from the street line. The complex is held together by a street side canopy and a low connecting wing at the back of the plot. In addition, the sensitive handling of light which is typical of Finnish architecture is manifest both in Aalto's 1954 Rautatalo (Iron House) and in the Academic Bookshop of 1969 in which he developed further the inventive modes of roof-lighting that he had used earlier in the Library in Viipuri. From 1961 to 1972 Aalto worked on a monumental vision for the centre of Helsinki, consisting of a large, fan-shaped, terraced square and a series of cultural buildings set along the west shore of Töölö Bay. The only fragment of the plan to be carried out so far consists of the Finlandia Hall (1971) and its congress wing (1975).[12]

The main buildings of Helsinki University of Technology (1964-70), designed by Alvar Aalto, form the centre of the large campus area of Otaniemi, Espoo. (Photo Jussi Tiainen 1997, Helsinki City Museum)

VIII Helsinki and the Rebuilding of Finland

The Housing Challenge

As mentioned earlier the damage the war caused in Helsinki was relatively small and the fact that the main state and civic buildings were intact allowed work by the national civilian leadership as well as the civic authorities to continue uninterrupted throughout the war. Therefore, while the politicians and the industrial experts embarked on negotiations about the details of paying Finland's war reparations to the Soviet Union, other Helsinki-based authorities were able to start solving the social and economic problems facing the country as a whole.

The most urgent of these challenges was the need to relocate the 420,000 evacuees from the ceded areas of Karelia and the problem of resettling the demobilised forces. Both these tasks required the repairing of damaged buildings and the constructing of new buildings to replace some 120,000 homes, i.e. 10 % of all dwellings, that had either been destroyed by the wars or abandoned in the ceded areas[1] while the setting up of industrial plants for war reparation requirements was also extremely urgent. All of these tasks were intertwined in a vicious circle: all needed capital, materials and workers none of which would be fully available until the major tasks were completed. War casualties had reduced the national workforce by some 200,000 while all possible capital available after the two wars as well as materials and manpower were needed for the massive expansion of the Finnish metal industry so that it could meet Soviet requirements for metal and engineering goods at a time when Finland's major industries were still based on wood. Again, no industry could operate efficiently without a speedy recovery of food production. This would require the urgent resettlement of

The Snake House (Käärmetalo) was a sinuous, 300 metre long municipal block of flats designed by architect Yrjö Lindgren. Its completion in 1951 indicates how quickly the disciplines of functionalism were abandoned. Every dwelling in the Snake House had an individual relation to the environment. (Helsinki City Museum)

Finnish children in Denmark. Altogether 70,000 children were sent from Finland during the Winter War (1939–1940) and the Continuation War (1941–1944). Of those 4,000 were sent to Denmark and the rest to Sweden. It has been estimated that after the war approximately 6,000–15,000 did not return or returned only for a time, because they had forgotten their Finnish or they had difficulties in adapting to life with their own family after so many years. (Archives of the Mannerheim League for Child Welfare)

farming people as well as providing them with some form of dwelling. Amid this tangle the nation had also to secure the future for some 31,000 war widows and 50,000 orphans. The problem of their well-being along with that of war invalids presented a major challenge to the welfare and child care authorities whose main task was to provide adequate education and employment rehabilitation.[2] In 1945 in Helsinki alone there were 1,566 war widows and 1,693 orphans. Moreover, there were 70,000 children who had been sent to Sweden to escape the perils of wartime Finland and although as many as 15,000 of them had remained there,[3] something that must have been heartbreaking for their Finnish families, many of those who returned had to relearn the Finnish language, almost forgotten during their years with their foster families.[4] Problems also emerged when Swedish and Danish foster families wanted to adopt the children who had been sent to them for safety. The Helsinki Child Welfare Board, following the ideas of Arvo Ylppö,

decided to oppose adoptions even in the cases where the biological, Finnish parents had died. Nevertheless, the courts in the countries of destination were not bound by the decision of this Board and in approximately half the cases ratified adoptions contrary to the Finnish decisions.[5]

Because it had suffered relatively limited damage the city of Helsinki itself was restored reasonably quickly.[6] It was also able to receive some 30,000 Karelians[7] of whom some 20,000 were from the ceded city of Viipuri[8] while, importantly, about half of Viipuri's 171 largest companies, among them the famous 18th century trading house Hackman, also moved to Helsinki thus giving its business life new vigour.[9] In accordance with the 1945 Land Acquisition Act[10] the city provided evacuees and war veterans, totalling 11,000,[11] with some 300 hectares of agricultural land for smallholdings and parcelled out nearly 100 hectares to provide plots for one family houses mainly in the eastern parts of the city.[12] The plots thus acquired provided sites for nearly 3,000 one family houses and more than 50 sites for blocks of flats.[13]

Nevertheless, all this was far from adequate to meet the demand for housing in the city intensified by the settlement of demobilized forces and evacuees. Apart from the need to cope with the flood of newly-wed couples and the subsequent baby-boom[14] Helsinki had also to deal with two additional concerns: it had to find accommodation for all the new workers needed by the city's expanding metal industry and it also had to provide lodgings for 6,000 young people wishing to start their university studies delayed by the war. [15] All this was at a time when the Finnish authorities had decided to give priority to the construction of new dwellings in the countryside in order to settle the Karelians, of whom over half were drawn from the farming population,[16] and to get food production going. According to a rough estimate the net migration into Helsinki in 1946–50 was over 24,000 including 9,000 Karelians.[17]

In 1946 to solve their own accommodation problem students in Helsinki again took the initiative and launched their own housing project, as they had done ninety years earlier. This took the form of a scheme for the construction of three seven storey houses as student accommodation, and so highly valued were university studies and so good were the contacts of the Helsinki University Student Association that private companies, cities, local authorities and organisations contributed to this Domus Academica project. Subse-

quently the construction of these student houses became a national enter-
prise with Parliament acting as guarantor for part of the loans. It reflects the
courage of the student leaders, many of whom had spent their youth at the
front, that they were willing to take the risk of financing the rest of the project
at a high interest rate and with short term loans to cover any costs not met
by their own fundraising campaigns. One of the most welcome of these
ventures for Helsinki people, still suffering from rationing, involved the sale
of 30,000 kilos of coffee donated in 1947 by the South-American based
Finnish businessman Eino Heinonen.[18] Another present day landmark, the
Kaivotalo building opposite Helsinki Railway Station, was also a product of
post-war student enterprise. The development of this business property as a
permanent fundraiser was just one example of the enterprise shown by the
Helsinki University Student Association, which later expanded its business
involvement by becoming the founder proprietor of Gaudeamus Oy, one of the
leading academic publishers in Finland, as well as a major shareholder in a
large multinational student travel agency. [19]

But in the 1940s any relief of the housing queues provided by Domus
Academica was far from enough to alleviate the general shortage and Helsin-
ki citizens were compelled to let their spare rooms to lodgers allocated to
them by the city. It was not until the late 1940s that Parliament finally made
resources generally available to the cities to build new dwellings and to
replace the old sub-standard ones under the "ARAVA system". This provided
state-subsidized loans for housing construction while allowing the occupants
gradually to purchase their dwellings. Among the first ARAVA blocks of flats in
Helsinki was the 300 metre long, literally meandering building, soon to be
known as "the Snakehouse", at block 857 in Mäkelänkatu, built in 1949–51.

After the war, the growth of population was
very considerable in Finland, and the 1950s
saw the birth of a state fund for housing and
the construction of new housing estates. The
most famous is probably Tapiola in Espoo.
According to architect Otto Meurman about
one half of the dwellings were to be in blocks
of flats, the remainder were to consist of
single-family homes and row houses. (Museum
of Finnish Architecture)

The idea of Tapiola was to take advantage of the topographic profile and scatter the houses amid the trees of the forest, thus giving everyone a view of nature. (Museum of Finnish Architecture)

While this construction still carried on the tradition of carefully planned small austerity dwellings, its twisting shape also ensured for each flat a free flow of light and an individual vista, heralding architectural trends which led in the 1950s to the construction of the famous Tapiola garden suburb.[20] Yet, the fact that by 1950 some 14 % of Helsinki people were still living as subtenants demonstrates the severity of an accommodation shortage in the city that continued for some time after the war.[21]

While the city fathers were thus kept busy supervising housing as well as running the post-war rationing scheme, other Helsinki people made a major contribution to the national life in the 1940s with their innovative planning and provision of leadership for national recovery schemes organised by the state in conjunction with professional and non-profitmaking organisations.

Some of these schemes had already begun during wartime and a most striking example is provided in the field of housing. The resettling of evacuees had actually had to take place not once but three times: i.e. in March 1940 at the end of the Winter War; in the autumn of 1941 and early 1942 when the Karelians started to return to their old, often burnt-out, homes; and again in the summer of 1944 when Finnish Karelians had to be re-evacuated for the second and final time. This was followed also by the need for a massive reconstruction programme in Lapland to replace the province's buildings that had been razed to the ground in late 1944 and early 1945 by retreating German troops.

On each occasion the Finns had been reluctant to establish refugee camps preferring to billet the Karelians on private farms while in 1944–45 the majority of Lapland people had taken refuge in Sweden. Given the reduced manpower and shortage of materials a joint approach by the state authorities and professional and non-profitmaking organisations to the re-settlement issue and the development of housing became therefore of vital importance. Needless to say, most of the bodies involved were based in Helsinki.

After the Winter War Parliament had passed an Emergency Land Acquisition Act as well as imposing the first of two capital levies to finance the settlement of the Karelians as quickly as possible.[22] It had also transferred the supervision of reconstruction in the countryside from an overworked government office to the Central League of Farming Associations (Maatalous-seurojen Keskusliitto),[23] a national advisory body for rural Finland. The League swiftly set up in Helsinki a construction office for producing general building plans and information, while its regional and local committees were responsible for planning and supervising the local building work in detail. [24]

At the same time the idea of producing standardised buildings had been stimulated by an undertaking by Sweden to donate 2,000 pre-fabricated houses, 200 of which were distributed in the autumn of 1940 to the Pirkkola region of Helsinki.[25] The basic plans for these one-family detached houses had actually been drawn up in Finland even if the elements were constructed in Sweden to Swedish standards and were using construction methods developed there[26] and the way that such Finnish plans had been successfully developed gave the necessary confidence to Finnish manufacturers to expand their own earlier experiments into full scale production for military and

After the Continuation War from June 1941 to September 1944, Helsinki received foreign aid for reconstruction from Sweden and the USA. These wooden houses in Pirkkola, on the north-western outskirts of Helsinki were built with financial assistance from Sweden.(Helsinki City Museum).

civilian purposes during the Continuation War.[27] The arrival of the Swedish houses also spurred the Finnish Association of Architects (SAFA) and a number of other bodies, including the League of Farming Associations and the cities of Helsinki, Turku and Tampere,[28] into starting the development of their own plans for standardised houses.

In this spirit of joining forces in the national effort SAFA also suggested early in 1942, in order help the return of the Karelians, that every architect in the country should give a minimum of two weeks' unpaid planning time per annum to this work and established its own reconstruction office in Helsinki[29] Standardisation as a means of providing efficiency was particularly strongly promoted by the well-known architect Alvar Aalto, who had recently returned from the USA, while similar plans had also been drafted by the co-operative property development company Haka in Helsinki.[30] To hammer home the message of standardisation as *the* key issue in building, Aalto also published a booklet on architecture and standardisation together with the well-known novelist Mika Waltari.[31] While producing standard plans for houses this SAFA

During the war some 120,000 dwellings were destroyed in Finland. After the war new homes were built on the one hand in the suburbs and on the other hand in the countryside. The heavy migration of people from the countryside into the cities beginning in the 1960s intensified the need for housing and the triumph of prefabricated concrete in housing construction began. The largest construction companies began the concentrated production of large prefabricated blocks to be used for the first time in the Pihlajamäki district in the south-western part of Helsinki (1962–1965). (Helsinki City Museum)

office was therefore soon also entrusted by the state authorities with the task of standardising building elements. Consequently SAFA launched in 1943 a system of building files, known as RT cards, which provided information on the standardised house construction elements. Thus when a local professional or amateur DIY builder embarked on a building project using the standardised plans designed by the League's reconstruction office, he was able to use these cards instead of needing supplementary drawings of parts and working details.[32] On the basis of these plans soldiers at the front were thus able, during lulls in the fighting, to construct over a thousand log houses to be sent back for the use of the widows of their fallen comrades.[33] The total of some 22,000 buildings of various kinds, erected in 1943 amid the war in the Karelian countryside,[34] also compared very favourably with the total of 13,600 dwellings that had been built in the Finnish countryside during the peak peacetime construction year of 1938.[35]

Once the Finns realised, in early 1943, that during the reconstruction of post-war Europe the likely shortage of materials would force Finland to manage her own restoration work without any foreign aid, the state authorities required an intensive rationalisation of the entire construction industry

as well as thorough research on construction technology and on possible substitute materials. In collaboration with SAFA, the Central League of Farming Associations and the Work Rationalisation Association (Työtehoseura), the Helsinki-based Technical Research Centre (VTT) was therefore engaged from 1943 onwards in exploring new technologies and materials as well as setting standards for building materials.[36] It also developed further cost and labour efficient construction methods including module systems, based on Swedish models, which were applied to the planning and building of wall elements as well as to ventilation and heating systems. Other VTT innovations included a new type of brick which could save up to 40 % of the brick mass needed in constructing fireplaces and chimneys and a new brick wall structure which could provide savings in the materials needed while still maintaining the quality.[37] The main target was now, as during the early war years, to assist in the cost-efficient construction of permanent buildings which were likely to last and to avoid wasteful temporary solutions.[38]

Thus by the armistice in the autumn of 1944 sets of standard plans for one family houses had been fully developed to suit both the rural and urban environment mainly utilising wood, the only raw material relatively freely available throughout the country.[39] By the end of the 1940s over 70,000 of these standardised one and a half storey detached houses, looking like cubes with a pitched roof, were built, together with nearly 100,000 outbuildings[40] often needing only the labour of the owner-occupier and the members of his family. All this decisively changed the Finnish landscape in all parts of the country. That the reconstruction had been carried out using almost entirely Finnish building materials was also a major achievement as before the war Finland had imported many essential construction materials from other countries.[41]

The Challenge of the Reparations

Perhaps the best compliment to the expertise Finns had gained in constructing prefabricated houses was the fact that the Soviet Union requested as part of the war reparations some 7,000 Finnish prefabricated wooden houses and 17 complete factories in which to produce them. It is ironic that a number of Finnish wooden houses actually proved useful in the reconstruc-

tion of Stalingrad[42] and there is no doubt that the Russians were satisfied with their quality, as in the 1950s they bought an additional 5,000,000 prefabricated wooden houses from Finland.[43]

However, any suggestions that there might be future business prospects of that magnitude would have sounded incredible to the Finns as they embarked on the war reparation discussions in October 1944. When the first Soviet proposals were presented in March 1944 the reaction had been more than gloomy; in fact Finnish economic experts considered the task so impossible to manage that the Finnish negotiators refused to discuss the proposed peace settlement any further.[44] The Soviet offensive in June, however, made the Finns eventually accept the inevitable and the subsequent armistice, including the articles on reparations, was signed on 19th September.[45]

In essence the level of the reparations remained unchanged from what had been proposed in March, that is 300 million dollars at the 1938 currency rate or nearly 600 million dollars in current terms, payable within six years. The Soviet Union's line in discussions with the other Allies from 1943 onwards had always been that Finland should pay 50 % of the cost of the destruction she had caused during the war.[46]

During the negotiations it became clear that the Russians had become increasingly interested in Finnish metal industry products[47] though the Finns would have preferred to pay by means of their traditional main export, in goods from the wood-based industries, after it became obvious that the option of raising foreign loans in order to make the payments was unacceptable to all the Allies.[48] When the agreement on reparations was signed on 17th December it did indeed list a total of 199 different products of which only 33 % were from the wood based industries. The onus of the task was clearly to be placed on the heavy metal industries as one third of the products in terms of value consisted, among others, of 30 turn-key industrial plants (including the above mentioned prefabricated house factories), over 50,000 electric motors and many hundreds of items of land transport equipment along with 517 boats, the latter forming some 20 % of all reparations in terms of value. The rest consisted of an assorted selection of cables (totalling over 8 %) and Finnish merchant ships that had already been confiscated (less than 5 %).[49] These ships consisted of more than a hundred vessels that were handed over to the Russians. They had formed 25 % of the Finnish merchant fleet and included some of its best and most modern

A view in the suburb of Mellunmäki, built in the 1970s. In the 1950s and 1960s new suburbs were built in forests and fields. In the very first modern Finnish suburbs nature had a more significant role than in most foreign cities. Tall blocks of flats in the suburbs offered magnificent views of the surroundings. Having a view of forest demonstrated the strong relation Finns have with nature. (Photo by Kari Malvinen)

craft.[50] As Finland also had to make its merchant navy available for the use of the Allies in 1945, some 30 Finnish vessels were also commissioned for this task leaving just about 10 % of its pre-war capacity for the use of the Finns themselves.[51]

Helsinki was again the nerve centre of national activities concerning the war reparations. In October 1944 the city received another Soviet delegation, in addition to the Russian members of the Allied's Control Commission, and their job was to supervise the quality of products and delivery schedules. This Soviet Administration of War Reparations had initially some 40 members later to expand to 200. They were accommodated in the Hotel Karelia at the Railway Square end of Kaisaniemenkatu, where Soviet and Finnish officials met almost daily for eight years until the end of the reparation process in September 1952.[52] The Finnish War Reparation Office, SOTEVA, the highest executive and supervisory body entrusted with almost dictatorial powers by the government, was conveniently located on the opposite side of the Square in the Sokos building, where it ended up occupying the top four floors.[53] These daily discussions were needed as the Russians proved to be extremely strict in matters of product quality and production schedules, though they could, in the face of impossible adversity, demonstrate co-operation and leniency.[54] Similar attitudes at the highest level were experienced within the first year of the operation of the reparation programme when Stalin himself agreed to lengthen the payment period from the original six to eight years while in 1948 the Soviet Union decided to cut their remaining reparation requirements by 50 %, i.e. by 73.5 million dollars.[55]

Such understanding was very welcome, as the most frequent single reason for late deliveries was not Finnish inefficiency but the delay in receiving steel from other European countries, themselves in the throes of their own post-war reconstruction.[56] Another serious obstacle was the lack of heavy metal industry plants and consequently of a skilled work force not only on the shop floor but also in the design departments. This was in great part due to the fact that before the war the Finnish engineering industry had in the main operated using foreign licences based on foreign designs and plans[57] and on a scale only a fraction of that required by the reparations programme. The ship-building industry, for example, was to provide over new 500 vessels of various types while before the war the average annual production had been a mere three vessels. To manage the reparation programme in its peak years it was necessary to produce some 60 vessels, which required the annual production of some 20 new university trained ship building engineers instead of the three per annum produced before the war.[58]

In spite of this shortage of trained staff the old Helsinki companies were much involved in the war reparation programme. The Hietalahti shipyard produced a total of 55 ships evolving during this process from a dockyard specialising in repairs to a yard producing new modern vessels.[59] Apart from three 3000 ton sea barges the Valmet shipyard constructed ten fishing trawlers, a type of vessel never before built in Finland. Each of the vessels also contained a fish meal plant, and Valmet was later to export them to Sweden which was then also engaged in producing trawlers for the Soviet Union. The most complicated engineering projects were allocated to the venerable engineering company Kone ja Silta while the equally highly esteemed Strömberg electrical company undertook the construction of over 50,000 electrical motors. Kone Oy produced 100 goods elevators, 200 cranes and scores of hoisting apparatuses, finding the latter also much sought after in Western Europe. The sole producer of all the cables required was Suomen Kaapeli Oy, which had to make its production more efficient to meet the needs of expanding Finnish industry as well.[60] As all these companies needed to expand their production the total workforce employed in Helsinki in the metal and engineering industries doubled from 14,723 in 1944[61] to 28,385 in 1952.[62]

The training of such numbers of new staff was only possible through learning on the job, i.e. with newcomers serving first as helpmates of the experienced workers until the required level of skills was achieved.[63] Astonishingly enough this informal, though age-old learning method proved quite successful in the Hietalahti shipyard, for example, if measured by the quality of the workmanship required by the Russians. Their inspectors were constantly present at the shipyard and the workforce soon learned the standards expected of their products. In the production of these vessels a new welding method had been developed by the VTT's laboratories and the arrival of mobile x-ray equipment helped the quality control of the welding.[64]

The shortage of trained designers was another major obstacle as the Soviet Union had only stated the amount of each type of equipment needed and its required capacity, leaving the task of solving technical details to the Finnish engineers. However, the release, after the war, of some 300 trained industrial draughtsmen and constructors from the State Aeroplane Manufacturing Company, experienced in designing complicated engine constructions, much eased the situation.[65] Moreover, the Finnish manufacturing industries had inherited a business culture of adaptability and development from the years of war when they had had to resort to new technical solutions and production methods to overcome the shortage of everything.[66]

One extreme case involved a request for a timber transporter never before seen in Finland. All that the Russians provided as a guide was a rough sketch literally drawn on the back of a cigarette packet. Yet the Finns eventually produced the transporter on the basis of a photograph acquired from the US specialist publication *Timber* after a more than hectic search, with the final design being developed from discussions involving SOTEVA, the Soviet Repair Administration and the factory. However, once this "straddle carrier" had at last been delivered, a memo was received from the USSR listing 18 points to be rectified. A downhearted SOTEVA representative had again to cross the Railway Square in order to ask the Russians to drop their demand for this "failed" product and ask for something easier, at which the Russian chief engineer burst into laughter, managing finally to retort,

> **"What is the matter with you in SOTEVA? 18 points of complaint? I can assure you that in any other country the production of such a difficult construction on the basis of only a photograph would have resulted in at least 18 <u>pages</u> of points to be rectified. Give my warmest congratulations to your chief engineer."[67]**

The rationing of foodstuffs continued in Finland until 1954 when coffee rationing ended. Helsinki residents received help during and after the war from their relatives living in the countryside. Moreover, the cultivation of gardens also helped to alleviate the shortage. The Herttoniemi allotments, established in 1934, was one of the oldest, including 182 lots on each of which a 24 square metre cabin could be built. (Helsinki City Museum)

During the eight years of meeting war reparation demands a total of over 140,000 train wagon loads of goods were sent to the Soviet Union while all ships delivered to the USSR would have stretched for 12 miles head to tail.[68] It was calculated later that, in spite of the reduction of the original programme, during the reparation period Finland paid a total of 444.7 million dollars at the price level of the time of delivery and 546 million dollars at the 1952 rate.[69] Comparing the burden of the reparations on a Finnish population of less than four million with that placed on the Germans after the First World War, it is a very telling fact that the burden per capita on Finns was far heavier even though the imposition on the Germans has been deemed an impossible task to achieve.[70]

The factors contributing to Finland's successful completion of this "impossible task" were of course many. Unlike many other European countries Finland did not benefit from the Marshall Plan given that she wished to stay outside any Great Power disputes already being caused by the Plan.[71] Even so, much of the success was due to the other foreign loans and grants,

received, especially in the early years, from Sweden and later from the USA, as well as to the goodwill of countries providing raw materials with Sweden again playing the central role.[72] However, the major onus – and credit – for financing the expansion of the metal industries and purchases of raw materials fell on the Finnish forest industries which had already in 1948 fulfilled its share of reparation payments[73] and was from then on able to earn much needed foreign currency by supplying timber for the reconstruction of post-war Europe.[74]

Nevertheless, according to Ilmari Harki, the Vice-Chairman of SOTEVA and the managing director of Europe's largest copper mine, Outokumpu, the ultimate explanation for the Finnish success was given in 1946 by a visiting British industrialist. He had come to Finland to investigate how the human capital of Finnish industry would stand up to the war reparation pressure and whether the Finns would break under it. After visiting a number of companies in Helsinki, Tampere and Turku he dropped into the SOTEVA office and asked his host what he thought was the real strength of the Finnish people. When Harki tried to offer the traditional Finnish answer *sisu* and the need for survival as an answer to his question, the British visitor brushed these aside as significant but not key factors saying,

> **"In impossible circumstances these characteristics are important but not adequate alone. What is needed is the third one that is your real strength - and this strength is your unbelievable capacity for improvisation which knows no bounds. Never forget it when the better times come as that is obviously your real national treasure."[75]**

The Challenge of the Olympic Games

The fact that the Finns were succeeding, through *sisu,* organisational capacity and unyielding tenacity in achieving the war reparations targets gave the nation a feeling of relief. It also gave them a new optimism in tackling the third great post-war challenge to Helsinki, the organizing of the Olympic Games in the summer of 1952.

The dream of organising the event in Finland was evident already in the 1920s when plans were made to apply for the games and to construct a stadium for the event. In 1932 the City of Helsinki submitted an application for the organising of the 1936 summer Olympics even though people in

Finland were far from convinced that this would lead to a positive result. Indeed, the application was simply meant to attract the attention of the world to the possibility of bringing the games to Helsinki and staging them in 1940 was considered a more realistic prospect. As a result of tactical manouvering Helsinki at first lost out to Tokio in the decisive vote, yet, once Japan had attacked China in 1937 the hosting of the 1940 games were offered istead to Helsinki, which agreed to take on their organisation with only two years' notice. Consequently they set about the construction of the main Olympic Stadium, the Velodrome and the sites for rowing and swimming, although the latter was never actually completed at that time as the water heating equipment was lost when the ship transporting it was sunk in 1940. In face of the turmoil following the German attack on Poland at the beginning of September 1939, the Finnish organisers tried to maintain their optimism and an invitation to participate in the 1940 games was sent to 64 countries in English, Spanish, French, Swedish and German expecting some four thousand athletes to accept. Tickets were already being sold in the summer of 1939 at special offices in Paris and Toronto and in many countries the games were publicised with a striking poster showing Paavo Nurmi, the legendary Flying Finn, the athlete who had taken a record of nine gold medals in running events during a career which stretched from the 1920 Olympic Games in Antwerp to the 1932 games in Los Angeles and was to culminate in a last public appearance as a runner in 1952 when he carried the olympic torch into the Helsinki stadium and thousands rushed to get a glimpse of this heroic athlete.

When the Soviet Union attacked Finland at the end of November the offices of the organising committee were closed and public discussion of the games came to an end. Nevertheless even while the enemy pilots were bombing Helsinki, the organising committee was still to be found sitting in a shelter judging the competition for the composing of the Olympic Games' opening fanfare. Once the Winter War ended in mid-March 1940 the organising committee had to decide whether to carry on the preparations or not. Naturally they decided not to continue and officially the whole preparation organisation was dissolved in July 1940 and the first houses of the Olympic Village, consisting of 426 completed flats, were then used to house mainly Karelian evacuees.

The Olympic Games ticket office in Paris close to the Opera, with posters advertising Finland. Everything, including the entrance tickets, was ready for the 1940 Olympics in Helsinki by the summer of 1939 but the world war changed everything. (Helsinki City Archives)

Once Helsinki began to recover from the war the municipal authorities made clear in early 1947 the city's willingness to host the 1952 Games. It was prepared to construct new sports venues and applied for loans to cover potential organising losses. The International Olympic Committee was sceptical about the suitability of Helsinki as a host town and Finland's ability to manage the organisational tasks, given the country's involvement in paying such huge war reparations. Nevertheless in the second vote Helsinki gained the required majority and this decision gave new enthusiasm to a nation struggling to solve its reconstruction problems. The news of the decision led to flags being hoisted all over Finland in celebration.

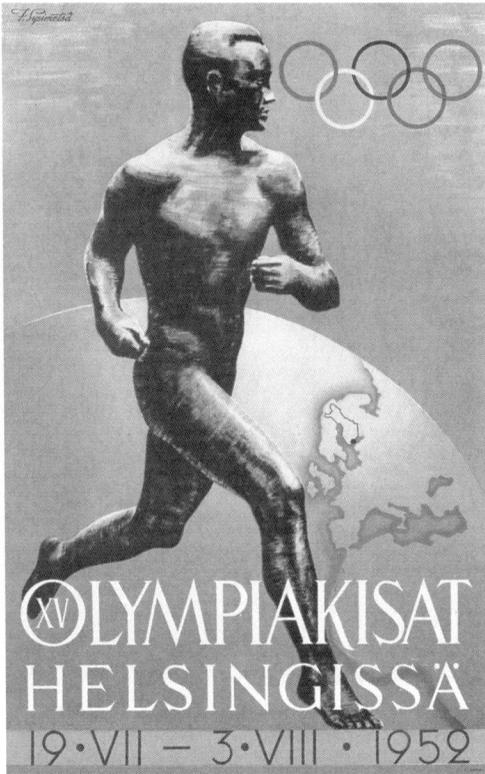

Paavo Nurmi, the "Flying Finn," symbol of the country's heyday in athletics in the 1920s and early 1930s. It was not until 1952 that the Olympic Games were finally organised in Helsinki and Nurmi lit the Olympic flame in the stadium. This poster by Paavo Sysimetsä dates from 1939. (Helsinki City Archives)

Invitations to the games were sent to a total of 81 countries and 79 of them sent athletes to take part in a total of 148 events while 82,000 copies of the renewed 1940 poster were printed in 29 languages.

The construction of the Olympic Village for 1940 had actually formed a part of the City of Helsinki's welfare housing programme and within this framework the city built 23 stone buildings providing accommodation for some 3,200 participants. For the 1952 games the scheme was expanded to house 4,800 athletes.

The organisers also wanted to apply new technologies. Among the innovations were an electronic score board, designed for the 1940 games, and the Swiss watch maker Omega provided free use of its timers, linked to photo-finish cameras, a combination that had already been used in the London Olympic Games of 1948. Further encouragement was provided by the many donations received by the organising committee: bananas from Belgium, tea

and biscuits from Britain, fruit and vegetables from the Netherlands, cod liver oil from Ireland, coffee from Colombia, Coca-Cola from France and cheese and eggs from Denmark.

The organising of facilities for broadcasting to other countries was a major task, as it required new equipment and the hiring of people with technical and language skills. In face of the need to serve scores of foreign radio broadcasters there was a shortage of qualified sound controllers, and a couple of enterprising correspondence institutes were quick off the mark to offer training.[76] In fact all the major broadcasting companies brought along their own sound technicians to prepare for broadcasting a total of 1,474 radio programmes in 34 languages to 47 countries lasting a total of total 639 hours.

As important as the broadcasting facilities were the telegraph links to serve the representatives of the world press. To this end the Finnish Post and Telegraph Board surveyed, in co-operation with the Swedish Telegraph Office, the anticipated need for telephone connections and the sound frequency bands required by them. In 1951 a new sea cable was laid between Marienhamn in the Åland Islands and Hammarudden in Sweden while the existing telephone links were also improved. Consequently journalists were able to use 62 direct telephone lines. The photo telegraph centre of Helsinki, by using the Muirhead Jarvis photo telegraph equipment, transmitted 438 telephotos while private photo telegraph was used also for the transmission of a total of 1,100 telephotos.

All in all the 1952 Olympic Games brought to Helsinki a total of 1,848 representatives of the media from 69 countries as well as representatives of 17 international news agencies. Naturally Sweden as a neighbour sent the greatest number, 124, but sizeable contingents arrived also from France (70), Great Britain (51) and Italy (49).

Amid the general optimism the organizers had expected that huge crowds of tourists would flood into Helsinki, but they did not realise that in an impoverished post-war Europe every kind of tourism was at its lowest ebb. Therefore the need for accommodation during the games was grossly over estimated, and the camping site in Lauttasaari for 6,000 people was used at most by 483 overnight visitors, although admittedly the other camping areas in Lehtisaari and Seurasaari did attract thousands of youngsters. Similarly

over 700 people were trained as guides but only some 400 had enough work. Even expectations regarding the sale of guidebooks were over optimistic; out of a print of 158,000 booklets printed in seven languages three quarters remained unsold.

Yet the number of visitors was still quite respectable bearing in mind that Helsinki was the smallest city and Finland the smallest country ever to have hosted the summer Olympic games. During the games a total of 13,624 people arrived, using the flights of 26 different airlines while the number of people who arrived by boat was three times higher, i.e. 44,603. These passengers included 44 different foreign delegations, such as members of the International Olympic Committee and members of the national Olympic Committees as well as technical experts of international athletic organisations and other distinguished foreign visitors. Thus even if the Games did not bring the expected financial gain to the city, they greatly increased goodwill towards Finland while making Helsinki as a city really known for the first time on the world stage.

Moreover, it proved to Finns themselves that the country really had recovered from the war.

In preparation for the Olympic Games Helsinki also built its first functionalist housing district, the Olympic Village (1939–1940) to plans by Hilding Ekelund and Martti Välikangas. It was the first large residential area in Helsinki to be built by a construction company belonging to the cooperative movement and during the war Karelian evacuees were housed there. From Viipuri alone 20,000 inhabitants moved to Helsinki. (Helsinki City Archives)

Erik von Frenckell, later the Assistant City Manager of Helsinki, first suggested the idea of holding the Olympic Games in Helsinki as early as 1912 and Oy Stadion Ab was founded in 1927 to manage the construction of a stadium. The Olympics speeded up the application of modern technology in Finland with the Stadium itself becoming a functionalist symbol of modern Finland. The winners of the architectural competition were Yrjö Lindegren and Toivo Jäntti and the construction work was completed in 1938. (Helsinki City Archives)

Helsinki – the Base Camp of Finnish Design

Apart from the Helsinki Olympic Games in 1952 Finland gained international acclaim in the 1950s in design, and much of this limelight was naturally due to Helsinki as the site of the main training institutions as well as of the major establishments of Finnish design in general and the ceramics and textile design in particular.

From the 1951 Milan Triennale, when Finland won no less than six Grand Prix, seven gold medals and eight silver medals, until towards the end of the 1960s Finland was internationally considered one of the major players in the field of design. The foundation of this reputation gained in 1951 was further strengthened at the 1954 and 1957 Triennales, then considered the most prestigious design exhibitions in the world. This success even inspired some to calculate that the Finnish artists were awarded 25 % of Grand Prix and that between 1951 and 1964 their average had been about one fifth of the total awarded.[1] The names of such Helsinki based designers as Tapio Wirkkala, Timo Sarpaneva and Kai Franck became known not only among their foreign professional colleagues but also among wider international audiences interested in design.

In the 1960s their success was followed by the fame gained by Marimekko textiles and by such young furniture designers as Antti Nurmesniemi and Eero Aarnio, whose Globe chair in particular became an icon of the 1960s, considered as evocative as the mini skirt or the Mini Cooper, for it was used by Mary Quant in her new Bond Street boutique in 1968, in the 1960s cult series "The Prisoner" and in films such as *The Italian Job*, starring Michael Caine.[2]

It was not Helsinki, the national hub, but Turku that became the centre of modernism in architecture and painting in the 1930s.[3] Yet in Helsinki there emerged a number of businesses, which quietly started to create new, modern designs especially for use in Finnish homes. They included the still continuing Arabia Studio (crockery, glass), launched in 1932 to supplement the production of mass table ware and sanitary porcelain, Stockmann's Studio (furniture), Taito Oy (lamps) and finally Artek, which was established in 1935 to market furniture, glass and textiles designed by Alvar and Aino Aalto, the forerunners of Finnish modernism. It was thus Helsinki, which continued as the centre of Finnish design also between the wars and the main channel for the diffusion of modernist visual images was through Finnish homes. Admittedly the first modernist experiments in glass were deemed mediocre copies of Swedish glass. But in textiles, and especially in carpets and wall hangings Finnish modern design began to get foreign acclaim and Maija Kansanen, for example, was frequently mentioned as a master of new design, which used abstract forms and elements found in other European countries mainly in ultramodern paintings. It is hardly an exaggeration to say that it was the Finnish textile designers operating in Helsinki, that initiated the Finnish general public into the modern visual language: in the 142 Helsinki homes of all social classes (as photographed for a publication presenting Finnish homes for international audiences) some two thirds had modern floor carpets even though the items of furniture in most of them were merely real or reproduced antiques and the pictures of traditional figurative style.[4] It is also evident that modern textiles

Tapio Wirkkala, internationally the best- known of Finnish designers, worked for Iittala Glass Works and collaborated with a number of other manufacturers and offices. The *Chantarelle* vase, one of his early works, was strongly inspired by Finnish nature. (The Finnish Glass Museum)

were first adopted in the capital as only one third of the pictured homes outside Helsinki displayed modern textiles similar to those that were so popular in the capital.

While the Second World War obviously hampered the work of the design circles it did not, however, entirely stop the development of Finnish applied arts and design. In the 1930s Arabia's design department had laid the foundation for its post-war public success and the same thing was happening in Ateneum, where Armas Lindgren of the triumvirate Gesellius, Lindgren, Saarinen had worked from the 1920s onwards as artistic director of the Central School of Applied Arts training all students in general design. It is generally accepted that it was his generalist study module that laid the foundation for Finnish design's later fame, as major Finnish designers had often actually trained in a totally different field of the applied arts from that in which they later worked. Franck for example was originally an interior designer[5] and Vuokko Nurmesniemi – textile designer – was a potter by training.[6] Another important element was the need to apply the aesthetics of meagre resources as Vuokko Eskolin-Nurmesniemi recalled her studies after the war:

"It is difficult to understand today in which circumstances we were then working; we had no information channels in order to follow events outside. There were no sources of information where we could have gained news from the world outside – we knew nothing about Picasso, nothing about Matisse – Our only information was our own fantasy material and our own willingness to create. – Everything was spontaneous, bohemian and full of virtuosity."[7]

Therefore in Finland the 1940s was an innovative period as such and Nordic exhibitions created intensive debates in Helsinki on the objects of industrial arts and their national forms of expression. The 1940s was also the golden age of unique and experimental craft products. Franck even considered design craft products as "the imagination of industry".[8]

Wirkkala's *Iceberg* vase reflects the severity of the Finnish winter. Today, leading auction houses such as Sotheby's and Christie's in London are taking an increasing interest in classic Finnish design. (The Finnish Glass Museum)

In 1967 Olof Bäckström changed the world of scissors design with the shock-resistant and lightweight, plastic and steel, orange-handled Fiskars scissors. Since their arrival on the market Fiskars scissors have been among the best-known Finnish products; internationally respected for their quality, innovation and design. They are thus also among the most pirated examples of Finnish design.

The Finnish design success in the 1950s and 60s may have been based on the foundations laid in the earlier decades, but as in the Jugend era, it was frequently grasped by young, daring designers. Thus Vuokko Nurmesniemi, for example, was only 21 when she became the head designer for Marimekko,[9] a Helsinki based textile company that shot into world fame in the late 1950s once Jacqueline Kennedy had bought a score of Marimekko's cotton dresses as maternity clothes.

But if in the 1950s unique design objects remained, until the mid-1950s, the prevailing image of design while at the same time breaking ground for potential innovations,[10] it was the industrial Marimekko, which was to sell almost ten million striped tricot garments by spring 1999 that can be considered the flagship of Finnish design in the 1960s and 1970s - even if Finnish furniture also gained much acclaim (for example, strongly influencing the development of Habitat in England) and there was a general design boom penetrating all social groups. At that time Finland faced an even more accelerated urbanisation while the standard of living generally rose. This created a domestic market for Finnish design products and the ideal of the 1920s of using beautiful objects for everyday life did in fact become true. Every Finnish household in cities and countryside alike had some design object: designed cooking pots; red enamel coffee pot; Fiskars scissors; Valencia crockery or design glass such as Aalto's Savoy vase and Marimekko had a target of getting at least one dress (mekko) into every Finnish woman's wardrobe. It was not therefore until the 1980s that competitively priced foreign products started to gain a market in Finland at a time when increasing foreign travel had made Finns more familiar with the visual traditions of other countries. Finnishness began to be experienced as parochial and the increasing wealth facilitated also in Finland an increasing demand for international designer goods. As the designers of the 1970s had concentrated on the ergonomically best designs and the requirements of the handicapped,[11] they could not easily adapt to the creation of more commercial products just for the sake of competitiveness. As a result it was only in the 1990s that a new generation of Finnish designers started to break again on to the international scene.

Compared with other Nordic countries the Finns had a less broad base: the collection of Scandinavian glass and ceramics at the Victoria & Albert Museum in London lists the work of fewer designers and factories from Finland than from Sweden, which had started earlier (1840s) with their Slöjd Association and coined the phrase of Scandinavian Design through their success in the 1920s. On the other hand those Finns that are listed did in their time receive higher accolades than the Swedes or the Danes.[12] It has also been claimed that much of the Finnish success was based on the marketing skills of H.O.Gummerus, the head of Public Relations at the Arabia factory[13] while Armi Ratia, the founder of Marimekko, was also known as a marketing genius.[14] Yet, after half a century Wirkkala, Sarpaneva and Franck are still recognised by the international design surveys.[15] Franck also is nowadays increasingly appreciated as a true reformer while Marimekko is similarly recognized in works dealing with the design of the 1960s.

In Finland Helsinki has maintained its central role as the main base of Finnish design and in spite of the recession of the early 1990s there are signs of new encouraging developments. One of the design firms that has reinvented itself for the contemporary world is Woodnotes Oy located in Lauttasaari. It was established in 1987 as a family company after the textile designer Ritva Puotila

had rediscovered the use of paper cord and started to use it for rugs, window blinds, bags and upholstery fabric. Following a commercial breakthrough at the furniture fair in Cologne in 1992 the company is now exporting 90% of its production to over 30 countries. It can be considered an example of finding a market niche utilised with technological innovation and good design. [16]

At the end of the 20th century trends in Finnish design indicate increasing internationalisation. Hackman's new tableware series "Tools" was designed by a team of five European designers including Renzo Piano and Antonio Citerio from Italy[17] and the renowned glass company Iittala used an international team to design its Relation glass range.[18] This could herald a similar impact for Finnish design on the international markets as was seen in the 1960s and 1970s when cheap imitations of the glassware of Sarpaneva and Wirkkala were sold round the world while copies of the yellow handled Fiskars scissors are still commonly used in households and offices everywhere.

To help its students in embracing this internationalisation the University of Art and Design UIAH in Helsinki has developed an action plan. Teachers and students of UIAH participated in the *Varde*-exhibition of Nordic universities of industrial art touring in 1994-1997 to London, Rome, Budapest, Berlin, Barcelona, Sapporo, Taipei, Soul and Linz.[19] From 1997 onwards UIAH has also run the *Galleria TaiK* programme, which aims to train students to operate professionally in an international art world. As part of the programme student works were sent to foreign galleries, exhibitions, trade fairs and museums[20], and for example the first public presentation of Galleria TaiK in Stockholm in the spring of 1998 produced invitations from the best Swedish galleries as well as sales to important museums. The tour, which continued to Denmark, Holland, France, Britain and Spain, also meant an international breakthrough for young Finnish photographers and in spring 2000 Galleria TaiK again attended the Stockholm Art Fair selling a number of its works to the Guggenheim Museum.[21]

The UIAH has also systematically created an international studying environment. As a result of active participation in congresses the staff of the UIAH have made significant international contacts also for the benefit of their students. During the 1990s a total of 700 students from UIAH studied abroad while some 1,200 students arrived at the same time from 30 different countries, the annual number of new foreigners almost equalling that of the new native students. Through training schemes organised under the Leonardo programme students have also been able to work in firms elsewhere in Europe.[22] Bearing in mind the significance of foreign contacts in the development of for example the young Eliel Saarinen and Alvar Aalto one can only guess at the significance for future Finnish design of these international links forged during their student years in Helsinki.

Stefan Lindfors, perhaps the internationally most noted Finnish designer of today, commented on the UIAH's student exhibition for the year 2000 entitled *Think!*:

"The products and the art on display in *Think* are above all the search of their producers' own identities. Many a student has dared to venture beyond the skills provided by their own department, which is good. ... the daring of students to break their boundaries can, at best, produce an accidental surprise which can become a starting point of a trend or an innovation."[23]

IX Helsinki – the Keys to Success

In early 2002 William M. Mercer Consulting claimed that Helsinki is the sixth best place to live among the big cities of the world when measured in terms of political stability, education, personal safety, public services, standard of living, equality among its citizens, the health care system, the environment and sport facilities (Zurich was in the first place and Vienna the second place). It also topped the list of unpolluted and clean capitals in the countries of the EU.[1]

The city of Helsinki has invested considerably in development and in the furthering of the well being of its inhabitants. In this chapter some aspects of Helsinki as a prosperous city are introduced, beginning with economic factors. Moreover, such characteristics of Helsinki as are interconnected with the economy, advanced level of education, research and development, women's active participation in society and work-life, internationalisation, mobility, and culture are also discussed.

Economic Development and Changes in Trade Structure

The growth of population in Helsinki and the Helsinki region speeded up rapidly after the 1940s and during the 1950s it grew annually by 8,000 inhabitants because the manufacturing and construction industries created a need for the labour force. This is manifest in the figures for the employed labour force in industry (see appendix III and figure 1) and this development continued until the end of the 1960s. During that decade Helsinki and the

The Helsinki Science Park, located on the Viikki Campus, built in the fields of the Latokartano Estate (approx. 1,000 hectares), is a remarkable concentration of biological sciences. The goal was to combine academic reseach and study with the product-development work and marketing expertise of enterprises in the field. There is a Biocentre for biological sciences and technology by architect Kaarina Löfström and an Information Centre (Infocentre Korona) by architects Hannu Huttunen, Markku Erholtz, Pentti Kareoja. The third centre is the Gardenia Centre by Hannu Tikka. In recent years natural and biosciences have received more public funding than the humanities or social sciences, but more applied research is being conducted in those fields also. (Helsinki University)

FIGURE 1.

Jobs in Helsinki 1950–1998

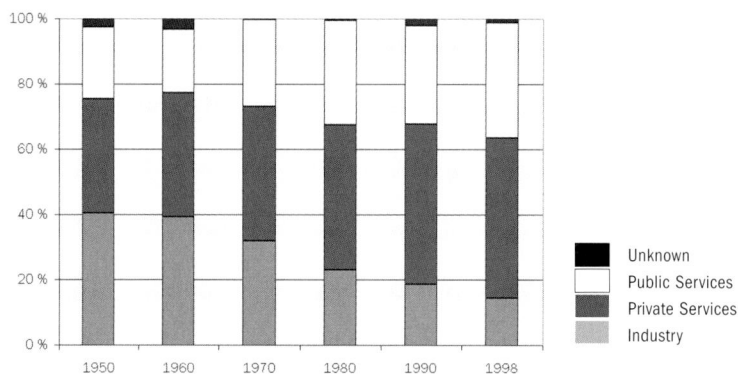

Source: Helsinki tilastoina 1800-luvulta nykypäivään, p. 68; City of Helsinki Urban Facts.

whole country experienced a rapid change of industrial structure (see appendix I and figure 1) while migration to the southern part of the country and emigration to Sweden increased. People also moved into towns from the countryside.

The population of the city grew by 51,000 inhabitants because of annexations of the surrounding suburban areas in 1946 and then amounted to 341,600. Ten years later the population of the city was already 412,000 exceeding half a million by 1966 [2] and by 31.12.2000 it had reached 555,474 inhabitants. The greater Helsinki area, comprising the City itself, Espoo, Vantaa and Kauniainen, now forms a population centre of approximately a million people (see appendix II).[3]

The change of focus towards information technology shows in the development of employment not only in Helsinki (see figure 2) but also in Vantaa and Espoo. Helsinki is the biggest centre of employment in Finland and has always offered employment to people from outside the city and has attracted young single people with its employment opportunities; in 2000 its biggest age group was the 32 year-olds.[4] At that time three in every five jobs in the Helsinki economic area were in the city itself.

During the inter-war period Helsinki was a city of three predominant branches of industry, metal and engineering, printing and textiles. It was significant for the growth of the city that its harbour was the biggest import harbour in

FIGURE 2. **Jobs in the information sector and other industries in Helsinki in 1993-1998 and projection in 1999 (Index, 1993=100)**

Index, 1993=100

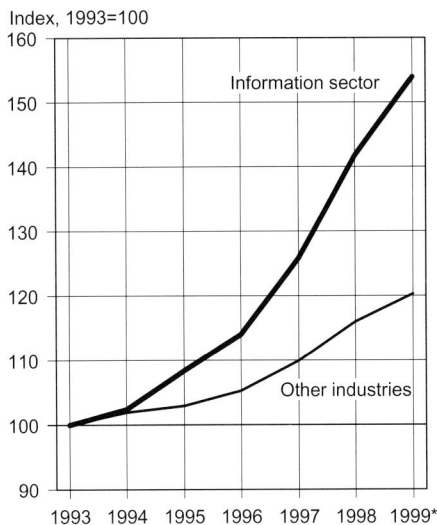

Source: Statistics Finland, City of Helsinki Urban Facts

the country excluding the oil refineries. In the 1930s approximately 35 % of Helsinki's labour force was engaged in industry and construction and the city's traditional industries continued to grow until the 1960s. During this period the food industry also grew rapidly.[5]

There were 212,000 jobs in Helsinki in 1950 of which 38 % were in secondary production, mostly in manufacturing and construction. Private services employed 28 % and public services 26 % of the labour force. The service sector later strengthened its position at the cost of manufacturing industry so that by 1970 when there were 327,000 jobs in Helsinki with 32 % in manufacturing industry and construction, 41 % in wholesale and retail trade, repair and other private services and 27 % in public services. By 1990 manufacturing industry employed only 32,200 people and its share of employed people had dropped to 13 % (see figure 1).

During the recession at the beginning of the 1990s, which lasted until 1993, unemployment increased heavily and jobs disappeared most rapidly in manufacturing, the construction industry and financial services. Once the

recession eased in 1994 real estate and other financial services hired more people, as did communications, especially telecommunications. The latter form an important branch of the information sector along with information processing services, publishing, broadcasting, advertising and management consultancy and these proved to be the engines of the economy in Helsinki and the capital area. In 1998 most jobs in Helsinki were in the service sector. Of the total of 344,493 jobs 16.8 % were in real estate, renting and business activities, a further 13.4 % in the wholesale and retail trade and repairs, 12 % in health and social work and 10 % in transport, storage and communications. Manufacturing jobs accounted for a mere 9.2 % of all jobs. (See appendix IV).[6]

Economic Development

In the 1990s Finland was one of the richest countries in the world and during the 20th century Finland's economic growth was among the most rapid of all the developed countries. The volume of GDP grew by 2.9 % yearly between 1865 and 1995 while the growth of the GDP per capita was 2.1 %.[7] The period of growth after the Second World War until the mid-1970s was exceptional. GDP grew by an annual average of nearly 5 %. However, the severe recession at the beginning of the 1990s dragged Finland below the level of the industrial countries. In 1994–2000 the growth of GDP was on average 4.7 % and by the end of the 1990s Finland has surpassed its former mother country. Sweden as measured by GDP per capita using purchasing power parities. The diagram shows how sharply GDP has grown in Finland as well as the impact of the economic recession at the beginning of the 1990s.[8] (See appendix V)

The value of Finnish exports was 19 % of GDP in 1990 and 38 % in 2000, representing a doubling of percentages during the 1990s. The strong growth of export goods explains the recovery from the recession and why the growth of GDP was great by international standards.[9]

At the beginning of the 1860s Finland's GDP per capita was approximately 25 % lower than the average of other European countries. However, during her autonomous period Finland enjoyed formal customs autonomy and in Russia Finnish goods had favoured tariff treatment with no or low tariffs and

this, in the final decades of the 19th century, helped Finland's industrialisa-
tion quite considerably benefiting in particular the paper, metal and engineer-
ing industries as well as factories producing consumer goods.[10] Finland's
economic growth thus was attributable to exports to Russia. This economic
development accelerated significantly from the 1860s onwards and prior to
the outbreak of the First World War the country's GDP per capita had already
caught up with the European average. Until the war Finland exported paper
and industrial goods to Russia, and timber, pulp and butter to the western
markets but as a result of the revolution when trade with Russia collapsed
Finland had to rely increasingly on goods based on the forest industries.[11] In
the years following independence Finland had no official trade relations and
no trade representation and the interwar period was a time of tedious
bilateral negotiations, which during the 1930s often produced strict protec-
tionist measures. Even so Finnish exports grew significantly faster than world
trade during the inter-war period. Thus exports in 1938 were double and
imports 1.7 times the level in 1913.[12]

During the war economy of 1939–1945 Finland had very limited foreign
economic connections. In fact, Sweden and, between 1940 and 1944,
Germany and Denmark were the only significant trade partners. After the war
Finland was dependent on economic aid from Sweden and the re-establish-
ment of foreign trade relations was a difficult process throughout Europe.
There were shortages of goods, currency, and trade agreements. Moreover,
as we have seen, Finland was burdened with very heavy war reparation,
payable to the Soviet Union in goods and when the war with the Soviet Union
ended in 1944 the Finnish shipping industry was stagnant because of the
mine danger. In addition the best ships had to be assigned to the Soviet
Union as part of the reparations. Connections beyond the Baltic Sea reo-
pened in the autumn of 1945, but after that the recovery of old trade links
was rapid.[13]

Trade between Finland and its large eastern neighbour continued to be
lively between when the war reparations were completed and the collapse of
the Soviet Union. Finland exported in particular manufactured products such
as machines, clothing and foodstuffs and imported mainly energy and raw
materials. In 1989 exports to the Soviet Union accounted for 15.4 % of the
total, to Sweden 14.9 %, to the UK 11.4 % and to the German Federal
Republic 10.9 %. After the USSR's collapse Finnish exports to the former

Soviet area dropped by two thirds and this was one of the factors behind the recession of the 1990s, a recession deeper in Finland than in any other developed western country, in fact, worse than in the recession of the 1930s. Since then exports to Russia have only recovered moderately and in 2000 only 4 % of Finland's exports went to that country making it the seventh on a list of the countries receiving Finnish exports.[14]

Efforts to take advantage of the international division of labour have been clearly reflected in Finnish trade policy decisions. In 1948 Finland joined the International Bank for Reconstruction and Development (IBRD) and the International Monetary Fund (IMF), and in the following year, the General Agreement on Tariffs and Trade (GATT). Finland's trade was kept strictly regulated throughout most of the 1950s. In 1961 Finland signed a special FINEFTA agreement with the EFTA countries and in 1969 joined the OECD. In 1970 a further possible opening of markets became a topical question when the United Kingdom, an important buyer of Finnish goods, joined the EEC. The government then started free trade negotiations with the EEC, reaching an agreement in 1974.

European integration has increased trade between Western European countries since the 1960s. Traditionally, two thirds of Finland's foreign trade have been – and still are – with the present European Union and EFTA Countries. The nature of export goods has changed, however, from being raw materials e.g. sawn goods and paper, into more sophisticated products. After a century long development, Finnish companies now export products requiring advanced technology and know how.

Economic growth has been associated with a process of structural change in which the share of the primary sector has fallen and the proportions of secondary production and the service sectors have grown side by side – except during the last 20–30 years. Particularly in the late 80s service-sector investments rose sharply and its capacity expanded considerably compared with the industrial sector which was competing with foreign production. Since the 90s investment growth has focused on non-material investments. Instead of buildings, machines and equipment, companies have invested in intangible assets such as knowledge and R & D.

As a remote and small market with a culture and language of its own, Finland has obviously not been very a tempting market for foreign direct

investment. Compared with other industrialised countries, internationalisation of Finnish companies began relatively late, in the late 1970s. On the other hand, the Finnish Senate and later the government of an independent Finland have tightly controlled foreign economic activities. Legislation restricted most foreign ownership in Finland from 1850 until the agreement on the European Economic Area in 1994[15] although direct foreign investments in Finland did pick up in the 1980s.

In the 1990s, foreign companies increased investments in Finland following the deregulation of foreign ownership in 1994 and EU membership in 1995. However, the stock of Finnish companies' investment abroad is still double that of foreign investment stock in Finland. International Companies ICL, IBM, Siemens, Hewlett Packard, Ericsson and Lotus have set up research units in the Helsinki region and they have increased their co-operation with Finnish firms. According to *Statistics Finland* there were in 1998 almost 1500 foreign-owned companies in Finland as a whole. They employed almost 130,000 people, or 10 % of all those employed by the business sector corresponding to 10–11 % of GDP. In industry their share of all the employed was approximately 13 %. Foreign capital has been invested in technology more intensively, on a larger scale and more successfully than in other Finnish companies because the Finnish technological competence has been so tempting[16].

The most quickly developing agglomeration of knowledge-intensive activities is the ICT cluster formed by information and communications sector companies. Its core is Nokia, but it also includes a network of hundreds of small and medium-sized companies as well as a rapidly growing operator and service sector. In a decade Finland has risen to join the group of leading producers and users of information and communication technologies. Its economy has shifted from a production structure intensive in its use of capital, raw materials and energy to an information-intensive one.[17]

The technological factor has been crucial in economic growth over the past hundred years or so. It has caused an extraordinarily rapid improvement of labour productivity. It is estimated that two thirds of Finland's economic growth has been derived from improved productivity and one-third from additional labour input. [18]

One characteristic of Finnish industry when compared with that of, for example, Southern European countries is that proportionally the largest number of jobs is in large-scale enterprises and not in small and medium size enterprises.

Today Finland is competitive in high tech, communication equipment and paper machinery. Finnish paper machines have gained a significant share of the market throughout the world. At the beginning of the 21st century Finns are in more ways than ever connected with the international economy and the capital market has been internationalised even further through the establishment of a common European currency.

R & D Investments as an Economic Success Factor

In Finnish science and technology the general development strategy has been to increase "knowledge and know-how" by developing a national system of innovation. An intricate part of the strategy has been the supporting of high-level research. Since the 1990s the strategic plan has been to establish complex research environments and thus funding has been increasingly directed to centres of excellence.[19]

In September 1996 the government decided to increase funding for research so that it would reach 2.9 % of GDP by 1999. Further the government saw it necessary to ensure the real level of principal resources of universities until 2000 by passing a special law. The purpose of the government's agenda was that the funds gained from the rearrangement of ownership in the state-owned companies were to be directed to strengthening the foundations of industrial productivity and restructuring. In accordance with this decision research investment by the state in 1997–1999 would gradually increase yearly by 83 million euros. The main recipients of this additional funding were basic research and technology. Specifically the aim of additional funding was to strengthen the performance of innovative systems for the benefit of the economy, business and employment. The main bulk of the additional funding was to be directed into research and development through technology and science management and especially through increasing the funding available from the National Technology Agency (TEKES) and the Academy of Finland through competitions.[20]

Already in the 1980s the State Council of Sciences set new, exacting objectives for the increasing of research funding. Particular attention was paid to basic research, research supporting social policy and services, energy research and research and development work for promoting technological development and industry. Proportionally technological research increased faster than basic research funded by the Academy of Finland and universities. In 1983 the National Technology Agency was founded to prepare and execute technology policies. The Agency is analogous to the Finnish Academy but concentrates on technology. The electrical and electronics industries were the trump card of technological research.

In 1991–1999 the average yearly growth rate of the total amount of research and development expenditure (R & D) in real terms has been approximately 9 %; it remained the same despite the deep recession in Finland at the beginning of the 1990s. Due to the recession the development of resources for the Academy of Finland and universities was slowed down. Moreover the focuses of research changed. It was increasingly directed towards applied utility research dependent on the needs of the economy and business.[21]

Science and technology quickly overcame the recession. The increase in R & D expenditure in 1995–1999 was 14 %, which shows that the pace was accelerating at the end of the millennium. During the 1990s R & D expenditure in real terms has almost doubled: in 1989 it was 1.81 % of GDP, in 1991 2.04 % that is 1.93 billion Euros, and in 1999 3.19 % of GDP or 3.98 billion Euros.

The research working years of all employed people is another indicator useful in international comparisons. Finland with its 19.6 per mil was placed first among the OECD countries. On average it is also clearly higher than in the other EU countries. Of all the OECD countries the development of research intensity in the 1990s was at its most rapid in Finland, Ireland and South Korea.[22] Although the research intensity was, and continues to be, at its highest in Sweden the increment there has nevertheless been slower than in Finland.

R & D expenditure has been directed all the more to applied research because the research activity of businesses has grown. The share of corporate sector expenditure in research and development investments has grown from 57 % in 1991 to 68 % in 1999. This growth is accounted for almost

solely by the R & D expenditure made in the electrical and electronics industries: since 1991 investments have grown heavily and had quintupled by 1999. The rapid growth of R & D expenditure by the corporate sector has caused all the more research to be done in corporations in Finland as has happened also in other OECD countries.

New Infrastructure and Changes in Travelling

The importance of travelling and tourism for development and the economy have always been recognised in Helsinki, and in this regard the Olympic Games in particular hastened the development of the city's infrastructure and enabled the city to catch up with developments elsewhere in the world. A trip to London was made in 1948 in order to study the electric lighting of the Olympic arenas, street lighting improvements for the games and festive lighting. The Helsinki Olympic Stadium was equipped with a scoreboard which differed radically from earlier examples and the final results were announced with the aid of an optical score board using electricity.[23]

There were also traffic improvements. The idea of traffic lights was already a familiar one by the end of the 1930s, but the war had halted plans for their adoption in Helsinki. The Olympics-related trip to London emphasised the need for such a system and one year before the games the first traffic lights were switched on in central Helsinki, at the corner of Aleksanterinkatu and Mikonkatu in 1951. However any real breakthrough did not take place until the 1960s when the maintenance of traffic lights ceased to be the responsibility of the power utility and was transferred to Helsinki city planning office[24].

By far the most important new innovation in the city was, however, the transition to a district heating system whereby hot water was distributed directly to homes and businesses. The Olympiakylän Lämpökeskus (the heating centre for the Olympic village) was established already with the 1940 Games already in view. Moreover, the Olympic village built to house the athletes during the games was in 1952 the first area in Helsinki to have the benefits of district heating, provided by the Olympiakylän Lämpökeskus. In general the provision of district heating in Finland was defined as a task for the power utility as early as the autumn of 1953.

Already in the late 1960s almost half of Helsinki's population enjoyed district heating. The Hanasaari power plant is one of the many plants that provide such heating for the Helsinki area. (Helsinki City Museum)

There had already been some steam distribution in the 1920s from Suvisaari power plant to a repair workshop on the other side of the Sörnäinen boulevard and steam from the same pipe was later also sold to the city's concrete pipe foundry and eventually to the gasworks. At the beginning of the 1950s other consumers started to get their share. These included the Lindström laundry and a slaughterhouse. Hot water began to be distributed in a similar way from Salmisaari in 1956. Combined production of electricity and heating began at Hanasaari in 1960 after many experiments and by 1962 there were 569 receiving points for district heating, increasing to 6,182 by 1981. During the 1960s the number of people living in district heated buildings was 230 000, in other words 45 % of the city population.[25] From the 1970s onwards, electric heating began to compete with hydroelectric district heating.

Internal traffic connections were improved significantly when trolleybuses entered the street scene in 1948. The creation of this system was the great achievement of Helsinki City public transport services. The trolleybuses got their electric energy from the power utility network; the feed system decided to use a 600 volts direct current and they had many advantages.

As can be seen here traffic easily gets congested as on Kulosaari Bridge in the 1970s. Helsinki's location on a peninsula jutting out into the Baltic Sea means that there are only three main thoroughfares in and out of the city. (Helsinki City Museum)

"There was no noise or smells when the trolleybus moved. They accelerated well, consistently and continuously. They were a success among the passengers".[26]

The first trolleybus was tested in September 11, 1948 and early the next year a regular route started to run in Helsinki.[27] This was helped by the fact that asphalt had become more common after the Second World War. When the runways at Helsinki airport were being paved in 1952, there were three asphalt stations, and the first permanently functional stations were introduced in Helsinki in 1959.[28] Concrete pavement materials were also coming into use.[29]

Like in most other major cities, horse cabs dominated the Helsinki street scene in the early 20th century and it was not until the 1950s that motorcars started to become increasingly common. The number of cars registered in Helsinki in 1915 was a mere 170; in the whole country the number had increased tenfold by 1920.[30] In 1998 the number of cars in Helsinki was 172,886, i.e. 359 cars per thousand people. The number increased in the following years although Helsinki has successfully invested in creating a

functional public transport system and thus on 31 December 2000 the number of registered cars per 1,000 inhabitants in Helsinki was 336 whereas in the rest of the country it was 412. [31]

The outstanding innovation of the 1960s was the underground railway the planning of which had commenced in 1954. This took two years but a decision to go ahead with its construction was not made until 1969 and the first trains did not run until 1982. Meanwhile electric trains became normal on all suburban lines in 1969.[32]

Sea traffic

In the 1880s the Helsinki-based Suomen Höyrylaiva Osakeyhtiö further developed seafaring into a regular line service and by the beginning of the First World War the network consisted of 26 different lines of which most started from or ended in Helsinki. A regular shipping line to South America started in 1926 and ten years later to North America, although the busiest lines were, of course, those to Tallinn and to Stockholm. Altogether in 1929 a total of 35,500 passengers arrived in Helsinki by sea and within ten years the number had almost doubled to 61,000 in 1939.

However, the most rapid increase in passenger ship traffic in Finland, and also in Helsinki, took place in the 1960s and 1970s, and it can be linked to the arrival of the car ferries. The first car ferry company had started to operate in 1959 and

There has been an explosive growth in ferry traffic since Estonian independence in 1991 and the most heavily trafficked route is currently between Tallinn and Helsinki carrying 4.6 million passengers in 2000. In the same year the largest shipping companies, Viking and Silja Lines, ferried a total of 6.6 million passengers from Helsinki or Turku to Stockholm and back.
(Photo Jussi Kautto)

launched a small ferry, converted from an ordinary passenger vessel, to sail between Marienhamn in the Åland Islands and Sweden[33], and soon car ferries were also sailing across the Gulf of Bothnia between Vaasa and Sweden. The first modern car ferry M/S *Aallotar* started to sail between Helsinki and Stockholm in 1972.

Much of the popularity of travelling by sea has been due to the big luxury car ferries, which began first to serve passenger traffic in the Åland sea and in the Gulf of Finland. Particularly significant were the *SS Bore* and *Skandia* plying between Turku and Stockholm while Finnjet, the world's first passenger ship powered by gas turbines provided something new and innovative from 1977 onwards for the sailing between Finland and the German Federal Republic. In its first year alone this ferry carried over 205,000 passengers.[34]

The growth in sea passengers was at its greatest both in Helsinki and in the rest of Finland during the 1960s and 1970s. In 1970 some 170,000 passengers arrived in Helsinki by sea and by 1980 this had risen to 635,000. During the 1990s the passenger traffic by sea again grew and in 1998 some 4.3 million people arrived in the city. However, one has to take into account that the 1998 figure also includes people taking part in round trips, "cruises", to Sweden or Estonia.[35] Passengers of the ferries sailing to Sweden accounted for 1.2 million and those travelling to Tallinn for 2.8 million. These figures represent 53.9 % of all passengers arriving in Finland by sea and demonstrate that Helsinki has maintained its position as a premier port for passenger traffic. It is also likely to hold this position as some thirty vessels daily are currently using the Helsinki–Tallinn route including a few very fast ferries[36] and since the collapse of the Soviet Union Estonia and Tallinn in particular have become increasingly popular destinations.

Air traffic

A major breakthrough in establishing traffic connections was the starting of air services. Finnair is one of the world's oldest airline companies still in business. Under its original name Aero Oy (which was changed in 1968 to Finnair Oy) it began to fly to Tallinn in March 1924 and to Stockholm in the same summer.[37]

The services were begun with single-engine Junkers F-13 monoplanes fixed with floats in summer and skis in winter. They could take up to four passengers as well as mailbags, which on the first flight weighed 162 kilograms. During the first operational year the company transported 269 passengers.[38] The preparations being made for the 1940 Olympic Games helped the planning of air traffic.[39]

FIGURE 3.

Passengers on international flights in 1953-1999

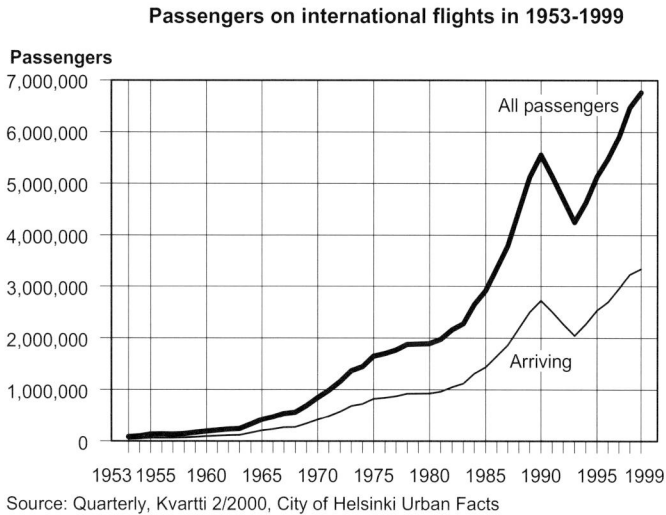

Passengers

7,000,000

6,000,000

5,000,000

4,000,000

3,000,000

2,000,000

1,000,000

0

1953 1955 1960 1965 1970 1975 1980 1985 1990 1995 1999

All passengers

Arriving

Source: Quarterly, Kvartti 2/2000, City of Helsinki Urban Facts

Before the Second World War Helsinki had a direct flight route to Berlin and from there to several other German cities. Flights to Riga via Tallinn were begun in 1927. Before the Second World War flying times were still long; even by air a journey from Helsinki to London or Paris could take 11 hours.[40] The opening of land based airports heralded in a new era, as flights were possible all year round. In 1938 flights departed from Malmi Airport to Berlin with stopovers in Tallinn, Riga, Königsberg and Danzig.[41] In wartime there were night flights to Stockholm some of which carried Finnish children to Sweden away from the dangers of war.

After the Continuation War flights from Finland to abroad were stopped altogether from September 1944 to January 1945 and again from early spring 1945 onwards and thus there were no longer direct flights to Berlin, Riga or Tallinn. Malmi Airport only came back into civilian use after the Paris Peace Treaty in 1947. International flights began anew in 1948 with Finnair flying to Copenhagen and Amsterdam. Five years later they began flying to Paris, to London in 1954, to Moscow in 1956 and to Frankfurt in 1957.[42] Once the new Helsinki–Vantaa airport was opened at Seutula in 1952 for the

Passengers at Helsinki's Malmi Airport in 1947. The end of the 1940s was a time of shortages. At that time Aero, the old name for the present Finnair, had just two Junkers, two DC 2s and one de Havilland Dragon Rapide. Direct air connections were opened between Helsinki and Copenhagen, Amsterdam and Norrköping in 1948. It was not until the 1960s that it was possible to fly direct to most European capitals. In 2000, 7.5 million passengers flew with Finnair. (Helsinki City Museum)

Olympic Games all scheduled flights were transferred there. In 1953 international flight passengers arriving in Helsinki totalled 43,000 and the number of passengers on internal flights was twice as many.

Yet it was not until the 1960s that there was a further expansion of air travel. Direct flights from Helsinki were introduced

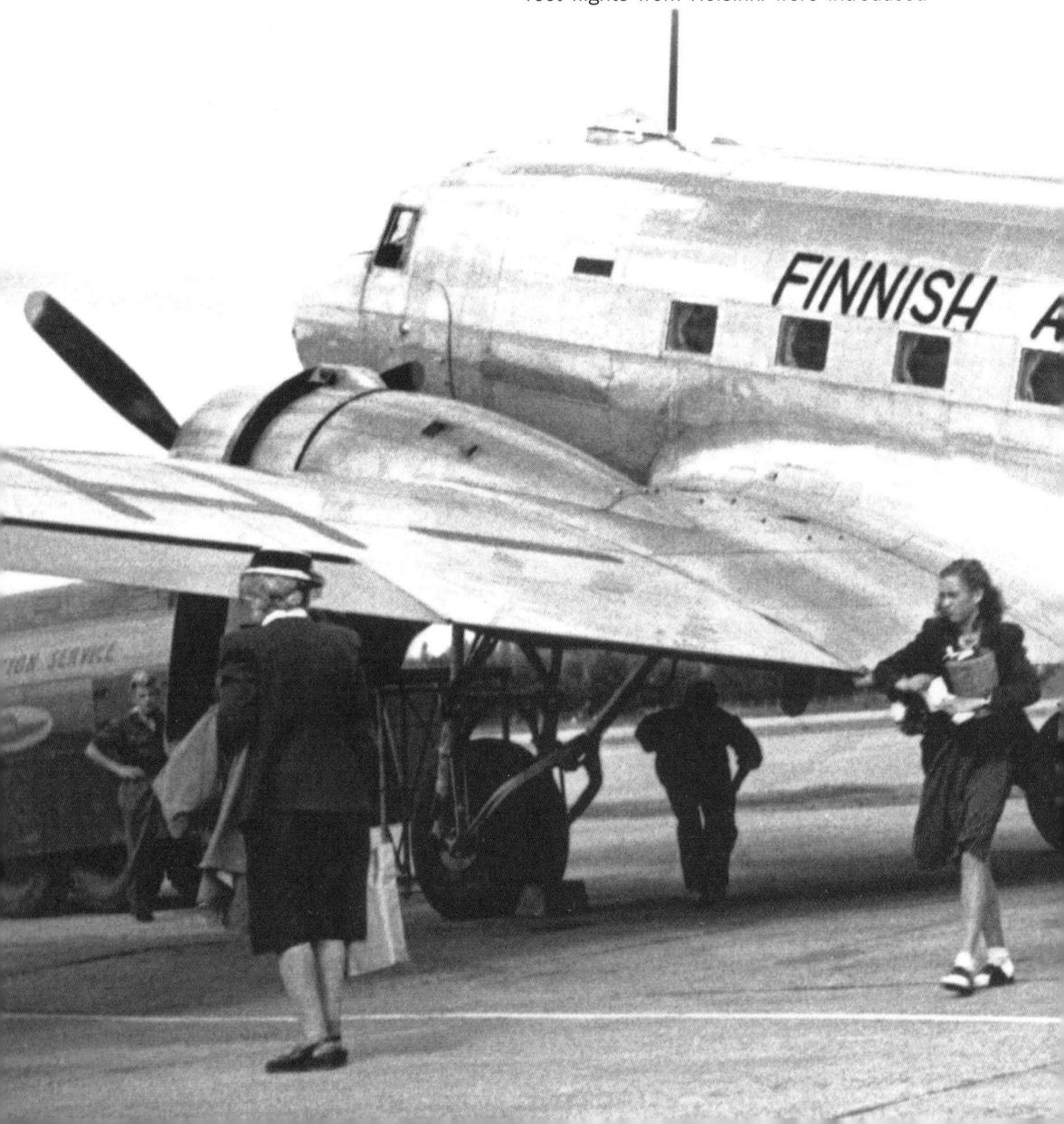

to Oslo in 1960, Barcelona in 1964, Brussels in 1966, New York, Prague and Budapest in 1969 and Rome in 1977. Once Finnair had acquired their first new DC-aircraft, flights to Seattle and Tokyo became a reality in 1983. On the Tokyo flights Finnair was the first airline in the world regularly to fly over the North Pole, but later Gunnar Korhonen, Finnair's long standing CEO, persuaded the Soviet authorities to allow these flights to take a route over Siberia.[43]

Consequently Finnair's passenger numbers displayed a decisive increase from the 1950s to the mid-1960s, when a total of 200,000 passengers were using the company's international flights while twice as many people used the domestic flights. In 1981 over one million passengers arrived in Helsinki on international flights. In 1998 they numbered 3.2 million, including transit passengers.[44](see figure 3) In the same year 1.5 million passengers used charter flights according to Finnair statistics.[45]

Finnair's services have been particularly significant on domestic routes simply because the distances to be covered in a country over 1,000 kilometres long. In fact they have ironed out some of the regional differences in Finland. Therefore annual passenger numbers on all domestic flights were for a long time greater than those on international flights and it was not until 1993 that the latter carried more passengers than the domestic routes.

The competition provided by foreign airlines is evident from the fact that while a total of 6.1 million passengers used Finnair's scheduled flights in 2001 the total of international flight passengers at all Finnish airports was 7.7 million. If those using charter flights (1.4 million) are added, the total number of passengers using Finnair aircraft in 2001 was 7.5 million. Including passengers carried by foreign airlines the total flight passenger numbers have now reached the 13.8 million.[46]

Universities, Schools and Libraries

*F*rankfurter Allgemeine Zeitung published on 9 February 2002 an extensive and laudatory article on Finland's educational strategies by journalist Heike Schmoll.[47] In his article he suggested that teachers in Germany would become positively envious if they knew that all Finnish schools have school curators, school psychologists, teachers for special needs and so on. Commenting on the Finnish comprehensive school system the writer pointed out that, unlike in Germany, the Finnish teacher could not transfer less able children to schools, which have lower standards. So far as the teaching was concerned the article gave prominence to the freedom and responsibility of the students themselves something permitted by the modular structure of the curriculum. In addition the article drew the reader's attention to the fact that in Finland the study of the first foreign language begins as early as the third grade and notes also that on Finnish television one can actually hear English, German and French being spoken while in Germany all foreign language films are dubbed into German.

FIGURE 4.

University students 1900-1999

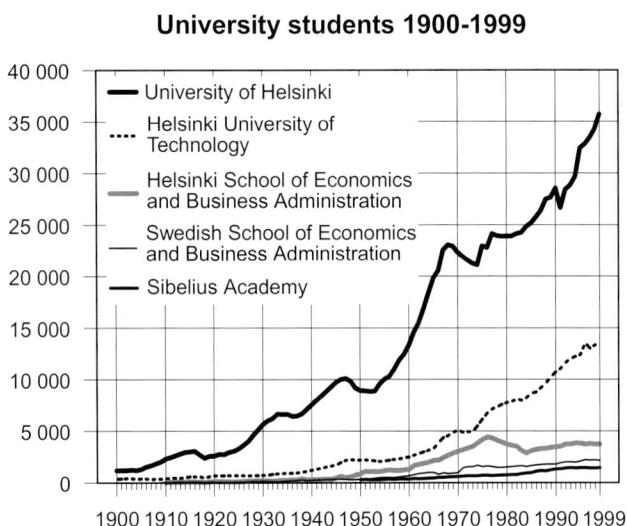

Source: Helsinki tilastoina 1800-luvulta nykypäivään,2000:15 Tilastoja,
Helsingin kaupungin tietokeskus [Statistical description of Helsinki from
the 19th century to the present day. In Finnish]

The standard of education and study opportunities in Finland and in Helsinki owe something to a number of factors. As a result of various actions taken by the Finnish Lutheran clergy to encourage literacy a reasonable level was reached quite early. According to the census of 1910 90 % and of 1920 94 % of Helsinki people over the age of 15 were able to read and write. The literacy rate among women in Helsinki increased faster than that among men and went into the lead for the first time in the 1900 census. A municipal elementary school system was introduced in the city in 1867 but actual school attendance became more common when the law on compulsory education came into operation. The law had already been drafted in the late autonomous period but it was finally passed in 1921 after Finland gained her independence. Both Finnish and Swedish language private and municipal elementary schools operated in Helsinki and the majority of children went to the municipal schools, so that in 1920, for example, there were 13,000 pupils at the city elementary schools. Also among the middle schools, i.e. junior secondary schools, there were both private and municipal institu-tions.[48] In 1950 12 % (44,160) of those over 15 in Helsinki had completed

middle school and 9 % (32,900) had passed the matriculation examination required for university studies. In 1970 every fifth person over 15 years of age had completed middle school in Helsinki.[49]

The metropolitan area population has the highest level of education in Finland. By the end of 1998 one in three Helsinki people over 16 years of age had a degree from some branch of higher education. The education level in the outer parts of the region has also risen and now exceeds the average level for Finland as a whole. One example is the small town of Kauniainen close to Helsinki, where 52.7 % of inhabitants over the age of 16 had tertiary education. In comparison a third of all those over 16 in Helsinki itself had tertiary education and the same proportion an upper secondary education. One reason for this high level of education is the abundance of educational opportunities in the Helsinki Region.[50]

The universities there have a total of some 60,000 students (See fig. 4). The oldest and biggest is the University of Helsinki, which was originally founded in Turku in 1640 as we saw in Chapter one. Today it has nine faculties: theology, law, medicine, humanities, mathematics and natural sciences, education, political and social sciences, agriculture and forestry as well as veterinary science.[51]

Secondary school graduates and education generally have always been greatly appreciated in Finnish society. The saying "What the graduates do today the same the nation will do tomorrow" illustrates this. Secondary

For decades the student cap has been a valued symbol in Finland signifying the beginning of an academic career and the successful completion of the matriculation examination. In the 1920s and 1930s the cap was worn all through the summer. Nowadays it is worn only at some academic celebrations or in processions, for example on Independence Day or May Day, the greatest celebration for the secondary school graduates. On May Day Eve (*vappuaatto*), April 30th, students gather to crown with a student cap Havis Amanda, the statue by Ville Vallgren in Helsinki's Market Place.
(Photo Kalle Parkkinen, Lehtikuva)

school graduates wearing their student's caps have been a familiar sight on the streets of Helsinki for decades. These caps used to be worn all though the summer until the 1930s but nowadays are mostly seen on the eve of 1st May, which is the great spring holiday, when graduates gather in Helsinki Market Place to cap *Havis Amanda,* the statue of a young maiden by Ville Vallgren. Caps are also worn on May Day when the graduates and university students come together in Ullanlinna field in Kaivopuisto to sing spring

During the Independence Day on 6th December students walk carrying torches through the city to the Senate Square in order to listen the Mayor of the city. (Photo Sanna Liimatainen, Lehtikuva)

songs. Moreover secondary school graduates are an impressive part of the Independence Day celebrations in Helsinki on 6th December when they walk carrying torches through the city from the graves of Marshal Mannerheim and the victims of the wars to Senate Square where they listen to the Mayor of the city speaking from the steps of the Cathedral.

Apart from the University both the Finnish and Swedish language Schools of Economics and Business Administration are located in the city centre. Other university standard higher educational institutes in the capital include the Sibelius Academy of Music, the Academy of Fine Arts, the Helsinki University of Art and Design (UIAH), the Theatre Academy and the Military Academy while the Helsinki University of Technology nowadays is located just beyond the city border in the neighbouring municipality of Espoo and offers degree programmes in engineering, architecture and landscape architecture.[52] Moreover Helsinki has four polytechnics offering degree programmes in technology and communications, social welfare and health care, culture and services, business economics and administration, catering, economics and tourism as well as education. It was not until the 1990s that the City of Helsinki sought active cooperation with the universities in Helsinki. An indication of this new cooperation was the establishment of six academic Urban Studies chairs in the late 1990s.[53] The universities, research establishments, businesses and local authorities in the Helsinki region also collaborate in science parks, an industrial art centre and business incubators.

In this connection should be mentioned also the cooperation between the Helsinki School of Technology and the University of Arts and Design (UIAH). The joint research centre for audiovisual media or LUME is operating in UIAH's new premises in Arabianranta. Its state-of-the art film, television and video studios are suitable both for production and for research and development work. LUME is part of a broader centre for art and culture, which also include an institute of pop and jazz music and various businesses and workshops for industrial design, ceramics and textiles.[54]

The Sibelius Academy is the third largest classical music university in Europe. Some 1,345 students were engaged in master's degree programmes at the institution during 1998, studying such subjects as musical performance, music teaching, church music, jazz and folk music.[55] In 2000 the students numbered 1,427of which 108 were graduate students and 148 Masters or Bachelors of Music graduated in that year[56]: Especially popular in the last few years have been the studies in orchestral conducting and composition. The Sibelius Academy, under professor Jorma Panula, has produced several internationally acclaimed conductors such as Esa-Pekka Salonen, Jukka-Pekka Saraste, Leif Segerstam, Osmo Vänskä, Hannu Lintu and Mikko Franck to name but a few.

In national politics and regional policies an answer to the problem of equal opportunities in education has been the establishment of universities across Finland[57] all of which are state universities and where the teaching is virtually free. Moreover, students are chosen on similar criteria in all the universities: both the matriculation examination and success in an entrance examination are taken into account. Entrance examinations are now arranged in almost all subjects.

In the 1990s Finnish higher education began to be organised in two sectors, the university sector and the non-university sector. The latter category includes polytechnics, which have been developed from the highest vocationally oriented educational institutions. This reform started with the passing of the 1991 law after which 20 experimental polytechnics were set up. The aim of this reform was to raise the general standard of education and to make the polytechnics an attractive alternative to the more theoretically oriented universities and universities of technology.[58]

Helsinki University Library is the National Library of Finland. The library has an internationally significant department of Slavic material developed during the autonomous period. Finland had the right to copies of all publications printed in Russia. Later donations include, for example, the Monrepos Manor Library, a valuable collection owned by the Nicolay family near Viipuri. (Helsinki City Information Office)

Reform of Comprehensive Schools

The reason for the increasingly improving level of education was a major educational reform, which took place in the 1970s when a comprehensive school system was adopted in Finland. It combined the former elementary school and the middle school (7–16 years). The aim was to provide each child with equal educational services. However, to equalize the educational opportunities for people living in the remote parts of the country, which has inferior provision, this reform was first implemented in the most northern municipalities and only last of all in the Helsinki Region in 1977–78. The reform was introduced in Helsinki to facilitate the education of children who had had to move with their parents from northern Finland to towns in the south.

Comprehensive school offered education to all regardless of the parents' level of income and after the nine-year long comprehensive school the sixth-form colleges to which separate application had to be made, provided a general education and a way into university that placed an emphasis on either languages or mathematics. In Finnish sixth-form colleges students study 14 different subjects.

From the beginning of the reform special music classes were provided in the schools of the biggest cities, and later also in sixth-form colleges of music. Other special sixth-form colleges were established with a particular emphasis on, for example, arts and articulacy, science and sports. In Helsinki there are several of these specialist colleges, for example the Sibelius high school of music, the Torkkeli visual arts high school, the Mäkelärinne sports high school and the Meilahti science high school. In addition there are several specialist sixth-form colleges in Espoo and Vantaa. Despite the special emphasis on various subjects the students all participate in the national matriculation examination and take exams in four compulsory subjects, one of which is the Swedish language obligatory for all Finnish-speaking children and the Finnish obligatory for all Swedish-speaking children in comprehensive and upper secondary schools, in addition to which the examination can be taken in several optional subjects. Moreover Helsinki has several international schools, for example, German, English, French and Russian schools.

The policy for raising educational standards all over the country has resulted in a narrowing of regional differences as is evident in the results of the matriculation examination (see table 6). Improved teacher education, which was also offered more equally all around the country after the reform, has also contributed to the equalisation of regional differences. The table illustrates this development.

In 2000 there were 208 Finnish, Swedish or foreign language comprehensive schools and sixth form colleges in the City of Helsinki with a total of 70,666 pupils.[59] The schools offered teaching groups in English in addition to the teaching in English offered by the IB sixth-form colleges. Language immersion classes were educational novelties used especially for teaching the other national language to those speaking Finnish. Special instruction was also provided in their own groups for refugees and other immigrants.

Table 6. The percentage share of students who gained highest mark (laudatur) and those who failed among all students taking the matriculation examination in the districts of Uusimaa, Northern Karelia and Lapland in 1973 and in 1995:

District	Highest mark (laudatur) % of all students		Failed % of all students	
	1973	1995	1973	1995
Uusimaa[1]	18.46	23.30	9.41	3.50
Northern Karelia	16.19	18.06	11.10	3.33
Lapland[1]	13.26	16.57	16.01	7.30

[1] Uusimaa district includes the southernmost, and Lapland district the northernmost parts of Finland.

Source: The Statistics of the Matriculation Examination Board, the Archives of the Matriculation Examination Board, Helsinki.

General education for adults was provided by the adult sixth-form colleges and evening institutes where approximately 5,000 adults studied in the 1990s.[60]

Helsinki inhabitants have actively adopted the idea of life long learning and are enthusiastic about the possibility of continuing the process of learning all through their lives. This is manifest for example in the popular studies offered by the various adult education organizations, which were first founded in the 1880s to offer lectures for working people. Later this activity was broadened and education was offered more generally and thus the first institute was founded in 1914. It became obvious that this kind of education was attractive to the general public and thus in 1955 in Helsinki there were already 5,200 attending courses taught in Finnish and 2,100 at those taught in Swedish. This enthusiasm has continued: in 1993 there were over 100,000 registrations for the courses offered at the institutes.[61]

Libraries

It is said that public libraries are the most frequently used cultural service in Finland. The average Finn goes to the library once a month, and this is also true of Helsinki residents. Library services reach most of the population. According to a study of the use of city services from the year 1998, 80 % of Helsinki residents had visited the library at least once during the preceding year.[62]

In 2000, the Bill and Melinda Gates Foundation awarded the glass sculpture *Connections* and one million dollars to Helsinki's City Library in recognition of its exceptionally successful work in bringing its users closer to the sources of knowledge and culture over the Internet. The City Library was the first recipient of this *Access to Learning* prize.

Helsinki City Library is Finland's largest public library, with a main library and 36 subsidiaries, two library buses and 18 hospital and institution libraries as well as one newspaper reading room. It also has a home delivery service and its web site www.lib.hel.fi offers various features 24 hours a day. In 2000, the City Library had 2 million books or recordings and almost 500 permanent employees. In the same year there were 9.1 million loans, 7.1 million visits to its premises and 15 million web site visits. Helsinki citizens borrowed on average 16.6 works and visited the library 13 times. (Helsinki City Library)

The founding of libraries was part of the shaping the Finnish nation during Russian rule and an essential part of popular education at the end of the 19th century.[63]

In Finland the first libraries were founded at the beginning of the 19th century but already during the 18th century Lutheran churches owned collections of books and Bibles to be lent to the common people. Following the model of Sweden and Germany, study circles and libraries were founded in the 1790s in affluent coastal towns in Finland where merchants as well as professional groups established libraries, and the foundation of public libraries became common in the whole country from the 1860s onwards. Many associations also had libraries of their own. The country's youth association movement, for example, had 390 libraries in 1905.[64]

The Helsinki City Library began as a private library but was taken over by the City in 1876. In its first year 50 volumes were loaned to every 100 inhabitants but the increase was rapid: already by 1910 there were two loans to every inhabitant in Helsinki.[65]

The factors that have made Helsinki City Library successful were the same as those that have given Finnish public libraries as a whole an

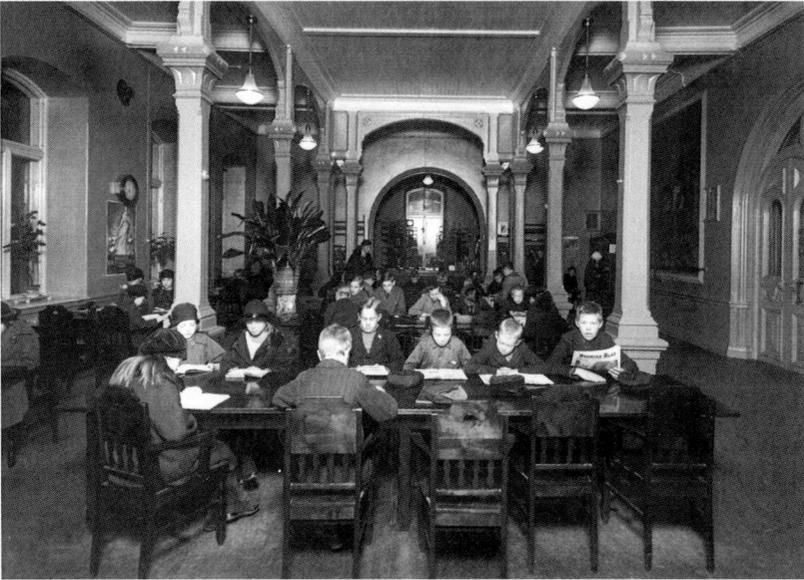

The most popular facilities that Helsinki City Library has to offer are the reading rooms, especially the newspaper and magazine reading rooms and the children's departments where, traditionally, story hours are a weekly highlight. (Helsinki City Library)

excellent reputation: "High rates of use, high standard library buildings, the rapid introduction of information technology, a high profile in society and low user costs and high efficiency". For many years past the public libraries have been viewed as a local centre for information, cultural and learning services. Another welcome addition to the library services has been the 'story hour' for children[66].

During the past ten years Finnish libraries, and especially the Helsinki City Library, have responded actively to the challenges of an information society. The city opened its Cable Book Library in 1994. This has specialized in data networks and the Internet and has played a pivotal role in pioneering not only its own network services, but also those of other Finnish libraries. High quality information technology services to readers are available equally to everyone at all branches of the Helsinki City Library and in mobile libraries. The Ministry of Education has also assigned to the Helsinki Library the task of serving as a national central library for public libraries all over the country. More than 90 % of all public libraries provide their readers with access to the

The Internet café and reading room of Helsinki City Library in the _Lasipalatsi_ building, in the heart of Helsinki. The Library of _Kirjakaapeli_ specialises in data technology and offers its users efficient computers and fast Internet access. (Helsinki City Library)

Internet and the library network services seem to have attracted new users, known as specific users, who have already discovered from their home terminals whether a particular work is available.[67]

In 2000 the Helsinki City Library had 37 branches, two of which were specialist children's libraries. It had a large collection of musical recordings that were first acquired on cassettes and later on CDs. The music collection had first been made available for loan in the 1970s.[68] Moreover the library had a specialist music department. At the end of the year 2000 there were 1,800,000 books and 224,000 items of other material. There were 9,150,000 loans, that is 16.6 loans per inhabitant and on average each of them made 13 visits a year to the various branches of the Library.[69] From figure 5. one can see that loans per inhabitant increased dramatically during the 1970s and 1990s. The annual number of loans per inhabitant increased especially during the economic crisis of the 1990s. Over 20 % of the books at the library are now in languages other than Finnish and books and other materials are available in about 60 languages. Half of the non-Finnish language literature is in Swedish and the other half is mainly in English, German and French, though it also includes literature in Russian, Italian and Spanish. There is also a specialist library to serve foreigners.[70]

A comparative study of 26 European cities, the nine European Cities of Culture in 2000 and another 17 important European cultural centres,[71]

FIGURE 5.

Loans and books per inhabitant in 1910-1999

Number per inhabitant

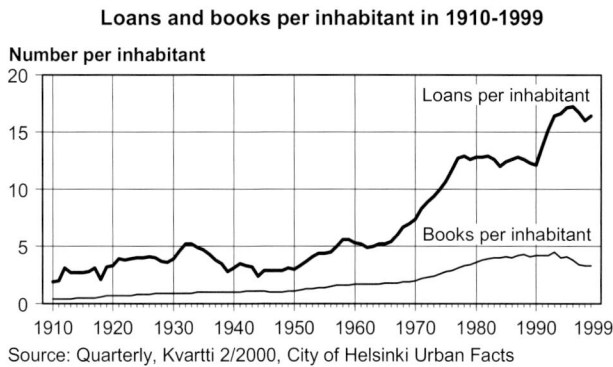

Source: Quarterly, Kvartti 2/2000, City of Helsinki Urban Facts

investigated "their cultural offerings and facilities, the uptake of these services and the support they provide for culture in 1998." In this comparative study Vilnius, Helsinki, Copenhagen, St Petersburg, Reykjavik and Riga had noticeably more book loans per resident than the others. This survey also revealed that Helsinki, along with Nuremberg, Stockholm, Bologna and Copenhagen, was among those cities which extensively supported their cultural life in terms of cultural spending.[72]

The long tradition of providing, and using, public library services serves to explain the extensive use of these services in Finland. Libraries have not only been used for entertainment and leisure time activity but also as sources of information in the way that the Internet is now used. That Finns have a keen interest in scientific literature is evident from the increase in the proportion of scientific books loaned from the Helsinki City Library. This rose from 25 % to 39 % between 1980 and 1998.[73]

The importance of the Helsinki City Library is shown by the two national functions that have been bestowed upon it: 1) it functions as the central library for general libraries developing working practices and centralising services; and 2) the services it offers to members of linguistic minorities. Future challenges include, for example, the development of shared network services.

International Mobility

Working and studying abroad have become an everyday phenomenon in Finland during the past 15 years. Internationalisation of research and science can be studied by focusing on factors such as the mobility of scholars, international exchange programmes at universities, research cooperation and international publications.

Finnish science and research have always been international in nature. In fact already in the Middle Ages Finnish students sought their way to European universities; during the Autonomous period, and also in the period following Independence, German universities and research institutes were the most important destinations for post-graduate students and this continued to be so until the Second World War although the Nordic countries were also popular destinations in the 1920s and 1930s. The most important financier of study visits by university teachers and scholars was the University of Helsinki, which received a portion of customs revenues until 1917. Independence, however, changed the basis of travel because University funds declined and the value of stipend funds lessened amid the inflation of the 1920s. To compensate other financial sources emerged: grants from various foundations and state scholarships although, of course, the scholars themselves naturally also paid for some of their trips.

In their memoirs scholars have described the problems and shortages in the years following the Second World War: Central Europe was in ruins and contacts with countries there decreased significantly. Trips to Germany in particular were almost totally discontinued. The new destination was Sweden to which there were good travel connections by ferry and from where monetary help was also forthcoming. Invitations received from Sweden made study visits possible and the same applied to the United States of America, which also sent monetary aid. In many fields of science the US was already becoming the leading country of research given the flight of so many eminent scientists from Germany to North America in the 1930s.

Asla Grants

Having refused the benefits of Marshall Aid, the European rebuilding programme initiated by the United States in July 1947, because of opposition

from the Soviet Union, the Finnish government tried to remain at a reasonable distance from the conflicts of the great powers. This was understandable in view of the fact that the peace treaty had still not been ratified and an Allied Control Commission was still operating in Helsinki.[74]

This refusal of Marshall Aid was a decision that cost the country millions of dollars, but probably did more than anything else to reinforce the credibility of the Finnish leaders' post-war policies in the eyes of the Soviet Union. According to Max Jacobson, "The Marshall Plan was designed to save Europe from communism, but Finland may have saved itself from communism by saying no to the Marshall Plan."[75]

The Fulbright programme was instigated in the aftermath of the war. As envisioned by Senator J. William Fulbright of Arkansas, funding for the programme was provided by the repayment of loans that the United States had granted to nations purchasing military surplus left over from the war. Funds thus accumulated were directed to finance cultural, academic and professional exchanges between the United States and the debtor countries. Young people from the programme's member countries were offered a chance to study abroad in order, as Senator Fulbright put it, to "bring a little more knowledge, a little more reason, and a little more compassion into world affairs and thereby increase the chance that nations will learn at last to live in peace and friendship." The Fulbright cultural exchange holds the distinction of being the largest academic exchange programme of all time. To date, over 200,000 graduate students, scholars, professors and teachers from 150 countries have participated.[76]

The Asla scholarship programme established in August 1949 did benefit Finland. This programme facilitated study visits by Finnish students and scholars to the leading universities and research institutes in the USA. Moreover the programme also permitted the buying of research books and equipment. The Asla grant was also used to improve the situation in Finnish scientific libraries that had fallen behind in acquiring the newest research literature during the war. Such research literature was required for example for the libraries of the University of Helsinki and the University of Technology, the latter having been completely destroyed in the bombings on the very first day of the Winter War. The newest research especially in the field of technology was crucial for Finland in its endeavour to complete the payment of war

Finland became a member of the European Union in 1995. European flags decorate the centre of Helsinki. (Helsinki City Information Office)

reparations. Behind these developments were long negotiations that were advanced by the international contacts of the Helsinki City Chief Librarian, Lauri O. Tudeer and through the activities of the Finnish Ambassador to Washington, K. T. Jutila who already prior to the war had had contacts in the Library of Congress and the American Library Association. The signing of the Agreement of Friendship, Cooperation and Mutual Assistance on Finland's terms had stabilised the situation so much that payments on the loan were now possible.[77]

The new programme having been established it was natural that in the fields of natural science, medicine and technology researchers increasingly moved in an American direction. By 2001 3,000 Finns and 1,000 Americans had taken advantage of the Asla scholarships.

Proportionally Finnish researchers made the most study visits (2,492) in the Asla scholarship programme in 1950-82. Among those receiving grants there were 413 senior scientists, 286 teachers, 953 graduate students, 840 directors or other experts. Of the 1,395 Finnish professors who responded to an inquiry into Finnish-American academic and professional exchanges in 1983 a total of 485 had made at least one trip to United States of at least two months' duration for purposes of research, teaching, or graduate study. In proportion to her population Finland sent a higher number of researchers, students and trainees to the USA than any other country in Europe.[78]

In an analysis of the benefits of the programme for high level research and science it became evident that in total the Asla/Fulbright scholarship programme brought altogether 578 persons to Finland in 1950–82 including professors, lecturers, and graduate students. The largest number of visits to Finland by Americans, 242, were made in the 1960s, but in the 1970s the number of visits declined by half. The University of Helsinki benefited most from the programme hosting 493 Fulbright grantees between 1953 and 1982.[79]

Further Possibilities for Internationalisation

Finland's position in post-war Europe attracted the attention of the other Nordic countries. In the early 1950s Swedish politicians were of the opinion that "due to her geographical position" Finland could not join in Nordic co-operation, and therefore cultural contacts should be strengthened. Therefore part of the war debts should be devoted to a fund for this purpose.[80]

Later, in addition to the Fulbright programme a number of other exchange schemes, such as the Youth for Understanding for school children, were also devised and included Finland. Youth for Understanding is one of the oldest and biggest student exchange programmes in the world operating in 40 countries. It has now operated for over 40 years and has taken over 12,000 exchange students to the USA from Finland during its operation.[81]

The 1960s and 1970s saw increasing Finnish interest in foreign travel and studies abroad. Following the events of 1968 in Czechoslovakia, the Soviet Union, which had so far mainly trained active members of the Finnish political extreme left, became increasingly the destination of a wider range of Finnish university students and, in the 1970s, other countries of the Soviet block, especially East Germany and Poland attracted an increasing number of young Finnish people. By the beginning of the 1990s, however, Britain and Western Europe had once more become the destination of the majority, not least as a result of the popularity of cheap Inter-rail travel and the development of the Au Pair system.

In the sheer number of young people of both sexes that it affected the Inter-rail scheme was a very significant development as it helped the Olympic summer babies and their younger siblings to become independently familiar with the world outside Finland's boundaries. The scheme was originally introduced in 1972 by the International Union of Railways to mark its 50th anniversary and the aim was to offer youngsters under 21 an opportunity for unlimited travel on the European railway network for up to a month at a rock bottom price. Finnish youngsters especially were keen to use this new opportunity, which had to be continued due to general demand, and during its first fifteen years over 200,000 Inter-rail passes were sold in Finland alone and it is estimated that during that time some 130,000 boys and girls were able to make at least one visit to at least one other European country. In proportion to the total population Finns were the keenest users of Inter-rail in the whole of Europe.[82]

The obvious enthusiasm of these Inter-railing youngsters, of whom the great majority were female students from the Helsinki region who also had other experience of foreign travel, attracted the attention of the Finnish authorities and, in the face of the emerging student exchange plans within the European Union. Christopher Taxell, the Finnish Minister of Education at the end of the 1980s fixed the ambitious target that one third of each generation of Finnish students should be provided with an opportunity to study abroad for at least a few months.

Mobility of Youngsters, Students and Reseachers

By the early 1990s youth organisations themselves estimated that each year some 30,000 young Finnish people studied, trained or worked abroad.[83] The 1993–94 statistics also indicated again that, if measured in proportion to the total population, almost three times more Finns than Germans or French and five times more Finns than Britons studied abroad within the European Union's Erasmus programme alone. Needless to say, the majority of these Finns were again young women.[84]

The opportunity to travel coupled with a generally improved command of foreign languages, especially English (boosted by satellite television and the use of home PCs) was bound to increase the personal confidence of a whole generation of young Finnish people, as has been demonstrated in sports successes as well as in the lively cultural climate that Helsinki has seen grow since the 1980s.

During recent decades internationalisation and internationalisation-related strategies have become a normal part of work at universities. A growing degree of international cooperation and scholar mobility, especially moving in both directions, has become important both for research and the development of human capital.

International offices at universities for their part manage student and teacher exchanges in addition to scholar exchanges. In 1991 CIMO (The Centre for International Mobility) was founded to manage the coordination of educational programmes, public relations, trainee exchange programmes and various international scholarship programmes at a national level. In 2000 there were altogether 15,000 participants in CIMO programmes: 7,700 in the EU's Education Programmes; 2,359 in youth programmes: approximately 1,630 in Leonardo programmes; 1,160 in scholarship programmes; 219 in culture programmes; 1,667 in trainee exchange and 213 in summer courses in the Finnish language and culture.[85] The total funding was 96.6 million marks (16.25 million euros), with half coming from the government (Ministry of Education) and half from other sources. Two thirds of the total were awarded as grants.

The University of Helsinki had exchange agreements with approximately 80 foreign universities in 2001. Lately agreements have been signed with

universities in East and Southeast Asia, Japan, New Zealand and Latin America and the University of Helsinki has about a dozen student exchange agreements with Chinese universities alone.

According to KOTA statistics 743 visits abroad lasting at least four weeks were made from Finnish universities in 2000. On average these visits lasted for 4.6 months. Most of them, 195, were made by scholars from the University of Helsinki while in addition there were over 100 visits from the Universities of Turku and Oulu.

Calculated in terms of persons participating in the exchanges the highest number was from the University of Helsinki, which provided one fifth. On average 6 % of the teaching and research staffs at the universities participated in the exchanges in 1999. Between 1990 and 1999 the number of exchanges from Finland decreased by 12 % and those to Finland by 44 %. Still, these numbers are considerable higher if lecture visits and expert tasks abroad are taken into account. University of Helsinki teachers and researchers, for example, made 3,538 presentations abroad in 2000, were expert referees for 1,939 international scientific publications and acted as opponents and made preliminary inspections of 85 doctoral dissertations.[86]

In 2000 a total of 1,154 foreign researchers visited Finnish universities. The highest number went to the Helsinki University of Technology, the second highest to the University of Helsinki and the third largest to Tampere University of Technology. The most active fields for scholar exchanges were the natural sciences and technology. Moreover, the Academy of Finland has also invested in the international mobility of scholars. In 1999, for example, 208 stipends were granted to scholars working abroad. Some of the recipients were working on their doctoral dissertations, some were young researchers exploring their way into post-doctoral studies. Over a third of all the grants were to the US and a fifth to Great Britain. Through CIMO 809 stipends for both longer term dissertation work and shorter research visits abroad were given. Of all the stipends 70 % were granted for exchanges to Finland from abroad. The most common foreign grantees came from Russia, Estonia and the other Baltic countries as well as Hungary. The principal aim of the CIMO stipend programmes is to increase the appreciation of Finnish graduate studies in these countries and other countries of Eastern Europe.[87]

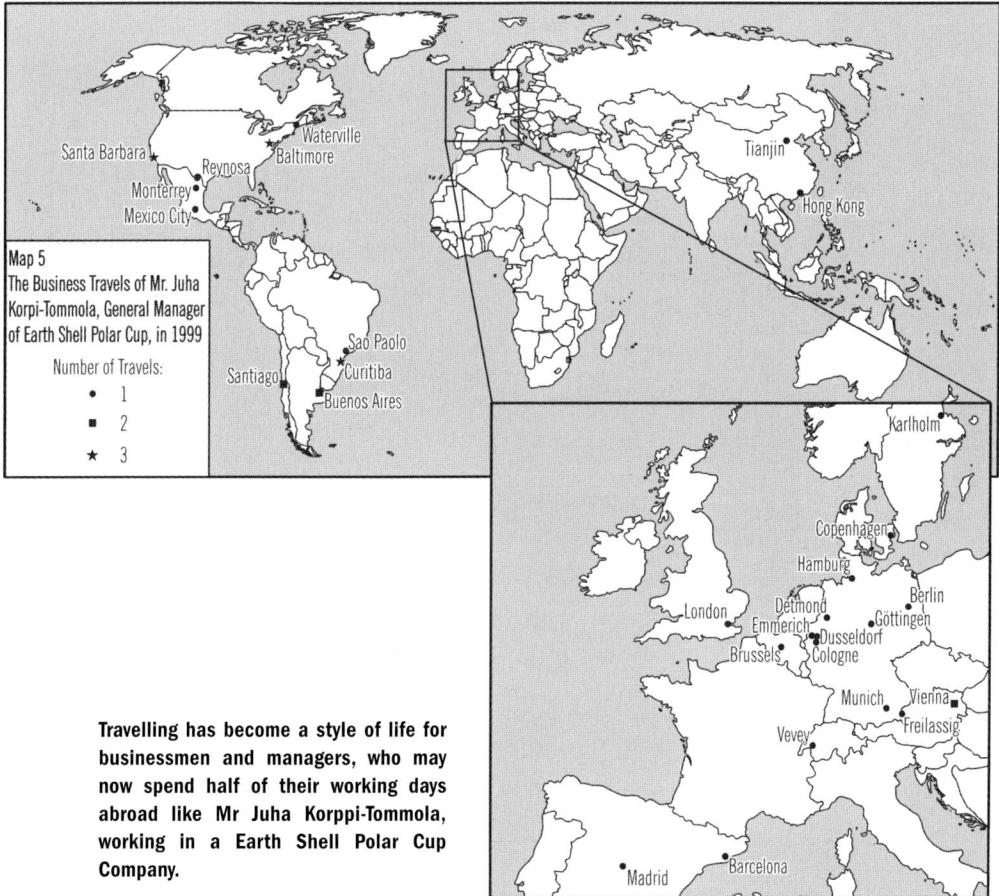

Map 5
The Business Travels of Mr. Juha Korpi-Tommola, General Manager of Earth Shell Polar Cup, in 1999

Number of Travels:
- • 1
- ▪ 2
- ★ 3

Travelling has become a style of life for businessmen and managers, who may now spend half of their working days abroad like Mr Juha Korppi-Tommola, working in a Earth Shell Polar Cup Company.

EU projects provide new ways of promoting internationalisation. According to recent statistics 1,400 organisations in all participated in Fifth Framework Programme research projects between 1998 and 2000. In the Fourth Framework Programme 2,637 Finnish organizations participated in 1,850 projects while the corresponding numbers in the Third Framework Programme were 500 organisations in 400 projects. Proportionally Finns participated the most in the telematics and telecommunications projects. Also COST cooperation has increased significantly in the 1990s and Finland has been active in projects concerned with forestry, community engineering and meteorology.

At the beginning of the new millennium there were approximately 300 foreign language programmes at Finnish universities. These programmes had

been developed to answer the need to ensure the reciprocity of exchanges. Mobility between the EU universities has also been increased by the possibilities provided for students to take a degree at a foreign university and thus the new challenge for the future will be the equal acceptance of foreign degrees.

In a 2001 internationalisation strategy memo from the Finnish universities it was proposed that in all 10,000 to 15,000 students from abroad should be encouraged to come to study in Finland. In the autumn of 2001 the number of international students arriving in Finland was still only 6,000.[88] The number of Finnish students studying for their basic degree abroad grew from 3,168 in the academic year 1991/92 to 5,161 in 2000/1.[89]

Positive development has taken place in the transparency and visibility of Finnish research. In international series almost 7,000 researchers' reports written by Finnish scholars themselves or in cooperation with their foreign colleagues were published in 1999. The number of publications grew yearly by on average 6.4 % between 1991 and 1999. This growth was the ninth fastest among the OECD countries. In proportion to population and GDP Finland is among the leading countries in scientific publishing: 1.4 publications to every 1,000 inhabitants or 1 % of all the world's scientific publications.[90]

Today science is more international than ever and student and scholar exchanges begin early and in a broader framework. Information spreads in real time through the Internet. What previously seemed long distances have lost their significance and there is no longer a need for Finnish scholars to travel abroad to seek the newest scientific information. Still scholars continue to visit the top universities and research institutions to become participants in creative research environments, to meet esteemed gurus of science and to receive support and supervision for their work. Finnish scholars have been granted equal access to notable universities and research institutes; they have also participated in various research projects and applied their know-how on returning to Finland. Funding for internationalisation has come from both national and international foundations. The most significant change has appeared in the show of initiative by Finnish scholars: today they act as the initiators and the directors of many international research projects.

The faculty of agriculture and forestry promotion procession proceeding from the university to the Cathedral in 1984, led by the conferrer of degrees Eeva Tapio. Many academic traditions have been maintained in Finland that in many other countries were abandoned in the 1970s. The faculties at the University of Helsinki arrange their own master's and doctor's promotions that usually last for three days. (Helsinki University)

Women, education, work

When the focus is put on women's education, women's participation in work-life and political activity, and its ramifications for the society, it can be argued that women in Finland have in many ways led the way for other women round the world.

Equality

Already in 1967 there were as many women as men enrolling in the universities. In 1990 56 % of students were women and in 1999 they earned 57 % of all university degrees. The proportion of women among all those gaining doctorates during the period 1987 to 1999 grew significantly increasing from 28 % to 43 % while among professors at the Finnish universities the proportion of women grew between 1988 and 2002 from 10 % to 20 %.[91]

In Finland women have enjoyed a certain degree of equality from very early times. One evidence of this is that in the Finnish language the personal pronoun, *hän*, does not distinguish gender, as it does in most languages. In agriculture, the labour of women was an essential part of farming, and in the working class the low wage levels of men, together with the lack of any development of sickness and unemployment insurance during the first decades of the 20th century, forced women also to earn an income. In Finland the inflexible structures found elsewhere whereby men were the breadwinners and women the housewives were never able to develop. Thus it is no wonder that Finnish women were the first in Europe to receive both the right to vote and the right to stand for parliament (1906). In the very first parliamentary elections in 1907 women formed 10 % of the elected candidates and their number has, internationally speaking, been high ever since. In the 1990s it was some 40 %[92] and the other Nordic countries reached the Finnish levels only in the 1970s.[93]

The idea of coeducation, as discussed in Chapter five, was first put into operation in the capital in the 1880s and afterwards spread to the provinces. In the 1910s there were approximately the same number of girls and boys in the secondary schools. In the school year 1946–1947 the number of girls in the secondary schools reached 58.4 %.[94] Gender uniformity meant that girls were placed in institutions created by men, and thus had to acquire everyday skills at home. Women's preparation for work and an occupation, on the other hand, grew from these everyday skills. This became necessary because of increased knowledge, as in medicine, and also because tasks were transferred from the small-scale private arena to institutions and public control. The schools and colleges developed separately from the emancipation struggle and partly even before the arrival of feminist ideas in Finland.[95]

The first girl to take part in the university entrance examination did so in 1870. She needed special permission from the university's chancellor, the Russian Crown Prince. Such permission was actually denied two of the applicants in the 1870s and this probably had a discouraging effect on other women as only a few girls entered the university before the mid 1880s. However, obtaining such permission became a matter of routine in the following decade and the system was finally abolished in 1901 by which time some 14 % of all undergraduates were women. The opening of the doors of academia to women went virtually unopposed in Finland. In 1918 38 % of all

undergraduates in the university of Helsinki were women and of those three quarters were Finnish speaking. Before the Second World War about one-third of all those matriculating were women and by the 1950s the figure was half.[96]

The first women with university degrees began to enter society in the 1880s and the first dissertations from women for a doctoral degree were accepted in 1894 in medicine and in 1895 in history. When Signe Hornborg graduated from the Polytechnic Institute Helsinki in 1890 she became the first professionally trained woman (the first female architect) in Finland and possibly in Europe.[97]

At the turn of the 20th century the university degrees earned by women still did not qualify them for higher positions. Not until 1926 was this rectified and women were declared competent to occupy positions in the civil service. During the 19th century it was health care, the arts and teaching that offered jobs for women. The training of nurses began during 1880s on the basis of models borrowed from Sweden and Great Britain. The driving force behind the nurses´ schools in the Surgical Hospital in Helsinki was Baroness Sophie Mannerheim, who had studied in London at the nurses' training school established by Florence Nightingale at St. Thomas Hospital.[98] At the turn of the 20th century of all those working in the health service some 66 % were women. The only white-collar occupation with numerically more women was teaching, where they numbered some 5,100 or 57 % of all teachers. Both elementary and private secondary schools frequently employed women as teachers. Teaching positions in state

Dentist Kaija Vuoristo in her surgery in 1981. Dentistry training began at the University of Helsinki in 1892. Unlike in many other countries, the profession of dentistry became extremely popular with women who numbered some 3,300 of almost 5,000 members of the Finnish Dental Association at the beginning of 2001. (Helsinki City Museum)

schools were opened to women in 1915. In the final decades of the 19th century government offices, banks and commercial companies begun to take on women to perform clerical duties. In the early 20th century the range expanded to include transport, trade and numerous service fields.[99]

Women worked with men in the same movements, but also created their own modes of action being very active not only in the women's rights movements but also in many other civil organizations. At the turn of the 20th century the temperance and workers´ movements and the religious revivalists, in particular, drew women into social action, uniting Finns across the division of gender.[100]

Mothers Leave for Work: Need of Child Care

Finland has been famous for innovations related to child welfare, kindergartens and day-care centres, as well as to public health and education. The significant aspect of all these services has been their availability to all, free of charge or at low cost regardless of the population group to which an individual family belongs. This equality has been guaranteed by government support. When the services have been financed by tax revenues, as in all Scandinavian countries, it has resulted in very high taxation by international standards. Finland also has a very even income distribution compared to other countries.

Thanks to the equality movement, public day-care facilities and maternity leave became subjects of political debate during the 1970s and even the political parties were forced to recognise the problems of reconciling family and work – particularly as an increasingly large number of women voters went out to work. In the 1950s and 1960s, the proportion of Finnish women in waged work was the largest in the western world. This was not necessarily considered progress. As late as the 1950s, it was believed that the west European model of the family where the mother stayed at home would also become widespread in Finland as the country became more prosperous. This did not turn out to be the case because of the feminist movement and the equality politics of the 1960s. Waged work for women was held to be a precondition of women's economic and social independence and today gender equality has become an accepted goal in all Western countries. [101]

Researcher Raija Julkunen has described the Finnish way of life as a strongly work-centred culture. Since the economic crisis of the 1990s working hours have been lengthening, especially for those women, who work full time. Finland has adapted to full time waged work for women by reducing house-work. Finnish culture, family and everyday life have adapted to this by rationalising the home and home life, and the majority of working mothers and fathers feel they can cope and reconcile work and family. Part time work is rarely seen as a solution because women and women's professional organisations see it as a trap, which narrows women's independence and livelihood.[102] The provision of warm school meals and of adequate day care facilities have been essential preconditions for women's full time working.

Maternity insurance formed part of the legislation on health insurance (1964), but from the 1970s onwards maternity leave was gradually lengt-hened from an initial 12 weeks and the eventual 29-weeks leave, introduced as early as 1974, was the longest anywhere in the world. A short paternity leave associated with childbirth was also introduced in 1978, and parental leave in 1980.[103]

The parenthood allowance is payable for 263 days. For the first 105 days, it is paid to the mother as a "maternity allowance". For the next 158 days the "parental allowance" can be paid alternatively to the mother or the father and a cohabiting father qualifies. Entitlement to the benefit begins on the 155th day of pregnancy, and the recipient can choose to have payment started 30-50 working days before the estimated time of birth.[104] The Finnish media for their part have focused on fathers who are on paternity leave to underline the shared responsibilities in parenting. The most visible example has been prime minister Paavo Lipponen whose fatherhood leave also attracted the attention of the media elsewhere in Europe.

It was after the Second World War that the Finnish government assumed increasingly comprehensive responsibility for families. Child benefits were launched in 1948. Family benefits and income supplements became more numerous and their levels varied. Society's participation in the economic support of families was seen as an essential factor promoting equality.

The education of home helps in the 1940s gave birth to a new profession, that is home helps who also act as instructors on how to run a household. These were initially hired for service in private homes or industrial plants but

were later employed by municipalities. Between 1945–1986, nearly 4,000 home helps graduated from the Family Federation Institute of Learning. The Family Federation, founded in Helsinki in 1941, started the training of home helps for reasons of family policy. The Mannerheim League for Child Welfare began training families with sick children at the end of the 1930s. The objective was to assist families with many children. The Family Federation recommended that families should have 4 to 6 children. The keen eyes of the home helps detected many deficiencies in home hygiene, as well as incomplete interior furnishings and primitive utensils. They gave instruction on childcare and promoted the adoption of innovations related to eating and domestic hygiene.[105] From the 1950s onwards municipalities, including Helsinki city, also started to employ such home helps and Helsinki city took the responsibility for their training in the early 1980s.

However, it soon became increasingly obvious that any temporary or voluntary based system was not able sufficiently to meet the childcare needs of families when both parents were working outside the home. Although in Finland women have traditionally contributed to the family income, first in the countryside as wives of independent farmers, then in towns, this trend was particularly strong in the 1960s, which saw a dramatic change in the Finnish employment structure. This created the need for a comprehensive day care system, especially as women's participation in the labour market increased considerably. In 1975 they formed about 44 % of the labour force in the whole country.[106] By 1995 the proportion of Finnish women working in paid employment had risen to 60.2 % for women while the corresponding figure for men was 61.9 %.[107] Comparing this with the proportion of women working in Helsinki where 63.7 % of women of the active population aged 20–64, were working in paid employment in 1997 one can conclude that women working outside home was at least as common or even slightly higher in Helsinki than in the rest of the country.

In Helsinki, where more than a half the female population were working, this increased the pressure to establish new day care centres. Unlike in some other countries, such as Britain, this was seen primarily as the task of municipalities, which were obliged to maintain day care centres or to organise day care in private homes in accordance with the demand in the municipality. According to Jorma Sipilä and Anneli Anttonen continental European countries divide into two so far as services offered for children and old

In Finland today, all children under school age are guaranteed a place either in a day-care centre or with a family day-care provider. Public day-care facilities and long maternity leave enable Finnish mothers to play an active part both in family and working life. The Vilppula day care centre in Malmi. (Photo Lehtikuva)

people are concerned. France and Belgium have plentiful child-care services, the Netherlands and Germany few. In terms of caring, the Nordic countries can be characterised as following the public service model, while the English speaking countries follow the model of provision according to need and southern Europe the traditional model of caring.[108]

The objective of the public day care system was to secure a day care place for all children under three years of age, or a private care allowance for families, by the end of the 1980s.[109] A law for municipal day-care began a long struggle between the policy of public day-care for children supported mainly by left-wing women, and that of centrist women, who advocated a home-care policy based on home care allowances. Political discussion on the

subject came to a head in 1973 with the introduction of a law providing municipal day care as an adjunct to home care for all families who needed it.[110] The law on children's day care came into force in 1973 and gave the municipalities more extensive economic and administrative responsibilities and obligations for the organisation of children's day care centres and care in private families. Municipalities received a state subsidy of 35–38 % to cover day care expenditure. Qualitative supervision and development also commenced at the same time. It all became a well-organised system of social service with the objective of promoting the children's healthy growth and development. After 1990 the municipalities were obliged to arrange day care for all children under the age of three and since 1996 for all children under school age.[111] Since 1996 parents have had the right to choose either financial support for home care or a free place at a day care centre and the reconciling of work and family life has been one of the enduring themes of modern social policy.[112]

The number of day care centres has increased by one third since 1980, when Helsinki had 213 municipal day care centres, attended by 12,959 children. In 1999 there were 336 municipal day care centres attended by 19,900 children while the number of private day care centres in Helsinki amounted to 120 and the children cared for to 3,254. In the same year a total of 2,472 children were cared for by municipal private carers within the system of supervised municipal day care but actually in private homes. Moreover 329 children were in private supervised day care in private homes.[113] (See figure 6) Municipal full-time playgrounds and playgrounds which were open for a part of the year have also been a part of the services for children. There were 17 of them in 1955 and 60 in 1997.

At the moment, kindergartens and kindergarten teacher training represent, indeed, a very strong Finnish repository of skills, which nowadays are taught at universities and experts have for long visited Helsinki to familiarise themselves with the Finnish know-how in this area as we saw in Chapter six. Indeed, foreign experts visit Finnish kindergartens more frequently now than in the past for only a few did so in the 1950s and 1960s.[114] Today the main challenges come not from the day care system, but from schoolchildren who generally have gone alone to school and spent the afternoon on their own. A safe environment, hot lunches served at school and a social norm that

FIGURE 6.

**The number of kindergartens or day care
centres for children in 1888-1998**

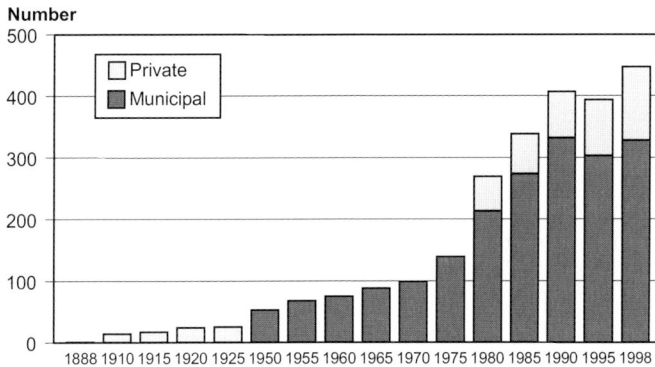

Source:Quarterly, Kvartti 2/2000, City of Helsinki Urban Facts

allows children to be alone have eased full time work for women. On the other hand almost every schoolchild in the Helsinki region has a mobile phone of their own and parents can easily keep in touch. Today some schools in Helsinki have also organised afternoon activities for schoolchildren.

Helsinki Exhibitions Touring the World

In addition to travelling and tourism Helsinki has become internationalised also through international exhibitions that have made Finnish design well known and appreciated round the world. In fact the post-war years saw a determined effort by the city to sell itself abroad especially from the 1960s onwards.

In some ways this was not a new idea.[115] Helsinki City planning department had participated actively in international exhibitions involving town planning and construction from the 1910s onwards. From the point of view of Finnish town planning the Berlin town exhibition (Städtebau-Ausstellung) in the year 1910 had been especially important as an event influencing Eliel Saarinen in his planning of the Munkkiniemi–Haaga district of the Finnish capital.[116] However, little attention has been paid to the fact that the building department of Helsinki City also exhibited planning related maps of Helsinki for the first time in Berlin including one demonstrating land ownership, as

well as examples of garden cities and Helsinki's general development between 1800 and 1910. There were also several databases relating to the planning of the Töölö district with plans and competition entries (G. Nyström, H. Norrmen, B. Sonck, W. Thome).

In 1910 a part of the Töölö exhibit also went to the Düsseldorf Internationale Städtebau-Ausstellung of 1910 and to the Royal Institute of British Architects Town Planning Conference. In the next year Helsinki was also represented at the celebrated International Hygiene Exhibition in Dresden and two years later at a similar exhibition in St Petersburg where visitors saw maps showing the city's population density, the Meilahti plans, and the central park plan. At the Construction Exhibition in Leipzig in 1923, Helsinki exhibited eleven maps describing the city's occupational structure, industry, public life, traffic system, administration, building heights and land ownership as well as parks.

In 1923 Helsinki also took part in the Gothenburg city building exhibition showing maps, photographs, and miniature models. In addition to population and building intensity, the maps showed new area annexations. Apart from the Meilahti area these districts included Käpylä, Vallila, Backas, and the plan of the people's park in Mustikkamaa. The Internationale Verband für Wohnungswesen und Städtebau organised an exhibition in Stockholm in July 1939 and Helsinki participated with maps and photographs. In addition to the general town plan, there were also pictures related to outdoor recreation and leisure. The visitor could study the Töölö and Meilahti plans, and also the one-family house districts of Käpylä and Oulunkylä, the allotments of Kumpula, Herttoniemi, and Vallila, the Uunisaari and Hietalahti swimming beaches, and winter sports opportunities in Helsinki.

The Helsinki exhibitions of the 1960s represented a total change of strategy. While Helsinki had hitherto participated in other people's exhibitions by showing maps and photographs of the city, the new marketing of the capital also involved a touring exhibition displaying Finnish design and interior decoration accompanied by lectures, concerts and theatrical events. In the 1960s the City authorities were also actively involved and in particular the Mayor, Lauri Aho, and the head of the information department, Bengt Broms. The marketing of the exhibitions was naturally also helped by the active role

Helsinki Police Band on the opening day of the Helsinki Exhibition in Vienna, mounted jointly with the cities of Turku and Tampere in April 1965. Not only the cities, but also the whole of Finland were given publicity when the Austrian Broadcasting Company made programmes about Finland and a major business street was devoted to Finnish products. The exhibition was planned by artist Tapio Wirkkala and attracted much attention. After Vienna, the exhibition went to Germany, France, Great Britain, the United States, the Netherlands, Belgium and Denmark. (Photo Lehtikuva)

played by Finnish embassies and in particular by R. R. Seppälä, Finnish Ambassador in Paris, while the credit for the exhibition's success in the Low Countries, especially in Amsterdam, belongs to Consul Tatu Tuohikorpi.

Bengt Broms as Helsinki's head of information was the chairman of the board preparing the Helsinki Exhibitions, which aimed to present to international audiences Helsinki's dynamic growth, its bold development plans and its high standards of architecture.[117] The designing and executing of the exhibition was entrusted to Tapio Wirkkala and the cornerstone of the exhibition was a several metres long model of Alvar Aalto's plan for Helsinki city centre. It also included an average Helsinki home furnished by Wirkkala and a slide show for which Broms had selected the slides and music and written the texts. The arrangements were done on a mutual basis: the receiving city provided premises free of charge and also met the exhibition's building costs on the understanding that Helsinki would receive on the same terms the host city's exhibition in Helsinki.[118]

A special Finnish exhibition opened in Vienna in April 1965 in exchange for a Viennese exhibition in Helsinki[119] and in this venture Helsinki was joined by the cities of Turku and Tampere.[120] Initially there was an attempt to link the entire event to the festivities surrounding the Sibelius centenary,[121] but the date was later changed to early spring. Austrian television was interested in filming documentaries about Finland, among others *"Kennst du das Land?"* and a programme about the safeguarding of Finnish neutrality. Two Vienna business streets were harnessed to the presentation of Finnish products[122] and the exhibition was meant to catch the attention of the Viennese themselves rather than to attract the attention of international tourists.

On a less impressive scale Finland had previously introduced herself to Vienna during the war, in 1941, at Vienna's autumn fair presenting a few animal hides, sporting equipment, skis and canoes with examples of the hobby crafts being carried on by troops at the front. A larger industrial art exhibition had been organised in 1958, and had been described by the Viennese press as a "Finnish construction paradise".[123] Tapio Wirkkala had also designed this exhibition, and it gave a general overview of Finnish culture. However the 1965 event was on an even bigger scale.

The Vienna week was opened on April 3 to the accompaniment of the Helsinki police orchestra. Mayor Aho and assistant mayor Øjvind Stadius came to the opening ceremony from Helsinki along with Tampere's mayor, Erik Lindfors. The Austrian foreign minister Kreisky attended the ceremony and in his opening address emphasised the importance of Finland as a model of neutrality and of co-operation between the EFTA countries.[124] The exhibition was organised in a central location at the Volkshalle des Rathauses. The opening day included a performance by the Laulun Ystävät Choir from Turku and a fashion show. The police orchestra led by Georg Malmsten gave two concerts by the statue of Johann Strauss.

There were three miniature models of Helsinki: Alvar Aalto's city centre plan, the wooden Käpylä district and the Myllypuro settlement area, as well as other exhibition material, including a typical Finnish State Housing Board apartment and a model of a ferry. Designer glass and other industrial art products were also on show.[125]

Mayor Lauri Aho (1901–1985) showing the Mayor of Vienna Franz Jonas (on the right) an illustrated book on Helsinki in conjunction with the Helsinki Exhibition in Vienna in 1965. Lauri Aho was mayor of Helsinki from 1956 to 1968. Before being elected mayor, he already had a long career as a journalist behind him. This, coupled with his long career as a leading Conservative figure in local government, gave him extensive social contacts. He also had many cultural interests and was particularly influential in the development of the Sibelius Festival, which was later to develop into the Helsinki Festival with its extensive range of cultural events. Helsinki also began actively to market itself abroad during Aho's time. He emphasised the importance of improving the city's public and internal image, its communications and its training of civil servants. He was also behind Alvar Aalto's plans for a new city centre and promoted the underground railway project. (Photo Lehtikuva).

The press covered Finnish design, music and arctic life on many pages. The *Arbeiter Zeitung,* the Austrian Social Democrat Party organ, published a Finland supplement on April 3, edited by Alois Brunnthaler, and *Die Presse* included a special Finland page.[126]

The inhabitants of Vienna got an opportunity to glimpse the whole of Finnish society through this exhibition of the three Finnish cities. The newspaper articles praised the Finnish "architecture of tomorrow"[127] and the comfortable Finnish housing. The special supplement of the *Arbeiter Zeitung* described the Finnish household's standard of equipment. They noted that there was more than one radio per household and that common items on the list

were an electric iron, a washing machine, and a vacuum cleaner, followed by a refrigerator and a freezer.[128] The interest of the Austrian press in Finnish achievements was evident. The same *Arbeiter-Zeitung* festive issue noted that Finnair was the first airline in the world to use Super Caravelles and that 16 Finnish towns already had regular air traffic connections. The well-organised train and bus services and the Baltic Sea boat traffic received just as much attention. In the exhibition, the steel industry and modern technology joined the traditional wood industries. Finns were equally admired for their orientation to specialisation and competition with quality products.[129]

Finnish products were exhibited in display windows; among others the Philipp Haas & Söhne company arranged a display window competition and the Gordis company set up in their small shop and exhibition rooms an exhibition of Finnish design. The Otto Groh company, the agents of Marimekko and Wärtsilä, arranged a Marimekko fashion show on April 2 centred on exhibiting Finnish products in the company's shops. 33,000 visitors came to the exhibition; and only an exhibition in Rome was more popular, attracting 47,000 visitors.[130]

Alvar Aalto´s City plan was shown at the Helsinki exhibitions visiting different cities in Europe. However, this plan from the 1960s was never realised. Today there are again plans to develop the Töölönlahti district as a "down town" area, but they have raised much opposition.

The exhibition next travelled to Germany visiting Nuremberg, Munich, Frankfurt and Lübeck. During the period May 7–23 in Nuremberg, 19,000 people came to visit the exhibition. It was considered an unofficial Finland Week. There were events related to Finland in the city, among others a Sibelius concert by the Nuremberg orchestra. There was a readiness to market city planning ideas here as well. Due to the fame of Alvar Aalto, Finnish modern city planning was always guaranteed an international audience. Helsinki City architect Sakari Siitonen lectured on "How Helsinki plans and builds" to 200 German experts[131] and at the same time there was in Hamburg an exhibition of Finnish industry.[132]

In June the exhibition moved from Nuremberg to Munich, Frankfurt and Lübeck. There were plenty of visitors in Munich, and 16,300 spectators came to see this exhibition from Helsinki, the White City of the North. The miniature model of the city centre and a glass cabinet exhibiting Finnish ceramic art aroused special interest among the audience.[133]

The three-city exhibition at Lübeck was particularly significant, as larger audiences had never been seen there; seven to eight hundred visitors came to the exhibition at the Dom Museum each day. This fact is perhaps explained by the traditionally lively contacts between Lübeck and Helsinki as it has been estimated that 137 families moved to Finland between the early nineteenth century and the Second World War and of them over a hundred settled in Helsinki. [134]The most important shopping street in Lübeck, Breite Strasse, had various products of Finnish export industry in the display windows and architect Aarne Ervi lectured on Helsinki city planning. Two hundred German city planners had been invited to this lecture.[135] There was a particular demand for Finnish products in Lübeck, as a Finnish-German chamber of commerce had operated there ever since the early 1920s.[136] The Helsinki Symphony Orchestra also gave a concert around the same time.

In February 1966 the three-city exhibition moved to Paris, where it was located in the Museum of Modern Art.[137] The exhibition had gained so much publicity in Vienna that R. R. Seppälä, Finland's ambassador to France invited the exhibition to Paris "as it is in my opinion the best possible advertisement for Finnish education and tourism (and is) suitable also for France". The exhibition also planned to go to Marseilles, Nancy, and Caen in addition to Paris. However the limits set by finance and timetables meant that the plans had to be changed and after Paris the exhibition went only to Strasbourg,

Rouen, and Nancy. In any case in 1964 a Finnish architecture exhibition had already been organised in Lyons and Marseilles.[138] The positive publicity that it had received was undoubtedly one of the reasons for the popularity of the three-city exhibition. *Le Figaro* praised Finnish architecture under the heading "Finnish exhibition arouses a desire to visit the forested country. The exceptional forest landscape of Finland allows the architects to create dormitories so perfectly hidden by green nature that it seems impossible to detect the feeling of desolation of which certain large French entities are being accused." The exhibition was reviewed positively by press, television and radio, and negatively only by the newspaper *Combat*.[139] Even so although the three-city exhibition aroused a desire in some to visit Finland, only 7,000 French people visited the exhibition itself. Nevertheless, the postscripts emphasized the significance of the exhibition in terms of tourism.[140]

At the same time as the three-city exhibition was touring Germany, marketing in the other Nordic countries was being made more efficient. There was a Finland festival in Oslo in October with the opening ceremony taking place in the Town Hall. There were six exhibitions, one of them about Helsinki[141] and the following autumn Stockholm staged an exhibition with its focus being on Alvar Aalto's city centre plan. The exhibition in Stockholm was the beginning of a Finland festival – an exhibition of ready-made clothes, design etc.[142]

One year later there was an exhibition in London opened by the British Minister of Education, Anthony Crosland. The exhibition was again designed by Tapio Wirkkala and included a display of Finnish books. It was intended to be an introduction to Helsinki past and present and the items exhibited included the apartment of a typical young couple, a photographic exhibition of Finnish arts, and a stall where Helsinki's industrial art was displayed[143] but the feedback was both positive and negative.

Lucia van der Post of *The Sunday Telegraph* was positive:

> "Giant photographs lining the exhibition hall describe the atmosphere of Finland in a manner no words, no individual articles could accomplish. They portray new apartment buildings (and how I envy them, especially the buildings only ten minutes away from downtown Helsinki, completely surrounded by pine trees and seemingly endless landscapes) hospitals, flats and self-evidently, the beautiful forests and saunas."

> "The plans for Helsinki's new city centre, planned by Finnish architecture's grand old man Alvar Aalto, are presented with the help of plastic models, aerial views, areas of

the new satellite city. An ordinary visitor is probably more interested in the four-room flat exhibited with furniture typical of a Finnish middle-class home."

"There are no such trinkets as we Englishmen like so much, no small porcelain things and such. Only utility articles! Everything is beautifully crafted from good, simple materials. All the shelves, whenever possible, are embedded in the walls."

"The Finns do not add decorative details; they allow the natural structure of wood, the contours of exquisitely designed utility articles, the interplay of shadows and light to create the only decorative details."

In his review in *The Guardian* Terence Bendixon asked

"Can Helsinki really be such an orderly and flawless city that one flawless photograph after another leads us to believe? Are all her inhabitants young skiers springing up from the snow? Are there no tired old ladies who have come from the neighbouring countryside and are resting their weary feet? I am positive that not every Helsinki inhabitant lives in modern blocks of flats in the middle of stands of pines."

"The evidence of the fact that they do not can be seen in the groups of buildings dimly seen in the background of certain architecture photographs. On the contrary, the exhibition gives an image of people with discerning taste who have an acute feeling for, and intimate closeness to, the glittering lakes and black forests from where they come. It is a tourist's view of Finland, but as we have learned not to trust a tourist's view of France, this version of Helsinki is also suspect."

"It seems that I am recalling the lines of the official advertisement leaflet where Tapio Wirkkala is quoted: "My idea is to tell the inhabitants of London how we live in Helsinki."

"While Wirkkala is not able to tell us anything about the odours and hum of his town, he does manage to show us a stage where the city's inhabitants perform. It is a city which has authorised the country's most prominent architect Alva (the misspelling is *The Guardian's*) Aalto to reorganise the city centre. Edinburgh could follow suit and do the same to get rid of her traffic chaos."

"The exhibition also provides a surprise caused by typical kitchen cupboards. Their grey paint and polished aluminium handles possess an undeniable taste of quality. However, a brief inspection proves that they are the same cheap furniture that one can buy in the Old Kent Road – except that these ones look more cheerful. It seems that good outward appearance is not always dependent on money."

In Amsterdam the exhibition was combined with a Helsinki festival (opening on September 20, 1968), when Finnish products were extensively exhibited in shopping streets. The organisers included the export promotion office of the Ministry of Trade and Industry as well as Finland's Foreign Trade Association and an exceptionally long planning period preceded the exhibition.[144] The Helsinki exhibition at the Fodor Museum stayed open for ten days. The ballet of Finland's National Opera was among the guests. After Amsterdam, the exhibition moved to Brussels and Antwerp.[145]

In September 1969 Helsinki was exhibited in Copenhagen and *Helsingin Sanomat* wrote about the exhibition under the headline "Helsinki launched our Denmark campaign" when Helsinki's Lord Mayor and fifteen city councillors attended the exhibition. As in Stockholm, the premises used were those of the city's town hall. Tapio Wirkkala again designed the exhibition, which included another miniature model of the Käpylä wooden house district as well as gold jewellery, Aalto's city centre plan, and old maps and paintings.[146]

All these exhibitions of the 1960s benefited from the fame of Finnish design and Wirkkala's excellent reputation around Europe as well as from the fame of Sibelius's music and the name of Alvar Aalto.[147]

The attempt was always to present modern Finland combined with the nature element and the displays of Helsinki suburbs built in the middle of nature were received surprisingly well but it is clear that when the same exhibition moved from city to city the reception was influenced by the traditions of the country in question. It appears that the three-city exhibition succeeded best in those foreign cities where there was already some knowledge of Finland acquired either through earlier exhibitions (Vienna, Frankfurt, Strasbourg) or long trade relations (Lübeck, Amsterdam). The British criticism of too much simplification did not dampen the enthusiasm of British firms, such as Habitat, who were keen to introduce modern design and functionalism to the British public while the example of France shows that masses of people could not be attracted in the absence of efficient marketing.

The Helsinki exhibitions organised in the 1970s were not so successful. There were major problems for example when Helsinki City organised an exhibition in Los Angeles in connection with the bicentennial celebration of the United States. The exhibition was located in an exhibition hall in a park

somewhat away from the city centre. Unfortunately next door there was at the same time a poultry exhibition. During the press conference before the opening ceremonies a symphony of cackling made the opening speech by Broms inaudible. It died down during the opening speech by the Mayor of Helsinki, Teuvo Aura, until his last words, which were followed by a ceremonial fanfare of a mighty cock-a-doodle-doo from next door.[148] Only 40,000 spectators visited the exhibition perhaps because it was open for only twelve days in April-May 1976. Ambassador Tuominen wrote – in reference to the California Design exhibition – that at least 100,000 people could have visited the exhibition had it stayed open for eight weeks instead of twelve days, but a particular complaint was that for most of the time the exhibition was located in an airfield hall in the small city of Oakland.[149] In addition a transport strike meant that it was not possible to set up the exhibition in Los Angeles in time. The consequence was that not a single representative of the press visited the exhibition; the local press did not even mention it and only Finns living in America attended the opening ceremony. Even Tom Bradley, the Mayor of Los Angeles, did not attend.[150]

It can be seen from the correspondence of ambassador Tuominen and Teuvo Aura that the intention was to bring the exhibition back for a town planning conference to be held in Helsinki. The ambassador expressed his regret at the fact that so many failed to see such an extensive and excellent city exhibition and thought that "it would probably have kindled enthusiasm in tens of thousands of wealthy California residents to visit Finland and her beautiful capital". Mayor Teuvo Aura's letter indicates that Helsinki City intended the exhibition to help the Bicentennial Committee to organise as versatile a Finnish programme as possible. The justification for the choice of the Oakland airfield hall lay in Finnair's plans to establish an air route to Oakland and to get the necessary aviation licence.[151]

Finally a Helsinki exhibition visited by 28,000 spectators was again organised in 1978 in Vienna, and the same year saw many attempts to organise Helsinki exhibitions in Budapest, Bucharest, and Greece but only the Budapest exhibition actually took place. The intention there was to exhibit modern Finnish achievements as "exhibitions held in Budapest so far (had) concentrated too much on exhibiting traditional folk culture". The ambassador Kaarlo Juhana Yrjö-Koskinen wrote: "In my opinion, the Helsinki exhibition would serve to make the image of Finland clearer in Hungary, which I

consider important in terms of promoting our exports alone." In this respect, the exhibition really served its purpose, and musical evenings and a cinema week were organised in connection with the exhibition in September 1978.[152] The Helsinki – Daughter of the Baltic exhibition in Budapest on 1–17 September 1978 was visited by 32,000 people, more than the number of spectators at the exhibition held in Vienna.[153]

From Sibelius Weeks to Helsinki Festival

In the spring of 1950, the Sports and Hiking Board of Helsinki City discussed the idea of organising a summertime arts festival. Consequently the city government set up a planning committee,[154] which reached the conclusion that Finnish music was one area of fine art which was world-famous and an object of interest particularly in the English-speaking world, where Finland was eager to develop new contacts after the war. The idea gathered impetus from ballet and theatre performances organised in Denmark, as well as from the Grieg music festival organised in Norway. The Swedes were also arranging theatre performances at Drottningholm castle and in the courtyard of Stockholm City Hall. These Nordic cultural events also defined the timetable to the extent that the date of the Sibelius festival was determined to be June 13–19, 1951. "It was thus planned to form part of a Nordic cultural sequence. During the four weeks, visitors to the Nordic Countries could take in the Grieg Festival in Oslo, the Ballet week in Copenhagen, the performances at the eighteenth century theatre at Drottningholm castle near Stockholm, and the Sibelius festival." An important justification for the festival was that it could attract masses of tourists to Finland, especially if they could combine several cultural events in their itinerary.[155]

The models for the organisation of what was to called the Sibelius Week were the two major music festivals in Europe, Salzburg and Edinburgh, for although Helsinki had in its turn staged two Nordic Music Festivals, in 1921 and 1932, each lasting a week,[156] as well as the massive Kalevala Centenary Celebrations in the Helsinki Fair Hall in 1935,[157] up-to-date know-how was needed for the organising of a major international event in the post-war world.

"The first Sibelius week consisted of eight concerts, given by the Helsinki City Orchestra, the Finnish Radio Orchestra and the Sibelius String Quartet. Eugene Ormandy came from Philadelphia to conduct the opening and the third concert, and Tauno Hannikainen, now back in his own country from Chicago, conducted two. Jussi Jalas, the son-in-law of Sibelius and conductor at the Finnish Opera House, and Nils-Eric Fougstedt, director of the Finnish Radio Orchestra, took over the remaining programmes." Upon his arrival in Finland, Tauno Hannikainen commented that according to Olin Downes, the distinguished *New York Times* music critic, the Sibelius week was the most important musical event in Europe, although even so, the *New York Times* was unable to send a representative to cover it.

The programmes included all of the Sibelius symphonies, several symphonic poems, the string quartet *Voces Intimae*, and various works for choir and for solo voice. So called 'younger' Finnish composers were also represented. However, Sibelius himself was not present at any of the concerts. At 85 he never left his country home, but he promised to listen to the festival concerts on the radio and quite exceptionally broke his solitude to receive Mr. Ormandy at his home. The success of Ormandy was clear:

> "His second concert left his audience completely electrified. It opened with the Fourth Symphony – the "Bark Bread" symphony. Under his baton its fragmentary themes were marvellously welded into a whole, and the tempo largo of the third movement had a spell – binding and mysterious sonority. The Fourth Symphony was followed by the two Kalevala legends; *The Swan of Tuonela* played with all its mournful charm, and *Lemminkainen´s Homecoming*, which had a dazzling brilliance. Then followed so dynamic a performance of *Finlandia* that Mr Ormandy had to repeat it while the entire audience remained standing."[158]

Later the Sibelius Week was extended to consist of twelve concerts, and the musical content was also widened, so that in 1957 there was also a church recital of music from the eighteenth century, and a folk music concert. The skeleton of the festival still consisted of Sibelius' seven symphonies and the Violin Concerto. A measure of the international significance of the festival was the number of international visitors arriving in Helsinki. Moreover, the extensive broadcasting of the festival was an important means of making it known. In 1956, 30 foreign radio stations broadcast the programme and it

reached an audience estimated at 250 million.[159] International conductors and orchestras visited Finland throughout the 1950s, among them the Concertgebouw Orchestra of Amsterdam in 1957.

However, Helsinki had not been the only place to launch a new music festival. By the late 1950s it was calculated that more than 150 music festivals of various kinds were then being organised around Europe[160] for the middle-classes who wanted to include cultural events in their holidays. Although travelling had become much easier and the availability of high class records had increased the general appreciation of and need for live music, it became obvious that the Sibelius festival did not arouse sufficient interest among foreign tourists; in 1959 a critic in Edinburgh even wrote that Finland was a cultural backwater.[161] Among the Finnish people also the Sibelius Weeks started to lose their status so that by the mid-1960s only the international names could still attract audiences.[162] As the critic Markku Valkonen has pointed out, the post-war baby boom generation was then reaching their adulthood and, unlike the generation of war, rebuilding and reparations, they were seeking new directions based on international trends. [163] For them the Sibelius Week had become an old-fashioned, anaemic and backward looking elitist event.

A clear indicator of this cultural change was the popularity of the Jyväskylä Music and Cultural Festival, launched in 1957 by composer Seppo Nummi then aged 25. Nummi was the youngest member of a cultured Helsinki family, whose brother Yki was a talented designer while another brother Lassi was equally known as a modernist poet. Seppo Nummi himself had been only sixteen, when his first composition had been performed on the radio. Under his directorship the Jyväskylä Arts Festival developed into an ambitious summer forum of modern and classical arts, noisy debates on the avant-garde and political issues and a multitude of planned and extempore happenings. Karlheinz Stockhausen's visit in 1961 and such later landmark events as the performances of Benjamin Britten's opera *The Turn of the Screw* and Edward Albee's play *The Sandbox* at the 1963 festival along with concerts by Oleg Kagan and Ravi Shankar, confirmed the festival's standing as the premier cultural summer event in Finland, keenly covered by Finnish televisi-

on. Jyväskylä Summer became a must to see and also a place to be seen for the younger generation in Helsinki and the rest of the country, and a record number of 40,000 participants was reached in 1966.[164]

The increasing success of the Jyväskylä event emphasised the disappointing audience numbers of the Sibelius Week. The organisers wanted, therefore, to develop the valuable musical traditions of the Sibelius Week into an important overall survey of Finland's entire artistic life and in particular the performing arts, employing both Finnish and international artists. The committee, chaired by Veikko Loppi, was appointed in December 1964 and delivered its report in the following June.[165] Their suggestion was that the festival should be moved to the autumn, that the name should be changed to the Helsinki Festival and that the programme should cover all kinds of events likely to attract large numbers of people. While developing the form of the organisation, the committee chose Stockholm's Festspel and the Festspillene i Bergen as models. The Festival had to get an authoritative executive director, and a foundation was considered the most suitable form of organisation.[166] These changes especially pleased those on the left, and *Kansan Uutiset*, the leading left wing paper, was happy about the fact that the festival was to be made more appealing to the masses. If the festival was to become a cultural event that the audience would remember, the programme had to be highly varied. It was suggested that entertainment for the general public should be concentrated at Linnanmäki amusement park, where there could be light orchestral concerts, jazz sessions and performances by famous popular singers.[167] Nevertheless, for the first two years the programme followed traditional lines until Seppo Nummi, the newly appointed director and self-proclaimed elitist, re-focussed the programme for the 1969 festival on a younger audience introducing free events, jazz, pop music and film. The programme also included a performance by a Helsinki-based underground ensemble called The Sperm, which announced the birth of new life and new art by handing out fresh vegetables to the audience.

This determined change in the programming paid off in soaring audiences. From 42,000 in the first year it quadrupled to 167,000 in 1970 and peaked in 1976 with a total attendance of 680,000, which exceeded the total population of the city. This was partly due to the free events of which the most popular was the Kaivopuisto rock concert and partly to the shifting of the time of the festival to late August and early September in 1971. The

The Finlandia Hall, completed in 1971, is one of the last works of the celebrated architect Alvar Aalto. Many foreigners ask: why does Finland have so many distinguished conductors? One reason is the network of musical institutes that covers most of the country and "catches" people of talent who, after many years of study ending in the Sibelius Academy, become skilled professionals. Probably the most famous of the Academy's graduates today are the conductors Esa-Pekka Salonen, Jukka-Pekka Saraste and Osmo Vänskä. (Helsinki Philharmonic Orchestra)

Helsinki Festival has now become an established event, which closes the season of Finnish summer festivals and opens the autumn season of the arts and it has also encouraged many art institutions and private galleries to display their best exhibits during these three weeks.[168]

Apart from the expansion of the programme "from Bach to rock, from Gilels to Zappa, from open-air happenings to Orthodox transcendence; film, ballet, Isaac Stern, Ravi Shankar; Europe, America, India..." to quote Bengt Broms, the Helsinki Festival also introduced over the years a number of new forms of activity such as the Marathon Concert at the Finlandia Hall, with music playing simultaneously in two auditoria giving audiences an option to change concerts at the intermission. The Artist of the Year exhibition, another novelty of the Festival, has become the most important single art event of the nation, and contemporary artists have become classics in this pro-

cess. During the Helsinki Festivals art has become an essential part of day-to-day urban life as sculptures and environmental art have been displayed in the streets and the parks of the city.[169]

However, perhaps the most innovative new feature has been "The Night of the Arts", which was first organised in 1989. The idea was initially proposed by a young art historian Helka Ketonen, and the original aim was to provide in the centre of the city a bold and exceptional introduction to different forms of culture while avoiding massive preliminary preparations and stifling over-organisation. It provided space for surprises. The partners in the project included the Helsinki Festivals, the Academic Bookshop and a great number of volunteers and members of the art association Porkkana ry, which was a particularly active promoter of he idea of a Museum of Contemporary Art for Helsinki.

The first Night of the Arts, which was organised impulsively and in a very short planning time, exceeded all expectations. It was estimated that some 20–30,000 people were milling around in the dark of a warm August night until the early hours visiting galleries, museums, bookshops and performances in open-air venues. Everything was based on unpaid voluntary work and the public was positive and appreciative. The general atmosphere was that of searching for and finding something new, in fact a major cultural event. For many people Helsinki at last really became a European city of culture.[170]

Subsequently the Night of the Arts has expanded and the Esplanade Park has become one of its focal points. Art performances now take place not only in galleries and museums, but also in a number of different watering holes round the city. The event has also become increasingly commercialised. Furthermore, the Turku Music Festival and the Tampere Theatre Festival and others have also adopted the concept.[171] Yet it has remained essentially *the* autumn carnival for tens of thousands of young adults in Helsinki.

Timo Cantell has made a particular study of the Night of the Arts. According to him it "has had a major impact in the way the cultural life of Helsinki has been experienced and changed." He discusses how it has affected street culture and above all how it has brought a number of the main public areas of the city to life – returning them, in a way, to the citizens and to civil society. Cantell argues that the Night of the Arts initiated and interpreted a

process of cultural change in Helsinki that included major transformations in terms of the usage of public places for public events, licensing, street life, and the overall ambience of the city.[172]

Cantell sees the Night of the Arts with its performances, exhibitions and street theatre, its different programmes suited to different age groups, and its open-air events, as part of a wider development. "The fact is that cultural industries are becoming increasingly important for the future success of cities." Cantell's point of departure is Lefebre's discussion of representations of space and his belief that representational space offers an account from which to read Helsinki's development. Cultural performances and events like the Night of the Arts offer opportunities to reveal existing representations of space, the dominant space of the city authorities, planners, police, etc. and to question this order through carnivalesque ambivalence. This ambivalence also provides opportunities for new representational spaces to emerge, a chance to introduce new and unexplored ideas and see and experience the city in a new light. According to Cantell, participants in the Night of the Arts offer their own view of Helsinki and show how to use the city centre imaginatively, in uncommon ways; so that the event changes the way people see, experience, develop and live in their own city.[173]

Helsinki - the Music Capital of Finland

When Helsinki was selected to become one of the European Cities of Culture in the year 2000 one of the major factors must have been the unprecedented renaissance of Helsinki musical life during the last decades of the 20th century.

At the end of the 1990s there were operating, within a 15 kilometre radius from Helsinki Railway Station, four full size symphony orchestras, three smaller orchestras, several chamber music ensembles, a junior string orchestra[1] and scores of pop music bands serving the Helsinki Metropolitan Area. Esa-Pekka Salonen, Jukka-Pekka Saraste, Sakari Oramo and Osmo Vänskä have become internationally known conductors of British and American symphony orchestras. At the same time Karita Mattila, Soile Isokoski, Monica Groop and Matti Salminen have been performing in the major international opera houses while numerous other Finnish opera singers have established a career in Germany. Furthermore, in 1998 the Strasbourg Music Festival included 26 works by the Finnish composer Magnus Lindberg, who was also commissioned by the Cleveland Symphony Orchestra to write a new orchestral work. Kaija Saariaho was commissioned to compose for the New York Symphony Orchestra and the year 2000 saw not only the world premiere of her first opera,

L'Amour de loin, at the Salzburg Festival[2] but also the world premieres of not less than 14 other new Finnish operas, three of them at the Helsinki Festival.[3]

The same year saw the international triumphs of the Helsinki-based band Bomfunk MC's, which specialises in hip hop dance music and of HIM, which combines gothic metal, glamrock and pop melodies into a "love metal" mixture. Together with the Turku-born dance artist Darude they are following in the steps of Jimi Tenor, whose mix of jazz, funk and electronica has been especially popular in London; Apocalyptica, a band of four classically trained cellists have sold over a million albums of metal rock world wide; and the Leningrad Cowboys, "the worst rock band in the world" who were first featured in films by Aki Kaurismäki, have acquired a cult status in Germany. Clearly the international reputation of Finnish music is thus no longer based on the single name of Jean Sibelius.

When Sibelius arrived in Helsinki from Hämeenlinna in1885, he was lucky to find the infrastructure of an organised musical life already in place. The university had brought its tradition of student choral societies when it arrived from Turku and an early landmark was the appointment in 1835 of the German Frederick Pacius as music teacher at the University. The composer of the Finnish national anthem, first performed in 1848, and of the first Finnish opera (*Kung Karls jakt*, 1852) Pacius also trained musicians and composers and assembled an orchestra while Helsinki musical life was also enlivened by regular visits by foreign musicians on their way between Stockholm and St Petersburg.[4] The next milestone came in 1882, when Martin Wegelius opened the Helsinki Institute of Music, later to evolve into the present Sibelius Academy, while the Helsinki Organists' School, later the Church Music College, was also founded in that same year. Furthermore, Robert Kajanus, who had studied in Leipzig, Paris and Dresden, then founded the Helsinki Orchestral Society, the predecessor of the Helsinki City Orchestra (Helsinki Philharmonic), the first permanent symphony orchestra in the Nordic countries, which was to premiere all the symphonies of Sibelius apart from the seventh.[5] The establishment in 1911 of the Finnish

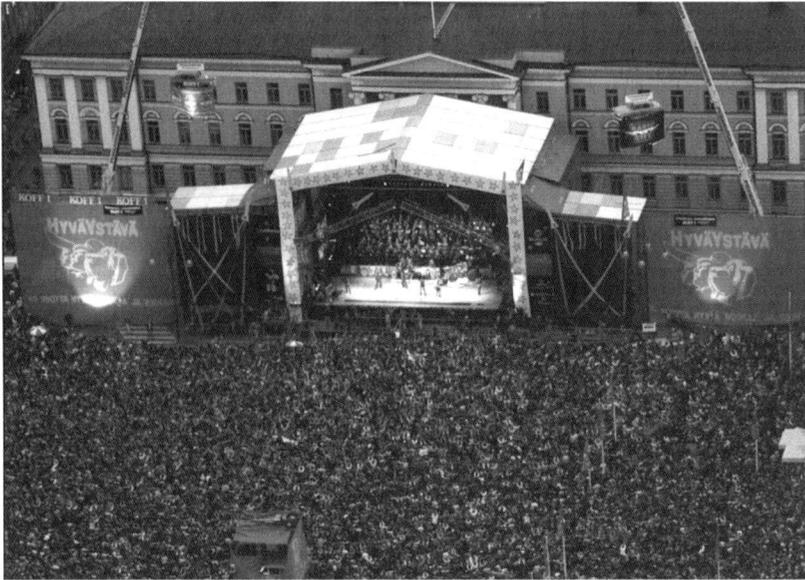

The *Total Balalaika Show* in Helsinki's Senate Square in June 1993. After the collapse of the Soviet Union, the Red Army Choir began co-operating with the Finnish rock group Leningrad Cowboys. Their joint concerts were a great success both in Finland and Germany. (Ariel Ilmakuva Oy, Helsinki City Museum)

Opera and in 1922 of the National Ballet, both in Helsinki, completed the musical infrastructure.

Sibelius,[6] who also studied in Berlin and Vienna, took themes from *Kalevala* as the basis of many of his compositions and was therefore also an extremely important exponent of Finnish nationalist sentiments. Other Finnish musicians however, although talented, did not manage in his time to gain a similar status abroad though Finnish singers, such as Alma Fohström, Hortense Synnerberg and Aino Ackté, were the exception and performed in European and American opera housès.[7]

Yet, the relative shortness of the Finnish musical tradition became an advantage when Helsinki's musical life began to progress from the late 1950s onwards, providing opportunities without too many rigid limitations. The 1960s saw the introduction in Finland of contemporary music and rock together with the revival of jazz (which had been first heard in Helsinki in 1921) whereas the remarkable phenomenon, the Finnish-style tango, had been developing steadily since the end of the war.[8] Experiments in musical pedagogy coupled with the creation of a network of regional music institutes and orchestras also had a major influence as they gave an increasing number of children round the country the opportunity to study music while the launching of more and more cultural festivals from the 1960s onwards[9] provided an important forum for presenting new developments in music to a wider public. In the 1960s emphasis on democracy and pluralism

led in Finland to both an expansion of "musical literacy" among the whole of the population and to the widening of the range of "acceptable" forms of music.

Arguably most fundamental for future developments was the innovative work carried out by a few outstanding music pedagogues in the Helsinki region. In the early days the best known was undoubtedly Erkki Pohjola, a music teacher at Tapiola Secondary School who experimented with the methods of Zoltán Kodály and was in 1964 engaged in the production of new study materials for music studies in schools.[10] An Orff-studio, using German models, was established to explore the combined impact of singing, instrument playing, physical exercise and improvisation on the music teaching of 7-8 year old Finnish children while Tapiola Secondary School provided an invaluable testing ground for new materials.

The Musica -series, developed by Pohjola and a strong team of leading Finnish musicians and music pedagogues, took as its starting point children's real musical environment in an emerging media culture and it was based on the systematic development of their natural sense of melody and rhythm. Compared with earlier Finnish materials the concept was revolutionary in providing students with an introduction to various styles of music from religious to electronic, embracing pop and rock music as well as western classical, folk and African, Japanese and Indian music. Furthermore, it encouraged pupils not only as amateurs but also as future professionals.[11] International recognition for the success of this new broadly based Finnish music education came in 1971 when the Tapiola Choir, conducted by Pohjola, competing in the BBC contest *Let the People Sing*, won not only the school choir class but also the overall contest itself with a programme that included "Aglepta" by Arne Mellnäs, a piece of contemporary music deemed so difficult by some Scandinavian choirs that they refused to sing it.[12] More importantly, by 1988 the Musica series had sold more than two million copies of its student books[13] and thus contributed on a major scale to the awakening among Finnish children round the country of a lively interest in this subject.

In Helsinki this led, in Oulunkylä for example, to such enthusiasm over orchestral music in schools that the various bands of Oulunkylä Secondary School held their own joint concert in the Finlandia Hall.[14] The teacher, Klaus Järvinen, also founded in 1972 the Oulunkylä Pop/Jazz Institute (since 1986 a Conservatory), the pioneering institute for teaching light music in Finland. In the East Helsinki Music College the Hungarian-born brothers Géza and Csaba Szilvay, by using a colour string method, trained a great number of string players and the college orchestra, the Helsinki Junior Strings, later undertook many concert tours abroad.

This expansion of interest in music manifested itself in the establishment in 1975 of the UMO Jazz Orchestra in Helsinki with the support of the City of Helsinki, the Ministry of Education and the Finnish Broadcasting Company[15] while the Sibelius Academy - as a pioneer in the Nordic countries - established in 1983 new specialist jazz and folk music departments.[16] The first head of the latter, Heikki Laitinen, shifted the focus from fiddler's tunes to ancient Finnish music and from instrumental music to folk song, and in just over ten years the department produced professionals for such internationally known groups as JPP, Niekku and Värttinä as well as individual performers such as Maria Kalaniemi and Kimmo Pohjonen. Among the teachers at the Sibelius Academy who also made a major contribution to the further development of the Finnish

The monument to Jean Sibelius by sculptor Eila Hiltunen in the Sibelius Park. The organ pipe motif makes an appropriate musical reference.

musical renaissance was Jorma Panula, who as early as the mid-1960s had shown great ability as a conductor of contemporary Finnish music,[17] and was to train between 1973 and 1993 all the leading Finnish conductors. Another staff member, Paavo Heininen, a teacher of composition from 1966, had among his students Saariaho, Lindberg and Hämeenniemi.[18]

United in their post-serialist aesthetic these three and other modernists founded, in 1977, the *Korvat auki -yhdistys* (Ears Open Society). An essential part of their ideology was the demand to "keep up with international developments" and they showed their dissatisfaction with what they termed "national self-sufficiency," manifested in the 1970s boom in "Finnish" operas[19] such as Joonas Kokkonen's *Viimeiset kiusaukset* (Last Temptations) and Aulis Sallinen's *Ratsumies* (The Horseman) and *Punainen viiva* (The Red Line).[20] Nevertheless, Finnish opera with its heavily nationalistic features remained strong. However, the more internationally oriented and modernist post-serialists were gaining foreign awards and by the 1990s the *Ears Open* composers had become the new musical establishment.[21]

Almost coincidentally, in May 1978, the Helsinki rock music fans established *Elävän musiikin yhdistys Elmu* (The Live Music Society) to improve the conditions of rock music in Helsinki.[22] "Suomi-rock," sung in Finnish and sometimes taking its lyrics from Finnish folklore, had made its breakthrough in the early 1970s.[23] However, in the city there was an acute shortage not only of premises for rehearsals but also of the clubs and other concert venues increasingly demanded by the Inter-rail generation.[24] The student unions, the traditional venues for live youth music in Helsinki, were closed to the general public.

In late August 1978 *Elmu* organised its first "people's festival" in Kaivopuisto with a programme of rock music, events for pensioners and children and church music attracting some 20,000 people[25] and by the end of the year the new society had gained some 9,000 members while fourteen similar societies were established during the next year all over Finland.[26] The problem of rehearsal premises was solved when a few *Elmu* activists broke in and squatted in the empty night shelter for down-and-outs near Nokia's Cable Factory. With the support of younger members of Helsinki City Council[27] the society secured the tenancy of the building and it was refurbished by young volunteers. The basement was later used for rehearsals on a first-come-first-served basis by some 30-40 bands while upstairs there were art exhibitions, concerts and theatrical performances.[28] This building, known soon as *Lepakkoluola* (The Cave of Bats), was run by the young activists themselves and in 1987 they organised the first techno raves in the country. Together with the Cable Factory, it became the scene of regular raves attracting huge audiences

[332]

from late teens up to thirty something. From 1992 onwards with some support from the City's Youth Centre the 12-18 year olds were also catered for with gigs drawing hundreds of people to monthly "soft drink discos."[29]

In order to widen public access to rock music *Elmu* also launched in Lepakkoluola in spring 1985 the second and eventually the biggest local radio station in Finland, Radio City[30], which eventually organised in summer 1993 the celebrated *Total Balalaika Show* bringing together the Leningrad Cowboys and the Russian Red Army choir, orchestra and dance group on a platform in Senate Square.[31] This was one of those rare events after which people said, "Nothing would be the same again."

X High Tech Helsinki

"**B**ehind that lovely face lies Europe's city of intelligence" and "Don't be fooled by neo-classical Helsinki. The people are advanced and sharp."[1] These were some of the impressions of British journalists who visited Helsinki in the spring of 1999 in anticipation of Finland's taking over the presidency of the European Union in July of the same year.

Such comments might well have come as a surprise to those foreigners who had learned to agree with the German playwright Bertolt Brecht that the Finns are a people who are "silent in two languages". Yet, by the end of the 20th century these silent people had progressed to become among the first in the world as communicators via E-mail and to speak using some three million mobile phones. Indeed, to the observing foreign journalists in Helsinki mobile phones seemed to have become as normal as books among students and school children.[2]

Even more astonishing is the fact that a great many of those using mobile phones are using Nokia mobile phones developed in Finland, a country that had as late as the 1950s been in the main an agricultural economy relying on the pulp and paper industries. Since that time the country has managed to develop a manufacturing base in which high technology accounts for one fifth of all exports, two thirds of it consisting of advanced communications and electronic equipment.[3] Furthermore, while being a latecomer to the world of television, launching its first national services as late as the mid-1950s, Finland was in 1982, along with Norway and Malta, among the first countries in Europe to transmit satellite television programmes and nowadays has one of the continent's most extensive cable networks.[4] Again, how could a country known mainly for its wood-based industries launch, in 1981, a microcomputer, Mikro-Mikko, less than two months after the first PC developed by the computer giant IBM[5] with its mighty research facilities appeared

ABB and two leading shipyards, Kvaerner Masa-Yards Inc. and Italian Fincantieri, have founded a joint business, ABB Azipod Oy to take worldwide responsibility for the development, manufacture and sales of the Azipod propeller system, which has revolutionised the manoeuvring of large ships in a confined space. (Photo Gero Mylius. Lehtikuva)

Almost every schoolchild in Finland has a mobile phone to keep in touch with family and friends, to play games or to listen to music. (Nokia Press Photos 2002)

Forming part of a worldwide network mobile phones have provided Finns with a way of communicating efficiently regardless of distance or the situation of the user. Today mobile phones are also tools for officials. They are used for example in providing radio communication for the police and the fire, ambulance and other rescue services. Here a policeman is investigating a person's identity. (http://www.nokia.com)

on the market? How could it produce a computer guru like Linus Torvalds who, with his Linux operating sytem, is accepted as a serious challenger to the supremacy of the ubiquitous Windows system of Microsoft?

Many people have sought an explanation in the success story of Nokia, the Helsinki-based international telecommunications company, while others have found it in the investments that the Finnish government has made in the educational system and especially in research in universities and specialist institutes. The picture is more complicated, however. For more than two hundred years there has been a Finnish interest in electricity and its practical application in communications, lighting and power. These are concerns that are natural in a country with such long winter nights and such vast distances and over the years Finns have gradually gained confidence in their capacity to produce appropriate technological innovations. It was not always easy. In the middle of the famine years of the 1860s many people, including members of the Diet, were still seriously arguing that Finland could never compete with

western industrialised countries. They believed that there would never be enough job opportunities for graduates of technology and any expertise required would have to be gained abroad.[6] Yet, a hundred years later, Finns had gained sufficient confidence to develop many world-famous enterprises. These ranged from Helsinki' ice-breaker technology laboratory[7] to Nokia, which had by 1998 attracted staff of over 20 different nationalities to its research centre, also based in Helsinki.[8]

International Restart of Finnish Technological Research

Many promising developments were temporarily cut short by the onset of the Second World War, but from the technological viewpoint the five years of war followed by eight years of paying war reparations were vitally important for Finnish industry. They forced the country not only to develop further its manufacturing base in metal industries but also to rely on stet own innovative capacities. Many people believe that the spectacular post-war development of the Finnish metal industry was entirely due to the reparations but Häikiö points out that according to Finnish economic historians this is a myth and that investments in the years immediately preceding the war had been of far greater importance.[9] However, the extremely high standards required by the Russians in relation to reparation goods certainly forced the Finns to adopt much stricter quality controls as a part of the manufacturing process. As a result of the war years, the foreign grip on Finnish industries was also reduced for national security reasons, and a number of companies that had come to be foreign owned, such as Oy Strömberg Ab, were again transferred into Finnish hands.[10] All these factors provided Finnish industries with a good launching pad for later industrial expansion.

By the end of the war swift progress had been made in new technologies especially by the allied countries and Finland was determined not to be left out. In 1945 a department of technological physics was established in the Helsinki University of Technology to teach electronics and control engineering, the bases of process control and instrumentation technologies.[11] Yet, while the Finns had learned during the years of rationing, reconstruction and

reparation to appreciate the interactive roles of sciences, technology and industry in a modern society[12] there were hardly any funds available in the country for research equipment or materials. Thus for example Kaarlo Hartia-la, the future professor of medicine and later the Chancellor of the University of Turku, when researching for his PhD in the 1940s had had to sell liquor in Stockholm harbour in order to supplement his laboratory funds.[13] Some relief was brought in 1951 by the U.S grant of 14 million dollars, known as Truman funds, for the purchase of books and research equipment. However, for some years it was quite usual to believe that, due to its lack of resources, Finland would once more and in the future be at the receiving end of other people's scientific know-how. This pessimism even caused many promising scientists to consider moving abroad in search of better research facilities.[14]

This attitude, however, was to change to a great enthusiasm for the future as a result of a quite new development, the forging of Finnish links with international nuclear research bodies. The first contact was made in 1955 at an international nuclear energy conference held in Geneva where Finland had sent its delegation as observers. Two years later, in 1957, Finland joined the International Atomic Energy Agency (IAEA), which had been established in 1956 as a United Nations sub-organisation to develop the peaceful applications of nuclear energy and to aid nuclear research in member countries. The Finnish Atomic Energy Council, established in 1958, was chaired by Professor Erkki Laurila who was two years later elected to the board of the IAEA. For young scientists all this provided opportunities to get involved in international top level high tech research projects with the additional advantages, otherwise rare in the Finland of the1950s, of providing opportunities to study abroad and to attend international conferences.

These international connections helped the development of a wide-range of Finnish scientific-technological research projects and institutions, as the model pursued by Laurila was to direct money liberally to a number of universities, colleges and research institutes even though the projects concerned sometimes had no more than a superficial link with nuclear research. In this respect Finland differed from other western industrialised countries including Denmark, Norway and Sweden, all of which had established large institutes dealing solely with nuclear research. In fact, Laurila had doubts about the wisdom of investing all one's funds in a single huge institute, as

such organisations had not, according to him, led to the hoped for results[15] - though it is remarkable that the IAEA, and the USA which in practice controlled it, should have approved such a maverick arrangement.

The explanation may be political. The Finnish ambassador in Washington had in January 1955 reported that the USA was intending to follow keenly the potential spread of Soviet influence in Finland[16] and later that same year Finland concluded an agreement on scientific-technological co-operation with the Soviet Union.[17] It may be therefore that one possible explanation of the USA's tolerance of Laurila's scheme was its desire to support any measures likely to strengthen Finland's economy and its links with the western countries. This had certainly been the case in the late 1940s when export orders from the west were deliberately produced for the Finnish timber companies.[18] The liberal spreading of funds to a multitude of institutes and projects was bound to help to strengthen Finland's scientific and technological research system and therefore fits well into this pattern of quiet political support from the west.

Certainly these new research links meant the ending of Finland's ten year long isolation in the scientific world. Useful personal links were now forged and many Finns gained a much-needed self-confidence. Laurila's project meant that Finland got its first atomic research reactor from the USA in the autumn of 1962. Moreover, it forced Finnish universities and research institutes to face new scientific challenges, which strengthened the links between sciences and technologies. It also strengthened the links between science, technology and industry as a great number of scientists trained by Laurila's atomic research projects later moved into industrial life where they could use their capacities to establish research projects and the required laboratories. There was a new, perhaps unprecedented faith in Finnish scientific research and the confidence crisis in Finnish technology was over.

All this confidence and these technological resources were put to the test when Finland joined the European Free Trade Asscociation (EFTA) in 1961 and, in the face of the highly competitive western market, Finnish industry started, for the first time, to invest heavily in their own R & D operations. Consequently the Hietalahti shipyard, a part of the Wärtsilä concern and a noted producer of icebreakers, found new markets in producing large-scale hotel standard car ferries and luxury cruisers. Nevertheless, icebreakers

The old Nokia Cable Factory is today used for cultural purposes. More than a hundred artists work in the studios and workshops. There are also galleries and three museums: the Theatre Museum, the Hotel and Restaurant Museum and the Finnish Museum of Photography. The Dance Theatre Hurjaruuth and Zodiak, the centre for new dance, also perform in the Cable Factory. (Helsinki City Museum)

remained the Hietalahti speciality leading to the establishment in 1969 of a specialist laboratory for researching icebreaking technology. Eventually it found itself constructing two thirds of all icebreakers produced in the world between 1950 and 1980 and an order for ten further icebreakers in 1980 in practice meant that during the following decade it became the sole world producer of such vessels.[19]

On the other hand the venerable Kone ja Silta, another company of the Wärtsilä concern, which had pioneered the manufacturing of paper machines in Finland by delivering in 1949 to Czechoslovakia the first ever complete paper making machine wholly constructed in Finland, started not only to look for new production lines but also a new site outside Helsinki after producing a whole string of such machines for the Finnish paper mills in the 1950s.[20] Naturally enough both Oy Strömberg Ab and Suomen Kaapelitehdas started to look at electronics as a new growth area. Consequently Strömberg started by applying electronics to the controls of its traditional lines of industrial scale electrical generators and motors. From 1967 onwards it developed process control computers[21] for the paper mills and other processing industries while its SAMI frequency converter, developed in 1976, was subsequently exported to 30 countries. It became the company's internationally best known product and is still on the market.[22] Suomen Kaapelitehdas on

the other hand directed its attention towards the entirely new field of compu-
ters. This led to the formation of the Helsinki-based international electronic
giant Nokia and the arrival of its MikroMikko computer and its mobile phone,
that were due to transform the Finnish way of life.

High Tech Arrives in Helsinki

For ordinary Finnish people the first item of high tech of which they became
aware was undoubtedly television. As mentioned earlier some Helsinki media
experts had been planning to use it for broadcasting the 1940 Olympic
Games and after the war the State Technical Research Centre (VTT) had
suggested the commissioning of research and preparations for the launching
of television in Finland. The Finnish Broadcasting Company, eager to develop
its FM network, delayed their decision but they were forced to yield in the
mid-1950s apparently under pressure from a private television club of radio
engineers and students at Helsinki University of Technology. However, the
decisive factor was probably the introduction of broadcasts from powerful TV
transmitters in Tallinn which in 1954 were seen by some influential Finns as
a propaganda channel for the Soviet Union.[23]

The general public, unaware of these political considerations, fully enjo-
yed the new television services, first provided in May 1955 by the engineers'
and technology students' club and followed by regular services in 1956.[24]
Indeed, some people were so fascinated by this innovation that they were
seen to stare at the test card for half an hour before the beginning of the
actual programmes. Public enthusiasm soon led to the production of actual
television sets in Finland and this in turn was to prepare the way for the
production of computers in Finland.

As in the case of television, the potential of computers was realised
relatively early in Finland. Consequently one of the first major proposals of
the Academy of Finland, established in 1947, was the launching of research
on computers[25] and a year later the Chief Actuary of the Social Insurance
Institution of Finland, responsible for the pension registrations of over two
million Finns, made a study tour to the USA which also included a computer
course organised by IBM. Due to an increasing workload after a major

pension reform the Institution's Board decided in 1957 to investigate the replacement of the Hollerith punch card machines by computers, especially as the Finnish State Railways and the state owned Post Giro Bank were then also in the process of acquiring their own computers from IBM.[26] But it was not until the beginning of the 1960s that Finnish society was prosperous enough to enter the computer era on a large scale. In January 1960 the Social Insurance Institution received its first IMB 650 computer, and the Institute proudly announced itself to be the second national pension institute after the USA to use computers in the processing of pension payments.[27] In the same year, and approximately at the same time as merchant banks in Sweden, the Union Bank of Finland placed an order for an IBM 1401 computer which used magnetic tape. The Union Bank had already in the 1940s had punch cards for mechanical book-keeping and was the first bank in the Nordic countries to do so. Now they needed a computer to concentrate the bookkeeping for its Helsinki branches in the head office.[28] Other major offices in Helsinki soon followed the suit: the State Technical Research Centre (VTT) acquired its first Elliott 803 computers in the early 1960s, as did the State Computer Centre,[29] which had been established in Helsinki in 1964.[30] In 1966 Finns were the second in Europe to control paper-making machines by computer[31] and a few years later the layout of the national weekly magazine *Suomen Kuvalehti* was made by using computers for lino-tronic typesetting once solutions had been found for the grammatically correct hyphenating of the long compound words typical of the Finnish language.[32]

In October 1969 Finnair caused an international sensation by flying a jet across the North Atlantic using a computer instead of a human navigator.[33] This was an interesting and important development as on Atlantic flights the navigator held a key position determining the position of the aircraft every half hour. The position was so crucial that in Finland navigators had had to undergo the thorough specialist training of sea-going navigators.[34] For the Finns themselves almost as great a sensation was the news that the inertia navigation system (INS), used by their two new DC-8 aircrafts on the North Atlantic flights, had actually been adapted from a system originally developed for the Apollo moon flights and nuclear submarines. Independent of ground navigation aids and extremely accurate, the INS was coupled to the autopilot to provide the crew with a constant indication of the aircraft's precise

FIGURE 7.

Computers connected to the Internet, in January 2000 per 1000 inhabitants

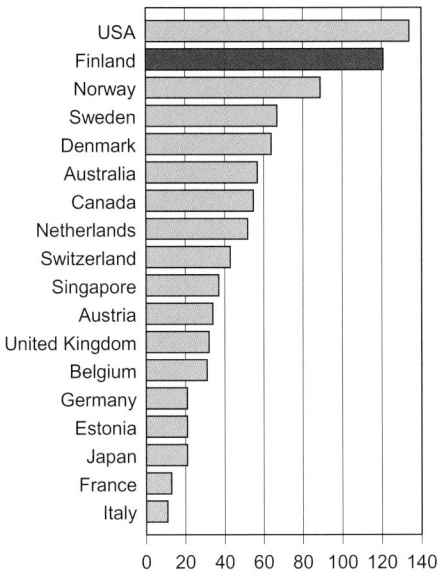

Source: OECD, Main science and technology indicators

position. To maximise passenger security Finnair decided to fit each aircraft with three INS systems,[35] all of which had to be operational when the plane left Helsinki and two when it started the return flight even though only one INS was needed for the actual navigation. Moreover, before the Finnish authorities approved the use of INS as the sole navigation system Finnair had to make one hundred flights across the Atlantic with an actual navigator on board. It may be asked why Finnair was the first airline to get permission to use the inertia system; the Finnish answer is that the company was the first to install this system in their whole fleet making long-haul flights (meaning these two DC-8's!). Finns also formed an opinion that other airlines had in practice acknowledged Finnair's pioneering status by scheduling fights, due to depart from Amsterdam around the same time of the day, to tail the Finnair flight so that their planes could follow the jet stream of the Finnish aircraft. [36]

From the early 1970s onwards computers were increasingly used as part of normal customer service in Helsinki banks and health centres[37] while libraries[38] and other institutes with huge data banks started to transfer their records to computer systems. One such institution was the Central Pension Security Institute, which computerised the registration of all the earnings of Finnish people as a calculation basis for their future earnings-related pensions. Furthermore, the year 1971 saw a further revolution in the Finnish banking system, when Helsinki banks started an experiment with cash dispensers, that provided customers with cash outside normal office hours,[39] and when the number of these cash dispensers increased to over 1000 this

fact was again reported by *The Times* in London. A further step was taken in 1980 when the Helsinki banks started to provide their customers with plastic cards as a method of payment through shop computer tills[40] and the banking revolution was completed in 1982–83, when it became possible to use home PCs with modems for the paying of bills. As four fifths of all payment transactions that reached the banks in 1998 were made by using computers, i.e. by PCs or by giro automated teller machines[41] (located in shops and exterior walls of banks) it meant that for Finns computers had by then become almost as normal a part of life as a fridge or a vacuum cleaner. In the Helsinki region taxis are even using a computer based booking system launched as early as 1987 and adapted from a Swedish system[42] while all public libraries now provide their customers with free Internet connections.

Computers and Mobile Phones

This triumph of the computer in Finland has much to do, not only with increasing general prosperity and the by now familiar Finnish drive for efficiency, but also with the development of a specifically Finnish computer from 1981 onwards. That Nokia got involved was a result of the company's need to look for new business opportunities after the war and ultimately of a series company mergers before and after the war. The origins of the Nokia corporation can be traced to the amalgamation of a papermill in Nokia (established in 1865), a galoshes and tyre factory in Nokia (with an office and another plant in Helsinki est. 1898) and a cable factory in Helsinki (est. 1912). Each of these companies had also had a strong tradition as a Finnish pioneer in its own particular field.[43]

Oy Nokia Ab had started its life as a wood-pulp mill in Nokia, near Tampere, for manufacturing paper at a time when sawmills were the normal form of timber related industry. Oy Suomen Gummitehdas Ab (The Finnish Rubber Works) started to manufacture galoshes in Helsinki but moved a few years later to Nokia where it prospered by manufacturing rubber tyres, then an innovation in Finland, during and after the First World War. Consequently it was able to take over its much bigger neighbour, the Nokia paper mill.[44] Like many other forest industry companies the Nokia mill had, since 1913, also become a provider of surplus electricity for Tampere developing this sideline

to the extent that in the 1920s its hydro power plant was the fourth biggest in Finland.[45] This activity of its subsidiary company Nokia made Oy Suomen Gummitehdas Ab aware of the potentialities emerging in the electricity industries. In 1922 it became a major shareholder in Oy Suomen Kaapelitehdas Ab (The Finnish Cable Works), a company which had been using rubber from Gummitehdas for insulating its cables for electricity and telephone lines.[46] However, although the three companies were obviously benefiting from their complementary activities it was not until 1967 that they merged to form the Nokia Group.

Nokia got involved in electronics through its Helsinki-based cable arm, Suomen Kaapelitehdas, which had established an Electronics Department in 1960. This was very auspicious timing as semiconductor technology was just making its way from the laboratories to industry. By the early 1960s the Electronics Department had become the sole import agent and support organisation in Finland for a number of well-known western computer manufacturers such as the British Elliott, the French Bull (later Bull-General Electric), the German Siemens and the American Honeywell.[47]

Moreover, as the company needed to train competent staff from among people who were deemed to be promising but had almost no previous knowledge of the area, the Electronics Department launched a systematic and extensive training programme, soon to be popularly referred to as the "University of Salmisaari" after the location in Helsinki of the Kaapelitehdas. The general atmosphere in this "university" was enthusiastic, not least because the training was linked very closely to the company's industrial operations. Some customers told the Finnish firm "IBM has better equipment and you have better people."[48] At the same time a physics teacher at Helsingin Reaalilyseo, a well-known Helsinki boys' secondary school, was so keen on the new technology that he invited members of staff at the Electronics Department of Kaapelitehdas to talk about computers in lessons at the school. Apparently these talks and excursions to Kaapelitehdas so fired the boys' imagination that 13 of them, i.e. one third of a form that had matriculated in 1964, later chose to take the radical step by entering this new, then still uncertain field to become professional computer experts.[49]

For computer enthusiasts the Helsinki of the late 1960s and 1970s was an exciting city. Computers were not only being installed in major banks and insurance companies but also in the headquarters of industrial companies and of nationwide businesses, and the technology was rapidly expanding into various forms of customer service. Those involved in this new industry were young and willing to help each other in the spirit of a team concerned with solving installation and programming problems irrespective of their customer firms' positions in the competitive markets.[50] An official recognition of the field was given when Helsinki University started to teach computer technology in 1969[51] and in the late 1970s Oy Nokia Ab Electronics, i.e. the former Electronics Department of Kaapelitehdas, started to develop the first Finnish computers.[52] What was also remarkable is that when Neste Oy, the Helsinki based oil company owned by the Finnish state, began in the 1970s to consider alternative routes for diversification its board ruled out electronics on the grounds that they were not willing to damage the potential success of Nokia which had already started to develop its electronics arm.[53] Consequently Neste branched out into plastics and also found a new area in alternative energy technology becoming one of the world leaders with its NAPS solar panels launched in 1986.

Before embarking on computers Nokia had already started to develop two other vital ingredients of the present information technological revolution, namely the mobile phone and the modem. The rapid increase in the number of cars during the 1960s, coupled with the brisk growth in the use of lorries as long distance transport vehicles, created the need for radiophones, which were to develop into mobile phones. Nokia had started to make radiophones in 1963 for the army, police, public utilities and emergency services. It was, however, the car phone utilising semiconductor technology that three years later started to persuade the Finnish public of the usefulness of mobile phones as such groups on the move as vets, surveyors and professional lorry drivers soon found the car phone not only convenient but also useful for their work. At the end of the 1960s Nokia made one of their most important strategy decisions ever by introducing the world's first 30 channel pulse code modulation transmission equipment using the CCITT standards, thus stepping very early into the digital technology which substantially increased the capacity of telephone cables. Consequently the company produced in 1982

the first fully digitalized local switch in Europe, the DX200, which started Nokia's development in switching systems. In the 1990s DX200 became a global success because of its modularity, which facilitates its easy extension and adaptations for various solutions.[54]

Another significant event was the establishment of the Nordic Mobile Telephone (NMT) services in 1981, then the world's first and largest common cellular network spanning several countries. During the 1980s NMT was also taken into use in many other European countries and also outside Europe.[55] This meant a huge potential market for Nokia as anybody could now acquire the mobile phone, which later was to become an invaluable part of the Finnish way of life. This was for two very Finnish reasons. One was the tradition of regular visits to summer cottages, which totalled some 400,000 by the early 1990s and were often located in such remote sites that a fixed phone line was not a practical option. Another was fact that the great majority of women were now in full time employment, and, once the volume of exports had brought down the price, they soon found mobile phones a handy way of keeping in touch with members of their family.

The modem, an indispensable tool for transferring data via telephone line and thus a necessity for the development and the use of the Internet, entered Nokia's programme in the mid-1960s. However, unlike firms in Germany and France, Nokia had no monopoly of its domestic market. As early as the establishment of the country's first local telephone networks in the late 19th century Finland had encouraged competition in the telecom industry and there had always been several local operators in Finland free to purchase equipment from any supplier. Furthermore, alongside the launch of the NMT, the Nordic countries were the first in the world to deregulate telecommunications. This naturally had an impact on the marketing of the modem. While in countries outside Scandinavia and Finland modem suppliers had monopoly positions supported by national telephone companies,[56] in Helsinki the local telephone company HPY simply provided required specifications leaving the customers to purchase from among many alternatives the equipment most suited to their particular needs.[57] Admittedly the need for modems was not huge to begin with. After the acquisition in October 1964 by Kesko, the Helsinki based co-operative of private shops, of a licence to operate four modems in the public telephone network their number had only increased after five years to a mere 73, all for use in computers.[58] However,

this non-monopoly principle forced Nokia to face competition from the very beginning[59] while the Finnish people were provided with an opportunity to get the latest technology for their data transfers if they so wished. What made the use of modems a reality, however, was the success of Nokia's MikroMikko, the Finnish PC that came on the market in October 1981 and made computer use far more widespread in Finland.

MikroMikko was not the first computer produced in Helsinki as students of the Helsinki University of Technology had constructed as early as 1958 an ESKO computer, which used radio valves and from 1977 onwards Finnish made kits for DIY computer constructors were also on the market.[60] Nevertheless it was the MikroMikkos that became *the* Finnish computers, not least as from the beginning they were built with efficient Intel processors and all their accessories were designed to be ergonomic, a quality appealing to the Finnish and Swedish people. They were quiet, the glare of their screens was minimal and above all, the model MikroMikko 2, which was launched in 1983, was the first computer in the world to have a white screen.[61] Subsequently MikroMikko 2 was awarded Die Gute Industrie Form -award at the Hanover International Fair in 1983 and by the end of the year it had become the market leader in Finland. The 100,000th MikroMikko was donated in November 1990 to Father Christmas in Finnish Lapland to help him in his administrative routines. Whether or not this marketing gimmick helped sales is uncertain. Nevertheless, the trebling of the export of MikroMikkos to nearly 163,000 during 1992 made computer exports from Finland exceed imports for the first time.[62]

The world leader in mobile communications, Nokia had, at the end of 2001, 18 production facilities in 10 countries around the world with research and development being carried on in 15 countries. (Nokia Press Photos 2002)

Jorma Ollila (born in 1950) personifies Finnish telecommunications. He first gained prominence as a director of Citibank and joined Nokia in 1985. Five years later he became managing director of Nokia Mobile Phones and in 1992 Nokia's CEO. (Nokia Press Photos 2002)

Nokia produced MikroMikkos in their Pitäjänmäki plant and later in Espoo until 1991, when Nokia Data, the computer-making arm of the concern, was sold to ICL to rescue the main company during a deep recession. As diversification was believed in the 1980s to offer protection against economic fluctuations Nokia had used the new market areas, emerging in Europe and the USA due to deregulation, for acquiring engineering, chemical, light bulb, capacitor, aluminium and plastics firms to place alongside its traditional manufacturing of paper, tyres and cables. By 1988 about 70% of Nokia's net sales originated outside Finland as it was one of the largest television manufacturers in Europe, the largest information technology company in the Nordic countries and furthermore sold its modems around the world. This variety of interests left the concern exposed, however, though the company itself was soon rescued thanks to its two strong arms, the Telecommunications Department and the Mobile Phones. Nokia Data – and MikroMikko – had to be offloaded along with other non-core operations, such as the production of televisions, which by the beginning of the 1990s had caused the company's serious financial crisis as a heavy loss-maker.[63] Instead Nokia concentrated on developing one product line only, that of mobile communications with all its future prospects. They saw clearly the opportunities provided by digital technology and invested in developing GSM technology, originally chosen by 18 countries to be the European standard. In 1991 Nokia concluded agreements to supply GSM networks to nine other European countries. Nokia's expertise in GSM technology thus not only rescued the company but also paved the way to its future international success.[64] In his history of Nokia Häikiö suggests that it was the company's pioneering status as a provider of digital GSM technology, first in Finland and then in Europe generally, that was one of the vital factors in its future success. It not only became the world leader in the most modern

applications of digital technology, but when deregulation opened the doors to new telecommunication operators it was already in the process of internationalisation and was immediately able to take advantage of the situation. According to Häikiö the present Nokia was actually born and grew up in the global market place.[65] Castells and Himanen have noted also Nokia's early vision of the mobile phone as a mass-market consumer product and this resulted in their keenness to develop user-friendly products of top class design. The fact that the company's financial base was no longer dominated by Finnish commercial banks but depended on American small investors, allowed the top management much more freedom to manoeuvre in changing market situations. Immensely important also has been the company's innovative operational model based on networking in partnership with universities, suppliers, and public authorities.[66]

In 2001 the firm's staff consisted of some 60,000 people working in Nokia Networks (a world leading supplier in GSM infrastructure), Nokia Mobile Phones (with sales in over 130 countries) and the Nokia Ventures Organization which explored new business areas facilitating future growth while the Nokia Research Centre maintained the company's technological competitiveness. The company's research and development took place in 55 different units in 15 different countries although Finnish know-how still formed 65% of Nokia's whole research and development input.[67]

FIGURE 8.

**Mobile phones, September 2000
Per 1000 inhabitants**

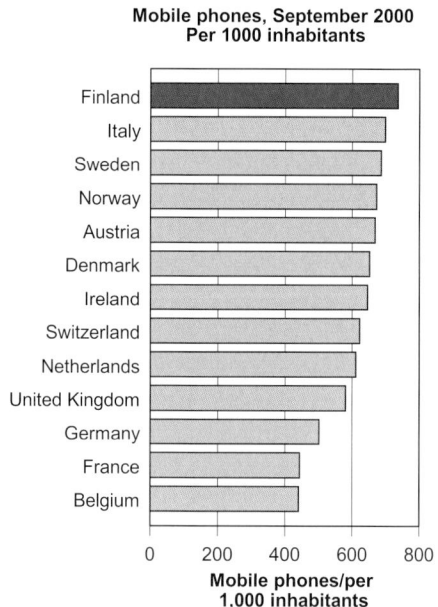

**Mobile phones/per
1,000 inhabitants**

Source: Telecommunications Statistics 2000/Ministry of Communications Finland

Traditions and Training

When Nokia Data was merged with ICL it was on the understanding that ICL would base R & D and part of production of their PCs in Finland among other countries. Five years later it was the turn of ICL to join forces with the Japanese Fujitsu. Nevertheless the new owners also decided to continue production of the PCs in Finland under the name Fujitsu ICL Computers Oy, (with only the last tag revealing the Finnish connection.)[68] This raises the question of what it was that the Finns had to offer to get two international companies to continue their electronics activities in the Helsinki area. True, to begin with, Nokia Data with its well-trained and innovative staff and quality products must have been very attractive to ICL and it made sense to let them carry on. One could say the same about Fujitsu. But why did ICL, which after all was not a Finnish company, still wish to continue to operate in Finland once Fujitsu had taken over the production of MikroMikko? Similarly, why did ASEA/ABB, the owner of Strömberg since 1986 and ICL's neighbour in Pitäjänmäki, strengthen its Finnish operations so that in the 1980s the factory once again became the biggest industrial plant in Helsinki?[69]

One natural explanation is the geographical position of Helsinki, a peaceful city in a democratic country with an excellent infrastructure. This made it a bridgehead not only to the rest of Finland but also to Russia and the Baltic countries. Thus ICL Finland, for example, is also operating in the Baltic countries while the headquarters of the concern are dealing with Russia.[70] Another attractive factor may have been the location, Pitäjänmäki, nowadays occasionally also called the Silicon Hill of Helsinki (-mäki = hill). Since Strömberg moved there in 1934, following the destruction by fire of their old factory in Sörnäinen, a true industrial community specialising in electricity and electronics had developed in the area. The pioneering radio manufacturer Oy Helvar Ab also have had their factory there since the 1930s and Slev Oy manufactured electric cookers there from 1940 until the early 1960s.[71] Good traffic connections later attracted not only Nokia Data but Cannon, a Nokia mobile phone plant and recently also a number of new electronic and IT businesses, and the city of Helsinki has proved very helpful in the further development of the area as a modern industrial and business centre.[72]

The aim of international companies arriving in Finland has also changed from that in the 1930s. When both ASEA and Brown Boveri Cie first tried to get control over Oy Strömberg Ab they wanted to acquire a market in Finland while the aim of the merger in the mid-1980s with the present ABB was rather to purchase Finnish know-how and skills. Furthermore, according to its strategy of concentrating operations in centres providing core competence, ABB has specified its Pitäjänmäki plant as the centre for the R&D and production of electronic frequency converters and electrical machines while providing these products, through corporate muscle, with global markets.[73]

Similarly when ICL purchased Nokia Data it was because the British company not only wanted to expand into the Finnish market but also because it was lacking in its own know-how in the field of PCs. What it had not bargained for was the volume and quality of application competence and the general high standard of know-how in a wide sector of information technology that Nokia Data brought along in the merger. That became very useful, however, when ICL decided to shed its hardware operations in order to become solely an IT service company. Having long customer relations with a number of Finnish public services and businesses, ICL utilised the application competence of its Finnish section and consequently focussed on Pitäjänmäki ICL's global development work in e-business, i.e. development of services which help organisations and businesses in some 40 countries to utilise the wast potential of the Internet. Moreover, a number of Finns have later become involved in high level decision making and strategic planning within the whole corporation and in February 2000 ICL Data Oy employed over 2000 people in Finland its turnover being some 10 % of that of the whole international concern.[74]

This stay by both ABB and ICL in Helsinki and Pitäjänmäki must therefore be seen as evidence of the high standards of the Finnish technological abilities and know-how. Certainly the traditions of the electricity industries were well rooted among the people of Pitäjänmäki offering a pool of people with "electrical industry in their blood." In February 2000 the ABB plant for example had on their payroll employees of the second or third generation of "Strömberg families" not only on the shop floor but also in engineering posts and they included even a grandson of Gottfried Strömberg himself.[75] In terms of numbers people in Pitäjänmäki alone could not, however, meet the needs

of all the companies operating there since the early 1990s. These had to rely also on newcomers to the industry. Yet, as the overall industrial tradition in Finland was relatively limited, Finland having remained predominantly an agricultural society until the 1950s, this obviously high standard of the Helsinki region workforce in international terms must reflect the success of the educational reforms that have taken place in Finland since the 1960s. This is also supported by the fact that in 1998 some 75 % of Nokia's R&D input was generated in Finland by some 7–8,000 research engineers round the country even though the corporation had a total of 36 research centres in 19 countries.[76]

Indeed, it is highly unlikely that the present level of high technology in Finland could have been possible without the reforms of Finland's education system in the 1950s and 1960s. This was coupled with the reorganisation of the highest research system as a result of President Kekkonen's orders in the mid-1960s,[77] and together they created the foundation for the Finnish product development and highly educated work force, as described in Chapter Nine. Consequently in Helsinki among the young adults, i.e. those between 25 and 34 years old, in 1997 a total of 81 % had been through university or vocational training.[78] As four-fifths of the same age group of all Finns also have the same educational background[79] there is also available a supply of high standard staff for the high-tech industries in Pitäjänmäki and Helsinki. For further in-house training the companies can use, and have used the services of Amiedu, a vocational further training centre established in 1973 by the Helsinki region municipalities with headquarters in Pitäjänmäki.[80] Through the Piimäki project, a new fast broadband network linking Pitäjänmäki companies launched in 1998 by ICL, Helsinki Telephone Company HPY, Nokia Telecommunications and Amiedu, targetted training can also be directed via computers from the Amiedu's auditorium to the desks of the course participants.[81]

The Piimäki project is a part of an information technology project of TEKES – the Technology Development Centre, the main government organisation financing applied and industrial R&D in Finland. Established in 1983 in Helsinki its main task is to finance research projects in state owned and private research laboratories. Thus TEKES linked Finnish industries to become a part of the Finnish research system while strengthening the links

between sciences, technology and industries and individual research projects were replaced with major national technology projects focussed on such high tech fields as semiconductor and computer technologies.[82]

The field of high technology is moving fast, however, and the development in high technology of such a stable product, as for example aspirin in pharmaceuticals may not even be possible. Networking and co-operation have therefore increasingly become the ways to push forward the R & D frontiers; companies will concentrate on their core know-how, will network their operations, produce more tailor made products and increase services which produce value added.[83] Thus the University of Oulu was and is among the key players in the development of the Nokia mobile phones[84] while ABB has close links with the Helsinki University of Technology in Espoo and to some extent also with the Technology Universities in Tampere and Lappeen-ranta.[85] ICL has close contacts with Helsinki University of Technology,[86] and Vaisala Oy's recent optical gas sensor was developed in close co-operation with the Technical Research Centre of Finland (VTT), located also in Espoo.[87] Even though the companies are concerned with the potential shortage of new talent to be found from among a mere five million Finns[88] so far this strategy appears to have been successful. In 1996 the number of Finnish patent applications in electricity and electronics submitted to the Finnish patent authorities exceeded for the first time that of foreign applications.[89] Each year from 1997 onwards the World Competitiveness Yearbook of the International Institute for Management Development has ranked Finland in its top ten. In 1998 it listed Finland as the top country in the world in technological cooperation between companies, in research cooperation between companies and universities and in the development and application of technology. It also listed Finland among the top countries in areas such as the level and availability of technologically competent human resources, scientific and technological expertise, and the ability to respond to basic business needs. In 2001 this Lausanne based institute ranked Finland as the third most competitive country in the world after the USA and Singapore.[90]

Bearing this in mind it is somewhat paradoxical that when pioneering the use of the Internet, the young Finnish computer enthusiasts of the 1980s and the early 90s were not particularly interested in the money to be made from their innovations. The fascination of the work itself seems to have been

enough. A group of students at the Helsinki University of Technology, for example, developed Erwise, the first web browser with a graphical user interface running on major Unix operating systems. This was in 1992, a year ahead of the launching of Mosaic and two years before the introduction of Netscape, but apparently they did not wish to go further and develop it into a commercial product.

Even so, Castells and Himanen believe that these first highly talented Finnish software programmers have played an exceptionally significant role in the Finnish technological revolution. The development of the Finnish national network, for example, depended on the efforts of the young Finnish computer enthusiasts who also brought about its linking to the international networks from 1985 onwards.[91] Moreover, they also helped to develop it from being merely a calculation capacity tool used largely by the academic community, which in Finland had employed the FUNET network, into a social communication medium for the general public, a fact which popularised its use in Finland faster than anywhere else. According to Castells and Himanen this process displayed an innovativeness equal to that demonstrated by Nokia when they turned the mobile phone into an everyday tool and an essential part of the contemporary lifestyle.[92]

The Information Technology Department of the University of Technology had provided one of the bases, where dedicated young students could write programmes into the small hours. They, along with colleagues elsewhere in the country, developed the major bulk of the most important software programmes used and, by developing new programmes for providing chat, safe links and anonymity, they transformed the Internet into a tool for global social communication. Among them was Tatu Ylönen, who in 1992 launched the SSH protocol, the standard for encrypted terminal connections on the Internet, and three years later founded his own company to develop it further. SSH Communications Security now operates globally and has made Ylönen not only a millionaire but also an inspiration to the younger generation. However, remaining true to the ethics of his student years, he has made his programme available to universities free of charge.

The most famous Finnish software programme of all, the Linux operating system, was developed by a Helsinki University man, Linus Thorwalds. He launched his project in April 1991 when he was only 22 and since then

thousands of other programmers all over the world have been able to take part in the further development of the system. This was the result of his decision to make the operating system's source code available to the public, thus applying the key concept of the Internet, openness, in its development. [93] Castells and Himanen believe that if the innovative, open model of Linus Thorwalds for programme development were gradually to become a generally used method, it might in the end prove to be the most radical innovation for stimulating further innovations in information technology. [94]

When analysing the structural factors behind this exceptionally strong Finnish software programmer culture Castells and Himanen note the strong positive attitude adopted in Finland towards technology. They also suggest that money as such has played a relatively minor role as an incentive for student programmers. It may be that because of the adequate funding from

Biomedicum is a high-level research and teaching centre located on the medical campus of the University of Helsinki in Meilahti. All in all Biomedicum offers facilities for over 1000 researchers and study facilities for 300 students of medicine and dentistry for the first two years of their studies. In addition to University of Helsinki funding, Biomedicum is supported by the state and industry as well as by the cities of Helsinki, Vantaa, and Espoo. Biomedicum was designed by Gullichsen-Vormala, Architects (chief architect Timo Vormala) and the building was completed in January 2001. (Photo Voitto Niemelä. Helsinki University)

grants and low-interest study loans they felt themselves under fewer pressures. As Finnish university studies allow students considerable choice in structuring their course programme as well as providing teaching of very high-standard it is not surprising that the system was capable of producing great numbers of very able programmers.[95] The latter has naturally been very important in attracting foreign information technological companies to Finland which can provide the Finns themselves with new interesting technical challenges and the opportunity for global operations. At the same time the young Finnish graduates of technology have increasingly begun to launch their own IT companies, and in order to facilitate this enterprise the Helsinki University of Technology, in the late 1990s, introduced the first courses in telecommunication venturing.[96] This is a move which may help to reduce the shortage of those start-up enterprises that in Silicon Valley have been the chief developers of radically innovative ideas. All this is likely to broaden the national base of information technological know-how in Finland.

Helsinki in High-Tech Finland

The success of Finnish – and Helsinki's – high technology companies has profoundly changed the country's industrial structure in terms of production and exports during the 1990s. Since 1990 the electronics and electrical industries increased their productivity four-fold by 1998 while their exports developed into the third industrial pillar with a 25 % share of total exports in 1997.[97]

At the same time the city of Helsinki is no longer the epicentre of electrical and electronic industries as Tampere and especially Oulu have become strong high technology centres. The capital's high technology pool has also expanded outside its boundaries. While Nokia's Research Centre, the Pitäjänmäki companies and the state funding organisations, the Finnish Academy and the Technology Development Centre still remain in the city of Helsinki, the Otaniemi technology campus of the Helsinki University of Technology and of the Technical Research Institute of Finland (VTT) as well as Nokia's and Neste's headquarters are now in neighbouring Espoo.[98] However, even this metropolitan area no longer has the sole hegemony of high tech in Finland. Over half of the companies listed in *High Technology Finland 1999,* a

publication of the Finnish Academies of Technology and the Finnish Foreign Trade Association, were in fact located all round the country beyond the Helsinki metropolitan area. The same applied to some 80 % of most important Finnish subcontractors of Nokia.[99] Indeed, some foreign observer noted that Finland appeared to be turning into an advanced information-led society where the engines of growth were to an increasing extent smallish companies, plugged into the new network of public and private R & D institutions and forward thinking enterprises.[100]

Helsinki is also potentially losing its traditional role as an exclusive academic centre. The Centre for Scientific Computing in Otaniemi links all Finnish universities into a national academic network FUNET and its metacomputer is used for the computation of the most demanding research projects in meteorology, physics, structural mechanics, chemistry and macro economics.[101] Universities in Turku, Tampere, Kuopio and Oulu have been fast developing their strong areas in graduate schools and post-doctoral training being duly rewarded with additional funds from the Finnish Academy for their centres of excellence.[102] Meanwhile the Virtual Open University of Finland has launched its information service on hundreds of subjects and thousands of courses are available all over the country in the open university programmes (and increasingly on their websites) of all the 19 universities in Finland.[103]

This does not mean, however, that Helsinki necessarily has lost its cutting edge regarding its potential in high tech innovations. The Pitäjänmäki area is an increasingly lively centre of high tech companies witnessing the expansion of Nokia plants and the recent construction of new housing areas amid the old industrial sites.[104] Linked with the fast roads to Otaniemi, on the other side of the Huopalahti Bay, with its high technology institutes and the headquarters of Nokia and Neste close by, Pitäjänmäki and Otaniemi now form on the western flank of Helsinki a high tech area where friendly co-operation spiced with healthy rivalry is likely to provide fertile ground for future innovations.

Another, equally interesting area with two innovative centres is currently being established on the eastern side of the city, on the shores of Vantaa Bay. The new Helsinki Science Park is located in Viikki, the site of Helsinki

The new audiovisual department of the University of Art and Design
Helsinki (UIAH) designed by Pentti Kareoja. UIAH is located in
Arabianranta where IT companies, such as IBM and Sonera are
creating a virtual community called Helsinki Virtual Village. This
project is seen as a test-bed for cutting-edge developments in mobile
technology. (Photo Juha Nenonen.)

University's agriculture and forestry faculty, which formed the core of the
Science Park. The other component, the Viikki Biocentre, was established in
1995. Being a co-operative venture of the University, the Science Park, the
Finnish Government, the City of Helsinki, the Finnish National Fund for
Research and Development (SITRA) and Finnish business organisations it
aims to become Finland's largest biocentre and a new model of collaboration
with industry. While it already has attracted the cream of Finnish biotechnolo-
gy, biomedical research and environmental technology,[105] all potentially the
high technologies of tomorrow, the real innovation in the Helsinki Science
Park Ltd is, nevertheless, the involvement among the shareholders not only
of the University and the Finnish and Swedish Schools of Economics and
Business Administration but also of the Sibelius Academy of Music and the

Theatre Academy as well as the Academy of Fine Arts and the Universtity of Art and Design![106] The Science Park will be complemented by the Viikki Ecological Neighbourhood, due to provide 13,000 homes and 6,000 jobs in the early 21st century.[107] As this eclectic mixture of interests and talents is coupled with the development of an Arts and Design City in Arabianranta, the area round the Arabia factory further south on the Helsinki peninsula, the eastern coast of the city may potentially become, within the next ten years or so, a real foundry of creativity feeding the city and its businesses with people capable of the high tech innovations of the future. In his survey of Helsinki projects in 1998 a British expert on urban development, Charles Landry, indeed assessed both projects as very innovative on a European scale and even considered the Viikki project, including its Ecological Neighbourhood, a landmark in the whole of Europe.[108]

However, in the eyes of a British journalist, Vic Keegan, visiting Helsinki in the autumn of 1999 the city was already not just the most advanced Internet city in the world but also a real world centre of high technology, where things were happening which would have been inconceivable even ten years earlier. Visiting Lasipalatsi Keegan was faced with a screen, a web camera and a microphone. To him this was the digital age's version of Speakers' Corner in Hyde Park "where people are encouraged to broadcast what is on their minds to politicians or anyone in the world prepared to watch or listen on the Internet." Moreover, there was the Arena 2000 project giving fast broadband Internet ac-

The new premises of the Sanoma Corporation, Sanoma House. The nine-storey building, made entirely from glass, is home to the editorial offices of three newspapers: *Helsingin Sanomat*, the largest newspaper in Finland with a circulation of 450,000, *Ilta Sanomat* and *Taloussanomat*. Sanoma House was designed by Sarc Architects Ltd (Jan Söderlund, Antti-Matti Siikala).

cess to most citizens enabling them "to do anything from tracking where the nearest buses and taxes are to ordering pizzas" and even enabling parents to see where their phone-bearing children are in the city. All this is the work of Risto Linturi, whose own house also demonstrated to Keegan the possibilities of the Finnish high tech world, a house "where the lights automatically and unobtrusively turn on and off as (they) pass and where it would soon be possible to move from room to room with one's favourite music following one through." Even more amazing was the fact that Linturi could open his Helsinki front door for friends using his mobile phone even if he himself was in Paris or London.[109]

It may be that ordinary Helsinki people will never need such facilities in their homes. What is obvious, however, is that the recent high tech developments have made Finland a much smaller place for its people and a much less remote place in relation to the rest of the world. It is now quite commonplace for one Finnish graphic artist, for example, when leaving a concert in Helsinki to walk along the street giving her immediate impressions through a text message to her pianist sister living in Cambridge. This means that for a country located in the northern edge of Europe "the terror of remoteness" is finally over. As early as in 1874 the chairman of the Finnish Literature Society, Yrjö Sakari Yrjö-Koskinen, a famous historian and later a senator, said that

> **"The whole history of Finland has consisted of a drive to get attached to the general progress of the wider world, and in our present nationalist drive there is a clear aim to get our people linked even more completely with general civilization, with mankind as a whole."**[110]

In making this a reality the people of Helsinki have truly played their part.

XI Helsinki – the Innovative City

Throughout the past two centuries Helsinki has appeared in foreign eyes to be above all a modern city[1] even if the townscape in the centre is full of architecture dating from the times of Engel and Saarinen. Some have also witnessed striking changes in the atmosphere of the city: there were more foreigners, more cultural events and more street cafes in 1995 than in 1986;[2] the creative professionalism in fields such as music and the Finnish film industry have reached European standards;[3] and the Helsinki of the 1970s with its empty streets after dusk had been transformed by the end of the 1990s into a city where "nightlife left nothing to be desired compared with the most lively of our continental metropolises."[4] It appears therefore that an essential part of Helsinki's spirit has been, and still is, a permanent drive for modernity, an ability to quickly reinvent itself while maintaining its historical environment.

According to Charles Landry, this capacity for adaptation has much to do with the creativity and innovativeness embedded in the city's traditions and the mentality of its people. In *Helsinki – The Innovative City. Historical Perspectives* we have, presenting examples, investigated innovation and creativity as they have been manifested in Finland's largest city during the past two hundred years. We have followed how Helsinki was transformed from a shipping town into a capital city, which became not only a centre of administration and higher education but also the hub of the nation's cultural life as well as a major industrial centre. At the same time we have paid attention to the ways in which Helsinki, as the capital, has influenced the development of Finland from a poor northern agricultural country into one of the major players in the world so far as information technology and telecommunications are concerned.

Helsinki looks with confidence to the future. (Photo, Lehtikuva)

[362]

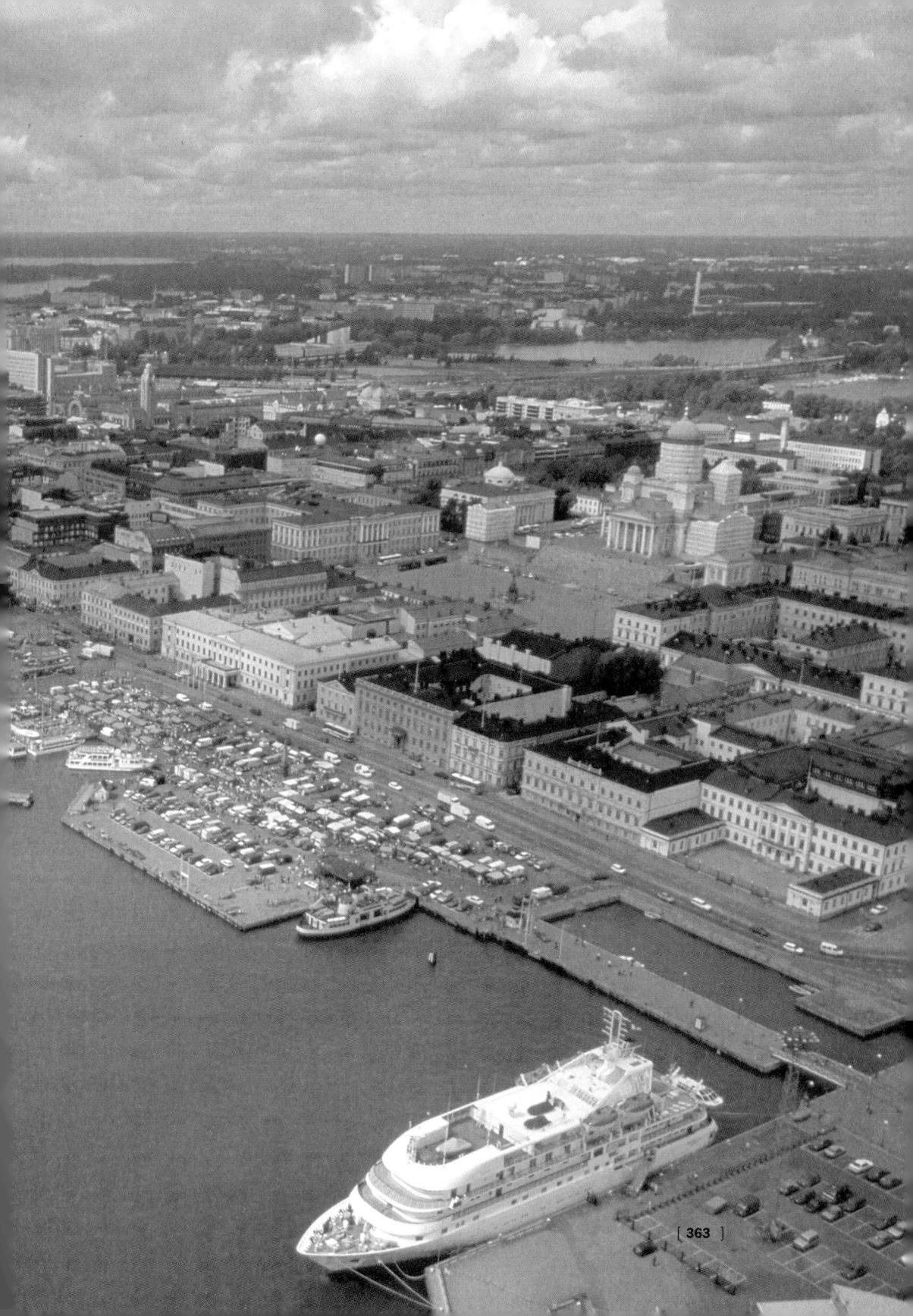

Modern studies of the innovative milieu cite, as major prerequisites for a creative environment, satisfactory institutions, buildings and support services, such as transport and communications, as well as various kinds of social networks. The former, which Landry[5] has termed the "hard infrastructure", provides the physical environment and continuity for the development of innovations while the "soft infrastructure", social networks in the form of informal groups, clubs and common interest networks, provides the forums for creative ideas and their initial development, development which can also take place within collaborative arrangements such as public/private partnerships for harnessing resources. These factors are included in the term "social capital."[6] This concept covers not only the institutions, which underpin the society, but also "the glue that holds them together" and embraces the relationships and norms that shape the quality and quantity of social interaction in any particular society as well as the role that families and firms play along with gender, democracy and ethnicity. In the case of Helsinki certain special factors have also played a major developmental role: the city's geographical location, the emergence of Finnish nationalism and the impact of Russian rule in the period between 1809 and 1917.

Until the mid-19th century, due to its geographical location, Helsinki was for months each year isolated from the rest of Europe by ice[7] and its links with inland Finland were not easy either. However, in spite of this remote location many Finns had since the Middle Ages been students at European universities and Finland was strongly linked with cultural trends in the West.[8] Even so, foreign travel had never been commonplace, and it was not until the appearance in the Baltic of steamboats and icebreakers and the construction of the railways that the people of Helsinki became linked all the year round with the European continent and the rest of Finland. Only then was the development of a national press possible while the subsequent appearance of telegrams, the telephone and radio made the transmission of news from the whole world instantaneous while air travel eventually enabled Helsinki people to reach all the major cities of Europe within a few hours.

Naturally norms and values much influence the nature of the creative milieu as well as the choice of the innovations to be adopted. In Helsinki the strong emphasis on education, typical of Finns, was demonstrated by the establishment of innovative secondary schools including the pioneering girls'

and co-educational schools. These Helsinki schools also reflected the strong position of women in Finnish society, manifested in the granting of universal suffrage in 1906, earlier than in any other European country, while they also strengthened the reputation of schooling as one of the most important means of promoting upward social mobility. This development was facilitated by democratic traditions which, especially since independence, have also led to the further development of regional equality in terms of the physical infrastructure, education and health care. Furthermore, like many other European countries, Finland has, since the early 19th century, been increasingly influenced by nationalist sentiments. All these are factors which have helped to form the ethos of Helsinki's innovativeness and creativity. They have also had an impact on the speed with which any particular innovation has been launched and developed in Finland.

As discussed in the first two chapters the Russian Tsars also played a major role not only as the early developers of the city's appearance but also in providing a basis for the development of its intellectual and cultural life by giving strong support to the University which they had moved from Turku. The benevolence shown towards Finland and Helsinki by the first three Tsars may have been motivated by the wish of Russian autocrats to show a good face to Western Europe. However, the fact that the use of postage stamps and the development of incorporated joint-stock banks occurred first in Finland and only later in Russia, suggests that the people of Helsinki were possibly encouraged from time to time to carry out pilot studies on behalf of the rest of the empire, although a final confirmation of this must await further research. It is also clear that during Alexander II's reign creativity in Helsinki became so strongly rooted in the liberal atmosphere that, as discussed in Chapter Five, it could not be destroyed by the later Tsars' oppression policies but actually resulted in a major creative period for Finnish artists as well as stimulating other forms of creative civil opposition, such as the co-operative movement.

Due the reform of municipal administration in the 1860s under Alexander II, Helsinki also gained a more democratically elected City Council. As discussed in Chapter Three, this Council and the municipal boards included among their members not only leading national politicians but also many of the best professional experts in the country. This made Helsinki eminently

able to take advantage of technological innovations when endeavouring to develop the city to standards that were commonplace in such major European cities as Berlin, Paris and London – the reference group of most Helsinki decision-makers. It also appears that during the period of Russian oppression the municipal authorities were even prepared, if necessary, to step into the place of the state "in the support and advancement of the material, intellectual and social development" of the country, to quote Leo Ehrnrooth, President of the Association of Finnish Towns.

In order to develop the city's municipal services the civic authorities, certainly like their colleagues in the Nordic cities and probably also elsewhere in Europe, were willing to finance fact-finding tours and visits to municipal conferences and exhibitions abroad as discussed in Chapter Four. What distinguished Helsinki in this respect was the very systematic approach the city adopted to maximise the efficiency of this search for relevant know-how. Travels by city officials and elected representatives were based on a careful preliminary study of statistical data and other material before the most promising destinations were selected. During the trip they spent much time in personal observation and the making of thorough comparisons before finally submitting an extensive report on their travels. This meant that the authorities were not only able to adopt innovations quickly and intelligently when required, but that they could also be cautious and selective, especially in the case of technical solutions to their problems and challenges. They first carried out experiments, for example, in working class housing; and sometimes delayed action in order to ensure the best results – a trait desirable in a body responsible for using public funds. But they could act speedily. Helsinki got electric lighting only some six months later than Berlin and also quickly developed a dense telephone network. The city was usually a keen adopter of the latest innovations in the late 19th century. With the help of links forged by the municipal officials the city was also able to adapt such innovations to suit Finnish circumstances and the process was both firmly supervised and generously financed by the state while some projects were also financed with German loans and, occasionally, even from St Petersburg.

In the decades following the First World War fact-finding tours became a major institution with the city empowering scores of employees, even at the lower levels, to travel abroad in search of the latest developments, as

discussed in Chapter Six. Moreover Helsinki pioneered childcare facilities as well as consumer advisory services and as the venue for the annual national commercial exhibitions the city also became a showcase for the application of modern materials and the products of the emerging consumer society. Another major contribution lay in the efforts of the city's electrical industries to encourage the use of electric power round the country. But perhaps the most far-reaching achievement of all in Helsinki was the development of a scientific infrastructure in the form of three major research institutes, which started to produce their own native innovations for the benefit and development of a newly independent Finland. This did not, however, mean the severing of Helsinki's international links. The city played host to an increasing number of foreign guests, who, especially in the 1930s, came to visit exhibitions or to view the latest developments in town planning and architecture, while city officials were actively keeping in touch with foreign experts in order to secure the latest technological innovations for the forthcoming Olympic Games in Helsinki, originally planned for 1940, and eventually postponed until 1952. By the closing ceremonies of this event Helsinki had emerged, perhaps for the first time, from the shadow of Finland the country into the international limelight as a place of importance in its own right.

By then Finland was already beginning gradually to overcome the shortage of capital, which had always been a major obstacle to the development of its infrastructure. It was lack of capital, for example, which had delayed the establishment of steamship companies in Helsinki until the 1850s and the installing of gas lighting until the 1860s. Due to the meagre financial resources available for education Helsinki University and the Polytechnic Institute remained the sole major academic institutions in Finland as the 20th century began and it was only later that the country's finances allowed them to be joined by a further set of major scientific institutions related to the country's economic needs.

As Chapter Nine discusses, it was only after the Second World War that Finland's economy became finally strong enough to support a satisfactory infrastructure to develop and support innovative and creative culture all over the country. New universities were founded from the late 1950s onwards in a number of major towns and this was coupled with the establishment of a state funded research and development system and the provision of new

forms of higher education in various creative fields. As a background to these developments Chapter Nine presents a picture of the country's economic growth over the past hundred years, which has been very much based on technological advance and the resulting extraordinarily rapid improvement in labour productivity. The economy has changed from one based on the intensive use of capital, raw materials and energy to an information-intensive one and in the last decade of the 20th century the country was to become one of the leading producers and users of information and communication technologies in the world. The core of this change was Nokia, based in the Helsinki region, but the Finnish IT sector also now includes a network of hundreds of small and medium-sized companies as well as a rapidly growing operator and service sector. This development was based on the creating of a national system of innovation in order to increase "knowledge and know-how" reserves.

An essential part has been played by the long-term support given by the state to high-level research in the universities and the specialist research institutes while R & D investments in the business sector have also increased considerably since the early 1990s. In fact R & D expenditure almost doubled in real terms during the 1990s, a growth accounted for almost entirely by R & D investment in the electrical and electronics industries.

Helsinki became the major site of the high-tech revolution even though Nokia, like many other major Finnish industries, was originally located deep in the countryside and was only later moved to the capital. This was the result of a number of factors. As discussed in Chapter Ten, some were political, some accidental and some reflected Helsinki's long standing commitment to the electrical industry. But the process was also helped by the city's own actions in providing the essential infrastructure, for example in Pitäjänmäki and in Arabianranta. It was thus displaying the same business acumen that led it to establish the Seurahuone Hotel and Assembly Rooms in the 1830s, to donate the site for the Ateneum and to promote not only the national exhibitions regularly held in the city but also the Helsinki Festival, which, especially from the 1970s onwards, has become a major cultural venture of benefit to both the citizens and the tourist industry, attracting an ever growing body of international visitors.

Yet, while Helsinki was thus advancing its own interests it has also operated, in a manner befitting a capital city, to promote the whole country internationally. Not only did it successfully host the Olympic Games in 1952 and the Conference on Security and Co-operation in Europe in 1975, but was also the major venue of major international meetings during Finland's presidency of the European Union in 1999. As discussed in Chapter Nine, it adopted, in the late 1960s, the role of active promoter of Finland abroad by launching a major series of city exhibitions touring Europe and the US and presenting an overall picture of Finnish culture incorporating themes peculiar to the city itself. Thus Helsinki, although it has now lost, perhaps forever, its former dominant role as the sole academic centre and base for high-tech industries as a result of deliberate decentralization, has reinvented itself as the hub of an internationalised Finland and as the main exporter of Finnish culture. In music, for example, it has exported to the outside world leading singers, conductors and composers, most of them graduates of the Sibelius Academy in Helsinki. This cultural dominance, like the city's economic prosperity has become possible because of the ever increasing influx of talented people from all round the country whose children attend its comprehensive schools and specialist secondary schools, which feed the institutions of creative and scientific endeavour based in the city.

As the new millennium began Helsinki epitomised three concurrent trends in Finnish society, the drive for tomorrow's high technology, the emphasising of cultural services and the nurturing of creative talent on a wide basis. Yet, the fortunes of Helsinki will depend, in the end, as they always have done, on its citizens. Helsinki people have, on average, an even better education than Finnish people in general; they appear also to be more avid users of the municipal library services than people in the rest of the country. Compared with even a century ago the comprehensive, state funded education system gives each individual a real opportunity to develop their talents and to reach the top should their abilities warrant it. So the future of Helsinki may well depend on how well its people have internalised the attitudes and ways of working of earlier generations and are willing to emulate the traditions of the past two hundred years.

One tradition manifested itself in civic creativity, for example, at the founding of the Kaivopuisto Spa which showed people's ability to improvise: if there is no medicinal spring, let's carry in the mineral waters – in Hartwall bottles! Similarly, it was creative inspiration that launched the co-operative movement as a measure of civil resistance to russification and devised the concentric barrage zones and bonfires that spared Helsinki the effects of intensive bombardment in the 1940s; it produced the successful designs of Arabia and Marimekko; it lay behind the artistic triumphs of *Nuori Suomi* and the 20th century architects; it produced the internationally admired system of child-care and the major encouragement of women's talents. More recently it showed itself in the musicians' squat in Lepakkoluola; and the establishment of the Night of the Arts. Perhaps it revealed itself most of all in its reaction to the challenge of paying off the war reparations which justified the 1946 observation of the British industrialist who insisted that Finland's real natio- nal treasure was its people's unbelievable capacity to improvise. Bearing in mind the blossoming of design in the city amid the shortage of materials in the late 1940s and early 1950s one is tempted to suggest that this could be applied specifically to the people of Helsinki also.

Helsinki people have also had a capacity for self-help. When the new capital lacked suitable schools young academics established the Helsingfors Lyceum, a model for the whole country. When lack of capital hampered the liberal reforms in the mid-19th century, they planned major innovations in modern banking and planned in detail their application in Finland. Thus they aided both the development of agriculture and the industrialisation of the whole country. Workers established their own joint-stock housing companies. They operated alongside the city authorities so that in the 1930s foreign observers could find no slums in Helsinki. The self-help tradition among students produced the Domus Academica project and the student village in Otaniemi as well as a successful publishing house. Pioneering teachers, using respected foreign models, set about revolutionising their own schools. Frequently the agents of change were informal groups such as the *Lauantai- seura* and *Helsingin Suomalainen Klubi* or professional groups ranging from the medical associations to the musical group *Ears Open*; or more formal associations such as the *Finnish Literature Society* and the *Finnish Women´s Association* In fact during the most creative and innovative periods of the 19th and the 20th centuries Helsinki was not only blessed with a forward

looking and enterprising City Council but also with a major upsurge in the number of individuals and civil organisations, often involved in both national and international networks and dedicated to the development of new ideas, whether scientific, administrative, industrial or artistic.

To apply the terms used by Landry one can conclude that although Helsinki sometimes lacked a "hard infrastructure" for innovations the city has always been teeming with the elements of a "soft infrastructure." The renaissance of Finnish music from the 1960s onwards, on the other hand, has had much to do with the simultaneous development of both hard and soft infrastructures throughout the whole country as well as the presence of a few pioneering music enthusiasts. This fittingly demonstrates how when all these three elements of a successful innovative environment are present they can produce results of international significance in Helsinki.

What were then the motives and impulses that have encouraged the Helsinki people of the last two centuries to embark on so many creative enterprises? As discussed in Chapter Four, civic, professional and personal pride as well as personal enthusiasm were among the elements that drove the Helsinki city officials and elected representatives to set out on their travels. But many of them were driven also by the Finnish nationalist spirit, which had been nurtured in academic circles since the days of *Lauantaiseura* and the philosopher J. V. Snellman and was manifested not only in the publication of *Kalevala* and the systematic development of the Finnish language into a tool for cultured communication but also in the various ventures aimed at strengthening the native economic base and laying the foundations of an infrastructure for Finnish design. What was remarkable, as discussed in Chapter Five, was that so many of Helsinki University's professors were motivated by innovative public spirit to take part in ventures where their professional expertise was irrelevant. At any given time the number of these prime movers was so small that they could hardly have filled a modern bus. Another, smaller coach could have been filled with the equally nationalist Helsinki-based group of artists and architects, who in the 1890s raised Finnish arts to standards high enough to attract the keen interest of Diaghilev and the *Mir Iskusstva* group in St Petersburg and to produce the much acclaimed Finnish pavilion at the 1900 Paris World's Fair.

But numbers were irrelevant to their impact on Helsinki and Finnish life. The total population of the Helsinki region, a million people, or even of the whole country, five million, is small compared with that of other European countries. Yet, bearing in mind the immense contribution of a number of Helsinki families and pioneering firms with their innovative traditions and silent knowledge it is obvious that, for the nurturing of innovation and creativity, even a small group of people prepared to develop their own talent and encourage it in others is usually sufficient.

Helsinki has owed a great deal also to the fact that it has become an ever more cosmopolitan city. Foreigners, coming to Helsinki as businessmen, founded not only many firms such as Stockmann, Fazer and Sinebrychoff which are still leading elements in the city's commercial life but also made major contributions to civic life in general. Others married into Helsinki families, like Elisabeth Järnefelt from St Petersburg or came to take up posts like the Swedish artist, Count Louis Sparre and A. W. Finch, the Anglo-Belgian painter and ceramic artist. All three had a major impact on the city's artistic life. They helped also to create the environment that made foreign travel quite a natural phenomenon in civic, professional and cultured circles leading to important developments not only in administration but also in technology, medicine, industry and the arts. Supported by state and academic grants, such travel became an indispensable part of the infrastructure in such a geographically remote city.

It is interesting to note how many of the significant innovations in Helsinki during the past two hundred years were the work of people who in their youth had encountered the challenge of foreign cultures whether by studying, working or inter-railing. The expert on public health, Albert Palmberg, for example, was able in his mature years, to act on visions dating back to his immediate post-graduation travels. Since the late 1980s the Finnish authorities have rightly encouraged young people to acquire similar potentially inspiring experiences through foreign study and have invited foreigners to study in Finland, while an increasing number of foreigners have also chosen the Helsinki region as their place of work.

As the new millennium began Helsinki was thus a city with an internationally oriented younger generation familiar with foreigners and foreign life and well able to exploit the potential of the Internet as a tool for international communication. Even so, judging from the overwhelming popularity of specifically Finnish pop music, which often takes its lyrics from Finnish folklore, and the decidedly Finnish names they chose to give their own children, these young people still have their roots firmly fixed in the Finnish national culture. Jean Sibelius and the artists of *Nuori Suomi* as well as the successful 20th century designers all realised that combining nationalism and internationalism is not only possible but very fruitful. Castells and Himanen see strong national identity as paradoxically one of the major factors in explaining the international success of the Finnish modern IT society. The combination of Finnish nationalism and international influences produced, in the early decades of the 19th century, a great step forward for Helsinki and turned it by the beginning of the 20th century into a European city of standing. We have tried to show that there are still in the city all the same ingredients that brought the new and unexpected successes in the past. Given the city's educationally based and ever more extensive infrastructure for producing innovations as well as its wide cultural services of international standing, Helsinki can look forward confidently to the challenges of the 21st century.

Endnotes

Introduction

1 Beijar, Kristina, "Under the Swedish King" in *Life in Two Languages - the Finnish Experience* (Schildts, Espoo 1997), 12-15.
2 Åström, Sven-Erik, "Kaupunkiyhteiskunta murrosvaiheessa in *Helsingin kaupungin historia IV:2. Ajanjakso 1875-1918* HKH IV:2 (Helsinki 1956), 31, 34. In 1890 Swedish-speakers in Helsinki totalled 29,860 or 45.6% and Finnish-speakers 29,787 or 45.5% of the population. By 1910 the Finnish-speakers (80,792) formed a clear majority of some 60% of the total population while the Swedish-speakers (47,907) formed some 35% of the population.
3 According to Heikki Paunonen the old Helsinki slang (1890-1919) differs from slangs spoken in other major cities such as London and Stockholm, where a form of dominant language was peppered with some loan words. In Helsinki the slang originates from the need of bi-lingual children and youth gangs, which were based on localities and not on language, to communicate with each other and with the Russians. The bulk of the words dating from the turn of the 20th century reflects the influence of Swedish, while Finnish has influenced some 20% of the vocabulary. Interestingly the impact of the Russian language was small, only some hundred words or 5% came from that language. Similarly only a few words in the old slang can be traced to other languages and they reflect Helsinki's life as a seaport and the arrival of cinema and foreign films. (Paunonen, Heikki - Paunonen, Marjatta, *Tsennaaks Stadii, bonjaaks slangii. Stadin slangin suursanakirja* (WSOY, Helsinki 2000), 17, 28-32.
4 Ormala, Erkki, "Finnish Innovation Policy in the European Perspective" in *Transformation Towards a Learning Economy. The Challenge for the Finnish Innovation System.* Gerd Schienstock and Osmo Kuusi (eds.) (Sitra 213, Helsinki 1999)
5 Landry, Charles, *The Creative City. A Toolkit for Urban Innovators* (Earthscan Publications, London 2000), 87-90.
6 In his recent works Manuel Castells has also paid attention to the formation of networks. Castells, Manuel, *The Information Age. Economy, Society and Culture. Vol. I: The Rise of the Network Society* (Blackwell, Oxford 1996); Castells, Manuel, *The Information Age. Economy, Society and Culture. Vol II: The Power of Identity* (Blackwell, Oxford 1997); Castells, Manuel, *The Information Age. Economy, Society and Culture. Vol II: End of Millennium* (Blackwell, Oxford 1998).

I Helsinki – The Innovation of a King, a Queen and Two Emperors

1 A good overall history of Finland is available in Jutikkala, Eino & Pirinen, Kauko, *A History of Finland.* 5th rev.ed. (WSOY, Porvoo 1996). A useful introduction is also given in Klinge, Matti, *A Brief History of Finland.* 10th ed. (Otava, Helsinki 1994). Other useful works related to Finnish history in general are Mead, W.R, *Finland* (Erns Benn, London 1968) and Singleton, Fred, *A Short History of Finland* (Cambridge University Press, Cambridge 1989) while George G. Schoolfield provides an erudite and very entertaining coverage of Helsinki during the period of Russian rule in his *Helsinki of the Czars. Finland's Capital: 1808-1918.* (Camden House, South Carolina 1996) and Jussila, Osmo, Hentilä, Seppo & Nevakivi, Jukka: *From Grand Duchy to a Modern State. A Political History of Finland since 1809.* (Hurst,

London 1999) provides the most up-to-date coverage of Finnish political history from 1809 onwards.

2 Suolahti, Eino E., *Helsingfors 1550-1950*. (Söderström & Co, Helsingfors 1950), 132-138.

3 The 1639 order of Queen Christina was published by Henrik Forsius in 1755 in his academic dissertation *De Helsingforsia, celebri Nylandiae emporio, pars priori* at the Academy of Turku. (*Entisaikain Helsinki vol. II);* Suolahti (1950), 137, 263, and Harmo, Maunu, "Vantaanjoen suun Helsingin sinettivaakuna", in *Helsinki 1550-1640* (Narinkka 1994. Helsinki City Museum. Helsinki 1994), 28-30, 34.

4 A very detailed description of the 1808-09 War is published in *Narrative of the Conquest of Finland by the Russians in the Years 1808-09*. This book, published in London in 1854, was based on a manuscript by "A Russian Officer of Rank". Its editor William Monteith was Lt.-General in the Indian Army.

5 See e.g. the proclamation issued by Count Bouxhoeven to the inhabitants of Finland on 18 February 1808 appended in Monteith (1854), 225-227. For the declaration by Alexander I on 17 June 1808, see Kirby, D.G. (Ed.), *Finland and Russia 1808-1920. From Autonomy to Independence. A Selection of Documents* (Macmillan, London and Basingstoke 1975), 12-14. See also Kirby (1975), 1, 11.

6 See e.g. Monteith (1854), vii and 69-70 on the plans of King Gustavus Adolphus IV to invade Denmark in February 1808 while Russian troops were in Finland. For the occupation of Helsinki by the Russians and the infamous capitulation of Sveaborg (nowadays Suomenlinna) the island fortress at the entrance to Helsinki habour in early May 1808 as well as its impact on the war, see Monteith (1854), 40-61.

7 For the first charter of Alexander I and his speech at the conclusion of the Diet of Porvoo, see Kirby (1975), 14-16. The same assurances were included in Para VI of the peace treaty between Sweden and Russia, 18 September 1809. For the full text of the treaty, see Monteith (1854), 231-241. Kirby also discusses the later significance of the Porvoo Diet and the different interpretations placed by the Finns and the Russians during the Russification period from 1898 onwards on the Tsar's statement concerning the elevation of Finland "amongst the rank of nations", Kirby (1975), 1-3.

8 Lieven, Dominic, *Empire. The Russian Empire and Its Rivals* (John Murray Ltd. London, 2000), 214.

9 Suolahti (1950), 148; Hornborg, Eirik, *Helsingin kaupungin historia II osa, ajanjakso 1721-1809* (Helsinki 1950), 616 suggests that the area destroyed by fire was one quarter of the town.

10 Hornborg, Helsingin kaupungin historia II (1950), 614.

11 Lindberg, Carolus & Rein, Gabriel, "Asemakaavoittelu ja rakennustoiminta" in *Helsingin kaupungin historia III osa, 1. vol. , ajanjakso 1809-1875* HKH III:1 (Helsinki 1950), 14, 23.

12 Hornborg, Helsingin kaupungin historia II (1950), 414-417.

13 Clarke quoted in Hawkins, Hildi & Lehtonen, Soila (eds.), *Helsinki: a LiteraryCompanion,* (Finnish Literary Society, Helsinki 2000), 17.

14 Hornborg, Helsingin kaupungin historia II (1950), 520.

15 Jutikkala, Eino, "The Distribution of Wealth in Finland" in *Historiantutkijan sana. Maisterista akateemikoksi. Historiallisia tutkimuksia 105*. (Suomen Historialllinen Seura. Helsinki 1977) Jutikkala (1977), 137-139; Schoolfield (1996), XVI; Hornborg, Helsingin kaupungin historia II (1950), 428-430.

16 Hornborg, Helsingin kaupungin historia II (1950), 216-226

17 Mäkeläinen, Eva-Christina, *Säätyläisten seuraelämä ja tapakulttuuri 1700-luvun jälkipuoliskolla Turussa, Viaporissa ja Savon kartanoalueella - The Social Life and Customs of the gentry in late XVIII Century Turku, Sveaborg and the Savo Estates Area (with English summary)* (Helsinki 1972), 266-268; Suolahti (1950), 129-131,133.

18 Jutikkala (1977), 137.

19 The inventory of the shopkeeper Matts Enning in 1795 published in *Narinkka 1981*. Hornborg, Helsingin kaupungin historia II (1950), 418.

20 Suolahti (1950), 133.

21 Wickberg, Nils Erik, "Yksityistaloja Helsingin Kruunuhaassa empire-ajalla" in *Entisaikain Helsinki. Helsingin Historiayhdistyksen vuosikirja I*. (Helsinki 1936), 15. The originator of the idea may have been the governor of Häme-Uusimaa province, Gustaf Fredrik Stjernvall, who returned to this matter frequently over the following months. Lindberg & Rein, Helsingin kaupungin historia III:1 (1950), 13, 18.

22 Kovero, Martti, "Helsinki liikennekeskuksena" in *Helsingin kaupungin historia III osa, 1. vol. , ajanjakso 1809-1875* HKH III:1 (Helsinki 1950), 276. Cf. Hornborg, Helsingin kaupungin historia II (1950), 473 stating that in the fortress there were 4,606 people.

23 Pulma, Panu, "Rauhoituspolitiikan kausi (1809-1815)" in *Suomen historian pikkujättiläinen*. (ed. Seppo Zetterberg). (WSOY, Porvoo 1997), 388: the Russian military leadership mooted the creating of a defensive triangle embracing

of Sveaborg/Viapori/Suomenlinna with Tallinn and Kronstadt to protect St Petersburg.

24 In 1805 the population of Turku was 11,300 being three times that of Helsinki without its garrison. Of all 22 Finnish towns in 1800 the inhabitants of Turku owned 40% of all property valued between 1,000 and 4,999 riksdalar banco, 39% with value between 5,000 and 19,999 r.b. and 29% over 20,000 r.b. In Helsinki 23% of real estate owners were in a state of bankruptcy (c.f.10% in Turku). (Jutikkala (1977),137-143). Sederholm died in 1805 leaving a property worth 62,000 riksdalar in addition to which he had made loans totalling 36,000 riksdalar including 19,000 riksdalar to the French state (Hornborg HKH II, 520).

25 Clarke quoted in *Helsinki: a literary companion* (2000), 17.

26 Hamilton, George Heard, *The Art and Architecture of Russia.* Pelican History of Art. (Yale University Press, New Haven and London 1983), 315-316 passim; Ometev, Boris & Stuart, John, *St Petersburg. Portrait of an Imperial City* (Cassell, London 1990), 10.

27 Sinisalo, Jarkko, "Pietari ja Suomen rakennustaide 1800-luvun alkupuoliskolla" in *Suomi & Pietari.* (ed. Maija Lapola). (Historiallinen kirjasto XXIII. Historian Ystäväin Liitto and WSOY, Juva 1995), 207.

28 The English title of the 1809-12 collection of elevations is translated from a Finnish translation of its original Russian title page. (See also Hamilton (1983), 315, 439 and footnote 5) The collection is known to have been available in both Turku and in Lappeenranta. The 1809-12 collection of three volumes, which had belonged to the Turku based architect P.J. Gylich, a contemporary of Engel, was in 1940s owned by Dr Svante Dahlström in Turku while vol. II was also found in the Lappeenranta city archives in the late 1920s. Viiste, Juhani O.V., *Viihtyisä vanha Wiipuri.* (Werner Söderström Osakeyhtiö, Porvoo 1943), 131.

29 Similar buildings existed also in Viipuri, which had come under Russian rule as early as1721. During an intensive rebuilding there between the years 1780 and 1800 the Viipuri people had used a volume of elevations for wooden and stone buildings authorised by Catherine the Great and her governors. This collection contained elevations for buildings for well-to-do civil servants and prosperous merchants as well as for peasants and artisans. It appears that the collection was also used in the Russian Baltic provinces of Estonia and Latvia. Viiste (1943), 66-67, 130.

30 Lindberg & Rein, Helsingin kaupungin historia III:1 (1950),14, 22, 28; Viiste (1943), 130.

31 Apart from C.L.Engel architects involved in the reconstruction of Helsinki included A.W.Arppe, A.F.Granstedt, the son of Pehr Granstedt, and J.E.Wiik, who all were also employed by the Office of Public Works. All of them also had an opportunity to work for private customers. Lindberg & Rein, Helsingin kaupungin historia III:1 (1950), 84-86, 146-148.

32 St Petersburg's central squares covered more than 100 acres. Šhwidkovsky, Dmitry, The Architecture of the Russian State: between East and West, 1600-1760, in *The Triumph of the Baroque. Architecture in Europe 1600-1750* ed. by Henry A. Millon (Palazzo Grassi, Venice & The Montreal Museum of Fine Arts, R.C.S. Libri S.p.A. 1999), 156; Ruble, Blair A., *Leningrad. Shaping a Soviet City* (University of California Press, Berkeley, Los Angeles, 1990), 30-34. For renovation of St Petersburg historic centre in the 1970s see Ruble (1990), 166.

33 Lehtovuori, Panu, Tapahtuma - toinen paikka? in *Urbs, kirja Helsingin kaupunkikulttuurista.* (Helsingin kaupungin tietokeskus & Edita. Helsinki 2000), 107.

34 St Petersburg's population exploded from 95,000 in 1750 to 420,000 by 1825. Ruble (1990), 27,30.

35 Atkinson, J. Beavington, *An Art Tour to Northern Capitals of Europe* (Macmillan & Co, London 1873), 144; Gallenga, Antonio, *A Summer Tour in Russia* (Chapman and Hall, London 1882), 111.

36 Pöykkö, Kalevi, *Carl Ludvig Engel 1778-1840 Pääkaupungin arkkitehti.* (Helsingin kaupunginmuseo. Memoria 6, Helsinki 1990), 17.

37 Hamilton (1983), 304-313; Pöykkö (1990), 35.

38 Engel's letter to Carl Herrlich on 15.8.1816, quoted in Pöykkö (1990), 24; Nikula, Riitta (1993 a), *Architecture and Landscape. The Building in Finland.* (Otava, Helsinki 1993), 69.

39 By 2001 Helsinki provided the set for at least a dozen other foreign films, including *Reds* (1981), *Gorky Park* (1983), *The Jigsaw Man* (1983) and *The Jackal* (1997). (Ilta-Sanomat, 30.6.2001, A10-11)

40 Topelius recalled how many burghers of Helsinki strongly resisted the changes and kept on fighting for years to defend the traditional location of their housing plots, gardens, magazines and storage rooms. Yet towards the end of the 19th century many of the premises had proved too small. According to Topelius only he barracks, hospitals and market places had been allocated adequate sites from the very beginning . Topelius, Z., *Muistiinpanoja vanhasta Helsingistä* (with introduction and comments by Torsten Steinby) (Helsinki-Seura, Jyväskylä 1986), 24, 28-30.

41 Oldenbourg, Zoé, *Catherine the Great.* (Corgi

Books, 1972), 339.

42 Lindberg & Rein, Helsingin kaupungin historia III:1 (1950), 51-52.

43 Waris, Heikki, "Helsinkiläisyhteiskunta" in *Helsingin kaupungin historia III osa, 2. vol. , ajanjakso 1809-1875* HKH III:2 (Helsinki 1951), 118.

44 Lindberg & Rein, Helsingin kaupungin historia III:1 (1950), 22, 53-54.

45 Lindberg & Rein, Helsingin kaupungin historia III:1 (1950), 62.

46 Lindberg & Rein, Helsingin kaupungin historia III:1 (1950), 26, 67.

47 In Britain the Prince Regent, later George IV, built the Royal Pavilion in Brighton and was instrumental in developing the Regent's Park in London. In France Louis Philippe completed a number of building projects in Paris (see e.g. Mathieu, Caroline & Bellenger, Sylvain, *Paris 1837* (Alain de Gourcuff, Paris 1999) while in Prussia Friedrich Wilhelm designed architectural projects for Potsdam and Berlin.

48 See Engel's letters Eduard Jacobi 10.11.1831, 11.12.1833 and 3.9.1839, published in *Helsinki: a literary companion* (2000), 27-32; Lindberg & Rein, Helsingin kaupungin historia III:1 (1950) , 69, 82.

49 Information on the the years of construction based on Pöykkö (1990): the Governor General's house, later the Town Hall (1817-1818), the Guard House (1818-19), the Senate building (1818-22, expanded in 1828), the Naval Barracks in Katajanokka (1820-25), the Russian Orphan School, later the Russian Military Hospital (1820-23), the house for the Russian military commander (1821-25), the Barracks of the Finnish Guard in Guard Square (1822), the Greek Orthodox Church (1824-26), the ÔOld' Lutheran Church (1826), the Esplanade theatre (1826-27), the University (1828-32), the Seurahuone assembly rooms and hotel, now the present City Hall (1829-32), the University Clinical Institute (1833), the Observatory (1834), the University Library (1836-44), the Lapinlahti Mental Asylum (1837-) and finally the Lutheran St. Nicholas Church, now the Cathedral of Helsinki (1830-1852).

50 Mustonen, Pertti, *Ravintolaelämää. Kulttuurikuvia, nostalgiaa, kulinarismia* (Kustannusosakeyhtiö Tammi, Helsinki 1990), 9-11.

51 Pöykkö (1990), 63.

52 Richards, J.M., *800 years of Finnish architecture*. (David & Charles. Newton Abbot, London, Vancouver 1978),70.

53 Klinge, Matti, "Yliopisto" in *Suomen kulttuurihistoria 2, Autonomian aika*. (WSOY, Helsinki 1983),144-145.

54 Richards (1978), 9.

55 Gardberg, C.J., "Empire", in *Art in Finland from the Middle Ages to the Present Day* (Schildts Ab, Helsinki 2000), 146; Helsinki's old main street, Suurkatu had been 10 metres wide. (Hornborg, Helsingin kaupungin historia II (1950) , 40).

56 Wickberg (1936), 25-27.

57 When the Swede Albert Lindhagen began to plan the outlying parts of Stockholm in 1866, he suggested that the illustrated volume of modern plans he was working on should include "many of the new plans approved in recent decades in the grand duchy of Finland." Eight of 13 booklets, which formed the collection (published in 1875), showed Finnish plans. (Gardberg (2000), 147).

58 Pöykkö (1990), 134.

59 Engel's letters to Carl Herrlich 3.7.1824 and 19.9.1825, quoted in Pöykkö (1990), 71.

60 Topelius recalled that many people in Helsinki considered Engel a German opportunist, who was a skilful architect but full of dangerous, unrealistic dreams. (Topelius (1986), 18; Lönnqvist, Bo & Rönkkö, Marja-Liisa, *Helsinki. Kuninkaankartanosta Suomen suurkaupungiksi.* (Tammi, Helsinki 1988), 99.

61 Lindberg & Rein, Helsingin kaupungin historia III:1 (1950), 83.

62 Sinisalo (1995), 212-213.

63 See Schoolfield (1996), 25-27.

64 Rein, Gabriel, "Helsinki maan ja läänin pääkaupunkina" in *Helsingin kaupungin historia III osa, 1. vol. , ajanjakso 1809-1875* HKH III:1 (Helsinki 1950), 164.

65 Klinge, Matti, *Ylioppilaskunnan historia, I osa 1828-1852* (WSOY 1967:1), 5.

66 Waris HKH Helsingin kaupungin historia III:2 (1951), 35.

67 Mustonen (1990), 9-13.

68 Jörgensen, Arne, *Universitetsbiblioteket I Helsingfors 1827-1848.* (Helsingfors universitetsbiblioteks skrifter XIV. Originally published in 1930. New imprint. Helsinki 1980), 144-146.

69 Tommila, Päiviö, "Tiedon leviäminen" in *Suomen kulttuurihistoria 2.* (WSOY Porvoo, 1980), 268.

70 In 1813 the value of imported books was 330 old marks and of playing cards 320 old marks while the total of imports were worth 1,162,400 old marks. The value of books imports in 1856 were 659,100 old marks and total imports 7,930,300 old marks. Kovero's figures are based on notoriously difficult sets of customs statistics. Nevertheless, they can be used to indicate the increase in the value of book imports and their relationship to the total imports. Kovero, Helsingin kaupungin historia III:1 (1950), 388, 394, 396-397 and 418.

71 Kovero, Helsingin kaupungin historia III:1 (1950), 548-557.

72 News from France of the fall of Napoleon in
1815 reached Finland within 45 days, of the
July revolution in 1830 within 24 days and of
the February revolution of 1848 within 18
days. Paasivirta, Juhani, "Suomi jäsentyy
kansakuntana Eurooppaan. Kulttuurisuhteet
1800- ja 1900-luvuilla" in *Suomi Euroopassa.
Talous- ja kulttuurisuhteiden historiaa* (Ed.
Mauno Jokipii) (Atena, Jyväskylä 1991), 173).

73 Castrén, Gunnar, "Helsinki
kulttuurikeskuksena" in *Helsingin kaupungin
historia III osa, 2. vol. , ajanjakso 1809-1875*
HKH III:2 (Helsinki 1951), 563-568.

74 Ruuth, Martti, "Koulut" in *Helsingin kaupungin
historia III osa, 2. vol. , ajanjakso 1809-1875*
HKH III:2 (Helsinki 1951), 46-463; Klinge,
Matti (1997b), *Keisarin Suomi.* (Schildts,
Espoo 1997), 139.

75 Ruuth, Helsingin kaupungin historia III:2
(1951), 451-455; Halila, Aimo,
"Oppikoululaitos" in *Suomen kulttuurihistoria II,*
eds. Päiviö Tommila, Aimo Reitala and Veikko
Kallio (Porvoo 1980), 178; Iisalo, Taimo, *The
Science of Education in Finland 1828-1918.*
(Societas Scientiarum Fennica 18. Helsinki
1979), 19.

76 Iisalo (1979), 19; Ruuth, Helsingin kaupungin
historia III:2 (1951), 453. The Helsingfors
Lyceum followed the lines of the most
advanced pedagogical trends in Western
Europe. In the recruiting of staff and the writing
of textbooks it drew on the services of young
university graduates many of whom had also
gained pedagogical experience as private tutors
with families of rank in the Finnish countryside.

77 Kovero, Helsingin kaupungin historia III:1
(1950), 470; Pöykkö (1990), 134.

78 Waris, Helsingin kaupungin historia III:2
(1951), 28; Mustonen, Pertti, *Keskellä
kaupunkia.* (Kirjayhtymä, Helsinki 1987), 58-
59, 66. On the other hand the art of street
cobbling was a much more difficult skill to
transfer. Helsinki had received its first cobble
layers as early as in 1818 on temporary loan
from Turku and was later able to provide a
similar loan of its own experts to Porvoo,
Loviisa and Viipuri. Yet in the 1850s Helsinki's
own skilled workforce proved insufficient when
Helsinki launched its major street paving
project, and the city authorities invited street
cobblers from Sweden, St Petersburg and
Berlin, but to no avail due to a shortage of
these specialists throughout Europe at that
time. The problem was not solved until the
1860s when highly skilled Russian gangs from
St Petersburg came to Helsinki's rescue.
(Waris, Helsingin kaupungin historia III:2
(1951), 106).

79 See Jussila, Osmo, Hentilä, Seppo & Nevakivi,
Jukka: *From Grand Duchy to a Modern State. A*

Political History of Finland since 1809. (Hurst
& Company, London 1999) for a discussion of
the foundation of Finland as an autonomous
grand duchy.

80 Lieven (2000), 252-253; From 1730s onwards
these principles were also applied by the
Russians in "Old Finland", i.e. the parts of
Finland that Russia had conquered in 1721and
1743. See e.g. Ranta, Raimo, "Venäläinen
kauppiaskunta ja sen kauppa Vanhassa
Suomessa," in *Venäläiset Suomessa 1809-
1917.* (Historiallinen Arkisto 83. Suomen
Historiallinen Seura, Helsinki 1985), 38, 45-
46.

81 Jussila, Osmo, "Foreword," in *Venäläiset
Suomessa 1809-1917.* (Historiallinen Arkisto
83. Suomen Historiallinen Seura. Helsinki
1985), 7.

82 Kovero, Helsingin kaupungin historia III:1
(1950), 452.

83 Waris, Helsingin kaupungin historia III:2
(1951), 28-29. In his study of the old Helsinki
slang of the period 1890-1919, Heikki
Paunonen suggests that even after some eighty
years of Russian rule the impact of the
Russian language was small with only some
hundred words or 5% coming from that
language, a sign of the separation in Helsinki
of the Russian and Finnish working class
communities. Paunonen, Heikki & Paunonen,
Marjatta, *Tsennaaks Stadii, bonjaaks slangii.
Stadin slangin suursanakirja* (WSOY, Helsinki
2000), 17, 28-32.

84 Wiherheimo, Onni - Rein, Gabriel,
"Kunnalliselämä" in *Helsingin kaupungin
historia III:2. Ajanjakso 1809-1875* HKH III:2
(1951), 290.

85 Suolahti (1950), 169.

86 Hornborg, Eirik, "Sotaväki ja sotatapahtumat"
in *Helsingin kaupungin historia III osa, 1. vol. ,
ajanjakso 1809-1875* HKH III:1 (Helsinki
1950), 228-229.

87 Tommila, Päiviö, *Helsinki kylpyläkaupunkina
1830 - 50-luvuilla.* (Helsinki-Seura, Huhmari
1982), 104. Interestingly it was the popularity
of Biedermeier style furniture, which spread the
St Petersburg visual style throughout Finland,
especially after legislation of 1824, which
enabled country carpenters to produce sets of
such furniture for the local notables and
individual chairs for the agricultural and
emerging industrial population. Not surprisingly,
therefore, it has been claimed that the
Biedermeier chair spread more effectively in
Finland than any other piece of furniture not
only geographically but also throughout all
social groups. (Vuoristo, Osmo, "Kansantaide"
in *Ars – Suomen taide 5* (Weilin & Göös, Otava,
Keuruu 1990), 30).

88 Wiherheimo & Rein Helsingin kaupungin

historia III:2 (1951), 289; Nokela (1992), 219.

[89] As early as in 1817 the Councillor of State, Edelhelm, purchased a manor house for summer use near Helsinki as did the Privy Councillor Walleen in 1829 and the Borgströms in 1837. Many government officials, professors and businessmen followed this trend while others rented large farm houses for summer residence.
(Castrén, Helsingin kaupungin historia III:2 (1951), 588-589). Cf. By the late 1820s it was customary in St Petersburg for the Court, the principal families, the merchants and even the better sort of tradesmen to leave the city for their estates, or for the villages and islands around the capital. (Bater, James H., *St Petersburg. Industrialization and Change.* Studies in Urban History 4, General editor H.J.Dyos. (Edward Arnold, London 1976), 69.

[90] Tommila (1982), 8.

[91] Ibid. 9-13.

[92] Ibid. 12-13.

[93] In Henrik Borgström's life (1799- 1883) the decisive influence was his stay in Liverpool in 1818-1821. There he worked in the firm Joseph Leigh & Co thoroughly learning English business practices. Equally significantly he gained a good general education as well as developing his lifelong love of music. In Helsinki Helsinki Borgström established an agency for Leigh & Co of Liverpool; he was also the agent for Lloyds of London and the Hamburger Assurandörer as well as for other prominent firms based in London, Hull, Amsterdam, Bordeaux, Cadiz and Mediterranean ports. In 1834 he was granted a licence for tobacco manufacturing, which became the basis of Borgström's great wealth.
(Hoving, Victor, *Henrik Borgström, en storborgare i det gamla Helsingfors.* (Söderström & Co, Helsinki 1949), 109-112).

[94] Kovero, Helsingin kaupungin historia III:1 (1950), 315.

[95] Tommila (1987), 24.

[96] Tommila (1982), 39; Hoving (1949), 113.

[97] Tommila (1982), 43-44.

[98] Faddei Bulgarin, the Polish-born writer and former soldier in the Russian army described the Helsinki of 1838 in a travelogue published in St Petersburg the next year. For an extract in English see *Helsinki: a literary companion* (2000), 44-52.

[99] Quoted in *Helsinki: a literary companion* (2000), 53-54.

[100] Tommila (1982), 107-108.

[101] It was rumoured that the Princess had a young friend stationed in the Russian garrison across the harbour in the Suomenlinna island fortress. Others were convinced that he was one of the prisoners held there.

[102] Castrén, Helsingin kaupungin historia III:2 (1951), 584-585.

[103] Eyre, Karen & Galinou, Mireille, *Picnics* (The Museum of London, 1988), 6-8.

[104] Tommila (1982), 89.

[105] Ibid. 81, 112-113.

[106] Ibid. 143. See also Maxwell, John S., *The Czar, his Court and People; including a tour in Norway and Sweden* (New York, 1848).

[107] Maxwell (1848), 85.

[108] In 1811 Helsinki harbour was used by a mere 118 passengers. Kovero, Helsingin kaupungin historia III:1 (1950), 320.

[109] Tommila (1982), 96. The pioneer in publishing guidebooks was John Murray, who started his series in 1820. The German Karl Baedeker used this model from 1829 onwards to develop his celebrated series of travel guides.

[110] Ibid. 32-33.

[111] Ibid. 143; Thomas Cook in July 1841organised the first publicly advertised excursion by train in England from Leicester to Loughborough.

[112] Hoving (1949), 113.

[113] Tommila (1982), 144.

II "Handsome Appearance with Nothing Inside"?

[1] Topelius (1986), 30.

[2] Lindberg & Rein, Helsingin kaupungin historia III:1 (1950), 116-117.

[3] Kovero, Martti (1950 c), "Teollisuus" in *Helsingin kaupungin historia III:1. Ajanjakso 1809-1875* HKH III:1 (Helsinki 1950), 472.

[4] One year, 1805, saw the establishment of new guilds of gold and silversmiths, wagon makers, hatters, brass-casters, copper-smiths and turners. Waris, Helsingin kaupungin historia III:2 (1951), 60-61.

[5] Möller, Sylvi, "Ammattikuntien kukoistuskaudelta Helsingissä" in *Entisaikain Helsinki* (Helsingin Historiayhdistyksen vuosikirja I, Helsinki 1936), Appendix, 95-96.

[6] Castrén, Helsingin kaupungin historia III:2 (1951), 578-579. Jacob Grot arrived in Helsinki in 1840 and from 1841 onwards was the first professor of Russian literature and history at Helsinki University. He had close contacts with a number of Finnish intellectuals, promoted cultural links between Russia and Finland and translated Runeberg into Russian.

7 Wiherheimo & Rein, Helsingin kaupungin historia III:2 (1951), 298.

8 Tommila (1982), 69.

9 Ibid. 100.

10 Waris, Helsingin kaupungin historia III:2 (1951), 69-70.

11 Donner, Jörn, *Fazer 100*. (Oy Karl Fazer Ab, Keuruu 1991), 23-24.

12 Blackbourn, David, *The Fontana History of Germany 1780-1918: The Long Nineteenth Century* (Fontana Press, London 1997), 115.

13 Möller (1936), 54-55. In his article "The Finns in St Petersburg" Max Engman suggests that over half of all migrants from Finnish towns were journeymen and craftsmen specialising in metal work, in which a long period of "on the job training" was required. (Engman, Max (1992a), "The Finns in St Petersburg" in *Ethnic Identity in Urban Europe. Comparative Studies on Governmets and Non-dominant Ethnic Groups in Europe, 1850-1940, Vol VIII*, ed. by Max Engman in collaboration with Francis W. Carter, A.C. Hepburn and Colin Pooley (European Science Foundation, New York University Press, Dartmouth 1992), 101-103.

14 In 1869 there were 46,000 Germans and 11,100 Poles in St.Petersburg. Engman (1992b), 78-79.

15 The Holmström – Pihl family included August Holmström (head jeweller at Fabergé 1857-1903), his son Albert whose jewellery workshop in St Petersburg was a supplier to Fabergé, his son-in-law Knut Oskar Pihl who was the head of the Fabergé workshops in Moscow, as well as his niece Alma Pihl. Alma Pihl's sketch books are now the property of Wartski, the famous London jewellers. – Fabergé operated by having exclusive rights over all the products of individual workshops located on different floors of the same building. Of the firm's three head work-masters two were Finns: Erik Kollin (head work master 1870-1886), whose workshop produced the first Imperial Easter Egg in 1885; and Henrik Wigström (head work-master 1903-18) who supervised the production of 20 out of a total of 50 Imperial Easter Eggs and whose pattern book from 1911-15 included 1,000 different objects of art and luxurious utility items. (Tillander-Godenhielm, Ulla, "Kultaseppiä Pietarissa" in Klinge, Matti, *Keisarin Suomi* (Schildts, Espoo 1997), 191 and Tillander-Godenhielm, Ulla (1998a), "Fabergé – korujen mestari" in *Rakkaat vanhat tavarat* (ed. Leena Nokela) (Otava, Helsinki 1998), 215-217). - For further information about the Finnish craftsmen at the House of Fabergé, see e.g. von Habsburg-Lothringen, G. & von Solodkoff, A., *Fabergé. Court Jeweler to the Tsars* (Rizzoli, New York 1979), 46-52 and 153-154. It lists a total of 28 work-masters, of whom 22 were Finnish or members of families of Finnish origin (see pages 153-154). Alma Pihl's role, however, appears to have been unknown to the authors of this book.

16 Kruskopf, Erik, *Finlands konstindustri. Den finländska konstflitens utvecklingshistoria* (WSOY, Porvoo 1989), 173; Tillander-Godenhielm, Ulla (1998b), "Suomen korutaide" in *Rakkaat vanhat tavarat* (ed. Leena Nokela) (Otava. Helsinki 1998), 207-208

17 Blackbourn (1997), 113-115, 121-126.

18 Waris, Helsingin kaupungin historia III:2 (1951), 32-33.

19 Kidd, Alan, *Manchester*. 2nd edition. (Keele University Press, Keele. England. 1996), 162.

20 Castrén, Matti J., "Helsingin koti-ja ulkomaankauppiaat vv. 1809-1853" in *Kauppiaiden ja merenkulkijain Helsinki*. (Entisaikain Helsinki V. Helsinki-Seura, Helsinki 1954), 230-231.

21 Between 1810 and 1850 industrial enterprises increased from the 12 operating in 1810 to 59 in 1850 while their workforce increased from 118 to 646. (Kovero, Helsingin kaupungin historia III:1 (1950), 473, see the appendix in the same volume on industrial plants .)

22 In Germany almost two-thirds of those engaged in manufacturing still worked in the mid-1870s for firms employing five people or less. (Blackbourn, (1997), 187).

23 Kovero, Helsingin kaupungin historia III:1 (1950), 473, see the appendix on industrial plants.

24 Ibid. 514 and the appendix on industrial plants.

25 Ibid. 314; Schoolfield (1996) 34-35 .

26 Tommila (1982), 17, 27; Schoolfield (1996), 35.

27 Kovero, Helsingin kaupungin historia III:1 (1950), 307, 544, 546.

28 Jutikkala (1977), 137-138.

29 Castrén (1954), 198-204; Hornborg, Helsingin kaupungin historia II (1950), 416-417, 432-435.

30 Lindberg & Rein, Helsingin kaupungin historia III:1 (1950), 28.

31 Castrén (1954), 206.

32 Castrén (1954), 228; Ranta (1985), 30.

33 By 1860 there were some 400 steamboats on Russian rivers. However, of all the vessels bringing goods to Russian ports during the second half of the 19th century, less than 20% were owned by Russians and by 1900 their share was reduced to little more than 10%. (Dukes, Paul, *A History of Russia. Medieval, Modern, Contemporary*. 2nd Edition (Macmillan, London 1990), 146, 174)

34 Castrén (1954), 209, Kovero, Helsingin

kaupungin historia III:1 (1950), 304-305.

35 Castrén (1954), 206, 253, 256.

36 Hoving (1949), 65-67, 73-74; Castrén (1954), 256; Kovero, Helsingin kaupungin historia III:1 (1950), 551.

37 Hoving (1949), 74

38 Tommila (1982),19,26.

39 Tommila (1982),103-109. The prospective landlords covered all social classes in Helsinki including not only Alderman Nordin and the Master Baker Silverberg, who owned a dozen houses, but also such luminaries of Helsinki society as Professor af Hällström and Councillors of State Weissenberg, Synnerberg and Tawaststjerna.

40 Between 1826 and 1855 a total of 311 plots for private houses were bought in Helsinki. Of those 203 or over 2/3 were acquired in the 1830s. See Waris, Helsingin kaupungin historia III:2 (1951), 165-166.

41 From 1841 onwards the publication in the Helsinki papers of some 60-70 "To Let" advertisements a day was not uncommon in early spring. (Tommila (1982), 103-110)

42 Engman, Max (1992b), Kaksoiskotka ja Leijona. Nikolai Valapaton muisto ja muita kirjoituksia. (Kleio ja nykypäivä. VAPK-Kustannus, Helsinki 1992), 84.

43 Klinge (1997b), 19, 28, 76; Klinge in Ars Universitaria 1640-1990. Portraits from the Collections of the University of Helsinki. Biographical notes by Prof. Matti Klinge. (Helsinki 1990), 77; see also Ramel, Stig, Gustaf Mauritz Armfelt 1757-1814. Dödsdöm kungagunstling I Sverige. Årad statsgrundare I Finland (Atlantis, Stockholm 1997), first chapter.

44 Jussila et al. (1999), 21; Jussila, Osmo, "Konservatiivinen imperiumi" in Venäjän historia ed. by Heikki Kirkinen (Otava, Helsinki 2000), 208.

45 Lieven (2000), 220,273.

46 Klinge (1997b), 47; Klinge in Ars Universitaria, Portraits, 77.

47 Laur, Mati & Lukas, Tinis & Mäesalu, Ain & Pajur, Ago & Tannberg, Tinu, History of Estonia (Avita - A/S BIT, Tallinn 2000), 164.

48 Dukes (1990),148.

49 Klinge, Matti, Keisarillinen Aleksanterin yliopisto 1808-1917 (Otava, Helsinki 1989), 40-41.

50 Strömberg, John, "Ylioppilaat" in Helsingin yliopisto 1640-1990. 2: Keisarillinen Aleksanterin yliopisto 1808-1917 (Otava, Helsinki 1989), 292-293, 303.

51 Westwood, J.N., Endurance and Endeavour. Russian History 1812-1971 (Oxford University Press 1973), 28-29; Dukes (1990), 148.

52 In St Petersburg such institutions included the School of Navigation, the Mining Institute, the Military Medical Academy, the Institute of Transport Engineers, the Forestry Institute, the Main School of Engineers and the Mikhail Artillery School. (Westwood (1973), 30; Klinge (1989), 194).

53 Klinge (1980),187. However in the Russian Empire universities were quite commonly provided with handsome buildings (Knapas, Rainer, "Yliopiston rakennukset" in Helsingin yliopisto 1640-1990. 2: Keisarillinen Aleksanterin yliopisto 1808-1917 (Otava, Helsinki 1989), 239).

54 Klinge (1989), 94-96.

55 Westwood (1973), 28-31.

56 Klinge in Ars Universitaria, Portraits, 44.

57 Ibid. 34.

58 Ibid. 29; Klinge (1989), 41;

59 Korhonen, Nina, "The new bloom of the Botanical Garden" in Universitas Helsingiensis, 2/1999. Vol. XVIII, 5.

60 Jörgensen (1980), 9-10, 63-67, 81-82

61 Ibid. 10.

62 In 1831 university enrolment in Russia dropped by one third (Westwood (1973), 53).

63 Strömberg (1989), 292; Bell, Robert & Tight, Malcolm, Open Universities: A British Tradition? (The Society for Research into Higher Education & Open University Press, Buckingham 1993), 15.

64 In the autumn term of 1826 the number of students present in Turku was 478. During the 1830s and 1840s the number in Helsinki was some 15% lower. (Grotenfelt, Arvi, "Korkeakoulut ja tieteellinen tutkimus" in Suomen kulttuurihistoria IV: Industrialismin ja kansallisen nousun aika (WSOY, Porvoo-Helsinki 1936), 536-537). In the 1830s and 1840s the number of burghers' sons from Helsinki attending the university remained lower than from any other major Finnish town while Viipuri and Porvoo also provided very few burghers' sons. (Waris, Heikki, "Yliopisto sosiaalisen kohoamisen väylänä. Tilastollinen tutkimus säätykierrosta Suomessa 1810-67," in Historiallinen Arkisto XLVII (Suomen Historiallinen Seura, Helsinki 1940), 224-224).

65 The Russian Minister of Education, Uvarov, had already in 1840 noted that the increasing university and school fees was an efficient way to protect the university and the civil service from the harmful impact of the lower social classes. (Waris (1940), 233-234) Re: Russia under Nicholas I, see Lieven (1989), 28-29; Jussila (2000), 227. Re: Prussia, see Craig, Gordon, Germany 1866-1945 (Oxford History of Modern Europe) (Clarendon Press, Oxford 1978), 188-189.

66 Klinge (1989), 194-197.

67 A Finnish chemist, P.A. von Bonsdorff, had undertaken in the 1820s a long foreign journey

studying in Stockholm, London,and Paris as well as in German university towns and he kept up the contacts he had then established. In the early 19th century a number of other academics also undertook foreign travels, which were financed by grants and occasionally by private funds. (Leikola, Anto, "Tiedeyhteydet syntyvät henkilökontaktien avulla", in *Suomi Euroopassa. Talous- ja kulttuurisuhteiden historiaa*. (Ed. Mauno Jokipii) (Atena, Jyväskylä 1991) 167-170).

68 See e.g. Westwood (1973), 31-32.

69 Klinge (1967:1), 25, footnote 3. Everybody could in principle become an object of such surveillance and even the highest Finnish civil servant of the Tsar, the Minister State Secretary R.H. Rehbinder, suspected that he was being spied upon in his own home

70 Von Bonsdorff was a chemist who had specialised in mineral waters (Tommila (1982), 23-24) while C.G. Mannerheim was a highly respected entymologist (Klinge (1989), 196).

71 The system of 14 ranks was originally created by Peter the Great in 1722 with titles borrowed from Prussian and western European sources. Each rank had an appropriate honorific title: Your Supreme Excellency (classes 1-2), Your Excellency (classes 3-5), Your Supreme Honour (classes 6-8), and Your Honour (classes 9-14) (Hingley, Ronald, *Russian Writers and Society, 1825-1904*. (World University Library. Weidenfeld and Nicholson, London 1967), 167,189-190). According to the statutes of Alexander I students belonged to class 14 but a doctorate earned a rise to the 8th class, which was the equivalent of an army major and conferred hereditary nobility (Westwood (1973), 28-29); *Re: uniforms:* Lönnqvist, Bo & Rönkkö, Marja-Liisa, *Helsinki. Kuninkaankartanosta Suomen suurkaupungiksi* (Tammi, Helsinki 1988), 104.

72 Waris, Helsingin kaupungin historia III:2 (1951), 42.

73 Matti Klinge has commented that as a result life in Helsinki in the 1830s much resembled the world of Gogol's "Government Inspector". Klinge (1967:1), 4-5.

74 Jussila (1999), 33.

75 Ibid. 39-40.

76 Rähesoo, Jaak, *Estonian Theatre*. (Estonian Theatre Union, Tallinn 1999), 24; Pihlak, Evi, *Eesti maal - Estonian Painting*. ("Kunst", Tallinn 1982), 253; Raun, Toivo U. *Viron historia* (Otava, Helsinki 1989), 103; Laur et al. (2000), 167.

77 Jussila (1999), 39.

78 Klinge (1997b), 77.

79 Iisalo (1979), 25,33.

80 Once these innovations were found successful in Finland prepaid envelopes were first introduced in Moscow in 1846 and in 1848 throughout the Empire while stamps were introduced in Russia in 1858. (Rossiter, Stuart & Flower, John, *The Stamp Atlas*. (McDonald & Co, London & Sydney 1989,103, 105-106; Sillanpää suggests that Finland was the second country after Britain to introduce prepaid envelopes. (Sillanpää, Kari J., "Varmuuspainannan historiaa", in *Suomen Pankin setelipaino 1885-1985* (Suomen Pankin setelipaino, Vantaa 1985), 35). According to Dukes stamps were introduced in Russia for internal deliveries in 1857 and for foreign mailing in 1864 (Dukes (1990), 174).

81 Topelius, Zacharias, *Elämäkerrallisia muistiinpanoja*. A facsimile edition of the first edition published in 1923 (Otava, Helsinki 1998), 202.

82 Klinge in *Ars Universitaria, Portraits*, 77; Jussila (2000), 236

83 Lieven (2000), 215.

84 For a lively description of the bombardment of Helsinki and its impact on town life by August Schauman, see *Helsinki: a literary companion*, (2000), 67-72.

85 Kaukiainen, Yrjö, "Kehitysmaa-Suomi" in *Suomen taloushistoria 1. Agraarinen Suomi*, Eino Jutikkala, Yrjö Kaukiainen & Sven Erik Åström (ed.) (Tammi, Helsinki 1980), 484-487.

86 Jussila (1999), 53.

87 Frederiksen, N.C., *Finland. Its Public and Private Economy* (Edward Arnold, London 1902), 194.

88 Granfelt, G., *Suomen Yhdys-Pankki 1862-1912* (Helsinki 1912),Appendix II, 6; Schybergson, Per, *Aktiebolagformens genombrott i Finland. Utvecklingen fore 1895 års lag*. (Bidrag till kännedom av Finlands natur och folk utgivna av Finska vetenskaps-societeten. H. 109. Helsingfors 1964), 24; Laati, Iisakki, "Kunnalliselämä" in *Helsingin kaupungin historia IV:2. Ajanjakso 1875-1918* HKH IV:2 (Helsinki 1956), 367.

89 The eldest son of the businessman Henrik Borgström Snr, Henrik Borgström Jnr had since the early 1850s been a member of a debating club of young academics in Helsinki that aimed to keep the door open to European liberal ideas. When studying economics and the laws governing national economic life, he had become especially interested in banking and private banks, a subject very topical in the 1850s when new banks were being established all round Europe. (Pipping, Hugo E., *Sata vuotta pankkitoimintaa. Pohjoismaiden Yhdyspankki*. (Helsinki 1962), 38-40)

90 Pipping, Hugo E., *Paperiruplasta kultamarkkaan. Suomen Pankki 1811-1877*. (Helsinki 1961), 324; Schybergson (1964) 18; Frederiksen (1902), 189.

91 Frederiksen (1902), 185-186.

92 Urbans, Runar, *Suomen säästöpankkilaitos 1822-1922* (Suomen Säästöpankkiliitto, 1963), 80-82, 87-88.

93 Stockmann got his starting capital from his former employer Adolf Törngren (Damstén, Birger, *Stockmann sadan vuoden aikana* (Stockmann, Helsinki 1961), 34); Gustav Paulig from Paul Sinebrychoff (Lodenius, Erik, *Hundra år med Paulig 1876-1976.* (Helsingfors 1976), 6-8) and Karl Fazer from Renlund (Donner, Jörn, *Fazer 100.* (Oy Karl Fazer Ab, Helsinki 1991), 27).

94 Urbans (1963), 88-91, 95-96, 98, 102-103, 107, 170.

95 Pipping (1961), 16.

96 Granfelt (1912), 9-11.

97 Borgström, Henrik, *Om Hypoteks-föreningar* (Finska Litteratur-sällskapets tryckeri, Helsingfors 1858). Borgström used as examples credit associations in Prussia, Hanover and other German principalities as well as in Austria, Denmark, Russia and its Baltic provinces Poland, Sweden, Switzerland, Belgium and France.

98 Borgström, Henrik, *Penningstälningen år 1859 och privatbanker* (Wasenius & Komp. Förlag, Helsingfors 1859). In this book Borgström discussed banking citing examples from England, Scotland, France, Sweden, Russia, Poland and Austria. He not only quoted classics such as J.Mill's "Eléments d'Economie politique" (Paris 1823); Adam Smith's "An Inquiry into the Nature and Causes of the Wealth of Nations" (Edinburgh 1817); and Rau's "Lehrbuch der Politischen Oekonomie" (Heidelberg 1841) but based his arguments on such recent works as Michael Chevalier's "La Monnaie" (Paris 1850); J.W. Gilbert's "The Elements of Banking" (London 1854); Otto Hübner's "Die Banken" (Leipzig 1853); Courcelle-Seneuil's "Traité théorique et practique des Opérations de Banque" (Paris 1853); M.L.Wolowski's "De l'Organisation du Crédit Foncier" (Paris 1848); John Stuart Mill's "Principles of Political Economy" (London 1857); Skogman's "Anteckningar om Rikets Ständers Bank" (Stockholm 1845) and Nordström's "Bidrag till penningeväsendets historia i Sverige i Gustaf I:s tid" (Stockholm 1851).

99 Hoving (1949), 196; Pipping (1962), 22.

100 Borgström (1859), 129.

101 Ibid. 1-6, 149.

102 Ibid. 151-152.

103 Pipping (1962), 29-30.

104 Markkula, Auli, Maataloudelliset luottolaitokset Suomessa, in *Oma maa V* (WSOY, Porvoo 1924), 265-266.

105 Frederiksen (1902), 197; Pipping (1962), 27.

106 Pipping (1962), 29; Masur, Gerhard, *Imperial Berlin* (Routledge & Kegan Paul 1974), 63; Korpisaari, Paavo, "Pankit" in *Valtiotieteiden käsikirja III,* (Tietosanakirja-osakeyhtiö, Helsinki 1923), 49-50; *Encyclopedia Britannica* 1967 vol. 3, 94, 98-99;

107 Especially in England the government had been very hesitant to grant limited liability to business companies, and it was not until 1856 that the British Joint-Stock Companies Act was passed and was only extended to banks and insurance companies in 1858-62. Encyclopedia Britannica 1967, vol. 6, 220).

108 Schybergson (1964), 26-28.

109 Ibid.107-108.

110 Ibid. 37, 41.

111 Suomen Yhdys-Pankki perustetaan, in *Vuosien varrelta valittua. Yhdyspankin henkilökunnalle pankin tyttäessä 90 vuotta 21.5.1952* (Suomen Yhdyspankki, Helsinki 1952), 4.

112 Granfelt (1912), 48-50. The first seven branch offices were in Turku, Tampere, Hämeenlinna, Loviisa, Viipuri, Kuopio and Porvoo. In September further branches were opened in Vaasa, Oulu and Mikkeli.

113 The chronology of events was as follows: Autumn 1857, the banking committee meetings; 9.1.1858 Borgström proposed a mortgage association; in May 1859 the Tsar Alexander II approved the matter in principle and a decision on its establishment was made in September 1859 when Borgström also published his proposal for private banks and suggested the establishment of a Finnish currency based on metal.; 15.2.1860 Alexander II ordered the Senate to draft a proposal for the establishment of " a smaller monetary unit for Finland" (Granfelt (1912), 38); early July 1860 there was held the founding meeting of the Mortgage Association which also decided to establish a private bank; mid-December 1860 Borgström's talk on the bank published in the Government's official organ; May-July 1861 the preliminary marking of shares; 14.9.1861 there was a meeting which 1) decided formally to establish a private bank; 2)elected a steering committee, which included both Henrik Borgströms, father and son; 3) authorised the establishment and location of branches , and 4) approved the constitution and operational guidelines; 23.9.1861 the constitution was submitted for the Senate's approval; 14.10.1861 the Bank of Finland made a supportive statement; 21.2.1862 the Senate submitted the proposal to the Tsar; 21.5.1862 the final approval was given; 1.7.1862 trading began in Helsinki and seven branch offices. (See Granfelt (1912), chapters I and II.)

114 Alexander II's approval of the principles of the

Mortgage Association, his order for the creation of a metal-based currency in Finland in Feb. 1860, the total change of attitude by the Bank of Finland in 1861 towards the establishment of a private bank as well as the approval of the limited liability of the Union Bank's shareholders in 1862 (i.e. two years before Finnish company law was revised to cover it), all suggest the active involvement of the Tsar. Moreover without knowing of his support the promoters of the new bank would hardly have been as ready to decide, at their meeting on 14 September 1861, not only the detailed operational guidelines and the membership of the steering committee but also such minor matters as the petty cash arrangements in branch offices at a time when they had not even as yet submitted the bank's constitution for approval. (Granfelt (1912), 46-47).

[115] Jussila (1999), 42-43.

[116] Russia was experiencing a major banking crisis in mid-1859 due to ambitious railway construction and river steamship ventures while facing the major economic undertaking of the emancipation of the serfs in 1861. (Garvy, George, "Banking Under the Tsars and the Soviets" in *Journal of Economic History* 4/ 1972 (New York 1972), 878; Lincoln, W. Bruce, *The Great Reforms. Autocracy, Bureaucracy, and the Politics of Change in Imperial Russia.* (Northern Illinois Univerity Press. DeKalb, Ill., 1990), 83).

[117] Borgström (1859), 140-141.

[118] Granfelt (1912), 51.

[119] Borgström commented that at that time only in Russia, Poland and Finland was banking exclusively a state monopoly. (Borgström (1859), 102).

[120] In Russia provincial noble land banks had been established in 1785 "in order that each proprietor should be able to retain his land, improve it and establish for all time the necessary income for his household" (Gatrell, Peter, *The Tsarist Economy 1850-1917* (B.T. Batsford, London 1986), 204)

[121] Pullerits, Albert, *Estonia – population, cultural and economic life* (Tallinn, 1937), appendix, 47.

[122] Borgström (1858), 10, 21.

[123] Schybergson (1964), 37.

[124] Gatrell (1986), 209-210.

[125] In Russia the first joint stock commercial bank, the St Petersburg Private Commercial Bank, was established in 1864 (Lyaschenko, Petr I., *History of the National Economy of Russia to the 1917 Revolution* (Macmillan, New York, 1949), 847; Garvy (1972), 879); Estonia's oldest bank, A/S Tartu Pank (The Dorpat Bank Ltd or Dorpater Bank A/G) was registered in

1868. (Pullerits (1937), appendix, 51); and the oldest Polish commercial bank, the Bank Handlowy w Warzawie SA in 1870 (Leslie, R.F. et al., *The History of Poland since 1863* (Cambridge University Press, Cambridge 1980), 66; http://www.citibank.pl). - Since the era of Peter the Great Russians had been in the habit of sending people abroad on fact-finding tours, and in 1858-60 a young Russian, Kulomzin, had toured Western Europe for two years studying among other things financial and fiscal systems. In Britain he had paid particular attention to Scottish banking, (Lieven,(1989), 169, 235)

[126] Heikkinen, Sakari - Hjerppe, Riitta, *Suomen teollisuus ja teollinen käsityö 1860-1913.* (Suomen Pankin Julkaisuja. Kasvututkimuksia XII. Helsinki 1986), 49-50.

[127] Jutikkala, quoted in Schybergson (1964), 58.

[128] Granfelt (1912), 27; *Vuosien varrelta valittua* (1952), 6, 17, 27.

[129] Waris, Helsingin kaupungin historia III:2 (1951), 200; Åström, Sven-Erik, "Kaupunkiyhteiskunta murrosvaiheessa" in *Helsingin kaupungin historia IV:2. Ajanjakso 1875-1918* HKH IV:2 (Helsinki 1956), 158-161; Schoolfield (1996), 124.

[130] Garvy (1972),869-893, e.g. 871-873 and note 4, 880-882.

[131] Heikkinen - Hjerppe (1986), 50-51.

[132] Jussila (2000), 236.

[133] Waris, Helsingin kaupungin historia III:2 (1951), 455.

[134] According to Heikki Waris, the number of students and schoolboys over 15 years of age domiciled in Helsinki was 39 in 1830, 170 in 1850 and 624 in 1870. (Waris, Helsingin kaupungin historia III:2 (1951), 40).

[135] Strömberg (1989), 295.

[136] Castrén HKH III:2, 500; Lindberg & Rein, Helsingin kaupungin historia III:1 (1950), 124-126.

[137] Aurora Karamzin, a former lady-in-waiting to the Empress and widow of one of the wealthiest men in Russia, had been a star attraction for members of society in both St. Petersburg and Helsinki. Waris, Helsingin kaupungin historia III:2 (1951), 247-248.

[138] Kovero, Helsingin kaupungin historia III:1 (1950), 560-572.

[139] Ibid. 472-473.

[140] Jussila (2000), 241.

[141] Waris, Helsingin kaupungin historia III:2 (1951), 33,52.

[142] Ibid. 120-122.

[143] Ibid. 92-93.

[144] Ibid. 11. A classic study of the emergence of a working glass comminity in the area of the present Kallio and Sörnäinen is: Waris, Heikki, *Työläisyhteiskunnan syntyminen Helsingin Pitkänsillan pohjoispuolelle* (Weilin&Göös, Helsinki, 1973).

Innovative Immigrants

1 Wiherheimo & Rein, Helsingin kaupungin historia III:2 (1951), 344.
2 Helminen, Martti, "Olutkaupunki Helsinki vuodesta 1550", in *Kvartti* 4/97, 20-21.
3 Byckling (1995) 183-184.
4 Anttila, Helsingin kaupungin historia IV:2 (1956), 531-532.
5 Åström, Helsingin kaupungin historia IV:2 (1956), 31-38.
6 The Roman catholic parish was established in 1855 and the Estonian Lettish Military Parish in 1858. (Ruuth, Helsingin kaupungin historia III:2 (1951), 438, 442)
7 Helminen.
8 Hirn (1991), 30,258.
9 Helminen, Kvartti 2000; Waris, Helsingin kaupungin historia III:2 (1951), 30-32.
10 Between 1800-1930 from alone 151 Germans moved to Finland in order to earn their living, and even if they first went to Turku or Viipuri, after 1860 they usually ended in Helsinki, where they found a market for luxury goods and specialist services expanding along the modernization of Finland.
11 Anttila, Helsingin kaupungin historia IV:2 (1956), 530-531.
12 Donner (1991), 24.
13 Hoffman in *100 Faces from Finland,* 101.
14 Soon Fazer products were also exported and as early as 1914 the company was selling jellied fruit sweets and assorted chocolates to Scandinavia, Germany, Belgium, the Netherlands, Britain as well as to America, Africa and Australia. Some of Fazer's oldest export products still manufactured today include Finlandia jellied fruit sold in boxes decorated with the English crown and Wiener Nougat chocolates both of which date originally from the early 1900s. Fazer was also quick to utilise new marketing opportunities: in 1912 the firm launched the Helsinki City Jubileum caramel to commemorate the centenary of Helsinki as the capital and in 1926 it purchased the right to use for a pastille the name of Paavo Nurmi, then at the peak of his fame as an athlete. It became a pioneer in advertising and marketing through newspapers and magazines in addition to which it was quick to utilise the advertising opportunities first provided by the cinemas in the 1930s and TV in the early 1960s.

15 Frank Stockmann arrived to Nuutajärvi, in 1852, opened a shop in Helsinki 1859 and in 1862 established a trading house for the export and import trade. Kovero, Helsingin kaupungin historia IV:2 (1955), 326-327.
16 Eduard Paulig arrived in Nokia in 1871, the firm was established Helsinki in 1876. Lodenius (1976), 5-6
17 Damstén (1961), 42.
18 Hoving, Victor, *Kauppahuone Gustav Paulig 1876-1951* (Helsinki 1952).

III The City of Helsinki and "the Urban Question"

1 Hjerppe, Riitta – Lamberg, Juha-Antti, "Finland's international economic relations" in *Historiallinen aikakauskirja* 2/1997, 136-143
2 Marjatta Hietala (2000 c), Helsinki in the International Context. In: *Capital Cities. Images and Realities in the Historical Development of European Capital Cities,* ed. Lars Nilsson. Studier i stads- och kommunhistoria 22, Stads- och kommunhistoriska institutet, Stockholm 2000, 103-123.
3 Kuusanmäki (1992), 7-8. Where not stated otherwise, this section is based on chapter Helsingin kaupunginhallinto innovaatioalustana, pages 7-16 in Jussi Kuusanmäki's study *Sosiaalipolitiikkaa ja kaupunkisuunnittelua.* Part 2 of *Tietoa, taitoa, asiantuntemusta. Helsinki eurooppalaisessa kehityksessä 1875-1917.* (Historiallinen Arkisto 99:2/SHS and Helsingin kaupungin tietokeskuksen tutkimuksia 1992:5:2. Helsinki 1992)
4 Hietala, Marjatta (1992 a), "Innovaatioiden ja kansainvälistymisen vuosikymmenet" in *Tietoa, taitoa, asiantuntemusta. Helsinki eurooppalaisessa kehityksessä 1875-1917 I* (Historiallinen Arkisto 99:1/ Suomen Historiallinen Seura. Helsingin tietokeskuksen tutkimuksia 1992:5:1. Helsinki 1992), s. 43.
5 Kuusanmäki's quotation from VPAK 59/1909, 2-3. Ibid 8.
6 Hietala (1992 a), 269.
7 It was six men, the majority of the Swedish Party's election committee, who could ultimately decide the composition of the Helsinki City Council. (Kuusanmäki, Jussi – Piilonen, Juhani, *Helsingin kaupunginvaltuuston historia. Ensimmäinen osa 1875-1918* (Helsingin kaupunki, Helsinki 1987), 31,48).
8 Where not stated otherwise, this and the subsequent sections are based on chapter "Voimaa koneisiin, valoa kaduille ja asuntoihin" by Jaakko Pöyhönen, pages 183-347 in Part 3 of Ahonen, Kirsi & Niemi, Marjaana & Pöyhönen, Jaakko, *Tietoa, taitoa, asiantuntemusta. Helsinki eurooppalaisessa kehityksessä 1875-1917.* (Historiallinen Arkisto 99:3/SHS and Helsingin kaupungin

tietokeskuksen tutkimuksia 1992:5:3. Helsinki 1992)

9 Volkov, Solomon, *Pietari: eurooppalainen kulttuurikaupunki* (Otava, Helsinki 1996), 27.

10 Lukkonen, Tapio, *Sähköistä antiikkia. Käteen käyvät ja sähköllä toimivat* (Art House, Jyväskylä 1997):II section 13.

11 Myllyntaus, Timo, *Electrifying Finland. The Transfer of a New Technology into a Late Industrialising Economy* (ETLA – The Research Institute of the Finnish Economy Series A15. Macmillan Academic and Professional Ltd, London 1991), 80.

12 Pöyhönen (1992), 202-203.

13 *Vuosisata sähköä Suomessa.* Suomen Sähkölaitos ry. Espoo 1982, 8.

14 In May 1987 a new law on telecommunication was enacted replacing the old Telephone Act of 1886 and the Telegraph Act of 1919. This new law facilitated distance telecommunication operations.

15 Pipping, Hugo E., *Sata vuotta pankkitoimintaa. Pohjoismaiden Yhdyspankki.* (Helsinki 1962), 408.

16 Myllyntaus (1991), 27.

17 Seppälä, Raimo, *Strömberg – mies josta tuli tavaramerkki* (Art House Oy, Jyväskylä 1997), 20,34-35,332.

18 Hoffman, Kai "Elinkeinot" in *Helsingin historia vuodesta 1945 I. Väestö, kaupunkisuunnittelu ja asuminen* (Helsingin kaupunki, Helsinki 1997), 294.

19 Tweedie, Mrs Alec, *Through Finland in Carts.* (Adam and Charles Black, London 1898), 8, 23.

20 Hoffman (1997), 467; Bater (1976), 363.

21 Hoffman (1997), 214-215; Myllyntaus (1991), 28.

22 Laati, Iisakki, "Kunnalliselämä" in *Helsingin kaupungin historia IV:2* (Helsinki 1956), 381-382.

23 *Vuosisata sähköä Suomessa* (1982), 19.

24 Pöyhönen (1992), 336. Pöyhönen's conclusion is based on the articles in the *Teknikern* magazine. Maskineningeniörlaboratorier, *Teknikern* 1901, 115,124-126, 134-135. and *Teknikern* 1899, 232.

25 Laati (1956), 381-382.

26 Hietala, Marjatta, *Services and Urbanization at the Turn of the Century. The Diffusion of Innovations* (Studia historica 23. Finnish Historical Society. Helsinki 1987), 148-178.

27 Bater, James H., *St. Petersburg: Industrialization and Change* (Arnold, London 1976), 124, 361-363, 369.

28 Turpeinen, Oiva, *Helsingin seudun puhelinlaitos 1882-1982* (Helsingin puhelinyhdisty, Helsinki 1981), 120.

IV The Quest for International Know-How

1 Hietala, Marjatta (1992 a), "Innovaatioiden ja kansainvälistymisen vuosikymmenet" in *Tietoa, taitoa, asiantuntemusta. Helsinki eurooppalaisessa kehityksessä 1875-1917 I* (Historiallinen Arkisto 99:1/ Suomen Historiallinen Seura. Helsingin tietokeskusksen tutkimuksia 1992:5:1. Helsinki 1992), 263.

2 Ibid. 268; Hietala, Marjatta, *Services and Urbanization at the Turn of the Century. The Diffusion of Innovations* (Studia historica 23. Finnish Historical Society. Helsinki 1987), 24-25.

3 Ibid. 12, footnote 4.

4 Nipperdey, Thomas, *Deutsche Geschichte 1866-1918 Erster Band. Arbeitswelt und Bürgergeist* (München 1990), 375.

5 *The Statistical Yearbook of Helsinki* 1915, table 84.

6 Perkin, Harold, *The Rise of Professional Society. England since 1880* (Routledge, London 1989), 14, 20-23.

7 Larson, Magali Sarfatti, *The rise of professionalism : a sociological analysis* (University of California Press, Berkeley 1977), 4-8; Stinchcombe, Arthur L., "Social Structure and Organizations" in *Handbook of Organizations*, ed. James G. March (Rand McNally, Chicago 1965), Chapter 4.

8 von Bonsdorff, Bertel, *The History of Medicine in Finland 1828-1918* (Societas Scientiarum Fennica, Helsinki 1975), 29-31; Hietala (1992 a), 100-105.

9 Hietala (1992 a), 27-29.

10 Ibid. 33.

11 Hietala (1987), 78-84.

12 Hietala (1992 a), 40-41.

13 Laati, Iisakki, "Kunnalliselämä" in *Helsingin kaupungin historia IV:2* (Helsinki 1956), 349-350.

14 Hietala (1992 b), 263.

15 Hietala (1992 a), 38.

16 Sutcliffe, Anthony, *Towards the Planned City. German, Britain, the United States and France 1780-1914.* Comparative Studies in Social and Economic History 3, (Oxford 1981), 163-200; Hietala (1987), 358-59.

17 Turpeinen, Oiva, *Malliksi maailmalle. Suomen televiestinnän monopolien murtuminen 1977-1996* (Finnet-liitto, Helsinki 1996), 167-168.

18 Pipping, Hugo E., *Sata vuotta pankkitoimintaa. Pohjoismaiden Yhdyspankki.* (Helsinki 1962), 408.

19 Lahtinen, Merja, *Suomalaisten lääkärien ulkomaiset opintomatkat vuosina 1860-1889.* MA thesis in general history (Department of History, University of Helsinki 1998), 8-13; Merja Lahtinen's sources included Helsingfors

Dagblad 11.5.1867; Hufvudstadsbladet 23.5.1871; Helsingfors Dagblad 24.4.1873; Uusi Suometar 4.6.1878 & 21.11.1885; Finland 15.8.1888 & 19.10.1888.

20 Niemi, Marjaana, "In the Public Interest and for Private Gain. Finns' study trips abroad from the 16th to the 20th century" in *En Route!. Finnish architects' studies abroad* (eds. Timo Tuomi, Elina Standertsköld, Kristiina Paatero, Eija Rauske, Esa Laaksonen) (Museum of Finnish Architecture, Helsinki 1999), 32.

21 Tweedie, Mrs Alec, *Through Finland in Carts*. (Adam and Charles Black, London 1898), 15-19.

22 Hietala (1992 a), 209.

23 Ibid. 210.

24 Ibid. 276.

25 Ibid. 213-214.

26 Leo Ehrnrooth, Minutes of the Association of Finnish Towns in 1912.

27 Hietala (1992 a), 214.

28 Ibid. 214.

29 Hietala (1992 a), 83-84. Palmberg was well-known for his books on health care, such as *Allmän hälsovårdslära på grund av dess tillämpning i olika länder* (Borgå 1889). The French edition of this book was published in 1890, the Spanish edition in 1892 and the English edition in 1893. Palmberg was a corresponding member of the following foreign societies: since 1887 Société d'Hygiène de'l Enfance (Paris), Société d'Hygiène (Montreal), Société des Sciences naturelles et de Climatologie (Algerie), since 1893 a foreign member of Société Française d'Hygiène (Paris), since 1895 Société hongroise d'Hygiène (Hungary), Svenska Läkaresällskapet, a honorary member of The Public Health Medical Society (England) 1891, and the Royal Sanitary Institute. Hietala (1987), 304; and Hietala (1992 a), 82-83.

30 Bater, James H., *St. Petersburg: Industrialization and Change* (Arnold, London 1976), 83.

31 Ruble, Blair A., *Leningrad: Shaping a Soviet City* (California University Press, Berkeley 1990), 37-39.

32 In 1909 the rate of infant mortality in St Petersbrg was 25.0%, in Mosow 32.6% and in Warsaw 18.3%. (Hietala (1992 a), 52).

33 Hietala (1992 a), 127-128. During the 1893 cholera epidemic, a total of 1,297 ships and 14,663 people coming from Russia were inspected in Finland on arrival. In Helsinki doctors and health inspectors handled 83 ships and 1,735 sailors.

34 Hietala (1992 a), 219-220.

35 Ibid. 224-227 based on Meriläinen (1990), 25.

36 Ibid. 175-181.

37 Palmberg, Albert, *Verlden sedd från hygienisk synpunkt. Reseberättelse* (Wiborg 1887).

38 Hietala (1992 a), 83-84, 89-100.

39 Konrad Relander, *Kertomus hygieeniseltä opintomatkalta Euurooppaan 1894-1895*. Lääkintöhallitus, Matkakertomukset, National Archives.

40 Hietala (1992 a), 104-105.

41 Ibid. 178.

42 Niemi, Marjaana, "Uudistuva kansakoulu. Opettajien kansainväliset yhteydet muutosvoimana" in *Tietoa, taitoa, asiantuntemusta. Helsinki eurooppalaisessa kehityksessä 1875-1917 III: Henkistä kasvua, teknistä taitoa* (ed. Kirsi Ahonen, Marjaana Niemi, Jaakko Pöyhönen). (Hark 99:3 Finnish Historical Society, Helsinki 1992), 103-136.

43 Ibid. 139-143. For the study trips, see also, Helsingin kaupungin kansakoulut, vuosikertomukset 1902-08; Helsingin kaupungin suomenkieliset kansakoulut, vuosikertomukset 1908-14; Helsingfors stads svenskspråkiga folkskolor, årsberättelser 1908-14. (Annual Reports of the Helsinki elementary schools 1902-1914).

44 Niemi (1992), 137-175.

45 Ahonen, Kirsi, "Sivistystä ja kasvatusta työväestölle. Ulkomaiset mallit ja niiden soveltaminen" in *Tietoa, taitoa, asiantuntemusta. Helsinki eurooppalaisessa kehityksessä 1875-1917 III: Henkistä kasvua, teknistä taitoa* (ed. Kirsi Ahonen, Marjaana Niemi, Jaakko Pöyhönen). (Hark 99:3 Finnish Historical Society, Helsinki 1992), 24-29.

46 Ibid. 83; Hietala (1992 a), 273.

47 Ahonen (1992), 82-83.

48 Hollenberg, Günter, *Englisches Intresse am Kaiserreich. Die Attraktivität Preussen-Deutschlands für konservative und liberale Kreise in Grossbritannien 1860-1914* (Wiesbaden 1974), 60-113.

49 Hietala (1987), 365-381.

50 Saunier, Yves, "Changing the city: urban international information and the Lyon municipality, 1900-1940" in *Planning Perspectives*, 14 (1999), 21-22.

51 Marjatta Hietala's personal observation at the archives.

52 Hietala (1987), 387-391.

53 Ibid. 21-22, 361-381.

54 Hietala (1992 a), 277.

55 Ibid. 31-33.

56 Ibid. 278-279.

V A Metropolis of Modest Proportions

1 Tweedie (1898), 3.
2 Ganivet, Angel, *Cartas finlandesas*. (Originally published in 1896-97 in *El Defensor de Granada*. Reissued by Editorial Losada S.A., Buenos Aires 1940),13.
3 See for example the summary (in English) in Hietala, Marjatta (1992 a), "Innovaatioiden ja kansainvälistymisen vuosikymmenet" in *Tietoa, taitoa, asiantuntemusta. Helsinki eurooppalaisessa kehityksessä 1875-1917 I* (Historiallinen Arkisto 99:1/ Suomen Historiallinen Seura. Helsingin tietokeskuksen tutkimuksia 1992:5:1. Helsinki 1992) and Chapters Three and Four of this volume.
4 Ringbom, Sixten, "The Gothic Revival, Industrial Architecture and the Renaissance Revival" in *Art in Finland. From the Middle Ages to the Present day*. (Schildts, Helsinki 2000), 167.
5 An excellent summary of Helsinki's architectural developments in English is given by Riitta Nikula, in her *Architecture and Landscape. The Building in Finland*. (Otava. Helsinki 1993). See also Richards (1978), 89-91; Ringbom, Sixten (2000b), "The Gothic Revival, Industrial Architecture and the Renaissance Revival" in *Art in Finland. From the Middle Ages to the Present day* (Schildts Ab, Helsinki 2000), 149-168; af Schulten, Marius, "Rakennustaide" in *Helsingin kaupungin historia IV:1. Ajanjakso 1875-1918* (Helsinki 1955), 54-68.
6 Helander, Vilhelm & Rista, Simo, *Suomalainen rakennustaide – Modern Architecture in Finland* (Kirjayhtymä, Helsinki 1995), 15.
7 Ganivet (1940), 50, 143 and chapter 19 on theatres; Tweedie (1898), 82-83.
8 Tweedie (1898), 8-9, 23; Ganivet (1940), 52, 172.
9 The question of central heating, ventilation and indoor water closets became topical in Helsinki in the 1880s. According to 1882 trade journals, most apartments in the newly completed Grönqvist building on the North Esplanade "had such modern conveniences as bathrooms and water closets etc." (af Schultén, Helsingin kaupungin historia IV:1 (1955),60-61). In 1883 the new building of the Finnish-language girls' school in Helsinki attracted much attention because of its heating and air conditioning systems based on warm water circulating in pipes (Haila, Sirpa, *Suomalaisuutta rakentamassa. Arkkitehti Sebastian Gripenberg kulttuurifennomanian lipunkantajana*. Historiallisian tutkimuksia 201. (Suomen Historiallinen Seura, Helsinki 1998), 142); and in 1884 at the Engineering Society's meeting it was suggested that more experience was needed before assessing the apparatus available (Viljo, Eeva Maija, "The Architectural Profession in Finlad in the Latter Half of the 19th Century" in *The Work of Architects; The Finnish Association of Architects 1892-1992* (The Finnish Association of Architects and the Finnish Building Centre (Rakennustieto Oy), Helsinki 1992), 44). The 1895 building order provided for the installation of indoor water closets and it soon became popular in all new buildings while heating pipes, hot water, gas and electricity gradually began to be installed also in older buildings. (af Schultén, Helsingin kaupungin historia IV:1 (1955),101).
10 In the 1890s Helsinki's cultural life revolved around the following institutions: the Drawing School of the Fine Art Association of Finland (est. 1848), which was the main art college of the country; Helsinki conservatory (est. 1882), the Helsinki orchestra (est. 1882), the Swedish Theatre (from 1820s), the Finnish Theatre (est. 1872). In addition there were regular seasons by Russian dramatic groups and annual art exhibitions organised in the spring by the Fine Arts Association and in the autumn by the Association of Finnish Artists. Moreover, the 1890s saw a number of exhibitions in Helsinki by foreign artists. Interestingly the first cinema performance had taken place in Helsinki in June 1896 only six months after the first world performance, but this was not noted by either of the foreign visitors. (Anttila, Aarne, "Kulttuurielämä" in *Helsingin kaupungin historia IV:2. Ajanjakso 1875-1918* (Helsinki 1956, 585-624).
11 Tweedie (1898), 23.
12 Ganivet (1940), chapter 9 and page 76 in particular.
13 Tweedie (1898),161-163. Bearing in mind the rapid expansion of the population in Finland, as was obvious in the growth of Helsinki, she quite obviously did not refer to celibacy. The use of condoms had become increasingly common in Helsinki since the mid 1880s, and birth control was being openly discussed by educated women in the 1890s (Häggman, Kai, *Perheen vuosisata. Perheen ihanne ja sivistyneistön elämäntapa 1800-luvun Suomessa*. (Historiallisia Tutkimuksia 179. Suomen Historiallinen Seura. Helsinki 1994), 104 and footnote 179.
14 Häggman (1994), 164-172, 251.
15 Tweedie (1898), 165. Riitta Konttinen presents as examples of such families with shared interests: Juhani Aho (writer) and his wife Venny Soldan-Brofelt (painter) who were married in 1891; Axel Gallén (painter and designer) and his wife Mary (executor of many designs) who were married in 1890; and later Väinö Blomstedt (painter and crafts designer)

and his wife Gertrud (executor of crafts design) who were married in 1899 (Konttinen, Riitta, *Sammon takojat. Nuoren Suomen taiteilijat ja suomalaisuuden kuvat.* (Otava, Helsinki 2001), 116, 121). Equally well-known were Hannes Gebhard (university dozent and later a professor) and his wife Hedvig who married in 1892. She was a university graduate and shared his enthusiasm for social issues and the co-operative movement. She was also one of the early leaders of the women's movement in Finland.

[16] Häggman (1994),128-133.

[17] Tweedie (1898), 163. A few years later N.C. Frederiksen, the Danish Professor of Political Economy and Finances, even suggested that there was hardly any other country where women made similar efforts to obtain education and work. (Frederiksen, (1902), 287).

[18] Ganivet (1940), 63-64, 77-78.

[19] Anttila, Helsingin kaupungin historia IV:2 (1956), 529.

[20] Anttila, Helsingin kaupungin historia IV:2 (1956), 514-530.

[21] Tweedie (1898), 169.

[22] *Statistisk Årsbok för Finland sjätte årgången 1908- Annuaire Statistique de Finlande sixieme année 1908*, (Helsingfors 1908), table 196c .

[23] Six women had enrolled to study architecture at the Polytechnic Insititute in 1884-1894, and in 1890 Signe Hornborg became probably the first woman in Europe to graduate in architecture. See Renja Suominen-Kokkonen's article on Finnish women architects in *The Work of Architects. The Finnish Association of Architects 1892-1992.* (The Finnish Association of Architects and The Finnish Building Centre, Helsinki 1992).

[24] Of the total of 168 new women students in 1894-96 the majority, 107, were studying arts, 54 were mathematics and physics while eight had opted to study law. Moreover, in 1895 six women were already studying medicine and one woman theology while five women were studying at the Polytechnic Institute, the training place of architects and engineers. (*Statistisk Årsbok för Finland 1908,* table 196a; table 196c and table 199). Between 1887 and 1908 a total of 27 women were studying architecture of whom 18 graduated. In 1890 Signe Hornborg became probably the first woman in Europe to graduate in architecture and in 1905 Jenny Markelin became Finland's first woman to graduate in engineering. Suominen-Kokkonen, Renja, "Women architects - Training, Professional Lives and Roles" in *The Work of Architects. The Finnish Association of Architects 1892-1992.* (The Finnish Association of Architects and The Finnish Building Centre

Ltd. Helsinki 1992), 74-76.

[25] Art historian Bo Lindberg has even suggested that in the late 19th century more women artists were working in Finland than in any other country. Among the best-known were Fanny Churberg, Helene Schjerfbeck, Ellen Thesleff, Maria Wiik, Amelie Lundahl, Elin Danielson-Gambogi, Venny Soldan-Brofelt, Hanna Frosterus-Segerstråhle and Helena Westermarck. (Lindberg, Bo, "Painting from Romanticism to Realism," in *Art in Finland from the Middle Ages to the Present Day* (Schildts, Helsinki 2000), 212-215). For a useful overview in English, see Valkonen, Markku, *Finnish Art over the Centuries.* (Otava. Helsinki 1992), 58-67; Konttinen, Riitta, *Suomalaisia naistaiteilijoita 1880-luvulta.* (Otava, Helsinki 2000), 20-21, 270-278.

[26] Ganivet (1940),18-20; Tweedie (1898), 3.

[27] Among Helsinki's upper classes there were 4,227 Swedish-speakers, a total of 1,083 speakers of Russian, German and other languages while Finnish-speakers amounted to only 340 (Waris Helsingin kaupungin historia III:2 (1950), 17-23). In 1890 the number of Swedish-speakers in Helsinki was 29,860 or 45.6% and Finnish-speakers 29,787 or 45.5% of the total population (Åström, Helsingin kaupungin historia IV:2 (1956), 31).

[28] Tawaststjerna, Erik, *Sibelius* , ed. by Erik T. Tawaststjerna (Otava, Helsinki 1997), 71, 133. The Helsinki Symphony Orchestra, established by Robert Kajanus in 1882, had at its core over thirty German musicians (Ibid. 29).

[29] Paasivirta (1991) 163.

[30] Paasivirta, Juhani, *Finland and Europe. International Crises in the Period of Autonomy 1808-1914* (C. Hurst and Co , London 1981), 163. Apart from the future Marshall Mannerheim a number of Finns served in the Russian military forces and four Finnish generals and two admirals even served in the Russian State Council in 1894-14 (Lieven, Dominic, *Russia's Rulers under the Old Regime* (Yale University Press, New Haven 1989), 34). Among Finnish engineers working in Russia was Verner Weckman, the first ever Finnish Olympic gold medallist and the future managing director of Suomen Kaapelitehdas (the Finnish Cable Works) in Helsinki. He worked in the Urals 1909-1921 and made study tours to Sweden 1911, Germany and Switzerland in 1914 and Denmark in 1928 and 1929. (Häikiö, Martti (2001 a), *Nokia Oyj:n historia. 1: fuusio* (Edita, Helsinki 2001), 72-73.) In Russia there were a number of Finnish engineers working as Nobel employees in St Petersburg and Baku. Finnish business community in Russia included representatives of the Helsinki-based furniture manufacturers Helsingin Puuseppätehdas Oy

and Hietalahden Oy. The latter had sales rooms not only on Nevski Prospekt in St Petersburg but also in Moscow. (Sarantola-Weiss, Minna, *Kalusteita kaikille. Suomalaisen puusepänteollisuuden historia* (Puusepänteollisuuden liitto ry, Jyväskylä 1995), 68-69). On the eve of the First World the Finnish business community in St Petersburg War included Arvi Paloheimo, Sibelius's son-in-law and one of the representatives of the expanding Finnish paper industry. (Tawaststjerna (1997), 179).

31 Konttinen (2001) 24-27.

32 Seppälä, Anu, *Isa Gripenberg. Aatelisnaisen tarina* (Otava, Helsinki 1995), 45-51.

33 Paasivirta (1991) 176.

34 Virtanen, Keijo & Heikkonen, Esko, *Amerikkalaisen kulttuurin leviäminen Suomeen. Tutkimusraportti Suomen Akatemien tukemasta projektista.* (Turku 1985), 68, 75, 85.

35 Ibid. 87-88.

36 In the 1850s the value of the annual imports of books from Sweden averaged some 50,000 marks and imports from other countries totalled some 30,000 marks. In 1865 the value of books from Sweden trebled while the value of books imported from other countries increased five fold. From 1866 onwards the average value of books import remained at 140,000 marks per annum. (*Bidrag till Finlands officiella Statistik I, Finlands Sjöfart och Handel åren 1856-1865. Andra häftet; Suomenmaan Virallinen Tilasto I. Toinen jakso. Katsaus Suomen ulkomaiseen merenkulkuun ja kauppaan vuosina 1866-1870*, Helsinki 1872). The likely reason for this increase may have been a general relaxing of censorship and/or improving economic conditions. The orientation towards Scandinavian and Central-European cultures is demonstrated by the level of book imports in 1905. In 1905 the book import totalled 1,342,343 marks made up as follows: from Sweden 799,723 marks; Germany 420,344 marks; Russia 57,900 marks; Denmark 36,155 marks; Great Britain 14,649 marks; France 10,980 marks; Norway 928 marks; Austria 626 marks; Swizerland 464 marks; Belgium 365 marks; Italy 168 marks. (*Bidrag till Finlands officiella Statistik IA, Finlands handel på Ryssland och utrikesresor,* Januari 1905, Helsingfors 1905).

37 Axel Lundegård's estimate quoted by Salme Sarajas-Korte (Sarajas-Korte, Salme, *Suomen varhaissymbolismi ja sen lähteet* (Otava, Helsinki 1966), 14)

38 Virtanen-Heikkonen (1985), 86.

39 Paasivirta (1991), 75.

40 Sarajas-Korte (1966), 64.

41 Paasivirta (1981), 162. In a work published in 1902 the Danish professor N.C. Frederiksen

even suggested "At present the Finnish upper classes are probably more cosmopolitan and intellectually liberal than the Swedes; for, with their mixed nationality, they more readily learn other languages and the ideas of other nations" (Frederiksen (1902), 292).

42 During the reign of Nicholas I many Russians had shared the spirit of western style romantic nationalism and had not wished to impose Russianism on the other countries of the empire even if they expected that within Russia itself non-Russians should be become russified. (Westwood (1973), 46) Even though the events of 1863 led to the crushing of Polish autonomy, in the 1850s and 1860s the St Petersburg salons still supported the strategy of creating institutions enabling the various social and ethnic groups of the Empire to express themselves and to take part in the political process. However, after German unification the earlier strategy was replaced by one of attempting to russify the empire's non-Russian inhabitants, a policy consciously pursued by both Alexander III and Nicholas II. (Hosking, Geoffrey, *Russia. People & Empire 1552-1917.* (Fontana Press, London 1998), 319). As early as 1885 the newly appointed Governor General of Estonia had announced as his task "the joining of the Estonians to the great family of Russians." (Laur et al. (2000), 180).

43 For most of the reign of Alexander II Finland had appeared "a much-petted province" to foreign visitors. This had created jealousy among the Russians but they tolerated it as they hoped that similar policies might at some time in the future be equally inaugurated for the general benefit (Atkinson (1873), 144; Gallenga (1882), 114). The Finns themselves meanwhile had started to see their country as a separate unit and joined to the Russian empire only through the personal figure of the Tsar. (Jussila et al. (1999), 63-65).

44 For a learned and entertaining account of Finnish cultural life see Schoolfield (1996), 171-251.

45 Tweedie (1898), 148.

46 Damstén (1961), 45.

47 Kuisma, Markku & Hentinen, Annastiina & Karhu, Sami & Pohls, Maritta, *Kansan talous. Pellervo ja yhteisen yrittämisen idea 1899-1999* (Pellervo-Seura ry & Kirjayhtymä , Helsinki 1999), 16. When comparing turnovers Kuisma has not included the turnover of the co-operative business group attached to the Finnish labour movement, which also stemmed from the same actions of Helsinki professors. The split between the bourgeoisie and labour groups took place only in 1916.

48 Åström, Helsingin kaupungin historia IV:2

(1956), 80-81

49 *Re insurance company Kaleva*, est. 1874, J.A
Estlander was Professor of Surgery, Leo
Mechelin Professor of Constitutional Law,
Robert Montgomery, Professor of Civilian and
Roman Law (Eskelinen, Heikki, *Sata vuotta
suomalaista henkivakuutustoimintaa.
Vakuutusyhtiö Kaleva 1874-1974* (Keskinäinen
vakuutusyhtiö Kaleva, Espoo 1978), 20). *Re
insurance company Pohjola*, est. 1890, Otto
Donner was professor of sanskrit, Anders
Donner professor of astronomy and E.G.
Palmén professor of history (Lyytinen, Eino,
Pohjola-yhtiöt sata vuotta (WSOY, Porvoo
1991), 41). *Re KOP* Founders included not
only Otto and Anders Donner (see above) but
also Jaakko Forsman professor of history of
law; *Re the co-operative movement* Hannes
Gebhard, future extraordinary professor of
agricultural economy and statistics, Oswald
Kairamo, professor of botany; E.G. Palmén
professor of history; O.E. Tudeer and Ivar
Heikel, professors of Greek literature; Valfrid
Vasenius, a future professor of Nordic
literature; Mikael Soininen, a future professor
of pedagogy; and Rabbe Wrede, professor of
law.(Simonen, Seppo, *Pellervolaisen
osuustoiminnan historia*. (Pellervo-Seura,
Helsinki 1949), 52-55).

50 The number of professors at the university in
1880 was 37 and there were 14 privat
dozents. In 1890 professors numbered 39
and privat dozents 36.(*Statistisk Årsbok för
Finland 1908*, table 195, 323.)

51 The names of the people mentioned in note 49
can also be found in the history of the
university student corps by Klinge, which
indicates their general attitude to active
involvement in organisations. This career
information is derived from biographical notes
in Klinge, Matti, *Ylioppilaskunnan historia, IV
osa 1918-1960* (WSOY, Porvoo 1968).

52 Klinge (1983), 30-33, 41.

53 Palmén, E.G., *Suomalaisen Kirjallisuuden
Seuran viisikymmenvuotinen toimi ynnä
suomalaisuuden edistys 1831-1881.*
(Suomalaisen Kirjallisuuden Seuran kirjapaino,
Helsinki 1881), Appendix I, 120-121. For
example Mattias Akiander (chair in 1868-70)
was professor of Russian language and
literature; Herman Kellgren (secretary 1845-
1846) professor of oriental languages; E.A.
Ingman (secretary 1844-45) lecturer in
medicine; K.G. Borg (secretary 1861-63)
director of the Finnish State Treasury; A.
Schauman (treasurer 1851-57) editor of
Hufvudstadsbladet; and V.A.A. Boehm
(treasurer from 1876-) chief accountant of the
Finnish Mortgage Association. This career
information is derived from biographical notes

in Klinge (1968).

54 Ibid. Appendix III,122. Kultala was used as a
Finnish language textbook at some schools
from 1841 onwards (Ibid. 38).

55 Ibid. 69.

56 In 1871 the Finnish Literature Society decided
to award an annual prize for the best Finnish
translation from foreign literature. Suggested
works in the 1878 competition announcement
included classics of Greek, Latin, French,
English, German, Hungarian, Spanish and
Swedish literature. (Vasenius, Valfrid,
*Suomalainen kirjallisuus. Aakkosellinen ja
aineenmukainen luettelo. 1. lisävihko 1878-
1879 ynnä lisätietoja vanhemmista kirjoista -
La literature finnoise. Catalogue alphabétique
et systématique. Supplément I. 1878-1879
avec des renseignements additionels sur les
livres parus auparavant.* (Suomalaisen
Kirjallisuuden Seuran toimituksia 57
osa.(Helsinki 1880), 67).

57 Palmén (1881), 64-70, 96-100, Appendix III,
122-125

58 Vasenius (1880), 1-66.

59 The serious crop failures in 1862, 1865 and
1866 but especially the total crop failure of
1867 caused famine on a scale never
experienced before in Finland. In 1865 the
population of Finland was 1,843,245. During
the years 1866-68 a total of 269,388 people
died more than half of whom, 137,720 died in
the last winter of horror 1868. As in 1866-68 a
total of 161,744 babies were born alive, the
percentage loss of population in 1866-68 was
13.4% (*Statistisk Årsbok för Finland 1908*,
tables 4, 22 and 28).

60 Rein, Helsingin kaupungin historia III:1 (1950),
195-196. In Helsinki the annual death rate
also doubled. In 1867 it was 685, but in 1868
it increased to 1,596 although in 1869 it
returned to the more normal 742. (Waris,
Helsingin kaupungin historia III:2 (1950), 145.)

61 Quoted in Klinge (1982), 172.

62 Naylor, Gillian, "Domesticity and Design
Reform: the European Context" in *Carl and
Karin Larsson Creators of the Swedish Style*,
ed. by Michael Snodin and Elisabet Stavenow-
Hidemark (V&A Publications, London 1997),
85-86.

63 Ringbom, Sixten, (2000a) "Applied arts and
design after 1870," in *Art in Finland. From the
Middle Ages to the Present day*. (Schildts Ab,
Helsinki 2000), 228. In 1875 the Craft School
was renamed the Central School of Applied
Arts; in 1949 it became the Institute of
Industrial Arts and from 1973 the University of
Industrial Arts in Helsinki. The present name,
the University of Art and Design in Helsinki
(UIAH), was adopted in the 1990s.

64 Ringbom (2000a) 228-229; Priha, Päikki,

Rakkaat ystävät. Suomen Käsityön Ystävät 120 vuotta. (Ajatus, Helsinki 1999), 9-12.

65 Anttila, Helsingin kaupungin historia IV:2 (1956), 586.

66 Ringbom (2000a), 228-230; Anttila Helsingin kaupungin historia IV:2 (1956), 541-542; Maunula, Leena, "Taideteollisen järjestäytyminen aika 1870-1910" in *Ars - Suomen Taide 4.* (Weilin &Göös. Otava 1989),184-186.

67 Whitford, Frank, *Bauhaus* (Thames & Hudson, London 1984), 27.

68 In 1897 Louis Sparre, the pioneer of modern Finnish industrial art, invited A.W. Finch to work in the Iris ceramic factory which he was about to establish in Porvoo (Supinen, Marja, "A.W. Finch et les ateliers "Iris" 1897-1902" in *A.W. Finch 1854-1930*. Catalogue of "Alfred William Finch 1854-1930" exhibition at the Musées royaux des Beaux-Arts de Belgique à Bruxelles (Crédit Communal, Brussels 1992), 66-68) and from 1902 until 1930 Finch was a teacher of ceramics at the Central School of Art and Design in Helsinki (Aav, Marianne, "A.W. Finch, professeur a l'Ecole Centrale des Arts Décoratifs" in *A.W. Finch 1854-1930*. Catalogue of "Alfred William Finch 1854-1930" exhibition at the Musées royaux des Beaux-Arts de Belgique à Bruxelles (Crédit Communal, Brussels 1992) Sparre had also been one of the first artists in Finland to become interested in graphic art and through his own graphics Finch also influenced the development of this art form in Finland (Malme, Heikki, "A.W. Finch, peintre-graveur 1897-1930" in *A.W. Finch 1854-1930*. Same catalogue).

69 Maunula (1989), 186.

70 Akseli Gallén-Kallela, the Finnish nationalist painter and designer who had spent some years in Paris from 1884 onwards, was invited to be the ultimate decision-maker with regard to Finnish pavilion and its displays. It was he who insisted on the simplification of Saarinen's design for the pavilion and he also deemed some national-romantic furniture to be too old-fashioned. The critical success of the pavilion and the Iris room, designed by Gallen-Kallela himself, proved that he was right. (Fredrikson, Erkki, *Le Pavillon finlandais à l'Exposition universelle de 1900.* (Publication du Musée de Finland centrale. Jyväskylä 2001), 22-25, 50-51, 54, 74-77.) See also note 122.

71 Saarenheimo, Eero, *Suomalaisuutta rakentamassa. Helsingin Suomalainen Klubi 1876-1976.* (Helsingin Suomalainen Klubi, Helsinki 1976), 39-40.

72 Apart from 18 professors and other university men there were 16 lawyers and civil servants and 35 other university graduates while only the remaining 20 were drawn from in practical

occupations. (Saarenheimo (1976), 44.)

73 Lyytinen, (1991) 37.

74 Ibid. 37; Haila (1998), 56.

75 In Finland there were three Russian, six Swedish, four German, two British, two American and one French insurance companies providing life insurance (Lyytinen (1991), 34-35).

76 Eskelinen (1978), 34.

77 Of the seven members of the preparatory committee of the Suomi company, five were professors, (Lyytinen, 41); a professor chaired the founding meeting of KOP (Kansallis-Osake-Pankki 1889-1939 (Helsinki 1940), 25, 33); and the first managing director of Otava was a university dozent and future professor. (Simonen (1949, 38)

78 Regarding the russification in Finland, see Jakobson, Max, *Finland in the New Europe* (The Washington Papers/175. Centre for Strategic and International Studies, Washington & Praeger, Westport CT and London, 1998), 16-21. A detailed account of developments is provided by Osmo Jussila (Jussila et.al (1999), 61-98). D.K. Kirby published in English a selection of documents relating to the periods of Russian oppression (1899-1905 and 1907-1917) (Kirby (1975), 69-143). See also Hosking, Geoffrey, *Russia and the Russians. A History from the Rus to the Russian Federation.* (Allen Lane. Penguin, London 2001), 337-340).

79 Konttinen (2001), 9-14; quotation p. 11. Almost all people involved were under 30 years of age at that time and they included Jean Sibelius, who was finalising his *Kullervo* symphony there in the spring of 1892; as well as the writer Juhani Aho and his painter wife Venny Soldan-Brofeldt; Arvid Järnefelt, with wife Emmy, had arrived earlier and worked on his breakthrough novel; in the autumn arrived Pekka Halonen, another painter, and later inhabitants included the painter Albert Gebhard.

80 They included Arvid Järnefelt's brothers of whom Eero was a promising painter and Armas a future composer while Kasper was a formidable arts critic. Their sister Aino was engaged to Sibelius whose circle also included the conductor Robert Kajanus. The crowd of friends also included painters Albert Edelfelt and Axel Gallén (later Akseli Gallen-Kallela), writer J.H.Erkko, cultural critic Werner Söderhjelm as well as journalists Santeri Ingman (later Ivalo), Kasimir Leino and Eero Erkko, who all worked for *Päivälehti,* the organ of the liberal faction of the younger Fennomen and the predecessor of *Helsingin Sanomat.* Apart from Edelfelt and J.H. Erkko they were of the same generation as people mentioned in

footnote 79.

81 Zetterberg , Seppo, *Eero Erkko* (Otava, Helsinki 2001), 172-173; Konttinen (2001), 9-14, quotation p 14.

82 Sarajas-Korte (1966), 56-57; *Akseli Gallen-Kallela*, exhibition catalogue 1996 (The Finnish National Gallery, Ateneum, Helsinki 1996), 12.

83 By the mid 1890s this group started to disperse as each member developed their own lives, and Halonen complained of his alienation in Helsinki in 1895. Although the membership of this group evolved as younger artists joined while older members established their own atelier homes, some like Gallén-Kallela in the country at Ruovesi and Halonen, Eero Järnefelt, Aho and Sibelius in Järvenpää, they still maintained their links with each other. Väinö Blomstedt, Pekka Halonen and Albert Gebhard had studied at the same time and travelled abroad together. Blomstedt was a friend of Sibelius, Magnus Enckell, E. Järnefelt, Akseli Gallen-Kallela, Wikström, and Saarinen et al. (Konttinen (2001), 83, 13, 117-118).

84 Christ-Janer, Albert, *Eliel Saarinen. Finnish-American Architect and Educator*. Rev. edition. (The University Chicago Press, Chicago & London 1984), 10.

85 Kontinen (2001), 28,31. All generations of the Finnish intelligentsia joined forces to demonstrate to foreigners the strength of Finnish culture by publishing an extensive handbook on Finland and its economic, social and cultural life. This luxury publication, originally published in Swedish, was translated into Finnish, French, German and English. The editor was the former senator Leo Mechelin and the editorial committee consisted of C.G. Estlander, L. Lindelöf, a mathematician of international fame; Th. Rein, historian, and Zachris Topelius, while painters G. Berndtson, Albert Edelfelt and Eero Järnefelt were responsible for the illustrations. (*Finland in the Nineteenth Century by Finnish Authors, Illustrated by Finnish Artists*. (F.Tilgmann, Helsingfors 1894).

86 Konttinen (2001), 22,29.

87 Ibid. 40. The magazine published e.g. in 1899-1901 each year including Gallen-Kallela's *Kullervo's Curse (1900)*, Halonen's *Clearing a Road in Karelia* (1900), Rissanen's *Blind Woman* (1899) and Simberg's *Potatoe Girl* (1901), which all are now considered clssics.

88 Zetterberg (2001), 178; Salmenhaara, Erkki, "The Birth of National and Musical Culture in Finland" in Aho, Kalevi et al., *Finnish Music* (Otava, Helsinki/Keuruu 1996), 55.

89 Konttinen (2001), 21.

90 Ibid. 93-95.

91 Ibid. 95.

92 *Re Estonian art:* Pihlak, Evi, *Eesti maal -*

Estonian Painting. ("Kunst", Tallinn 1982), 253. On the basis of works included in this book one can suggest that Ants Laikmaa, Nikolai Triik, Kristjan Raud, Oskar Kallis and Konrad Mägi had all been to some extent influenced by Finnish artists. *Re Latvian art:* Ksenija Rudzite suggests that the great influence exerted by Finnish art on young Latvian artists was due to several contacts created by Finnish art exhibitions in Riga in 1900 and 1935 and through the personal links of Janiz Rozentals whose wife was the Finnish singer Elli Forssell. (Rudzite, Ksenija, "Latvia - kulttuurien kohtauspaikka," in *Latvia taiteiden risteyksessä. Latvian tasavallan 75-vuotisjuhlanäyttely. Ulkomaisen taiteen museo Sinebrychoff.* (Valtion taidemuseo, Helsinki 1993), 8-10,16).

93 Volkov, Solomon, *St Petersburg: A Cultural History*. (Sinclair-Stevenson. Reed International Books Ltd. London 1996),127.

94 "Suomen Taiteesta" in *Päivälehti* 28.12.1898, quoted in Konttinen (2001), 295.

95 Reitala, Aimo, "*The World of Art* and Finnish Artists," in *Mir iskusstva. On the Centenary of the Exhibition of Russian and Finnish Artists 1898.* Exhib. Cat. by the Russian State Museum & the Museum of Finnish Art, Ateneum (Palace Editions 1998), 220-228.

96 Kruglov, Vladimir, "On the Centenary of the *World of Art*," in the *Mir iskusstva* catalogue (1998), 30.

97 Reitala (1998), 217.

98 Leo Bakst: biographical notes in the *Mir iskusstva* catalogue (1998), 255.

99 Spencer, Charles, *Leon Bakst*. (Academy Editions, London 1978), 23-24.

100 Kruglov (1998), 39.

101 Ibid. 45-48. - Each city was represented by ten artists. The Finns involved were Edelfelt, Vallgren, Gallen-Kallela, Blomstedt, Enckell, Engberg, Gebhard, Halonen, Järnefelt and Lagerstam. (Kruglov (1998), 39,45; Reitala (1998), 220).

102 Kruglov (1998), 39; Reitala (1998), 220, also considered this exhibition to be the first public appearance of the *Mir isskustva* group.

103 The absence of Finnish women artists is conspicuous in the Russo-Finnish links of artists, although they formed a particularly talented group at that time and the art historian Riitta Konttinen has emphasized that Finnish Naturalism was largely developed by women. (See Valkonen (1992), 58-67). An explanation may be the fact that Finnish nationalist themes did not have such a central status in the works of the women artists, who normally did not take part either in the social life of the Young Finland group. One of the few exceptions was Venny Soldan-Brofelt.

(Konttinen (2001), 41, 119-120).

104 Yovleva, Lidia, "The Itinerants. On the history of Russian painting in the second half of the 19th century," in *Great Russian Masters 1950-1900*. Exhib.cat. (Ateneum, Helsinki 1995), 127-134; Hamilton (1983), 375, 380, 401.

105 Volkov (1996), 130.

106 The most notable exceptions were Eero Järnefelt, whose uncle Michael Clodt-von Jürgersburg was a professor at the St Petersburg Academy of Arts; Venny Soldan-Brofelt, whose father had studied engineering in that city; and Juho Rissanen, who had studied under the guidance of Ilya Repin.

107 Lindberg (2000), 208-210; Claustrat, Frank, "L´œuvre d´Albert Edelfelt et sa reception en France 1877-1889", in *L´Horizon inconnu. L´art en Finlande 1870-1920*. (Ateneum, Helsinki 1999), 20-31. Edelfelt's most famous portrait was that of Louis Pasteur, for which he was made an officer of the Legion d'Honneur. The portrait is on display at the Museé d'Orsay, in Paris.

108 Ringbom, Sixten, (2000d) "Symbolism, Synthetism and the Kalevala," in *Art in Finland. From the Middle Ages to the Present day*. (Schildts Ab, Helsinki 2000) 221-222; J.J. Tikkanen in *Finland in the 19th Century* (1894), 347; see also e.g. Valkonen (1992), 67-69; Rapetti, Rodolphe, "Gallen-Kallela et le symbolisme international: l'exemple d'Ad Astra", in *L'horizon inconnu. L'art en Finlande 1870-1920*. (Ateneum, Helsinki 1999), 48-59; Ilvas, Juha, "The Defecne of the Sampo", in *Akseli Gallen-Kallela*, catalogue 1996 (Ateneum, Helsinki 1996), 76; Sarajas-Korte, Salme, "Axel Gallén's Swan Symbolism," in *Akseli Gallen-Kallela*, catalogue 1996 (Ateneum, Helsinki 1996), 48-59.

109 Ringbom (2000d), 218-220; Sarajas-Korte (1966), 59, 87,105; Wood, Ghislaine & Greenhalgh, Paul, "Symbols of the Sacred and Profane" in *Art Nouveau 1890-1914*, ed. by Paul Greenhalgh (V&A Publications, London 2000), 75.

110 Ringbom (2000d), 220.

111 Buckle, Richard, *Diaghilev* (Hamish Hamilton Ltd, London 1979), 43.

112 Reitala (1998), 228.

113 Sinisalo, Soili, "The St Petersburg - Helsinki Axis One Hundred years Ago," in the *Mir iskusstva* catalogue (1998), 10-11.

114 Reitala (1998), 228.

115 Buckle (1979), 44-46.

116 Reitala (1998), 228.

117 Ibid. 228. Informal contacts with Russian avant-garde did not break down permanently. The journal *Mir iskusstva* featured Finnish art and architecture, including a review of the 1903 Finnish Artists' Exhibition, while in 1905

the exhibition of Russian portraits in St Petersburg, organized by Diaghilev, included works by Edelfelt. The Russian painter Nikolai Roerich, who later became chairman of *Mir iskusstva*, had formed a close friendship with Gallen-Kallela and visited Finland (Reitala (1998), 236; Rudzite (1994), 13). Both Gallen-Kallela and Saarinen later had connections with Maxim Gorki and even helped him to hide from the Russian police (Christ-Janert (1979), 21 and *Akseli Gallen-Kallela* (1996), 23).

118 Kaipainen, Marja, *Albert Edelfelt. Kuihtumaton ruusutarha*. (Watti-kustannus, Jyväskylä1994), 201-202.

119 Quotation originally published in: Gustave Babin, Les Sections Etrangères. *Livre d'Or de l'Exposition*, 157-159 Paris 1900. Republished in Karvonen-Kannas, Kerttu, "The First Grand Master of Finnish Design. The Paris World's Fair 1900," in *Akseli Gallen-Kallela* (Ateneum, Helsinki 1996), 104.

120 Moorhouse, Jonathan, Carapetian, Michael and Ahtola-Moorhouse, Leena, *Helsingin jugendarkkitehtuuri 1895-1915* (Otava, Helsinki 1987), 208.

121 Once a competition for the Finnish interior design had failed to produce satisfactory results Sparre considered Gallen-Kallela the only person in Finland able to undertake the project and persuaded him to do so. Interestingly, Gallen-Kallela, the cosmopolitan Finnish nationalist painter who had studied for four years in Paris from 1885 and had later travelled also to Germany, Britain and Italy as well as to Russia, only promised to design furniture and textiles in a style which he himself would welcome in his own home. (Karvonen-Kannas (1996), 106; *Akseli Gallen-Kallela* (1996), 10-19)

122 Valkonen, Olli, "Wassily Kandinsky's Early Contacts with Finland," in *Kandinsky*, exhibition catalogue (Retretti Ltd, Punkaharju, Finland 1998), 54. Valkonen reports that Kandinsky had become familiar with Gallen-Kallela's work at the Munich Secession exhibition in 1898, where the *Defence of the Sampo* had attracted much attention. It has been suggested that this work and Gallen-Kallela's frescoes for the Finnish pavilion at the Paris World's Fair in 1900 had influenced Kandinsky in developing his important theme, St.George and the Dragon. Kandinsky encountered Gallen-Kallela's applied arts in 1902 at an exhibition of the Phalanx society of artists as well as in late 1906 and early 1907 where Gallen-Kallela took part, as a member, in the *Die Brücke* group's exhibition of woodcuts.

123 Konttinen (2001), 42-45.

124 Smeds, Kerstin, *Helsingfors-Paris. Finland på världsutställningarna 1851-1900*. (Svenska

litteratursällskapet i Finland. Finska Historiska Samfundet, Helsinki 1996), 372-373. Helene Schjerfbeck, who did not take part in the 1900 Paris fair, had received a bronze medal at the Paris 1889 exhibition, where nine Finnish women artists had take part. (Smeds (1996), 371-372, 376).

125 Stevens, Maryanne, "The Exposition Universelle: 'This vast competition of effort, realisation and victories' " in *1900 Art at the Crossroads* exhib.cat. ed. by Rosenblum, Robert, Stevens, Maryanne and Dumas, Ann (Royal Academy of Arts, London & Solomon Guggenheim Museum, New York, London 2000), 67.

126 The Exhibition in 2000 included works by Elin Danielson-Gambogi, Edelfelt, Enckell, Gallen-Kallela, Halonen and Järnefelt, (*1900: Art at the Crossroads* (2000), 436-439 and biographical notes 366-435).

127 Art et décoration, vol VIII, 1900, p.12. Quoted in Opie, Jennifer, "Helsinki: Saarinen and Finnish Jugend," in *Art Nouveau 1890-1914*, ed. by Paul Greenhalgh (V&A Publications, London 2000) (2000), 375.

128 Ibid. 381-383.

129 Helander &Rista (1995), 17. See also note 120. *Re nationalism v. internationalism* in *Germany* see e.g. Craig, Gordon, *Germany 1866-1945* (Oxford History of Modern Europe, Clarendon Press, Oxford 1978), 204-206 for general discussion. How this dichotomy was reflecting in German art see e.g. Forster-Hahn, Françoise, "Art without a National Centre. German Painting in the Nineteenth Century" in *Spirit of an Age. Nineteenth-Century Paintings from the Nationalgalerie, Berlin* Exhib. cat. (National Gallery Company, London 2001), 36-37; *in Russia* see for example e.g. Ruble (1990),39-40; Volkov (1996),127-130.

130 Laur et al. (2000),180.

131 Kuisma (1999), 15.

132 Quotation in Simonen (1949), 49-50.

133 Lyaschenko (1949), 846-847.

134 Simonen (1949), 25-31, 46-48.

135 They included professors of botany, history, law and two professors of Greek language and literature as well as future professors of Nordic literature, pedagogy and agricultural economics. Two other members were the future head of the Department of Agriculture and a head of a folk high school. (Simonen (1949), 52-56). Again each had been sufficiently active member of the Student Union to merit a mentioning in the history of the student corporation (Klinge (1968), biographical notes). On average they were 41.5 years old.

136 Simonen (1949), 51-59.

137 Kuisma (1999),13.

138 Simonen (1949), 66-68.

139 They included a Great Address, signed by over 500,000 people or one-fifth of the population and conveyed to St Petersburg by a 500 strong deputation (which Nicholas II refused to receive); campaigns for international support; the launching of a covert organisation "Kagal" to organise passive resistance. Some conscripts refused to report for duty and were concealed by other citizens. Hosking, Geoffrey, *Russia and the Russians. A History from the Rus to the Russian Federation.* (Allen Lane. The Penguin Press, London 2001) discusses the russification policies in general (333-341) and in Finland in particular (337-338). See also Jussila (1999), 72-83 and 87-91.

140 The first year saw the founding of 140 new farmers' associations. The first dairy co-operatives were established in 1901, co-operative banks the next year and consumer co-operatives in 1904-05 including *Elanto* in Helsinki; in 1906 the co-operative shops had 50,000 members, the banks 5,000 and the dairies 30,000 (Jussila (1999), 60).

141 Gide, Charles, *Consumers' Co-operative Societies* (T.Fisher Unwin, London & The Co-operative Union Ltd. Manchester 1921), 30-31.

142 Stenius, Henrik, *Frivilligt jämlikt samfällt. Föreningsväsendets utveckling i Finland fram till 1900-talets början med speciell hänsyn till massorganisationsprincipens genombrott.* (Svenska litteratursällskapet i Finland, Helsingfors 1987), 325.

143 The two department stores in Helsinki were Sokos (bourgeoisie), next to the main post office in Mannerheimintie, and Elanto (labour movement) in Aleksanterinkatu; the third was, of course, Stockmann's. Figures for 1970 were derived from the *Otavan Iso Focus* encyclopedia vol 5, 3008. The co-operative movement in Finland now operates under three separate umbrella organisations: Pellervo-Seura , KK (the progressive consumers' organisation) and the Swedish-speaking Finland's Svenska Andelsförbund. Their activities include not only dairies, slaughterhouses, banks, insurance companies, publishing houses and a major forestry company but also they also run consumer goods corporations including factories producing food stuff, garments, furniture etc. as well as their wholesale and retailing through their own department stores (Sokos), supermarkets (Maxi) and other retail outlets.

144 The company was called *Alku* (Beginning). It was established in 1886 and produced a total of six buildings grouped round a courtyard. Each flat consisted of a room and a kitchen with a proper range and running water while storage space was allocated to each flat in the

attic and the basement. Although the toilet was still outside and gas and electricity unknown, the workers' own housing development represented a very high housing standard at that time. Tanner also recalled six such workers joint-stock housing companies having been established in Helsinki before the year 1900 and that from the beginning of the 20ᵗʰ century they had become quite common. (Tanner, Väinö, *Näin Helsingin kasvavan* (Tammi, Helsinki 1947), 26-32. Tanner studied co-operation in Hamburg on a state scholarship and saw the Hamburg slums in 1902 before the urban redevelopment. (Tanner, Väinö, *Nuorukainen etsii sijaansa yhteiskunnassa* (Tammi, Helsinki 1951), 60).

¹⁴⁵ Nikula (1993), 114-115; Jussi Kuusanmäki discusses the matter in great detail in Kuusanmäki (1992), 46-120.

¹⁴⁶ Martinsen, Rolf, "Vallila and its Wooden Houses. Model Dwellings for Workers in Early 20ᵗʰ Century Helsinki" (also in German and in French) in Koivumäki, Matti, *Puu-Vallilan kasvot. Vanhaa Vallilaa 1974-76.* (Entisaikain Helsinki XV. Helsinki-Seura, Helsinki 2001), 120-121; see also Nikula (1993a) 115.

¹⁴⁷ Once the failure in Vallila was recognised the City of Helsinki established in 1913 the Social Affairs Board, which drew up new leases for sites and in the following years launched a number of housing experiments in Vallila. (af Schultén, Helsingin kaupungin historia IV:1 (1955),102). These experiments led, in the 1920s, to the development of a garden suburb in Käpylä, built by the municipal construction company. This Käpylä development comprised wooden buildings in a uniform style designed to accommodate 2-12 families in apartments of 1-3 rooms plus kitchen, and between the wars Käpylä was regarded as Helsinki's biggest success story in housing development. (Martinsen (2001), 121). Moreover, in the 1920s, the city also encouraged the construction in Vallila of new housing blocks by workers' joint-stock housing companies. This New Vallila of narrow framed appartment blocks made of rendered brick is the most uniformly Classicist district in Helsinki (Nikula (1993a) 115).

¹⁴⁸ Nikula (1993a), 114.

¹⁴⁹ Ringbom, Sixten, (2000c) "Jugendstil, National Romanticism and Rationalism," in *Art in Finland. From the Middle Ages to the Present day.* (Schildts Ab, Helsinki 2000) 243-244; *20ᵗʰ Century Architecture: Finland* (2000), 150-51; Brunila, Helsingin kaupungin historia IV:1 (1955), 27-28. See also Nikula (1993a), 111-114.

¹⁵⁰ Nikula (1993a), 114. As in many other European cities, e.g. London, Manchester and Berlin, such developments were built along railway lines. Nikula also reports that, according to Heikki Waris, at least 21 companies and societies were active between 1895 and 1930 in land speculation in the Helsinki region.

¹⁵¹ Brunila, Helsingin kaupungin historia IV:1 (1955), 35-36, 41-42.

¹⁵² Moorhouse et al (1987), 14.

¹⁵³ Wäre, Ritva, "From Historicist Architecture to Early Modernism," in *20ᵗʰ Century Architecture: Finland* (Exhib.cat. eds. Marja-Riitta Norri, Elina Standertskjöld and Wilfried Wang) (Museum of Finnish Architecture, Helsinki & Deutsches Architektur-Museum, Frankfurt am Main, Helsinki 2000), 21.

¹⁵⁴ Opie (2000), 376-377; Wäre (2000), 22.

¹⁵⁵ Most importantly almost all of the buildings in Katajanokka still standing are from this period as are most of the buildings in Eira, built 1910-14. Furthermore, Jonathan Moorhouse has demonstrated that in the mid 1980s even the oldest part of Helsinki, the Kluuvi district, had then 39 buildings dating from 1895-1915 while almost 30% of Kaartinkaupunki had been built between 1901-12. Other major areas of Jugendstil buildings are Ullanlinna and Kruununhaka, while a number can also be seen, for example, in Kamppi, Punavuori and Kallio. (Moorhouse et al. (1987) 72, 94, 127, 198, 231, 285) Due to Finnish achievements in jugendstil architecture and design Helsinki was the only Nordic capital featured in a major Art Nouveau exhibition organised by the Victoria and Albert Museum in London and in the National Gallery of Art in Washington in 2000. (Art Nouveau 1890-1914. Ed. Paul Greenhalgh. V&A Publications, London 2000).

¹⁵⁶ See e.g. Greenhalgh, Paul (2000b), "Le Style and the Age" in *Art Nouveau 1890-1914.* (V&A Publications, London 2000), 49-52.

¹⁵⁷ Ringbom (2000c), 235. Finnish artists began to read *The Studio* in 1894 (Maunula (1989), 190) and Gallen-Kallela's works, for example, reflect its influence (*Akseli Gallen-Kallela* (1996), 15).

¹⁵⁸ Maunula (1989), 190. Gallen-Kallela became so enthusiastic about his stay in London, that he persuaded his pupil Hugo Simberg, later to become another major Finnish artist, to study there. However, after a month in rainy London the 23-year old Simberg moved to Paris (*Hugo Simberg ABC Book* ed. by Marjatta Levanto (Ateneum, Helsinki 2000), 81, 94).

¹⁵⁹ Sarantola-Weiss (1995), 67. Sparre had made two tours in 1896 and 1897 to major European art centres and became the agent in Finland for the London-based Liberty's department store in 1897. Once the Sparres had moved to Sweden architect Gustav Strengell took over as

agent for Liberty's in Finland. (Maunula (1989), 192, 196)

160 Due to the ample working opportunities the average graduating age of Finnish architects was a mere 23.6 years (Moorhouse et al. (1987), Table on Architects, 30); in 1913 the number of architectural firms in Helsinki was 46 in addition to which qualified master builders had established 39 building firms (Kovero, Helsingin kaupungin historia IV:1 (1955), 456).

161 Opie (2000), 375.

162 Opie (2000), 377; Wäre (2000), 34. In their later works it became increasingly obvious that especially during the "post-Jugend" period from 1904 onwards Finnish architects were also open to influences from Britain (especially Scotland) as well as from the USA and European Art Nouveau. (Opie (2000), 377-379; Helander & Rista (1995), 16-18).

163 Nikula (2000), 45.

164 For Saarinen's original design see 20ᵗʰ Century Architecture: Finland (2000, page 26) where it appears alongside the competition entry by Sigurd Frosterus. The latter had worked for some six months in the studio of Henry van de Velde, and was by 1904 gaining a reputation as an arch-realist. Among the best known of his architectural designs is the Stockmann department store. Frosterus was also among the early collectors of modern art in Finland.

165 Sigurd Frosterus's seminal article is published in English in 20ᵗʰ Century Architecture: Finland (2000), 121-126.

166 See Cowie, Peter, Finnish Cinema. (1991) (Finnish Film Archive and VAPK- Publishing, Helsinki 1991), 14-18. The first permanent cinema in Helsinki opened in 1901, earlier than Los Angeles, which got its first cinema in 1902; London, St Petersburg and Oslo had to wait till 1904 and Tallinn till 1907. The first Finnish documentaries were shot in the autumn of 1904 in Helsinki and the first Finnish fictional film was premiered there in May 1907. Interestingly the director of this film was Louis Sparre who was assisted by Teuvo Puro from the National Theatre. The first Finnish film company was launched in 1910 and the first purpose built studio was constructed in Kulosaari in 1915. (Uusitalo, Kari, Eläviksi syntyneet kuvat. Suomalaisen elokuvan mykät vuodet 1896-1930. Filmografia Fennica 1904-1930. (Otava, Helsinki 1972) 23,27, 36) By the end of 1908 the Finnish company Pohjoismainen Biografikomppania had announced that they were planning to expand their film production and to aim at exporting their products. It is very likely that the target was Russia, as the company established a branch and a production unit there.(Hirn,

Sven, Kuvat elävät. Elokuvatoimintaa Suomessa 1908-1918 (VAPK-kustannus & Suomen elokuva-arkisto, Helsinki 1991), 28) Russia's own film production did not start until 1908.

167 Vasily Kandinsky's exhibitions took place in Helsinki in 1906 and in 1914 when he took as a member of the Blaue Reiter group. Furthermore, in 1916 he not only had his solo exhibition in Helsinki but his works were also displayed in the Russian Art Exhibition which also included 36 works by Marc Chagall. (Valkonen (1998), 53-63). A solo exhibition of Much's work was held in Helsinki in 1909 (Karjalainen, Tuula, Uuden kuvan rakentajat. Konkretismin läpimurto Suomessa. (WSOY Porvoo 1990), 24.)

168 Frosterus, Sigurd, "Architecture: a Challenge," in 20ᵗʰ Century Architecture: Finland (eds. Marja-Riitta Norri, Elina Standertskjöld and Wilfried Wang) (Museum of Finnish Architecture, Helsinki & Deutsches Architektur-Museum, Frankfurt am Main, Helsinki 2000), 125.

VI Helsinki Turns Finland into a Modern Society

1 Re: the 1918 events and their background see Jussila, Osmo, Hentilä, Seppo & Nevakivi, Jukka, From Grand Duchy to a Modern Political State. A Political History of Finland since 1809 (Hurst & Company, London 1999), 107-120. See also Jakobson, Max, Finland in the New Europe (Praeger, Westport (Conn.) 1998), 20.

2 Recently disclosed documents in the Russian archives reveal that despite its recognition of Finland's independence 31.12.1917 the Russian Bolshevik government still entertained, in January – February 1918, the idea of overthrowing the Finnish government with the aid of Russian troops and a revolt staged by the Finnish socialists. Muistelmia aktivismista ja vapaussodasta, (eds. Ohto Manninen, Vesa Määttä) (Edita, Helsinki 1999), 3-4.

3 Siipi, Jouko, "Pääkaupunkiyhteiskunta ja sen sosiaalipolitiikka" in Helsingin kaupungin historia V:1. (Helsinki 1962), 311-312.

4 Hänninen, Sisko-Liisa & Valli, Siiri, Suomen lastentarhatyön ja varhaiskasvatuksen historia (Otava 1986), 135.

5 In the early 1920s members of the Child Welfare Board studied child welfare in Stockholm, Copenhagen (1923), and Christiania (1924) (Minutes of FD, 8.5. 1923, article 1342; AR 1923, 234; Minutes of FD 8.4 article 601 and 13.5. article 771 and 27.55.1924 article 835; AR 1924, 258) and Professor Oscar von Hellens, chairman of the Health Care Board, studied Danish child welfare activities together with teacher J. Hopeakoski in 1926.(Minutes of FD 30.3.1926, article 532 and 20.4.1926, article 634, AR, 206). The school physician A. Ruotsalainen travelled to Berlin in 1938 to familiarise himself with German school physicians' activities. (AR 1938, II Kaupunginhallitus, 146.).

6 Åström, Sven-Erik, "Kaupunkiyhteiskunta murrosvaiheessa" in *Helsingin kaupungin historia IV:2. Ajanjakso 1875-1918* (Helsinki 1956), 267-268.

7 Ståhlberg, Ester, *Kauniit, katkerat vuodet. Presidentin rouvan päiväkirja 1920-25* (WSOY, Porvoo 1985), 10, 72-89, 106-107, 334.

8 Saukkonen, Jussi, "Helsingin kunnaliselämä vv. 1918-1945" in *Helsingin kaupungin historia V:1. Ajanjakso 1918-1945* (Helsinki 1962), 432. The actual figures are 43% in 1919 and 40% in 1920 of a total of 60 seats.

9 Åström (1956), 267-271.

10 Siipi (1962),318.

11 Ibid. 318-319.

12 Ibid. 319.

13 Eino Kuusi's review of educational questions: titled Terveysopillista, Damasche, 1908, 50-53.

14 Åström (1956), 222.

15 Oker-Blom, Max, *Hos Morbror-Doktorn på landet* (Helsingfors 1903); Hietala, Marjatta (1992 a), "Innovaatioiden ja kansainvälistymisen vuosikymmenet" in *Tietoa, taitoa, asiantuntemusta. Helsinki eurooppalaisessa kehityksessä 1875-1917 I* (Historiallinen Arkisto 99:1/ Suomen Historiallinen Seura. Helsingin tietokeskuksen tutkimuksia 1992:5:1. Helsinki 1992), 89; Niemi, Marjaana, "Uudistuva kansakoulu. Opettajien kansainväliset yhteydet muutosvoimana" in *Tietoa, taitoa, asiantuntemusta. Helsinki eurooppalaisessa kehityksessä 1875-1917 III: Henkistä kasvua, teknistä taitoa* (ed. Kirsi Ahonen, Marjaana Niemi, Jaakko Pöyhönen). (Hark 99:3 Finnish Historical Society, Helsinki 1992), 154-155.

16 Åström (1956), 270.

17 Helsingin kaupunginvaltuuston painetut asiakirjat 30.1.1917.

18 Hietala, Marjatta, *Services and Urbanization at the Turn of the Century. The Diffusion of Innovations* (Studia historica 23. Finnish

19 Historical Society. Helsinki 1987), 303-304.

19 Gilmour, Kay, *Finland* (London 1931), 57.

20 Ibid. 58-59.

21 Ibid. 59.

22 Mee, Arthur (ed.), *Children's Encyclopaedia* (London 1941).

23 Havu, I., "Sivistyselämä" in *Helsingin kaupungin historia V:2. Ajanjakso 1918-1945* (Helsinki 1965), 251-252.

24 Hänninen-Valli (1986), 138.

25 A travel report by Miss Thyra Gahmberg, inspector of municipal kindergartens in Helsinki. Helsingin kaupunginvaltuuston painetut asiakirjat 1913, No. 62.; Hietala, Marjatta, "The diffusion of infrastructural innovations in Finland", in S.Vuori and P. Ylä-Anttila (eds), *Mastering Technology Diffusion - The Finnish Experience* (ETLA) (The Research Institute of Finnish Economy), Series B No. 82, (Helsinki 1992), 267-268; Hietala (1992 a), 182-184.

26 Kaupunginvaltuuston pöytäkirja 16.5.1923 article 24, Helsinki City Archives.

27 Kertomus Helsingin kunnallishallinnosta 1919 (Annual Report of the Helsinki Municipal Administration (AR) 1919), 123.

28 Hietala (1992 a), 214-215.

29 Helsingin kaupunginvaltuuston pöytäkirja 12.11.1918, article 38 (Minutes of the City Council of Helsinki (CC)) 12.11.1918 article 38; AR 1918, 161.

30 Hietala, Marjatta, "Kontakte zwischen deutschen und finnischen Wissenschaftlern" in Hietala, Marjatta, "Kontakte zwischen deutschen und finnischen Wissenschaftlern" in *Am Rande der Ostsee. Aufsätze von IV Symposium deutscher und finnischer Historiker in Turku 4.-7. September 1996*, hrsg von Eero Kuparinen (Turku 1998), 164.

31 AR, Finance Department of Helsinki City (FD) 1927, 236.

32 Kertomus Helsingin kaupungin hallinnosta, Kaupunginhallitus 160, 29.8.1935 article 1384. (AR, City Executive Board (CEB) 160, 29.8.1935, article 1384.

33 AR, FD, 243, 30.4, article 850.

34 Nikula, Riitta, "Suomen taiteen 1920-1940-luvut" in *Ars - Suomen Taide 5* (Weilin &Göös. Kustannusosakeyhtiö Otava 1990), 87.

35 AR, 243. FD 4.2, article 313.

36 Minutes of CEB 25.8.1932, article 1266, AR 1932, CEB II, 236.

37 AR, CEB 14.2.1935, article 305.

38 AR, CC 1923, 115.

39 Siipi (1962), 350.

40 *Statistical Yearbook of the City of Helsinki 1934* (Helsingin kaupunki, Helsinki 1934).

41 *Helsinki tilastoina 1800-luvulta nykypäivään. Tilastoja 2000:15* (Helsingin kaupungin tietokeskus, Helsinki 2000), 35.

42 Minutes of CEB 3.3.1938, article 498. AR II
 CEB, 147.
43 Minutes of FD 15.4.1930, article 794, AR
 1930, 316.
44 Minutes of CEB 22.4.1937, article 844; AR
 1937, 125.
45 Michelsen, Karl-Erik, *Valtio, teknologia,
 tutkimus. VTT ja kansallisen
 tutkimusjärjestelmän kehitys* (VTT, Valtion
 teknillinen tutkimuskeskus, Espoo 1993), 47 -
 48.
46 Leikola, Anto, "Luonnontieteet" in *Suomen
 kulttuurihistoria 2. Autonomian aika* (WSOY
 Porvoo 1983), 246, 251.
47 *Statistical Yearbook of Finland 1908* (Helsinki
 1908), table 102, 170.
48 Valio Annual Report 1916, cited in Michelsen
 (1993), 56.
49 Jotuni, Pertti, "Tekniset tieteet" in *Suomen
 kulttuurihistoria 3. Itsenäisyyden aika* (WSOY,
 Porvoo 1984), 318.
50 Michelsen (1993), 56-60.
51 Ibid. 184-185.
52 Jotuni (1984), 300-301.
53 Herranen, Timo, *Valtakunnan
 sähköistyskysymys. Strategiat,
 siirtojärjestelmät sekä alueellinen sähköistys
 vuoteen 1940* (Bibliotheca Historica 14.
 Suomen Historiallinen Seura. Helsinki 1996),
 207.
54 Myllyntaus, Timo, *Electrifying Finland. The
 Transfer of a New Technology into a Late
 Industrialising Economy* (ETLA – The Research
 Institute of the Finnish Economy Series A15.
 Macmillan Academic and Professional, London
 1991), 145.
55 A schoolboy inventor, Eric Tigerstedt (1887-
 1925) became interested in electro-technology
 at the age of eleven. In 1905, at the age of
 18, he used his self-made radio to
 communicate with Russian warships situated
 off Helsinki. His equipment was confiscated as
 the civilian use of radio was forbidden before
 the First World War, but was returned once the
 Russian professor Aleksander Popov, one of
 the inventors of radio, had declared that
 Tigerstedt was "not dangerous, but a
 remarkably talented technician." After
 graduating in Germany and training there with
 Siemens & Halske, Tigerstedt succeeded in
 1914 in constructing a radio valve in which the
 grid and the anode were placed as two
 concentric electrodes around the cathode. This
 was patented in Germany but as the patent
 was annulled during the war the Germans were
 free to apply his discovery later. Later
 Tigerstedt worked in Denmark and the USA
 registering over 400 patents not only in the
 field of radio but also in electro-acoustic
 technology, such as the electronic tube, the
 electro-gramophone, the radio, sound recording
 and moving pictures, which paved the way for
 the development of sound movies and
 television. Ilmonen Kari, "The Basis of it all –
 technology" in *Yleisradion 1926-1996. A
 History of Broadcasting in Finland* (ed. Rauno
 Enden) (Yleisradio Oy 1996), 231; Myllyntaus
 (1991), 367-368; Kuusela, Pertti,
 E.M.C.Tigerstedt – Suomen Edison
 (Insinööritieto Oy, Helsinki 1989), 114-117.
56 Myllyntaus (1991), 52-53.
57 Seppälä, Raimo, *Strömberg – mies josta tuli
 tavaramerkki* (Art House Oy, Jyväskylä 1997),
 48.
58 Björkvist, Heimer, "Teollisuuden kehitys
 Helsingin kaupungissa vv. 1918-1945" in
 Helsingin kaupungin historia V:3 (Helsinki
 1967), 346.
59 Myllyntaus (1991), 196-197.
60 Björkqvist (1967), 347.
61 Michelsen, Karl-Erik, *Viides sääty. Insinöörit
 suomalaisessa yhteiskunnassa.* (Tekniikan
 Akateemisten Liitto TEK & Suomen
 Historiallinen Seura, Helsinki 1999), 164.
62 Ibid. 228.
63 Seppälä (1997), 304-313; Björkqvist (1967),
 344.
64 Seppälä (1997), 312-313.
65 Michelsen (1999), 199.
66 Ibid. 228.
67 Cited in Michelsen (1999), 228.
68 Hietala, Marjatta, "Städtischer Nahverkehr als
 Innovation. Verkehr als Thema des
 internationalen Erfahrungsaustausches" in
 Stadt und Verkehr im Industriezeitalter, Horst
 Matzerath (hrsg.), Städteforschung 41 (Böhlau
 Verlag, Köln 1996), 259.
69 Myllyntaus (1991), 81.
70 Ibid. 80.
71 The number of electricity related publications
 was 40 in the years 1910-1919 and 78 in the
 1920s. A comprehensive list of all electricity
 related publications in Finland between 1757
 and 1970 is given in Lukkonen, Tapio,
 *Sähköistä antiikkia. Käteen käyvät ja sähköllä
 toimivat* (Art House, Jyväskylä 1997).
72 Herranen, Timo, *Valtakunnan
 sähköistyskysymys. Strategiat,
 siirtojärjestelmät sekä alueellinen sähköistys
 vuoteen 1940* (Bibliotheca Historica 14.
 Suomen Historiallinen Seura. Helsinki 1996),
 47 ,49, 143.
73 Myllyntaus (1991), 197.
74 Björkqvist (1967), 342-343.
75 Ibid. 344-345.
76 Hoffman, Kai "Elinkeinot" in *Helsingin historia
 vuodesta 1945 I. Väestö, kaupunkisuunnittelu
 ja asuminen* (Helsingin kaupunki, Helsinki
 1997), 287-288.
77 Ibid. 293.

78 Björkqvist (1967), 346; Hoffman (1997), 293.

79 Jotuni (1984), 320; Lagerspetz, Kari, "Luonnontieteet" in *Suomen kulttuurihistoria 3, Itsenäisyyden aika* (WSOY Porvoo 1982), 279.

80 *High technology Finland 1999*, 61.

81 Lepistö, Vuokko, *Joko teillä on primuskeitin? Kotitalousteknologian saatavuus ja tarjonta Helsingissä 1800-luvun puolivälistä 1910-luvun lopulle* (Historiallisia tutkimuksia 181. Finnish Historical Society, Helsinki 1994), 99-100.

82 Turpeinen, Oiva, *Energiaa pääkaupungille. Sähkölaitostoimintaa Helsingissä 1884-1984* (Espoo 1984), 111-112.

83 *Helsinki tilastoina 1800-luvulta nykypäivään. Tilastoja 2000:15* (Helsingin kaupungin tietokeskus, Helsinki 2000), 55.

84 Lepistö (1994), 82-86, 106. In 1910 the total of dwellings with gas was 9,354 or 36.6%. From 1918 onwards the Annual Reports on the Helsinki Municipal Administration no longer mention the consumption of lighting gas.

85 Turpeinen (1984), 111.

86 Lepistö (1994), 105-106.

87 Ibid. 99-100.

88 Quoted in Turpeinen (1984), 114.

89 Lepistö (1994), 102. Note that this is a minumum estimate, as the Municipal Electricity Company was no longer able to list all new household equipment.

90 In 1910 almost 30% of middle class payers of municipal tax in Helsinki were women (Åström (1956), 50-51) while in 1930 of all municipal tax payers 48% were women (Siipi (1962), 180).

91 According to Åström (1956), 50-51 there were 8,299 domestic servants in 1904 and 10,526 in 1914. Siipi's figures (1962) show that this trend continued: there were 10,543 domestic servants in 1920 and 11,925 in 1930.

92 The 1930 census contained a survey of the use of electrical household appliances. In Helsinki there were a total of 41,528 such appliances including 18,048 irons; 9,958 vacuum cleaners; 3,233 electric cushions; 2,735 cooking pots and pans; 2,661 kettles; 1,056 room heaters and 616 cooking plates. Sewing machines totalled 295, refrigerators 172 and washing machines a mere 29. (Turpeinen (1984), 115).

93 Siipi (1962), 264.

94 Saukkonen (1962), 451.

95 Lepistö (1994), 94-95.

96 Saukkonen (1962), 454; Turpeinen (1984), 116.

97 Turpeinen (1984), 115-116; re gas ovens at the Girls' Vocational School see Lepistö (1994), 89.

98 Röneholm, Harry (1945 a), *Markkinat, messut, näyttelyt I* (Suomen Messut Osuuskunta, Helsinki 1945), 287,290 re 1932 food stuff fair; Röneholm, Harry (1945 b), *Markkinat, messut, näyttelyt II* (Suomen Messut Osuuskunta, Helsinki 1945), 435 re 1936 electricity fair.

99 Re Finnish made electric irons Röneholm (1945a), 240; Finnish made electric cookers Röneholm (1945a), 284, 290; the Strömberg range of household appliances Björkqvist (1967), 344-345 and by Metalliteos Oy and Opa Röneholm (1945b), 444.

100 Turpeinen (1984), 117.

101 Röneholm (1945a), 114-119.

102 Ibid. 102-115.

103 Ibid. 114, 119; Holopainen, Orvokki, "The First Finnish Fair" in *Memoria 5* (Helsinki City Museum Helsinki 1990), 16-24.

104 Suomen Messut Helsingissä 1920, Luettelo, (Finland Fair in Helsinki in 1920, catalogue) Helsinki City Archives.

105 Röneholm (1945a), 127-128.

106 Ibid., 34; Topelius, Z., *Matkahavaintoja puoli vuosisataa sitten* (Werner Söderströmin kirjapaino, Porvoo 1904), 336-344.

107 From Finland's point of view, the most significant World Fairs were those of Paris 1867, Vienna 1873, Philadelphia 1876, and Paris 1878, 1889, and 1900. Finnish products were given awards at all of them. Particularly important was the Paris World Fair of 1900, when Finnish entries won 11 Grand Prix, 26 gold medals, 45 silver medals and 32 bronze medals. The gold medallists included G. Strömberg, Helsinki Artisan School, and Arabia while the Finnish Pavilion and musical performances received exceptional praise from the French and international press.

108 Röneholm (1945a), 99-100.

109 Ibid. 99.

110 http://www.avainlippu.fi/stl/historia.asp

111 Public invitation to the 1920 fair. Röneholm (1945a), 99-100. Also the opening speeches emphasised this fact. Röneholm (1945a), 176.

112 Ibid. 98-99.

113 Heinonen, Visa, *Talonpoikainen etiikka ja kulutuksen henki. Kotitalousneuvonnasta kuluttajapolitiikkaan 1900-luvun Suomessa* (Bibliotheca Historica 33. Suomen Historiallinen Seura, Helsinki 1998), 68, 112, 434; see also Ollila, Anne, *Suomen kotien päivä valkenee. Martta järjestö suomalaisessa yhteiskunnassa vuoteen 1939* (Historiallisia tutkimuksia 173. Suomen Historiallinen Seura, Helsinki 1993).

114 Heinonen (1998), 154-155, 395.

115 Ibid. 168, 332.

116 Röneholm (1945a), 120, 127.

117 Ibid. 329-331.

118 Ibid. 336.

119 Ibid. 175.The chronology of specialist exhibitions and fairs mounted in Helsinki

between general exhibitions gives an
interesting picture of the priorities at a given
time and the expansion of topical interests:
motoring (1926,1927, 1928, 1936), textiles
(1926), food (1926, 1932,1938), furniture and
home (1927,1933, 1937), radio (1928),
advertising (1928), aviation (1929, 1938),
industrial arts (1930), boat building (1931),
electricity (1936) and tourism (1936); from
mid-1930s onwards these exhibitions were
merely titled as spring or innovation
exhibitions. Röneholm (1945a and 1945b).
120 Röneholm (1945a), 152, 155.
121 Björkqvist (1967), 104.
122 Ibid. 305.
123 There is a number of memoirs referring to lively
life in upper-middle class Helsinki in the 1920s,
Among those available in English is Henrik
Tikkanen's Snobs' Island (Chatto & Windus,
London 1980). Tikkanen (1980) 10-11, 13;
Seppälä, Anu, Isa Gripenberg. Aatelisnaisen
tarina (Otava, Helsinki 1995), 34-36; Broms,
Bengt, Elämää sivusta sisältä sitoutumatta
(WSOY, Porvoo 1986), 8-9; Ståhlberg (1985),
187-189; Re: glamour of cars Veltheim, Katri,
Tuntematon vuosikymmeneni 30-luku (Jyväskylä
1989), 12; Ivalo, Mielikki, Visavuoren
paljasjalka. Nuoruudenmuistoja ja päiväkirjoja
vuosilta 1907-1927 (Weilin + Göös, Espoo
1984), 103, 109-110,113, 120.
124 Mäntylä, Ilkka, Viinissä totuus. Viinin historia
Suomessa (Otava, Helsinki 1998), 165-166.
125 Röneholm (1945a), 145, 149.
126 Mäntylä (1998), 165-166.
127 Röneholm (1945a), 115, 122, 232.
128 Sarvis Oy, established in 1921 in Tampere,
was the first manufacturer of plastics in
Finland. It was followed in Helsinki by Oy
Hartsiteollisuus Ab in 1932, which was the
first to use bakelite, a fully synthetic plastic. By
the end of the 1930s some dozen plastic
companies were operating in Finland. (Laalo
(1990), 316-317).
129 Röneholm (1945a) re casein:129, 148;
stainless steel: 152; aluminium: 238.
130 Röneholm (1945b) 572.
131 The Hutchinson Chronology of World History.
Vol IV (Helicon, Oxford 1999), 9, 65.
132 Compare pictures in Röneholm (1945a) 110,
113/1920; 134, 136/1922; 142/1923; 177-
178/textile fair 1926; 310-311/1933; and
Röneholm (1945b) 520, 522, 531/1938 and
574, 578, 581-582, 589, 591/1939.
133 Röneholm (1945a) 179-182/1926 and
Röneholm (1945b) 552, 554, 558/1938.
134 Röneholm (1945a), 260-261.
135 Ibid. 261.
136 Schildt, Göran (ed. and annotated), Alvar Aalto
in His Own Words (Rizzoli, New York 1997), 76.
137 Schildt (1997), 78.
138 Siipi (1962), 246.
139 Schildt (1997), 78.
140 Aalto's article published in Domus 1930, issue
10. Quoted in Schildt (1997), 78.
141 Röneholm (1945a), see e.g. 107-109 for 1920
fairs; 185-186 for 1927 fairs.
142 Röneholm (1945a and 1945b).
143 Röneholm (1945a), 306-308.
144 Helsingin Sanomat 27.6.1933 re Finnish
business delegation; 4.7.1933 re Mr Frank T.
Green; 20.-21.8. re Lord Baden-Powell; 27.5.-
5.6.1934 re concerts in London by the Helsinki
City Orchestra.
145 Röneholm (1945a), 306-308. Englantilainen
viikko (A British week) Helsingin Sanomat
9.9.1933. Helsingin Sanomat reported on the
events in extensive articles every day from 4.9.
until 11.9.; Uusi Suomi and Hufvudstadsbladet
also covered the events.
146 E.A. Halsley, järjestelytoimikunnan sihteeri
Arthur Söderholmille (E.A. Halsley, the
secretary of the Organising Board to Arthur
Söderholm) 21.7.1933, Stockmann Archives;
Mainokset: Englantilaisen viikon johdosta,
(Advertisement for the British week) Uusi
Suomi 3.9 and 6.9.
147 Engelsk keramikutställning, (Exhibition of
English ceramics) Hufvudstadsbladet 5.9.1933,
Helsingin Sanomat 6.9.1933.
148 Björkqvist (1967), 180.
149 Röneholm (1945b), 417.
150 Ibid. 425-435.
151 They included Hertie A.G. Kaufhaus des
Westens and Eestdeutsche Kaufhof A.G.,
(Germany); Nordiska Kompaniet, Paul
U.Bergström Ab, Militär Ekiperings Ab and
Åhlen & Holm Ab (Sweden); Grands Magasins
à l'Innovation (Belgium); Au Printemps, Les
Grands Magasins du Louvre, La Societé
Parisienne d'Achats et Manutention, Aux
Galeries Lafayette Societé (France); Magazin
zum Globus (Switzerland); A.Gerngross (Austria
and department stores and branches in Paris,
London, Lyons and Prague); Harrods and Heal
& Son (Britain); Dom Towarowy racia
Jablkowsky (Poland); Steel Ström A/S (Norway);
Puhk ja Pojad (Estonia); Corvin aruhaz
(Hungary), and Armijas Ekonomiskais Weikals
(Latvia). See Röneholm (1945b), 475-476.
152 Liiketaito 1937, Stockmann Archives;
Arkitekten 1939 (Suomen arkkitehtiliitto,
Helsinki).
153 Benedict, Burton, The Anthropology of World's
Fairs. San Francisco Panama Pacific
International Exposition of 1915 (Scholar
Press, Berkeley 1983).
154 Björkqvist (1967), 190.
155 Ibid. 344-345.
156 In the Helsinki textile industry between 1920
and 1938 the number of workplaces expanded

from 59 to 139, employees from 1,275 to 6,370 and the gross production value from 62.5 million marks to 458.3. (Björkqvist (1967), 366).

157 In food industry between 1920 and 1939 the number of workplaces expanded from 70 to 92, employees from 2,372 to 4,547and the gross production value from 352.3 million to 1,167.1million marks. (Björkqvist (1967), 355-357).

158 Röneholm (1945a) 169, 182.

159 Ibid. re: 1928 advertising fair 195, 197; re: 1929 Turku fair 200-202.

160 Ibid. re: Antwerp fair 231-235; re: Poznan fair 239; re: Helsinki fair 245-247.

161 Ibid. 261; see 312-313 for 1933 fair and Röneholm (1945b) 621-623 for 1939 housing fair.

162 Röneholm (1945b), 597.

163 Ibid. 602.

VII The Interruption of the Second World War

1 A Viljanen, T.V.: Helsinki toisessa maailmansodassa, in *Helsingin kaupungin historia V:2*. Porvoo 1964, 428-429. The Soviet Union demanded security discussions with the Baltic countries in late September and early October and succeeded in getting military bases in their territories. See note 4. for further developments. On October 10, Finland's minister of the interior had been invited to Moscow to negotiate concerning the bases demanded by the Soviet Union. - The programme of the Kuusinen puppet government is reproduced e.g. by the war correspondent John Langdon-Davies in *Finland the First Total War* (London 1940), p 168-169. He also discusses in detail (p. 169-194) how the programme failed as being out of tune with the Finnish interwar social-economic and welfare reforms. See also Upton (1974) 149-150 on the changes in Soviet policy concerning the possible use of this tactic in order to bring about a Soviet Finland.

2 Upton, Anthony F., *Finland 1939-1940* (London 1974), 150, 154; Zetterberg, Seppo, *Finland after 1917* (Keuruu 1991), 87. The text of the peace treaty in Moscow on 12.3.1940 is reproduced in English e.g. in the appendix of Tanner, Väinö: *The Winter War. Finland against Russia 1939-40*. Stanford University Press,

Stanford Cal. 1957. Tanner, who was the Finnish Foreign Minister during the war gives a detailed account of the political developments of the Finnish-Soviet relationship from 1938 until the peace treaty.

3 Upton (1974), 156; Zetterberg (1991), 89.

4 The Soviet Union had presented demands for military bases to the Baltic countries from late September 1939 onwards. Estonia entered into an assistance agreement with the Soviet Union on September 28 and Latvia and Lithuania in early October. Consequently the Soviet Union got several military bases in these countries. Between 15 - 17 June 1940 the Soviet Union army occupied Estonia, Latvia and Lithuania and on 27 July 1940 newly elected parliaments in the Baltic countries unanimously declared them to be Soviet Socialist Republics. Between 3 - 6 August the Soviet Union announced the annexation of the Baltic countries to the USSR. See Kirby, D. G. (Ed.), *Finland and Russia 1808-1920. From Autonomy to Independence* (Macmillan, London 1975), 120, 129.

5 Upton, Anthony F., *Finland in Crisis 1940-1941. A study in small-power politics* (London 1964), 92, 102-103.

6 By 1939 Finland was 91% self-sufficient in grain. However, after the Winter War she had lost 280,000 hectares of arable land in Karelia in addition to which some 150,000 cows and a great number of pigs and sheep had had to be slaughtered during the hasty evacuation of the Karelian population in the middle of winter. In later years the absence of men and horses serving at the front also had an impact on the yields. Moreover weather conditions in the early 1940s were exceptionally unfavourable. The extremely dry summers of 1940 and 1941 much reduced the normal grain yields. In 1942 winter arrived early preventing the harvesting of part of the potato crop and the ploughing of fields in preparation for the next summer. The shortage of fodder further reduced the stock of animals increasing the food shortage. Thus Finland could only avoid famine each year of the war because of grain received from Germany and also later from Sweden. In early 1942 even ice prevented the arrival of food so that at one point in Helsinki there was only enough bread for two days. Simonen, Seppo, *Maatalouden vallankumous* (Porvoo 1945), 225-227.

7 Kirby (1979), 131.

8 Kirby (1979), 133; Zetterberg (1991), 89-90; Palm, Thede, *The Finnish-Soviet Armistice Negotiations of 1944* (Acta Academiae Regiae Scientiarum Upsaliensis 14. Uppsala 1971), 12-14.

9 Palm (1971), 25-27.

10 The minutes in English of the 1944 armistice

negotiation in Moscow in March and September 1944 as well as the proposed terms in March and the final agreement in September are reproduced in Palm, Thede: The Finnish-Soviet Armistice Negotiations of 1944. The book also contains an insightful introduction on Finland's joining the war in 1941 and its consequences.

11 Björkqvist (1967), 283-284, 291, 293-294.
12 Hietala, Marjatta, (2000 a) "Damage caused by War in Towns. Helsinki and Rovaniemi in the Second World War". In Stadtzerstörumg und Wiederaufbau / Destruction and Reconstruction of Towns / Destruction et reconstruction des villes, Band 2/Vol 2. ed/ Hrsg. Martin Körner (Verlag Paul Haupt, Bern 2000), 317-318.
13 Pesonen, Aake, Helsinki sodassa (Kirjayhtymä, Helsinki 1985), 115, 164, 177-178.
14 Alanen, Pertti, Ilmatorjuntavoitto 1944: Helsinki pelastui (Porvoo 1994), 16.
15 Pesonen (1985), 164.
16 Hietala, Marjatta (2000 a), 113-118.
17 Pesonen (1985), 164; Alanen (1994), 17.
18 Knuuttila, Jukka, Helsingin väestönsuojelu: väestönsuojelun taustaa, toimintaa ja tapahtumia 1927-1989 (Helsinki 1990), 18.
19 Knuuttila (1990), 15-16,19-21; Larsio (1967), 148. The shelter was large enough to protect not only customers and staff but also a number of passers-by. Stockmann's had also stocked gas mask for sale from 1931 onwards but the demand had not been too high.
20 Knuuttila (1990), 140.
21 Langdon-Davies, John, Finland. The First Total War (London 1940), 141-147. Due to careful signposting and training of the staff Stockmann's could move its customers and staff to their basement shelter in less than ten minutes. Later the time required was reduced to four minutes. Larsio (1967), 149.
22 Pesonen (1985), 115-116; Upton (1974) also indicates this possibility, 75.
23 Knuuttila (1990), 140.
24 Burleigh, Michael, The Third Reich: A New History (Macmillan, London 2000), 489.
25 At the suggestion of Aarno Saarensivu, an inspector of Helsinki City's Finnish-language elementary schools, Helsinki in the autumn 1942 sent 14 teachers (11 to Sweden and 3 to Denmark) and paid their salaries and all schoolbooks and other learning material. Swedish voluntary orgnisations met their accommodation costs and many local authorities gave premises free of charge. This allowed the establishment in Sweden of two Finnish-language schools in Stockholm, and one each in Norrköping, Motala, Linköping, Eskilstuna, Lindesberg, Falun, Grönnesberg, Borås and Osby. Thus some 500 Finnish children from Helsinki and other municipalities could continue their school education in their own mother tongue. (Suomen lasten kiitos Ruotsille, (Helsinki 1943), 62-67).
26 Alanen (1994), 6; Pesonen (1985), 121-122; Knuuttila (1990), 67; A very readable account of the development of the barrage system and its working during the bombings is in Mäkelä (1967).
27 For the development of the Soviet and the other Allied policies toward Finland between 1941-March 1944 see Palm (1971), 30-36.
28 Alanen (1994), 5, 14; Hietala (2000 a), 301-326.
29 Pesonen (1985), 148.
30 Ibid. 155; Alanen (1994), 15; Mäkelä (1967), 180-181.
31 Alanen (1994), 18.
32 Ekelund (1962), 129.
33 Siipi (1962), 256.
34 Alanen (1994), 18; Mäkelä (1967), 210-212; Obviously the Russians believed these reports as Mäkelä states that this agent, called "Petteri" by the Finns, afterwards received a radio message from Leningrad announcing that he had been granted a high decoration.
35 Viljanen, T.V., "Helsinki toisessa maailmansodassa" in Helsingin kaupungin historia V:2 (Porvoo 1964), 454.
36 Mäkelä (1967), 214-215.
37 Hietanen, Silvo, "Sota ja väestökysymys" in Historian päivät 1985 (Suomen Historiallinen Seura, Helsinki 1986), 213-214.
38 Viljanen (1964), 459.
39 Sunday Times 28.1.1945 "Finnish fared lightly in the war".
40 Nevakivi, Jukka, Apu, jota ei pyydetty (Tammi, Helsinki 1984), 161-162.
41 Ibid. 161.
42 Viljanen (1964), 427, 437.
43 Ibid. 433, 441; Suomi 1944, 104: Women's share in the industrial workforce was about half and in the munition industry 75% at its peak.
44 Viljanen (1964), 443; Stockmann's department store had established their own task force of 120 people including 30 fire fighters as well as members of the management and some 60 guards and trained nurses, who lived through the entire Winter War in the Stockmann building. Larsio (1967), 148.
45 Erkamo, Viljo, "Kuka muistaa "Suomen nuorison iskujoukot"?" in Narinkka (Helsingin kaupunginmuseo, Helsinki 1989), 123-131.
46 Suomi 1944, 109.
47 von Bagh, Peter, Suomalaisen elokuvan kultainen kirja (Keuruu 1992), 137.
48 Valvanne (1991b), 20.
49 Saraste (1984), 108.
50 Suomen lasten kiitos Ruotsille (1943), 95-96.
51 Hoffman (1997), 259-260.
52 Nevakivi (1984), 162-163.

53 Ibid. 166.
54 Vihavainen (1996), 99.
55 Ibid. 78, 84-85.
56 von Bagh (1992), 13.
57 Ibid. 145.
58 Nevakivi (1984), 166; Suomi 1944, 179.
59 *Suomi sodassa: talvi- ja jatkosodan tärkeät päivät*, (Valitut Palat, Helsinki 1982), 478.
60 Like Sweden Finland had allowed German replacement troops to proceed to Norway through Lapland in September 1940. Later the aim of the German troops in Lapland had been to support a Northern offensive against the Russians - and to secure the availability of the Petsamo nickel, which formed 80% of all the nickel that Germany used for its tanks. In their final withdrawal to the Arctic the Germans burned Rovaniemi and the rest of Lapland causing deeply felt bitterness among the population who had been evacuated to Sweden for safety. A fatigued Finnish army and its officers, who had been ordered to fight against their former "brothers-in-arms" accepted the change and thus Finns avoided a civil war unlike in some other countries where former allies also had to turn their guns on German troops and some had refused.
61 Jutikkala, Eino – Pirinen, Kauko, *A History of Finland*, 4th rev. ed. (Weilin + Göös, Helsinki 1984), 258.
62 Nevakivi (1984), 164.
63 Soikkanen (1987), 163.

Nature and the City Milieu

1 Helander, Vilhelm & Rista, Simo, *Suomalainen rakennustaide – Modern Architecture in Finland* (Kirjayhtymä, Helsinki 1995), 17.
2 See Liisa Lindgren, *Monumentum. Muistomerkkien aatteita ja aikaa.(* Suomalaisen kirjallisuuden seura toimituksia 782, Hämeenlinna 2000).
3 Kruskopf, Erik, *Veistosten kaupunki. Taidetta Helsingin katukuvassa*, (Gummerus, Jyväskylä 2000).
4 The Fishing Bear, The Bear and The Bear at an Ant Hill, Mother Earth and The Bear.
5 Saarikangas, Kirsi, Wood, Forest and Nature, Architecture and the construction of Finnishness in *Europe´s northern Frontier,* ed. Tuomas M..S. Lehtonen, (PS- Kustannus, Porvoo 1999), 176-179.
6 Kullervo Speaks statue in 1868 and Ilmarinen and Väinämöinen in 1880. Tellervo got her statue in the 1920s.
7 Aallotar 1942, Tursas and Mermaid 1941, Ilmatar and Sotka 1946 and the statue of rune singer Larin Paraske 1949.

8 In the 1950s building of blocks of flats spread out to the areas of Herttoniemi, Roihuvuori and Pohjois-Haaga while the 1960s saw the development of Myllypuro, Laajasalo ja Puotila suburbs. Timo Herranen, "Kaupunkisuunnittelu ja asuminen" in *Helsingin kaupungin historia vuodesta 1945*, I, (Helsingin kaupunki 1997,) 130-142.
9 Helander & Rista (1995), 24-25.
10 Leikola, Anto, "Töölö, lapsuuteni maa", *Helsinki - kaupunki graniittisilla juurilla, avaralla niemellä* ed. Paavo Haavikko (Art House, Helsinki 2000), 265.
11 Richards, J.M., *800 years of Finnish architecture*. (David & Charles. Newton Abbot, London, Vancouver 1978), 166-168.
12 Nikula, Riitta, *Architecture and landscape. The building of Finland* (Otava 1993), 131-146.

VIII Helsinki and the Rebuilding of Finland

1 Nikula, Riitta (1993 b), "Suomalainen funkkiskaupunki kasvaa metsiin" in *Suomalaisten tarina 3. Jälleenrakentajien aika 1937-1967* (Jyväskylä 1993), 171.
2 Pulma, Panu, "Kasvun katveessa" in *Helsingin kaupungin historia vuodesta 1945, 2. Suunnittelu ja rakentaminen. Sosiaaliset ongelmat, urheilu* (Helsingin kaupunki, Helsinki 2000), 113-114.
3 Hulkko (1993), 32.
4 Among such children was Veikko Vilhelmi Kopra, who had experienced Helsinki bombings during the Winter War. Copeland (2000), 81.
5 Pulma (2000), 116.
6 Siipi (1962), 256.
7 Waris (1954), 10.
8 Siipi (1962), 148.
9 Larsio (1967), 165.
10 The Land Acquisition Acts were passed by Parliament first in 1940 and then in 1945 to confiscate land from the estates of the Finnish state, local authorities, companies, parishes and private individuals in order to settle the refugees, of whom some 55% were originally farming people, as well as war veterans and those who had lost their homes. As a result a total of 142,751 smallholdings were established by the end of 1958 (Rikkinen, Kalevi, "Suomalainen asuttaa maaseutua ja kasvattaa taajamia samanaikaisesti" in *Suomalaisten tarina 3: Rakentajien aika 1937-1967* (Jyväskylä 1993), 40) and Finland's agriculture was thus solidly based in farming by independent smallholders.
11 Schulman (2000), 29.

12 Hoffman (1997), 266.
13 Schulman (2000), 29-30.
14 While in 1916-1935 the total number of marriages in Helsinki had been 9.0 - 10.1/ 1000 inhabitants this number increased towards the end of the 1930s and remained constant at 13.0-13.5 until 1950. The number of births/1000 married women increased from 83.9 (in 1936-1940) to 129.5 (in 1941-1945) and 171.2 (in 1946-1950) Siipi (1962), 144. As elsewhere in Europe this was a common phenomenon and in Finland it added some half a million new citizens between 1946-49. See Rikkinen (1993), 42.
15 Itälä & Autio (1993), 62.
16 Helamaa (1983), 72-74, 100.
17 Pulma (2000), 123.
18 Kolbe (1993), 105-106, 133. Coffee rationing was particularly hard on Finns, the biggest consumers in the world of coffee per capita. It was nevertheless the last item to be freed from rationing in 1954.
19 Kolbe (1993), 135-137.
20 Helamaa (1983), 104.
21 Herranen (1997), 221.
22 Upton (1974), 155; Apart from the financing of the settlement of Karelians in 1940 the first capital levy resulted in the establishment of the Jenny and Antti Wihuri Foundation, today a major Finnish foundation for medical research. By 1939 Antti Wihuri had developed his Helsinki-based shipping company into one of the biggest in Finland. Due to a heavy capital levy imposed on him by tax officials he had to sell his fleet to manage the payments. Because of a very good price the surplus funds were then used for the establishment of the Wihuri Foundation "as there was so much money that I didn't need it" as Antti Wihuri is reported to have explained. Larsio (1967), 116.
23 Helamaa (1983), 74.
24 Michelsen (1999), 158.
25 Ekelund (1962), 129.
26 Helamaa (1983), 68.
27 Ibid. 76.
28 Ibid. 80.
29 Ibid. 86.
30 Ibid. 96, 137 see notes 21 and 22.
31 Ibid. 96. Mika Waltari (1908 - 1979) was a major figure among the young writers in Finland of the 1930s taking his subjects mainly from modern urban life in Helsinki and Europe. During the war he worked in the State Information Office while writing The Egyptian, the first of his historical novels, published in 1945. This world-famous bestseller was translated into 25 languages and formed the basis of the film Cleopatra with Elizabeth Taylor and Richard Burton in leading roles.

32 Helamaa (1983), 74-78, 96.
33 Ibid. 22.
34 Rikkinen (1993), 39.
35 Helamaa (1983), 67.
36 Michelsen (1999), 104.
37 Ibid. 158-159.
38 Helamaa (1983), 100.
39 Ibid. 80.
40 Michelsen (1999), 115.
41 Ibid. 158-159.
42 Harki (1971), 122.
43 Michelsen (1999), 155.
44 See Palm (1971), 44-52, on March 1944 negotiations. Harki (1971), 14. A detailed discussion of the political background of the war reparation issues is to be found in Heikkilä (1989).
45 As mentioned above the text in English of the armistice is to be found in Palm (1971), 155-160.
46 Heikkilä (1989), 20-22.
47 Ibid. 43.
48 Ibid.
49 Harki (1971), 69-70.
50 Ibid. 39; Larsio (1967), 161.
51 Larsio (1967), 162.
52 Harki (1971), 92.
53 Ibid. 83.
54 Ibid.
55 Heikkilä (1989), 111; Harki (1971), 114-116.
56 Harki (1971), 112-113.
57 Ibid. 190-191.
58 Michelsen (1999), 142.
59 Hakkarainen, Helena – Putkonen, Lauri, Helsingin kantakaupungin teollisuusympäristöt: teollisuusrakennusten inventointiraportti (Helsingin kaupunginmuseo, Helsinki 1995), 99.
60 Harki (1971), 132, 146, 205, 243, 245, 259.
61 Björkvist, Heimer, "Teollisuuden kehitys Helsingin kaupungissa vv. 1918-1945" in Helsingin kaupungin historia V:3 (Helsinki 1967), 330.
62 Hoffman (1997), 281.
63 Harki (1971), 101, 134.
64 Michelsen (1999), 145-146.
65 Ibid. 142-143.
66 Harki (1971), 101.
67 Ibid. 226-227.
68 Michelsen (1999), 115; Harki gives the exact figure as 141,490 wagons and 20 kilometres (Harki (1971), 337.
69 Heikkilä (1989), 47.
70 Kuisma (1993), 99.
71 The newly-elected President J.K. Paasikivi in July 1947 rejected an invitation to attend the Marshall Plan conference: "Since Finland's political position has not yet stabilised by means of a permanent peace treaty, and since the Marshall Plan has developed into an object of dispute between the Great Powers, Finland

unfortunately does not consider It possible to participate in this conference and wishes to remain outside international conflicts." See Zetterberg (1991), 103-104.

[72] Loans for war waging from Sweden amounted to 290 million kronas (Jutikkala (1992), 63); Harki (1971), 343; Zetterberg (1991), 103.

[73] Harki (1971), 119.

[74] In Britain alone it was calculated that the need for new dwellings was some 1,7 million. See Heikkilä (1989).

[75] Harki (1971), 345-346.

[76] Lukkonen, Tapio, "Puhelin kuulotorvesta kuvapuhelimeen" in *Poimintoja puhelin- ja lennätintoiminnan historiasta. Jatko-osa 1989* (PTL-tele, Helsinki 1989), 40-59.

Helsinki – the Base Camp of Finnish Design

[1] Hall, Wendy, *Finns and Their Country* (Max Parrish. London 1967), 182.

[2] Jackson, Lesley, *The Sixties. Decade of Design Revolution.* (Phaidon Press, London 2000), 111. A useful summary of Finnish design as part of a wider Scandinavian design world is provided by Polster, Bernd , "Decades: History of Scandinavian Design from 1845 to today" in his *Design Directory Scandinavia* (Universe Publishing, New York, 1999), 50-81. A more extensive coverage is provided in *Finnish Modern Design. Utopian Ideals and Everyday Realities, 1930-1997* (Eds. Marianne Aav & Nina Stritzler-Levine) (The Bard Graduate Center for Studies in the Decorative Arts and Yale University Press, New Haven and London, 1998)

[3] See e.g. Nikula (1993), 125-129 and Nummelin, Rolf, "Painting and graphic art 1918- ca 1960" in *Art in Finland* (Schildts, Helsinki 2000), 300-30. Interestingly, at the end of the 1990s E & D, one of the biggest industrial design studios in Finland used by Nokia, Hackman, Asko etc was located in Turku (Polster (1999) 370; *Form Function Finland 1/ 1996*, 21-25).

[4] For discussion of the role of Finnish textile designers as pioneers of modernism in Finnish homes, see e.g. Svinhufvud, Leena, "Finnish Textiles en Route to Modernity" in *Finnish Modern Design. Utopian Ideals and Everyday Realities, 1930-1997* (1998), 181-207. For examples how Finnish design was influencing Helsinki homes, see *Suomalaisia koteja - Hem i Finland - Homes in Finland* Ed. Ella Grönroos (Werner Söderström, Porvoo- Helsinki 1950), which shows included photos of 142 homes in the capital. It is quite obvious that it was only in the 1950s that Helsinki families became eager to acquire a variety of designer furniture and other objects. In this book, dated 1950, examples of Jugendstil furniture were to be seen in only four of these homes while Alvar Aalto's furniture occupied pride of place in only eight. On the other hand standard manufactured furniture of the 1930s appears in 30% of photos. Interestingly, half of the homes had a bookcase in a prominent place and all homes had pictures or other works of art. However, modern non-figurative art featured in only eight homes, of which four were owned by artists.

[5] Polster (1999), 180.

[6] Ibid. 290.

[7] *Ateneum Maskerad. Taideteollisuuden muotoja ja murroksia*, (Ed. Yrjö Sotamaa) (Taideteollinen korkeakoulu, Helsinki 1999), 144.

[8] Kalha, Harri, *Muotopuolen merenneidon pauloissa. Suomen taideteollisuuden kultakausi: mielikuvat, markkinointi, diskurssit* (Suomen Historiallinen Seura &Taideteollisuusmuseo & Apeiron/ Taideteollisuusmuseo. Helsinki 1998), 25.

[9] Polster (1999), 290

[10] Kalha (1998), 21.

[11] Kolehmainen, Esa, "Finnish design in the cross-current of international pressures" in *Finnish Industrial Design* (Ed. Tuula Poutasuo) (Kirjayhtymä, Helsinki 1987), 12-14.

[12] In the collection of glass and ceramics of the Victoria and Albert Museum in London designers and factories represented in 1989 were as follows: Denmark 66 designers and 9 factories; Finland 43 designers and 6 factories; Norway 37 designers and 6 factories; Sweden 61 designers and 18 factories. On the other hand the number of awards won by these designers at the Milan Triennale between 1933 and 1963 was: Denmark 9, Finland 42, Norway 12 and Sweden 17. Interestingly there were more high-standard women designers in Finland than in the other Nordic countries: 56% of Finnish designers were women while in Denmark only 31%, in Norway 46% and in Sweden 36%. (Opie, Jennifer, *Scandinavia: Ceramics & Glass in the Twentieth Century. The Collections of the Victoria and Albert Museum* (V& A Publications, 2001), Biographies and factory histories 149-179).

[13] Kalha (1998), 130-135.

[14] Ratia, Viljo, "Alkuvuosien kiemuroita" in *Marimekko ilmiö* (Eds. Pekka Suhonen and Juhani Pallasmaa) (Marimekko Oy, Helsinki 1986), 24-29.

[15] See for example Guidot, Raymond, *Histoire du design 1940-2000* (Editions Hazan, Paris 2000); Polster, Bernd, *Design Directory*

Scandinavia (Universe Publishing, New York, 1999); Tambini, Michael, *The Look of the Century. Design Icons of the 20th Century* (Revised edition, Dorling Kindersley, London 1999).

16 Polster (1999), 359.

17 Polster (1999), 197. The team also included Glen Oliver Löw from Germany, Stefan Lindfors from Finland and Carina Seth-Anderson and Björn Dahlström both from Sweden. During the product development process Hackman's production team not only consulted professional cooks but also futurologists and anthropologists (*Welcome to Finland 1999*, 45-47). See also *Form Function Finland 1/1999*, 11.

18 Advertisement in *Form Function Finland 1/ 1999*, 17, 38-39. See also Polster (1999), 216. The team included 1 German, 2 Finns, 1 Australian and 1 Swede. By the end of the millennium multinational teamwork was becoming increasingly common, which will make it more difficult in the future to distinguish which product is an original Finnish design and which is only produced in Finland. (Stenros, Anne, "Finnish Design 125 Years" in *Form Function Finland 2/2000*, 51-53). This trend was much aided by the formation in the Nordic countries of two major design conglomerates, which are probably the largest design firms in Europe. In Finland Hackman, noted for their cutlery and metalware, in 1990 incorporated into their Hackman Designor Oy Ab group both the Arabia porcelain factory (together with the Swedish Rörstrand) and the Iittala glass works while the Danish Royal Scandinavian since the 1980s has included the Danish firms Royal Copenhagen, Georg Jensen and Holmegaard as well as the Swedish Orrefors/Kosta Boda (Polster (1999), 76, 197, 317-320).

19 *Ateneum Maskerad* (1999), 290

20 Ibid. 290.

21 Head of UIAH, Yrjö Sotamaa in *Arttu* 3/2000 published by the University of Industrial Art in Helsinki, 1

22 *Ateneum Maskerad* (1999), 289.

23 *Arttu 3/2000*, 13.

IX Helsinki – the Keys to Success

1 Iltalehti 12.3.2002.

2 Turpeinen (1997), 17-18;*Helsinki tilastoina 1800-luvulta nykypäivään* (2000), 22-23.

3 *Statistical Yearbook of Finland 2001*, table 35.

4 *Helsinki tilastoina 1800-luvulta nykypäivään*, 22-23.

5 Hoffman (1997), 276-278.

6 *Helsinki tilastoina 1800-luvulta nykypäivään*, 66-72.

7 Hjerppe (1990), 34, 50-51.

8 *The story of Finland* (2001), 48-59.

9 *Statistical Yearbook of Finland 1992*; *Statistical Yearbook of Finland 2001*.

10 Hjerppe – Lamberg (1997), 136-143.

11 Kuisma (1997), 144-152.

12 Pihkala, Erkki, *Suomalaiset maailmantaloudessa keskiajalta EU-Suomeen*. Tietolipas 181 (SKS, Helsinki 2001), 160-162.

13 Ibid. 174.

14 *Statistical Yearbook of Finland 1992*; *Statistical Yearbook of Finland 2001*.

15 Pihkala (2001), 142, 276-278.

16 Ibid. 340-341.

17 *The story of Finland* (2001), 96-99.

18 Hjerppe (1990), 110.

19 Centres of excellence consist of one or more high level research groups. To become a center of excellence the group/groups must have a prospect of becoming one of the leading research groups in its field and explicit objectives of research. 26 new centres of excellence started their work in the beginning of 2000. They are funded for a six-year period.

20 *Suomi: Tiedon ja osaamisen yhteiskunta* (Valtion tiede- ja teknologianeuvosto, Helsinki 1996), 53-62.

21 Havèn, Heikki, *Korkeakouluista valmistuneiden työllistyminen: vuosina 1989-1993 valmistuneiden työllistyminen vuonna 1993* (Tilastokeskus, Helsinki 1996).

22 *Tiede ja Teknologia* (2000), Tiede, teknologia ja tutkimus 2000:4, 42-47; *Tutkimus ja kehittämistoiminta* (1999), Tiede, teknologia, tutkimus 2000:3.

23 Turpeinen (1984), 332-333.

24 Ibid. 299.

25 Ibid. 266-283.

26 Ibid. 295 (citation of MSc(Eng.) Martola).

27 Ibid. 295.

28 AR (VIII yleiset työt), 43-48; Turpeinen (1995), 214.

29 Turpeinen (1995), 208.

30 Rekisteröidyt moottoriajoneuvot Helsingissä. Helsingin tilastollinen vuosikirja 1999, table 4.1. In the whole country the number of cars was 50,000 and in Helsinki 5,000 in 1939.

31 Facts about Helsinki (2001), 24 <http:// www.hel.fi/tietokeskus/tilastoja/taskutilasto/

engl2001.pdf>

32 Hoffman (1997), 434.

33 Ibid. 450.

34 Vapalahti, Hannu, Suomalaiset matkustajalaivat 1960-1996, osa I, Aallottaresta Isabellaan, Judicor Oy, Tampere 1996, 134-136; Riutta, Kari – Vartiainen, Hannu, Autolautoista univiksi hotelleiksi, in Navis Fennica, Suomen merenkulun historia, osa 2, ed. Erkki Riimala, Helsinki 1994, 338.

35 Helsinki tilastoina 1800-luvulta nykypäivään. Helsingin kaupungin tietokeskus. Tilastoja 2000:15, Helsinki 2000, 152-153.

36 Matkustajaliikenne, Suomen Tilastollinen Vuosikirja 1999, taulukko 248. (Passenger transport capacity 1960-1998, table 248, Statistical Yearbook of Finland 1999).

37 Consul Lucander's initiative on 1 November 1923. Wegg (1983), 21-24.

38 Wegg (1983), 22, 288; 75 vuotta sinivalkoisin siivin, Finnair News 5/98.

39 Ibid. 68-69.

40 Helsinki tilastoina 1800-luvulta nykypäivään. Helsingin kaupungin tietokeskus. Tilastoja 2000:15, 150.

41 Wegg (1983), 61, 275.

42 Ibid. 103-104.

43 Ibid. 173-174.

44 Helsinki tilastoina 1800-luvulta nykypäivään, 152-153; Figure 9.4.

45 Finnair. Annual Report 1999/2000 <http://www.finnair.fi/uploaded_files/docs/on20020115/VSK9900engl.pdf>

46 Finnair Communications: Finnair Air Transport; Ilmailulaitoksen antamat tiedot kansainvälisen liikenteen matkustajista. (Passengers in International traffic, Statistics of Civil Aviation Administration.) <http://www.ilmailulaitos.com/netcomm/Chunker/download.asp?id=2603;210212>

47 During his visit to Finland the writer of the article, Herr Schmoll, had also met Jukka Sarjala, the Director General of the Board of Education. In the article spanning six columns under a headline "The Finns know the limits of the principle of equality" Frankfurter Allgemeine Zeitung covers the reasons for and background factors of the Finnish success in the international Pisa study, in which German school children scored very low. The paper quoted Sarjala who said that, "We need all our students and cannot accept that any case is hopeless." Herr Schmoll also points out that Finnish school children "say nothing and only open their mouths (like Finnish adults) when they have something to say." The teachers aim to encourage children and to avoid humiliating them in front of the rest of the class.

48 Helsinki tilastoina 1800-luvulta nykypäivään.

Tilastoja 2000:15 (Helsingin kaupungin tietokeskus, Helsinki 2000), 122-124.

49 Ibid. 122.

50 Helsinki Region 2000, table 7.1 and page 11

51 Originally the first university in Finland, the Academy of Turku, was founded in Turku (Åbo), but it was transferred to Helsinki after it had suffered extensive damages in the 1827 great fire of Turku, and under the name the Imperial Alexander University in Finland remained as the sole university during the whole period of Russian rule. The establishment of a second university was already under consideration before Finland became independent in 1917, but the language conflict between Finnish-speakers and Swedish-speakers actually led to the foundation with private funding of two new universities in the old capital, Turku, where the Åbo Akademi (Swedish-language and established in 1917) opened its doors in 1919 while the University of Turku (Finnish-language, established in 1920) started to teach in 1922

52 Helsinki University of Technology became a university in 1908. When the main building in Helsinki was badly damaged during the bombing of the Second World War the university began its move to Otaniemi in Espoo. It also established an affiliated institution in Tampere in 1965, which became an independent Tampere University of Technology in 1972.

53 The chairs were established in the following subjects: urban sociology, urban history, urban economics, urban social policy, urban geography and urban biology.

54 Arts and Culture 1999. Statistics 1999:15 (Helsingin kaupungin tietokeskus, Helsinki 1999), 10.

55 Ibid. 14.

56 Taulukoita KOTA-tietokannasta, http://www.minedu.fi/julkaisut/pdf/87kota.pdf.

57 In 1925, the predecessor of Tampere University was established in Helsinki, but was moved to Tampere in 1960 and became a university in 1966. In the same year university status was given to the University of Jyväskylä, which was originally established in 1863 as a training centre for primary school teachers and had become a university level College of Education in 1934. Of the new universities that of Oulu was established in 1958, Vaasa in 1968, Joensuu in 1969, Kuopio in 1970 and the last one, the University of Lapland, in Rovaniemi in 1979. The founding of Joensuu, Kuopio and universities formed part of the higher education policies of the 1960s which emphasized the regional development of higher education. This is true also of Lappeenranta University of Technology (1969) which has developed from a regional college into a

university recruiting nationwide, Nuorteva, Jussi "Higher Education" in Finland. *A Cultural Encyclopaedia* (Finnish Literary Society, Helsinki 1997), 137-140.

58 Ibid. 141.

59 *Facts about Helsinki* (2001), http://www.hel.fi/ tietokeskus/tilastoja/taskutilasto/ engl2001.pdf.

60 *Helsinki tilastoina 1800-luvulta nykypäivään* (2000), 126.

61 Ibid. 132.

62 Keskinen, Vesa *Palvelut puntarissa: kaupunkipalvelututkimus Helsingissä 1983, 1989, 1993 ja 1997* (Helsingin kaupungin tietokeskus, Helsinki 1998), qtd. in *Arts and Culture, Tilastoja 1999*, 46.

63 Hietala, Marjatta, Perceptions of Backwardness: the case of the European North in Criteria and Indicators of Backwardness, in: *Criteria and Indicators of backwardness; Essays on Uneven Development on European History*, eds. Miroslav Hroch and Luda Klusáková (University of Prag, Prag 1996), 162.

64 Karjalainen, Marjaana, *Kansankirjastojen kehitys Suomessa vuosina 1802-1906* (Kirjastopalvelu, Helsinki 1977), 5.

65 *Helsinki tilastoina 1800-luvulta nykypäivään* (2000), 136-137.

66 Mäkinen, Ilkka, "The Golden Age of Finnish Public Libraries: Institutional, Structural and Ideological Background since the 1960's" in *Finnish Public Libraries in the 20th Century*, Ilkka Mäkinen (ed.) (Tampere University Press, Tampere 2001), 116-150.

67 *Helsingin kaupunginkirjaston toimintakertomus 1999; Arts and Culture 1999*, 43- 44.

68 *Helsinki tilastoina 1800-luvulta nykypäivään*, 136.

69 *Facts about Helsinki* (2001), http://www.hel.fi/ tietokeskus/tilastoja/taskutilasto/ engl2001.pdf

70 *Helsingin kaupunginkirjaston toimintakertomus 1999*, 17-19.

71 The European Cities of Culture: Bergen, Bologna, Brussels, Helsinki. Krakow, Prague, Reykjavik, Santiago de Compostela, as well as Athens, Bilbao, Copenhagen, Dublin, Edinburgh, Glasgow, Hamburg, Lille, Nuremberg, Riga, St. Petersburg, Stockholm, Tallinn, Vienna, Vilnius and Zürich.

72 *Arts and Culture 1999*, 94-96, Figure 5.

73 *Helsinki tilastoina 1800-luvulta nykypäivään*, 138.

74 Nevakivi (1999), 282.

75 Jakobson (1998), 54.

76 Mäkinen (1998), 143-148.

77 Ibid.

78 Virtanen & Heikkonen (1985), 158, 162.

79 Vuorinen and Heikkonen (1983), 24-40.

80 Jutikkala (1992), 10.

81 Suomen Youth For Understanding ry, http://www.yfu.fi

82 Jauhiainen (1989), 23-25.

83 Nuorisotyö 1992:2, 12-13.

84 Erasmus statistics 1993-94, http://europa.eu.int/comm/education/erasmus/ statisti/stat1.pdf.

85 What is CIMO, http:// www.cimo.fi

86 Taulukoita KOTA-tietokannasta, http://www.minedu.fi/julkaisut/pdf/87kota.pdf; University of Helsinki in brief, http://www.helsinki.fi/english/uhinbrief01.html

87 Science and technology in Finland, http://www.stat.fi/tk/yr/st2000.html, Statistics Finland; Tiede, teknologia ja tutkimus 2000:4, 79-85; http://www.minedu.fi/julkaisut/pdf/87kota.pdf.

88 Korkeakoulutuksen kansainvälisen toiminnan strategia, http://www.minedu.fi/julkaisut/ julkaisusarjat/23kk_kvstrategia/ 23kvstrategia.pdf

89 Ulkomailla tutkintoaan suorittavat suomalaiset 1991-2001, http://www.cimo.fi/tilastot/muut/ studabr.html.

90 Tieteellinen julkaisutoiminta, http://www.research.fi/k_julk_fi.html, 12.1.2002.

91 Taulukoita KOTA-tietokannasta.

92 Korppi-Tommola, Aura (1990 a), "Education - the road to work and equality", in: *The Lady with the Bow. The Story of Finnish Women*, ed. by Merja Manninen and Päivi Setälä (Otava , Helsinki 1990), 31-40.

93 Jaana Kuusipalo, Finnish women in politics, in: *Women in Finland*, (Otava Keuruu 1999,55.

94 Kaarninen, Mervi, *Nykyajan tytöt: koulutus, luokka ja sukupuoli 1920- ja 1930-luvun Suomessa* (Suomen Historiallinen Seura, Helsinki 1995); Korppi-Tommola (1990 a), 39.

95 Korppi-Tommola (1990 a), 33.

96 Korppi-Tommola, Aura (1990 b), "Fighting together for fFreedom. Nationalism, Socialism, Feminism and Women´s Suffrage in Finland 1906" in *Scandinavian Journal of History* Vol.15, no 3, 1990, 181-191.

97 Riitta Nikula, "Women in the History of Finnish Art", in *Lady with the Bow. The Story of Finnish Women*, ed. Päivi Setälä and Merja Manninen, (Keuruu 1990), 88-89.

98 Korppi-Tommola (1990 a), 37-38.

99 Ibid. 31-40.

100 Korppi-Tommola (1990 b), 185.

101 Raija Julkunen (1999), Gender, work, welfare state. Finland in comparison, *Women in Finland,* 79-80.

102 Other important reforms from point of view of women´s rights took place in 1970s. These were the liberal abortion law (1970) the institution of equality policy in government administration, contraception advice for all (the National Health Law, 1972), Separate taxation

for married people (1974), abolition of restrictions on women in government posts (1972-1976), equalising of the legal status of illegitimate children, children of divorced parents and children born in wedlock., see Julkunen (1999), 89.

103 *Statistical Yearbook of the Social Insurance Institution 1999.*

104 Hietala, (1991), 128-171.

105 Anna-Maija Lehto (1999), Women in working life in Finland, *Women in Finland,* 101-108.

106 The labour force and the persons not in the labour force 1995-1996, table 11.8 and table 16.12, *Statistical Yearbook of the City of Helsinki 1997.*

107 Julkunen (1999), 95-96.

108 Reseach results of Jorma Sipilä and Anneli Anttonen in Julkunen (1999), 83.

109 *Päivähoidon kasvatustavoitekomitean mietintö 1980.*

110 Kuusipalo (1999), 66.

111 Laki lasten päivähoidosta 36/1993, Asetus lasten päivähoidosta 239/1973

112 Childhood, in *Finland – a Cultural Encyclopedia,* 49.

113 *Statistical Yearbook of the City of Helsinki 2000.*

114 Based on statistics of visits of foreign experts. (Helsingin kaupunginvaltuuston painetut asiakirjat)(Minutes of the City Council of Helsinki).

115 Näyttelyluettelo, (Catalogue on exhibitions) Kaupunkisuunnitteluvirasto, Helsinki City Archives.

116 Kuusanmäki (1992.

117 Bengt Broms (1986), 262.

118 Ibid. 211-212.

119 Helsingin Sanomat 3.4.1965.

120 Yrjö Kaarne to the Finnish Embassy in Vienna, 30.11.1964, Archives of Foreign Affairs.

121 Ambassador Otso Wartiovaara to Bengt Broms, head of the Helsinki City Information Department, 16.3.1964. Archives of Foreign Affairs.

122 Yrjö Väänänen to section manager Matti Tuovinen, 26.10.1964; Yrjö Väänänen, Suomen esitteleminen Itävallan televisiossa (Presentation of Finland on Austrian television), 22.10.1964; Otso Wartiowaara, Helsinkiä esittelevä näyttely Wienissä 1965 ja siihen liittyvät kaupalliset tilaisuudet (An exhibition on Helsinki in Vienna 1965 and the commercial occasions related to it). 27.10.1964; Yrjö Väänänen, Helsinki-Tampere-Turku- näyttely Wienissä 1965 sekä siihen liittyvät Suomea esittelevät tilaisuudet (An exhibition on Helsinki, Tampere and Turku in Vienna 1965 and the occasions related to it, presenting Finland), 30.3.1965, Archives of Foreign Affairs.

123 Kolmen kaupunkimme näyttely avaa ovensa Wienissä tänään, Helsingin Sanomien kirjeenvaihtajalta 3.4.1965 ("The exhibition on three Finnish cities opens today in Vienna", from Helsingin Sanomat correspondent 3.4.1965).

124 Aussenminister Dr. Bruno Kreisky, Partner und Freund, AZ-Finnlandbeilage, Sonntag 4.4.1965

125 Helsinki, Turku ja Tampere esiintyvät keväiselle Wienille, Suomen Sosialidemokraatti 28.3.1965. (Helsinki, Turku and Tampere presented in Vienna spring, Suomen Sosialidemokraatti 28.3.1965.)

126 Otso Wartiovaara Ulkoasiainministeriölle 20.4.1965, (Otso Wartiovaara to Ministry of Foreign Affairs 20.4.1965) Archives of Foreign Affairs.

127 Finnlandausstellung: Bekanntschaft mit der Architektur von morgen, Arbeiter-Zeitung 4.45.1965.

128 Land mit Wohnkomfort, AZ-Finnlandbeilage 4.4.1965; Margarethe Scharsach, Finnlands Lebensstandard steigt, Presse 3/ 4.4.1965;Helsingin Sanomat 3.4.1965.

129 Zum Geburtstag 6 Caravelles, AZ-Finnlandbeilage 4.4.1965; Alois Brunnthaler, Bewunderer und Vorbild, AZ-Finnlandbeilage 4.4.1965; Finnland: Nicht Holz allein, AZ-Finnlandbeilage 4.4.1965.

130 Otso Wartiowaara Ulkoasiainministeriölle (Otso Wartiowaara to Ministry of Foreign Affairs); Helsinki-Tampere-Turku-näyttely Wienissä huhtikuussa 1965 sekä siihen liittyneet Suomea esitelleet tilaisuudet (An exhibition on Helsinki, Tampere and Turku in Vienna 1965 and the events related to it, presenting Finland), 20.4.1965, Archives of Foreign Affairs.

131 Helsinki-näyttely saanut hyvän vastaanoton Nürnbergissä. Koko kaupunki sinivalkoisissa väreissä. (Praise for the Helsinki exhibition in Nuremberg) Helsingin Sanomat 9.5.1965; Yli 33 000 kävijää näyttelyssä Wienissä. Nürnberg nyt vuorossa, (Over 33 000 visitors in Vienna, now the exhibition is in Nuremberg), Uusi Suomi 21.4.1965

132 Helsingin Sanomat 12.6.1965

133 Helsingin Sanomat 1.8.1965

134 Schweitzer, Robert, *Lübecker in Finnland* (Saksalaisen kulttuurin edistämissäätiö, Helsinki 1991).

135 Sähkejäljennös Lyypekistä Ulkoasiainministeriölle 1.10.1965 (A copy of telegram from Lübeck to Ministry of Foreign Affairs), Archives of Foreign Affairs

136 Hietala (1986), 176,-195.

137 Broms (1986), 213.

138 R.R. Seppälä Ulkoasiainministeriölle (R.R. Seppälä to Ministry of Foreign Affairs)10.5.1965; Helsingin

näyttelytoimikunnan puheenjohtaja Bengt
Broms R.R . Seppälälle (Chairman of the
Helsinki Exhibition Board, Bengt Broms to R.R.
Seppälä) 20.9.1965 ,Archives of Foreign
Affairs.

139 Helsingin Sanomien kirjeenvaihtaja Lauri Karen
(Pariisi) Suomalaisnäyttely herättää halun
käydä metsien maassa. le Figaro ylistää
arkkitehtuuriamme, (Helsingin Sanomat
correspondent in Paris Lauri Karen "Finland
Exhibition inspires people to visit the land of
forests. Le Figaro praises our architecture")
Helsingin Sanomat 15.2.1966.

140 Helsingin Sanomat 26.2.1966.

141 Helsingin Sanomat 5.10.1965.

142 Helsingin Sanomat 22.9.1966.

143 Helsingin Sanomat 19.2.1967.

144 Tatu Tuohikorpi Ulkoasiainministeriölle (Tatu
Tuohikorpi to Ministry of Foreign Affairs)
21.4.1966; Suurlähetystösihteeri O Väinölä
Ulkoasiainministeriölle (Secretary of Embassy
O. Väinölä to Ministry of Foreign Affairs)
13.4.1967; Bengt Broms johtaja Tatu
Tuohikorvelle (Bengt Broms to director Tatu
Tuohikorpi) 29.4.1967; Bengt Broms
suurlähettiläs Sigurd von Numersille (Bengt
Broms to Ambassador Sigurd von Numers)
14.7.1967; Pöytäkirja Helsinki viikon
merkeissä Fis Nationaal Verkeersbureau voor
de Beneluxin toimistossa (A minute relating to
the Helsinki week in the office of Fis Nationaal
verkeersbureau voor de Benelüx) 5.12.1967;
Sigurd von Numers Ulkoministeriölle (Sigurd
von Numers to Ministry of Foreign Affairs)
25.1.1968, Archives of Foreign Affairs.

145 Bengt Broms V.A. asiainhoitaja Ensio
Helaniemelle (Bengt Broms to Ensio Helaniemi)
30.10.1967, Archives of Foreign Affairs.

146 Helsingin Sanomat 13.9.1969.

147 See also Broms (1986), 214.

148 Broms (1986), 216-217.

149 Leo Tuominen 15.7-1976 to the Foreign
Ministry, Helsinki exhibition opening ceremony
in Los Angeles 14.4.1976; reply to Lord Mayor
Teuvo Aura's letter on the issue. Leo Tuominen
23.4.1976, Helsinki exhibition opening
ceremony in Los Angeles 14.4.1976;
Assessing the expediency of the exhibition,
Ulkoministeriön arkisto (Archives of Foreign
Ministry).

150 Leo Tuominen 23.4.1976, ibid.

151 Teuvo Aura to Secretary of State Matti Tuovinen
1.7.1976∏Leo Tuominen to the Foreign
Ministry 15.7.1976 . Helsinki exhibition
opening ceremony in Los Angeles (Archives of
the Foreign Ministry).

152 Kaarlo Juhana Yrjö-Koskinen, Telegram replica,
Budapest 1.6.1977 (Archives of the Foreign
Ministry).

153 Kaarlo Juhana Yrjö-Koskinen, Telegram to the
Foreign Ministry 26.5. 1978; 22.9.1978
(Archives of the Foreign Ministry).

154 The committee included representatives from
the city music board, the Finnish Broadcasting
Company, the Union of Finnish Composers, the
Finnish Musicians' Union, the Finnish Tourist
Board, the Workers' Travel Union, and the
Helsinki Society.

155 The United States Ambassador Avra Warren
was considered the father of the idea. A
summertime music festival in Helsinki being
planned. Vierumäki is the other alternative.
Uusi Suomi 15.11.1950.

156 Ringbom (1965) HKH V:2, p 340.

157 Valkonen, Kaija & Valkonen, Markku, *Festival
Fever. Finland Festivals* (Otava, Helsinki 1994),
25.

158 Musical America, July 1951.

159 More extensive Sibelius festival, Helsingin
Sanomat 26.5.1957.

160 Valkonen & Valkonen (1994), 9.

161 Ibid. 11.

162 Ibid. 122.

163 Ibid. 13.

164 Ibid. 11-13, 59-61.

165 The chairman of the committee was the
Chairman of the Helsinki City Music Board,
director Veikko Loppi, and members Olli Närvä
from the Ministry of Education; Alfons Almi,
director of the Finnish National Opera; Kai
Maasalo, the head of music at the Finnish
Broadcasting Company; Nils Eric Ringbom,
composer and the intendent of the Helsinki City
Orchestra; Viggo Groundstroem, CEO of
Musiikki Fazer, the largest concert agency in
Finland, and Verneri Veistäjä representing
theatrical intrests; Sibeliusveckan skall
ersättas av festspel, Hufvudstadsbladet
3.6.1964.

166 The name of the Sibelius Festival changes.
Committee report delivered to city government,
Helsingin Sanomat 3.6.1964.

167 "Sibelius Festival replaced by Helsinki Festival
Committee" report delivered yesterday, Kansan
Uutiset 3.6.1964

168 Valkonen & Valkonen (1994), 123-125, 127.

169 Ibid. 125.

170 Cantell, Timo, "Tarpeesta taiteeseen, taiteesta
tarpeeseen - Taiteiden yön tarina," in *Helsingin
Yö*. Eds by Jaana Lähtenmaa & Laura Mäkelä.
(Helsingin kaupungin tietokeskus, Helsinki
1995), 120-121.

171 Valkonen & Valkonen (1994), 128.

172 Lefebre (1991), 38-39; Cantell (1999), 139;
152-153.

173 Cantell (1999), 256-258.

Helsinki – the Music Capital of Finland

[1] The Helsinki Philharmonic Orchestra (est. 1882), the Radio Symphony Orchestra (1927), the Finnish National Opera Orchestra (1963), Sibelius Academy's Symphony Orchestra and Junior Strings of the East Helsinki College of Music are all based in Helsinki. Tapiola Sinfonietta (1988), the City Orchestra of Espoo, is noted for chamber music while the municipally subsidised orchestra in Vantaa has focussed its programme on light music. The Avanti!Chamber Orchestra (est. 1983) and the Finnish Chamber Orchestra (est. 1990) are freelance orchestras composed of the leading musicians of the country whereas the "Sixth Floor Orchestra," which specialises in early music, draws its members from young Finnish specialists who perform in other similar orchestras around Europe and gather a few times a year for rehearsals on 6th floor premises in Helsinki. (Antti Pajamo in *Finnish Music Quarterly* 1/1995,)

[2] Hako, Pekka, "Musiikin menestys" in *Kanava* 4-5/1999, 307; Wheatcroft, Geoffrey "On Top of the World" in *The Guardian* 30.11.2001.

[3] A good overall discussion of contemporary Finnish opera is given e.g. in Kuusisaari, Hannu, "Come, come I am a King" in *Nordic Sounds 3/*2000, 12-17.' *Helsinki European City of Culture 2000, Programme* , 141. The operas included in this programme demonstrated both the pluralism and nationalism of Finnish music at the end of the 20th century: one is about the famous Finnish athlete Paavo Nurmi, the other about King Lear while the third, "The Mastersingers of Mars" is based on cartoons.

[4] Salmenhaara, Erkki, "Birth of a national and Musical Culture in Finland" in *Finnish Music* by Kalevi Aho, Pekka Jalkanen, Erkki Salmenhaara and Keijo Virtamo (Otava Publishing Co Ltd, Helsinki 1996), 9, 27- 30. This gives a comprehensive and an up-to-date picture of Finnish musical life from the Swedish period until the mid-1990s A good overview until the mid-1960s is also given in *The Music of Finland* by Denby Richards (Hugh Evelyn, London 1968); *Finnish Music Quarterly* 1/ 1995, 5-6;

[5] Salmenhaara (1996), 36-39. Virtamo, Keijo, "Performing Music" in *Finnish Music* by Kalevi Aho, Pekka Jalkanen, Erkki Salmenhaara and Keijo Virtamo (Otava, Helsinki 1996),170.

[6] Salmenhaara (1996) gives a brief portrait of Sibelius (40-55) while Robert Layton has published a more extensive biography of Sibelius (*The Master Musicians: Sibelius* (J.M.Dent, London 1992) in addition to which he has translated into English the extensive three volume biography by Erik Tawaststjerna published by Faber & Faber, London.

[7] Richards (1968), 75-77; Virtamo (1996), 187-196.

[8] Jalkanen, Pekka, "Popular Music" in *Finnish Music* by Kalevi Aho, Pekka Jalkanen, Erkki Salmenhaara and Keijo Virtamo (Otava, Helsinki 1996), 210 (jazz); the tango came to Finland in 1913 (210). The article also discusses extensively the development of Finnish rock music.

[9] In 1994 the programme of Finnish festivals included more than 50 major cultural festivals. Of these 6 featured general music, 12 chamber music, 2 opera, 7 jazz and 2 rock. In addition there were 15 events dedicated to folk, brass and accordion music as well as some organ and choir music festivals, a major dance festival and a hugely popular tango festival. A detailed overview of cultural festivals in Finland is given in Valkonen, Kaija & Valkonen, Markku, *Festival Fever. Finland Festivals* (Otava, Helsinki 1994)

[10] Pohjola, Erkki - Tuomisto, Matti, *Tapiola Sound* (Werner Söderström, Porvoo, Helsinki, Juva 1992), 52-54.

[11] See e.g. Musica 7-9 (1980) and Musica 8-9 (1987) both published by Fazer, Helsinki. By the early 1990s this music teaching in Tapiola Secondary School alone had produced some hundred professional musicians or people working in the field of music as well as other people distinguished in such creative fields as film, animation and poetry (Pohjola-Tuomisto (1992), 65, 230-231).

[12] Ibid. 73-76.

[13] Ibid. 58-59.

[14] *Mitä-missä-milloin 1974*, 362.

[15] *Finnish Music Quarterly* 1/1995, 10; Jalkanen sees the UMO big band as an essential outlet for Finnish jazz composers and arrangers (Jalkanen (1996), 214-215).

[16] Jalkanen (1996), 236.

[17] Richards (1968), 73.

[18] Aho, Kalevi, "Finnish Music in the Post-War Years" in *Finnish Music* by Kalevi Aho, Pekka Jalkanen, Erkki Salmenhaara and Keijo Virtamo (Otava, Helsinki 1996), 123-124.

[19] Ibid. 139-140.

[20] Ibid. 104-106.

[21] Ibid. 140-141.

[22] Rantanen, Miska, *Lepakkoluola. Lepakon ja Liekkihotellin tapahtumia ja ihmisiä 1940-1999* (Werner Söderström, Porvoo-Helsinki-Juva 2000), 92.

[23] Jalkanen (1996), 220.

[24] Inter-Rail travel had become increasingly popular in the 1970s and in the peak years of Inter-railing 1985 and 1986 some 20,000 young Finns travelled by Inter-rail to Europe.

Among the most important destinations was London, the trendsetter of music and youth wear. Berlin and New York were other attractive urban metropolises for young Helsinki people in the early 1980s. (Rantanen (2000), 132,137)

25 Ibid. 96. Succeeding Kaivopuisto festivals were even bigger events attracting 25 -30,000 people (Ibid. 106), and by 1982 the arrangements had become so demanding that the star of the event, Markku Arokanto, arrived by helicopter (Arokanto, Rantala interview).

26 *Elmu* was one of the first cultural organisations in the Finland of the 1970s consciously to distance itself from any political delineation. This attracted young people, who had observed during their inter-rail trips the underground cultures in Central European cities and saw now an opportunity to introduce similar activities in Finland. (Rantanen (2000), 92-95).

27 Among the first and prominent supporters of Elmu in the City Council were Erkki Tuomioja, (the Social Democrat assistant city manager and one of the most prominent youth politicians of the 1960s) as well as the Conservatives Sem Schubak and Ben Zyskowicz and the Social Democrat Arja Alho. (Rantanen (2000), 83-85, 120-123).

28 Markku Arokanto and Jaana Rantala both emphasise this strict policy of making no discrimination against any youth group wishing to use the premises. This gradually attracted a great variety of youth groups ranging from those with a general interest in avant-garde culture to anarchist punks and motorcycle groups and helped to overcome the confrontational attitudes of youth groups dating from the 1960s. (Interview 17.10.2001) Later it was also used by established performance and theatre ensembles as well as fashion shows and dance schools. After 1982 Lepakkoluola became also a concert venue for a number of foreign bands. Some scenes in the films *Calamari Union* (1985) by Aki Kaurismäki and *Zombie and the Ghost Train* (1991) by Mika Kaurismäki were shot in Lepakkoluola as were a few music videos. (Rantanen (2000) 125-129, 137, 150).

29 Ibid. 117-118,160-163.

30 The name Radion City was chosen to attract all sub-cultures and freak groups in the city. (Ibid. 140-146).

31 Ibid. 170; Jalkanen (1996), 220.

X High Tech Helsinki

1 *The Daily Telegraph*, special report 25.3.1999

2 *The Daily Telegraph* special report 25.3.1999; The Guardian Online 16.9.1999

3 *High Technology Finland 1999* Herring, Peter (Ed.) (Finnish Academies of Technology, Forssa 1998), 10-11.

4 *Finland a cultural encyclopedia* 1997, 277.

5 Lukkonen (1997), 65.

6 Michelsen has referred to the minutes of the estates in the Nobility, the Clergy and the Peasants of the Diet of 1867 and points out that although all the estates approved the suggestion of transforming the Helsinki Realschule into a polytechnic institute the Senate and its manufacturing board delayed action so that it was not until 1872 that the Helsinki Polytechnic Institute was operational. (Michelsen (1993), 37-40). However, advanced technical teaching was organised in Helsinki quite early compared with, for example, Manchester, where the Mechanics Institute became Manchester Technical School ten years later, in 1882 (Kidd (1996), 157).

7 Hoffman, Kai "Elinkeinot" in *Helsingin historia vuodesta 1945*. (Helsingin kaupunki, Helsinki 1997), 305.

8 Estola, Kari-Pekka, Nokia Research Centre, *Tutkas 3/1998* (ed. Ulla Gabrielsson and published by the Society of Finnish Parliamentarians and Scholars, Helsinki) , 27.

9 Häikiö, Martti (2001 a), *Nokia Oyj:n historia. 1:Fuusio* (Edita, Helsinki 2001), 74-75.

10 Hoffman, Helsingin historia vuodesta 1945 (1997), 297.

11 Jotuni, Pertti, "Tekniset tieteet" in *Suomen kulttuurihistoria 3. Itsenäisyyden aika*. (WSOY Porvoo 1984), 308.

12 Michelsen (1993), 177.

13 Lagerspetz, Kari, "Luonnontieteet" in *Suomen kulttuurihistoria 3. Itsenäisyyden aika*. (WSOY Porvoo 1984), 290; on page 266 he quotes the comments in 1947 on the shortage of funds and assistants by Prof. Gustaf Komppa, a former professor of chemistry in the Helsinki University of Technology.

14 Michelsen (1993),119, 184. Michelsen quotes Prof. Martti Levon, the rector of the University of Technology in Helsinki. This phenomenon was, however, quite common in post-war Europe, and for example, British scientists were keen to move to the USA and Canada in order to have better research facilities. This "brain-drain" continued for several decades.

15 Ibid. 188-191.

16 Cited in Kuisma, Markku, *Kylmä sota, kuuma öljy. Neste, Suomi ja kaksi Eurooppaa* (WSOY, Porvoo 1997), 550.

17 Jalonen, Olli, *Kansa kulttuurien virroissa*.

Tuontikulttuurin suuntia ja sisältöjä Suomessa itsenäisyyden aikana (Otava, Helsinki 1985), 36. Finland's first bi-lateral cultural exchange agreements were ratified with Hungary and Estonia (both in 1937) and with Poland (1938) and Finland was among the first to employ this method of international co-operation. After the Second World War Finland made a number of important cultural exchange agreements between 1947 and 1955 with both the US and the USSR. However, the majority of the bi-lateral cultural agreements have come into force since 1959, when the first was made again with Hungary (now the Socialist People's Republic) followed by the USSR and Sweden (both in 1960) and Poland (1964). The 1970s was a decade of 18 such agreements including that with France 1970, Czechoslovakia 1973, Great Britain, Italy, DDR and USA in 1976. The first five years of the 1980s saw 13 new agreements (Jalonen (1985), 28-29).

18 Kuisma (1997), 552-555.

19 Hoffman, Helsingin historia vuodesta 1945 (1997), 304-306.

20 Ibid. 286.

21 Jotuni (1984), 322.

22 Hoffman, Helsingin historia vuodesta 1945 (1997), 297.

23 Salokangas, Raimo, "The Finnish Broadcasting Company and a Changing Finnish Society 1949-1996" in *Yleisradio 1926-1996. A History of Broadcasting in Finland*, (ed. Rauno Endén) (Finnish Historical Society, Helsinki, 1996), 133-135. It is ironic to note, that by the end of the 1960s Finnish television could be seen but not heard in Estonia. Once the Estonians had acquired apparatuses for receiving the sound from across the Gulf of Finland in the 1970s, the whole of Northern Estonia was able to follow the international news through the TV broadcasts of their Finnish neighbours. (Lapin, Leonhard, *Pimeydestä valoon. Viron taiteen avantgarde neuvostomiehityksen aikana.* (Otava, Helsinki 1996), p 98)

24 Salokangas (1996),134.

25 Blomstedt, Yrjö, "Korkeakoululaitos ja tiedepolitiikka" in *Suomen kulttuurihistoria 3: Itsenäisyyden aika* (WSOY, Porvoo-Helsinki-Juva 1984), 145.

26 Häggman, Kai, *Suurten muutosten Suomessa. Kansaneläkelaitos 1937-1997* (Kansaneläkelaitos, Helsinki 1997), 108, 120-121.

27 Ibid. 121

28 Pipping (1962), 408.

29 Michelsen (1993), 223.

30 Jotuni (1982), 322.

31 Kanervisto, interview 19.11.1999.

32 Wegg, John, *Finnair. The Art of Flying since 1923* (Finnair, Helsinki, 1983), 137-138; *The Times* 23.10.1969.

33 Uola, Mikko, *Ylitse maan ja veen" 1924-1999: Suomen liikennelentäjäliitto ry:n 50-vuotisjuhlajulkaisu* (Helsinki, 1999), 192.

34 Wegg (1983), 138.

35 Uola (1999), 197,200.

36 The Helsinki Student's Health Centre, for example, used a computer in the early 1980s for registering appointments for patients (*Suomen Kulttuurihistoria 3* (1984), 321).

37 Mäkinen, Ilkka, "Heittämällä tulevaisuuteen: kirjastot vuoden 1961 lain jälkeen" in *Kirjastojen vuosisata. Yleiset kirjastot Suomessa 1900-luvulla*, (Ed. Ilkka Mäkinen) (BTJ Kirjastopalvelu, Helsinki 1999),196.

38 Hirvonen, interview 17.11.1999.

39 *The Times* 28.5.1976.

40 *Orava* 8/1980, 6,28.

41 Hirvonen, interview 17.11.1999.

42 Mauranen, Tapani, *aksi! Matka suomalaisen taksin historiaan.* (Suomen Taksiliitto ry. Forssa 1995), 356-357.

43 Häikiö, Martti, *Nokia - The Inside Story* (Pearson Education, London 2002), 49-54; Further analysis given in Kuisma, Markku, "Suomi Nokiana, Nokia Suomena eli metsäteollisuuden maan muodonmuutos teleteknologian pikkujättiläiseksi" in *Suomi: maa, kansa,kulttuurit* (Ed. by Kolbe, Laura & Löytönen, Markku) (Suomalaisen Kirjallisuuden Seura, Helsinki 1999), 172, 174-178.

44 Hoffman, Helsingin historia vuodesta 1945 (1997), 290.

45 Herranen, Timo, *Valtakunnan sähköistyskysymys. Strategiat, siirtojärjestelmät sekä alueellinen sähköistys vuoteen 1940.* (Bibliotheca Historica 14. Suomen Historiallinen Seura. Helsinki 1996), 82-83, 107-108.

46 Hoffman, Helsingin historia vuodesta 1945 (1997), 290.

47 Häikiö (2002), 54-56; Kuisma (1999), 178; Wuorenheimo, interview 5.11.1999.

48 Häikiö (2001a), 91-92.

49 Wuorenheimo, interview 5.11.1999.

50 Wuorenheimo, interview 5.11.1999.

51 Klinge 1990, appendix. Teaching of computer sciences had actually started a couple of years earlier in Finland in Tampere and later Helsinki Universities as part of courses on other mathematical subjects. (Wuorenheimo, interview 5.11.1999)

52 Häikiö (2002), 56-57; Hoffman, Helsingin historia vuodesta 1945 (1997), 290-291; Developments listing 5.3.1997 in the archives of MikroMikkoOy.

53 Kuisma (1997), 507.

54 *Towards Telecommunications* (1999), 7-9. See also Häikiö (2002), 56-59, 68.

55 Ibid, 11.

56 Wuorenheimo, interview 5.11.1999; Niininen, Petri, "Nokian valtatie" in Kansantaloudellinen aikakauskirja 4/1999.
57 *Towards Telecommunications*, (1999), 9; Wuorenheimo, interview 5.11.1999.
58 Turpeinen, Helsingin kaupungin historia vuodesta 1945 (1997), 66.
59 Häikiö (2002), 58-59.The same principle of asking tenders from Finnish and foreign suppliers had also been, since the 1920s, a standard practice among Finnish state and private enterprises as well as in infrastructure projects when these were looking for the highest quality products available. This forced for example Suomen Kaapelitehdas to ensure that their product quality was always very advanced by international standards in spite of their dominant position in Finland as a cable supplier in the 1930s onwards. Similarly the Finnish metal industry companies had to face international competition before getting orders from the fast growing Finnish forestry industries, and this helped them to become internationally significant manufacturers of, for example, paper making machines. Kuisma (1999), 178-179.
60 Lukkonen, (1997), II section, 8.
61 Heinonen, ICL, interview 18.2.2000; Häikiö (2001b), 114.
62 *Kotimaisia Mikro Mikkoja vuodesta 1981.* A 6 page summary of developments, dated 5.3.1997. Mikro Mikko Oy:n arkisto.
63 Häikiö (2002), 106-110, see also Chapter 7 for Nokia's television productions; Niininen (1999), 854.
64 Häikiö (2002), 76-77; *Towards Telecommunications* (1999), 22.
65 Häikiö (2002), 29-30, and Chapter 15-17; Häikiö (2001 c), 236-242, 244, 264-265.
66 Castells, Manuel & Himanen,Pekka, *Suomen tietoyhteiskuntamalli* (WSOY & SITRA, Helsinki 2001), 29-32. See Häikiö (2002), 167-171 and Chapter 18.
67 Häikiö (2002), 115-116, 184-186; Häikiö (2001 a), 22; Castells & Himanen (2001), 26,37.
68 Developments listing 5.3.1997 in the archives of MikroMikko Oy.
69 Hoffman, Helsingin historia vuodesta 1945 (1997), 297-298.
70 Ehrstedt, ICL, interview 21.2.2000.
71 Hoffman, Helsingin historia vuodesta 1945 (1997), 293-295.
72 Nuutinen, ABB, interview 17.2.2000; Heinonen, ICL, interview 18.2.2000.
73 Nuutinen, ABB, interview 17.2.2000.
74 Heinonen, ICL, interview 18.2.2000.
75 Ronkainen, ABB, interview 17.2.2000.
76 Estola, Nokia, in *Tutkas 3/1998*, 27-29. See Häikiö (2002), 184-186.

77 Michelsen (1993), 186.
78 Helsingin kaupungin tietokeskus- tilastoja
79 *High Technology Finland (1999)*, 11.
80 Ahlholm, Amiedu, interview 20.2.2000.
81 educ@se 1/1999(Customer magazine, published by Amiedu, Helsinki 1999), 14-16. The project was also publicized for example in http://www.icl.fi/ajassa/1999/touko/piimaki/htm.
82 Michelsen (1993), 264-265.
83 Saarnivaara, Veli-Pekka, TEKES, in *Tutkas 3/1998*, 11.
84 Häikiö (2002), 116; Michelsen (1993), 329.
85 Nuutinen, ABB, interview 17.2.2000.
86 Ehrstedt, ICL, interview 21.2.2000.
87 *High Technology Finland 1999*, 58.
88 Estola, Nokia, in *Tutkas 3/1998*, 27; Nuutinen, ABB, interview 17.2.2000; Lammintausta, Risto, Hormos Medical Oy, *Tutkas 3/1998*, 46.
89 Based on data received 23.11.1999 from the library of Patentti ja rekisterihallitus, (National Board of Patents and Registration of Finland) Helsinki.
90 *World Competitiveness Yearbooks 1997-2001* (International Institute of Management, Lausanne, Switzerland).
91 Castells & Himanen (2001), 65.
92 Ibid. 64-67.
93 Ibid. 64-67, 71-73.
94 Ibid., 73-74.
95 Ibid. 74-75.
96 Sävilammi J., interview 19.3.2002. Innopoli in the university campus provides premises for start-up firms, which can also use the resources of the university, and it is a part of a general drive to encourage business formation (Smalén and Sävilammi, M., interview 2.3.2002). Students of the Helsinki University of Technology have traditionally been noted for their initiative. The Teekkarikylä student campus in Otaniemi was established in the early 1950s on their own initiative and by their own fundraising efforts requiring vision, leadership qualities and innovativeness in carrying out the projec; this "business culture," which invariably involved a form of humour peculiar to technology students, was supported by the University. Later generations of students have maintained this tradition in their numerous campaigns for topical good causes. These included raising funds for technological research in 1953 and drawing attention, in the 1990s, to issues of mental health and the use of time. Students have also organized annual national competitions between technology universities for the most innovative student pranks (in Finnish "jäynä"). (Levón, Martti, *Tekniikka, työ ja teekkarihenki. Insinöörin muistelmia.* (WSOY, Porvoo-Helsinki, 1967), 271-279; Myllykangas, interview

19.7.2001, see also http://www.tky.hut.fi/Ossi85)

97 *High Technology Finland 1999*, 40.
98 Michelsen (1993), 193-200.
99 *Helsingin Sanomat* 1.8.1999, Section E, 1.
100 Joe White in *High Technology Finland 1999*, 10-11.
101 *High Technology Finland 1999*, 44-45.
102 Lammintausta, *Tutkas 3/1998*, 47; Tampere University of Technology concentrated on semiconductor research and by 1998 this resulted in the foundation of two companies in Tampere region specialising in the products of semiconductor technology. At that time a third such company operated in the Helsinki region while there was none in the whole of Scandinavia. (Pessa, Markus, Tampere University of Technology, *Tutkas 3/1998*, 41); In the field of medicine universities of Turku, Kuopio and Oulu have developed academic culture which has resulted in the emergence of medical innovation companies. *Tutkas 3/1998* listed 8 in Kuopio, 14 in Turku, 4 in the Helsinki region and one in Oulu (*Tutkas 3/1998*, 49-50, 53). The vital role of the University of Oulu in the development of the Nokia mobile phone has been mentioned earlier.
103 Kyhäräinen, Jukka & Pilli-Sihvola, Mirva, "Virtual University" in *Universitas Helsingiensis 3/1998* , 12-14.
104 Kaijanto, ICL, interview 17.2.2000.
105 Landry (1998), 55.
106 *High Technology Finland 1999*, 32.
107 Landry (1998), 55.
108 Ibid. 50, 57.
109 *The Guardian*, 18.9.1999.
110 Quoted in Palmén (1881), 111.

XI Helsinki – the Innovative City

1 Helsinki was seen above all as a modern city by the following observers: Maxwell (1848), 85; Atkinson (1873), 144; Gallenga (1881), 111; Ganivet (writing in 1896) (1949), 13; Gilmore (1931), 81; Hall (1967), 33; Cowie (1976), 10; British journalists writing 1948-1996 (*Helsingin imago Lontoossa* (Helsingin kaupunginkanslian tiedotustoimisto, 1998)), p 41.
2 An American diplomat, James Ford Cooper, noted that in Helsinki there were more foreigners, more cultural events and more street cafes in 1995 than in 1986 when he worked in Helsinki. (Cooper, James Ford, *Asemamaana Suomi. Amerikkalaisdiplomaatti*

Suomessa kylmän sodan aikana. (Kustannus Oy Tammi, Helsinki 1998), 276).

3 The British film critic Peter Cowie recognized a major change in the Finnish film industry. Having previously lagged a decade or so behind the rest of the world Finnish films had , by the early 1990s, clearly reached European professional standards. (Cowie, Peter, *Finnish Cinema*. (Finnish Film Archive and VAPK-Publishing, Helsinki 1991), 9).
4 Cowie had visited Helsinki in the mid-1970s and had commented on the empty streets in Helsinki after dusk. (Cowie, Peter, *Finnish Cinema* (The Tantivy Press, London, A.S. Barnes . South Brunswick and New York and The Finnish Film Foundation, Helsinki, 1976), 10); for comments on Helsinki night life in the late 1990s see *Le guide du routard: Finlande, Islande 1999/2000*, (Hachette Tourisme, Paris 1999), 90).
5 Landry (1998), 6.
6 http://worldbank.org/poverty/scapital
7 A classic study of the impact of a sub-Arctic climate in Finland is Mead, W.R. and Smeds, Helmer, *Winter in Finland* (Hugh Evelyn , London 1967).
8 Finland was never too isolated from European movements and intellectual trends. Mikael Agricola, for example, studied under Luther in Wittenberg and Alexander Armfelt at the beginning of the 19th century in Edinburgh while Yrjö Kauko, a civil engineer from Helsinki, attended the lectures of Albert Einstein and Gunnar Nordström, another Finn, was developing his own theory of relativity at the same time as Einstein. (Keskinen, Raimo, Gunnar Nordström – Suomen Einstein, Tieteessä tapahtuu 7/1997).

Bibliography

PRIMARY SOURCES
ARCHIVES:

Archives of Foreign Ministry:
Records on Helsinki, Turku, Tampere-exhibitions

The Archives of the Matriculation Examination Board:
The Statistics of the Matriculation Examination
Board, Helsinki

Archives of MikroMikko:
Developments listing on 5.3.1997

Helsinki City Archives:
Annual Reports of the Helsinki Municipial
Administration (AR) 1918-1969
Catalogue on exhibitions. Kaupungin
suunnitteluvirasto
Finance Department of Helsinki City (FD) 1927,
1929-1930
Helsinki City Board of Health Annual Reports 1910-
1911
Minutes of the City Council of Helsinki (CC)
Minutes of the Helsinki City Executive Board (CEB)
1918-1919, 1923, 1932, 1936-1939
Suomen Messut Helsingissä 1920, Luettelo

National Archives:
Konrad Relander, Kertomus hygieeniseltä
opintomatkalta Eurooppaan 1894-1895.
Lääkintöhallitus, matkakertomukset

Stockmann Archives:
The British Week

STATISTICS:

Arts and Culture, Tilastoja 1999: 15 (Helsingin
kaupungin tietokeskus, Helsinki 1999)
*Bidrag till Finlands officiella Statistik I, Finlands
Sjöfart och Handel åren 1856-1865. Andra
häftet; Suomenmaan Virallinen Tilasto I. Toinen
jakso. Katsaus Suomen ulkomaiseen
merenkulkuun ja kauppaan vuosina 1866-1870*
(Helsinki 1872)
*Bidrag till Finlands officiella Statistik IA, Finlands
handel på Ryssland och utrikesresor, Januari
1905,* (Helsingfors 1905)
Finland in Figures (Statistics Finland, Helsinki
1999)
Finland in Figures (Statistics Finland, Helsinki
2000)

Helsingin kaupungin tilastollinen vuosikirja 1999
(Helsingin kaupungin tietokeskus, Helsinki 1999)
*Helsinki Region 2000. Statistical Comparisons
2000* (Helsingin kaupungin tietokeskus, Helsinki
2000)
*Helsinki tilastoina 1800-luvulta nykypäivään.
Tilastoja 2000:15* (Helsingin kaupungin
tietokeskus, Helsinki 2000)
*Statistical Yearbook of Finland 1908 / Statistisk
Årsbok för Finland sjätte årgången 1908* (Helsinki
1908)
Statistical Yearbook of Finland 1989
(Tilastokeskus, Helsinki 1989)
Statistical Yearbook of Finland 1992 (Tilastokeskus,
Helsinki 1992)
Statistical Yearbook of Finland 1999 (Tilastokeskus,
Helsinki 1999)
Statistical Yearbook of Finland 2001 (Tilastokeskus,
Helsinki 2001)
Statistical Yearbook of the City of Helsinki 1934
(Helsingin kaupunki, Helsinki 1934)
Statistical Yearbook of the City of Helsinki
(Helsingin kaupunki, Helsinki 1953-1996)
Statistical Yearbook of the City of Helsinki
(Helsingin kaupungin tietokeskus, Helsinki 1997)
Statistical Yearbook of the City of Helsinki
(Helsingin kaupungin tietokeskus, Helsinki 1998)
Statistical Yearbook of the City of Helsinki
(Helsingin kaupungin tietokeskus, Helsinki 1999)
Statistical Yearbook of the City of Helsinki
(Helsingin kaupungin tietokeskus, Helsinki 2000)
Statistical Yearbook of the Social Insurance
Institution 1999
(Kansaneläkelaitos, Helsinki 2000)
*Statistics Finland, regional employment statistics
1993-1998* (Tilastokeskus, Helsinki)
Statistics 1999:15. City of Helsinki Urban Facts
(Helsinki, 1999)
Tiede ja teknologia 2000
(Tiede, teknologia ja tutkimus 2000:4)
(Tilastokeskus, Helsinki 2000)
Tutkimus- ja kehittämistoiminta Suomessa
(Tilastokeskus, Helsinki 1999)
Yearbook of Nordic Statistics, Vol. 24: 1985
(Nordiska rådet, Stockholm 1986)

OTHER PRIMARY SOURCES:
Asetus lasten päivähoidosta 239/1973
Ehnrooth, Leo, Minutes of the Association of the
Finnish towns in 1912, Suomen kaupunkiliiton
pöytäkirjat 1912 (Suomen kaupunkiliitto)

Helsingin kaupunginkirjaston toimintakertomus 1999
(Helsingin kaupunginkirjasto, Helsinki)
Helsinki European City of Culture 2000, Programme
(Helsinki 2000)
Laki lasten päivähoidosta 36/1993
Naisten tutkijanuran seurantatyöryhmän muistio
29.2.2000 (Academy of Finland, Helsinki 2000)
Päivähoidon kasvatustavoitekomitean mietintö
(Valtioneuvosto, Helsinki 1980)

NEWSPAPERS AND PERIODICALS:
AZ-Finnlandbeilage, Sonntag 4.4.1965
Die Arbeiterzeitungen 1965
Daily Telegraph 1999
educ@se 1/1999(Published by Amiedu, Helsinki
1999)
Express am Morgen 1965
Frankfurter Allgemeine Zeitung 2002
Guardian 1999
Helsingin Sanomat 1933, 1957, 1964-1969, 1999
Hufvudstadsbladet 1933, 1964
Iltalehti 2002
Ilta-Sanomat 2001
Kansan Uutiset 1964
Nuori Suomi *1899-1901*, Helsinki
Orava 1/1981, Helsinki
Die Presse 1965
Suomen Sosialidemokraatti 1965
The Times 1976
Tutkas *3/1998* (Published by the Society of Finnish
Parliamentarians and Scholars, Helsinki)
Uusi Suomi 1933, 1950, 1965-1969

LITERATURE

Aav, Marianne, "A.W. Finch, professeur a l'Ecole
Centrale des Arts Décoratifs" in *A.W. Finch 1854-*
1930. Catalogue of "Alfred William Finch 1854-
1930" exhibition at the Musées royaux des
Beaux-Arts de Belgique à Bruxelles (Crédit
Communal, Brussels 1992)
Aho, Kalevi, "Finnish Music in the Post-War Years"
in *Finnish Music* by Kalevi Aho, Pekka Jalkanen,
Erkki Salmenhaara and Keijo Virtamo (Otava,
Helsinki 1996)
Ahonen, Kirsi, "Sivistystä ja kasvatusta
työväestölle. Ulkomaiset mallit ja niiden
soveltaminen" in *Tietoa, taitoa, asiantuntemusta.*
Helsinki eurooppalaisessa kehityksessä 1875-
1917 III: Henkistä kasvua, teknistä taitoa (ed.
Kirsi Ahonen, Marjaana Niemi, Jaakko Pöyhönen).
(Hark 99:3 Finnish Historical Society, Helsinki
1992)
Akseli Gallen-Kallela, exhibition catalogue 1996
(The Finnish National Gallery, Ateneum, Helsinki
1996)

Alanen, Pertti, *Ilmatorjuntavoitto 1944: Helsinki*
pelastui (Porvoo 1994)
Annual Report 1998 (The Finnish Fair Corporation
Annual report, Finnexpo 1998)
Anttila, Aarne, "Kulttuurielämä" in *Helsingin*
kaupungin historia IV:2. Ajanjakso 1875-1918
(Helsinki 1956)
Ars Universitaria 1640-1990. Portraits from the
Collections of the University of Helsinki.
Biographical notes by Prof. Matti Klinge (Helsinki
1990)
Arttu 3/2000, published by the University of
Industrial Art in Helsinki
Ateneum Maskerad. Taideteollisuuden muotoja ja
murroksia, päätoimittaja Yrjö Sotamaa
(Taideteollinen korkeakoulu, Helsinki 1999)
Atkinson, J. Beavington, *An Art Tour to Northern*
Capitals of Europe (Macmillan & Co, London
1873)
von Bagh, Peter, *Suomalaisen elokuvan kultainen*
kirja (Keuruu 1992)
Bater, James H., *St Petersburg. Industrialization*
and Change. Studies in Urban History 4, General
editor H.J.Dyos (Edward Arnold, London 1976)
Beijar, Kristina, "Under the Swedish King" in *Life in*
Two Languages - the Finnish Experience (Schildts,
Espoo 1997)
Bell, Robert & Tight, Malcolm, *Open universities. A*
British tradition? (The Society for Research into
Higher Education & Open University Press,
Buckingham 1993)
Benedict, Burton, *The Anthropology of World's*
Fairs. San Francisco Panama Pacific International
Exposition of 1915 (Scholar Press, Berkeley
1983)
Björkqvist, Heimer, "Merenkulku ja liikenne" in
Helsingin kaupungin historia V:3 (Helsinki 1967)
Björkvist, Heimer, "Teollisuuden kehitys Helsingin
kaupungissa vv. 1918-1945" in *Helsingin*
kaupungin historia V:3 (Helsinki 1967)
Blackbourn, David, *The Fontana History of Germany*
1780-1918: The Long Nineteenth Century
(Fontana Press, London 1997)
Blomstedt, Yrjö, "Korkeakoululaitos ja
tiedepolitiikka" in *Suomen kulttuurihistoria 3:*
Itsenäisyyden aika (WSOY, Porvoo-Helsinki-Juva
1984)
von Bonsdorff, Bertel, *The History of Medicine in*
Finland 1828-1918 (Societas Scientiarum
Fennica, Helsinki 1975)
Borgström, Henrik, *Om Hypoteks-föreningar* (Finska
Litteratur-sällskapets tryckeri, Helsingfors 1858)
Borgström, Henrik,'*Penningställningen år 1859 och*
privatbanker (Wasenius, Helsingfors 1859)
Broms, Bengt, *Elämää sivusta sisältä sitoutumatta*
(WSOY, Porvoo 1986)
Brunila, Birger, "Asemakaava" in *Helsingin*
kaupungin historia IV:1(Helsinki 1955)
Buckle, Richard, *Diaghilev* (Hamish Hamilton,
London 1979)

Burleigh, Michael, *The Third Reich: A New History* (London, Macmillan 2000)

Byckling, Liisa, "Teatterivierailuja vuosisadan vaihteessa" in *Suomi & Pietari* (Ed. Maija Lapola) (WSOY, Juva 1995)

Cantell, Timo, "Tarpeesta taiteeseen, taiteesta tarpeeseen - Taiteiden yön tarina," in *Helsingin Yö.* Eds by Jaana Lähtenmaa & Laura Mäkelä (Helsingin kaupungin tietokeskus, Helsinki 1995)

Cantell, Timo, *Helsinki and a vision of place* (City of Helsinki Urban Facts, 1999)

Castells, Manuel, *The Information Age. Economy, Society and Culture. Vol. I: The Rise of the Network Society* (Blackwell, Oxford 1996)

Castells, Manuel, *The Information Age. Economy, Society and Culture. Vol II: The Power of Identity* (Blackwell, Oxford 1997)

Castells, Manuel, *The Information Age. Economy, Society and Culture. Vol III: End of Millennium* (Blackwell, Oxford 1998)

Castells, Manuel & Himanen,Pekka, *Suomen tietoyhteiskuntamalli* (WSOY & SITRA, Helsinki 2001)

Castrén, Gunnar, "Helsinki kulttuurikeskuksena" in *Helsingin kaupungin historia III:2. Ajanjakso 1809-1875* (Helsinki 1951)

Castrén, Matti J., "Helsingin koti- ja ulkomaankauppiaat vv. 1809-1853" in *Kauppiaiden ja merenkulkijain Helsinki* (Entisaikain Helsinki V. Helsinki-Seura 1954)

Christ-Janer, Albert, *Eliel Saarinen. Finnish-American Architect and Educator.* Rev. edition. (The University Chicago Press, Chicago & London 1984)

Claustrat, Frank,"L´œuvre d´Albert Edelfelt et sa reception en France 1877-1889", in *L´Horizon inconnu. L´art en Finlande 1870-1920.* (Ateneum, Helsinki 1999)

Cooper, James Ford,'*Asemamaana Suomi. Amerikkalaisdiplomaatti Suomessa kylmän sodan aikana*'(Tammi, Helsinki 1998)

Copeland, William R., "Laughing Pills. Personal Snapmemories of the Pearl-of-the-Baltic," in *Helsinki 450-vuotias. Kaupunki meren sylissä. Helsinki info. Juhlanumero 12.6.2000*

Cowie, Peter, *Finnish Cinema* (The Tantivy Press, London, A.S. Barnes . South Brunswick and New York and The Finnish Film Foundation, Helsinki, 1976)

Cowie, Peter, *Finnish Cinema.* (Finnish Film Archive and VAPK- Publishing, Helsinki 1991

Craig, Gordon A., *Germany 1866-1945* (Clarendon Press, Oxford 1978)

Damaschke, Adolf, *Kunnallispolitiikan tehtävistä.* Suom. ja suomalaisia oloja koskevilla lis. varustanut Eino Kuusi (WSOY, Porvoo 1908)

Damstén, Birger, *Stockmann sadan vuoden aikana* (Stockmann, Helsinki 1961) / Damstén, Birger, *Stockholm genom hundra år* (Helsingfors 1961)

Donner, Jörn, *Fazer 100* (Oy Karl Fazer Ab, Keuruu

1991)

Dukes, Paul, *A History of Russia. Medieval, Modern, Contemporary.* 2nd Edition (Macmillan, London 1990)

The Economic History of Finland. 3: Historical Statistics. Kaarina Vattula (ed.) (Tammi, Helsinki 1983)

Ekelund, Hilding, "Rakennustaide ja rakennustoiminta 1918-1947" in *Helsingin kaupungin historia V:1* (Helsinki 1962)

Encyclopedia Britannica 1967: 3 (London 1967)

Encyclopedia Britannica 1967: 6 (London 1967)

Engman, Max (1992a), "The Finns in St Petersburg" in *Ethnic Identity in Urban Europe. Comparative Studies on Governmets and Non-dominant Ethnic Groups in Europe, 1850-1940, Vol VIII,* ed. by Max Engman in collaboration with Francis W. Carter, A.C. Hepburn and Colin Pooley (European Science Foundation, New York University Press, Dartmouth 1992)

Engman, Max (1992b), *Kaksoiskotka ja Leijona. Nikolai Valapaton muisto ja muita kirjoituksia* (Kleio ja nykypäivä. VAPK-Kustannus, Helsinki 1992)

Erkamo, Viljo, "Kuka muistaa "Suomen nuorison iskujoukot"?" in *Narinkka* (Helsingin kaupunginmuseo, Helsinki 1989)

Eskelinen, Heikki, *Sata vuotta suomalaista henkivakuutustoimintaa. Vakuutusyhtiö Kaleva 1874-1974* (Keskinäinen vakuutusyhtiö Kaleva, Espoo 1978)

Eskelinen, H. (ed.), Regional Specialisation and Local Environment - Learning and Competitiveness (NordREFO 1997)

Estola, Kari-Pekka, *Huipputekniikan tutkimus – Suomen kehityksen moottori?* (Tutkas julkaisuja 3/1998 Ed. By Ulla Gabrielson)

Eyre, Karen – Galinou, Mireille, *Picnics* (Museum of London, London 1988)

Finland. A Cultural Encyclopedia (Finnish Literature Society, Helsinki 1997)

Finland in the Nineteenth Century by Finnish Authors, Illustrated by Finnish Artists. (F.Tilgmann, Helsingfors 1894)

Finnish Modern Design. Utopian Ideals and Everyday Realities, 1930-1997 (Eds. Marianne Aav & Nina Stritzler-Levine) (The Bard Graduate Center for Studies in the Decorative Arts and Yale University Press, New Haven and London, 1998)

Finnish Music Quarterly *1/1995*

Form Function Finland *1/1999, 2/2000*

Forsius, Henrik, "Helsingistä, Uudenmaan kuuluisasta kauppakaupungista. Osa I" (Originally publ. 1755), in *Entisaikain Helsinki. Helsingin Historiayhdistyksen vuosikirja II.* (Helsinki 1937)

Forsius, Henrik, "Historiallinen ja kansantaloudellinen kuvaus Helsingistä, Uudenmaan tapulikaupungista. Osa II" (Originally publ. 1757), in *Entisaikain Helsinki. Helsingin*

Historiayhdistyksen vuosikirja II. (Helsinki 1937)

Forster-Hahn, Françoise, "Art without a National Centre. German Painting in the Nineteenth Century" in *Spirit of an Age. Nineteenth-Century Paintings from the Nationalgalerie, Berlin* Exhib. cat. (National Gallery Company, London 2001)

Frederiksen, N.C., *Finland. Its Public and Private Economy* (Edward Arnold, London 1902)

Fredrikson, Erkki, *Le Pavillon finlandais à l'Exposition universelle de 1900.* (Publication du Musée de Finland centrale, Jyväskylä 2001)

Frosterus, Sigurd, "Architecture: a Challenge," in *20th Century Architecture: Finland* (eds. Marja-Riitta Norri, Elina Standertskjöld and Wilfried Wang) (Museum of Finnish Architecture, Helsinki & Deutsches Architektur-Museum, Frankfurt am Main, Helsinki 2000)

Gallenga, Antonio, *A Summer Tour in Russia* (Chapman and Hall, London 1882)

Ganivet, Angel, *Cartas finlandesas* (Originally published in 1896-97 in *El Defensor de Granada*. Reissued by Editorial Losada S.A., Buenos Aires 1940)

Gardberg, C.J., "Empire", in *Art in Finland from the Middle Ages to the Present Day* (Schildts Ab, Helsinki 2000)

Garvy, George, "Banking Under the Tsars and the Soviets" in *Journal of Economic History* 4/1972 (New York 1972)

Gatrell, Peter, *The tsarist economy 1850-1917* (Batsford, London 1986)

Gide, Charles, *Consumers' Co-operative Societies* (T.Fisher Unwin, London & The Co-operative Union Ltd. Manchester 1921)

Gilmour, Kay, *Finland* (Methuen, London 1931)

Granfelt, G., *Suomen Yhdys-Pankki 1862-1912* (Helsinki 1912)

Greenhalgh, Paul (2000), "Le Style and the Age" in *Art Nouveau 1890-1914* (V&A Publications, London 2000)

Grotenfelt, Arvi, "Korkeakoulut ja tieteellinen tutkimus" in *Suomen kulttuurihistoria IV: Industrialismin ja kansallisen nousun aika* (WSOY, Porvoo-Helsinki 1936)

Grönroos, Ella (ed.), *Suomalaisia koteja – Hem i Finland'– Homes in Finland* (Werner Söderström Osakeyhtiö, Porvoo 1950) Le guide du routard: Finlande, Islande 1999/2000, (Hachette Tourisme Paris 1999)

Guidot, Raymond, *Histoire du design 1940-2000* (Editions Hazan, Paris 2000)

von Habsburg-Lothringen, G. & von Solodkoff, A., *Fabergé. Court Jeweler to the Tsars* (Rizzoli, New York 1979)

Haila, Sirpa, *Suomalaisuutta rakentamassa. Arkkitehti Sebastian Gripenberg kulttuurifennomanian lipunkantajana.* Historiallisia tutkimuksia 201 (Suomen Historiallinen Seura, Helsinki 1998)

Hakkarainen, Helena - Putkonen, Lauri, *Helsingin* kantakaupungin teollisuusympäristöt. Teollisuusrakennusten inventointiraportti. Helsingin kaupunginmuseon tutkimuksia ja raportteja 1/95 (Helsinki 1995)

Hako, Pekka, "Musiikin menestys" in *Kanava* 4-5/1999

Halila, Aimo, "Oppikoululaitos" in *Suomen kulttuurihistoria II,* (eds. Päiviö Tommila, Aimo Reitala and Veikko Kallio)(Porvoo 1980)

Hall, Wendy, *Finns and Their Country* (Max Parrish, London 1967)

Hamilton, George Heard, *The Art and Architecture of Russia*. Pelican History of Art. (Yale University Press, New Haven and London 1983)

Harki, Ilmari, *Sotakorvausten aika* (Jyväskylä 1971)

Harmo, Maunu, "Vantaanjoen suun Helsingin sinettivaakuna" in *Narinkka* (Helsingin kaupunginmuseo, Helsinki 1994)

Havén, Heikki,—*Korkeakouluista valmistuneiden työllistyminen: vuosina 1989-1993 valmistuneiden työllistyminen vuonna 1993* (Tilastokeskus, Helsinki 1996)

Havu, I., "Sivistyselämä" in *Helsingin kaupungin historia V:2. Ajanjakso 1918-1945* (Helsinki 1965)

Heikkilä, Hannu, *The Question of European Reparations in Allied Policy, 1943-1947* (Studia Historica 27. Suomen Historiallinen Seura, Jyväskylä 1989)

Heikkinen, Sakari – Hjerppe, Riitta, *Suomen teollisuus ja teollinen käsityö 1860-1913* (Suomen Pankki, Helsinki 1986)

Heinonen, Visa, *Talonpoikainen etiikka ja kulutuksen henki. Kotitalousneuvonnasta kuluttajapolitiikkaan 1900-luvun Suomessa* (Bibliotheca Historica 33. Suomen Historiallinen Seura, Helsinki 1998)

Helamaa, Erkki, *40-luku. Korsujen ja jälleenrakentamisen vuosikymmen* (Helsinki 1983)

Helander, Vilhelm – Rista, Simo, *Suomalainen rakennustaide / Modern architecture in Finland* 4th ed. (Kirjayhtymä, Helsinki 1995)

Helminen, Martti, "Olutkaupunki Helsinki vuodesta 1550", in *Helsinki Quarterly / Kvartti* 4/97

Helminen, Martti, "Foreign enterprise during Helsinki's 450 years", in *Helsinki Quarterly / Kvartti* 2/2000

Helsingin imago Lontoossa (Helsingin kaupunginkanslian tiedotustoimisto, Helsinki 1998)

Helsinki: a literary companion, Hildi Hawkins and Soila Lehtonen (ed.) (Finnish Literature Society, Helsinki 2000)

Helsinki Quarterly 2/ 2000 (City of Helsinki Urban Facts, Helsinki 2000)

Herranen, Timo, *Hevosbusseista metroon. Vuosisata Helsingin joukkoliikennettä* (Helsinki 1988)

Herranen, Timo, "Kaupunkisuunnittelu ja asuminen"

in *Helsingin historia vuodesta 1945: 1 Väestö, kaupunkisuunnittelu ja asuminen, elinkeinot* (Helsingin kaupunki, Helsinki 1997)

Herranen, Timo, *Valtakunnan sähköistyskysymys. Strategiat, siirtojärjestelmät sekä alueellinen sähköistys vuoteen 1940* (Bibliotheca Historica 14. Suomen Historiallinen Seura, Helsinki 1996)

Hietala, Marjatta, "Katsaus saksalais-suomalaisiin kulttuurisuhteisiin 1921-1933" in *Kansallisuuskysymyksiä ja rotuasenteita* (ed. Aira Kemiläinen) (Jyväskylä 1986)

Hietala, Marjatta, *Services and Urbanization at the Turn of the Century. The Diffusion of Innovations* (Studia historica 23. Finnish Historical Society. Helsinki 1987)

Hietala, Marjatta, "Kotisisar äidin sijaisena", in *Perheen puolesta. Väestöliitto 1941-1991* (Otava, Keuruu 1991)

Hietala, Marjatta (1992a), "Innovaatioiden ja kansainvälistymisen vuosikymmenet" in *Tietoa, taitoa, asiantuntemusta. Helsinki eurooppalaisessa kehityksessä 1875-1917 I* (Historiallinen Arkisto 99:1/ Suomen Historiallinen Seura. Helsingin tietokeskuksen tutkimuksia 1992:5:1. Helsinki 1992)

Hietala, Marjatta (1992b), "The Diffusion of Infrastructural Innovations in Finland" in *Mastering Technology Diffusion - The Finnish Experience* (ETLA -The Research Institute of the Finnish Economy) Series B No. 82 (Helsinki 1992)

Hietala, Marjatta, Perceptions of Backwardness: the case of European North in Criteria and Indicators of Backwardness, in: *Criteria and Indicators of backwardness; Essays on Uneven Development on European History,* eds. Miroslav Hroch and Luda Klusáková (University of Prag, Prag 1996)

Hietala, Marjatta, "Städtischer Nahverkehr als Innovation. Verkehr als Thema des internationalen Erfahrungsaustausches" in *Stadt und Verkehr im Industriezeitalter*, Horst Matzerath (hrsg.), Städteforschung 41 (Böhlau Verlag, Köln 1996)

Hietala, Marjatta, "Kontakte zwischen deutschen und finnischen Wissenschaftlern" in *Am Rande der Ostsee. Aufsätze von IV Symposium deutscher und finnischer Historiker in Turku 4.-7. September 1996*, hrsg. von Eero Kuparinen (Turku 1998)

Hietala, Marjatta, "Finnische Wissenschaftler in Deutschland 1860-1950. Allgemeine Bemerkungen mit besonderer Berücksichtigung medizinischer Kontakte" in *Deutschland und Finnland im. 20 Jahrhundert* Edgar Hösch, Jorma Kalela, Hermann Beyer-Thoma (hrsg.) (Harrassowitz Verlag, Wiesbaden 1999)

Hietala, Marjatta (2000a), "Damage caused by War in Towns. Helsinki and Rovaniemi in the Second World War". In *Stadtzerstörumg und Wiederaufbau / Destruction and Reconstruction of Towns / Destruction et reconstruction des villes, Band 2/Vol 2.* ed/Hrsg. Martin Körner (Verlag Paul Haupt, Bern 2000)

Hietala, Marjatta (2000b),'"Helsinki at exhibitions and fairs" in Helsinki Quarterly 2/ 2000 (City of Helsinki Urban Facts, Helsinki 2000)

Hietala, Marjatta (2000c), Helsinki in the International Context. In: *Capital Cities. Images and Realities in the Historical Development of European Capital Cities,* ed. Lars Nilsson. Studier i stads- och kommunhistoria 22, Stads- och kommunhistoriska institutet, Stockholm 2000

Hietanen, Silvo, "Sota ja väestökysymys" in *Historian päivät 1985.* (Historiallinen Arkisto 88.Suomen Historiallinen Seura, Helsinki 1986

High technology Finland 1999, Herring, Peter (Ed.) (Finnish Academies of Technology, Forssa 1998)

Hingley, Ronald, *Russian writers and society, 1825-1904* (Weidenfeld & Nicholson 1967)

Hirn, Sven, *Kuvat elävät. Elokuvatoimintaa Suomessa 1908-1918* (VAPK-kustannus & Suomen elokuva-arkisto, Helsinki 1991)

Hjerppe, Riitta, *Kasvun vuosisata* (VAPK-kustannus, Helsinki 1990)

Hjerppe, Riitta – Lamberg, Juha-Antti, "Finland's international economic relations" in *Historiallinen aikakauskirja* 2/1997

Hoffman, Kai "Elinkeinot" in *Helsingin historia vuodesta 1945 I. Väestö, kaupunkisuunnittelu ja asuminen* (Helsingin kaupunki, Helsinki 1997)

Hoffman, Kai, "Karl Fazer" in *100 Faces from Finland* (ed. Ulpu Marjomaa) (Finnish Literature Society, Helsinki 2000)

Hollenberg, Günter, *Englisches Intresse am Kaiserreich. Die Attraktivität Preussen-Deutschlands für konservative und liberale Kreise in Grossbritannien 1860-1914* (Wiesbaden 1974)

Holopainen, Orvokki, "The First Finnish Fair" in *Memoria 5* (Helsinki City Museum, Helsinki 1990)

Hornborg, Eirik (1950a), *Helsingin kaupungin historia II: Ajanjakso 1721-1809* (Helsinki 1950).

Hornborg, Eirik (1950b), "Sotaväki ja sotatapahtumat" in *Helsingin kaupungin historia III:1 Ajanjakso 1809-1875* (Helsinki 1950)

Hosking, Geoffrey, *Russia. People and Empire 1552-1917* (Fontana Press, London 1997)

Hosking, Geoffrey, *Russia and the Russians. A History from the Rus to the Russian Federation.* (Allen Lane. Penguin, London 2001)

Hoving, Victor, *Henrik Borgström, en storborgare i det gamla Helsingfors.* (Söderström & Co Förlagsaktiebolag, Helsinki 1949)

Hoving, Victor, *Kauppahuone Gustav Paulig 1876-1951* (Helsinki 1952)

Hugo Simberg ABC Book ed. by Marjatta Levanto (Ateneum, Helsinki 2000)

Hulkko, Jouko, "Perhe kestää - perhepolitiikka alkaa " in *Suomalaisten tarina 3: Rakentajien aika 1937-67* (Kirjayhtymä 1993)

100 Faces from Finland. A Biographical Caleidoscope, ed. by Ulpu Marjomaa (Finnish

Literature Society, Helsinki 2000)

The Hutchinson Chronology of World History. Vol II-IV Ed. by Neville Williams (Helicon, Oxford 1999)

Hägerstrand, Torsten, *Aspects of Spatial Structure of Social Communication and the Diffusion Information* (Regional Science Association Papers, Philadelphia 1966)

Häggman, Kai, *Perheen vuosisata. Perheen ihanne ja sivistyneistön elämäntapa 1800-luvun Suomessa* Historiallisia Tutkimuksia 179 (Suomen Historiallinen Seura, Helsinki 1994)

Häggman, Kai, *Suurten muutosten Suomessa. Kansaneläkelaitos 1937-1997* (Kansaneläkelaitos, Helsinki 1997)

Häikiö, Martti (2001a), *Nokia Oyj:n historia. 1: fuusio* (Edita, Helsinki 2001)

Häikiö, Martti (2001b), *Nokia Oyj:n historia. 2: Sturm und Drang* (Edita, Helsinki 2001)

Häikiö, Martti (2001c), *Nokia Oyj:n historia. 3: globalisaatio* (Edita, Helsinki 2001)

Häikiö, Martti, *Nokia - The Inside Story* (Pearson Education, London 2002)

Hänninen, Sisko-Liisa & Valli, Siiri, *Suomen lastentarhatyön ja varhaiskasvatuksen historia* (Otava 1986)

Iisalo, Taimo, *The science of education in Finland 1828-1918* (Societas Scientiarum Fennica, Helsinki 1979)

Ilmonen Kari, "The Basis of it all – technology" in *Yleisradio 1926-1996. A History of Broadcasting in Finland* (ed. Rauno Enden) (Finnish Historical Society, Helsinki 1996)

Ivalo, Mielikki, *Visavuoren paljasjalka. Nuoruuden-muistoja ja päiväkirjoja vuosilta 1907-1927* (Weilin + Göös, Espoo 1984)

Jackson, Lesley, *The Sixties. Decade of Design Revolution* (Phaidon Press, London 2000)

Jakobson, Max, *Finland in the New Europe* (Phaidon Press, London 2000)

Jalkanen, Pekka, "Popular Music" in *Finnish Music* by Kalevi Aho, Pekka Jalkanen, Erkki Salmenhaara and Keijo Virtamo (Otava, Helsinki 1996)

Jalonen, Olli, *Kansa kulttuurien virroissa. Tuontikulttuurin suuntia ja sisältöjä Suomessa itsenäisyyden aikana* (Otava, Helsinki 1985)

Jauhiainen, Jussi, *Suomalaisten interrailmatkailu* (Helsinki 1989)

Jotuni, Pertti, "Tekniset tieteet" in *Suomen kulttuurihistoria 3. Itsenäisyyden aika* (WSOY, Porvoo 1984)

Julkunen, Raija, "Gender, work, welfare state, Finland in comparison" in *Women in Finland* (Otava, Helsinki 1999)

Jussila, Osmo, "Foreword," in *Venäläiset Suomessa 1809-1917*. Historiallinen Arkisto 83. (Suomen Historiallinen Seura, Helsinki 1985)

Jussila, Osmo, Hentilä, Seppo & Nevakivi, Jukka, *From Grand Duchy to a Modern Political State. A Political History of Finland since 1809* (Hurst,

London 1999)

Jussila, Osmo, "Konservatiivinen imperiumi" in *Venäjän historia* ed. by Heikki Kirkinen (Otava. Helsinki 2000)

Jutikkala, Eino, "Väestö ja asutus 1500-luvulta 1800-luvun puoliväliin" in *Suomen kulttuurihistoria II*, (Gummerus Jyväskylä 1934)

Jutikkala, Eino, *Suomen talonpojan historia* (Suomalaisen Kirjallisuuden Seuran toimituksia 257. Helsinki 1958)

Jutikkala, Eino, "The Distribution of Wealth in Finland" in *Historiantutkijan sana. Maisterista akateemikoksi* (Historiallisia tutkimuksia 105. Suomen Historialllinen Seura, Helsinki 1977)

Jutikkala, Eino, *Yhteistyötä yli Pohjanlahden. Suomalais-ruotsalainen kulttuurirahasto 1960-1990* (Kustannusosakeyhtiö Otava, Helsinki 1992)

Jutikkala, Eino & Pirinen, Kauko, *A History of Finland*. 5th rev.ed. (WSOY, Porvoo 1996)

Jörgensen, Arne, *Universitetsbiblioteket i Helsingfors 1827-1848* (Helsingfors 1980)

Kaarninen, Mervi, *Nykyajan tytöt: koulutus, luokka ja sukupuoli 1920- ja 1930-luvun Suomessa* (Suomen Historiallinen Seura, Helsinki 1995)

Kaipainen, Marja, *Albert Edelfelt. Kuihtumaton ruusutarha.* (Watti-kustannus, Jyväskylä1994)

Kalha, Harri, *Muotopuolen merenneidon pauloissa. Suomen taideteollisuuden kultakausi: mielikuvat, markkinointi, diskurssit* (Suomen Historiallinen Seura &Taideteollisuusmuseo & Apeiron/ Taideteollisuusmuseo, Helsinki 1998)

Karjalainen, Marjaana, *Kansankirjastojen kehitys Suomessa vuosina 1802-1906* (Kirjastopalvelu, Helsinki 1977)

Kansallis-Osake-Pankki 1889-1939 (kirj. Jonni Säntti & Wäinö Ahonen) (Helsinki 1940)

Karjalainen, Tuula, *Uuden kuvan rakentajat. Konkretismin läpimurto Suomessa* (WSOY, Porvoo 1990)

Karvonen-Kannas, Kerttu, "The First Grand Master of Finnish Design. The Paris World's Fair 1900," in *Akseli Gallen-Kallela* (Ateneum, Helsinki 1996)

Kaukiainen, Yrjö, "Kehitysmaa-Suomi" in *Suomen taloushistoria 1. Agraarinen Suomi*, Eino Jutikkala, Yrjö Kaukiainen & Sven Erik Åström (ed.) (Tammi, Helsinki 1980)

Keskinen, Raimo, "Gunnar Nordström – Suomen Einstein", in *Tieteessä tapahtuu* 7/1997

Keskinen, Vesa, *Palvelut puntarissa: kaupunkipalvelututkimus Helsingissä 1983, 1989, 1993 ja 1997* (Helsingin kaupungin tietokeskus, Helsinki 1998)

Kidd, Alan, *Manchester*. 2nd edition (Keele University Press, Keele, Staffordshire 1996)

Kirby, D. G. (Ed.), *Finland and Russia 1808-1920. From Autonomy to Independence* (Macmillan, London 1975)

Kirby, D. G., *Finland in the Twentieth Century* (Hurst, London 1979)

Klinge, Matti, *Ylioppilaskunnan historia, I osa 1828-1852* (WSOY, Porvoo 1967)

Klinge, Matti, *Ylioppilaskunnan historia, IV osa 1918-1960* (WSOY, Porvoo 1968)

Klinge, Matti, "Yliopisto" in *Suomen kulttuurihistoria 2, Autonomian aika* (WSOY, Porvoo-Helsinki-Juva 1983)

Klinge, Matti, *Kaksi Suomea* (Kustannusosakeyhtiö Otava, Helsinki 1982)

Klinge, Matti, "Keisarillinen yliopisto" in *Helsingin yliopisto 1640-1990. 2: Keisarillinen Aleksanterin yliopisto 1808-1917* (Otava, Helsinki 1989)

Klinge, Matti, *A Brief History of Finland*. 10th ed. (Otava, Helsinki 1994)

Klinge, Matti (1997a), *Kaukana ja kotona* (Schildts, Espoo 1997)

Klinge, Matti (1997b), *Keisarin Suomi* (Schildts, Espoo 1997)

Knapas, Rainer, "Yliopiston rakennukset" in *Helsingin yliopisto 1640-1990. 2: Keisarillinen Aleksanterin yliopisto 1808-1917* (Otava, Helsinki 1989)

Knuuttila, Jukka, *Helsingin väestönsuojelu: väestönsuojelun taustaa, toimintaa ja tapahtumia 1927-1989* (Helsinki 1990)

Kolbe, Laura, *Sivistyneistön rooli: Helsingin yliopiston ylioppilaskunta 1944-1959* (Otava, Helsinki 1993)

Kolehmainen, Esa, "Finnish design in the cross-current of international pressures" in *Finnish Industrial Design* (Ed. Tuula Poutasuo) (Kirjayhtymä, Helsinki 1987)

Konttinen, Riitta (1992), *Suomalaisia naistaiteilijoita 1880-luvulta* (Otava, Helsinki 2000)

Konttinen, Riitta, *Sammon takojat. Nuoren Suomen taiteilijat ja suomalaisuuden kuvat* (Otava, Helsinki 2001)

Korhonen, Nina, "The new bloom of the Botanical Garden" in *Universitas Helsingiensis*, 2/1999. Vol. XVIII

Korpisaari, Paavo (1923a), *Pankit ja pankkiliike* (Otava, Helsinki 1923)

Korpisaari, Paavo (1923b), "Pankit" in *Valtiotieteiden käsikirja III,* (Tietosanakirja-osakeyhtiö, Helsinki 1923)

Korppi-Tommola, Aura (1990a), "Education – the road to work and equality" in *The Lady with the Bow. The Story of Finnish Women*, ed. by Merja Manninen and Päivi Setälä (Otava, Helsinki 1990)

Korppi-Tommola, Aura (1990b), "Fighting together for freedom. Nationalism, Socialism, Feminism and Women´s Suffrage in Finland 1906, Scandinavian Journal of History 15, 1991

Korppi-Tommola, Aura,'"Arvo Ylppö (1887-1992), archiatre and professor of pediatrics" in *100 Faces from Finland: A Biographical Kaleidoscope*, Ulpu Marjomaa (ed.) (Finnish Literature Society, Helsinki 2000)

Kruglov, Vladimir, "On the Centenary of the *World of Art*," in *Mir iskusstva. On the Centenary of the Exhibition of Russian and Finnish Artists 1898*. Exhib. Cat. by the Russian State Museum & the Museum of Finnish Art, Ateneum (Palace Editions 1998)

Kruskopf, Erik, *Finlands konstindustri. Den finländska konstflitens utvecklingshistoria* (WSOY, Porvoo 1989) / Kruskopf, Erik, *Suomen taideteollisuus. Suomalaisen muotoilun vaiheita* (WSOY, Porvoo 1989)

Kruskopf, Erik, *Veistosten kaupunki: taidetta Helsingin katukuvassa* (Gummerus, Jyväskylä 2000)

Kuisma, Markku, *Teollisuuden vuosisata* (Otava, Keuruu 1993)

Kuisma, Markku, *Kylmä sota, kuuma öljy. Neste, Suomi ja kaksi Eurooppaa* (WSOY 1997)

Kuisma, Markku, "Suomi Nokiana, Nokia Suomena eli metsäteollisuuden maan muodonmuutos teleteknologian pikkujättiläiseksi" in *Suomi : maa, kansa, kulttuurit*. Laura Kolbe - Markku Löytönen *(toim.)* (Suomalaisen Kirjallisuuden Seura, Helsinki, 1999)

Kuisma, Markku & Hentinen, Annastiina & Karhu, Sami & Pohls, Maritta, *Kansan talous. Pellervo ja yhteisen yrittämisen idea 1899-1999* (Pellervo-Seura ry & Kirjayhtymä , Helsinki 1999)

Kuusanmäki, Jussi – Piilonen, Juhani, *Helsingin kaupunginvaltuuston historia. Ensimmäinen osa 1875-1918* (Helsingin kaupunki, Helsinki 1987)

Kuusanmäki, Jussi, "Sosiaalipolitiikkaa ja kaupunkisuunnittelua" in *Tietoa, taitoa ja asiantuntemusta. Helsinki eurooppalaisessa kehityksessä 1875-1917 2.* (Historiallinen Arkisto 99:2/ Suomen Historiallinen Seura. Helsingin tietokeskuksen tutkimuksia 1992:5:2. Helsinki 1992)

Kuusela, Pertti, *E.M.C.Tigerstedt – Suomen Edison* (Insinööritieto, Helsinki 1989)

Kuusipalo, Jaana, "Finnish women in Politics" in *Women in Finland* (Otava, Helsinki 1999)

Kuusisaari, Hannu, "Come, come I am a King" in *Nordic Sounds 3/2000*

Kyhäräinen, Jukka & Pilli-Sihvola, Mirva, "Virtual University" in *Universitas Helsingiensis* 3/1998

Körner, Martin, "Destruction and Reconstruction of Towns: Topic, Statement of the Questions and the Results of Research" in *Stadtzerstörung und Wiederaufbau. Sclussbericht / Destruction and Reconstruction of Towns. Final Report / Destruction et reconstruction des villes. Rapport final*, ed. by Martin Körner (Verlag Paul Haupt, Bern 2000)

Laalo, Kalevi, *Nappikaupasta muoviaikaan. 70 vuotta suomalaista muoviteollisuutta* (Hämeenlinna 1990)

Laati, Iisakki, "Kunnalliselämä" in *Helsingin kaupungin historia IV:2. Ajanjakso 1875-1918* (Helsinki 1956)

Lagerspetz, Kari, "Luonnontieteet" in *Suomen*

kulttuurihistoria 3, Itsenäisyyden aika (WSOY Porvoo 1982)

Lammintausta, Risto, "Hormos Medical Oy" in Tutkas 3/1998

Landry, Charles, Helsinki: Towards a Creative City. Seizing the opportunity and maximising potential (City of Helsinki Urban Facts, Helsinki 1998)

Landry, Charles, The Creative City. A Toolkit for Urban Innovators (Earthscan Publications, London 2000)

Langdon-Davies, John, Finland. The First Total War (London 1940)

Lapin, Leonhard, Pimeydestä valoon. Viron taiteen avantgarde neuvostomiehityksen aikana. (Otava, Helsinki 1996)

Larsio, Rauno, Kehittyvä talous - kasvava kaupunki. Helsingin kauppakamarin 50-vuotisen toiminnan taustaa (Helsinki 1967)

Larson, Magali Sarfatti, The rise of professionalism: a sociological analysis (University of California Press, Berkeley 1977)

Latvia taiteiden risteyksessä. Latvian tasavallan 75-vuotisjuhlanäyttely 18.11.1993-31.1.1994, Ulkomaisen taiteen museo Sinebrychoff, Valtion Taidemuseo, Helsinki 1993

Laur, Mati & Lukas, Tõnis & Mäesalu, Ain & Pajur, Ago & Tannberg, Tõnu, History of Estonia (Avita - A/S BIT, Tallinn 2000)

Layton, Robert, Sibelius. (J.M. Dent & Sons, London 1992)

Lefebre, H., The Production of Space (Blackwell, Oxford 1991)

Lehto, Anna-Maija, "Women in working life in Finland" in Women in Finland (Otava, Helsinki 1999)

Lehtovuori, Panu, "Tapahtuma – toinen paikka?" in Urbs : kirja Helsingin kaupunkikulttuurista (Helsingin kaupungin tietokeskus, Helsinki 2000)

Leikola, Anto, "Luonnontieteet" in Suomen kulttuurihistoria 2. Autonomian aika (WSOY, Porvoo 1983)

Leikola, Anto, " Tiedeyhteydet syntyvät henkilökontaktien avulla" in Suomi Euroopassa : talous- ja kulttuurisuhteiden historiaa (ed. Mauno Jokipii) (Atena, Jyväskylä 1991)

Leikola, Anto, "Töölö, lapsuuteni maa", Helsinki - kaupunki graniittisilla juurilla, avaralla niemellä, (toim. Paavo Haavikko) (Art House, Helsinki 2000)

Lepistö, Vuokko, Joko teillä on primuskeitin? Kotitalousteknologian saatavuus ja tarjonta Helsingissä 1800-luvun puolivälistä 1910-luvun lopulle (Historiallisia tutkimuksia 181. Finnish Historical Society, Helsinki 1994)

Leslie, R.F. et al., The History of Poland since 1863 (Cambridge University Press, Cambridge 1980)

Lieven, Dominic, The Russian Empire and Its Rivals (John Murray, London 2000)

Lieven, Dominic, Russia's rulers under the old regime (Yale University Press, New Haven 1989)

Levón, Martti, Tekniikka, työ ja teekkarihenki. Insinöörin muistelmia. (WSOY, Porvoo-Helsinki, 1967)

Lincoln, W. Bruce, The great reforms. Autocracy, bureaucracy, and the politics of change in Imperial Russia (Northern Illinois University Press, DeKalb 1990)

Lindberg, Bo, "Painting from Romanticism to Realism," in Art in Finland from the Middle Ages to the Present Day (Schildts, Helsinki 2000)

Lindberg, Carolus & Rein, Gabriel, "Asemakaava ja rakennustoiminta" in Helsingin kaupungin historia III:1 (Helsinki 1950)

Lindfors, Jukka & Salo, Markku, Ensimmäinen aalto. Helsingin underground 1967-1970 (Odessa, Helsinki 1988)

Lindgren, Liisa, Monumentum: muistomerkkien aatteita ja aikaa. Suomalaisen kirjallisuuden seurna toimituksia 782 (Suomalaisen Kirjallisuuden Seura, Helsinki 2000)

Lodenius, Erik, Hundra år med Paulig 1876-1976 (Helsingfors 1976)

Lukkonen, Tapio, "Puhelin kuulotorvesta kuvapuhelimeen" in Poimintoja puhelin- ja lennätintoiminnan historiasta. Jatko-osa 1989 (PTL-Tele, Helsinki 1989)

Lukkonen, Tapio, Sähköistä antiikkia. Käteen käyvät ja sähköllä toimivat (Art House, Jyväskylä 1997)

Lyaschenko, Petr I., History of the National Economy of Russia to the 1917 Revolution (Macmillan , New York, 1949)

Lyytinen, Eino, Pohjola-yhtiöt sata vuotta (WSOY, Porvoo 1991)

Lönnqvist, Bo & Rönkkö, Marja-Liisa, Helsinki. Kuninkaankartanosta Suomen suurkaupungiksi (Tammi, Helsinki 1988)

MacKeith, Peter B. & Smeds, Kerstin, The Finland Pavillion. Finland at the Universal Expositions 1900-1992 (Kustannus Oy City, Tampere 1993)

Malme, Heikki, "A.W. Finch, peintre-graveur 1897-1930" in A.W. Finch 1854-1930. Catalogue of "Alfred William Finch 1854-1930" exhibition at the Musées royaux des Beaux-Arts de Belgique à Bruxelles (Crédit Communal, Brussels 1992)

Manninen, Ohto & Määttä, Vesa (Eds), Muistelmia aktivismista ja vapaussodasta (Vapaussodan invalidien muistosäätiö & Edita, Helsinki 1999)

Markkula, Auli, "Maataloudelliset luottolaitokset Suomessa" in Oma maa. Tietokirja Suomen kodeille. 2. p. V osa (WSOY, Porvoo 1924)

Martinsen, Rolf, "Vallila and its Wooden Houses. Model Dwellings for Workers in Early 20th Century Helsinki" (also in German and in French) in Koivumäki, Matti, Puu-Vallilan kasvot. Vanhaa Vallilaa 1974-76. (Entisaikain Helsinki XV. Helsinki-Seura, Helsinki 2001)

Masur, Gerhard, Imperial Berlin (Routledge & Kegan Paul 1974)

Mathieu, Caroline & Bellenger, Sylvain, Paris 1837 (Alain de Gourcuff, Paris 1999)

Maunula, Leena, "Taideteollisen järjestäytyminen aika 1870-1910" in *Ars - Suomen Taide 4.* (Weilin &Göös. Otava 1989)

Maunula, Leena (1990a), "Taideteollisen funktionalismin synty 1910-1940" in *Ars - Suomen Taide 5.* (Weilin &Göös. Otava 1990)

Maunula, Leena (1990b), "Taideteollisuuden rakentamisen aika 1940-1990" in *Ars - Suomen Taide 6.* (Weilin &Göös. Otava 1990)

Mauranen, Tapani, *Taksi! Matka suomalaisen taksin historiaan* (Suomen Taksiliitto ry., Forssa 1995)

Maxwell, John S., *The Czar, his Court and People; including a tour in Norway and Sweden* (New York, 1848)

Mead, W.R, *Finland* (Erns Benn, London 1968)

Mead, W.R. and Smeds, Helmer, *Winter in Finland* (Hugh Evelyn , London 1967)

Mee, Arthur (ed.), *Children's Encyclopaedia* (London 1941)

Meurman, Otto-Iivari, "Asemakaava" in *Tekniikan käsikirja* (Jyväskylä 1952)

Michelsen, Karl-Erik, *Valtio, teknologia, tutkimus. VTT ja kansallisen tutkimusjärjestelmän kehitys* (VTT, Valtion teknillinen tutkimuskeskus, Espoo 1993)

Michelsen, Karl-Erik, *Viides sääty. Insinöörit suomalaisessa yhteiskunnassa* (Tekniikan Akateemisten Liitto TEK & Suomen Historiallinen Seura, Helsinki 1999)

Mir iskusstva On the Centenary of the Exhibition of Russian and Finnish Artists 1898. Exhibition catalogue by the State Russian Museum & the Museum of Finnish Art, Ateneum (Palace Editions 1998)

Mitä-missä-milloin 1974 (Otava, Helsinki 1973)

Monteith, William, *Narrative of the Conquest of Finland by the Russians in the Years 1808-09* (London 1854)

Moorhouse, Jonathan, Carapetian, Michael and Ahtola-Moorhouse, Leena, *Helsingin jugendarkkitehtuuri 1895-1915* (Otava, Helsinki 1987)

Musica 7-9 (Fazer, Helsinki 1980)

Musica 8-9 (Fazer, Helsinki 1987)

Musical America, July 1951

Mustonen, Pertti, *Keskellä kaupunkia* (Kirjayhtymä, Helsinki 1987)

Mustonen, Pertti, *Ravintolaelämää: kulttuurikuvia, nostalgiaa, kulinarismia* (Tammi, Helsinki 1990)

Myllyntaus, Timo, *Electrifying Finland. The Transfer of a New Technology into a Late Industrialising Economy* (ETLA – The Research Institute of the Finnish Economy Series A15. Macmillan Academic and Professional Ltd, London 1991)

Mäkelä, Jukka L., *Helsinki liekeissä: suurpommitukset helmikuussa 1944* (Porvoo 1967)

Mäkeläinen, Eva-Christina,*Säätyläisten seuraelämä ja tapakulttuuri 1700-luvun jälkipuoliskolla Turussa, Viaporissa ja Savon kartanoalueella -

The Social Life and Customs of the gentry in late XVIII Century Turku, Sveaborg and the Savo Estates Area (with English summary) (Forssa 1972)

Mäkinen, Ilkka, "Kirjallisuuden hätäavusta ASLA-kirjoihin" in Signum, vol 31 no 7, 1998

Mäkinen, Ilkka, "Heittämällä tulevaisuuteen: kirjastot vuoden 1961 lain jälkeen" in *Kirjastojen vuosisata. Yleiset kirjastot Suomessa 1900-luvulla*, (toim. Ilkka Mäkinen) (BTJ Kirjastopalvelu, Helsinki 1999)

Mäkinen, Ilkka, "The Golden Age of Finnish Public Libraries: Institutional, Structural and Ideological Background since the 1960's" in *Finnish Public Libraries in the 20th Century*, Ilkka Mäkinen (ed.) (Tampere University Press, Tampere 2001)

Mäntylä, Ilkka, *Viinissä totuus. Viinin historia Suomessa* (Otava, Helsinki 1998)

Möller, Sylvi, "Ammattikuntien kukoistuskaudelta Helsingissä" in *Entisaikain Helsinki* (Helsingin Historiayhdistyksen vuosikirja I, Helsinki 1936)

Narinkka 1981, toim. Leena Arkio, Marja-Liisa Lampinen (Helsingin kaupunginmuseo, Helsinki, 1982)

Naylor, Gillian, "Domesticity and Design Reform: the European Context" in *Carl and Karin Larsson Creators of the Swedish Style*, ed. by Michael Snodin and Elisabet Stavenow-Hidemark (V&A Publications, London 1997)

Nevakivi, Jukka, *Apu, jota ei pyydetty* (Tammi, Helsinki 1984)

Nevakivi, Jukka, "From The Continuation War to the Present 1944-1999", in Jussila-Hentilä-Nevakivi,'*From Grand Duchy to a Modern State. A Political History of Finland since 1809* (Hurst, London 1999)

Niemi, Marjaana, "Uudistuva kansakoulu. Opettajien kansainväliset yhteydet muutosvoimana" in *Tietoa, taitoa, asiantuntemusta. Helsinki eurooppalaisessa kehityksessä 1875-1917 III: Henkistä kasvua, teknistä taitoa* (ed. Kirsi Ahonen, Marjaana Niemi, Jaakko Pöyhönen). (Hark 99:3 Finnish Historical Society, Helsinki 1992)

Niemi, Marjaana, "In the Public Interest and for Private Gain. Finns' study trips abroad from the 16th to the 20th century" in *En Route!. Finnish architects' studies abroad* (eds. Timo Tuomi, Elina Standertsköld, Kristiina Paatero, Eija Rauske, Esa Laaksonen) (Museum of Finnish Architecture, Helsinki 1999)

Niininen, Petri, "Nokian valtatie", in *Kansantaloudellinen Aikakauskirja* 4/1999

Nikander, Gabriel (1935), "Kaupunkiyhteiskunta" in *Suomen Kulttuurihistoria III* (Gummerus, Jyväskylä – Helsinki 1935)

Nikula, Riitta, "Suomen taiteen 1920-1940-luvut" in *Ars - Suomen Taide 5* (Weilin &Göös. Kustannusosakeyhtiö Otava 1990)

Nikula, Riitta, "Women in the History of Finnish

Art", in *Lady with the Bow. The Story of Finnish Women*, ed. Päivi Setälä and Merja Manninen, (Keuruu 1990)

Nikula, Riitta (1993a), *Architecture and Landscape. The Building in Finland* (Otava, Keuruu 1993)

Nikula, Riitta (1993b), "Suomalainen funkkiskaupunki kasvaa metsiin" in *Suomalaisten tarina 3. Jälleenrakentajien aika 1937-1967* (Jyväskylä 1993)

Nikula, Riitta, "The Inter-War Period: the Architecture of the Young Republic," *20th Century Architecture: Finland* (eds. Marja-Riitta Norri, Elina Standertskjöld and Wilfried Wang) (Museum of Finnish Architecture, Helsinki & Deutsches Architektur-Museum, Frankfurt am Main, Helsinki 2000)

Nipperdey, Thomas, *Deutsche Geschichte 1866-1918 Erster Band. Arbeitswelt und Bürgergeist* (München 1990)

Nokela, Leena, *Sisustustyylit antiikista nykyaikaan.* (Otava, Helsinki 1992)

Nummelin, Rolf, "Painting and graphic art 1918- ca 1960" in *Art in Finland* (Schildts, Helsinki 2000)

Nuorisotyö 1992:2

Nuorteva, Jussi, "Higher Education" in *Finland. A Cultural Encyclopedia* (Finnish Literature Society, Helsinki 1997)

Näitä polkuja. Venäläinen Helsinki (Helsingin kaupunginmuseo 2000)

OECD, Main science and technology indicators (Organisation for Economic Co-operation and Development, Paris 1988-)

Oker-Blom, Max, *Hos Morbror-Doktorn på landet* (Helsingfors 1903)

Oldenbourg, Zoé, *Catherine the Great* (Corgi Books, Suffolk 1972)

Ollila, Anne, *Suomen kotien päivä valkenee. Martta järjestö suomalaisessa yhteiskunnassa vuoteen 1939* (Historiallisia tutkimuksia 173. Suomen Historiallinen Seura, Helsinki 1993)

Olympiakaupunki Helsinki 1952, Memoria 7 (Helsingin kaupunginmuseo, Hämeenlinna 1992)

Ometev, Boris & Stuart, John, *St Petersburg. Portrait of an Imperial City* (Cassell, London 1990)

Opie, Jennifer, "Helsinki: Saarinen and Finnish Jugend," in *Art Nouveau 1890-1914*, ed. by Paul Greenhalgh (V&A Publications, London 2000)

Opie, Jennifer, *Scandinavia: Ceramics & Glass in the Twentieth Century. The Collections of the Victoria & Albert Museum* (V& A Publications, 2001)

Ormala, Erkki "Finnish Innovation Policy in the European Perspective" in *Transformation Towards a learning Economy. The Challenge for the Finnish Innovation System*. Gerd Schienstock and Osmo Kuusi (eds.), Sitra 213 (Helsinki 1999)

Paasivirta, Juhani, *Finland and Europe. International crises in the period of autonomy 1808-1914* (University of Minnesota Press, Minneapolis 1981)

Paasivirta, Juhani (1995a), *Suomen kulttuurisuhteet 1800- ja 1900-luvuilla (Turun yliopisto, Turku 1991)*

Paasivirta, Juhani (1995b), "Suomi jäsentyy kansakuntana Euroopan. Kulttuurisuhteet 1800- ja 1900-luvuilla" in *Suomi Euroopassa. Talous- ja kulttuurisuhteiden historiaa.* (Ed. Mauno Jokipii) (Atena, Jyväskylä 1991)

Paavolainen, Jaakko, *Helsingin kaupunginvaltuuston historia. Toinen osa 1919-1976* (Helsinki 1989)

Pajamo, Antti, "Well-orchestrated Helsinki" in *Finnish Music Quarterly* 1/1995

Palm, Thede, *The Finnish-Soviet Armistice Negotiations of 1944* (Acta Academiae Regiae Scientiarum Upsaliensis 14. Uppsala 1971)

Palmberg, Albert, *Verlden sedd från hygienisk synpunkt. Reseberättelse* (Wiborg 1887)

Palmén, E.G., *Suomalaisen Kirjallisuuden Seuran viisikymmenvuotinen toimi ynnä suomalaisuuden edistys 1831-1881* (Suomalaisen Kirjallisuuden Seuran kirjapaino, Helsinki 1881)

Paunonen, Heikki - Paunonen, Marjatta, *Tsennaaks Stadii, bonjaaks slangii. Stadin slangin suursanakirja* (WSOY, Helsinki 2000)

Perkin, Harold, *The Rise of Professional Society. England since 1880* (Routledge, London 1989)

Pesonen, Aake, *Helsinki sodassa* (Kirjayhtymä, Helsinki 1985)

Pessa, Markus, "Tampere University of Technology" in *Tutkas* 3/1998

Pihkala, Erkki, *Suomalaiset maailmantaloudessa keskiajalta EU-Suomeen.* Tietolipas 181 (SKS, Helsinki 2001)

Pihlak, Evi, *Eesti maal - Estonian Painting.* ("Kunst", Tallinn 1982)

Pipping, Hugo E., *Paperiruplasta kultamarkkaan. Suomen Pankki 1811-1877* (Suomen Pankki, Helsinki 1961)

Pipping, Hugo E., *Sata vuotta pankkitoimintaa. Pohjoismaiden Yhdyspankki.* (Helsinki 1962)

Pohjola, Erkki - Tuomisto, Matti, *Tapiola Sound* (WSOY, Porvoo, Helsinki, Juva 1992)

Polster, Bernd, *Design Directory Scandinavia* (Universe Publishing, New York, 1999)

Priha, Päikki, *Rakkaat ystävät. Suomen Käsityön Ystävät 120 vuotta.* (Ajatus, Helsinki 1999)

Pullerits, Albert, *Estonia. Population, cultural and economic life* (Tallinn 1937)

Pulma, Panu, "Kasvun katveessa" in *Helsingin kaupungin historia vuodesta 1945, 2. Suunnittelu ja rakentaminen. Sosiaaliset ongelmat, urheilu* (Helsingin kaupunki, Helsinki 2000)

Pulma, Panu, "Rauhoituspolitiikan kausi (1809-1815)" in *Suomen historian pikkujättiläinen* (ed. Seppo Zetterberg). (WSOY, Porvoo 1997)

Pöyhönen, Jaakko, "Voimaa koneisiin, valoa kaduille ja asuntoihin" in *Tietoa, taitoa, asiantuntemusta. Helsinki eurooppalaisessa kehityksessä 1875-1917 3* (Kirsi Ahonen, Marjaana Niemi, Jaakko

Pöyhönen eds.), (Historiallinen Arkisto 99:3/ Suomen Historiallinen Seura. Helsingin tietokeskuksen tutkimuksia 1992:5:3. Helsinki 1992)

Pöykkö, Kalevi, *Carl Ludvig Engel 1778-1840. Pääkaupungin arkkitehti*. Memoria 6 (Helsingin kaupunginmuseo, 1990)

Raikes, Thomas, *A Visit to St. Petersburg, in the Winter of 1829-30* (London 1838)

Ramel, Stig, *Gustaf Mauritz Armfelt 1757-1814. Dödsdömd kungagunstling i Sverige, ärad statsgrundare i Finland* (Atlantis, Stockholm 1997)

Ranta, Raimo (1985), "Venäläinen kauppiaskunta ja sen kauppa Vanhassa Suomessa," in *Venäläiset Suomessa 1809-1917*. Historiallinen Arkisto 83. (Suomen Historiallinen Seura, Helsinki 1985)

Rantanen, Miska, *Lepakkoluola. Lepakon ja Liekkihotellin tapahtumia ja ihmisiä 1940-1999* (WSOY, Helsinki 2000)

Rapetti, Rodolphe, "Gallen-Kallela et le symbolisme international: l'exemple d'Ad Astra", in *L'horizon inconnu. L'art en Finlande 1870-1920.'* (Ateneum, Helsinki 1999)

Ratia, Viljo, "Alkuvuosien kiemuroita" in *Marimekko ilmiö* (Eds. Pekka Suhonen and Juhani Pallasmaa) (Marimekko Oy, Helsinki 1986)

Raun, Toivo U., *Viron historia* (Otava, Helsinki 1989)

Rautio, Antero, *Pääkaupunkiseudun julkiset muistomerkit ja taideteokset. Sibeliusmonumentista Oodiin 60000 järvelle* (Karisto, Hämeenlinna 1998)

Rein, Gabriel ja Wiherheimo, Onni, "Kunnalliselämä" in *Helsingin kaupungin historia III:2. Ajanjakso 1809-1875* (Helsinki, 1951)

Reitala, Aimo, "The World of Art and Finnish Artists," in *Mir iskusstva. On the Centenary of the Exhibition of Russian and Finnish Artists 1898*. Exhib. Cat. by the Russian State Museum & the Museum of Finnish Art, Ateneum (Palace Editions 1998)

Richards, Denby, *The Music of Finland,* (Hugh Evelyn, London 1968)

Richards, J.M., *800 years of Finnish architecture* (David & Charles. Newton Abbot, London, Vancouver 1978)

Rikkinen, Kalevi, "Suomalainen asuttaa maaseutua ja kasvattaa taajamia samanaikaisesti" in *Suomalaisten tarina 3: Rakentajien aika 1937-1967* (Jyväskylä 1993)

Ringbom, Nils-Erik, "Musiikkielämä" in *Helsingin kaupungin histori V:2* (Helsinki 1965)

Ringbom, Sixten, (2000a) "Applied arts and design after 1870," in *Art in Finland. From the Middle Ages to the Present day* (Schildts, Helsinki 2000)

Ringbom, Sixten (2000b), "The Gothic Revival, Industrial Architecture and the Renaissance Revival" in *Art in Finland. From the Middle Ages to the Present day* (Schildts Ab, Helsinki 2000)

Ringbom, Sixten, (2000c) "Jugendstil, National Romanticism and Rationalism," in *Art in Finland. From the Middle Ages to the Present day*. (Schildts, Helsinki 2000)

Ringbom, Sixten, (2000d) "Symbolism, Synthetism and the Kalevala," in *Art in Finland. From the Middle Ages to the Present day*. (Schildts, Helsinki 2000)

Riutta, Kari-Vartiainen, Hannu, "Autolautoista uiviksi hotelleiksi" in *Navis Fennica. Suomen merenkulun historia, osa 2,* ed. by Erkki Riimala (WSOY 1994)

Rogers, Everett, *Diffusion of Innovations*, 4. Rev. edition (New York, London 1995)

Rossiter, Stuart & Flower, John, *The Stamp Atlas*. (McDonald & Co (Publishers) Ltd. London & Sydney 1989)

Ruble, Blair A., *Leningrad. Shaping a Soviet City* (University of California Press, Berkeley, Los Angeles, 1990)

Rudzite, Ksenija, "Latvia - kulttuurien kohtauspaikka," in *Latvia taiteiden risteyksessä. Latvian tasavallan 75-vuotisjuhlanäyttely. Ulkomaisen taiteen museo Sinebrychoff.* (Valtion taidemuseo, Helsinki 1993)

Ruuth, Martti, "Koulut" in *Helsingin kaupungin historia III:2. Ajanjakso 1809-1875* (Helsinki 1950)

Rähesoo, Jaak, *Estonian Theatre* (Estonian Theatre Union, Tallinn 1999)

Röneholm, Harry (1945a), *Markkinat, messut, näyttelyt I* (Suomen Messut Osuuskunta, Helsinki 1945)

Röneholm, Harry (1945b), *Markkinat, messut, näyttelyt II* (Suomen Messut Osuuskunta, Helsinki 1945)

Rönkkö, Marja-Liisa, Lehto, Marja-Liisa, Lönnquist, Bo, *Koti kaupungissa. 100 vuotta asumista Helsingissä* (Tammi, Helsinki 1986)

Saarenheimo, Eero, *Suomalaisuutta rakentamassa. Helsingin Suomalainen Klubi 1876-1976.* (Helsingin Suomalainen Klubi, Helsinki 1976)

Saarikangas, Kirsi, "Wood, Forest and Nature. Architecture and the construction of Finnishness" in: *Europe´s Northern Frontier*, (ed. Tuomas M.S.Lehtonen) (PS-kustannus, Jyväskylä 1999)

Saarnivaara, Veli-Pekka, "TEKES" in *Tutkas* 3/1998

Salmenhaara, Erkki, "The Birth of National and Musical Culture in Finland" in Aho, Kalevi et al., *Finnish Music* (Otava, Helsinki 1996)

Salokangas, Raimo, (1996) "The Finnish Broadcasting Company and a Changing Finnish Society 1949-1996" in *Yleisradio 1926-1996. A History of Broadcasting in Finland*, (ed. by Rauno Endén) (Finnish Historical Society, Helsinki, 1996)

Sarajas-Korte, Salme, *Suomen varhaissymbolismi ja sen lähteet. Tutkielma Suomen maalaustaiteesta 1891-1895* (Otava, Helsinki 1966)

Sarajas-Korte, Salme, "Axel Gallén's Swan Symbolism," in *Akseli Gallen-Kallela*, catalogue

1996 (Ateneum, Helsinki 1996)

Sarantola-Weiss, Minna, *Kalusteita kaikille. Suomalaisen puusepänteollisuuden historia* (Puusepänteollisuuden liitto, Helsinki 1995)

Saraste, Erja, "Työvoimapolitiikka sodan ja rauhan kriisissä" in *Suomi 1944: sodasta rauhaan* (Tammi, Helsinki 1984)

Saukkonen, Jussi, "Helsingin kunnalliselämä vv. 1918-1945" in *Helsingin kaupungin historia V:1. Ajanjakso 1918-1945* (Helsinki 1962)

Saunier, Yves, "Changing the city: urban international information and the Lyon municipality, 1900-1940" in *Planning Perspectives*, 14 (1999)

Schildt, Göran (ed. and annotated), *Alvar Aalto in His Own Words* (Rizzoli, New York 1997)

Schoolfield, George G., *Helsinki of the Czars. Finland's Capital: 1808-1918* (Camden House, South Carolina 1996)

Schulman, Harry, "Helsingin suunnittelu ja rakentuminen", in Schulman, Harry, Pulma, Panu & Aalto, Seppo, *Helsingin historia vuodesta 1945, 2* (Helsingin kaupunki, Helsinki 2000)

af Schulten, Marius, "Rakennustaide" in *Helsingin kaupungin historia IV:1. Ajanjakso 1875-1918* (Helsinki 1955)

Schweitzer, Robert, *Lübecker in Finnland* (Saksalaisen kulttuurin edistämissäätiö, Helsinki 1991)

Schybergson, Per, *Aktiebolagsformens genombrott i Finland*, Bidrag till kännedom av Finlands natur och folk 109 (Finska veteskaps-societen 1964)

75 vuotta sinivalkoisin siivin, Finnair News, 5/98

Seppälä, Anu, *Isa Gripenberg. Aatelisnaisen tarina* (Otava, Helsinki 1995)

Seppälä, Raimo,*Strömberg – mies josta tuli tavaramerkki* (Art House, Jyväskylä 1997)

Šhwidkovsky, Dmitry, "The Architecture of the Russian State: between East and West, 1600-1760", in *The Triumph of the Baroque. Architecture in Europe 1600-1750* ed. by Henry A. Millon (Palazzo Grassi, Venice & The Montreal Museum of Fine Arts, R.C.S. Libri S.p.A. 1999)

Siipi, Jouko, "Pääkaupunkiyhteiskunta ja sen sosiaalipolitiikka" in *Helsingin kaupungin historia V:1.* (Helsinki 1962)

Sillanpää, Kari J., "Varmuuspainannan historiaa", in *Suomen Pankin setelipaino 1885-1985* (Suomen Pankin setelipaino, Vantaa 1985)

Simonen, Seppo, *Maatalouden vallankumous* (Porvoo 1945)

Simonen, Seppo, *Pellervolaisen osuustoiminnan historia* (Pellervo-Seura, Helsinki 1949)

Singleton, Fred, *A Short History of Finland* (Cambridge University Press, Cambridge 1989)

Sinisalo, Jarkko, "Pietari ja Suomen rakennustaide 1800-luvun alkupuoliskolla" in *Suomi & Pietari.* (ed. Maija Lapola) (Historiallinen kirjasto XXIII. Historian Ystäväin Liitto and WSOY, Juva 1995)

Sinisalo, Soili, "The St Petersburg - Helsinki Axis

One Hundred years Ago," in *Mir iskusstva. On the Centenary of the Exhibition of Russian and Finnish Artists 1898.* Exhib. Cat. by the Russian State Museum & the Museum of Finnish Art, Ateneum (Palace Editions 1998)

Sironen, Esa, "Paavo Nurmi" in *Finland. A Cultural Encyclopedia* (Finnish Literature Society, Helsinki 1997)

Smeds, Kerstin, *Helsingfors-Paris. Finland på världsutställningarna 1851-1900* (Svenska litteratursällskapet i Finland. Finska Historiska Samfundet, Helsinki 1996)

Soikkanen, Hannu, *Kohti kansan valtaa 2.: 1937-1944* (Joensuu 1987)

Spencer, Charles, *Leon Bakst.* (Academy Editions, London 1978)

The State and Quality of Scientific Research in Finland. A Review of Scientific Research and Its Environment in the Late 1990s, ed. Kari Husso, Sakari Karjalainen & Tuomas Parkkari (Academy of Finland, Helsinki 2000)

Stenius, Henrik, *Frivilligt jämlikt samfällt. Föreningsväsendets utveckling i Finland fram till 1900-talets början med speciell hänsyn till massorganisationsprincipens genombrott* (Svenska litteratursällskapet i Finland, Helsingfors 1987)

Stenros, Anne, "Finnish Design 125 Years" in *Form Function Finland 2/2000*

Stevens, Maryanne, "The Exposition Universelle: 'This vast competition of effort, realisation and victories' " in *1900 Art at the Crossroads* exhib.cat. ed. by Rosenblum, Robert, Stevens, Maryanne and Dumas, Ann (Royal Academy of Arts, London & Solomon Guggenheim Museum, New York,London 2000)

Stinchcombe, Arthur L., "Social Structure and Organizations" in *Handbook of Organizations*, ed. James G. March (Rand McNally, Chicago 1965)

The Story of Finland (Finnfacts 2001)

Strömberg, John, "Ylioppilaat" in *Helsingin yliopisto 1640-1990. 2: Keisarillinen Aleksanterin yliopisto 1808-1917* (Otava, Helsinki 1989)

Strömmer, Aarno, "Väestönkehitys ja väestöpolitiikka" in *Perheen puolesta. Väestöliitto 1941-1991* (Keuruu 1991)

Ståhlberg, Ester,—*Kauniit, katkerat vuodet. Presidentin rouvan päiväkirja 1920-25* (WSOY, Porvoo 1985)

Suolahti, Eino E., *Helsingfors 1550-1950.* (Söderström & Co, Helsingfors 1950)

Suomalaisia koteja – Hem in Finland – Homes in Finland. (ed. Ella Grönroos) (Werner Söderström Osakeyhtiö, Porvoo 1950)

Suomen lasten kiitos Ruotsille (Eds. Kustaa Vilkuna, Elsa Bruun, Eino Mäkinen, Sirkka-Liisa Virtamo) (Finlandia uutistoimisto, Helsinki 1943)

Suomi sodassa 1939-1945 (ed. Seppo Myllyniemi) (Otava, Helsinki 1982)

Suomi sodassa: talvi- ja jatkosodan tärkeät päivät

(Valitut Palat, Helsinki 1982)

Suomi: Tiedon ja osaamisen yhteiskunta (Valtion tiede- ja teknologianeuvosto, Helsinki 1996)

Suomi 1944: sodasta rauhaan (Tammi, Helsinki 1984)

Suomi 76 vuotta (Weilin & Göös. Gummerus, Jyväskylä 1991)

Suominen-Kokkonen, Renja, "Women architects - Training, Professional Lives and Roles" in The Work of Architects. The Finnish Association of Architects 1892-1992 (The Finnish Association of Architects and The Finnish Building Centre, Helsinki 1992)

Supinen, Marja, "A.W. Finch et les ateliers'"Iris" 1897-1902" in A.W. Finch 1854-1930. Catalogue of "Alfred William Finch 1854-1930" exhibition at the Musées royaux des Beaux-Arts de Belgique à Bruxelles (Crédit Communal, Brussels 1992)

Sutcliffe, Anthony, Towards the Planned City. German, Britain, the United States and France 1780-1914. Comparative Studies in Social and Economic History 3, (Oxford 1981)

Svinhufvud, Leena, "Finnish Textiles en Route to Modernity" in Finnish Modern Design. Utopian Ideals and Everyday Realities, 1930-1997 (Eds. Marianne Aav & Nina Stritzler-Levine) (The Bard Graduate Center for Studies in the Decorative Arts and Yale University Press, New Haven and London , 1998)

Tambini, Michael, The Look of the Century. Design Icons of the 20th Century (Revised edition, Dorling Kindersley, London 1999)

Tanner, Väinö, Näin Helsingin kasvavan (Tammi, Helsinki 1947)

Tanner, Väinö, Nuorukainen etsii sijaansa yhteiskunnassa (Tammi, Helsinki 1951)

Tanner, Väinö, The Winter War. Finland against Russia 1939-1940 (Stanford 1957)

Tawaststjerna, Erik, Sibelius (Otava, Helsinki 1997)

Tikkanen, Henrik,'Snobs' Island (Chatto & Windus, London 1980)

Tillander-Godenhielm, Ulla, "Kultaseppiä Pietarissa" in Klinge, Matti, Keisarin Suomi (Schildts Förlag Ab, Espoo 1997)

Tillander-Godenhielm, Ulla (1998a), "Fabergé – korujen mestari" in Rakkaat vanhat tavarat (ed. Leena Nokela) (Otava, Helsinki 1998)

Tillander-Godenhielm, Ulla (1998b), "Suomen korutaide" in Rakkaat vanhat tavarat (ed. Leena Nokela) (Otava, Helsinki 1998)

Time flies. Finnair 75 years, Heikki Haapavaara (Helsinki 1999)

Tommila, Päiviö, "Tiedon leviäminen" in Suomen kulttuurihistoria 2. (Porvoo 1980)

Tommila, Päiviö, Helsinki kylpyläkaupunkina 1830 - 50-luvuilla (Helsinki-Seura, Huhmari 1982)

Topelius, Z., Matkahavaintoja puoli vuosisataa sitten (Werner Söderströmin kirjapaino, Porvoo 1904)

Topelius, Z., Muistiinpanoja vanhasta Helsingistä

(with introduction and comments by Torsten Steinby) (Helsinki-Seura, Jyväskylä 1986)

Topelius, Zacharias, Elämäkerrallisia muistiinpanoja. A facsimile edition of the first edition published in 1923 (Otava, Helsinki 1998)

Towards Telecommunications. Nokia since 1985 (1999)

Turpeinen, Oiva, Helsingin seudun puhelinlaitos 1882-1982 (Helsingin puhelinyhdisty, Helsinki 1981)

Turpeinen, Oiva, Energiaa pääkaupungille. Sähkölaitostoimintaa Helsingissä 1884-1984 (Espoo 1984)

Turpeinen, Oiva, Kunnallistekniikka Suomessa keskiajalta 1990-luvulle (Jyväskylä 1995)

Turpeinen, Oiva, Malliksi maailmalle. Suomen televiestinnän monopolien murtuminen 1977-1996 (Finnet-liitto, Helsinki 1996)

Turpeinen, Oiva, "Väestö" in Helsingin kaupungin historia vuodesta 1945 (Helsinki 1997)

Tweedie, Mrs Alec, Through Finland in Carts (Adam and Charles Black, London 1898)

20th century architecture Finland, ed. by Marja-Riitta Norri, Elina Strandertskjöld and Wilfried Wang (Museum of Finnish Architecture, Helsinki 2000)

Uola, Mikko, "Ylitse maan ja veen" 1924-1999: Suomen liikennelentäjäliitto ry:n 50-vuotisjuhlajulkaisu (Helsinki, 1999)

Upton, Anthony F., Finland in Crisis 1940-1941. A study in small-power politics (Faber & Faber, London 1964)

Upton, Anthony F., Finland 1939-1940 (Davis-Poynter, London 1974)

Urbans, Runar, Suomen säästöpankkilaitos 1822-1922 (Suomen säästöpankkiliitto, Vammala 1963)

Uusitalo, Kari, Eläviksi syntyneet kuvat. Suomalaisen elokuvan mykät vuodet 1896-1930. Filmografia Fennica 1904-1930. (Otava, Helsinki 1972)

Valkonen, Kaija – Valkonen, Markku,'Festival Fever. Finland Festivals (Otava, Helsinki 1994)

Valkonen, Markku, Finnish Art over the Centuries. (Otava, Helsinki 1992)

Valkonen, Olli, Golden age. Finnish Art 1850-1907 (WSOY, Porvoo 1992)

Valkonen, Olli, "Wassily Kandinsky's Early Contacts with Finland," in Kandinsky, exhibition catalogue (Retretti, Punkaharju, Finland 1998)

Valvanne, Leena, "Välähdyksiä ajalta, jolloin opeteltiin elämään niukkuudessa" in Perheen puolesta. Väestöliitto 1941-1991 (Keuruu 1991)

Vapalahti, Hannu, Suomalaiset matkustajalaivat 1960-1996, osa 1. Aallottaresta Isabellaan (Judicor, Tampere 1996)

Vasenius, Valfrid, Suomalainen kirjallisuus. Aakkosellinen ja aineenmukainen luettelo. 1. lisävihko 1878-1879 ynnä lisätietoja vanhemmista kirjoista - La literature finnoise. Catalogue alphabétique et systématique.

Supplément I. 1878-1879 avec des renseignements additionels sur les livres parus auparavant. (Suomalaisen Kirjallisuuden Seuran toimituksia 57 osa.(Helsinki 1880)

Veltheim, Katri, *Tuntematon vuosikymmeneni 30-luku* (Jyväskylä 1989)

Venäläiset Suomessa 1809-1917 (ed. Pauli Kurkinen). (Historiallinen Arkisto 83. Suomen Historiallinen Seura, Helsinki 1984)

Vihavainen, Timo, "Finnish Broadcasting Company during the War and the Late Forties" in Y*leisradio 1926-1996. A History of Broadcsating in Finland* (Finnish Historical Society & Yleisradio Oy, Helsinki 1996)

Wiherheimo, Onni - Rein, Gabriel, "Kunnalliselämä" in *Helsingin kaupungin historia III:2. Ajanjakso 1809-1875* (Helsinki, 1951)

Viiste, Juhani O.V., *Viihtyisä vanha Wiipuri* (Werner Söderström Osakeyhtiö, Porvoo 1943)

Viljanen, T.V.,""Helsinki toisessa maailmansodassa" in *Helsingin kaupungin historia V:2* (Porvoo 1964)

Viljo, Eeva Maija, "The Architectural Profession in Finlad in the Latter Half of the 19th Century" in *The Work of Architects; The Finnish Association of Architects 1892-1992* (The Finnish Association of Architects and the Finnish Building Centre (Rakennustieto, Helsinki 1992)

Virtamo, Keijo, "Performing Music" in *Finnish Music* by Kalevi Aho, Pekka Jalkanen, Erkki Salmenhaara and Keijo Virtamo (Otava, Helsinki 1996)

Virtanen, Keijo & Heikkonen, Esko, *Amerikkalaisen kulttuurin leviäminen Suomeen. Tutkimusraportti Suomen Akatemian tukemasta projektista* (Turku 1985)

Volkov, Solomon, *St. Petersburg: a cultural history* (Sinclair-Stevenson, London 1996) / Volkov, Solomon, *Pietari: eurooppalainen kulttuurikaupunki* (Otava, Helsinki 1996)

Vuorinen, Juha and Heikkonen, Iiris, "The Implementation of Finnish American Academic and Professional Exchanges" in *Finnish Academic and Professional Exchanges: Analyses and Reminiscenses* , William Copeland (ed.) (Foundation for Research in Higher Education and Science Policy, Espoo 1983)

Vuoristo, Osmo, "Kansantaide" in *Ars – Suomen taide 5* (Weilin & Göös. Kustannusosakeyhtiö Otava. Keuruu 1990)

Vuosien varrelta valittua. Yhdyspankin henkilökunnalle pankin tyttäessä 90 vuotta 21.5.1952 (Suomen Yhdyspankki, Helsinki 1952)

Vuosisata sähköä Suomessa (Suomen Sähkölaitos ry, Espoo 1982)

Waris, Heikki, "Yliopisto sosiaalisen kohoamisen väylänä. Tilastollinen tutkimus säätykierrosta Suomessa 1810-67," in *Historiallinen Arkisto XLVII* (Suomen Historiallinen Seura, Helsinki 1940)

Waris, Heikki, "Helsinkiläisyhteiskunta" in *Helsingin kaupungin historia III osa, 2. vol. , ajanjakso 1809-1875* HKH III:2 (Helsinki 1950)

Waris, Heikki, "Suurkaupungin kotiseutuharrastus" in *Kauppiaiden ja merenkulkijain Helsinki (Entisaikain Helsinki V).* (Helsinki 1954)

Waris, Heikki, *Työläisyhteiskunnan syntyminen Helsingin Pitkänsillan pohjoispuolelle.* 2nd revised edition (Oy Weilin & Göös Ab, Tapiola 1973)

Wegg, John, *The Art of Flying since 1923* (Helsinki, 1983)

Welcome to Finland (Helsinki 1999)

Westwood, J.N., *Endurance and endeavour: Russian history 1812-1971* (Oxford University Press, London 1973)

Wheatcroft, Geoffrey "On Top of the World" in *The Guardian* 30.11.2001

Whitford, Frank, *Bauhaus* (Thames & Hudson, London 1984)

Wickberg, Nils Erik, "Yksityistaloja Helsingin Kruunuhaassa empire-ajalla" in *Entisaikain Helsinki. Helsingin Historiayhdistyksen vuosikirja I.* (Helsinki 1936)

Wiener, Martin J., *English Culture and the Decline of the Industrial Spirit 1850-1980* (Penguin, London 1992)

Wiherheimo, Onni ja Rein, Gabriel, "Kunnalliselämä" in *Helsingin kaupungin historia III:2. Ajanjakso 1809-1875* (Helsinki, 1951)

Wood, Ghislaine & Greenhalgh, Paul, "Symbols of the Sacred and Profane" in *Art Nouveau 1890-1914*, ed. by Paul Greenhalgh (V&A Publications, London 2000)

The Work of Architects. The Finnish Association of Architects 1892-1992. (The Finnish Association of Architects and The Finnish Building Centre, Helsinki 1992)

The World Competitiveness Yearbook (Lausanne, 1998)

Wäre, Ritva,'"From Historicist Architecture to Early Modernism," in *20ᵗʰ Century Architecture: Finland* (Exhib.cat. eds. Marja-Riitta Norri, Elina Standertskjöld and Wilfried Wang) (Museum of Finnish Architecture, Helsinki & Deutsches Architektur-Museum, Frankfurt am Main, Helsinki 2000)

XV Olympiakisat Helsingissä 1952. Järjestelytoimikunnan virallinen kertomus (WSOY, Porvoo 1955)

Yovleva, Lidia, "The Itinerants. On the history of Russian painting in the second half of the 19ᵗʰ century," in *Great Russian Masters 1950-1900.* Exhib.cat. (Ateneum, Helsinki 1995)

Zetterberg, Seppo, *Finland after 1917* (Otava, Helsinki 1991)

Zetterberg, Seppo, *Eero Erkko* (Otava, Helsinki 2001)

Åström, Sven-Erik, "Kaupunkiyhteiskunta murrosvaiheessa" in *Helsingin kaupungin historia IV:2. Ajanjakso 1875-1918* (Helsinki 1956)

[**431**]

UNPUBLISHED:

Lahtinen, Merja, *Suomalaisten lääkärien ulkomaiset opintomatkat vuosina 1860-1889.* MA thesis in general history (Department of History, University of Helsinki 1998)

INTERNET:

Citibank.com
<URL: http://www.citibank.pl> (8.5.2002)
City of Helsinki Urban Facts - Statistics and Information Service
<URL: http://www.hel.fi/tietokeskus/en/tilastoja/ index.html> (9.5.2002)
Erasmus statistics 1993-94 (PDF-file)
<URL: http://europa.eu.int/comm/education/ erasmus/statisti/stat1.pdf> (8.5.2002)
Facts about Helsinki (2001) (PDF-file) <URL: http:// www.hel.fi/tietokeskus/tilastoja/taskutilasto/ engl2001.pdf> (8.5.2002)
Finnair. Annual Report 1999/2000 (PDF-file) <URL: http://www.finnair.fi/uploaded_files/docs/ on20020115/VSK9900engl.pdf > (8.5.2002)
Korkeakoulutuksen kansainvälisen toiminnan strategia (PDF-file)
<URL: http://www.minedu.fi/julkaisut/ julkaisusarjat/23kk_kvstrategia/ 23kvstrategia.pdf>
(Opetusministeriö, Helsinki 2001) (8.5.2002)
Passangers in International traffic
<URL: http://www.ilmailulaitos.com/netcomm/ Chunker/download.asp?id=2603;210212> (8.5.2002)
Science and technology in Finland
<URL: http://www.stat.fi/tk/yr/st2000.html> (Statistics Finland) (8.5.2002)
Social Capital for Development - Home Page
<URL: http://worldbank.org/poverty/scapital> (8.5.2002)
Suomalaisen Työn Liitto
<URL: http://www.avainlippu.fi/stl/historia.asp> (8.5.2002)
Suomen Youth For Understanding ry
<URL: http://www.yfu.fi> (8.5.2002)
Taulukoita KOTA-tietokannasta 2000 (PDF-file)
<URL: http://www.minedu.fi/julkaisut/pdf/ 87kota.pdf> (8.5.2002)
Tieteellinen julkaisutoiminta
<URL: http://www.research.fi/k_julk_fi.html> (8.5.2002)

Time series: student mobility per home country (1987-2000)
(PDF-file)
<URL: http://europa.eu.int/comm/education/ erasmus/statisti/stat1.pdf> (8.5.2002)
Työllisyys toimialoittain 2001/2 ja 2002/2
<URL: http://www.stat.fi/tk/el/tyoll03s.html> (8.5.2002)
Ulkomailla tutkintoaan suorittavat suomalaiset 1991-2001 <URL: http://www.cimo.fi/tilastot/ muut/studabr.html> (8.5.2002)
University of Helsinki in brief
<URL: http://www.helsinki.fi/english/ uhinbrief01.html> (8.5.2002)
Virtual Finland <URL:
http://virtual.finland.fi/finfo/english/ ortodeng.html> (8.5.2002)
What is CIMO
<URL: http://www.cimo.fi> (8.5.2002)

INTERVIEWS (interviewer Marjatta Bell):

Ahlholm, Marja, Head of the Open Learning Centre, Amiedu, Helsinki (20.2.2000)
Arokanto, Markku, Theatre Director, Helsinki (17.10.2001)
Ehrstedt, Henry, CEO, ICL Invia Oyj, Helsinki (21.2.2000)
Heinonen, Rauno, Head of Public Relations, ICL Invia Oyj, Helsinki (18.2.2000)
Hirvonen, Markku, Payment System Expert, The Finnish Bankers' Association, Helsinki (17.11.1999)
Kanervisto, Olavi, IT Support Officer, Yhtyneet Kuvalehdet Oyj, Helsinki (19.11.1999)
Myllykangas, Janne, MSc (Eng.), Imatra (19.7.2001)
Nuutinen, Pentti, Vice-President, Society Relations, ABB Oyj, Helsinki (17.2.2000)
Rantala, Jaana, Educational Planner, London (17.10.2001)
Ronkainen, Maj-Britt, Switch Board Operator, ABB Oyj, Helsinki (17.2.2000)
Smalén, Lauri, MSc (Eng.), Helsinki (2.3.2002)
Sävilammi, Jaakko, MSc (Eng.), Iocore Oyj, Helsinki (19.3.2002)
Sävilammi, Marjaana, MSc (Eng.), Helsinki (2.3.2002)
Wuorenheimo, H.O., Networking Specialist, Computer Sciences Corporation Inc., Frankfurt am Main, (5.11.1999)

Appendix I

Economically active population by source of income in Finland, 1880-2000 (percentages)

	1880	1900	1920	1940	1960	1980	2000
Agriculture and forestry	73	68	70	60	35.5	12.6	6
Manufacturing and construction	6	11	12	16	31.5	34.3	27.9
Trade and commerce	1	2	3	4	11.6	16.7	*)27,6
Transport and communications	2	3	3	4	6.3	7.9	7.1
Services	6	8	6	9	14.8	26.2	31.2
General workers	5	3	4	5			
Unknown	6	5	3	2	0.3	2.2	0.2
Totals	100	100	100	100	100	100	100

*)Including financial and business services

*Sources: The Economic History of Finland 3; Historical Statistics. Helsinki, 1983 ;
Yearbook of Nordic Statistics, Vol. 24. Copenhagen, 1985;
http://www.stat.fi/tk/el/tyoll03s.html (2/2000)*

Appendix II

Population of the Helsinki Region on 1 January 1875 - 2000

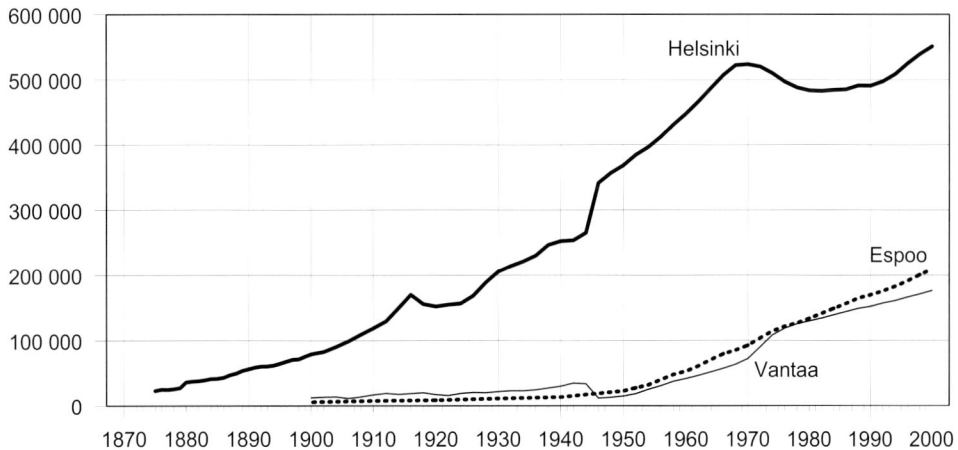

Source: Helsinki tilastoina 1800-luvulta nykypäivään, 2000:15 Tilastoja, Helsingin kaupungin tietokeskus.
[Statistical description of Helsinki from the 19th century to the present day. In Finnish]

Appendix III

Employed Labour Force by Industry in Helsinki 1880-1950

	1880	1890	1900	1910	1920	1930	1940	1950
Agriculture & Forestry	220	430	605	327	2004	2009	636	1608
Industry	3846	7397	10976	16147	24977	33907	52920	65114
Construction	1099	2113	2344	3850	6022	9867	12336	15220
General workers/ unskilled workers	3907	6532	7148	14810	2060	3919	1779	-
Wholesale and retail trade, repair	1187	2185	4556	5838	14383	22827	28070	42042
Transport	1232	2234	2665	4686	9798	9874	12254	18193
Services	9384	8981	18387	14683	25984	33331	53446	54496
Unknown	1530	1539	1931	14288	13936	10063	32542	3708
Labour force total	22405	31411	48612	74629	99164	125797	193983	200381

Employed Labour Force by Industry in Helsinki 1880-1950, percental share of total

	1880	1890	1900	1910	1920	1930	1940	1950
Agriculture & Forestry	1,0	1,4	1,2	0,4	2,0	1,6	0,3	0,8
Industry	17,2	23,5	22,6	21,6	25,2	27,0	27,3	32,5
Construction	5,0	6,7	4,8	5,2	6,0	7,8	6,4	7,6
General workers/ unskilled workers	17,4	20,8	14,7	19,8	2,1	3,1	0,9	-
Wholesale and retail trade, repair	5,3	7,0	9,4	7,8	14,5	18,1	14,5	21,0
Transport	5,5	7,1	5,5	6,3	10,0	7,8	6,3	9,1
Services	41,9	28,6	37,8	19,7	26,2	26,5	27,6	27,2
Unknown	6,7	4,9	4,0	19,2	14,0	8,1	16,7	1,8
Labour force total	100	100	100	100	100	100	100	100

Source: Helsinki tilastoina 1800-luvulta nykypäivään, p. 67.

Appendix IV

Number of jobs in Helsinki 1993-1998

	1993	1994	1995	1996	1997	1998
Manufacturing	27314	28739	29309	28979	29677	31853
Electricity, gas and water supply	3106	3029	2972	2837	2700	2618
Construction	10301	10212	10560	11836	12918	15186
Wholesale and retail trade, repair	41133	40678	41463	41926	44111	46169
Hotels and restaurants	10550	10882	11347	12461	13177	14169
Transport, storage and communication	27925	26425	27636	29689	31518	34403
Financial intermediation	19194	19944	18642	17099	16936	16600
Real estate, renting and business activities	36732	40263	41484	44644	48436	57908
Public administration and defense						
compulsory social security	27740	29591	29334	29983	29884	31022
Education	16081	15915	16732	18155	19652	20195
Health and social work	37245	36967	37686	38082	40051	41526
Other community, social and personal services	25974	25512	25364	26446	27368	28629
Other[1]	869	698	654	685	706	639
Industry unknown	6563	5382	4749	4692	4296	4022
Jobs total	290727	294237	297932	307514	321430	344939

[1]Includes agriculture, hunting, and forestry, fishing, mining and quarrying, extra-territorial organizations and bodies

Number of jobs in Helsinki 1993-1998, percental share of total

	1993	1994	1995	1996	1997	1998
Manufacturing	9,4	9,8	9,8	9,4	9,2	9,2
Electricity, gas and water supply	1,1	1,0	1,0	0,9	0,8	0,8
Construction	3,5	3,5	3,5	3,8	4,0	4,4
Wholesale and retail trade, repair	14,1	13,8	13,9	13,6	13,7	13,4
Hotels and restaurants	3,6	3,7	3,8	4,1	4,1	4,1
Transport, storage and communication	9,6	9,0	9,3	9,7	9,8	10,0
Financial intermediation	6,6	6,8	6,3	5,6	5,3	4,8
Real estate, renting and business activities	12,6	13,7	13,9	14,5	15,1	16,8
Public administration and defense						
compulsory social security	9,5	10,1	9,8	9,8	9,3	9,0
Education	5,5	5,4	5,6	5,9	6,1	5,9
Health and social work	12,8	12,6	12,6	12,4	12,5	12,0
Other community, social and personal services	8,9	8,7	8,5	8,6	8,5	8,3
Other[1]	0,5	0,1	0,4	0,2	0,3	0,1
Industry unknown	2,3	1,8	1,6	1,5	1,3	1,2
Jobs total	100	100	100	100	100	100

[1]Includes agriculture, hunting, and forestry, fishing, mining and quarrying, extra-territorial organizations and bodies

Source: Statistics Finland, regional employment Statistics 1993-1998.

Appendix V

Gross Domestic Product per capita in Finland 1860–2000*

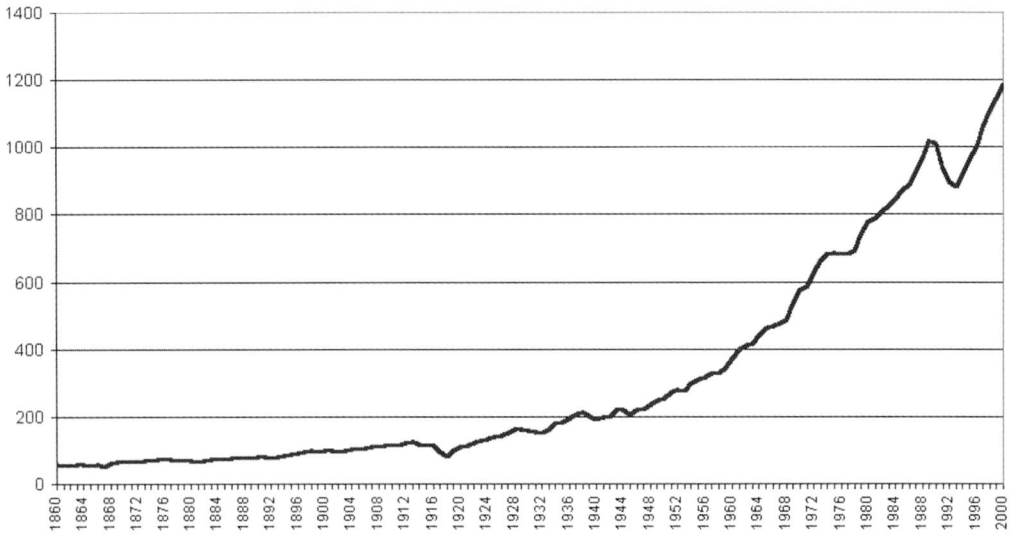

*NB. The economic recession at the beginning of the 1990s

Appendix VI

Support for the Political Parties in Municipal Elections

Year	1.	2.	3.	4.	5.	6.	7.	8.	9.	10.	11.	12.	13.	14.	15.	Total
1953	0,0	21,1	25,8	0,0	0,0	0,0	0,0	0,0	14,0	0,0	17,8	21,2	0,0	0,0	0,1	**100,0**
1956	0,0	19,0	24,4	0,0	0,0	0,0	0,0	0,0	15,2	0,0	18,2	23,1	0,0	0,0	0,1	**100,0**
1960	0,0	19,7	20,5	4,8	0,0	0,0	0,0	0,0	11,5	0,0	16,3	26,2	0,0	0,0	1,0	**100,0**
1964	0,0	19,3	26,6	2,2	0,0	0,0	0,0	0,0	9,3	0,0	14,1	27,2	0,0	0,0	1,3	**100,0**
1968	0,0	14,0	25,7	2,0	5,0	0,0	0,0	1,7	10,6	0,0	13,1	26,2	0,0	0,0	1,7	**100,0**
1970	0,0	15,0	28,0	0,0	3,0	0,0	0,0	1,2	10,1	1,7	12,0	29,0	0,0	0,0	0,0	**100,0**
1972	0,0	16,0	30,8	0,0	1,9	0,0	0,0	1,7	8,5	2,8	11,0	26,7	0,0	0,0	0,6	**100,0**
1976	0,0	17,7	25,1	0,0	1,1	0,0	0,0	3,5	6,8	4,0	7,8	28,7	0,0	4,8	0,5	**100,0**
1980	0,0	15,9	25,6	0,0	2,0	1,7	0,0	3,3	4,0	4,2	8,2	31,3	0,0	3,4	0,4	**100,0**
1984	2,7	10,1	21,5	0,0	3,5	8,2	4,5	3,2	0,0	3,5	9,2	29,8	0,0	3,0	0,8	**100,0**
1988	2,4	8,1	23,4	0,0	1,5	7,6	4,0	4,5	1,1	3,1	9,7	29,6	0,0	1,7	3,3	**100,0**
1992	0,0	8,6	22,8	0,0	0,6	17,0	4,7	3,3	1,5	2,8	9,0	23,2	0,0	1,6	4,9	**100,0**
1996	0,4	7,7	23,1	0,0	0,1	18,4	0,0	3,7	0,1	2,5	8,9	27,3	5,1	0,0	2,7	**100,0**
2000	1,6	8,2	20,4	0,0	0,1	23,5	0,0	4,6	0,0	3,5	7,6	28,9	0,0	0,0	1,6	**100,0**

Source: Statistical Yearbooks of Helsinki 1953-2000.

Parties:

1. Democratic Alternative
2. The Left Wing Alliance (former The Finnish People´s Democratic League)
3. The Finnish Social Democratic Party
4. Social Democratic Union of Workers and Smallholders
5. Finnish Rural Party
6. The Green Party
7. Helsinki 2000
8. The Finnish Centre Party
9. The Liberal Party of Finland (former The National Progressive Party)
10. The Christian Democrats (former The Finnish Christian Union)
11. The Swedish People´s Party
12. The National Coalition Party (The Conservatives)
14. The True Finns Party
15. Others

Appendix VII

Significant Dates in Helsinki's History

FINLAND		HELSINKI	
1150s	Consolidation of Swedish rule in Finland begins. Later Turku becomes the capital		
1527	Lutheran Reformation		
1543	*ABC-kiria*, the first Finnish language book	**1550**	Helsinki is founded by King Gustavus Vasa
1640	The first university in Finland is founded in Turku	**1640**	Helsinki is moved to its present site
		1748	The building of Sveaborg (Suomenlinna) begins
1809-09	War between Sweden and Russia. Finland becomes an Autonomous Grand Duchy of the Russian Empire	**1808**	Helsinki is invaded by the Russians and destroyed by fire
		1812	Alexander I makes Helsinki the capital of Finland
		1815	A new town plan is drawn up by J.A. Ehrenström
		1816	C.L. Engel is appointed architect to the city
		1827	First permanent theatre in Helsinki is opened
		1828	University is moved from Turku to Helsinki
1831	Founding of the Finnish Literature Society	**1831**	Helsingfors Lyceum, the first modern school, is established in Helsinki
1835	*Kalevala*, the national epic is published		
1838	Founding of the Finnish Society of Sciences and Letters	**1838**	Kaivopuisto Spa is opened to the public
1848	The first performance of the Finnish national anthem	**1845**	Founding of the Symphonic Society and the organising of the first art exhibition in Helsinki
1855	The Crimean War	**1855**	Suomenlinna is bombarded by the British and French fleets
1856	Alexander II visits Finland promulgating a programme of reforms in education, trade, industry and communications		
1860	Finland gets is own currency, the *markka*	**1860**	Gas lighting is introduced in Helsinki
1863	Regular meetings of the Diet begin	**1862**	Helsinki-Hämeenlinna railway opened
	Finnish language becomes an official language equal in status with Swedish		
1866-68	Years of the Great Famine		
1868	Abolition of craft guilds	**1870**	Helsinki-St Petersburg railway opened
		1875	New Helsinki City Council
		1876	First industrial exhibition in Helsinki
1879	Freedom of trade and occupation	**1877**	First telephone in Helsinki
		1884	Electrical lighting is introduced in Helsinki
1899	February Manifesto signals a start to the russification of Finland		

1904	Assassination of Governor General Bobrikov		
1906	Parliamentary reform launches unicameral *eduskunta* and universal suffrage for both men and women	**1906-08**	Building of first garden suburbs begins
1917	On 6.12. Parliament declares Finland an independent country		
1918	Civil War in January - May between the "Reds" and the "Whites"	**1918**	Helsinki is a base of the "Reds". German troops assist the victory of the "Whites" in Helsinki
1919	Finland becomes a republic		
		1920	First national trade exhibition organised in Helsinki
1923	Regular radio broadcasting starts in Tampere (1926 from Helsinki)	**1924**	First regular flights from Helsinki to Tallinn and to Stockholm
		1935	The foundation in Helsinki of the pioneering design firm Artek and of the Free Art School to promote modernism in Finland
1939-45	Winter War 1939-40 Continuation War 1941-44 Lapland War 1944-45	**1944**	Heavy bombings in Helsinki in February
1947-47	Soviet-British Allied Control Commission in Finland	**1946**	Incorporation of neighbouring areas expands Helsinki fivefold from c. 30 sq km to over 160 sq km
1948	Treaty of Friendship, Cooperation and Mutual Assistance with the Soviet Union		
		1951	First Sibelius Festival
1952	The Olympic Games are held in Helsinki War reparation payments are completed	**1952**	Opening of the present Helsinki-Vantaa airport
		1950s	Building of Tapiola Garden City
1955	Finland joins the United Nations and the Nordic Council	**1950s onwards**	New major suburbs developed on the outskirts of Helsinki
		1956	First regular TV transmissions by TES-TV
		1965	Alvar Aalto's plan for Helsinki City Centre
		1965	First Helsinki exhibition held in Vienna. In the following years it visits other European cities and Los Angeles
		1967	Helsinki City Theatre opened
1968	Act on school reform which created a comprehensive school system	**1968**	First Helsinki Festival replaces the Sibelius Festival. It develops into a major national arts event
		1971	Finlandia Hall opened
1973	Free trade agreement with the EEC		
1975	Finland hosts in Helsinki the Conference on Security and Cooperation in Europe		
		1978 1982	Helsinki-based HTV becomes one of the first companies in Europe to transmit cable and satellite television
		1982	The first metro line begins to operate
		1989	First "Night of the Arts" at the Helsinki Festival
		1993	Finnish band, Leningrad Cowboys, and the Red Army Ensemble perform together in Senate Square
1995	Finland joins the European Union		
		1998	Opening of Kiasma, the Museum of Contemporary Art
1999	Finland is the President of the European Union		
		2000	450th Anniversary celebrations. Helsinki is also one of the European Cities of Culture

Subject Index

Person Index

compiled by Eeva-Liisa Haanpää